MEDICINE

A TREASURY OF ART

AND LITERATURE

MEDICINE

A TREASURY OF ART AND LITERATURE

Edited by Ann G. Carmichael
and Richard M. Ratzan

Hugh Lauter Levin Associates, Inc.

Distributed by Macmillan Publishing Company, New York

Cyril P. Bryan. *Ancient Egyptian Medicine: The Papyrus Ebers.* Ares Publishers, Inc.

J. Worth Estes. "Surgical Problems and Solutions." *The Medical Skills of Ancient Egypt.* Science History Publications. Copyright © Watson Publishing International, 1989.

Edith Hamilton. *Mythology.* Copyright © 1942 by Edith Hamilton. Copyright © renewed 1969 by Dorian Fielding Reid and Doris Fielding Reid. By permission of Little, Brown and Company.

The Hippocratic Oath: Text and Translation. Translated by Ludwig Edelstein. Reprinted by permission of The Johns Hopkins University Press.

Hippocrates. Volume II. Translated by W.H.S. Jones. Loeb Classical Library. George Putnam's Sons, 1923.

Celsus. *On Medicine.* Volume III. Translated by W.G. Spencer, Cambridge, Mass. Harvard University Press, 1938. Reprinted by permission of the publishers and The Loeb Classical Library.

Galen. "A Case History," from *De Locis Affectis,* Book II. Translated by James Finlayson. *British Medical Journal,* 1892.

Chuang T'zu. *The Washing Away of Wrongs.* Translated by Brian E. McKnight. Center for Chinese Studies, The University of Michigan, 1981.

Anonymous. "How Derold Was Duped by a Certain Physician, but [Later] Duped Him." Translated in Loren C. MacKinney, *Bulletin of the History of Medicine,* 2(1934): 367–68.

Anonymous. "Admonitions of Hippocrates." Translated in Loren C. MacKinney *Bulletin of the History of Medicine,* 26(1952): 20–21. Reprinted by permission of The Johns Hopkins University Press.

Albucasis. "On the Extraction of Arrows" in Leo M. Zimmerman and Ilza Veith, *Great Ideas in the History of Surgery.* Copyright © 1967 by Leo M. Zimmerman and Ilza Veith. Copyright © 1961 by The William & Wilkins Company.

Rotha Mary Clay. *The Medieval Hospitals of England.* Methuen & Co. 1909.

A Medieval Woman's Guide to Health: An English Trotula Manuscript. Translated and Edited by Beryl Rowland. Copyright © 1981 by The Kent State University Press.

Barbara W. Tuchman. *A Distant Mirror.* Copyright © 1978 by Barbara W. Tuchman. Reprinted by permission of Alfred A. Knopf, Inc.

Chang Chieh-Pin. "Medicine Is Not a Petty Teaching" in Paul Unschuld, *Medical Ethics in Imperial China: A Study in Historical Anthropology,* pp. 81–84. Copyright © 1979, The Regents of the University of California.

Francesco Petrarch. *Letters from Petrarch.* Edited and translated by Morris Bishop. Copyright © Indiana University Press. Reprinted by permission of Indiana University Press, publisher, 1966.

Desiderius Erasmus. *The Colloquies of Erasmus.* Translated by Craig R. Thompson. Copyright © 1965 by The University of Chicago. All rights reserved.

Alessandro Benedetti. "The History of the Human Body" in *Studies in Pre-Vesalian Anatomy: Biography, Translations, Documents.* Translated and Edited by L. E. Lind. From the proceedings of the American Philosophical Society, vol. 119. Copyright © 1975, The American Philosophical Society.

Michel de Montaigne. *Autobiography.* Translated and Edited by Marvin Lowenthal. Houghton Mifflin Company, 1935.

Ambroise Paré. *The Ten Books of Surgery with the Magazine of the Necessary Instruments of It.* Translated by Robert White Linker and Nathan Womak. Published by The University of Georgia Press, 1969.

John Donne. *Selected Prose.* Edited by Helen Gardner. Copyright © 1967, Oxford University Press.

William Harvey. *On the Motion of the Heart and Blood in Animals.* Translated by Thomas Willis, revised and edited by Alexander Bower. Henry Regnery Company, Chicago.

Alessandro Manzoni. *The Betrothed.* Copyright © 1951, renewed © 1979 by E.P. Dutton. Used by permission of the Publisher, Dutton, an imprint of New American Library, a division of Penguin Books USA Inc.

Moliere. *The Imaginary Invalid.* Adapted by Miles Malleson. By kind permission of Samuel French Ltd.

Bernardino Ramazzini. *Diseases of Workers,* 1713. Translated by Dr. Wilmer Cave Wright. Copyright © 1940, The New York Academy of Medicine. Published by the University of Chicago Press.

Paul U. Unschuld. *Medicine in China: A History of Pharmaceutics.* Copyright © 1986, The Regents of the University of California.

A Midwife's Tale. The Life of Martha Ballard, Based on Her Diary, 1785–1812, by Laurel Thatcher Ulrich. Copyright © 1990 by Laurel Thatcher Ulrich. Reprinted by permission of Alfred A. Knopf, Inc.

Grace Goldin. "A Walk Through a Ward of the Eighteenth Century," pp. 121–138, Volume XXII, No. 2, April 1967. Copyright © *Journal of the History of Medicine and Allied Sciences, Inc.* New Haven, Connecticut, U.S.A., 1967.

Edward Jenner. *An Inquiry into the Causes and Effects of the Variolae Vaccinae, a Disease . . . Known by the Name of the Cow Pox.* London, 1798.

René Théophile Hyacinthe Laënnec. "The Invention of the Stethoscope" in *On Mediate Ausculation,* 1819. Translated by John Forbes, London, 1834.

Ignaz Semmelweis. *The Etiology, Concept, and Prophylaxis of Childbed Fever.* Translated by K. Codell Carter. Copyright © 1983. Reprinted by permission of The University of Wisconsin Press.

The Works of Heinrich Heine. Translated by Charles Godfrey Leland. William Heinemann, 1893.

John Snow. *On the Mode of Communication of Cholera,* 2nd ed. London, 1855.

John Collins Warren. "Inhalation of Ethereal Vapor for the Prevention of Pain in Surgical Operations." *Boston Medical and Surgical Journal* 36: 375, December 9, 1846.

John Kirk Townsend. *Narrative of a Journey Across the Rocky Mountains to the Columbia River.* 1839.

Sir William Osler. *William Beaumont: A Backwood Physiologist.* Journal of the American Medical Association. 39(1902): 1223–31.

Henry Clay Lewis. "The 'Mississippi Patent Plan' for Pulling Teeth." *Odd Leaves from the Life of a Louisiana Swamp Doctor,* 1850.

John G. Neihardt. *Black Elk Speaks: Being the Life Story of a Holy Man of the Oglala Sioux.* Copyright © 1961 by the John G. Neihardt Trust. Published by The University of Nebraska Press, 1961.

Iroquois People. "The Ritual of Condolence" in John Bierhorst, *Four Masterworks of American Indian Literature.* Copyright © by John Bierhorst. The University of Arizona Press.

David Livingstone. *Missionary Travels and Researches in Southern Africa,* as cited in Max Gluckman, ed., *The Allocation of Responsibility.*

Edward S. Ayensu. "A Worldwide Role for Healing Powers of Plants." *Smithsonian Magazine,* November 1981, pp. 86–90.

Lu Hsun. *Selected Stories of Lu Hsun.* Foreign Languages Press, 1972.

Thomas De Quincey. *Confessions of an English Opium Eater.* Courtesy Woodstock Books.

Howard Markel. "Charles Dickens and the Art of Medicine." *Annals of Internal Medicine,* 1984: 101: 408–411.

Sir Frederick Treves. *The Elephant Man and Other Reminiscences.* W.H. Allen & Co., Ltd., 1923.

Leo Tolstoy. *The Death of Ivan Ilyich and Other Stories.* Translated by Rosemary Edmonds (Penguin Classics, 1960), Copyright © by Rosemary Edmonds, 1960.

Giovanni Verga. *Little Novels of Sicily.* Translated by D.H. Lawrence. Grove Press, 1923.

W.B. Howie and S.A.B. Black. "Sidelights on Lister: A Patient's Account of Lister's Care." Reprinted with permission from the *Journal of the History of Medicine and Allied Sciences,* Volume XXXII, no. 3, July 1977, pp. 239–51.

Katherine Mansfield. *Journal of Katherine Mansfield.* Copyright © 1927 by Alfred A. Knopf, Inc. and renewed 1955 by J. Middleton Murry. Reprinted by permission of Alfred A. Knopf, Inc.

André Malraux. *Lazarus.* Translation copyright © 1977 by McDonald & Janes. Copyright © 1974 by Editions Gallimard.

Leonard Kriegel. "Falling into Life," in *The American Scholar.* Volume 57, 1988, pp. 407–18.

Clifford W. Beers. *A Mind That Found Itself: An Autobiography.* Longmans, Green & Co. 1908.

Robert Lowell. "Skunk Hour," in *Life Studies.* Copyright © 1956, 1959 by Robert Lowell. Copyright © renewal 1981, 1986, 1987 by Harriet W. Lowell, Caroline Lowell, and Sheridan Lowell. Reprinted by permission of Farrar, Straus & Giroux, Inc.

Louis Pasteur. "Prevention of Rabies," in *Source Book of Medical History.* Dover Publications, Inc.

Wilhelm Conrad Roentgen. "On a New Kind of Rays" in *Wilhelm Conrad Roentgen and the Early History of the Roentgen Rays* by Dr. Otto Glasser. Charles C. Thomas Publishers, 1934.

William Stewart Halsted. "The Training of the Surgeon," *American Medicine* 8(1904), pp. 69–75.

The Origins of Psychoanalysis: The Letters to Wilhelm Fliess, Drafts and Notes: 1887–1902, by Sigmund Freud. Edited by Marie Bonaparte, Anna Freud, and Ernst Kris. Authorized translation by Eric Mosbacher and James Strachey. Copyright © 1954 by Basic Books, Inc. Reprinted by permission of Basic Books, a division of Harper Collins Publisher.

Gwyn Macfarlane. *Alexander Fleming: The Man and the Myth.* First published by Chatto & Windus. Permission granted by Watson, Little, Ltd.

Albert Schweitzer. *On the Edge of the Primeval Forest.* Macmillan Company, 1931.

Bernard Shaw. In *Too True To Be Good.* By permission of The Society of Authors on behalf of the Bernard Shaw Estate.

For permission to reproduce Florence Nightingale's letter of November 14th, 1854, to William Bowman, the publishers acknowledge the Trustees of the Henry Bonham-Carter Will Trust.

Emily Elizabeth Parsons. *Memoir,* letter XXII to her mother, from *Memoir of Emily Elizabeth Parsons.* Edited by Theophilus Parsons. 1880.

Albert Haas. *The Doctor and the Damned.* Copyright © 1984 by Albert Haas, M.D. Used with permission of St. Martin's Press, Inc., New York.

Gordon S. Seagrave. *Burma Surgeon.* © 1943 by W.W. Norton & Co., Inc.

John Hersey. *Hiroshima.* Copyright © 1946. Copyright renewed 1973 by John Hersey. Copyright © 1985 by John Hersey. Reprinted by permission of Alfred A. Knopf, Inc.

Arthur Conan Doyle, *The Man From Archangel.* George H. Duran, Co., 1919.

Edgar Lee Masters. "Doctor Myers" from *Spoon River Anthology.* Reprinted by permission of Ellen C. Masters.

Hans Zinsser. *As I Remember Him.* Copyright © 1939, 1940 by Hans Zinsser. Little, Brown and Company.

Owen Tully Stratton. *Medicine Man.* Copyright © 1989 by the University of Oklahoma Press.

William Carlos Williams. *Imaginations.* Copyright © 1970 by Florence H. Williams. Reprinted by permission of New Directions Publishing Corporation.

Anne Sexton. "Doctors" in *The Awful Rowing Toward God.* Copyright © 1975 by Loring Conant, Jr., Executor of the Estate of Anne Sexton. Reprinted by permission of Houghton Mifflin Co.

James T. Farrell. "My Friend the Doctor," which appeared in *Tambour* #8 and *Eight Short Short Stories and Sketches.* Reprinted by permission from the Estate of James T. Farrell.

W.P. Kinsella. *Moccasin Telegraph.* Copyright © 1983 by W.P. Kinsella. Reprinted by permission of David R. Godine, Publisher.

Corey Ford. *And How Do We Feel This Morning?* Reprinted by permission of Harold Ober Associates Incorporated. Copyright © 1962 by Curtis Publishing Co. Copyright renewed 1990 by S. John Stebbins and Hugh Grey.

Richard Selzer. *Letters to a Young Doctor.* Copyright © 1982 by David Goldman and Janet Selzer, trustees. Reprinted by permission of Simon & Schuster, Inc.

Dannie Abse. "X-ray" from *One-Legged on Ice.* Copyright © 1982 by Dannie Abse. Used by permission of the University of Georgia Press.

John Stone. *In All This Rain.* Copyright © 1980 by John Stone. Reprinted by permission of Louisiana State University Press.

Sherwin B. Nuland. *Doctors: The Biography of Medicine.* Copyright © 1988 by Sherwin B. Nuland. Reprinted by permission of Alfred A. Knopf, Inc.

Lewis Thomas. "The Artificial Heart," Copyright © 1983 by Lewis Thomas. From *Late Night Thoughts on Listening to Mahler's Ninth* by Lewis Thomas. Used by permission of Viking Penguin, a division of Penguin Books USA, Inc.

Paul Monette. "Waiting to Die" in *Poets for Life.* Copyright © 1989 by Paul Monette. Reprinted by permission of the Wendy Weil Agency. Published by Crown Publishers, Inc., N.Y.

Anonymous. "Revised Hippocratic Oath." From *The Best of the Journal of Irreproducible Results,* copyright © 1983 by the Journal of Irreproducible Results and Barry Scherr. Reprinted by permission of Workman Publishing Company, Inc. All Rights Reserved.

ACKNOWLEDGMENTS

The authors are particularly grateful to a number of libraries and their staffs for generous use of their collections. The University of Connecticut Health Center Library, Trinity College Library, the University of Arizona libraries in Tucson, and the West Hartford Public Library, Main Branch, kindly assisted Richard M. Ratzan. Indiana University libraries, including the rich Lilly Library holdings, aided Ann Carmichael, as did the Indiana University offices of Research and Graduate Development in their creation of a supporting Center for the History of Medicine. Many individuals among Hugh Lauter Levin's staff and Harkavy Publishing Service worked hard to complete this collection, but with us especially was Ellin Silberblatt, to whom the authors owe a personal debt of thanks.

CONTENTS

Traditional Medicine

ENLIGHTENMENT: RITUAL AND THE WORLD WE HAVE LOST *103*

Modern Medicine

FROM THE PATIENT'S ILLNESS TO THE DOCTOR'S DISEASE *131*

NON-WESTERN VISIONS OF CARING AND CURING *176*

PATIENT VISIONS: THE LITERATURE OF ILLNESS 201

SCIENTIFIC MEDICINE: THE LITERATURE OF CURE 253

MEDICINE AND MODERN WAR 293

PREFACE

A book such as this treasury of the art and literature of medicine owes its readers two different surveys. The progress to knowledge, order, and hope that characterizes today's medicine must be told, even though no reader expects a naive, uniform, and unidirectional saga of medicine's past. Much of medicine is palliative and caring, today as in the past, for we shall never be able to cure mortality. Yet the collective evidence of image and text reassuringly testifies to the evolution of medicine from magic and myth to scientific thought.

The other survey we rightly expect to find is fair and balanced evidence of the inescapable triangular relationship between healer, patient, and illness—two humans and the event that brings them together in an activity that we recognize as medical. Though the rain doctor that David Livingstone met in southern Africa makes an impassioned and rational plea for enlarging the boundaries of what is called medicine, Livingstone himself felt obliged to respond to him more as a Christian missionary than as a physician. Here is not some simple Western cultural bias rejecting non-Western versions of "medicine." The very essence of a medical system, the larger purpose of medicine beyond the pragmatic and very personal activities involving the meetings of individual patients and doctors, does not translate well. We can more easily relate to the herbalists than to the rain doctors, or, as Edward Ayensu's optimistic survey reveals, to the process of training physicians. George Catlin, a gifted artist and observer, crafts both a verbal and a visual portrait of a Blackfoot Indian medicine man, showing the grander goals of medical effort in a system and culture far different from our own. Would that an outsider to Western medicine could hold the mirror up to the very essence of our own medicine! Perhaps the Western cultural bias, when it interferes with our sight and hearing, lies in our preference to believe that we no longer have larger, quasi-religious purposes bound to the healing process.

The images and texts before us suggest otherwise. The early Mediterranean gods of medicine, Imhotep and Aesculapius, articulate a theme common in Western, rational medicine: mortal men can, potentially at least, borrow power from true gods in order to reverse, mitigate, or delay death. The power of the gods is not loaned casually, however, and the healer's spiritual qualifications to receive divine aid are very important to his success. There is not so much an orthodoxy—a set doctrine of beliefs about the place of medicine and healers in society—to Western medicine as there is an orthopraxy, a right way of qualifying for and performing the deeds of curing. Black Elk, medicine man of the Oglala Sioux, never claims to have been given special powers through his own devices and merit. Instead, he cures and sees because the gods speak through him, the accident of his existence. Such mystics in our tradition are often very dangerous individuals even when they are revered, for the unalloyed voice of the gods can challenge every conceivable code of behavior and belief. Not surprisingly, there are no mystics in Euro-American medicine who have not been soundly rejected and ostracized from the nebulous body of great doctors. In the Middle Ages, the healing powers of saints superseded those of mortal doctors, but their powers emerged, safely, only after death.

Thus Western physicians qualify to practice medicine, passing tests that allow them to bear and brandish the symbols of their borrowed power, symbols that distance them from the general community. The rod and shield of Aesculapius is best known among these emblems, but it has been a symbol only. Metonymic representations of the physician are more typically the urine glass and long red robe of medieval and early modern physicians, the case of instruments and short robe of the surgeon, or the many tokens of a modern physician: stethoscope, white coat, and different varieties of head gear. In short, the centrality of the doctor, aided by unseen powers, is an anthropological feature of "our" medicine sanctioned for over 3,000 years, and it is quite different from the medicine of individual suffering and healing in early Taoist China, for example. Not surprisingly, the artistic artifacts of Western medicine concentrate on the healer himself, whether it be statues of Aesculapius; the proud personal triumphs that Galen and Osler describe, one in himself, one in another doctor; or the figures of surgeon-anatomists gathered around a lifeless body, as in Rembrandt's *The Anatomy Lesson of Dr. Nicolaes Tulp*. Western medicine is doctor-centered. The grand story of medicine is supposed to be a story about great doctors.

The voices of the ill are not so easy to discern in a tradition that celebrates the human-mediated miracle of healing. Even eloquent rhetoricians, like Petrarch and Montaigne, do not escape the omnipresent physician amidst their sufferings; in fact they fix their attention on the combined arrogance and inefficacy of some who affirm their

self-worth through the practice of medicine. The physician is still center stage. Without the doctor in the story, mere death, dying, and illness seem to lose much of their power and meaning, at least as events of direct interest to medicine. Among the selections gathered here to sample great medical testimony, only those of John Donne, Emily Dickinson, and Katherine Mansfield represent the rare voices of ill people. Perhaps Paul Monette's medicalized tribute to a dead loved one, one of the most powerful among a gathering storm of unsilenced patient voices in the AIDS epidemic, shows the winds of change to the doctor-centeredness of Western medicine. Our verbal languages seem best at describing the actor and the active—the doctor and the disease—but the artist is not similarly bound. Thus there are relatively more artistic witnesses to the patient's illness: Rembrandt's sketch of his ill wife; Edvard Munch's *Death in the Sickroom,* and a disproportionate number of small, sick children, who are always inarticulate before the engine of medicine.

From time to time the disease, when conceived as an existing entity, has been allowed to share the doctor's spotlight. Bernard Shaw satirically places the microbe on stage, adversary to both patient and physician, begging a more sympathetic, scientific audience for a little pity of his beleaguered position. Arnold Böcklin creates a terrifying image of plague sweeping the streets. Usually, however, the disease is only metaphorically presented, often as an emblem of evil, thus lending a subliminal religious meaning to medical intervention. Giovanni Verga's malaria is an actor in the relentless cycle of poverty among the politically, socially, and economically disenfranchised of the Italian Pontine marshes—an actor so strong that no physician is needed to balance the story.

This story telling is fundamental to medicine, and is used to convey both the larger story or history of medicine as well as the individual and personal. In order to make events comprehensible, humans relate stories, for this universal form of communication unites actors and actions in an intelligible form. The widespread use of narration in human discourse makes stories an ideal conveyor of meaning for both healer and patient, who commonly do not share the same framework for understanding action against illness. In fact, it is easier to understand something of medical systems radically different from our own, for example the concept of medicine among Native Americans such as Black Elk or the medicine of Confucian China, if the precepts are translated into a story. Stories help to bridge the gap between cultures, as well as among individuals.

A patient, at any time or place, has a story to tell about the discontinuity between what his or her life once was, and what it has become because of the events that the patient, family, friends, or society generally identify as symptoms of illness. The healer has his or her own narrative, often the process of discovery arriving at a name for or explanation of the patient's complaints. Less frequently a healer chronicles the story of his actions. The disease, or "dis-ease," carries a story in its name or localization, predicated on an understanding of what is normal.

At most places and times the exchange between sufferer and healer are a sort of micro-narrative, little stories that make meaning and sense of ordinary events in the lives of ordinary people, whether or not change in the sufferer's complaint is contemplated. For example, a man called a leper is most concerned with understanding how he in particular came to suffer, how his life choices will change, what the discrete diagnosis of leprosy will signify to his personal sense of identity, and how long he has to live. The healer is most concerned with gathering a story that tells when and why the leper departed a state of health and well-being, though not necessarily as a way of framing an answer to the patient's concerns. Some recognition of why the illness occurred confronts both patient and healer with the social realities of stigmatized disease: leprosy in most cultures is a stain, an uncleanliness, a defect that signals danger to the general community. Though the range of physical suffering to which the name leprosy was attached in the past often bears no relationship to our own diagnosis of Hansen's disease, or infection with *Mycobacterium leprae,* we are comfortable with the story as a representation of past medicine. The story of the particular case of leprosy and the story of its discovery in a sufferer can be simultaneously bound to the larger narratives about disease, in this case leprosy's taint with the brush of sin. In affirming the diagnosis of leprosy, the patient's and the doctor's stories both need to concur that this is leprosy, and not scabies or lupus or struma or elephantiasis or any of the other conditions that might carry different meaning to the sufferer.

For centuries leprosy was metaphorically linked to a meta-narrative of God or supernatural forces inflicting disease: where disease (or some diseases) come from. Linked to images of the Biblical Job, lepers might be punished not for their own sins, but for the sins of others. The overarching narrative of disease as punishment for wrongdoing governs many of the little stories voiced when an individual seeks medical attention. However attractive the saga of the history of medicine moving from magic to science, from superstition to experimentation, from miracle to discovery, from revelation to exploration, the script for illness as sin has not been purged from the active files, as our experience with AIDS has made particularly vivid.

The last two centuries of Western modern medicine have, for the layperson, been rather more verbal and textual than visual. Thus, in striking disproportion to the more remote past, we can hear both sufferers and healers speaking to the fundamental concerns of everyday medical experience. Before 1800, it is largely the meta-narratives that we

confront in the art and literature of medicine, the larger context that shaped talk about illness, health, death, and disease. Sometime after that date, as medicine becomes modern, the meta-narrative in text and image becomes rather more implicit than explicit, harder to see in much the same way the language of medical discourse is no longer readily accessible to the well-educated layperson. This treasury is in no way meant to be comprehensive, nor even rigidly representative of the balance of existing literature and images documenting the medical past, recent or remote. Instead, familiar items appear with those less known as a way to hear and see afresh the history and practice of medicine.

Since the nineteenth century physicians and historians of medicine have constructed a history that begins with the "primitive" precursors of our medicine, usually a mere preface. The presumption is that medicine in the early phases of settled, human prehistory resembled the varieties of medicine found among tribal societies discovered and studied as part of an optimistic extension of Enlightenment ideals. Ancient Egyptians, Greeks, Romans, or others about whom we know even less, surely had no vision of themselves as part of an evolutionary march of medicine. The Western discovery of truly "other" medical systems, codifying that which failed to conform to established norms, belongs not at the beginning of the volume but where it has here been placed: contemporary with nineteenth- and twentieth-century medical inquiry. Though medical historians can, and usually do, debate the particulars of a break in the story of medicine becoming modern, it is not difficult to locate this generally alongside the revolutionary secularization of religious ideas that we associate with the Enlightenment.

The standard story of medicine runs roughly like this. Once past the "primitives"—with consensus that they are not really like us with respect to medicine or any important activity—the medicine of antiquity is often presented as a heroic saga leading to, or leading from, Hippocrates, "father" to Western medicine. In the story of Aesculapius a mortal acquires godlike healing powers, powers that depend upon his strict observance of taboos and sanctions. But breaking the trust, Aesculapius begins to resurrect the dead, clearly overstepping the boundary of human medical possibilities, a boundary we will allow only a Christ figure to cross. At once the story speaks to human limitations and human aspirations, signalling not only doctor-centeredness but also the reason why so many believe that with the ancient Greeks we first glimpse the birth of medical science: the modern Western drive to control nature. The overwhelming temptation is to highlight the discontinuities and the dissimilarities between cultures, which will in turn illustrate and explain the story we just crafted: true medicine begins in Greece. For example, emphasizing the liminal restrictions of human medicine, medieval medicine appears strapped by stifling subservience to authority and order, unduly constricting Aesculapian possibilities, a backward era failing to realize medicine's birthright. No wonder this society was devastated by the plague, a story Barbara Tuchman tells so well.

With only minimal effort we could enlarge this history to show the varieties of medical intervention and medically oriented beliefs that document endless episodes of human suffering and sickness, a trail of medical activity traceable in every human society that left written records. In Mesopotamia, gods of disease and health such as Beelzebub, lord of the flies, and Sekmet, goddess of pestilence, wreaked destruction far beyond what humans could venture, and so were propitiated with gifts and sacrifices. Living in a region where political, military, and ecological instability was the rule, ancient Sumerians developed the earliest law codes, hoping to bring order to daily events, for the arbitrary inflictions of disease were beyond their power to control. The story of Greece as miracle shapes the story of earlier Babylon's insufficiency. Similarly the great systems of medicine developing in ancient India and ancient China—probably in the Mayan and Incan cultures as well, if only we knew more of them—have been measured by the Greek yardstick and found wanting, if only in their failure to produce Western-type progeny.

Ancient Egypt has long been a difficult case study of early medicine, because most of the documentary and artifactual evidence from Egypt antedates the age of Hippocrates (ca. 400 B.C.) by more than a millennium. Moreover, the insistence that the Greeks were the ancestors of modern medicine, symbolically represented in calling Hippocrates the father of medicine, led Egyptologists to analyze the particulars of medical papyri. There one can find theories of illness and aging, systematic diagnostic process, and a full range of clinical skills, from examination to intervention. We must refine again the description of Greek medicine. Perhaps naturalistic explanations were there first systematically linked to descriptive human anatomy; obviously throwing organs into Coptic jars taught Egyptian priest-physicians little about the structure of the body. Thus, not the need to control nature, but the study of the human body becomes the central feature of the Greek miracle. Such a hypothesis would at least help to link the artistic story with the textual narrative of the history of medicine.

The tendency to see the varieties of early human beliefs about the origins of disease as fitting a particular story—here "stages" in the development of medical thought—has been too difficult for many scholars to resist. The discontinuities and the dissimilarities between cultures seem to beg explanation, in terms that will make the eventual

outcome—the present—appear inevitable. Instead, the selections here, most of them typical and expected examples of premodern medicine, can be linked with ease to their commonalities. First, there is the struggle for placing medicine (and the suffering that permits its existence) among the noble activities of humans. Next, medicine is systematically relegated to a private rather than a public sphere; in no society is "true" medicine open to all. Finally, women, half the human race, are virtually excluded from the story, apart from their obviously crucial role in reproduction. To these three themes the visual record speaks as loudly as the written.

In Western tradition, immediately after the supposed "birth" of medicine, cleaved from the head or side of religion and superstition, a dualistic narrative of good vs. evil, myth vs. science, magic vs. experimentation, medicine man vs. herb woman, physician vs. quack, and so forth, takes over. Beating back the forces of darkness the larger story of medicine is the triumph of true knowledge over error and chaos. The catechism emphasizes a celebration of incremental additions to a fund of knowledge, pushing back frontiers, inventing, exploring, discovering. In other words, it is radically different from a more Platonic model of the unveiling of fundamental Truths, harmonically linked to all Nature. This conventional meta-narrative, as I am calling it, is enormously powerful and expansive, and it is worth examining it by reviewing some of the materials provided in this book, for only when we can see the story that is captured there can we begin to see what medical treasures of art and literature have been denied us.

I have already commented on the physicians' struggle to achieve a priestlike status, a noble role for medicine during antiquity. Thirty years ago, medical historian Owsei Temkin showed that Hippocratic physicians were probably more itinerant craftsmen than physicians protected by the state, religion, or individual patrons. They survived on the basis of their diagnostic and prognostic skills offered to a highly mobile population. Hippocratic physicians were a group among many other healers, however often at a competitive disadvantage. This is particularly true during patrician Rome, a time and a culture that denigrated those who worked with their hands. Celsus's description of the surgery for bladder stones is surprising in that he, an aristocrat, makes little of the typically wide disparity between the social position of ordinary practitioners of medicine and surgery and that of elite, educated men who were interested more in the philosophical placement and tenets of medicine.

Stories, both visual and verbal, depend upon the exposition of the commonplace, and build their messages through the inclusion of expected details and typical associations. Because stories selectively exclude all the little events that occur in order to frame a beginning, middle, and end to which the listener or viewer is to pay attention, the details amuse or reassure so that the audience is not overly distracted from the message. Yet it is the very details of art and literature, the content of the commonplace, that betray both the values and ideals of their medicine, and the boundaries of care. Ancient statuary—for example, the tombstones of wealthy people—when relatable to medicine reinforces the nobility of the craft or art. However, little of ancient medicine, text or image, relates to the health or interests of the vast majority of people living in ancient societies.

Medieval images are quite distinctive. First, it is rare to find medical images that do not involve words, despite the low levels of literacy in medieval Europe. At the same time, many texts were arranged almost like modern children's picture books, as a reassuring guide to the authority of knowledge carried by the words. Words were in turn controlled by those given access to a formal education. There was no particular need to offer a realistic representation of the body, for all knew that only the words could attempt that. Interestingly, plants are often the exception, and even very early medieval herbals provide realistic illustrations of medicinal herbs, suggesting that in this case the image was meant to be informative to the illiterate and uninitiated, rather than symbolically to reinforce the known order of Creation. Except for the fact that women are seldom represented as patients, and then only when their ailments have to do with pregnancy and distinctive features of female surface anatomy, in medieval texts the lack of social detail about the sufferers of illness and disease is common. Moreover, women are quite early depicted metonymically as uteruses, as in the ninth-century copy of Soranus's *Gynecology*. The healers are carefully distinguished, as, for example, is the sublime Galen when pictorially he visits a late-medieval hospital or clinic: he alone appears in ermine-rimmed garments. Albucasis's distinctions about the religious affiliations of his patients is immediately distinctive, challenging the commonplace depiction of patients as socially uniform. His story in part asks us to focus on that atypicality.

An even more striking change occurs with the texts and images of the Renaissance period. Surely the two features dominating this landscape are the appearance of a first-person authorial voice and the dominance of the human body as a principal focus of medical activity. Perhaps the failure of classical and medieval medicine to form truly effective means of dealing with recurrent plagues led physicians and surgeons to find some other way of maintaining their position and authority in society. Salaries of the period do not reflect any loss of prestige; if anything, physicians and surgeons benefited handsomely during and after each plague. But as spokesmen for natural order and natural philosophy, university physicians in particular may have felt a need for borrowed au-

thority, though not from traditional spiritual sources. The visual record is most powerful testimony that knowledge of the human body in the Renaissance brought physicians, surgeons, and artists together. Surgeons especially capitalized on the public and private demand for anatomizing.

Enlightenment Europe is probably the least favorite period for those generally interested in medicine's history, for the great doctors of the time emerge as oddly postscholastic aficionados of classification, system, and order. Plagues are orchestrated, as Manzoni's study shows; hospitals codify rules of patient behavior as well as the places and importance of everything medical or charitable in their operations. Their administrators even commission paintings to show the efficiency of this fearsome order, as Goldin's study of a Bruges hospital reveals. Our sympathies tend to lie with Molière, the great satirist of stuffy university physicians, and with the visualized criticism in eighteenth-century etchings of English artists Rowlandson, Hogarth, and Gillray. Great breakthroughs in medical science, such as Harvey's discovery of the circulation of the blood, Ramazzini's observations on the association of particular diseases with different occupational activities, and Anton van Leeuwenhoek's serviceable microscope, seem to go nowhere in the world of the great Enlightenment; we can even see this in the case of the great herbal compendia of the same era in China (the *Pen-Ts'ao*). Rituals of the past seem to dominate all phases of written medicine. The brief realistic school of late seventeenth-century Dutch masters seems to parallel that of the scientific revolution, only to be followed in the eighteenth century by storied scenes such as Pietro Longhi's, on the cover of this book. Longhi chooses to represent an ordinary apothecary's shop and what is probably a typical Venetian prostitute, in a posture typical of medical illustrations down to our own time: an active male medical representative with a passive, submissive patient. This subtext dominates the full period, 1650–1800, increasingly turning to women, especially young attractive women, as the idealized patient object. I strongly suspect that many of the important, implicit themes of modern medicine appeared during the Enlightenment period and are veiled but before us in these stories that artists tell.

The artists of this period for the first time expand our vision to the world of lesser, nonprivileged healers. Midwives, barber surgeons, tooth pullers, oculists (veterinarians, too, though we have not represented them here) were always an important part of the medical marketplace as far as patients were concerned. They seem to find advocates who remind the court of medicine of their existence among the realistic painters, the satirists, and the "genre" painters like Longhi, during the Enlightenment. Nowhere is the world of ordinary medicine in the traditional Western world better represented than in Ulrich's Pulitzer Prize-winning story of midwife Martha Ballard. The scant and scarce records of nonelite healers emerge at just the time the medical world they inhabit becomes endangered territory.

Sociologist N. D. Jewson and historian Michel Foucault independently and in quite different terms observed that the period launching modern hospital and scientific medicine was one during which even elite patients lost their privileges "negotiating" diagnosis and therapy. In the world we lost, sometime before 1800, educated patients could read much of what was available in medical thought and practice, cooperating in their own therapy. We already have been given a strong sense of this power of the medical triangle (disease, doctor, patient) in Petrarch's complaints. The medical "gaze" as Foucault called it, and the dramatic expansion of the hospital as a medical laboratory, rapidly distanced the physician-scientist from the patient's discourse and from the need to hear the patient's story. After all, the stethoscope neatly circumvents the doctor's need for the patient's version of where and how her chest hurts—the case Laënnec immediately presents us. In the physicians' narratives of this period the story of medicine is the adversarial relationship of doctor and disease. The patient (see Jenner, Laënnec, Semmelweis, Snow, Warren, and Osler, for explicit examples) has become a case study. The visual images are suddenly dominated by instrumentation mediating medical encounters. Paré had shown us pictures of the individual surgical instruments, and parts of persons when the tools were applied. Nineteenth-century image makers give us the full story of medical intervention mediated by technology. The patient's personness is wholly subjected to and dependent on the doctor wielding a form of borrowed power.

It is just then that Westerners become fascinated with the methods of non-Western healers, often just to reaffirm their own superiority (see the selection from Townsend). By the later nineteenth century, patients are no longer anesthetized recipients of medical maneuvers, and patients who tell their side of a story range from the elite to the humble young woman from the Shetland Islands who draws a very different picture of Lord Lister, a doctor she had worshipped, than the surgeon she had imagined in the medical theater. The literature of illness is partly aided by the power of great literary advocates, such as Dickens, Tolstoy, and Verga, willing to draw attention to the medically disenfranchised in a way that does not portray the poor and ill as a danger and menace to the rest of society. Interestingly, physician-authors, here represented by Treves and Conan Doyle, attempt to tell the patient's story, so that we can be sure to get the right message and meaning from individual suffering. The subtext is quite often positive only if the patient is fully resigned to the physician's care or to the inevitable fact of mortality.

Doctors' stories of the early twentieth century seem most comfortable with a new autobiographical reflection, emblematic of the larger, heroic successes of scientific medicine softened with the sympathetic presentation of medicine as artful caring.

With disease on the run, exiting stage left as Shaw would have it, an adversarial relationship of patient and physician seems, at first glance, to emerge in the texts and images of twentieth-century medicine. Doubtless such an assessment minimizes the spectacular achievements of scientific medicine in improving life prospects of all humans alive today. But the good old story, as Dr. Ratzan's reflection on the texts and images shows, still holds much hope of mending the strained relationships between unheard suffering patients and their chosen healers. Medicine can do and has done great good.

ANN G. CARMICHAEL

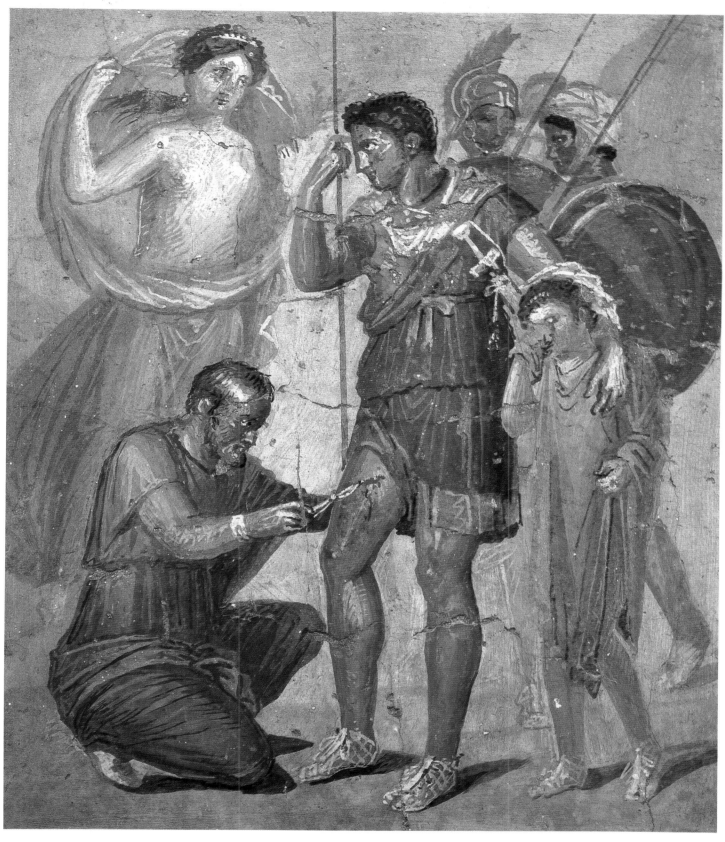

COLORPLATE I

Aeneas Having Arrowhead Removed from His Thigh with Cross-Legged Forceps, or *Aeneas Receiving Treatment for a Wound.* 1st century. Fresco. 17¾ × 18¹³⁄₁₆ in. (45.1 × 47.8 cm). Museo Nazionale, Naples. *Greek surgeon Iapyx removes an arrowhead from Aeneas's thigh.*

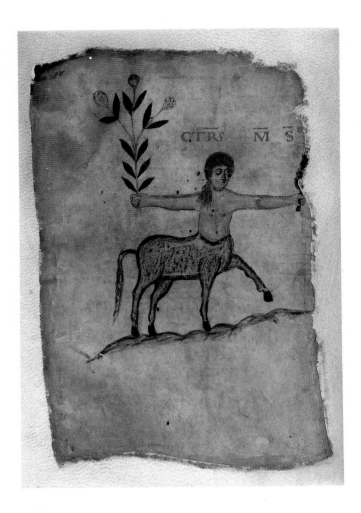

COLORPLATE 2

Centaur, the Master of Medicine.
Mid 9th century. Manuscript.
11¼ × 8¼ in. (28.6 × 21 cm).
Gesamthochschul-Bibliothek
Kassel. *Medieval legends held that
Chiron the Centaur, Aesculapius's
teacher, passed herbal secrets to
Apuleius, a famous Roman herbalist.*

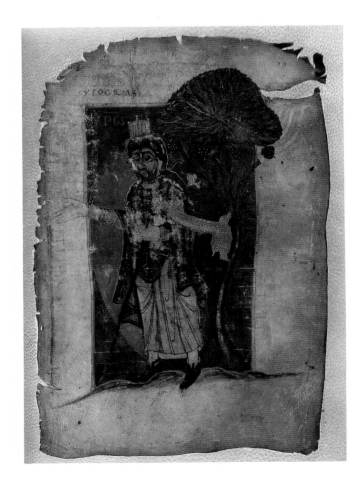

COLORPLATE 3

Crowned Hippocrates, Gesturing.
Mid 9th century. Manuscript.
11¼ × 8¼ in. (28.6 × 21 cm).
Gesamthochschul-Bibliothek
Kassel.

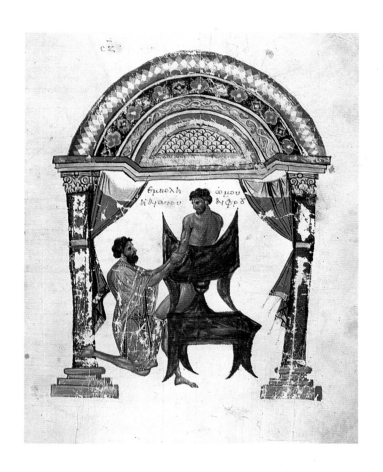

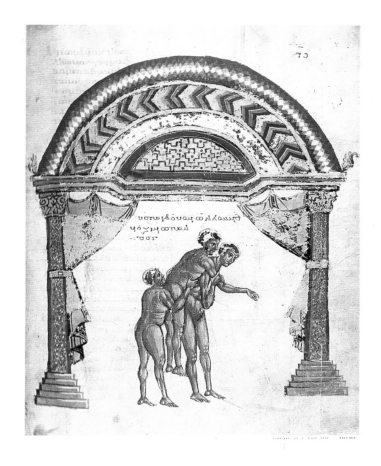

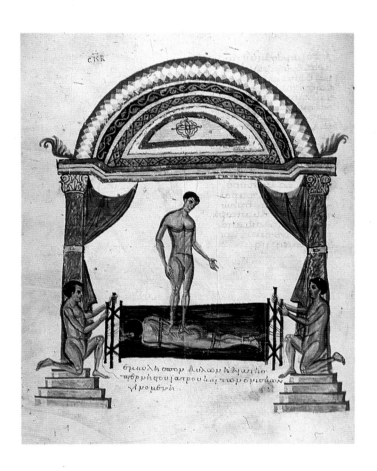

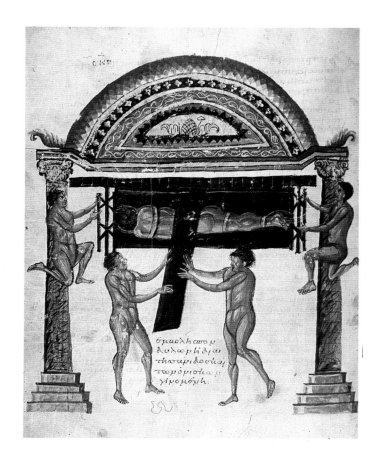

COLORPLATE 4

Reduction of Dislocations. 11th century. Illustration for the Hippocratic treatise *On Joints, a Commentary on Apollonios of Kition,* 4 views. c.1850, Biblioteca Medicea Laurenziana, Florence.

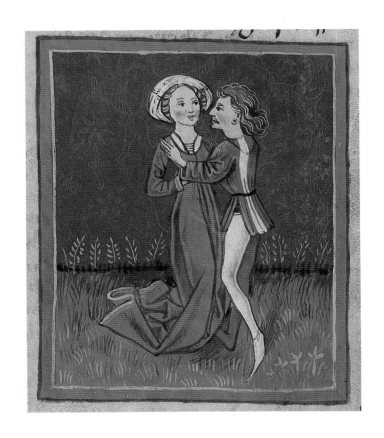

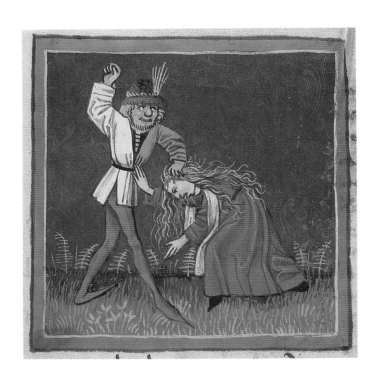

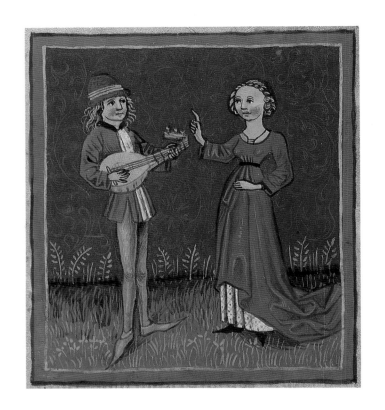

COLORPLATE 5

Illustration of Galen's Four Humors. c.1472. Manuscript. 11⅝ × 7⅝ in. (29.5 × 19.4 cm).
Zentralbibliothek, Zurich. *Galen did not ascribe personality types to the four humors governing human
health and disease, but his Arabic commentators did. This 13th-century Western manuscript illustrates
men dominated by the humors (from top left, clockwise) black bile (melancholic), phlegm (phlegmatic), yellow
bile (choleric), and blood (sanguinous). The woman's personality was not of interest.*

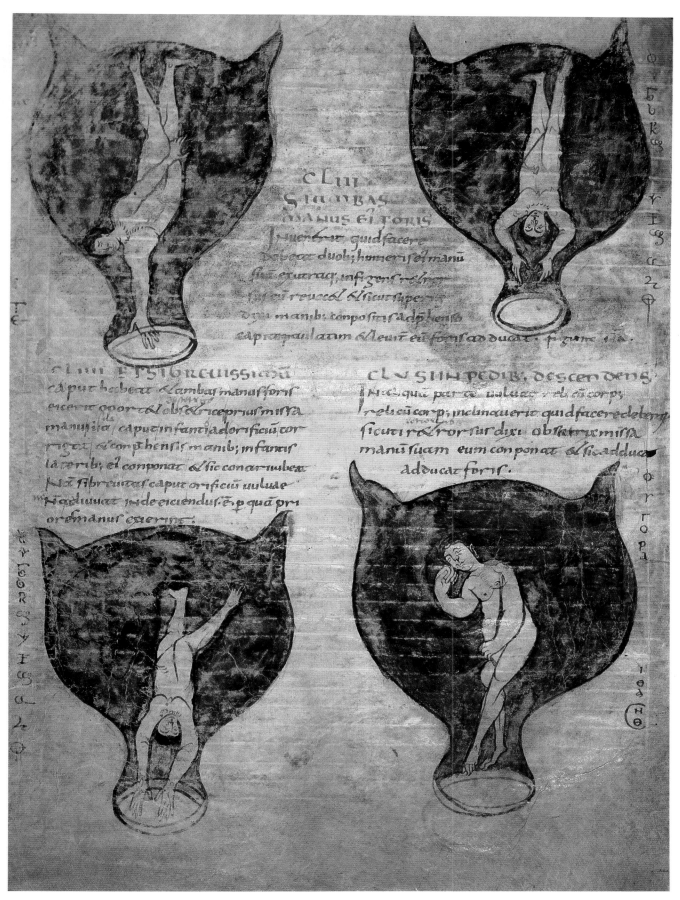

COLORPLATE 6

Presentation of the Fetus in Utero. 9th–10th century. Manuscript illustration from *Gynaikeia,*
by Soranus of Ephesus. 11⅛ × 7⅝ in. (28.3 × 19.4 cm). © Bibliothèque Royale Albert premier,
Brussels. *These medical miniatures accompanied a Carolingian copy of Soranus's* Gynecology. *The*
homunculi *illustrate various atypical fetal presentations that meant a difficult delivery for mother and child.*
The uterus is represented with small "horns," according to popular tradition.

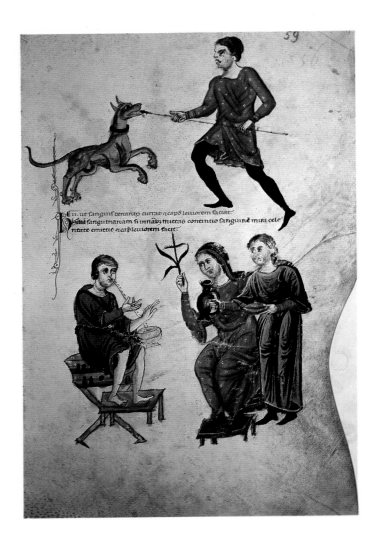

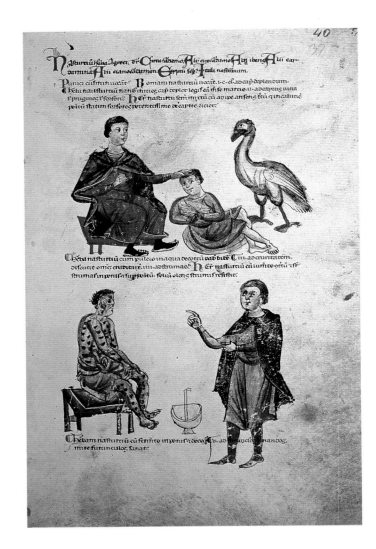

COLORPLATE 7

Manuscript miniatures from pseudo-Apuleius *Herbal*. Mid 13th century. Each image: 10¹³⁄₁₆ × 7⁵⁄₁₆ in. (27.5 × 18.6 cm). Österreichische Nationalbibliothek, Vienna. *The herb sanguinaria (left) was used to cure the bite of a dog and to induce nosebleed, draining bad cervical humors. Nasturtium (right) was used for loss of hair, ringworm, fungal infections, "struma," and furuncles.*

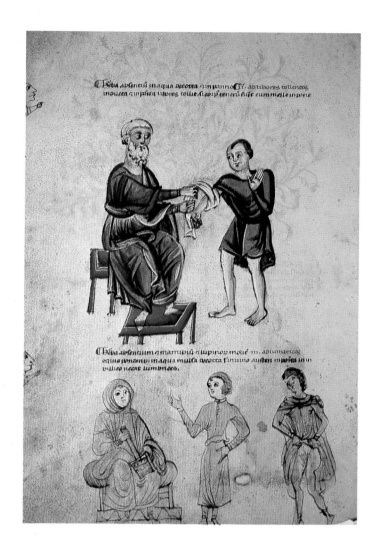
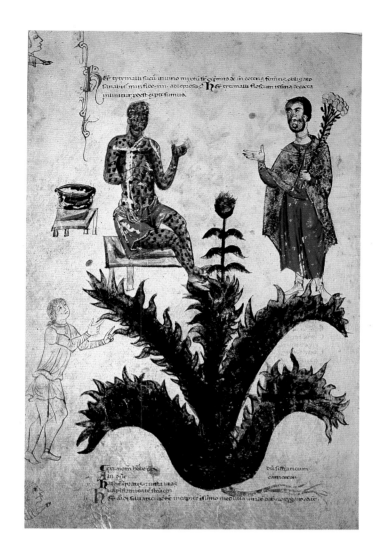

COLORPLATE 8

Manuscript miniatures from pseudo–Apuleius *Herbal*. Mid 13th century. Each image: 10¹³⁄₁₆ × 7⁵⁄₁₆ in.
(27.5 × 18.6 cm). Österreichische Nationalbibliothek, Vienna. *Absinthe, or absentium (left),
cooked and dissolved in cream or honey, was used to make a lotion for skin diseases and mixed with other herbs
to cure worms. The lower illustrations were added by a later illustrator seeking to depict all the uses of the
herb. Tytymallos gallastices, or verrucaria (right), held by the robed physician, was recommended for leprosy.
At bottom, Cardum silvaticum is pictured as a remedy for stomach problems.*

Oath of Hippocrates. 12th century. Byzantine manuscript. Vatican Biblioteca Apostolica, Rome. *Hippocrates was made Christian in this 12th-century Byzantine copy of the ancient* Oath, *shaped in the form of a cross.*

INTRODUCTION

"And what is a past when it is not a life story?" asks André Malraux in the selection from his *Lazarus*. Many, if not all, of the selections in this book are stories, some even life stories (or parts thereof), from the illustrations of surgical probes to the fiction of Lu Hsun to Hans Zinsser's autobiography. Even the lowly stethoscope has a story behind it, as Laënnec tells us. Some selections may appear to be telling one story, say a story of medical ethics, like the issue of truth-telling in "The Death of Ivan Ilyich," while others tell a purely historical story, like the account of Pasteur and the development of the rabies vaccine. Yet even the apparently straightforward anecdote of the rabies vaccine contains multiple stories, as the great Pasteur realized at the time when he hesitated to experiment on the child he was about to save. Heine's reportage of the cholera epidemic in Paris in 1832 is a blend of cultural, social, medical, and political journalism. The outfits worn by the physicians attending plague victims speak volumes about medical ignorance, medical fear, and the state of medical technology.

J. Worth Estes's *The Medical Skills of Ancient Egypt* is a good example of how the medical story reflects the cultural and social stories of the day. In his account, Estes credits circumcision with being the first surgical technique to be depicted pictorially, as evidenced by a wall carving in a Dynasty VI tomb over 4,000 years old. Clearly this social and religious custom was a driving force behind medical practice, although it may have surprised a *swnw* (*physician* in Egyptian) to learn that we are calling "medical practice" what he considered religious rite. We cannot tell from the carving whether this religious practice was the stimulus for unique medical instruments or whether the nearest flint blade recently used to cut a piece of hemp was used to perform the operation. However, we do know that war and medicine are old bedfellows; probes for wounds go back to the ancient Greeks. In recent years, the Korean and Vietnam conflicts have had beneficial legacies for civilians with shock lung.

We see this nexus between the military story and the medical story in the selection from Albucasis's, "On the Extraction of Arrows," when he discusses the treatment of arrow wounds. Although it would seem to be about the medical experiences of the day, this selection is more than that. To a historically minded reader it tells the story of warfare, and more precisely, of religious warfare, since Albucasis goes to the trouble of identifying the patient as a Jew or a Christian. It tells us, further, that Jews and Turks were fighting in the 11th century in Spain. This convergence, or simultaneity, of military and medical stories also takes place in the writings of Paré and the paintings of Henry Tonks. Walt Whitman's "The Dresser" and John Hersey's *Hiroshima* also relate at least two stories.

In *Hiroshima*, John Hersey combines his reporter's eye and his fictive imagination to record the known facts with fleshed-out details of the horrible stories, both social and medical, of the first use of the atomic bomb. His "coverage" of the initial events renders almost palpable the abrupt and total disruption (literally the ripping apart of entire buildings and things, down to Dr. Fujii's clothes and Dr. Sasaki's glasses) of Hiroshiman society. The intense chaos—the *human* fallout of the bomb—is graphic. It is seen, in another time and place, in Stanley Spencer's *Travoys Arriving with Wounded at a Dressing Station at Smol, Macedonia*, and Henry Tonks's *An Advanced Dressing-Station in France, 1918*.

Of course, in Spencer's and Tonks's paintings the different times and battlefields are overshadowed by the depiction of medical assistance. Picture the same devastation (except much worse in scale) without the stretchers, the ubiquitous slings and bandages (perhaps medicine's first response to war, as we can see on a 5th century B.C. Attic vase of Achilles dressing an upper extremity wound), or the presence of unwounded medics (in *Hiroshima*, Hersey tells us that 65 of 150 doctors were killed by the bomb). The story of Hiroshima, then, is one of social chaos and the unprecedented use of large bombs against civilians. It is also the unusual story of doctors and patients witnessing, as both participants and healers, the unfolding of a new disease—radiation sickness, a disease that was impossible before the discovery of X-rays less than fifty years earlier, and impossible on a large scale before the Manhattan Project.

Although the phenomenon of patients and physicians taking part in a new disease process is not new, the self-awareness of it—that is, the knowledge that one is suffering from a heretofore undiagnosed disease—*is* a relatively modern marvel that is infrequently encountered, paradoxically, since most diseases have already been described. Thus, although the capacity for self-awareness is present, the new disease process usually is not. Hersey captures this sense of mystery and anxiety acutely. Once the literature and art of AIDS mature, we can expect to see a similar mixture of awe and tragedy.

Yet another example of the marriage of medical and cultural stories is the practice of abortion and the cutting for (bladder) stone. In the Hippocratic Physician's Oath we read of injunctions against abortion and the cutting for stone. By Celsus's time, however, the latter is already common practice. In other words, as technology and social mores change, what is medically permissible changes *pari passu*. Consider today's fluid ethical-technological-medical environment, where such advances as *in utero* surgery on fetuses and *in vitro* fertilization have created a cottage industry of ethicists whose posed bioethical dilemmas have outstripped the most imaginative science fiction writer.

The rise of the public health movement as dramatized in literature and art of the 19th century is an expression of the realization that common sense and preventive, often simply preventive, measures are as important as newfangled drugs, laboratory discoveries, and surgical techniques. Emily Elizabeth Parsons's letter in this volume describes such measures and paints a scene very much like the clean ward in John Lavery's painting *The First Wounded in London Hospital, August 1914.*

Some of the selections tell a story that reveals a concern more for professional integrity than for illness. Albucasis is careful to enjoin his colleagues to practice self-protection. He warns them not to take on moribund patients, a caveat found repeatedly in the plague tractates in the Middle Ages and deriving at least in part from Hippocrates's writings on the control of information that physicians should give patients. This warning is based on the preservation of a good reputation, which translates into a high batting average in the clinic and at the bedside. As though Edgar Lee Masters had read him, his "Doctor Myers" validates Albucasis's advice as it succinctly tells of Dr. Myers's tragic life after losing a patient.

The relationship between death and healing, two of mankind's oldest stories, forms the core of several selections. Beginning as early as the myth of Aesculapius (see the Edith Hamilton excerpt), we see the "knot intrinsicate of life," as Shakespeare's Cleopatra called it, snatched from death on Coronis's funeral pyre. (This entwining of life and death recalls the caduceus, the ancient symbol of medicine.) In "Imelda," perhaps his finest story, Richard Selzer beautifully captures the intimacy between the dead and the living, offering a story that Henry Tonks's *The Birth of Plastic Surgery* graphically illustrates.

More commonly, however, this relationship between death and healing is obscured. Several selections, like Barbara Tuchman's, deal with death and the social fear of illness. Tuchman's account of the Black Death vividly depicts the story of the reaction of a terrified people to massive illness and massive fear, and the resultant hysteria. It was, as Guy de Chauliac noted, a time when "Charity was dead," recalling Apollo's complaint to Zeus in Book XXIV of the *Iliad* that Achilles has destroyed pity during *his* rampage, a mortal equivalent to the merciless, uncharitable plague in Book I that started all the feuding in the first place. The various images of plague in this book, like Arnold Böcklin's *The Plague,* which transmits a feeling similar to the content of *Cancer,* by Roger Brown, demonstrate the fear and hopelessness that the medieval victims of plague felt. This type of imagery in prose and paint is also evident in Poe's familiar "The Masque of the Red Death"—based on the same Paris cholera epidemic that Heine witnessed firsthand—and Besnard's *Indifference.*

Giovanni Verga's mesmerizing "Malaria" is a more recent (1880s) example of a kind of plague literature. If we recall that *malaria* derives etymologically from the Latin words for *bad air,* the connection with plague, also thought to issue from "bad air," becomes clear. The storyline concerns the inextricable relation of illness to medicine to social and economic forces. Verga's prose poem is an indictment against the poverty and trapped nature of Sicilian peasants of the 1880s. An oil of the same decade, Luigi Nono's *Convalescing Child,* captures the feeling of over-powering illness in Verga's story.

Children and death have captured the interest of writers and artists for millennia. The pathos of defenseless children caught up in illness, in war, or in human abuse or neglect, always will hold the interest of adults. It caused Camus to rage in *The Plague* when he cried out in the voice of Rieux, the physician laboring to care for the sick of Oran, "And until my dying day I shall refuse to love a scheme of things in which children are put to torture." The disbelieving mother in John Hersey's *Hiroshima,* who holds a stinking corpse of a child for days, tells the same story of maternal love, innocent children, and death, a drama Pablo Picasso painted in *The Sick Child.* Like Camus, Lu Hsun, a fellow revolutionary writer, pities the child seized by death. In his "Tomorrow," Lu Hsun condemns a society—here a feudal, backward one—that allows a child to perish for want of modern care. The children of Verga, Lu Hsun, and Camus cry out to us for the need for action, much of which is social and economic.

One reason physicians like Lu Hsun have become accomplished writers is the intimacy of the physician-patient relationship. Thus St. Luke, Rabelais, Sir Thomas Browne, Anton Chekhov, Somerset Maugham, Walker Percy, and others, have all been physicians. (Given a literature so vast, it will not surprise the reader that the present volume could not represent them all.) Whether it is an interest in people that lures them into medicine or the contact with people in distress that leads them into writing is not clear. Sir Frederick Treves, for example, typifies

this concern for the individual and attention to detail that exemplify both a careful surgeon and a careful writer. Both are craftsmen. In his "Two Women," Treves manifests an eye for character that does not come with the M.D. degree. The "secret" that the woman in our excerpt kept "too long" between herself and Dr. Treves summons to mind another physician-writer's remark that we are granted, as physicians, entrée to our patients' "secret gardens of the self," as William Carlos Williams put it in his autobiography.

One encounters careful observation in the work of other physician-writers as well, like Richard Selzer's "Imelda," in which the girl with the cleft lip and palate appears, in her moment of exposure, like a "beautiful bird with a crushed beak." A passion for detail, which is at the heart of clinical medicine of excellence, surfaces as early as Celsus's exhortation to his fellow physicians to pare their nails before examining a patient: "Then the surgeon having carefully pared his nails and anointed his left hand, gently introduces two fingers. . . ." Tolstoy depicts the behavioral equivalent of these particulars perhaps better than any other writer. He, along with Henry James and Proust, can write pages on the specific psychologic makeup of a social act and yet leave the reader yearning for even more. In "The Death of Ivan Ilyich," Tolstoy deftly comments on the impatience that friends, relatives, physicians, and nurses eventually betray for the patient:

> He reached home and began to tell his wife about it [his pain]. She listened but in the middle of his account his daughter came in with her hat on, ready to go out with her mother. . . . Reluctantly she half sat down to listen to this tiresome story, but she could not be patient for long, and her mother did not hear him to the end.

Yet wealth of detail and caring are not always synonymous. Observe Walt Whitman's economy when it comes to specifics (an anomaly for him) in "The Dresser." Instead of names, dates, places, we get the *feel* of action, war, wounds, and caring. Kathe Kollwitz's *Visit to the Children's Hospital* and Edvard Munch's *Death in the Sickroom* produce the same effect of abstracted emotion, which can be every bit as powerful as a profusion of detail. The paucity of particulars in Munch's masterpiece, the immobility, the downward direction of everything and everybody—all tell the story of death in the sickroom. The mood is somber. We do not need to know who these people are, or where, or when. They are everyone. And yet the story behind the story tells us that in a sense they are *not* everyone. They are everyone only in a basic human sense and even that statement must be qualified by asserting that they are everyone in fin-de-siècle Norway. This would not be the scene in 18th-century Sri Lanka or 5th-century Athens.

Physicians are storytellers to their patients as well. Patients expect physicians not only to tell them stories about pneumonia or cholecystitis, but to know the ending! We call this ability *prognostication*. In Tolstoy's "The Death of Ivan Ilyich," for example, Ilyich asks one of his doctors, " 'But tell me, in general, is this complaint dangerous or not?' " Ilyich doesn't care whether or not he has a floating kidney, which seems to represent an intellectual challenge to the doctor, a diagnostic quandary. Ilyich wants to know the ending: Was his case serious or not? Patients are interested in *prognosis*. It's their story and they are the heroes in it. Doctors are interested primarily in *diagnosis*. They are only the readers.

Many of the selections involve physicians as they are engaged in diagnosis and prognosis, for caring doctors *are* interested in prognosis. The stories of the practice of medicine have long been the staple of artists. Contrast Selzer's dramatic "Imelda" with the delightful vignette by Hans Zinsser in *As I Remember Him* and the excerpt from Albert Haas's *The Doctor and the Damned* and one can appreciate the appeal of surgical stories and the experience and skill with which they are related by these authors.

Life in the hospital also offers rich grist for writers. André Malraux's reflections in the hospital and existential ruminations that aptly capture the dreamlike state of such patients remind one of the reflections of one of his contemporaries, George Orwell, in "How the Poor Die." Both Malraux and Orwell, social critics and philosophers on the nature of man and meaning in a confused war-wracked century, use the hospital as a metaphor for the sickness-unto-death of the human condition. Margaret Mathewson's accounts of being a patient for eight months under the care of Joseph Lister offer an equally somber portrait of in-patient experiences. The rudeness at times (often unintentional), the nonexistence of the patient as human being, the imperial authority of physicians in the 19th century—all are relics of a more autocratic day. The selection from Montaigne's "Gravel and the Doctors" is as cultured an example of this genre as we are likely to read. The essayist par excellence for many, Montaigne blends phenomenological details with wonderful, and wonderfully acerbic, commentary on patients, their Job-like advisors, and their physicians. (When Montaigne asks which three doctors confronting the same patient think alike, he is in the grand tradition of Molière and Rowlandson.) His style is nonpareil. Who would not give a week's wages to have written, "Doctors are not satisfied to deal with the sick; they are forever meddling with the well,"

or, "To be afflicted by colic and to be afflicted by abstaining from oysters are two evils in the place of one." More urgent and devotional, but no less exquisite in its vivid and effective prose, John Donne's *Devotions Upon Emergent Occasions* is the account, *cum* reflection and prayer, of an acute, febrile, probably infectious, disease.

A more fanciful expression of the patient's voice is De Quincey, a morphine addict and another famous prose stylist-essayist. De Quincey's selection somehow doesn't quite ring true with the common stock of human experience with drug addiction, which is perhaps why his form of autobiography is often called "imaginative" or some such adjective. Eugène-Samuel Grasset's *Morphinomaniac* accords better with morphine addiction as most perceive it. The anguish and desperation in the young woman's face are a far cry from the intellectualizing defense of morphine's effects by De Quincey.

The selection by Clifford W. Beers represents an interesting variant of pathography. Although one can write about one's paralysis, provided one has the means and determination (like Christopher Nolan's *Under the Eye of the Clock*), or one's open-heart surgery (like William Nolen's *Surgeon Under the Knife*), or posttraumatic neuromuscular problems (like Oliver Sacks's *A Leg to Stand On*), writing about an illness that interferes with the cognitive process of writing makes autobiographies about Alzheimer's impossible and accounts of severe, incapacitating mental illness uncommon. Beers's, therefore, is interesting. The helplessness that comes through as one is driven by a "demon," as Beers describes this force of evil, gives insight into what may have possessed Edgar Allan Poe when he described his "Imp of the Perverse." This imp hurtles from the mouth in Munch's *The Scream,* lurks behind the eyes of the man in Ambroise Tardieu's *Mania Succeeded by Dementia,* and pullulates to and fro in Adolf Wölfli's drawing *Mental-Asylum Band-Hain.* The latter is a story that is confused, all detail with no informing structure to anyone but the artist, if to him. It approaches noise and represents the chaotic order-without-meaning in Wölfli's deranged but creative mind. Wölfli, a Swiss psychiatric patient hospitalized for sexual assaults, experienced auditory and visual hallucinations.

Research is a story, too. As the selection on Jenner illustrates, experimental medicine is the story of the development of knowledge that arises from a personal story—what philosophers call induction. Yet it too remains a story. Research is the working out of a universal story from particular stories. Edward Jenner found that he could not infect "with variolous matter" Joseph Merret, a gardener previously infected with cowpox. Other stories of the cowpox–smallpox relationship supported Jenner's suspicions, leading to the story of vaccination (or *cow*-ination since *vacca* is the Latin word for *cow*). Semmelweis also took an observation arising from individual stories, the stories of patients dying from childbed fever, and worked it, like a novelist, into a story that other scientists could read and agree was a truly universal story. Additionally, the selection from Semmelweis is an instance of one aspect of the creative process, what Pasteur called the prepared mind. While Semmelweis was working on the plot, as it were, of the childbed fever story, a colleague, Dr. Kolletschka, tragically died from a hospital-acquired infection. As soon as Semmelweis realized that Dr. Kolletschka's manner of death was clinically similar to childbed fever, he was able to see the story's denouement. The scientific method, in other words, converts anecdotes of a specific time and place into lasting stories that are as true in London as in Melbourne, in 1802 as in 2002.

Another way of putting it would be to say that the scientist is working on a story whose ending he doesn't know yet and is not expected to know. As we saw with Tolstoy's "The Death of Ivan Ilyich," this is a different story than the story to which the clinician is supposed to know the ending. The selection from Pasteur embodies this atmosphere of uncertainty, an uncertainty that is inherent in the process or it would not be research. The scientist becomes a reader of particular, then the author of general, stories.

Lest we become too enthralled with the noble nature of research in hindsight, it would behoove us to remember what some observers at the time thought of this newfangled science. James Gillray's *The Cow-Pock,* (or) *The Wonderful Effects of the New Inoculation!* is a colored etching, done in 1809, that depicts a scene probably situated in the Smallpox and Inoculation Hospital at St. Pancras. The inoculator bears a very strong resemblance to a portrait of Edward Jenner by Sir Thomas Lawrence. There is always more than one side to a story, especially when science takes place in a free society with talents like Rowlandson and Gillray.

What contemporary stories are *we* reading, hearing, and writing? Not much has changed: Doctors take care of patients and write fiction, *à la* Robin Cook, and nonfiction, *à la* Robert Coles. Playwrights, such as Brian Clark in *Whose Life Is It Anyway?,* study the ethical stories. Like the doctors and patients in *Hiroshima,* we are conscious of being part of history as we find ourselves in the midst of the AIDS epidemic. Writers like Paul Monette (in "Waiting to Die," a poem about a friend with AIDS), and artists like Keith Haring (in his 1989 AIDS poster), and even quilt makers, who honor patients like Dr. Tom Waddell, are telling stories about AIDS, and the people with it, and the people caring for the people with it. As long as there is the art and science of medicine, there will be such stories and pictures.

RICHARD M. RATZAN

Traditional Medicine

NOBILITY AND MEDICINE IN THE ANCIENT WORLD

FROM THE PAPYRUS EBERS
"Diagnosis"

Drawing upon sources even older, Egyptian scribes of the New Kingdom compiled papyri devoted solely to medicine. The Georg Ebers papyrus, written ca. 1500 B.C., is filled with practical remedies and regimens. The systematic medical process—listening to patients' complaints, framing a diagnosis based on physiological theories, and making a clinical examination—is earliest achieved in Egyptian medicine.

When thou examinest a person who suffers from an obstruction in his abdomen and thou findest that it goes-and-comes under thy fingers like oil-in-a-tube, then say thou: "It all comes from his mouth like slime!" Prepare for him:

> Fruit-of-the-Dompalm
> Dissolve in Man's Semen
> Crush, cook in Oil and Honey

> To be eaten by the Patient for four mornings.
> Afterwards let him be smeared with dried, crushed, and pressed maqutgrain.

<p style="text-align:center">★ ★ ★</p>

When thou examinest the obstruction in his abdomen and thou findest that he is not in a condition to leap the Nile, his stomach is swollen and his chest asthmatic, then say thou to him: "It is the Blood that has got itself fixed and does not circulate." Do thou cause an emptying by means of a medicinal remedy. Make him therefore:

Wormwood	$\frac{1}{8}$
Elderberries	$\frac{1}{16}$
sebesten	$\frac{1}{8}$
sasa–chips	$\frac{1}{8}$

Cook in Beer-that-has-been-brewed-from-many-ingredients, strain into one, thoroughly, and let the Patient drink.

This remedy drives out blood through his mouth or rectum which resembles Hog's Blood when-it-is-cooked. Either make him a poultice to cool him in front, or thou dost not prepare him this remedy, but makest for him the following really excellent Ointment composed of:

> Ox fat
> Saffron seeds
> Coriander
> Myrrh
> aager-tree

> Crush and apply as a poultice.

<p style="text-align:center">★ ★ ★</p>

When thou examinest a person who has a hardening, his stomach hurts him, his face is pale, his heart thumps; when thou examinest him and findest his heart and stomach burning and his body swollen, then it is the sexen-illness in the Depths and the fire is consuming him. Make him a remedy that quenches the fire and empties his bowels by drinking Sweet-Beer-that-has-stood-in-dry-Dough. This is to be eaten and drunk for Four days. Look every morning for six days following at what falls from his rectum. If excrement fall out of him like little black lumps, then say to him: "The body-fire has fallen from the stomach. The asi-disease in the body has diminished." If thou examinest him after this has come to pass and something steps forth from his rectum like the white of beans and drops shoot forth out of him like nesu-of-tepaut, then thou sayest: "What was in his abdomen has fallen down." MAKE FOR HIM THIS REMEDY SO THAT HIS FACE MAY COOL. Stand the cauldron over the fire, make a mixture in it and cook it in the usual way.

TO DRIVE AWAY THE HARDENING IN THE ABDOMEN:

Bread-of-the-Zizyphus-Lotus	1
Watermelon	1
Cat's dung	1
Sweet Beer	1
Wine	1

Make into one and apply as a poultice.

J. Worth Estes

FROM THE MEDICAL SKILLS OF ANCIENT EGYPT

"To Become Pregnant"

The fragmentary Kahun gynecological papyrus, ca. 1900 B.C., reveals the fundamental concern of the earliest written medicine: care for the pregnant woman. Subsequent medical papyri contribute to Dr. Estes' composite picture of Egyptian obstetrics forty centuries ago.

The Egyptians recognized some of the procreative relationships among the testes, phallus, semen, and pregnancy. They regarded the man's contribution as a "seed" that he planted in the fertile ground provided by the uterus. Semen was seen as originating in the spinal cord (an association that persisted, on and off, into nineteenth-century Western medicine), probably because priests who made sacrifices thought that the phallus of the bull was an extension of his spine, since bovine *retractor penis* muscles arise from the lowest (sacral) vertebrae. The teleological importance of protecting the source of the man's semen by the large bone (which really represents the fusion of four or five vertebrae) at the end of the spinal column, coupled with its role in the myth of the dismemberment of Osiris, seems to have given rise to the bone's traditional name, the *os sacrum* ("sacred bone"). As far as more speculative Egyptians could tell, semen also arose in the heart, whence it passed via two pathways (called *metu*) . . . to the testes for later delivery into the woman. For instance, in describing the sex act, one text notes that the "man laid his heart in the woman." Although the maternal contribution to the fetus was not clear to the Egyptians, since they did not realize that sperm traveled to the uterus, nor did they recognize the ovaries, they did regard the mother's nutritional role, via the placenta, as vitally important.

The exact duration of pregnancy may have been of little concern to the Egyptians until late in their history; the subject is virtually ignored in early texts. One text of unknown date specifies "up to the first day of the tenth month," while another mentions 294 days (9.8 months), simply because that was the length of the gestation of Horus, according to the prototypic national myth. The subject appears to have become more important, even if no better defined, when Roman law was imposed on the Egyptians. A ten-month gestation is mentioned in two texts from the Roman period that are concerned with the legitimacy of heirs, although one of these also specifies a lower limit of 182 days (six months). The basic problem then, as well as earlier, was probably that no one knew how to determine the exact time of conception.

Egyptians may have been more concerned with how to tell if a woman is pregnant. A number of chiefly magical methods for making the diagnosis have survived; none is predicated on the onset of amenorrhea (cessation of menses) as a clue. Several documents from both the Middle and New Kingdoms provide instructions for detecting whether a woman is capable of conceiving a child. One involves examining the "vessels" of her breast. Another states that the likelihood of becoming pregnant is proportional to the number of times the woman vomits while sitting on a floor that has been covered with the lees, or sediment, of beer and date mash. A third, also found in the much later Hippocratic writings, specifies that a woman can become pregnant if, on the day after an onion is inserted into her vagina, the onion's characteristic odor can be detected in her breath.

But not all women wanted to become pregnant. The oldest of all the surviving medical papyri, the Kahun Gynecological Papyrus, which was compiled around 1900 B.C. during the Middle Kingdom, lists several recipes for contraceptives to be inserted into the vagina. They included pessaries made of honey with a pinch of natron, of crocodile dung in sour milk, of sour milk alone, or of acacia gum. Recently the latter has been recognized as spermatocidal in the presence of vaginal lactic acid, and it is conceivable that sour milk, too, might be an effective spermatocide.

Predicting the sex of an unborn child was important to some Egyptians, and Berlin Papyrus No. 3038 (Dynasty XIX, about 1300 B.C.) gives one method for doing so: "Wheat and Spelt [a hardy wheat]: let the woman water them daily with her urine . . . in two bags. If they both grow, she will bear; if the wheat grows, it will be a boy; if the spelt grows, it will be a girl. If neither grows, she will not bear." The original rationale for this "test" probably lies in an ancient association of wheat and spelt with male and female divinities, respectively. In 1962 the method was assessed in a modern botany laboratory at Cairo, albeit in glass dishes rather than in bags. No germination was observed in samples treated with eight nonpregnant urines (including two from men), or in those treated with 12 of 40 urines from pregnant woman; another five of the latter resulted in only poor growth. Statistical analysis of the raw data (chi-squared $= 10.914$, $P < 0.005$) suggests, as the recent investigators inferred, that the pregnant urine samples might have contained a substance that inhibited seed germination. However, the method provided correct predictions of the newborn's sex in only 19 of 40 cases, as would, of course, be expected on the basis of chance alone.

In the absence of, or even despite, predictions about fertility or fetal sex, some Egyptians tried to exert direct influence on the outcome. For instance, milk from women who had been delivered of infant boys was given to a woman who wished to become pregnant, especially if she wanted a son. Mother's milk was sometimes stored for such use in jars

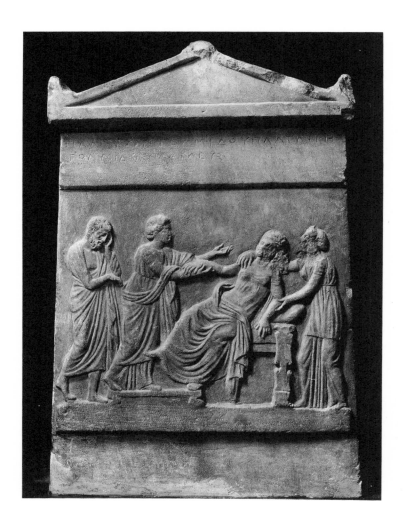

Women Attending a Delivery. Funeral stele. 4th century B.C. National Museum, Athens. *This votive tablet, found at Oropos, shows women attending another woman at delivery. Before modern times, men were usually barred from the birthing room. The man in this tablet must be the grieving husband.*

shaped like a mother nursing her baby . . . although human milk had several other nonspecific, and nonobstetric, uses in general "internal medicine."

The medical papyri devote little attention to medical problems that might arise at the time of delivery, although the Ebers Papyrus suggests a number of oils, salts, and aromatic resins for hastening birth when inserted into the vagina, as well as two clearly magical procedures for preventing miscarriage. The same document also notes that if the baby says *"nj"* at birth, he will live; if he says *"mbj,"* or moans, or turns his face downward, he will die. The mummy of one young woman shows that she died in or soon after childbirth about 1000 B.C., and another died because her infant's head was too large to pass between her pelvic bones. . . .

If all went well, when their time came women were delivered while squatting on two large bricks, or while sitting in a chair from which the center of the seat had been removed, as would become customary in medieval Europe. Women in labor were assisted, at least among the nobility, by two or three other women, not by *swnw* [pronounced *sounou:* lay practitioners—*eds.*]; New Kingdom pharaohs also knew that midwives and birth stools were employed by their Hebrew captives. Most of the few Egyptian pictures of birth show the infant emerging head first, as is normal. Indeed, the hieroglyphs for birth represent such cephalic presentations as well as the bricks.

Although the *swnw* did not attend births, they did treat gynecological disorders, even if not with surgical techniques. They knew that amenorrhea and dysmenorrhea (absent and painful menses, respectively) were abnormal, and they administered a variety of soothing aromatic oils and ointments for inflammations of the internal and external genitalia. Many remedies for women's diseases are described in both the Ebers and Kahun papyri. The latter describes some ailments of the eyes, mouth, and legs, as well as those of the lower abdomen and the pubic area, as conditions resulting from "defluxions" (discharges, whether visible or not) of the uterus. The *swnw's* concept of uterine anatomy was derived from the bicornuate uterus of cows, which does not much resemble the single-chambered uterus of women. Because the *swnw* thought that many uterine disorders occurred when the womb became malpositioned in the abdomen, treatments for uterine symptoms relied largely on methods that physicians thought would force it back into its usual alignment, albeit with drugs, not by manipulation. Drugs intended to act directly on the uterus were administered by having the patient sit or stand over the burning ingredients, by directly inserting the remedies into the vagina, or by mouth.

Edith Hamilton

FROM MYTHOLOGY

The Myth of Aesculapius

Aesculapius bears a resemblance to the Egyptian Imhotep (ca. 3500 B.C.), inventor of the pyramids. Both were mortals who later became gods of medicine. Throughout antiquity, followers of these two legendary physicians practiced in temples, ministering to those desperate for cures. Both gods healed, with the physicians' or priests' help, while the patient was asleep.

There was a maiden in Thessaly named Coronis, of beauty so surpassing that Apollo loved her. But strangely enough she did not care long for her divine lover; she preferred

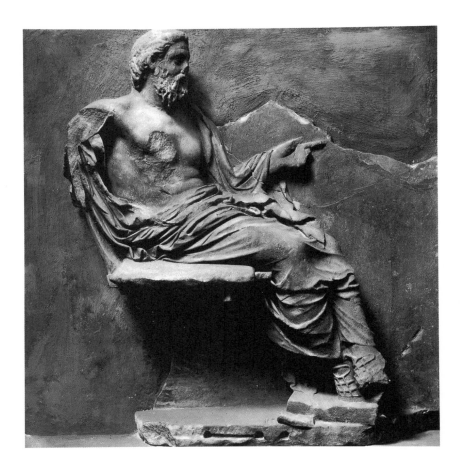

After THRASYMEDES. *Aesculapius.*
Musée National, Paris. *Aesculapius was
the Greeks' legendary god of medicine. In
classical antiquity, temples to him were
common throughout the Mediterranean,
attracting patients in hopes of miraculous
cures. Aesculapius's missing right hand
probably held his staff with coiling
serpent.*

a mere mortal. She did not reflect that Apollo, the God of Truth, who never deceived,
could not himself be deceived.

> The Pythian Lord of Delphi
> He has a comrade he can trust,
> Straightforward, never wandering astray.
> Which never touches falsehood, which no one
> Or god or mortal can outwit. He sees,
> Whether the deed is done, or only planned.

Coronis was foolish indeed to hope that he would not learn of her faithlessness. It is
said that the news was brought to him by his bird, the raven, then pure white with
beautiful snowy plumage, and that Apollo in a fit of furious anger, and with the complete
injustice the gods usually showed when they were angry, punished the faithful messenger
by turning his feathers black. Of course Coronis was killed. Some say that the god did
it himself, others that he got Artemis to shoot of her unerring arrows at her.

In spite of his ruthlessness, he felt a pang of grief as he watched the maiden placed on
the funeral pyre and the wild flames roar up. "At least I will save my child," he said to
himself; and just as Zeus had done when Semele perished, he snatched away the babe
which was very near birth. He took it to Chiron, the wise and kindly old Centaur, to
bring up in his cave on Mount Pelion, and told him to call the child Aesculapius. Many
notables had given Chiron their sons to rear, but of all his pupils the child of dead Coronis
was dearest to him. He was not like other lads, forever running about and bent on sport;
he wanted most of all to learn whatever his foster-father could teach him about the art of
healing. And that was not a little. Chiron was learned in the use of herbs and gentle
incantations and cooling potions. But his pupil surpassed him. He was able to give aid
in all manner of maladies. Whoever came to him suffering, whether from wounded limbs
or bodies wasting away with disease, even those who were sick unto death, he delivered
from their torment.

A gentle craftsman who drove pain away,
Soother of cruel pangs, a joy to men,
Bringing them golden health.

He was a universal benefactor. And yet he too drew down on himself the anger of the gods and by the sin the gods never forgave. He thought "thoughts too great for man." He was once given a large fee to raise one from the dead, and he did so. It is said by many that the man called back to life was Hippolytus. Theseus' son who died so unjustly, and that he never again fell under the power of death, but lived in Italy, immortal forever, where he was called Virbius and worshiped as a god.

However, the great physician who had delivered him from Hades had no such happy fate. Zeus would not allow a mortal to have power over the dead and he struck Aesculapius with his thunderbolt and slew him. Apollo, in great anger at his son's death, went to Etna, where the Cyclopes forged the thunderbolts; and killed with his arrows, some say the Cyclopes themselves, some say their sons. Zeus, greatly angered in his turn, condemned Apollo to serve King Admetus as a slave—for a period which is differently given as one or nine years. It was this Admetus whose wife, Alcestis, Hercules rescued from Hades.

But Aesculapius, even though he had so displeased the King of Gods and Men, was honored on earth as no other mortal. For hundreds of years after his death the sick and the maimed and the blind came for healing to his temples. There they would pray and sacrifice, and after that go to sleep. Then in their dreams the good physician would reveal to them how they could be cured. Snakes played some part in the cure, just what is not known, but they were held to be the sacred servants of Aesculapius.

It is certain that thousands upon thousands of sick people through the centuries believed that he had freed them from their pain and restored them to health.

Hippocrates
THE PHYSICIAN'S OATH

Some followers of Hippocrates of Cos (fl. 430 B.C.) may have taken this sacred oath, which regulated the conduct of the healer as well as his "professional" obligations. Works of surgery do appear in the large Hippocratic corpus, amassed between 400 and 100 B.C., and thus many of the Coan school were not bound to this code. Hippocrates himself surely did not write the oath.

I swear by Apollo Physician and Asclepius and Hygieia and Panaceia and all the gods and goddesses, making them my witnesses, that I will fulfil according to my ability and judgment this oath and this covenant:

To hold him who has taught me this art as equal to my parents and to live my life in partnership with him, and if he is in need of money to give him a share of mine, and to regard his offspring as equal to my brothers in male lineage and to teach them this art— if they desire to learn it—without fee and covenant; to give a share of precepts and oral instruction and all the other learning to my sons and to the sons of him who has instructed me and to pupils who have signed the covenant and have taken an oath according to the medical law, but to no one else.

I will apply dietetic measures for the benefit of the sick according to my ability and judgment; I will keep them from harm and injustice.

I will neither give a deadly drug to anybody if asked for it, nor will I make a suggestion to this effect. Similarly I will not give to a woman an abortive remedy. In purity and holiness I will guard my life and my art.

I will not use the knife, not even on sufferers from stone, but will withdraw in favor of such men as are engaged in this work.

Whatever houses I may visit, I will come for the benefit of the sick, remaining free of all intentional injustice, of all mischief and in particular of sexual relations with both female and male persons, be they free or slaves.

What I may see or hear in the course of the treatment or even outside of the treatment in regard to the life of men, which on no account one must spread abroad, I will keep to myself holding such things shameful to be spoken about.

If I fulfil this oath and do not violate it, many it be granted to me to enjoy life and art, being honored with fame among all men for all time to come; if I transgress it and swear falsely, may the opposite of all this be my lot.

Hippocrates

FROM DECORUM

Early Greek physicians were more craftsmen than priests, itinerant healers for whom Hippocratic medical theories improved the chances of a good diagnosis. Lay practitioners who do not borrow from the powers of a god, as this Hippocratic work illustrates, must attend to the practical details of the art of curing and caring.

———————

Between wisdom and medicine there is no gulf fixed; in fact medicine possesses all the qualities that make for wisdom. It has disinterestedness, shamefastness, modesty, reserve, sound opinion, judgment, quiet, pugnacity, purity, sententious speech, knowledge of the things good and necessary for life, selling of that which cleanses, freedom from super-stition, pre-excellence divine. What they have, they have in opposition to intemperance, vulgarity, greed, concupiscence, robbery, shamelessness. This is knowledge of one's income, use of what conduces to friendship, the way and manner to be adopted towards one's children and money. Now with medicine a kind of wisdom is an associate, seeing that the physician has both these things and indeed most things. . . . In fact it is especially knowledge of the gods that by medicine is woven into the stuff of the mind. For in affections generally, and especially in accidents, medicine is found mostly to be held in honour by the gods. Physicians have given place to the gods. For in medicine that which is powerful is not in excess. In fact, though physicians take many things in hand, many diseases are also overcome for them spontaneously. All that medicine has now mastered it will supply thence. The gods are the real physicians, though people do not think so. But the truth of this statement is shown by the phenomena of disease, which are co-extensive with the whole of medicine, changing in form or in quality, sometimes being cured by surgery, sometimes being relieved, either through treatment or through regi-men. The information I have given on these matters must serve as a summary.

. . . As all I have said is true, the physician must have at his command a certain ready wit, as dourness is repulsive both to the healthy and to the sick. He must also keep a most careful watch over himself, and neither expose much of his person nor gossip to laymen, but say only what is absolutely necessary. For he realizes that gossip may cause criticism

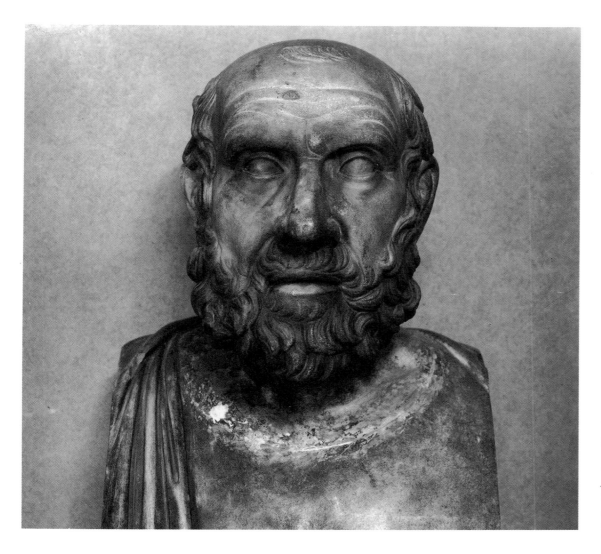

Hippocrates. 2nd century B.C.
Marble. 17¾ in. (45 cm).
Uffizi Gallery, Florence. *A
Roman bust celebrating the
founder of the most successful
medical "school" of antiquity:
Hippocrates of Cos, who lived in
the 5th century B.C.*

of his treatment. He will do none at all of these things in a way that savours of fuss or of show. Let all these things be thought out, so that they may be ready beforehand for use as required. Otherwise there must always be lack when need arises.

. . .You must practise these things in medicine with all reserve, in the matter of palpation, anointing, washing, to ensure elegance in moving the hands, in the matter of lint, compresses, bandages, ventilation, purges, for wounds and eye-troubles, and with regard to the various kinds of these things, in order that you may have ready beforehand instruments, appliances, knives and so forth. For lack in these matters means helplessness and harm. See that you have a second physician's case, of simpler make, that you can carry in your hands when on a journey. The most convenient is one methodically arranged, for the physician cannot possibly go through everything.

. . .Keep well in your memory drugs and their properties, both simple and compound, seeing that after all it is in the mind that are also the cures of diseases; remember their modes, and their number and variety in the several cases. This in medicine is beginning, middle and end.

. . .You must have prepared in advance emollients classified according to their various uses, and get ready powerful draughts prepared according to formula after their various kinds. You must make ready beforehand purgative medicines also, taken from suitable localities, prepared in the proper manner, after their various kinds and sizes, some preserved so as to last a long time, others fresh to be used at the time, and similarly with the rest.

. . .When you enter a sick man's room, having made these arrangements, that you may not be at a loss, and having everything in order for what is to be done, know what you must do before going in. For many cases need, not reasoning, but practical help. So

you must from your experience forecast what the issue will be. To do so adds to one's reputation, and the learning thereof is easy.

. . .On entering bear in mind your manner of sitting, reserve, arrangement of dress, decisive utterance, brevity of speech, composure, bedside manners, care, replies to objections, calm self-control to meet the troubles that occur, rebuke of disturbance, readiness to do what has to be done. In addition to these things be careful of your first preparation. Failing this, make no further mistake in the matters wherefrom instructions are given for readiness.

. . .Make frequent visits; be especially careful in your examinations, counteracting the things wherein you have been deceived at the changes. Thus you will know the case more easily, and at the same time you will also be more at your ease. For instability is characteristic of the humours, and so they may also be easily altered by nature and by chance. For failure to observe the proper season for help gives the disease a start and kills the patient, as there was nothing to relieve him. For when many things together produce a result there is difficulty. Sequences of single phenomena are more manageable, and are more easily learnt by experience.

. . .Keep a watch also on the faults of the patients, which often make them lie about the taking of things prescribed. For through not taking disagreeable drinks, purgative or other, they sometimes die. What they have done never results in a confession, but the blame is thrown upon the physician.

. . .The bed also must be considered. The season and the kind of illness will make a difference. Some patients are put into breezy spots, others into covered places or underground. Consider also noises and smells, especially the smell of wine. This is distinctly bad, and you must shun it or change it.

. . .Perform all this calmly and adroitly, concealing most things from the patient while you are attending to him. Give necessary orders with cheerfulness and serenity, turning his attention away from what is being done to him; sometimes reprove sharply and emphatically, and sometimes comfort with solicitude and attention, revealing nothing of

Tributes to a Greek physician. Stone bas-relief. c. 4th century B.C. Surgical instruments and the serpent in the tree signify the physician.

the patient's future or present condition. For many patients through this cause have taken a turn for the worse, I mean by the declaration I have mentioned of what is present, or by a forecast of what is to come.

. . .Let one of your pupils be left in charge, to carry out instructions without unpleasantness, and to administer the treatment. Choose out those who have been already admitted into the mysteries of the art, so as to add anything necessary, and to give treatment with safety. He is there also to prevent those things escaping notice that happen in the intervals between visits. Never put a layman in charge of anything, otherwise if a mischance occur the blame will fall on you. Let there never be any doubt about the points which will secure the success of your plan, and no blame will attach to you, but achievement will bring you pride. So say beforehand all this at the time the things are done, to those whose business it is to have fuller knowledge.

. . .Such being the things that make for good reputation and decorum, in wisdom, in medicine, and in the arts generally, the physician must mark off the parts about which I have spoken, wrap himself round always with the other, watch it and keep it, perform it and pass it on. For things that are glorious are closely guarded among all men. And those who have made their way through them are held in honour by parents and children; and if any of them do not know many things, they are brought to understanding by the facts of actual experience.

Celsus

FROM ON MEDICINE

Aulus Cornelius Celsus (fl. first century A.D.) is usually described as a Roman gentleman-scholar who surveyed Roman medical practice from his library. But his description of the surgery for stones in the bladder (lithotomy) goes beyond a casual layman's interest and suggests Celsus's direct medical experience. While Celsus's intact book was recovered only in the Renaissance, this operative procedure for lithiasis was the standard for a thousand years.

[I]n this procedure we must not act with haste, as in most cases, but so that safety is the first consideration; for an injury to the bladder causes spasm with danger of death. And the stone is first sought for about the neck of the bladder; when found there it is expelled with less trouble. . . . But if the stone is not found at the neck of the bladder, or if it has slipped backwards, the fingers are placed against the base of the bladder, while the surgeon's right hand too is placed above the stone and gradually follows it downwards. When the stone has been found, and it must fall between his hands, it is guided downwards with special care the smaller and the smoother it is, lest it escape. Therefore the right hand of the surgeon is always kept above the stone whilst the fingers of the left press it downwards until it arrives at the neck of the bladder: and it must be pressed towards this so that if oblong, it comes out end on; if flat it lies crossways; if cubical, it rests on two of its angles; if any part is larger, the smaller part comes out first. In the case of a spherical stone, it is clear that the shape makes no difference, except that if any part is the smoother this should be in front. When the stone has now got there, then the skin over the neck of the bladder next the anus should be incised by a semilunar cut, the horns of which point towards the hips; then a little lower down in that part of the incision which is concave, a second cut is to be made under the skin, at a right angle to the first, to open up the neck of the bladder until the urinary passage is opened so that the wound is a little

Roman Physician. Center panel from the front of a Roman sarcophagus, marble bas-relief. 4th century. Overall sarcophagus 21¾ × 84⅞ × 23¼ in. (55.2 × 215.6 × 59.1 cm). Metropolitan Museum of Art, New York. Gift of Earnest and Beata Brummer, in memory of Joseph Brummer. *The physician is seated before a cabinet displaying scrolls, surgical instruments, and a bowl.*

larger than the stone. For those who make a small opening for fear of a fistula, which in this situation the Greeks call *rhyas,* incur this same danger to a greater degree, because the stone, when it is pressed down with force, makes a way out for itself unless it is given one. And this is even more harmful if the shape of the stone or its roughness has caused any additional trouble. As a consequence bleeding and spasm may be set up. And even if the patient survives he will have nevertheless, a much wider fistula if the neck of the bladder has been torn, than he would have had if it had been cut.

Now when the urethra has been laid open, the stone comes into view; its colour is of no importance. If it is small, it can be pushed outwards with the fingers on one side, and extracted by those on the other. If large, we must put over the upper part of it the scoop made for the purpose. This is thin at the end, beaten out into a semicircular shape, smooth on the outer side, where it comes into contact with the body, rough on the inner where it touches the stone. The scoop must be rather long, for a short one has not the strength to extract. When the scoop has been put in, it should be moved to each side to see whether the stone is held, because if it has been well grasped, it is moved with the scoop. This is required lest when the scoop begins to be drawn forward, the stone should slip inwards and the scoop cut into and lacerate the wound opening, and I have noted above how dangerous this is. When it is certain that the stone is sufficiently held, almost simultaneously a triple movement is to be made; first towards each side, then outwards, this in such a way that the movement is gentle and the stone is at first drawn outwards but little; this done the one end is to be raised so that the scoop may stay further in, and more easily draw out the stone. But if at any time the stone cannot be properly caught from above, it will have to be taken hold of from one side. This is the simplest method of operation. But various contingencies call for some further observations.

There are some stones which are not merely rough but also spinous, which if they have come down to the neck of the bladder of their own accord may be extracted without any danger. But it is not safe to search for these within the bladder and draw them out, for when they have wounded the bladder they cause a speedy death from spasm, and much more so if a spinous stone sticks to the bladder, and when being drawn down has folded it over. Now it may be inferred that the stone is at the neck of the bladder, when the patient has difficulty in passing water: or that the stone is spinous, when he passes bloody urine in drops. And it is most important that the calculus should be felt under the fingers, and that the operation should not be proceeded with unless this is assured. And then too the fingers must be applied gently, lest they wound by pressing forcibly: the incision is then made. Many use a scalpel here also. Since this is rather weak, and may meet some projecting part of the stone, and while cutting the flesh over the projection fail to divide what is in the hollow beneath, but leave something which necessitates a second operation. Meges made a straight blade, with a wide border on its upper part, semicircular and sharp below. This knife, with its handle grasped between the two fingers,

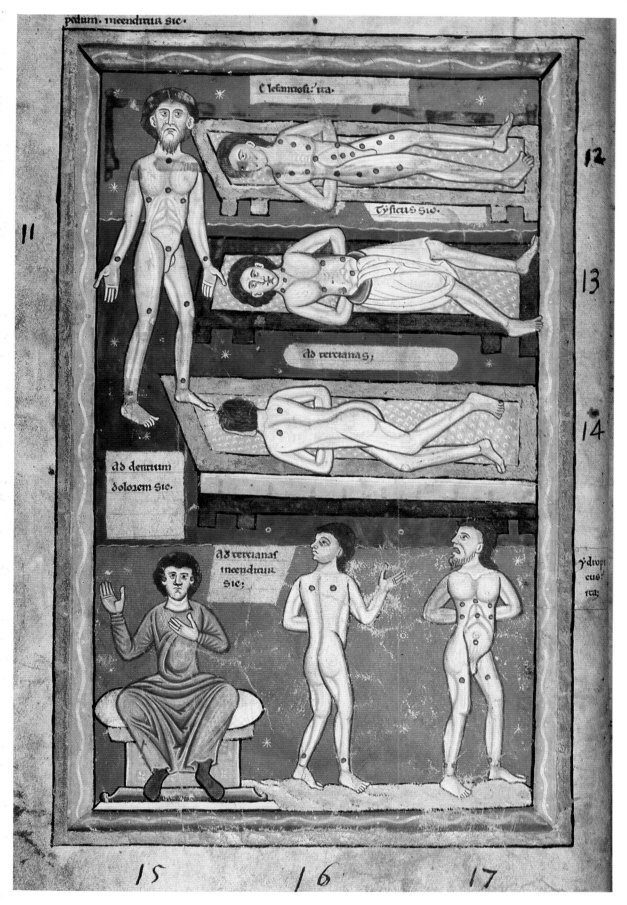

COLORPLATE 10

Chart Showing Points Where Hot Cauteries Could Be Applied to Remedy Certain Maladies.
Late 12th century. Illustration from pseudo-Apuleius *Herbal.* Painting on parchment.
11^{15}/$_{16}$ × 8^1/$_8$ in. (30.3 × 20.6 cm). The Bodleian Library, Oxford. *English miniature
illustrating the cautery points for treating elephantiasis (top left, standing man), asthma (top right),
tertian fever (the four remaining unclothed figures), and toothache (seated man).*

COLORPLATE II

Skeletal system from *Five Anatomical Figures*. Original, late 14th century. Illustration from *Tashrih Munsörī (Tashrīh bi 'l-taswīr), by Mansūr ibn Muhammad Fagih Ilyās*. Opaque watercolor. 16 × 9½ in. (40.6 × 24.1 cm). Courtesy British Library, London. *One of the many medieval versions of the skeletal system, this Persian miniature was meant to be a stylized representation of skeletal anatomy.*

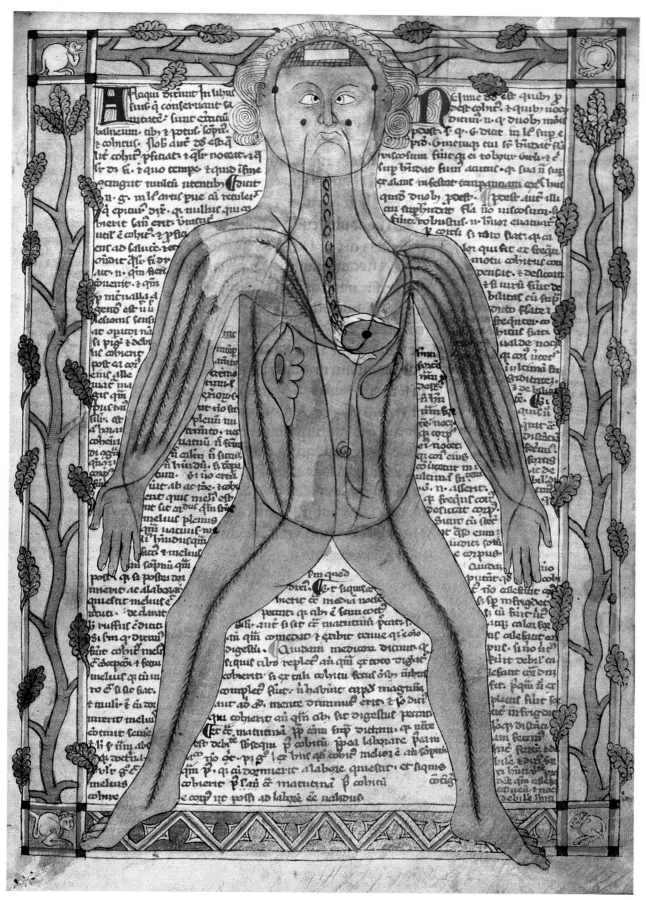

COLORPLATE 12

Circulatory System. Late 13th century. Manuscript, pen and wash on parchment.
10½ × 7½ in. (26.7 × 19.1 cm). The Bodleian Library, Oxford. *A Western representation
of the circulatory system in the medieval* Five Anatomical Figures. *Other standard figures in
the series included a nerve man, a muscle man, and a pregnant woman.*

COLORPLATE 13

Examination of a Breast Abscess. Manuscript illustration for *Chirurgia,* by Theodoric of Cervia. 13th century. 3½ × 3⁵⁄₁₆ in. (8.9 × 8.4 cm). University Library, Leiden. *A surgeon of the long robe—so called to distinguish him as educated at a university—examines a woman with a painful inflammation.*

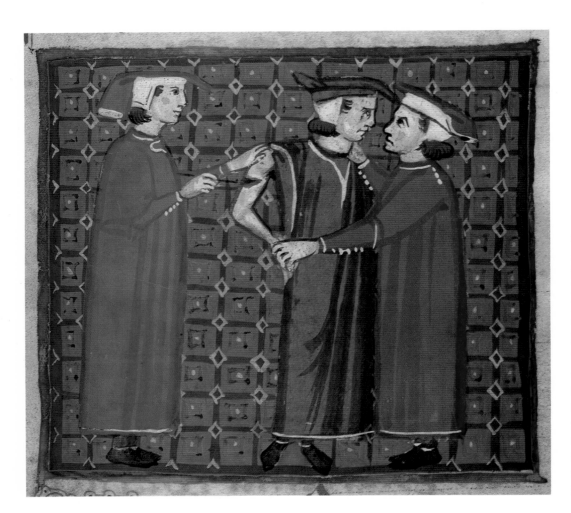

COLORPLATE 14

Operating on the Upper Arm. Manuscript illustration for *Chirurgia,* by Theodoric of Cervia. 13th century. 2¹³⁄₁₆ × 3¼ in. (7.1 × 8.3 cm). University Library, Leiden. *A surgeon of the long robe explores an arm wound while an assistant steadies the patient. Theodoric of Cervia stressed first cleansing the wound and approximating its edges. The wound was bandaged and left untouched for 5–6 days, unless the patient was in pain.*

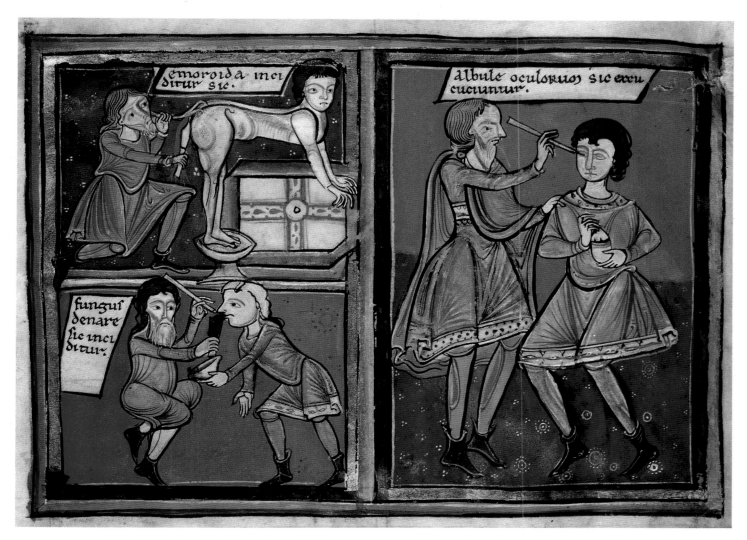

COLORPLATE 15

Surgery for Hemorrhoids, Nose Polyps, and Corneal Incision. c.1190–1200. Anglo-Norman illuminated manuscript. Pigments on vellum. 11¹³⁄₁₆ × 7¾ in. (30 × 19.7 cm). Courtesy British Library, London. *A 12th-century English miniature illustrating the surgery for hemorrhoids, nasal polyps, and cataracts, as performed by a short-robed surgeon. Medieval Latin texts of surgery rarely discussed corneal incision, a procedure left to itinerant specialists.*

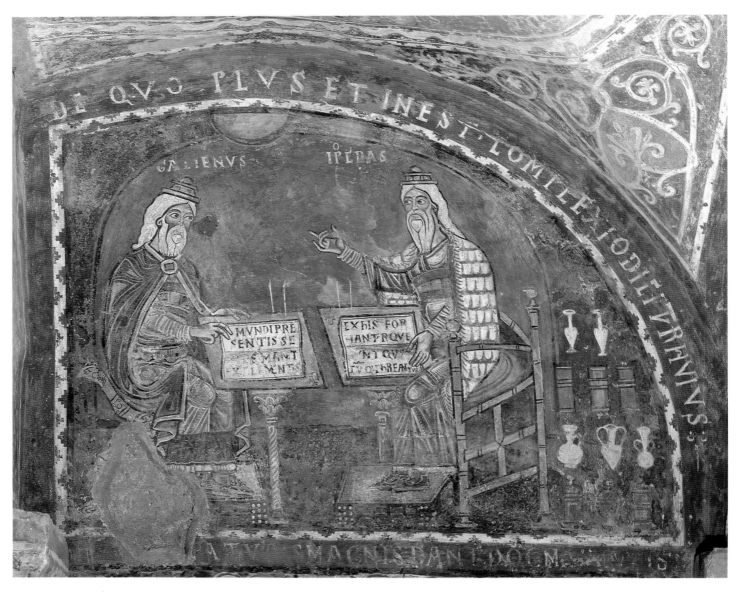

COLORPLATE 16

Hippocrates and Galen. 13th century. Fresco. Duomo, Anagni, Italy. *Galen (left) and Hippocrates in consultation, even though Galen lived almost 500 years later than Hippocrates.*

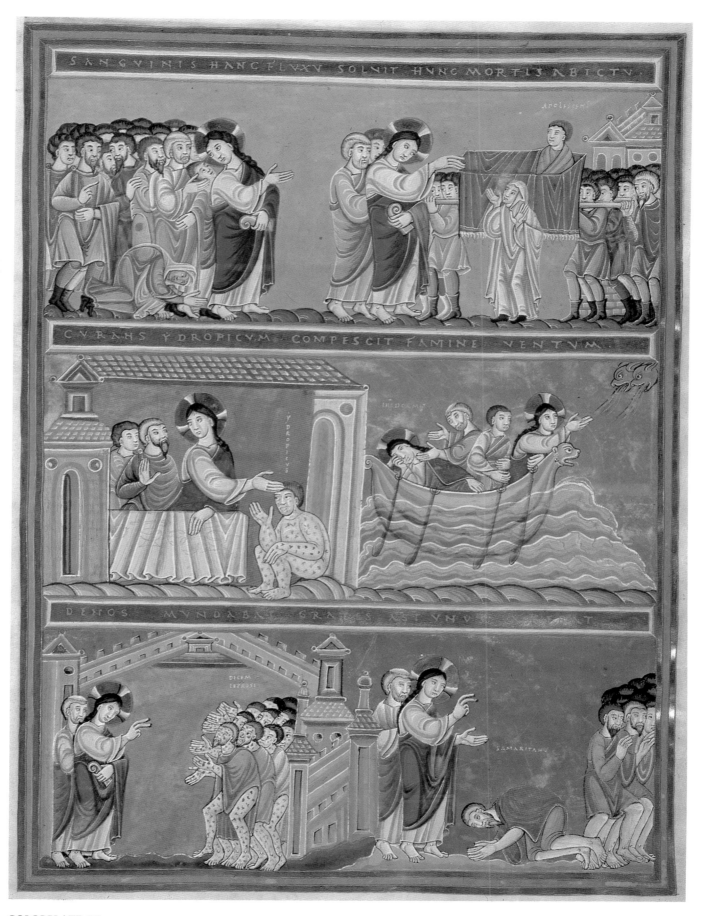

COLORPLATE 17

Christ Healing the Lepers, and Other Healing Miracles. 1020–1030. Manuscript illustration from *Codex Aureus Epternacensis.* 17⁵⁄₁₆ × 12¼ in. (44 × 31.1 cm). Germanisches Nationalmuseum, Nuremberg.

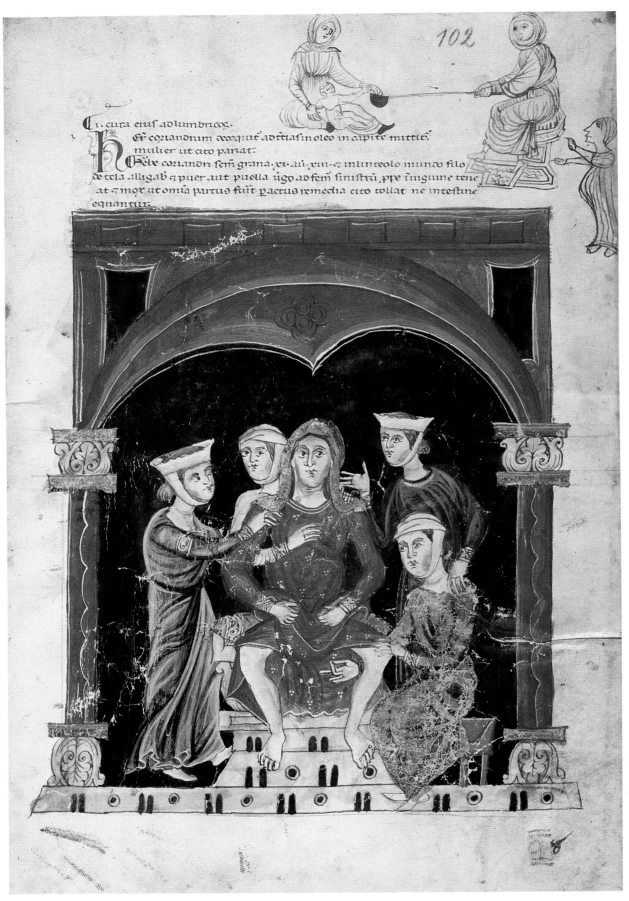

COLORPLATE 18

Women Attending a Birth; Application of Coriander. Mid 13th century. Manuscript miniature from pseudo-Apuleius *Herbal.* 10¹³⁄₁₆ × 7⁵⁄₁₆ in. (27.5 × 18.6 cm). Österreichische Nationalbibliothek, Vienna. *Women attending a birth, using coriander seed close to the vagina to hasten delivery. The text warns that the seed must be quickly removed at labor, otherwise the intestines may be expelled after the fetus! Drawings at the top illustrate other uses of coriander.*

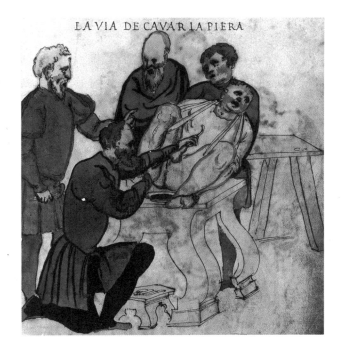

LA VIA DE CAVAR LA PIERA

HEINRICH KULLMAURER and ALBRECHT MEHER. *Cutting for the Stone: Introducing a Catheter to Localize Bladder Stone.* Illustration from *Sketchbook.* c. 1510. Pen and ink and watercolor. 16½ × 10⅝ in. (41.9 × 27 cm). Courtesy of the Trustees of the British Museum, London. *Lithotomy, or extraction of a bladder stone, was a common procedure in the 16th century. The surgeon inserts a catheter into the bladder to localize and fix the stone. Attendants immobilize the patient, and a pan catches the blood and urine.*

index and middle, and the thumb put upon the back of the blade, was so pressed down that any projection upon the stone might be cut through along with the flesh. By this means it followed that he made one opening of a sufficient size. But in whatever way the neck of the bladder is laid open, any rough stone should be extracted gently, and no force used to hasten matters. . . .

When the stone has been extracted, if the patient is strong and has not suffered excessively, it is well to let the bleeding go on, so that less inflammation may follow. Besides it is not unfitting for him to move about a little, in order that any blood clot still inside may drop out. But if again the bleeding does not cease of its own accord, it must be stopped lest all his strength be used up; and in weaker patients this is to be done immediately after the operation; since just as there is the risk of spasm from pushing about the bladder, so there is a second danger that so much blood may be lost as to prove fatal. To prevent this the patient should be seated in a bath of strong vinegar to which a little salt has been added; under this treatment the bleeding generally stops, and it also has an astringent effect on the bladder so that the inflammation there is lessened.

Galen

FROM ON AFFECTED PARTS

One of the greatest physicians of all time, Galen (ca. 130–210 A.D.) synthesized medical works of the Hippocratics, Aristotelian biology, and Platonic philosophy, creating a system of medical theory and practice that dominated Western and Islamic medicine until the 19th century. Galen preferred to think of himself as a brilliant diagnostician, heir to the best of the Hippocratic tradition, then over 500 years old.

Upon the occasion of my first visit to Rome I completely won the admiration of the philosopher Glaucon by the diagnosis which I made in the case of one of his friends. Meeting me one day in the street he shook hands with me and said: "I have just come

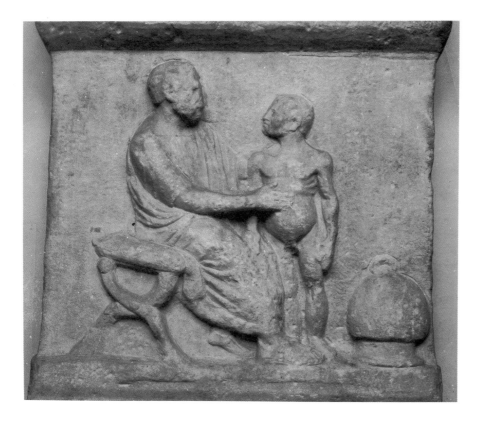

Athenian Physician, Jason. 2nd century. Greek sepulchral bas-relief. Pentelic marble. 2 ft. 7 in. × 1 ft. 10½ in. (78.7 × 57.2 cm). Courtesy of the Trustees of the British Museum, London. *Here a Greek physician examines the swollen abdomen of a young boy. At right, a large cupping glass serves to identify the man as a physician.*

from the house of a sick man, and I wish that you would visit him with me. He is a Sicilian physician, the same person with whom I was walking when you met me the other day." "What is the matter with him?" I asked. Then coming nearer to me he said, in the frankest manner possible: "Gorgias and Apelas told me yesterday that you had made some diagnoses and prognoses which looked to them more like acts of divination than products of the medical art pure and simple. I would therefore like very much to see some proof, not of your knowledge but of this extraordinary art which you are said to possess." At this very moment we reached the entrance of the patient's house, and so, to my regret, I was prevented from having any further conversation with him on the subject and from explaining to him how the element of good luck often renders it possible for a physician to give, as it were offhand, diagnoses and prognoses of this exceptional character.

Just as we were approaching the first door, after entering the house, we met a servant who had in his hand a basin which he had brought from the sick room and which he was on his way to empty upon the dung heap. As we passed him I appeared not to pay any attention to the contents of the basin, but at a mere glance I perceived that they consisted of a thin sanio-sanguinolent fluid, in which floated excrementitious masses that resembled shreds of flesh—an unmistakable evidence of disease of the liver. Glaucon and I, not a word having been spoken by either of us, passed on into the patient's room. When I put out my hand to feel of the latter's pulse, he called my attention to the fact that he had just had a stool, and that, owing to the circumstance of his having gotten out of bed, his pulse might be accelerated. It was in fact somewhat more rapid that it should be, but I attributed this to the existence of an inflammation. Then, observing upon the window sill a vessel containing a mixture of hyssop and honey and water, I made up my mind that the patient, who was himself a physician, believed that the malady from which he was suffering was a pleurisy; the pain which he experienced on the right side in the region of the false ribs (and which is also associated with inflammation of the liver) confirming him in this belief, and thus inducing him to order for the relief of the slight accompanying cough the mixture to which I have called attention.

It was then that the idea came into my mind that, as fortune had thrown the opportunity in my way, I would avail myself of it to enhance my reputation in Glaucon's

estimation. Accordingly, placing my hand on the patient's right side over the false rib, I remarked: "This is the spot where the disease is located." He, supposing that I must have gained this knowledge by simply feeling his pulse, replied with a look which plainly expressed admiration mingled with astonishment, that I was entirely right. "And," I added simply to increase his astonishment, "you will doubtless admit that at long intervals you feel impelled to indulge in a shallow, dry cough, unaccompanied by an expectoration." As luck would have it, he coughed in just this manner almost before I had got the words out of my mouth. At this Glaucon, who had hitherto not spoken a word, broke out into a volley of praises.

"Do not imagine," I replied, "that what you have observed represents the utmost of which medical art is capable in the matter of fathoming the mysteries of disease in a living person. There still remain one or two other symptoms to which I will direct your attention." Turning then to the patient I remarked: "When you draw a longer breath you feel a more marked pain, do you not, in the region which I indicated; and with this pain there is associated a sense of weight in the hypochondrium?" At these words the patient expressed his astonishment and admiration in the strongest possible terms. I wanted to go a step farther and announce to my audience still another symptom which is sometimes observed in the more serious maladies of the liver (scirrhus, for example), but I was afraid that I might compromise the laudation which had been bestowed upon me. It then occurred to me that I might safely make the announcement if I put it somewhat in the form of a prognosis. So I remarked to the patient: "You will probably soon experience, if you have not already done so, a sensation of something pulling upon the right clavicle." He admitted that he had already noticed this symptom. "Then I will give just one more evidence of this power of divination which you believe that I possess. You, yourself, before I arrived on the scene, had made up your mind that your ailment was an attack of pleurisy, etc."

Glaucon's confidence in me and in the medical art, after this episode, was unbounded.

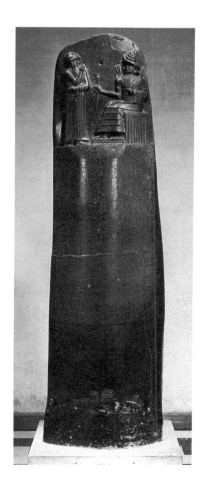

(left) Manuscript page from *Atharva-Veda*. Universitätsbibliothek, Tubingen. (right) *The Code of Hammurabi*. Basalt stele, from Susa, Iran. c. 1750 B.C. Approximately 88 in. high (223.5 cm). Louvre, Paris.

Chuang-Tzu
On a Cripple

This early Taoist description (ca. 500 B.C.) of a badly deformed man stands in contrast to the Confucian medicine that would dominate later imperial China. Confucians systematized and normalized ideas of health, disease, and therapy, much as their contemporaries in the West. The Taoist here sees the diversity and individuality of physical suffering, such that health is not a unique blessing. Taoism similarly championed diversity among medical practitioners.

There's Crippled Shu—chin stuck down in his navel, shoulders up above his head, pigtail pointing at the sky, his five organs on the top, his two thighs pressing his ribs. By sewing and washing, he gets enough to fill his mouth; by handling a winnow and sifting out the good grain, he makes enough to feed ten people. When the authorities call out the troops, he stands in the crowd waving good-by; when they get up a big work party, they pass him over because he's a chronic invalid. And when they are doling out grain to the ailing, he gets three big measures and ten bundles of firewood. With a crippled body, he's still able to look after himself and finish out the years Heaven gave him. How much better, then, if he had crippled virtue!

MEDIEVAL MEDICINE: AUTHORITY AND ORDER

Richter of Rheims
"How Derold Was Duped"

Richter's History *(ca. 990 A.D.) belies an image of the Dark Ages as devoid of learning. French cathedral schools offered medical training to clergy and laymen. This story boasts native medical skills, Bishop Derold's (ca. 940) in particular, over those of the rival palace doctors. The School of Salerno produced the age's most successful practitioners; other palace favorites—not mentioned here—were Jewish doctors.*

At this time there passed away Bishop Derold of Amiens, an important man of the palace, formerly much favored by the king, and very eminent in the profession of medicine. It was said of him that while he was still in the royal service at the palace, a Salernitan

physician duped him, but was in turn himself duped. Both men were most expert in the medical profession, but whereas the queen considered the Salernitan the better informed, the king preferred Derold. By a subterfuge the king found out which of them knew more about the nature of things. Carefully concealing his purpose he invited them to dine with him, and propounded many problems which each did his best to solve. But Derold, who was very erudite in the literary arts gave [the most] convincing solutions. The Salernitan although unlearned in letters had by reason of his natural intelligence acquired a wide experience in practical affairs. At the king's order they sat daily at this table and drank together. One day they were considering the different aspects of dinamidia, and were discussing further the effectiveness of pharmaceutics, surgery, and botany. The Salernitan, being unfamiliar with the strange names, blushingly avoided any explanation. On account of this he became very jealous of Derold and prepared a poison for the purpose of killing him; pretending, however, all the while to have the greatest of affection for him. Having planned his evil deed, while they sat at dinner the Salernitan dipped his finger, which he had impregnated with the poison, in the pepper-sauce with which they spiced their food. Unwittingly, Derold took some and with the spread of the poison soon began to weaken. But his friends took him away, and he counteracted the force of the poison by means of a theriac. After three days he returned and took his place once more at the table with the Salernitan. When asked what had happened to him, he said that he had been taken with a slight cold. By thus pretending that he was unaware of the crime, he made his enemy overconfident. But when they returned to the table, Derold dropped into the food which was about to be eaten, some poison which he had concealed between his ring and finger. Soon the spreading poison destroyed the vital warmth, and in great suffering the Salernitan was taken out. His efforts to expell the poison were ineffective. So, with praise for Derold and admission of his superiority in medicine he earnestly besought treatment from him. In response to the king's command Derold gave him antidotes for the poison, but deliberately made them incomplete. Consequently, when he took the theriac the powerful poison was so completely localized in his left foot, that, as he told his intimate friends, the poison rose from his foot through the vein like a chick pea, so to speak, and was driven back by the opposing antidote. These reactions continued until the epidermis of the foot was infected; illness followed and later after much suffering it was amputated by the surgeons.

Anonymous

ADMONITIONS OF HIPPOCRATES

On Learning the Art of Medicine

Respect for Hippocratic ideals in medical practice was widespread during the early Christian Middle Ages. Even for outside centers, such as Salerno, that copied ancient texts, medical ethics was a fundamental concern. Far beyond the compass of the ancient Hippocratic oath, medieval texts (Christian, Muslim, Jewish, and Chinese) emphasize literacy and the spiritual importance of ethical medical practice. Here is an excerpt from a translation by Loren MacKinney.

Let us begin to expound the admonitions of Hippocrates. Whoever wishes to become proficient in this art ought to be capable of unbounded literary effort, so that by long-standing perusal of various volumes his perception and discernment increase to the point

where facility in teaching is more readily acquired. Then he can proceed to the investigation of the art because he has become conversant with it and understands it fully. Before [studying medicine] the physician should be instructed in all subjects. First let him read the opinions of the philosophers, who always study in silence, even as Epicurus and others who have written about silence. Such ought he to be who wishes to enter this profession. He ought not to indulge in long ambiguous discourses, nor to spread abroad his private cures or the secrets of the art, excepting only data on cases already cured. He who is willing to repeat constantly what he finds out about the art of medicine tends to the profession of detractor. A physician ought not to be a deceiver. Like a friend he should maintain silence. Nor should the candidate for the art be a dullard. In age he should be neither too young nor too old, but such that at the outset as a learner, he may look into the theories of the art which he will see performed by hand, or may seek the practice of surgery. Thus he may arrive at a knowledge of the authorities.

<p style="text-align:center">★ ★ ★</p>

The physician ought also to be confidential, very chaste, sober, not a winebibber, and he ought not to be fastidious in everything, for this is what the profession demands. He ought to have an appearance and approach that is distinguished. In his dress there should not be an abundance of purple, nor should he be too fastidious with frequent cuttings of the hair. Everything ought to be in moderation, for these things are advantageous, so it is said. Be solicitous in your approach to the patient, not with head thrown back [arrogantly] or hesitantly with lowered glance, but with head inclined slightly as the art demands. . . .

He ought to hold his head humbly and evenly; his hair should not be too much smoothed down, nor his beard curled like that of a degenerate youth. He should not use ointment to excess on his hands or the tips of his fingers. He should wear white, or nearly white, garments. He should be lightly clad, and walk evenly without disturbance and not too slowly. Gravity signifies breadth of experience. He should approach the patient with moderate steps, not noisily, gazing calmly at the sick bed. He should endure peacefully the insults of the patient since those suffering from melancholic or frenetic beat by the feeling of the vein. By all means when taking the pulse have your hands warm rather than cold, lest the touch of cold hands upset the warm pulse and make it impossible to determine the true condition.

<p style="text-align:center">★ ★ ★</p>

For those who are ill, you ought to get up early so as to inquire about the preceding night, finding out the order of the causes [of the ailment] and the necessary treatment. At midday pay another visit, not so much to see about the patient's food as to plan for the beginning of a cure. For a third time, visit at about nightfall, staying for an hour in order to make arrangements for him to pass the night [comfortably] so as to be fortified to meet the next day unimpaired. . . .

Albucasis

FROM ALTASRIF

"On the Extraction of Arrows"

Muslim physicians of the medieval period were far more than passive transmitters of ancient medicine. Albucasis, born in Muslim Spain at the beginning of the 11th century, described an impressive

array of surgical methods and instruments in his encyclopedic Altasrif *("Collection"), a work used by university surgeons in Europe until the time of William Harvey.*

I will bring you several of my observations relative to arrows to guide you in your practice.

For then, a man was wounded by an arrow at the angle of the eye and close to the root of the nose. I extracted it from the opposite side below the lobule of the ear. The man recovered without sustaining any complication on the part of the eye!

I extracted another from a Jew, which had penetrated into the orbital cavity from below the lower lid: it had imbedded itself to the point that I was unable to take hold of it except for the little end by which it was attached to the shaft. It was a large arrow, shot by a Turkish bow, of iron, blunt and smooth, and having no barbs. The Jew recovered and had no complications in the eye.

I extracted another from the throat of a Christian. It was an Arabian arrow with barbs. I incised over it, between the jugular veins: it had penetrated deeply into the throat; I operated with precaution and I succeeded in extracting it. The Christian was saved and recovered.

I removed another arrow which had had penetrated into the abdomen of a man whom I believed to be lost. However, after some thirty days his condition had not changed; I incised over the arrow, and I did so well that I withdrew it without the patient feeling any effects since.

I have seen someone who received an arrow in the back. The wound scarred over, and seven years later the arrow came out through the buttock.

I have seen a woman who had received an arrow in the abdomen. The arrow remained there and the wound cicatrized. Nevertheless, she experienced no discomfort or pain, and missed no time whatever from her usual occupation.

Two examples of a *Wound Man. (below, left)* c.1485. Paper. 12⅝ × 7⅞ in. (31.5 × 20.3 cm). Bayerische Staatsbibliothek, Munich. *(below)* Illustration from *Dis Is das Buch der Cirurgia* by Heironymus Brunschwig. National Library of Medicine, Bethesda, Md. *Wound men were typical surgical illustrations of the treatment for various injuries.*

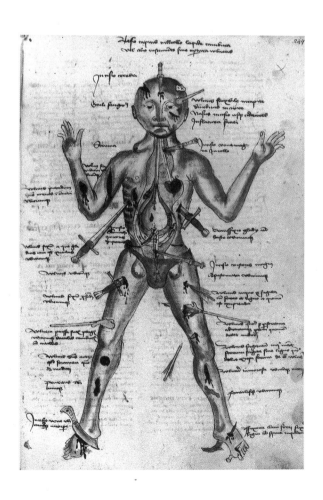

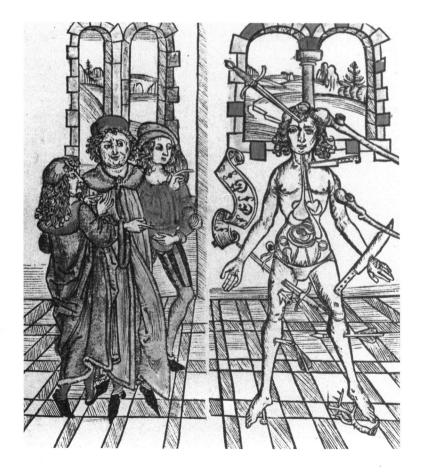

I have seen a man into whose face an arrow had penetrated. The wound cicatrized and the arrow remained without the subject suffering much. I have seen several cases of this sort.

I have also extracted an arrow from one of the officers of the Sultan. It had entered through the middle of the nose and inclined a little to the right: It had so deeply embedded itself that it had completely disappeared. I was called to care for him three days after the accident. I found the wound very narrow; I explored it with a fine stylet, but felt nothing. However, the patient experienced distress and pain to the right, below the ear. I thought that was the arrow. I therefore applied cataplasms made of digestive and attractive substances, hoping to myself that the region would swell, so that I would have signs of the arrow, and would be able to incise over it. But nothing happened to indicate where it had lodged. I continued to apply the cataplasms for several days, and nothing new occurred. In the meantime, the wound cicatrized and the patient continued to despair of its extraction for some time, when, one day, the arrow could be felt in the nose. I took part and applied, for several days, and irritant and caustic medicament, of a sort that the wound opened.

I explored it and felt the small end where it had been attached to the shaft. I continued to enlarge the opening by the application of caustic until I could see the end of the arrow. It was about four months that I had been treating the patient. Finally, when the wound was large enough so that I was able to introduce a forceps and I pulled and was able to move it, but did not succeed in withdrawing it. I did not stop, however, using all the means, all the artifices, and all the instruments until, one day, having taken hold of it with an excellent pincer which I have described at the end of this chapter, I removed it and dressed the wound. Several physicians claimed that the cartilage would not reunite: nevertheless, it reunited and the wound cicatrized, the subject recovered perfectly without experiencing any discomfort.

(below, left) JOHN OF ARDERNE. *De Arte Phisicali et de Cirurgia.* After 1412. Vellum scroll. 17 ft. 9⅝ in. × 1 ft. × 2³⁄₁₆ in. (5.43 × .30 × .05 m). Royal Library, Stockholm. *(below)* Illustrations in *Glossarium Salomonis.* 12th century. Parchment. 21¼ × 13¹⁵⁄₁₆ in. (54 × 35.5 cm). Bayerische Staatsbibliothek, Munich. *Typical illustrations based on an ancient Hellenistic format and designed for artistic effect rather than accuracy of representation.*

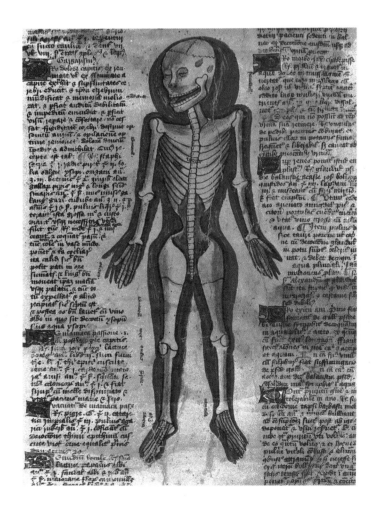

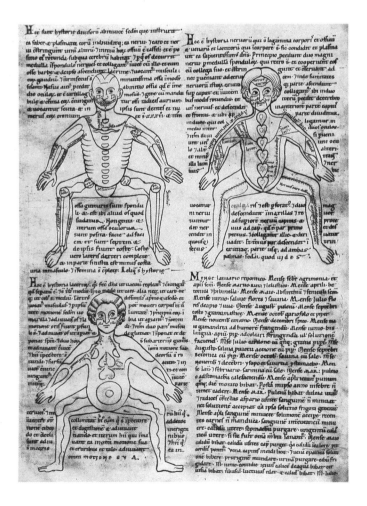

Anonymous

"Office at the Seclusion of a Leper"

The ancient Hebrew book of Leviticus prescribes rituals for identifying and expelling unclean sufferers of zara 'ath—later translated as leprosy. The medieval English ritual (translated here by Rotha M. Clay) of the 13th and 14th centuries still retained the priest's crucial function of diagnosing leprosy, but expanded isolation methods and adopted ceremonies and laws felt to protect the Christian community from both physical and moral contagion.

First of all the sick man or the leper clad in a cloak and in his usual dress, being in his house, ought to have notice of the coming of the priest who is on his way to the house to lead him to the Church, and must in that guise wait for him. For the priest vested in surplice and stole, with the Cross going before, makes his way to the sick man's house and addresses him with comforting words, pointing out and proving that if he blesses and praises God, and bears his sickness patiently, he may have a sure and certain hope that though he be sick in body he may be whole in soul, and may reach the home of everlasting welfare. And then with other words suitable to the occasion let the priest lead the leper to the Church, when he has sprinkled him with holy water, the Cross going before, the priest following, and last of all the sick man. Within the Church let a black cloth, if it can be had, be set upon two trestles at some distance apart before the altar, and let the sick man take his place on bended knees beneath it between the trestles, after the manner of a dead man, although by the grace of God he yet lives in body and spirit, and in this posture let him devoutly hear Mass. When this is finished, and he has been sprinkled with holy water, he must be led with the Cross through the presbytery to a place where a pause must be made. When the spot is reached the priest shall counsel him out of Holy Scripture, saying: "Remember thine end and thou shalt never do amiss." Whence Augustine says: "He readily esteems all things lightly, who ever bears in mind that he will die." The priest then with the spade (*palla*) casts earth on each of his feet, saying: "Be thou dead to the world, but alive again unto God."

And he comforts him and strengthens him to endure with the words of Isaiah spoken concerning our Lord Jesus Christ:—"Truly He hath borne our griefs and carried our sorrows, yet did we esteem Him as a leper smitten of God and afflicted;" let him say also: "If in weakness of body by means of suffering thou art made like unto Christ, thou mayest surely hope that thou wilt rejoice in spirit with God. May the Most High grant this to thee, numbering thee among His faithful ones in the book of life. Amen."

It is to be noted that the priest must lead him to the Church, from the Church to his house as a dead man, chanting the *Responsorium* Libera me, Domine, in such wise that the sick man is covered with a black cloth. And the Mass celebrated at his seclusion may be chosen either by the priest or by the sick man. . . .

When leaving the Church after Mass the priest ought to stand at the door to sprinkle him with holy water. And he ought to commend him to the care of the people. Before Mass the sick man ought to make his confession in the Church, and never again; and in leading him forth the priest again begins the *Responsorium* Libera me, Domine, with the other versicles. Then when he has come into the open fields he does as is aforesaid; and he ends by imposing prohibitions upon him in the following manner:—

"I forbid you ever to enter Churches, or to go into a market, or a mill, or a bakehouse, or into any assemblies of people.

Also I forbid you ever to wash your hands or even any of your belongings in spring or stream of water of any kind; and if you are thirsty you must drink water from your cup or some other vessel.

Also I forbid you ever henceforth to go out without your leper's dress, that you may be recognized by others; and you must not go outside your house unshod.

Also I forbid you, wherever you may be, to touch anything which you wish to buy, otherwise than with a rod or staff to show what you want.

Also I forbid you ever henceforth to enter taverns or other houses if you wish to buy wine; and take care even that what they give you they put into your cup.

Also I forbid you to have intercourse with any woman except your own wife.

Also I command you when you are on a journey not to return an answer to any one who questions you, till you have gone off the road to leeward, so that he may take no harm from you; and that you never go through a narrow lane lest you should meet some one.

Also I charge you if need require you to pass over some toll-way through rough ground, or elsewhere, that you touch no posts or things whereby you cross, till you have first put on your gloves.

Also I forbid you to touch infants or young folk, whosoever they may be, or to give to them or to others any of your possessions.

Also I forbid you henceforth to eat or drink in any company except that of lepers. And know that when you die you will be buried in your own house, unless it be, by favour obtained beforehand, in the Church."

And note that before he enters his house, he ought to have a coat and shoes of fur, his own plain shoes, and his signal the clappers, a hood and a cloak, two pair of sheets, a cup, a funnel, a girdle, a small knife, and a plate. His house ought to be small, with a well, a couch furnished with coverlets, a pillow, a chest, a table, a seat, a candlestick, a shovel, a pot, and other needful articles.

When all is complete the priest must point out to him the ten rules which he has made for him; and let him live on earth in peace with his neighbour. Next must be pointed out to him the ten commandments of God, that he may live in heaven with the saints, and the priest repeats them to him in the presence of the people. And let the priest also point out to him that every day each faithful Christian is bound to say devoutly *Pater noster, Ave Maria, Credo in Deum,* and *Credo in Spiritum,* and to protect himself with the sign of the Cross, saying often *Benedicite.* When the priest leaves him he says:—"Worship God, and give thanks to God. Have patience, and the Lord will be with thee. Amen."

Anonymous

On Unnatural Childbirth

A legendary Salernitan woman physician named Trotula received much of the credit for the large number of obstetric manuals of the later Middle Ages. Whatever their pretensions to a female audience, these texts were written and read by men. They were often copies of Soranus's first-century A.D., work on gynecology. Women in labor were attended by other women, but very few women were provided the means of entering the literate medical marketplace. This text, from a Middle English manuscript (early 15th century) in the British Museum, was translated by Beryl Rowland for her book A Medieval Woman's Guide to Health.

Sicknesses that women have bearing children are of two kinds, natural and unnatural. When it is natural, the child comes out in twenty pangs or within those twenty, and the child comes the way it should: first the head, and afterward the neck, and with the arms, shoulders, and other members properly as it should. In the second way, the child comes out unnaturally, and that may be in sixteen ways, as you will find in their proper chapters, and the first is as follows:

When the child's head appears, as it were, head first, and the rest of the child remains inside the uterus. The remedy for this is that the midwife, with her hand anointed with oils, that is, wild thyme oil, pure lily oil, or oil of musk, as is necessary, put her hand in and turn the child properly with her hands from the sides of the uterus. And [see that] the orifice of the womb is so well anointed that the child can come forth in right order.

The second mode of unnatural childbirth occurs when the child comes out with his feet jointly together, only the midwife can never bring the child out when it comes down like this. But when the child begins to come out in this way, the midwife with her hands anointed with oil must put them in and push him up again and so arrange him that he can come forth in the most natural manner, so that he does not flatten his hands in the sides of the uterus.

The third unnatural mode is if the child's head is so bulky and large that he cannot emerge: the midwife should then push him back and anoint the orifice, that is, the mouth of the privy member with fresh May butter or with common oil, and then the midwife's hand, oiled first and then put in and the orifice enlarged, brings the child forth by the head.

In the fourth mode of unnatural childbirth, the woman in labor shall be placed in a short, narrow, high-standing bed, with her head off the bed, and the midwife, with her hand anointed with oil, thrust her hand in after the child who is in an unnatural position, turns him correctly, and then brings him forth; but the bed that the woman should lie in must be made hard.

The fifth mode of unnatural childbirth is when the child extends his hand first, his head is turned back, and the mouth of the privy member is narrow or shut; then, with the inducement of the hands of the midwife, the orifice should be enlarged, and the child's hand put in again so that the child does not die as the result of the midwife's error. We prescribe that the midwife put her hand in, turning the child's shoulders toward the back and hands properly down at the side. And then take the head of the child; then slowly bring him forth.

The sixth mode of unnatural childbirth is when the child extends both his hands with his two shoulders, with his hands one on one side and one on the other, and the head is turned back in a reversed position into the side. The midwife with her hand shall put the child in again, as we said in the adjoining chapter, that is, she should put his hands to his

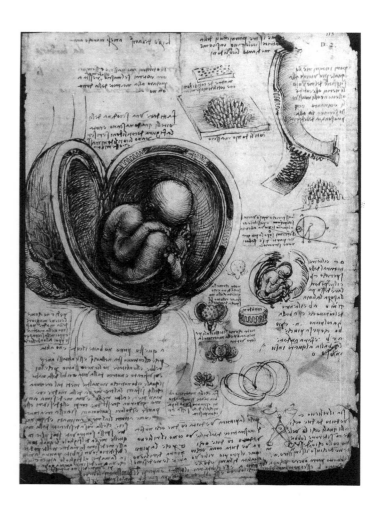

sides, take the child's head, and gently bring him forth. If he has a small head, and if he throws out his hands first, the midwife should arrange for the head to come to the mouth of the privy member, and so by her hands she shall bring him forth by the grace of God.

The seventh mode of unnatural childbirth occurs when the child first throws out his right foot, and the midwife will never deliver him in this way unless she first applies her fingers and puts the child up again; and after that, she must put in her hand and align that foot with the other foot to get both feet in the right position if possible, and the child's hands to his sides, and his feet as they should be, and then bring the child forth.

The eighth mode of unnatural childbirth occurs when the child puts out both feet and the rest of the child is left bent up in the body, as we said previously. The midwife with her hand shoved in should carefully arrange the child, and so bring him out, as I said previously.

The ninth mode of unnatural childbirth occurs when the child displays first one hand and one foot and covers his face with the other hand. The midwife places the fingers of one hand on the groin of the woman in labor, and with the other hand puts the child in again, as we have demonstrated before, and so brings the child forth if possible.

The tenth mode of unnatural childbirth occurs when the child presents first his feet apart, one hand between his feet, and his head hanging backward. The midwife with her hand put inside should correct the position of the child, placing one hand by the other down at his sides, adjusting the head in the best way, arranging the feet properly, and then bring the child forth.

The eleventh mode of unnatural childbirth occurs when the child's neck comes out first; then the midwife with her hand should push him up again by the shoulders, raise the child aloft, bring him down to the orifice, and so fetch him out.

The twelfth mode of unnatural childbirth occurs when the child first presents his knees bent; then the midwife shall push him back in again; the midwife should put her hands on both sides in the woman's groin and then, with her own hand anointed with oil put

(above, left) JOST AMMAN. *Childbirth.* 1554. Illustration from *De conceptu et generationis,* by Jacob Rueff; translated by Wolfgang Haller. Woodcut. $4^{15}/_{16} \times 4^{5}/_{16}$ in. (12.5 × 11 cm). Bodleian Library, Oxford. *Midwife and attendants deliver a woman in labor. The patient sits in a traditional birthing chair, with water at hand to cleanse mother, baby, and midwife. In the background, an astrologer predicts the child's complexion and fortune. (above)* LEONARDO DA VINCI. *Studies of the Fetus.* c.1510. Pen and ink. $11^{7}/_{8} \times 8^{7}/_{16}$ in. (30.2 × 21.4 cm). Windsor Castle Royal Library © 1990. Her Majesty Queen Elizabeth II. *Leonardo's study of the fetus in utero. He probably did not dissect a gravid uterus and has fancifully placed the ovaries in an inferior position, analogous to male testicles.*

inside, correct the position of the knees. And she should take the child by the shoulders and so gently bring him out backward. And so, when the position of his feet has been corrected and he has been put up in the right position, then bring him forth by the grace of God and the midwife's skill.

The thirteenth mode of unnatural childbirth occurs when the child first presents his thighs and comes forth with his buttocks first; then the midwife with her hand should put the child in again by the feet, and then bring him to the orifice, and deliver him smoothly.

The fourteenth mode of unnatural childbirth is if the child's head and the soles of his feet come together; we instruct the midwife in such circumstances to push her hand into the privy member so that the child be taken and carried upward into the womb again; then the child should be grasped by the head and brought out.

The fifteenth mode of unnatural childbirth occurs when the child lies prostrate or else upright, and his feet and hands are over his head. Then the midwife with her hand inside should straighten the child with her fingers; then, as far as she can, let the head come forward, and so bring the child out.

The sixteenth mode of unnatural childbirth occurs when there is more than one child, as happens every day, and they all come to the orifice at once; then let the midwife put one back again with her fingers while she brings out one of the children. And then afterward, another, so doing that the uterus is not constricted nor the children brought to grief, as often happens.

In order to deliver a woman of a child and to kill it if it cannot be brought out: take rue, savin, southernwood, and iris, and let her drink them. Also take 2 drachms each of the juice of hyssop, and of dittany, and 2 scruples of quicksilver, and this medicine is proved to be effective. Also take 4 drachms each of the juice of iris and bull's gall, 2 drachms of suitable oil, mix all these together, put it in a pessary, give it to the woman, and this medicine will bring out all the decomposed matter of the womb. And it will deliver a woman of a dead child, and of her secundines, and it brings on menstruation. Again, give to the pregnant woman 2 drachms of asafetida 3 times daily, and let the stomach and back be anointed with oil and gall, and afterward let oil, ox gall, and asafetida be placed in the vulva with a feather.

Barbara Tuchman

FROM A DISTANT MIRROR

The first pandemic of plague in late-medieval Europe (1348–1350) was later called the Black Death for its tremendous mortality. The urban Mediterranean areas were quite sophisticated in medical theory and practice, including routine public health, but traditional methods failed. Legislators eventually devised quarantine, pest houses, public health boards, and regular contagious-disease surveillance as ways to mitigate recurrences of Yersinia pestis.

Efforts to cope with the epidemic availed little, either in treatment or prevention. Helpless to alleviate the plague, the doctors' primary effort was to keep it at bay, chiefly by burning aromatic substances to purify the air. The leader of Christendom, Pope Clement VI, was preserved in health by this method, though for an unrecognized reason: Clement's doctor, Guy de Chauliac, ordered that two huge fires should burn in the papal apartments and

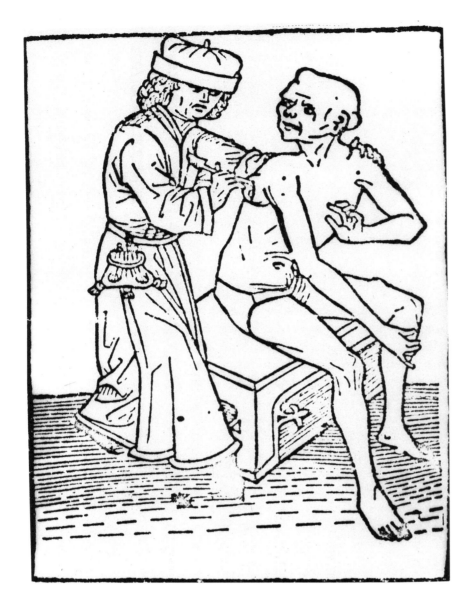

H. FOLCZ. *Surgeon Lancing a Plague Bubo.*
1482. Illustration from *Eion fast Köslicher
Spruch von der Pestilencz.* Engraving.
World Health Organization, Geneva.
*Plague buboes are quite painful, so surgeons
were enjoined to open them. Because they did
so, plague mortality among surgeons was
much higher than among physicians.*

required the Pope to sit between them in the heat of the Avignon summer. This drastic
treatment worked, doubtless because it discouraged the attention of fleas and also because
de Chauliac required the Pope to remain isolated in his chambers. Their lovely murals of
gardens, hunting, and other secular joys, painted at Clement's command, perhaps gave
him some refreshment. A Pope of prodigal splendor and "sensual vices," Clement was
also a man of great learning and a patron of arts and science who now encouraged dis-
sections of the dead "in order that the origins of this disease might be known." . . .

[T]he theory of humors, along with astrology, governed practice. All human tem-
peraments were considered to belong to one or another of the four humors—sanguine,
phlegmatic, choleric, and melancholic. In various permutations with the signs of the
zodiac, each of which governed a particular part of the body, the humors and constella-
tions determined the degrees of bodily heat, moisture, and proportion of masculinity and
femininity of each person.

Notwithstanding all their charts and stars, and medicaments barely short of witches'
brews, doctors gave great attention to diet, bodily health, and mental attitude. Nor were
they lacking in practical skills. They could set broken bones, extract teeth, remove bladder
stones, remove cataracts of the eye with a silver needle, and restore a mutilated face by
skin graft from the arm. They understood epilepsy and apoplexy as spasms of the brain.
They used urinalysis and pulse beat for diagnosis, knew what substances served as laxa-
tives and diuretics, applied a truss for hernia, a mixture of oil, vinegar, and sulfur for
toothache, and ground peony root with oil of roses for headache.

For ills beyond their powers they fell back on the supernatural or on elaborate compounds of metallic, botanic, and animal substances. The offensive, like the expensive, had extra value. Ringworm was treated by washing the scalp with a boy's urine, gout by a plaster of goat dung mixed with rosemary and honey. Relief of the patient was their object—cure being left to God—and psychological suggestion often their means. To prevent pockmarks, a smallpox patient would be wrapped in red cloth in a bed hung with red hangings. When surgery was unavailing, recourse was had to the aid of the Virgin or the relics of saints.

In their purple or red gowns and furred hoods, doctors were persons of important status. Allowed extra luxury by the sumptuary laws, they wore belts of silver thread, embroidered gloves, and, according to Petrarch's annoyed report, presumptuously donned golden spurs when they rode to their visits attended by a servant. Their wives were permitted greater expenditure on clothes than other women, perhaps in recognition of the large fees doctors could command. Not all were learned professors. Boccaccio's doctor Simon was a proctologist who had a chamber pot painted over his door to indicate his specialty.

When it came to the plague, sufferers were treated by various measures designed to draw poison or infection from the body: by bleeding, purging with laxatives or enemas, lancing or cauterizing the buboes, or application of hot plasters. None of this was of much use. Medicines ranged from pills of powdered stag's horn or myrrh and saffron to potions of potable gold. Compounds of rare spices and powdered pearls or emeralds were prescribed, possibly on the theory, not unknown to modern medicine, that a patient's sense of therapeutic value is in proportion to the expense.

Doctors advised that floors should be sprinkled, and hands, mouth, and nostrils washed with vinegar and rosewater. Bland diets, avoidance of excitement and anger especially at bedtime, mild exercise, and removal wherever possible from swamps and other sources of dank air were all recommended. Pomanders made of exotic compounds were to be carried on going out, probably more as antidote to the plague's odors than to its contagion. Conversely, in the curious belief that latrine attendants were immune, many people visited the public latrines on the theory that foul odors were efficacious.

Sewage disposal was not unprovided for in the 14th century, though far from adequate. Privies, cesspools, drainage pipes, and public latrines existed, though they did not replace open street sewers. Castles and wealthy town houses had privies built into bays jutting from an outside wall with a hole in the bottom allowing the deposit to fall into a river or into a ditch for subsequent removal. Town houses away from the riverbank had cesspools in the backyard at a regulated distance from the neighbor's. Although supposedly constructed under town ordinances, they frequently seeped into wells and other water sources. Except for household urinals, the contents of privies were prohibited from draining into street sewers. Public flouting of ordinances was more to blame for unsanitary streets than inadequate technology.

Some abbeys and large castles, including Coucy, had separate buildings to serve as latrines for the monks or garrison. The *donjon* at Coucy had latrines at each of its three levels. Drainage was channeled into vaulted stone ditches with ventilating holes and openings for removal, or into underground pits later mistaken by investigators of a more romantic period for secret passages and oubliettes. Under the concept of "noble" architecture, the 15th and later centuries preferred to ignore human elimination. Coucy probably had better sanitation than Versailles.

During the plague, as street cleaners and carters died, cities grew befouled, increasing the infection. Residents of a street might rent a cart in common to remove the waste, but energy and will were depressed. The breakdown in street-cleaning appears in a letter of Edward III to the Mayor of London in 1349, complaining that the streets and lanes of London were "foul with human faeces and the air of the city poisoned to the great danger of men passing, especially in this time of infectious disease." Removed as he probably was from the daily sight of corpses piling up, the King ordered that the streets be cleaned "as of old."

Chang Chieh-pin

"Medicine Is Not a Petty Teaching"

Mirroring their Western contemporaries, Confucian scholars of the 12th and 13th centuries elevated philosophical study far above the "petty" trades of medicine, agriculture, and prophecy. Orthodox Confucian Chang Chieh-pin (fl. 1624 A.D.) struggled against this stigmatization of medical practice, using the literary device of a stranger from the wilderness to voice a nobler place for medicine.

"Record [of an Instruction] That Medicine Is Not a Petty Teaching"

When I was already advanced in years I undertook a journey into the wilderness of the eastern border regions. There I met a strange person who looked at me casually and then asked me: "Did you also study medicine? Medicine is difficult; it demands the greatest conscientiousness from you!" Whereupon I replied: "Although medicine is a petty teaching, its concern focuses on life. How could I dare not to be aware of [the necessity for] conscientiousness. I take note of your instructions with respect." The stranger became very angry and addressed me in a voice filled with disdain: "In any case you do not belong to those who are familiar with medicine! If you claimed just now of your own accord that the aim of medicine is life, how can you say then at the same time that this is a matter of a petty teaching? The principle of life has its origin in the principle of the universe and is distributed over the entirety of all things. Not until life sprang forth did the five social relationships develop. Therefore creation constitutes, as it were, the forge of life, and the teaching of the principle is considered the guiding principle of life, and medicine and the drugs are the nurses of life. Thence it becomes evident that the significance of medicine is deeply rooted and that its assertions encompass a wide scope. Only superhuman intelligence has the power to advance to its most subtle details, and only the enlightenment to adhere to the middle position suffices to discern even the last details. An understanding of the basic traits and details of the medical principles corresponds to [an understanding of] the principles of peaceful government. An understanding of the effect and the failure of the medical principles corresponds to [an understanding of] the momentum of rise and decline. An understanding of the hesitation and of the urgency of the medical principles corresponds to [an understanding of] the mechanisms of attack and defense. An understanding of the change and the persistence of the medical principles corresponds to [an understanding of] the significance of social intercourse and private life. Whoever is penetrated inwardly by the principles and the influences can point to the changes and transformations [of all things] and calculate them. Whoever is in command of the connections of *yin* and *yang* to the point where he can play with them 'on the palm of his hand,' for him the walls of separation and the outside walls do not represent an obstacle to perceive [all things].

"Through the discipline of his body and his mind the Confucian scholar treats himself to complete honesty. The Buddhist and the Taoist treat themselves by purging themselves of faults in their previous lives through perfect observance of moral rules and [a life of] sincerity. Body and mind of other people and of oneself are unified by the principle. Hence whoever perceives that which is close by, perceives also that which is distant; whoever understands well that which is distant, also understands well that which is close at hand. Therefore it is said: 'If there are truthful people, there is true knowledge; if there is true knowledge, there is also a true medicine.' How is it therefore possible to say that medicine is trivial?

"But wherever we turn we find superficiality and commonness. [A patient's] itching is eliminated by pepper and sulphur, onions and shallots relieve [a patient] of his winds.

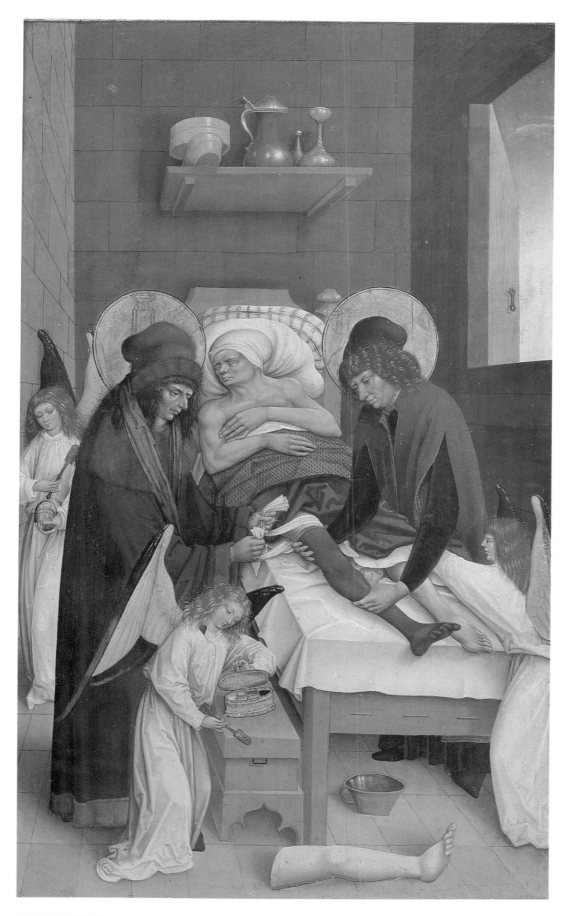

COLORPLATE 19

Limb Transplantation Miracle by Saints Cosmos and Damian. c. 1500. Swabian
wood-panel painting. 41¾ × 24¹³⁄₁₆ in. (106 × 63 cm). Württembergische
Landesmuseum, Stuttgart. *Legend held that these early Christian physicians successfully
transplanted the limb of a dead Moor after a white patient had his own cancerous leg
removed. Unique to this depiction, an angelic assistant draws back the covers.*

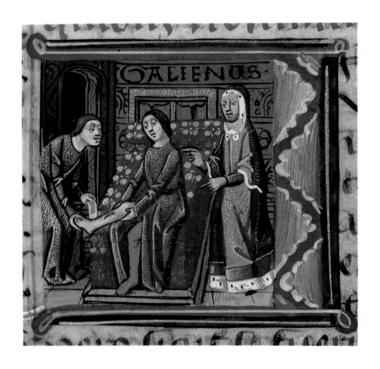

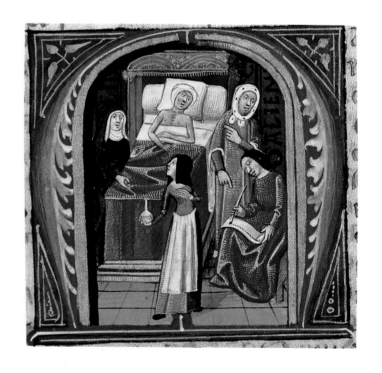

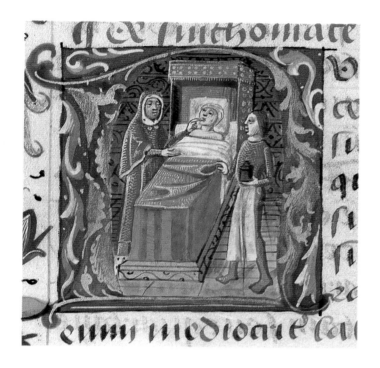

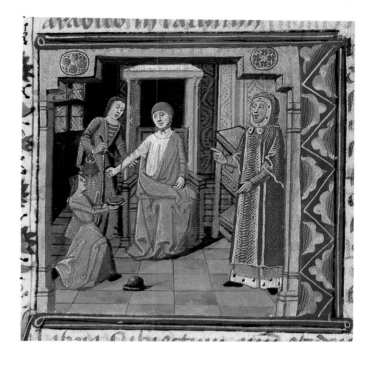

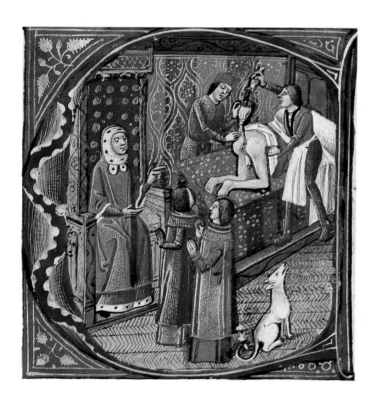

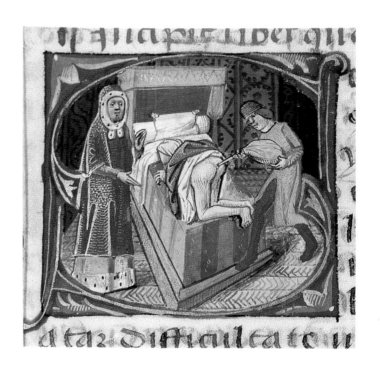

COLORPLATE 20

Scenes of the Practice of Medicine. Mid 15th century. Manuscript illustrations from various works by Galen. Sächsische Landesbibliothek, Dresden. *Galen is the red-robed physician with garments sumptuously trimmed in ermine. He gives instructions to physicians, surgeons, and nurses. Two illustrations of enemas, or the clyster, emphasize both mild interventions to relieve constipation and stronger therapy for conditions such as dry choler, flux, constant lustful desires, and putrid ulcers. Bloodletting was by venesection only, though here it is dramatized so much that the illustration resembles a puncture of the brachial artery.*

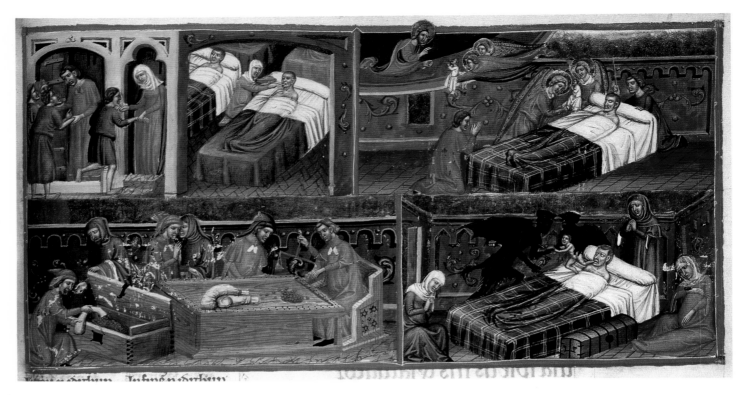

COLORPLATE 21

Reception and Treatment of the Impoverished Sick in a Monastery Infirmary. 13th century. Manuscript illustration. $5^{15}/_{16} \times 4^{15}/_{16}$ in. (15.1 × 12.5 cm). Bibliothèque Nationale, Paris. *Medieval hospitals offered charitable relief, not medical care, although here prayers help to cure a possessed patient of his demons.*

COLORPLATE 22 *(opposite)*

A Medieval Hospital. 14th century. Illustration from Avicenna's *Canon of Medicine.* Biblioteca Medicea Laurenziana, Florence. *This Ferrarese manuscript scene depicts the emerging modern hospital in Italy. Three long-robed physicians minister to various patient needs: admission, outpatient treatment of a leg ulcer, and bedside care of a patient with fever—the subject of the text.*

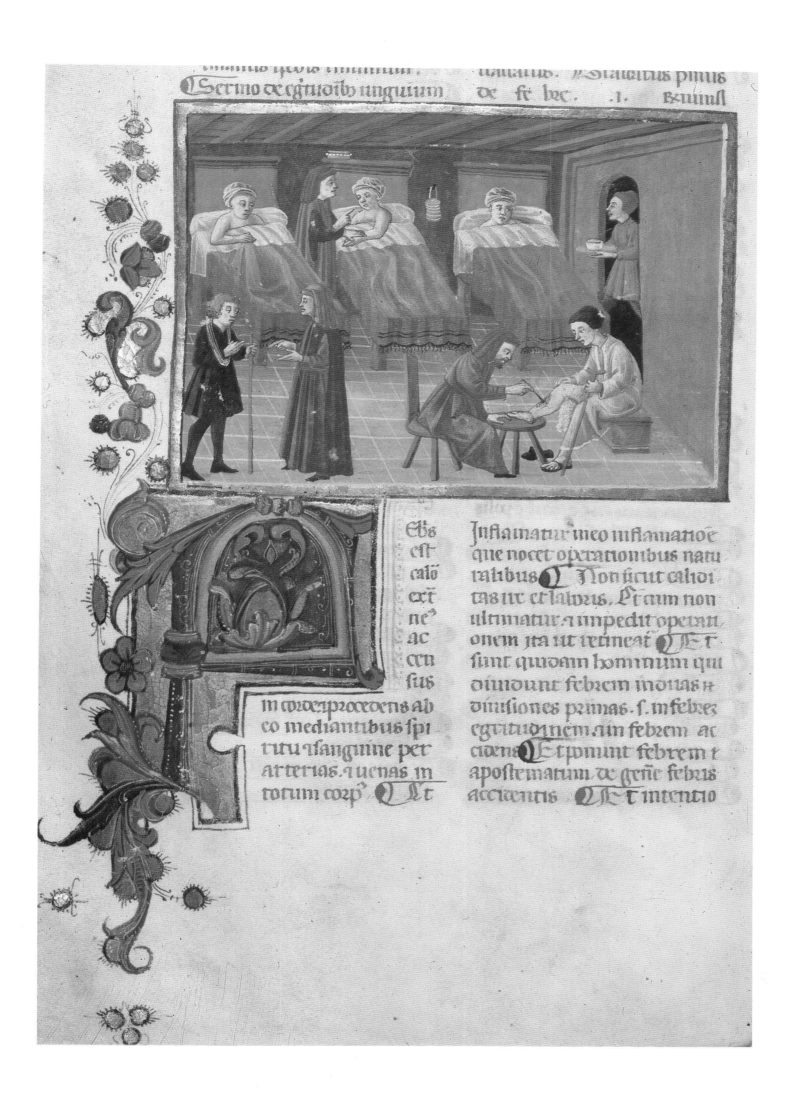

Ebs est calor extrine accensus in corde procedens ab eo mediantibus spiritu et sanguine per arterias et venas in totum corpus Et

Inflamatur meo inflamatioe que nocet operationibus naturalibus Non sicut caliditas et latitudinis Et cum non ultimatur et impedit operationem ita ut retineat Et sunt quidam hominum qui dividunt febrem in oras et divisiones primas s. in febres egritudinem et in febrem accidens Et ponunt febrem et apostematum de genere febris accidentis Et t intentio

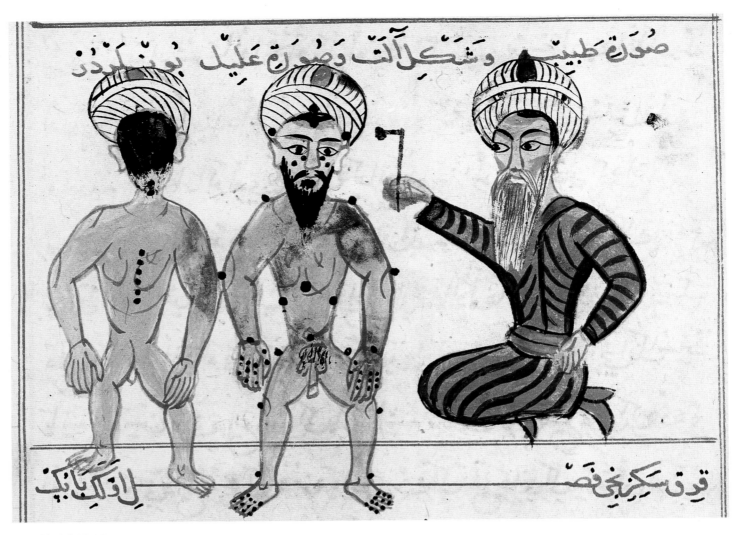

COLORPLATE 23

Cauterizing Leprous Lesions. c.1300. Illustration from *Treatise on Imperial Surgery.* Miniature. 4½ × 5⁵⁄₁₆ in. (11.4 × 13.5 cm). Bibliothèque Nationale, Paris. *In both Eastern and Western medicine, cautery was a common medical therapy from prehistory to the early 20th century, here illustrated in a Persian treatise translated into Turkish around 1300.*

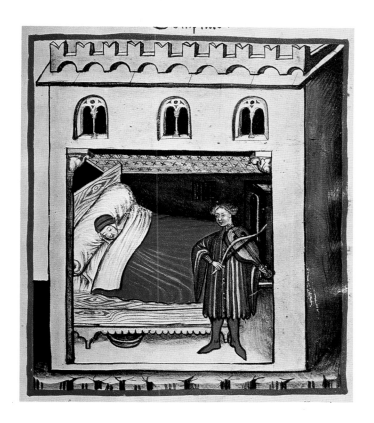

COLORPLATE 24

Scenes from a late–medieval *Herbal*. 14th century. Four Veronese or Lombard manuscript illustrations from *Tacuinum Sanitatis in Medicina*. Each image: 16⅝ × 9⅛ in. (33.3 × 23.2 cm). Österreichische Nationalbibliothek, Vienna. *(From top left, clockwise) Absentium, or wormwood, was used as a stimulant to digestion, especially in the elderly. Mandrake root, when used as a plaster, can help skin infections. As an aromatic, it induces sleep; thus, it was thought to aid those seeking pregnancy. The root was held to kill whoever touched it, so a chained dog uproots the plant when its master calls. Sleep is "refreshing for the soul and for the digestion of food." Vomiting can be a remedy as well as a symptom.*

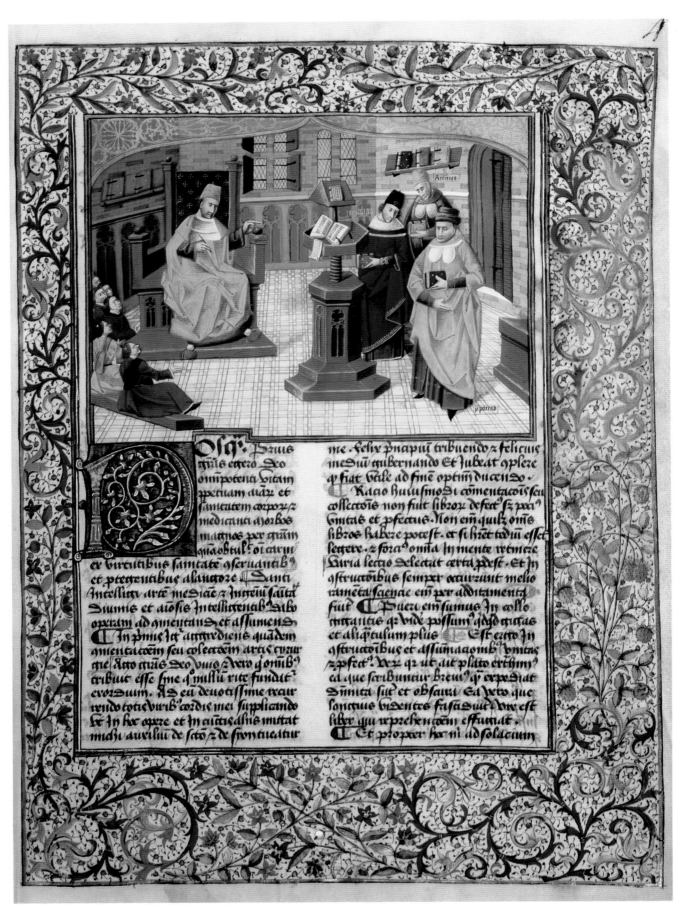

COLORPLATE 25

Bernard Teaching, with Six Listeners at His Feet. 1461. Illustration from *Chircurgie*, by Guy de Chauliac. Miniature. Bibliothèque Nationale, Paris. *Few students slept through the classes of Bernard of Gordon, Professor of the Theory of Medicine at Montpellier, 1282–1318: here he summons Galen, Avicenna, and Hippocrates before the class.*

Has anyone ever said: 'This is not medicine'? If someone but wears a black coat or a yellow cap, he is immediately called a Buddhist or a Taoist priest. And if someone speaks in an affected manner and displays pretentious mannerisms, what else could he be [in the eyes of the people] but a Confucian! Yet not even in the course of the same day would one speak of the mountains of *t'ai-shan* and of some small hills, of the streams and the sea and some ditches of water.

"Whoever has no understanding of *yin* and *yang*, and meddles with symptoms of excess and conditions of deficiency without knowing about them, whoever is endowed with a careless mind and the nature of a daredevil, hides in a cave and is one-sided and 'common,' will certainly not only fail to accomplish anything good, but on the very contrary he will cause harm [wherever he practices]. Such people do not even reach the level of those who use pepper, sulphur, onions and shallots, not to mention that they deserve the designation 'petty teaching' [for their activity]. On what basis would one be able to talk to them at all about medicine?

"Medicine is certainly difficult! Medicine is certainly sublime! It represents the earliest tradition of genuine supernatural and exemplary people, and the first duty of a people.

"My son you should not belittle it because it is apparently but a matter of herbs and trees. You should endeavor to penetrate to the realm where essence and spirit are joined, and proceed to the border regions, where the dark meets the mysterious. Once you understand the beginning and the end of all processes, and once you have grasped the origin and consequences of a result, it can be said that you have accomplished something in this field [of medicine]. You certainly have to take the greatest pains!"

I listened to this instruction and was profoundly disconcerted and greatly alarmed. I muttered some words in exchange and withdrew. My agitation lasted for several months. So as not to forget these admonitions, I have put them down in writing.

THE RENAISSANCE QUEST: BOUNDARIES OF HUMANITY

Francesco Petrarch

FROM SENILES

Letter to Boccaccio

Petrarch (1304–1374) survived the Black Death, carrying about southern Europe his chests of letters and poems. Called the father of the Renaissance, Petrarch was less impressed with the learning of natural philosophers—including university doctors—than with the more noble calling of literature. His distaste for the arrogance and theories of learned physicians increased with the inevitable infirmities attending old age.

I am glad that you approve of my advice, and that you are putting it into practice. Approval is clearly genuine when it is turned into action, while many have learned to exalt in words what they condemn in their hearts. You wrote me once—I forget when, but I remember the fact—that you had been seriously ill, but that thanks to God and a good doctor you had recovered. I replied (this I do remember) that I was astounded how that vulgar error had lodged in your high intelligence, and that God and your good constitution had done everything. I said that the doctor had done nothing at all, nor could he have done anything beyond the power of a longwinded bore, rich in banalities, poor in remedies. Now you write me that you didn't call in a doctor. I am not surprised that you got well so fast. There is no better way to health than to do without a physician. This may seem shocking to one who has had no experience; but to one who has been through it the words are obvious, tested, and true. Those doctors who profess to be aids to nature often go contrary to nature and fight on the side of disease. The least harmful of them hold to the middle ground and wait to see how the illness will turn out. They are the most truthful and trustworthy of their trade; they are spectators watching for the outcome, ready to jump with fortune. They unfurl their useless banners in honor of the victor, and creep in on the side of glory. . . .

Don't you see how they gain control over you by their professional right, how they look for money from your illness, how they learn their trade from your death? They offer you a lethal draught, according to the prescriptions of some authorities of Cos, Pergamum, or Arabia, who may have been learned, but were completely ignorant of our constitutions. Then they sit back and await the result. And you, feeling the ominous poison circulate through your veins and vitals, hope for relief from one who does not recognize your ills, and is meanwhile tortured with his own, for which he can find no cure. One forbids you to eat fruits, another vegetables and greens, without which many, especially of our race, find meals unpalatable, however expensively medicated. . . . And now this peremptory doctor calls fruits dangerous and abominable because he doesn't like them, or because they did him no particular good. And here is another doctor, perhaps himself bloodless and of low vitality, like so many of his kind, who counsels us never to let our blood but to preserve it as a treasure. But even at my age, if I didn't have an ample bleeding every spring and autumn, I should long since have felt myself oppressed by this Greek treasure. But these "secretaries of nature," who know everything, condemn in all what is outside of their own and their friends' experience, and thus they measure everything by themselves. Another doctor, no doubt a drinker of the strong wines of Greece, Crete, and Egypt, therefore uttered the famous condemnation: "I have found water of no use, except in critical illness." What a splendid pronouncement! I have made frequent and profitable use of water, and not in critical illnesses, which so far I have not experienced, and I hope I never do. But joking aside, and not to mention the thousands of mighty and healthy men who drink only water and find it healthful and delicious, I can allege my own case. If even in these winter nights I could not drink frequent draughts of cold water I think I should die. . . .

Would you like to know how much confidence doctors place in their own devices? (I am speaking of those, few I admit, who retain their innate sense of shame.) I call God and my memory to witness, that I once heard a physician of high standing in his profession say: "I am aware that I may be called ungrateful for disparaging the art that has brought me wealth and friends. But the truth is more important than one's feelings. Here is my sentiment and my contention. If a hundred men, or a thousand, of the same age and general constitution and accustomed to the same diet should all fall victim to a disease at the same time, and if half of them should follow the prescriptions of our contemporary doctors, and if the other half should be guided by their natural instinct and common sense, with no doctors at all, I have no doubt that the latter group would do better."

I knew another doctor, rather better known and a man of letters as well. One day in familiar conversation I asked him how it happened that he partook of foods that he forbade

to others. He answered placidly, without hesitation: "If a doctor's life were consistent with his advice, or if his advice were consistent with his life, he would suffer either in his health or in his pocketbook." This remark is clearly not a confession of ignorance but of untrustworthiness. That is obvious enough.

How many men be saved amid these pestilent creatures? If the well man is in danger, what may the sick man hope for but the end of all his dangers? Certainly no one need wonder if one who harms the hale kills the sickly. It is not easy to pull up a well-rooted tree, but when once it is dislodged one may easily throw it down. . . .

I have had many medical friends in the past, but of them all only four remain: one in Venice, one in Milan, and two in Padua. They are all cultivated and courtly men, who talk extremely well, argue with great keenness, harangue either with vehemence or with sweet persuasion; in short, they kill most plausibly, with the most convincing explanations. They have forever on the tip of their tongues Aristotle and Cicero and Seneca, also—this will surprise you—Virgil. Whether it is due to chance or madness or some mental quirk, they know all subjects better than the one trade they profess. But I shall drop this theme. My statement of home truths stirred up too much resentment and hurly-burly in the past. If ever my health is attacked, I shall admit these gentlemen as friends but not as doctors. As one who delights in friendship, I think that for the preservation and restoration of health nothing can match the pleasant faces and pleasant talk of good friends. If they lay any commands on me that fit my own ideas, I obey them and give them credit; otherwise I just listen, and do what I had intended all along. And I have ordered my attendants that if anything serious should happen to me none at all of the gentlemen's orders shall be executed upon my body, but nature shall be allowed to operate, or rather God who created me and set the term to my life which cannot be overpassed. . . .

Desiderius Erasmus

FROM *"A Marriage in Name Only"*

The famous northern humanist and Biblical scholar Erasmus (1466?–1536) witnessed the first virulent epidemic of syphilis in Europe. In the Renaissance format of a dialogue, the moral sin of the "French disease" is placed upon a philandering man—most atypical of the syphilis accusations in centuries to come. The ethical dimensions of quarantine, isolation, and punishment for sickness were handled well in the colloquial style Erasmus made popular.

GABRIEL. The girl who knowingly marries a diseased man perhaps deserves the trouble she's brought upon herself, though if I were head of the government I'd run them both out of town. But if she married this baneful pest when he misrepresented himself as sound—if I were pope I'd annul this marriage even if it had been made with six hundred marriage contracts.

PETRONIUS. On what pretext, since a marriage lawfully contracted cannot be annulled by mortal man?

GABRIEL. What? Do you think one made by a wicked fraud is contracted lawfully? The contract isn't valid if the girl is deceived into marrying a slave she thought a free man. Here the husband is slave to a most loathsome mistress, Pox, and this slavery is the more wretched because she sets none free; no hope of release can mitigate the misery of the bondage.

PETRONIUS. You've discovered a pretext, clearly.

GABRIEL. Besides, marriage exists only between the living. Here the girl is married to a dead man.

PETRONIUS. That's another pretext. But I suppose you'd permit scabby to marry scabby, in accordance with the old saw, "like to like."

GABRIEL. Were I permitted to do what would benefit the commonwealth, I'd let them marry, all right—but once they were married I'd burn them.

PETRONIUS. Then you'd be acting the part of a Phalaris, not a prince.

GABRIEL. Does the physician who amputates some fingers or cauterizes a part of the body, lest the whole body perish, seem a Phalaris to you? I regard it as mercy, not cruelty. Would it had been done when this mischief first began to appear! Then the welfare of the whole earth would have been promoted by the destruction of a few. And we find a precedent for this in French history.

PETRONIUS. But it would have been more merciful to castrate or deport them.

GABRIEL. What would you do with the women, then?

PETRONIUS. Put chastity belts on them.

GABRIEL. That would protect you against getting bad chicks from bad hens. But I'll admit this is the more merciful method if you'll admit the other is safer. For even eunuchs experience lust. Besides, the disease is transmitted not by one means alone but spreads to other persons by a kiss, by conversation, by touch, by having a little drink together. And

HANS HOLBEIN, THE YOUNGER. *Head of a Young Man*. Early 16th century. Black and colored chalks, black ink, and yellow and gray wash on cream antique laid paper. 8⅛ × 6 in. (20.6 × 15.2 cm). Courtesy of the Fogg Art Museum, Harvard University, Cambridge, Mass. Gift of Paul J. Sachs, "A testimonial to my friend Felix M. Warburg." *The facial lesions depicted have defied precise diagnosis. Once entitled* Portrait of a Leper, *the picture most likely illustrates secondary syphilis or infectious impetigo.*

we observe that this disease is accompanied by a mortal hatred, so that whoever is in its clutches takes pleasure in infecting as many others as possible, even though doing so is no help to him. If deported, they may possibly escape; they can fool others at night or take advantage of persons who don't know them. From the dead there's no danger, surely.

PETRONIUS. It's safer, I grant, but I don't know whether it suits Christian compassion.

GABRIEL. Come, tell me: which are the worse menace, mere thieves or these creatures?

PETRONIUS. Money's much commoner than good health, I admit.

GABRIEL. And yet we Christians crucify thieves, and that isn't called cruelty but justice. And it's a duty, if you consider the public welfare.

PETRONIUS. In that instance, however, the penalty is paid by the one responsible for the injury.

GABRIEL. These fellows make money by it, obviously. But let's grant that many people get this disease through no fault of their own (though all the same you'd find few victims who hadn't invited it by their own misconduct). Jurists hold that there are times when it is right for innocent persons to be put to death if this is essential to the public safety, just as the Greeks slew Astyanax, son of Hector, after the destruction of Troy lest the war be renewed through his efforts. And it is not thought wrong, after a tyrant is killed, to butcher his innocent children also. What about the fact that we Christians are constantly at war despite our realization that most of the evils in war befall those who haven't deserved to suffer? The same thing occurs in what are called "reprisals": the one who did the injury is safe, and the trader, who so far from being responsible for the deed never even heard of it, is robbed. Now if we use such remedies in cases of minor importance, what do you think should be done in the cruelest case of all?

PETRONIUS. I yield. It's true.

GABRIEL. Then consider this. In Italy, buildings are locked up at the first sign of pestilence; those who attend the sufferers are quarantined. Some call this inhumanity, though actually it's the highest humanity, for because of this precaution the plague is checked with few fatalities. How great the humanity of protecting the lives of so many thousands! Some people accuse the Italians of inhospitality because, if pestilence is reported, they banish a stranger at evening and make him spend the night in the open air; but it is morally right to inconvenience a few for the sake of the public good. Some fancy themselves very brave and dutiful because they dare to visit a sufferer from pestilence even if they haven't any business there. But when, on their return, they infect wives, children, and the entire family, what is more foolish than that "courage," what more undutiful than that "duty" of greeting somebody else to bring your nearest and dearest into imminent danger of their lives? Yet how much less is the peril from plague than from this pox! Once in a while the plague passes over close relatives; as a rule it spares the aged; and those it does attack it either releases quickly or restores to health stronger than ever. *This* disease is simply slow but sure death, or rather burial. Victims are wrapped like corpses in cloths and unguents.

PETRONIUS. Very true. At least so deadly a disease as this should have been treated with the same care as leprosy. But if this is too much to ask, no one should let his beard be cut, or else everybody should act as his own barber.

GABRIEL. What if everyone kept his mouth shut?

PETRONIUS. They'd spread the disease through the nose.

GABRIEL. There's a remedy for that trouble, too.

PETRONIUS. What?

GABRIEL. Let them imitate the alchemists: wear a mask that admits light through glass windows and allows you to breathe through mouth and nose by means of a tube extending from the mask over your shoulders and down your back.

PETRONIUS. Fine, if there were nothing to fear from contact with fingers, sheets, combs, and scissors.

GABRIEL. Then it would be best to let your beard grow to your knees.

PETRONIUS. Evidently. In the next place, make a law that the same man may not be both barber and surgeon.

GABRIEL. You'd reduce the barbers to starvation.

PETRONIUS. Let them cut costs and raise prices a little.

GABRIEL. Passed.

PETRONIUS. Then make a law to prohibit the common drinking cup.

GABRIEL. England would hardly stand for that!

PETRONIUS. And don't let two share the same bed unless they're husband and wife.

GABRIEL. Accepted.

PETRONIUS. Furthermore, don't permit a guest at an inn to sleep in sheets anyone else has slept in.

GABRIEL. What will you do with the Germans, who wash theirs barely twice a year?

PETRONIUS. Let them get after the washerwomen. Moreover, abolish the custom, no matter how ancient, of greeting with a kiss.

GABRIEL. Not even in church?

PETRONIUS. Let everyone put his hand against the board.

GABRIEL. What about conversation?

PETRONIUS. Avoid the Homeric advice to "bend the head near," and let the listener in turn close his lips tight.

GABRIEL. The Twelve Tablets would scarcely suffice for these laws.

PETRONIUS. But meanwhile what advice have you for the unhappy girl?

GABRIEL. Only that by being cheerful in her misery, she lessen her misery by that much; that she cover her mouth with her hand when her husband kisses her; and sleep with him armed.

PETRONIUS. Where do you hurry off to now?

GABRIEL. Straight to my study.

PETRONIUS. To do what?

GABRIEL. To compose an epitaph instead of the wedding song they ask for!

Alessandro Benedetti

FROM THE HISTORY OF THE HUMAN BODY

In Greek and Roman antiquity very few physicians were able to perform human dissections. But no specific proscriptions existed in Islam or Western Christendom, so occasional anatomical studies accompanied the expansion of literate medical practice. The Italian Renaissance celebration of the human body coincided with an unprecedented increase in anatomical dissection, as Venetian surgeon Benedetti (ca. 1450–1512) illustrates.

Tradition holds that kings themselves, taking counsel for the public safety, have accepted criminals from prison and dissected them alive in order that while breath remained they might search out the secrets of nature, how she acts within herself with great ingenuity, and should note carefully the position of the members, their color, shape, size, order, progression, and recession, many of which are changed in dead bodies. The kings did this carefully and more than piously in order that when wounds had been inflicted it should be understood what was intact and what was damaged. But our religion forbids this procedure, since it is most cruel or full of the horror inspired by an executioner, lest those who are about to die amidst such torture should in wretched despair lose the hope of a future life. Let barbarians of a foreign rite do such things which they have devised,

fond of these sacrifices and prodigies. But we, who more mercifully spare the living, shall investigate the inner secrets of nature upon the cadavers of criminals.

Early physicians observed that if anyone died of unknown diseases and they dissected cadavers they might discover the hidden origins of diseases with equal advantage to the living. Galen was not ashamed to do the same thing with his ape when the cause of its death was unknown, just as we have done in the case of the Gallic disease (syphilis). The pontifical regulations have for a long time permitted this form of dissection; otherwise, it would be regarded as most execrable and abominable or irreligious. Furthermore, ritual purifications of the physicians' souls take place and we propitiate their offense with prayers. Those who live in prison have sometimes asked to be handed over rather to the colleges of physicians rather than to be killed by the hand of the public executioner. Cadavers of this kind cannot be obtained except by papal consent. Thus by law only unknown and ignoble bodies can be sought for dissection, from distant regions, without injury to neighbors and relatives. Those who have been hanged are selected, of middle age, not thin nor obese, of taller stature, so that there may be available for spectators a more abundant and hence more visible material for dissection. For this a quite cold winter is required to keep the cadavers from rotting immediately. A temporary dissecting theater must be constructed in an ample, airy place with seats placed in a hollow semicircle such as can be seen at Rome and Verona, of such a size as to accommodate the spectators and prevent them from disturbing the masters of the wounds, who are the dissectors. These must be skillful and such as have dissected frequently. A seating order according to dignity must be given out. For this purpose there must be an overseer who takes care of all such matters. There must be guards to prevent the eager public from entering. Two treasurers

(below, left) Skeleton Man. Late 13th century. Illustration from *Five Anatomical Figures.* 11¹³⁄₁₆ × 8⁷⁄₁₆ in. (30 × 21.4 cm). University Library, Basel, Switzerland. *(below)* JAN VAN CALCAR. 1543. Illustration from *De Humani Corporis Fabrica,* by Andreas Vesalius. Woodcut. 16¾ × 10¹³⁄₁₆ in. (42.5 × 27.5 cm). Courtesy of the Lilly Library, Indiana University, Bloomington. *Vesalian muscle man, posterior view, labeled A–Z and a–z with Greek letters to identify the muscles. Vesalius's fellow countryman Jan van Calcar was a student of Titian.*

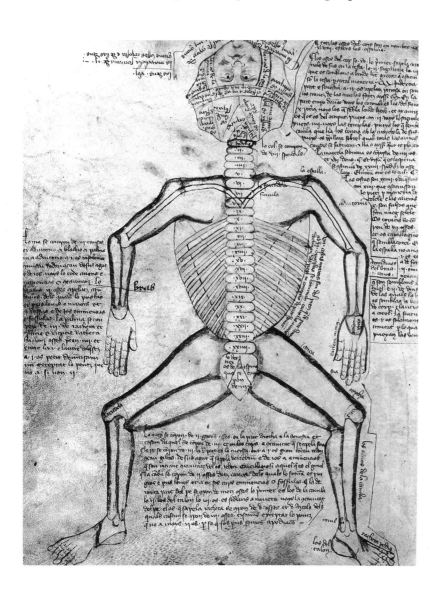

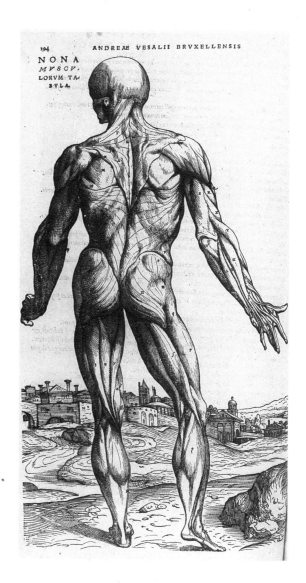

are to be chosen who will buy what is necessary from monies collected. The following are needed: razors, knives, hooks, drills, trepanning instruments (which the Greeks call chenicia), sponges with which to remove blood in dissection, paring knives, and basins. Torches must be also provided for the night. The cadaver is to be placed on a rather high bench in the middle of the theater in a lighted spot handy for the dissectors. A time for attendance is to be established, after which the gathering is dismissed so that the dissection may be completely carried out before the material putrefies. First let me run over briefly the form, shape, and dignity of the human body.

★ ★ ★

The human body was created for the sake of the soul and stands erect among other animals, as established by divine nature and reason so that it might look upward more comfortably, whence the Greeks gave it a name. Man alone has the power of thought; likewise he alone remembers. Memory and self-control, however, (as Aristotle says) he possesses in common with many animals. The members exist for the sake of their duties and functions, to which single features called dissimilars are accommodated. For in the human semen there is a heat with such great power and action that it can be gradually accommodated to any part of the body whatsoever. The heart was first created since it contains the principle of life and sense. Next came the brain and liver. Then nature, performing like a painter, sketched out the other members with a life-giving fluid; they gradually receive their colors from the blood, which is very abundant in man and stirs up very much heat. Hence the human body is more erect than others which would not be easy if the great bulk of the body were to sink down. Therefore man's head has very little flesh on it and holds the higher place in order that it may reflect that universal state in which the divine mind is considered. But the rest of the animals being heavier have their heads bent down to the earth and to them nature allotted front legs in place of arms and hands. Arms and hands were provided for man as the most foresighted of all animals so that he might use them suitably for many crafts. The eyes in the highest part of the head are the watchmen of the entire body; the ears are their counterparts in sound. The head is covered with hair as a protection against cold and heat. Eyebrows were added against the flow of sweat and eyelashes against harmful objects which fall upon them. The nose provides breathing, judges food before it is eaten, while the bones of the cheeks project to guard the eyes. The lips are necessary for voice and teeth. The neck holds up the head for turning it around and is fitted with many vertebrae. The sides together with the thorax form the ribcage with many bones and as it were a wall for the heart, making it easier to breathe than if that cage were made of one bone; we see this also in the arrangement of the spine. But the stomach is without bone and hence more adapted for food and for the female uterus. The pubis has a bone wherein we carry the intestines and women the child they conceive. The genitals are made of nerves and are not bony, as in some animals such as ferrets and weasels. The prepuce covers the glans so that it may not be injured by rubbing against the thigh. The Jews cut it off for the sake of cleanliness. The male genitals are external, the female genitals or vagina are located within the body; if they fall forward the male groin appears. The buttocks provide a cushion since it is not easy for man to continue standing erect but he desires rest in sitting. The arms and legs are bent in wondrous fashion, the legs inward, the arms outward, the latter for handicrafts and the former for walking. Nature also gave the fingers for seizing and pressing most suitably. The thumb, which is thicker and shorter, presses upward at the side in the lower region of the hand; the other fingers from above press downward. The thumb itself has powers equal to many needs, whence its name. The middle or long finger is like the middle of a boat. All fingers except the thumb are equal in grasping. The legs are the largest members of a man in proportion to his size because they preserve the entire body erect. The toes in the feet are short because they were given for no other use except for walking. I have, however, seen a woman born without arms who was skilled in using her feet instead of hands for spinning and sewing. Nails have been added on account of the weakness of the toes. . . .

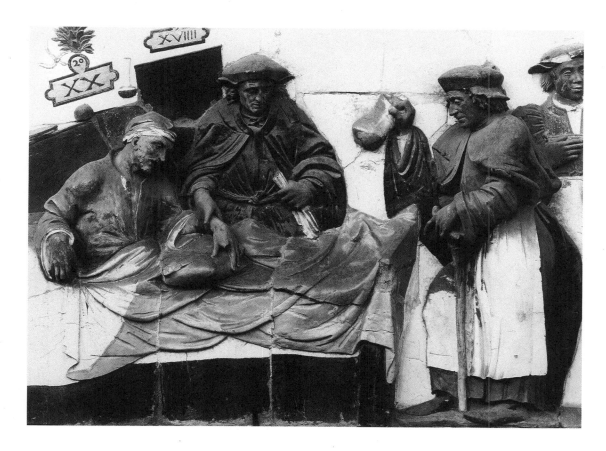

Michel de Montaigne
FROM AUTOBIOGRAPHY
"Gravel and the Doctors"

Very few of the great Renaissance humanists loved physicians. Montaigne (1533–1592) was no exception. Bladder stones in all age groups were commonplace before 1800, especially among children and older men. Until the 17th century, the operation described earlier by Celsus was the only resort if medical advice and self-treatment failed to reduce a stone problem to "gravel."

I am at grips with one of the worst diseases—painful, dreadful, and incurable. Yet even the pain itself, I find, is not so intolerable as to plunge a man of understanding into frenzy or despair. At least I have one advantage over the stone. It will gradually reconcile me to what I have always been loath to accept—the inevitable end. The more it presses and importunes me, the less I will fear to die.

As for the rest, I have found that the counsel to keep a stiff upper-lip in the face of suffering is pure show. Why should philosophy, which is concerned with the essential things of life, occupy itself with these externals? Let us leave that to actors and elocutionists who put such great weight on gestures. Philosophy should not hesitate to permit our giving voice to pain, even if it does no good. It should allow the sighs, sobs, palpitations, and pallor which nature renders involuntary, provided our courage is undaunted. What does it matter if we wring our hands, so long as we do not wring our thoughts?

In such extremities, it is no great matter if we screw up our face. If the body finds relief in complaining, let it complain. If agitation gives it ease, let it toss and tumble at

will. If the disease seems to evaporate (as some doctors think it helps women in childbirth) in loud outcries—or if they only divert us from its torments—let it roar at the top of its lungs. We have enough to do in dealing with the disease itself, without bothering over these superfluities.

In my own case I have come off a little better. I do not need to roar—merely groaning does the work. Not that I try to hold myself back; but either the pains are not excessive for me, or I have more than ordinary patience. When I am in the depths of torment, I try myself out; and I have always found I could talk, think, and give as coherent a reply as at any time—but not so steadily, due to the interruption of the pains.

When my visitors think I am striken worst and hesitate to trouble me with talk, I often essay my strength and set on foot a conversation as remote as possible from my ailment. I can do anything by fits and starts—but it must not be for long. What a pity I am not gifted like that man in Cicero who, dreaming he was lying with a wench, awoke to find he had discharged his stone in the sheets! My own pains have strangely blighted my taste for wenching.

During the intervals between attacks, when my vessels are merely sore and weak, I quickly recover my usual frame of mind. For I have always trained myself to take alarm at nothing but what is immediate and palpable.

Yet I have been rather roughly handled for a beginner. The stone caught me suddenly and unawares, dropping me at one swoop from an easy and pleasant life into the most dolorous that one can imagine. It attacked me at the outset more sharply than it does most men. The spells come so fast I am scarcely ever at ease. Yet up till now I have kept my head; and, if I can continue to hold my mind steady, I will be better off than thousands of others who suffer from no ills or fevers except those created by their own mental instability.

It may be that I inherited my hatred for doctoring, but in any case I have strengthened it by arguments and reasons. In the first place, the experience of others makes me fearful of it. No one, I see, falls sick so often and takes so long to recover as those who are enthralled by the rules of medicine. Their very health is weakened and injured by their diets and precautions. Doctors are not satisfied to deal with the sick; but they are forever meddling with the well, in order that no one shall escape from under their thumbs. I have been sick often enough to learn that I can endure my disease (and I have had a taste of all sorts) and get rid of it as nicely as anyone else, and without adding to it the vileness of their prescriptions.

My mode of living is the same in sickness as in health: the same bed, hours, food, and drink. I add nothing to them but moderation according to the state of my appetite. My health consists of maintaining my habitual course. I find that illness puts me off on one side; if I followed the doctors, they would put me off on the other—so that between nature and art I would be completely unseated.

I firmly believe that I cannot be harmed by things to which I have been long accustomed, and I lay great weight on my inclinations and desires. I do not like to cure one disease by another, and I hate remedies which are more troublesome than the disease itself. To be afflicted by colic and to be afflicted by abstaining from oysters are two evils in the place of one. Since we must run a chance one way or the other, let it be in the direction of our pleasures.

A gentleman in my neighborhood, who is terribly beset by the gout, was ordered to give up all salted meats. And he used to reply that in the height of the attacks he needed something to rage and swear at. By cursing now a Bologna sausage and again a smoked tongue he found great relief from his pains.

My appetite regulates itself according to the condition of my stomach. Wine is hurtful to sick people, and it is the first thing my palate disrelishes—and most invincibly. Whatever I take against my liking harms me, and nothing hurts me that I eat with appetite. I have never received harm from any action that was very agreeable to me, and accordingly I have made all my medical theories yield to my pleasures. Indeed, when I am sick I am often sorry I do not have some longing that would give me pleasure to satisfy.

You will always find in medicine an authority to endorse your whims. If your doctor does not approve of your drinking this kind of wine or eating that sort of food, do not worry over it. I'll find you another who will be of a different opinion.

<p style="text-align:center">★ ★ ★</p>

Doctors have a clever way of turning everything to their advantage. Whenever nature, luck, or anything else benefits our health, they lay it to their medicine. When things go badly they disown all responsibility and throw the blame on their patient. 'He lay with his arms uncovered—the rattle of a coach worsened him—somebody left the window open—he slept on his left side—he has the wrong mental outlook.'

Or else they make our turn for ill serve their own business. They try to tell us that without their treatment things would have been still worse. When they have plunged a man from a chill into a recurrent fever, they say that if it were not for them it would have been a continual fever. They run no risks of failing in their trade, for they convert even their losses into profits.

In antiquity and since then, there have been countless changes in medicine—for the most part sweeping and entire. In our times, for example, we have those introduced by Paracelsus, Fiorvanti, and Argentier. They have altered not only the prescriptions, but, I am told, the whole body and rules of the art, accusing all their predecessors of ignorance and imposition. At this rate you may imagine the plight of the poor patient.

How often we see one physician impute the death of a patient to the medicine of another physician! Yet how, God knows, shall a doctor discover the true symptoms of a disease when each is capable of an endless variety? How many controversies have raged between them on the significance of the urine? For my part, I would prefer to trust a physician who has himself suffered from the malady he would treat. The others describe diseases as our town-criers do a dog or horse—such color, height, and ears. But bring the beast to him, and he can't recognize it.

In my own sickness I have never found three doctors of the same opinion. Aperients, I am advised, are proper for a man afflicted with the stone—by dilating the vessels they help discharge the viscous matter out of which the gravel is formed. Again, aperients are dangerous, because, by dilating the vessels, they help the formative matter to reach the kidneys which naturally seize and retain it.

It is good, they say, to urinate frequently, for this prevents the gravel from settling in the bladder and coagulating into a stone. But frequent urinations are bad, because the deposits cannot be voided without grave violence to the tissues. It is good to have frequent intercourse with women, for that opens the passages; and it is bad, because it inflames, tires, and weakens the kidneys. Hot baths are good because they relax the parts, and they are bad because they help bake and harden the gravel. Because the doctors were afraid of stopping a dysentery lest they put the patient in a fever, they killed me a friend who was worth more than the whole pack of them together.

Thus they juggle and prate at our expense. They can't furnish me one argument that I'll not find a contrary of equal force. So let them not rail against those who, gripped by a disease, allow themselves to be gently guided by their own appetites and the promptings of nature, and trust to common luck. . . .

In short, I honor physicians not for their services, but for themselves. I have known many a good man among them, and most worthy of affection. I do not attack them, but their art. Nor do I blame them for taking advantage of our folly, for most men do as much. Many professions, both of greater and lesser dignity, live on gulling the public.

When I am sick, I send for them if they are near at hand, merely to have their company; and I pay them as others do. I give them leave to order me to keep myself warm, for I like to do it anyway. I let them recommend leeks or lettuce for my soup, put me on white wine or claret, or anything else that is indifferent to my taste and habits.

I know right well that I am not coddling them in this, for to them bitterness and strangeness is the very essence of a remedy. A neighbor of mine takes wine as an effective medicine for fever. Why? Because he abominates it.

Yet how many doctors do we see who, like myself, despise taking medicine, who live on a liberal diet and quite contrary to the rules they prescribe for their patients? What is this but sheer abuse of our simplicity!

It is fear of pain and death, impatience at being ill, and reckless search for cures, which blind us. It is pure cowardice that makes us so gullible. Yet most men do not so much believe in doctors as submit and consent to them.

William Shakespeare
FROM ROMEO AND JULIET

The trope of a poor apothecary must have amused Shakespeare's audiences. The sale of exotic drugs—including "mummy" from the ancient crypts of Egypt and all the novelties of the New World craftily marketed by the Fuggers—ensured the prosperity of many druggists and spicers. Perhaps the message to theatergoers was that the government regulation of apothecaries in Italy was actually effective.

ROMEO: I do remember an apothecary
 And hereabouts he dwells—whom late I noted
 In tatter'd weeds, with overwhelming brows,
 Culling of simples; meager were his looks,
 Sharp misery had worn him to the bones;
 And in his needy shop a tortoise hung,
 An alligator stuff'd and other skins,
 Of ill-shap'd fishes; and about his shelves
 A beggarly account of empty boxes,
 Green earthen pots, bladders, and musty seeds,
 Remnants of packthread, and old cakes of roses,
 Were thinly scattered to make up a show.
 Noting this penury, to myself I said—
 An if a man did need a poison now,

(below left) MATTHAUS GREUTER. *The Physician Curing Fantasy.* c.1534–1638. Engraving. 7⅝ × 10⅞ in. (19.4 × 27.6 cm). Philadelphia Museum of Art, SmithKline Beckman Corporation Fund. *(below) Preparation of Theriac, Ancient Universal Panacea.* Illustration from *Das Neu Distiller Buch.* 1537. Woodcut. 6½ × 6¾ in. (16.5 × 17.1 cm). National Library of Medicine, Bethesda, Md. *Two physicians preparing the popular panacea Theriac, which often contained 60 or more ingredients. Recipes for it were the carefully guarded secrets of successful physicians and pharmacists.*

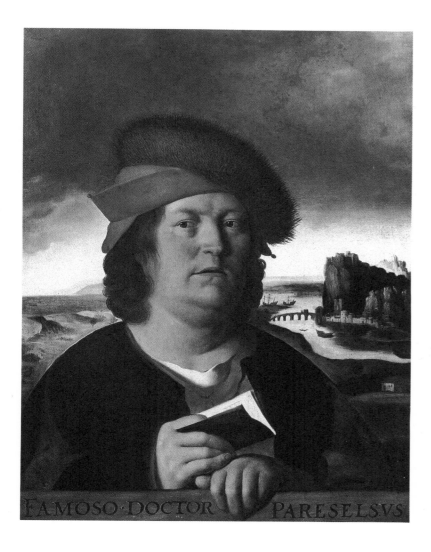

Attributed to QUENTIN DETSYS.
Portrait of Paracelsus. c.1550. Louvre,
Paris. *Theophrastus Philippus Aureolus*
Bombastus von Hohenheim
(1493–1541), the Swiss-born
physician, urged rejection of ancient
herbal medicine in favor of mineral
salts and opiates.

 Whose sale is present death in Mantua,
 Here lives a caitiff wretch would sell it him.
 O, this same thought did but fore-run my need;
 And this same needy man must sell it me.
 As I remember this should be the house;
 Being holiday, the beggar's shop is shut—
 What ho! Apothecary!
APOTHECARY: Who calls so loud?
ROMEO: Come hither, man. I see that thou art poor;
 Hold, there is forty ducats; let me have
 A dram of poison; such soon speeding gear
 As will disperse itself through all the veins,
 That the life-weary taker may fall dead;
 And that the trunk may be discharg'd of breath
 As violently as hasty powder fired
 Doth hurry from the fatal cannon's womb.
APOTHECARY: Such mortal drugs I have; but Mantua's law
 Is death to any he that utters them.
ROMEO: Art thou so bare, and full of wretchedness,
 And fear'st to die? famine is in thy cheeks.
 Need and oppression starveth in thy eyes,
 Contempt and beggary hangs upon thy back,
 The world is not thy friend, nor the world's law;
 The world affords no law to make thee rich;
 Then be not poor, but break it, and take this.

APOTHECARY: My poverty but not my will consents.

ROMEO: I pray thy poverty and not thy will.

APOTHECARY: Put this in any liquid thing you will
 And drink it off; and if you had the strength
 Of twenty men, it would despatch you straight.

ROMEO: There is thy gold, worse poison to men's souls
 Doing more murders in this loathsome world
 Than these poor compounds that thou may'st not sell.
 I sell thee poison, thou hast sold me none.
 Farewell; buy food, and get thyself in flesh.
 Come cordial, and not poison; go with me
 To Juliet's grave, for there I must use thee.

Ambroise Paré
FROM TEN BOOKS OF SURGERY

Paré (1510–1590) was famous for humanitarian surgical techniques and his pious celebration of the art. The rarity of this account lies not in the wound he suffered, for comminuted fractures were common in the military and equestrian classes. Paré's detached, clinical testimonial of the success of his own methods dramatically reinforces the belief that surgeons must not let the patient's pain interfere with therapy.

Having heretofore amply discoursed on the simple fractures of the bones, subsequently it behooves to discuss the manner by which a compound fracture is to be treated, that is to say, with wound. In order to show this more evidently, we shall take for example a leg of which the two fociles will be entirely broken with wound. This happened to me the fourth day of the month of May, 1561, as Monsieur Nestor, doctor regent in the Faculty of Medicine, Richard Hubert and Antoine Portail, master barber surgeons at Paris,

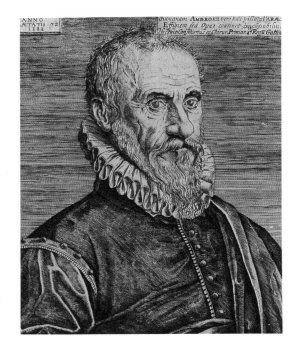

Attributed to ETIENNE DELAULNE. *Ambroise Paré at the Age of 72.* 1582. Copper engraving. Bibliothèque Nationale, Paris. *Paré's works of surgery appeared in French and were widely translated. He was well known for his humility in practice, saying of one patient, "I treated him; God cured him."*

whose renown is sufficiently known, will be amply able to testify, being summoned and I with them, to visit some patients in the village of Les Bons Hommes near Paris.

The misfortune befell me in the manner which follows: Wishing to pass across the water and trying to make my hackney enter a boat, I struck her on the crupper with a riding crop, stimulated by which the animal gave me such a kick that she broke entirely the two bones of my left leg at four inches above the juncture of the foot. Having received the blow and fearing that the horse might kick again, I stepped back one pace, and suddenly fell to the ground; the already fractured bones came out, and broke the flesh, the hose, and the boot, whence I felt such pain that it is not possible for a man (at least according to my judgment) to endure greater without death. My bones thus broken and my foot bent upward, I feared greatly that my leg had to be cut off to save my life. Therefore, casting my sight and my mind to heaven, I invoked the name of God and prayed Him that it might please Him of His benign grace to assist me in this extreme necessity.

I was quickly carried into the boat to cross to the other side in order to have me treated. But its shaking almost made me die, because the ends of the broken bones rubbed against the flesh, and those who were carrying me could not give it fit posture. From the boat I was carried into a house of the village with greater pain than I had endured in the boat, for one held my body, another my leg, the other my foot, and in walking one lifted to the left, the other lowered to the right. Finally, however, they placed me on a bed to regain my breath a little, where, while my dressing was being made, I had my whole body wiped dry, because I was in a general sweat. If I had been thrown in the water, I would not have been wetter. This done, I was treated with a medicament such as we were able to practice in the said place, which we compounded of white of eggs, wheat flour, oven soot, with fresh melted butter.

Above all, I prayed M. Richard Hubert not to spare me any more than if I had been the greatest stranger in the world as far as he was concerned, and that in reducing the fracture he put in oblivion the friendship that he bore me. Further, I admonished him, although he knew his art perfectly, to put my foot strongly in a straight line, and that if the wound were not sufficient in size, that he should increase it with a razor in order more easily to put the bones back in their natural position. Also, that he should search diligently in the wound with his fingers, rather than with another instrument (for the sense of feeling is more certain than any other instrument), in order to take out the fragments and pieces of bones which could be separated from their whole, and especially that he should express and make issue forth the blood which was in great abundance around the wound.

Having done this, that he should begin to bandage the wound and make three or four turns upon it, pressing it rather moderately, in order to express entirely the blood contained in the part; then that he should guide the rest of the bandage to near the knee, in order to prevent the blood and the humors from flowing back into the wound. Afterward that he should have a second bandage which would begin again on the wound one turn or two, which thereafter would be directed, tightening a little more, as far as on the foot in order to end there. Beside this, that he should take a third one and should begin his bandage on the foot, guiding it to the opposite of the first, so that its revolutions might be a little distant from each other and end at the same place as the first, in order that the muscles which had been in any way twisted by the first bandage and changed from their natural position might be put back in it. The leg thus bandaged will be placed in such a position as we have said. Then will be applied to it lengthwise a few splints or ferules, named by the Greeks *splenia*, two or three fingers wide, and as long as will be needed in order that they may aid to hold the bones in their natural position. Also, it behooves to put the splints far from each other by two fingers or about, especially to bend them a bit in order to lie better on the roundness of the member and to make them less broad at the ends, in order that they may compress the part better. These splints will be compressed and bound with small ribbons of thread, similar to those with which women wind their hair, and they will be tighter at the place of the fracture than in the other places. After

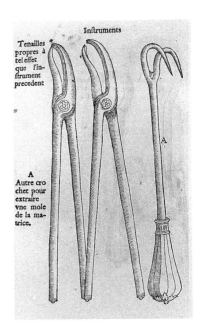

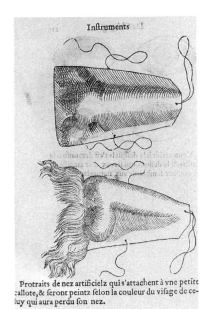

Protraits de nez artificielz qui s'attachent à vne petite callote, & feront peintz felon la couleur du visage de celuy qui aura perdu son nez.

AMBROISE PARÉ. Two illustrations from *Ten Books of Surgery*. 1564. National Library of Medicine, Bethesda, Md. *(left) Hooks and tenacula for drawing a dead fetus from the mother's uterus. This is Paré's illustration, though he probably never performed such an obstetrical procedure. (right) Artificial noses to improve the appearance of ravaged faces are pictured sideways on the page in Paré's book. Paré and other 16th-century surgeons commonly treated nasal disfigurements due to war, duels, and the mercury treatment of syphilis.*

the splints pads of straw will be applied, in which it will be necessary to put rather slender and strong sticks to hold the straw firm and stiff. Also, it will be necessary to wrap the pads in a linen cloth and to put them to the right and left of the broken member to hold it in a straight position. Finally, to place it on a small cushion. . . .

And there is no doubt that it is necessary to bandage over the wound, otherwise it would swell as receiving the humors from the other parts, whence many complications would occur. As one can see, if some fleshy and quite healthy part is bandaged only above and below without including the middle, the part not compressed will swell greatly, as we see by experience, and will change color, becoming livid because of the too great multitude of humors which are sent from the surrounding pressed parts. By stronger reason, such a thing will be done if the part is ulcerated, seeing that without ulcer or wound such a thing is done. For these causes, the ulcer is rendered insuppurative and lachrymose, that is to say that from it distils an unsavory and clear discharge, as are the tears which drip from the eyes when they are injured by inflammation. Now, if this unsavory humor flows and remains long on the substance of the bones, it alters and rots them, even sooner if they are thin and soft than if they are more solid and hard. This alteration and putrefaction would never occur if the patient were well bandaged and dressed. For this, I warn the surgeon not to fail to bandage on the wound if it is possible, that is to say, if there is not so great a pain and inflammation that it might hinder doing this. For then one would be forced to leave the proper treatment in order to relieve the complication, for the care of which there will be taken a cloth folded in two or three doubles, then in the fashion of a large compress, of such width that it can cover and compress the wound with a single revolution, it will be applied thereon, for making it too narrow (as says Hippocrates) it squeezes the wound like a belt, pressing it unevenly. By this it causes pain, inflammation, and other complications because of the humors which are attracted into it. However, it is always necessary to press and tighten on the wound less than in another part. The cloth will be attached and sewn at the side of the wound, and when one wishes to treat the patient, it will be necessary to unsew it without in any way, if it is possible, moving and shaking the fractured bones. For the fracture does not demand being moved often, as does the wound, in order to be dressed as is required. . . .

My leg treated thoroughly in the aforesaid manner, after dinner I was carried to my dwelling, where I had three saucers of blood drawn from my left basilic vein. At the second dressing and others following, I was cared for by my companion surgeons of Paris, principally by Master Estienne de la Riviere, surgeon ordinary of the King, who took the principal charge of treating me.

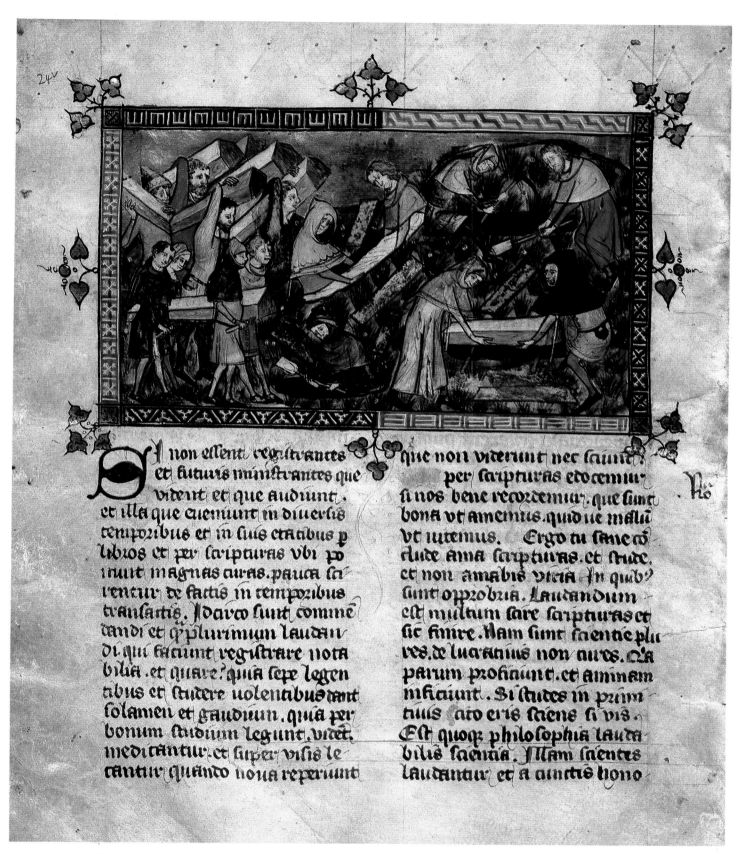

COLORPLATE 26

Coffin-Making and Burial During the Black Death. 1350s. Manuscript miniature from *Annales*, by
Giles de Mussis. 10¾ × 8 in. (27.3 × 20.3 cm). © Bibliothèque Royale Albert premier, Brussels.
*Coffin-making and burial during the bubonic plague in Tournai, Belgium, from a richly illustrated copy of the
chronicle of Giles de Mussis.*

COLORPLATE 27

Pen Ts'ao: Materia Medica. Late 18th or early 19th century. Watercolor. Each image: 4¹⁵⁄₁₆ × 3¾ in. (12.5 × 9.5 cm). Bibliothèque, Société Asiatique, Paris. *Depictions of a Confucian medical sage, a hunter, and a rubber or gum harvester among flora and fauna useful as medicine: pine trees (especially moss covering the tree), lichee fruit, a frog, coral, and the dragon.*

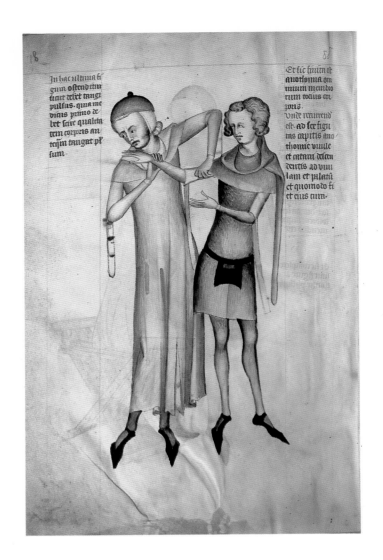 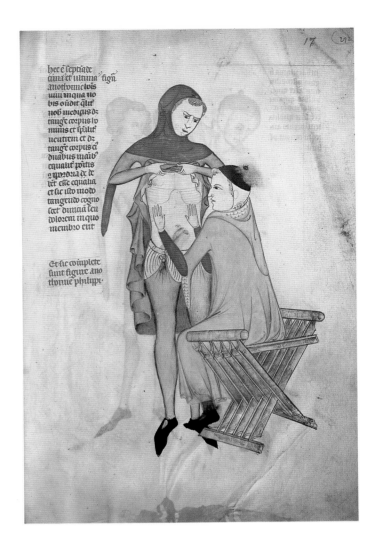

COLORPLATE 28

Manuscript illustrations from *Liber Notabilium Philippi VI,* "Anathomia," by Guido de Papia. 1345. Each image: 12½ × 8⅝ in. (31.8 × 21.9 cm). Musée Condé, Chantilly. "Doctor Taking a Patient's Pulse" (left); "General Clinical Examination" (right). *"The physician should know the condition of the body before taking the pulse," Guido wrote. Here the doctor awkwardly illustrates one of the ways of taking the pulse, high on the brachial artery; and he assesses the temperament, or humoral complexion, of the patient by lightly touching the abdomen.*

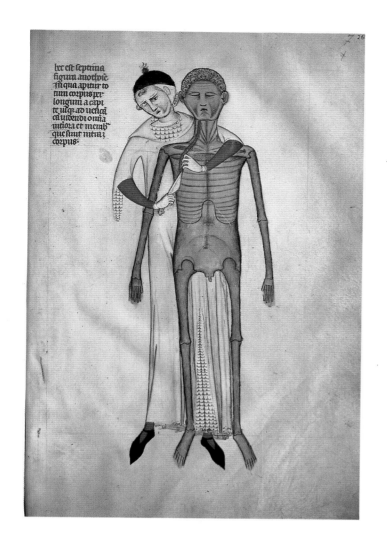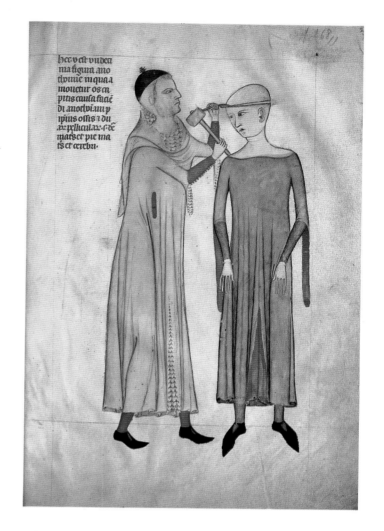

COLORPLATE 29

Manuscript illustrations from *Liber Notabilium Philippi VI,* "Anathomia," by Guido de Papia. 1345. Each image: 12½ × 8⅝ in. (31.8 × 21.9 cm). Musée Condé, Chantilly. *Two illustrations of dissection, opening the thorax and the cranium, accompanying Guido's anatomical treatise.*

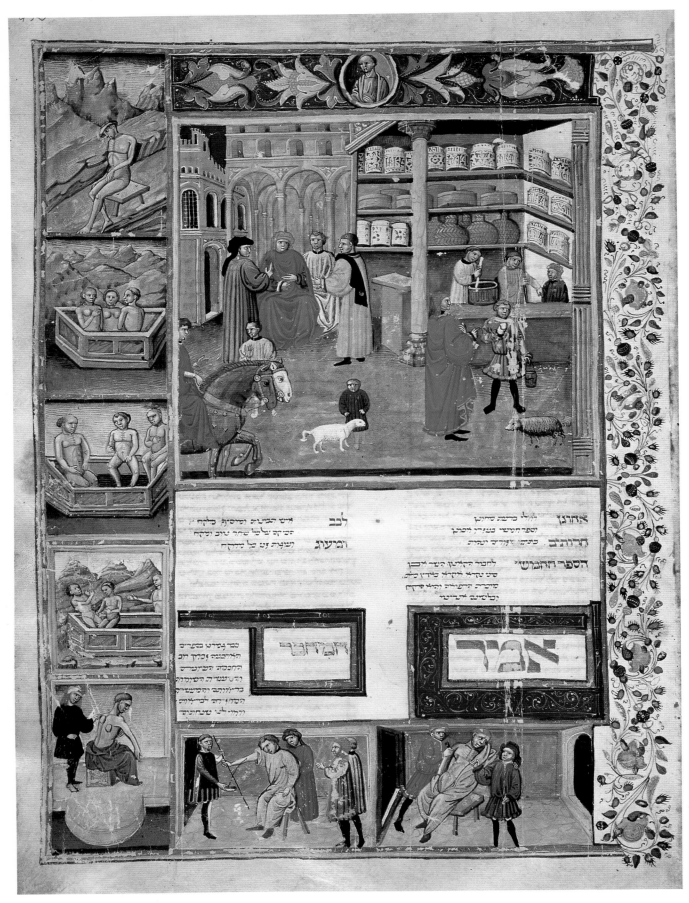

COLORPLATE 30

Scene in an Open-Air Pharmacy. c. 1440. Illuminated manuscript illustration from *Canon of Medicine,* by Avicenna. Biblioteca Universitaria, Bologna. *A deluxe 15th-century Hebrew edition of Avicenna's* Canon of Medicine, *featuring a pharmacy and many scenes of routine health care. Jewish physicians, among the best in the Middle Ages, were endangered intermediaries in the transmission of Arabic medicine to the Christian West.*

94

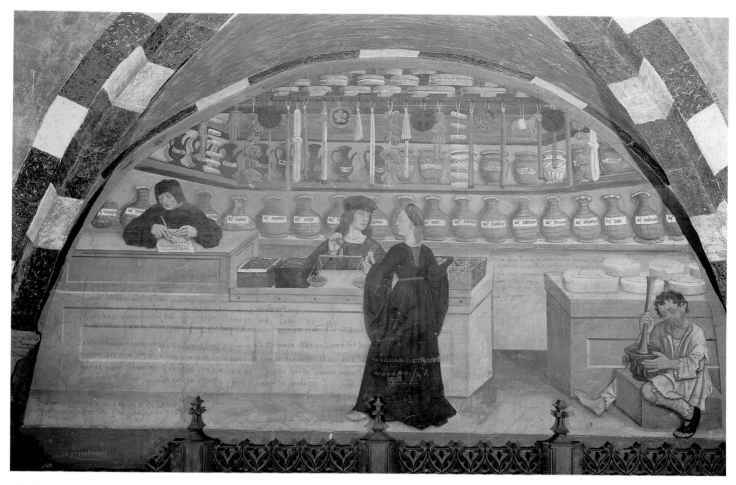

COLORPLATE 31

Scene of a Pharmacy. Late 15th century. Fresco. Castle of Issogne, Valle d'Aosta, Italy. *An Italian pharmacy with a full collection of herbs, ointments, oils, and rare substances. One of the most popular exotic remedies of the day was* mumia, *some of which came from the tombs of hapless pharaohs.*

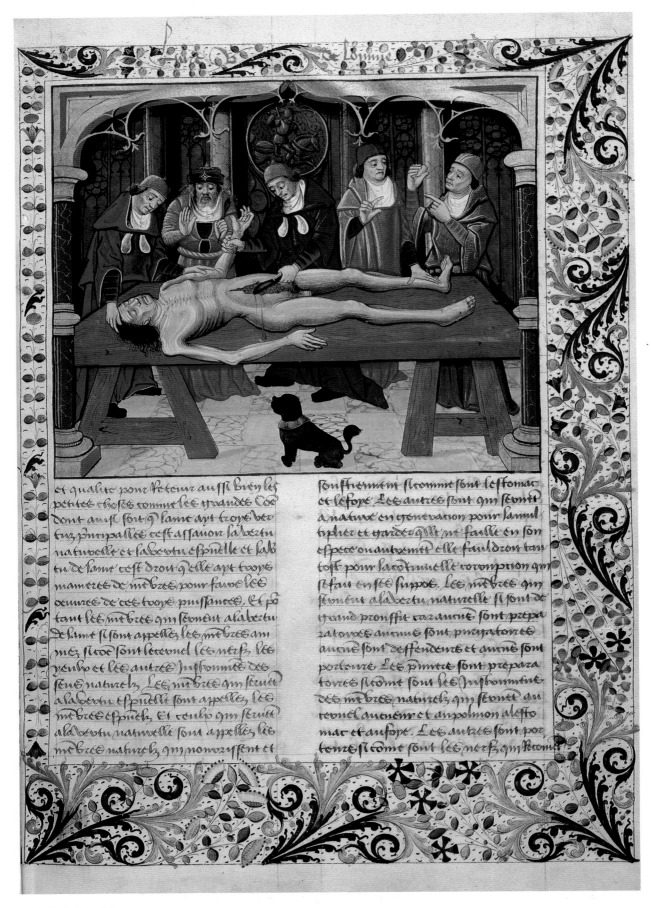

COLORPLATE 32

Dissection Scene, a chapter heading from *De Proprietatibus Rerum*, by Bartholomeus Anglicus. Late 15th century. 7¹⁵⁄₁₆ × 9½ in. (20.2 × 24.1 cm). Bibliothèque Nationale, Paris. *Bartholomeus's work was a popular compendium of natural science and magic of little direct medical interest, but at least nine different dissection scenes accompanied versions of this text between 1485 and 1500, each one more detailed than its predecessor.*

Around the wound and neighboring parts, I had rose ointment applied, which was continued until the abscess and suppuration occurred. The compresses and bandages were steeped in oxycrate, sometimes in thick and astringent wine to strengthen the part, to hold back and drive in the humors, and when they were dry I had them moistened with the oxycrate, for when they are too dry, pain and inflammation occur in the part because they compress the member more than they did when wet. There are many surgeons who in such case use only astringent and adhesive medicaments in opposition to Hippocrates and Galen, considering that their astriction and adhesiveness stop up the pores of the skin of the part. Doing this, they increase the foreign warmth with a great pruritus or itching, by means of which is formed beneath the skin a certain serous, acrid, and mordant humidity which makes ulcers, which shows clearly that such medicaments are not to be continued long. Rather, in their place, it is necessary to apply rose ointment which moderates the foreign warmth, prevents the pruritus, and appeases the pain.

<p align="center">★　★　★</p>

Now the signs which caused me to recognize that there were separated bones were that from the wound issued a clear and unsavory discharge. Likewise, the lips of the ulcer were very swollen and the flesh lax and soft as a sponge. Beyond which causes, it seems to me that the principal occasion of the fever and of the abscess arose from the fact that one night, while I was sleeping, my muscles drew back with so great a violence that I raised my leg in the air, indeed in such a way that the bones came out of their position and pressed the lips of the wound so that it was necessary again to pull my foot to reduce them. In doing this, I endured even more pain than I had done the first time I was treated. . . .

I do not wish to forget to say what I believe about the contraction and tremors of the muscles which in sleeping occur in fractures. The cause, in my opinion, is that in sleeping the natural warmth, withdrawing to the center of our body, causes the extremities to remain chilled. Whence it comes about that nature, wishing by its accustomed providence to send some spirits in order to succor the wounded part and not finding it disposed to receive them, permits them to withdraw suddenly to the inside whence they were sent. The muscles likewise pull the bones to which they are attached and, making this contraction, take them away from their position with very great pain. As for the fever, it continued in me for seven days, at the end of which it was ended, part by the abscess and part by very great sweats.

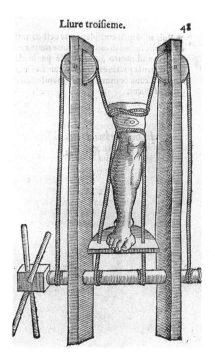
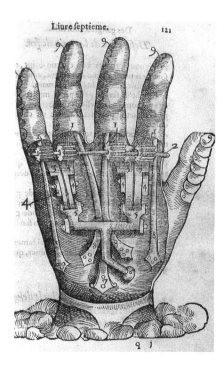

AMBROISE PARÉ. Two illustrations from *Ten Books of Surgery*. 1564. National Library of Medicine, Bethesda, Md. *(left) Paré's version of the ancient "glossocomium," used to exert traction in setting a broken femur. (right) An "iron," or artificial, hand. Although the hand functioned poorly, Paré's persistent concern was for the rehabilitation of his patients.*

John Donne

"Devotions upon Emergent Occasions"

Donne (1572–1631) wrote the chronicle of his illness—probably epidemic typhus fever—in the winter of 1623–24. Dean of St. Paul's, London, and an established popular preacher, Donne summoned medical details of his suffering and recovery in this, his finest prose-poem. The 23 segments, each divided into a Meditation, Expostulation, and Prayer—of which here we have but a sample—catch him watching the doctor and the disease as much as the prospect of mortality.

Variable, and therefore miserable condition of Man; this minute I was well, and am ill, this minute. I am surpriz'd with a sodaine change, and alteration to worse, and can impute it to no cause, nor call it by any name. We study *Health,* and we deliberate upon our *meat,* and *drink,* and *ayre,* and *exercises,* and we hew, and wee polish every stone, that goes to that building; and so our *Health* is a long and a regular work; But in a minute a *Canon* batters all, overthrowes all, demolishes all; a *Sicknes* unprevented for all our diligence, unsuspected for all our curiositie; nay, undeserved, if we consider only *disorder,* summons us, seizes us, possesses us, destroyes us in an instant. O miserable condition of Man, which was not imprinted by *God,* who as hee is *immortall* himselfe, had put a *coale,* a *beame* of *Immortalitie* into us, which we might have blowen into a *flame,* but blew it out, by our first sinne; wee beggard our selves by hearkning after false riches, and infatuated our selves by hearkning after false knowledge. So that now, we doe not onely die, but die upon the Rack, die by the torment of sicknesse; nor that onely, but are preafflicted, super-afflicted with these jelousies and suspitions, and apprehensions of *Sicknes,* before we can cal it a sicknes; we are not sure we are ill; one hand askes the other by the pulse, and our eye asks our urine, how we do. O multiplied misery! we die, and cannot enjoy death, because wee die in this torment of sicknes; we are tormented with sicknes, and cannot stay till the torment come, but preapprehensions and presages, prophecy those torments, which induce that *death* before either come; and our dissolution is conceived in these *first changes, quickned* in the *sicknes* it selfe, and *borne* in *death,* which beares date from these first changes. Is this the honour which Man hath by being a *litle world,* That he hath these *earthquakes* in him selfe, sodaine shakings; these *lightnings,* sodaine flashes; these *thunders,* sodaine noises; these *Eclypses,* sodain offuscations, and darknings of his senses; these *Blazing stars,* sodaine fiery exhalations; these *Rivers of blood,* sodaine red waters? Is he *a world* to himselfe only therefore, that he hath inough in himself, not only to destroy, and execute himselfe, but to presage that execution upon himselfe; to assist the sicknes, to antidate the sicknes, to make the sicknes the more irremediable, by sad apprehensions, and as if he would make a fire the more vehement, by sprinkling water upon the coales, so to wrap a hote fever in cold Melancholy, least the fever alone should not destroy fast enough, without this contribution, nor perfit the work (which is *destruction*) except we joynd an artificiall sicknes, of our owne *melancholy,* to our natural, our unnaturall fever. O perplex'd discomposition, O ridling distemper, O miserable condition of Man.

<p style="text-align:center">★　　★　　★</p>

Perchance hee for whom this *Bell* tolls, may be so ill, as that he knowes not it tolls for him; And perchance I may thinke my selfe so much better than I am, as that they who are about mee, and see my state, may have caused it to toll for mee, and I know not that. The *Church* is *Catholike, universall,* so are all her *Actions; All* that she does, belongs to *all.* When she *baptizes a child,* that action concernes mee; for that child is thereby connected to that *Head* which is my *Head* too, and engraffed into that *body,* whereof I am a *member.*

And when she *buries a Man,* that action concernes me: All *mankinde* is of one *Author,* and is one *volume;* when one Man dies, one *Chapter* is not *torne* out of the *book,* but *translated* into a better *language;* and every *Chapter* must be so *translated; God* emploies several *translators;* some peeces are translated by *age,* some by *sicknesse,* some by *warre,* some by *justice;* but *Gods* hand is in every *translation;* and his hand shall binde up all our scattered leaves againe, for that *Librarie* where every *booke* shall lie open to one another: As therefore the *Bell* that rings to a *Sermon,* calls not upon the *Preacher* onely, but upon the *Congregation* to come; so this *Bell* calls us all: but how much more mee, who am brought so neere the *doore* by this *sicknesse.* There was a *contention* as farre as a *suite,* (in which both *pietie* and *dignitie, religion,* and *estimation,* were mingled) which of the religious *Orders* should ring to *praiers* first in the *Morning;* and it was *determined, that they should ring first that rose earliest.* If we understand aright the *dignitie* of this *Bell* that tolls for our *evening prayer,* wee would bee glad to make it ours, by rising early, in that *application,* that it might bee ours, as wel as his, whose indeed it is. The *Bell* doth toll for him that *thinkes* it doth; and though it *intermit* againe, yet from that *minute,* that that occasion wrought upon him, hee is united to *God.* Who casts not up his *Eie* to the *Sunne* when it rises? but who takes off his *Eie* from a *Comet* when that breakes out? Who bends not his *eare* to any *bell,* which upon any occasion rings? but who can remove it from that *bell,* which is passing a *peece of himselfe* out of this *world?* No man is an *Iland,* intire of it selfe; every man is a *peece* of the *Continent,* a part of the *maine;* if a *Clod* bee washed away by the *Sea, Europe* is the lesse, as well as if a *Promontorie* were, as well as if a *Mannor* of they *friends* or of *thine owne* were; any mans *death* diminishes *me,* because I am involed in *Mankinde;* And therefore never send to know for whom the *bell* tolls; It tolls for *thee.* . . .

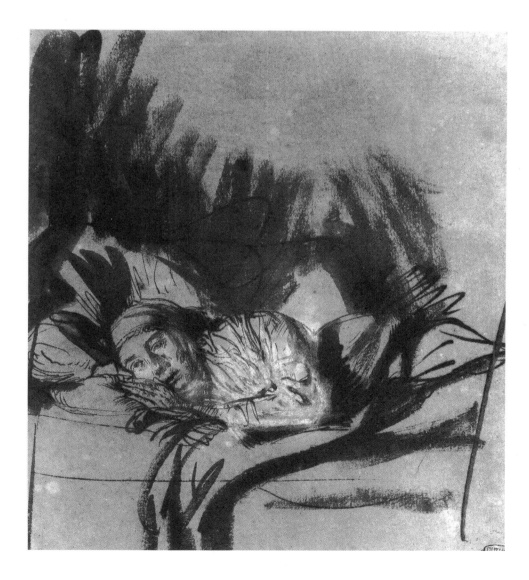

REMBRANDT VAN RIJN. *Woman Ill in Bed.* c. 1640. Drawing. 6½ × 5¹¹⁄₁₆ in. (16.5 × 14.4 cm). Musée du Petit Palais, Paris. Photo, Musées de la Ville de Paris.

William Harvey

FROM ON THE MOTION OF THE HEART AND BLOOD IN ANIMALS

With his 1628 demonstration of the circulation of the blood, Harvey (1578–1657) could have overturned Galenic physiology. Unlike contemporary scientific revolutions in astronomy and physics, Harvey's discovery had no immediate effect upon medical education or practice. His uses of anatomical investigation and animal experimentation, however, changed the terms by which old questions could be answered.

Thus far we have spoken of the quantity of blood passing through the heart and the lungs in the centre of the body, and in like manner from the arteries into the veins in the peripheral parts and the body at large. We have yet to explain, however, in what manner the blood finds its way back to the heart from the extremities by the veins, and how and in what way these are the only vessels that convey the blood from the external to the central parts; which done, I conceive that the three fundamental propositions laid down for the circulation of the blood will be so plain, so well established, so obviously true, that they may claim general credence. Now the remaining position will be made sufficiently clear from the valves which are found in the cavities of the veins themselves, from the uses of these, and from experiments cognizable by the senses.

The celebrated Hieronymus Fabricius of Aquapendente, a most skilful anatomist, and venerable old man, or, as the learned Riolan will have it, Jacobus Silvius, first gave representations of the valves in the veins, which consist of raised or loose portions of the inner membranes of these vessels, of extreme delicacy, and a sigmoid or semilunar shape. They are situated at different distances from one another, and diversely in different individuals; they are connate at the sides of the veins; they are directed upwards or towards the trunks of the veins; the two—for there are for the most part two together—regard each other, mutually touch, and are so ready to come into contact by their edges, that if anything attempt to pass from the trunks into the branches of the veins, or from the greater vessels into the less, they completely prevent it; they are farther so arranged, that the horns of those that succeed are opposite the middle of the convexity of those that precede, and so on alternately.

The discoverer of these valves did not rightly understand their use, nor have succeeding anatomists added anything to our knowledge: for their office is by no means explained when we are told that it is to hinder the blood, by its weight, from all flowing into inferior parts; for the edges of the valves in the jugular veins hang downwards, and are so contrived that they prevent the blood from rising upwards; the valves, in a word, do not invariably look upwards, but always towards the trunks of the veins, invariably towards the seat of the heart. I, and indeed others, have sometimes found valves in the emulgent veins, and in those of the mesentery, the edges of which were directed towards the vena cava and vena portæ. Let it be added that there are no valves in the arteries, and that dogs, oxen, etc., have invariably valves at the divisions of their crural veins, in the veins that meet towards the top of the os sacrum, and in those branches which come from the haunches, in which no such effect of gravity from the erect position was to be apprehended. Neither are there valves in the jugular veins for the purpose of guarding against apoplexy, as some have said; because in sleep the head is more apt to be influenced by the contents of the carotid arteries. Neither are the valves present in order that the blood may be retained in the divarications or smaller trunks and minuter branches, and not be suffered to flow

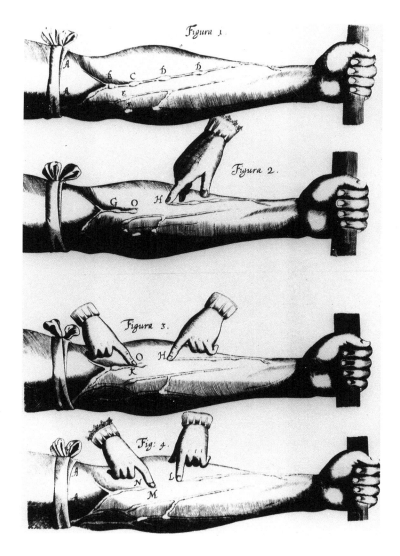

WILLIAM HARVEY. *Experiment on the Motion of Blood.* 1628. Illustration from *On the Motion of the Heart and Blood in Animals.* World Health Organization, Geneva. *Harvey's illustration of the unidirectional flow of venous blood through the venous valves. Once past a valve, blood did not return to distal parts to nourish the members, as Galenic physiology had dictated.*

entirely into the more open and capacious channels; for they occur where there are no divarications; although it must be owned that they are most frequent at the points where branches join. Neither do they exist for the purpose of rendering the current of blood more slow from the centre of the body; for it seems likely that the blood would be disposed to flow with sufficient slowness of its own accord, as it would have to pass from larger into continually smaller vessels, being separated from the mass and fountain head, and attaining from warmer into colder places.

But the valves are solely made and instituted lest the blood should pass from the greater into the lesser veins, and either rupture them or cause them to become varicose; lest, instead of advancing from the extreme to the central parts of the body, the blood should rather proceed along the veins from the centre to the extremities; but the delicate valves, while they readily open in the right direction, entirely prevent all such contrary motion, being so situated and arranged, that if anything escapes, or is less perfectly obstructed by the cornua of the one above, the fluid passing, as it were, by the chinks between the cornua, it is immediately received on the convexity of the one beneath, which is placed transversely with reference to the former, and so is effectually hindered from getting any farther.

And this I have frequently experienced in my dissections of the veins: if I attempted to pass a probe from the trunk of the veins into one of the smaller branches, whatever care I took I found it impossible to introduce it far any way, by reason of the valves; whilst, on the contrary, it was most easy to push it along in the opposite direction, from without inwards, or from the branches towards the trunks and roots. In many places two valves are so placed and fitted, that when raised they come exactly together in the middle of the vein, and are there united by the contact of their margins; and so accurate is the

adaptation, that neither by the eye nor by any other means of examination, can the slightest chink along the line of contact be perceived. But if the probe be now introduced from the extreme towards the more central parts, the valves, like the floodgates of a river, give way, and are most readily pushed aside. The effect of this arrangement plainly is to prevent all motion of the blood from the heart and vena cava, whether it be upwards towards the head, or downwards towards the feet, or to either side towards the arms, not a drop can pass; all motion of the blood, beginning in the larger and tending towards the smaller veins, is opposed and resisted by them; whilst the motion that proceeds from the lesser to end in the larger branches is favoured, or, at all events, a free and open passage is left for it.

But that this truth may be made the more apparent, let an arm be tied up above the elbow as if for phlebotomy (A, A, fig. 1). At intervals in the course of the veins, especially in labouring people and those whose veins are large, certain knots or elevations (B, C, D, E, F) will be perceived, and this not only at the places where a branch is received (E, F), but also where none enters (C, D): these knots or risings are all formed by valves, which thus show themselves externally. And now if you press the blood from the space above one of the valves, from H to O (fig. 2), and keep the point of a finger upon the vein inferiorly, you will see no influx of blood from above; the portion of the vein between the point of the finger and the valve O will be obliterated; yet will the vessel continue sufficiently distended above the valve (O, G). The blood being thus pressed out, and the vein emptied, if you now apply a finger of the other hand upon the distended part of the vein above the valve O (fig. 3), and press downwards, you will find that you cannot force the blood through or beyond the valve; but the greater effort you use, you will only see the portion of vein that is between the finger and the valve become more distended, that portion of the vein which is below the valve remaining all the while empty (H, O, fig. 3).

It would therefore appear that the function of the valves in the veins is the same as that of the three sigmoid valves which we find at the commencement of the aorta and pulmonary artery, viz., to prevent all reflux of the blood that is passing over them.

Farther, the arm being bound as before, and the veins looking full and distended, if you press at one part in the course of a vein with the point of a finger (L, fig. 4), and then with another finger streak the blood upwards beyond the next valve (N), you will perceive that this portion of the vein continues empty (L, N), and that the blood cannot retrograde, precisely as we have already seen the case to be in fig. 2; but the finger first applied (H, fig. 2, L, fig. 4), being removed, immediately the vein is filled from below, and the arm becomes as it appears at D C, fig. 1. That the blood in the veins therefore proceeds from inferior or more remote to superior parts, and towards the heart, moving in these vessels in this and not in the contrary direction, appears most obviously. And although in some places the valves, by not acting with such perfect accuracy, or where there is but a single valve, do not seem totally to prevent the passage of the blood from the centre, still the greater number of them plainly do so; and then, where things appear contrived more negligently, this is compensated either by the more frequent occurrence or more perfect action of the succeeding valves, or in some other way: the veins, in short, as they are the free and open conduits of the blood returning *to* the heart, so are they effectually prevented from serving as its channels of distribution *from* the heart.

But this other circumstance has to be noted: The arm being bound, and the veins made turgid, and the valves prominent, as before, apply the thumb or finger over a vein in the situation of one of the valves in such a way as to compress it, and prevent any blood from passing upwards from the hand; then, with a finger of the other hand, streak the blood in the vein upwards till it has passed the next valve above (N, fig. 4), the vessel now remains empty; but the finger at L being removed for an instant, the vein is immediately filled from below; apply the finger again, and having in the same manner streaked the blood upwards, again remove the finger below, and again the vessel becomes distended as before; and this repeat, say a thousand times, in a short space of time. And now compute the quantity of blood which you have thus pressed up beyond the valve, and then multiplying the assumed quantity by one thousand, you will find that so much blood

has passed through a certain portion of the vessel; and I do now believe that you will find yourself convinced of the circulation of the blood, and of its rapid motion. But if in this experiment you say that a violence is done to nature, I do not doubt but that, if you proceed in the same way, only taking as great a length of vein as possible, and merely remark with what rapidity the blood flows upwards, and fills the vessel from below, you will come to the same conclusion.

<p style="text-align:center">★ ★ ★</p>

And now I may be allowed to give in brief my view of the circulation of the blood, and to propose it for general adoption.

Since all things, both argument and ocular demonstration, show that the blood passes through the lungs and heart by the force of the ventricles, and is sent for distribution to all parts of the body, where it makes its way into the veins and porosities of the flesh, and then flows by the veins from the circumference on every side to the centre, from the lesser to the greater veins, and is by them finally discharged into the vena cava and right auricle of the heart, and this in such a quantity or in such a flux and reflux thither by the arteries, hither by the veins, as cannot possibly be supplied by the ingesta, and is much greater than can be required for mere purposes of nutrition; it is absolutely necessary to conclude that the blood in the animal body is impelled in a circle, and is in a state of ceaseless motion; that this is the act or function which the heart performs by means of its pulse; and that it is the sole and only end of the motion and contraction of the heart.

ENLIGHTENMENT: RITUAL AND THE WORLD WE HAVE LOST

Alessandro Manzoni

FROM THE BETROTHED

Manzoni (1785–1873), in recounting the plague of 1630 in Milan, horrified Enlightenment sensibilities with the story of men accused of spreading plague through homemade unguents. While unquestioning belief in the contagion theory supported the torture and execution of the untori, *Manzoni emphasized the "legal" injustices of prelates and judges. Here his description of a typical plague procession calls on details gleaned from careful historical research.*

Three days were spent in preparations. At dawn on the 11th June, which was the day fixed, the procession left the cathedral. In front went a long line of people, chiefly women, their faces covered with wide shawls, many barefoot and dressed in sackcloth. Then came the guilds preceded by their banners, and the confraternities in habits of various shapes and colours, then the monks and friars, then the secular clergy, each wearing the insignia of their rank, and carrying a taper or torch in their hands. In the middle, where the lights clustered thickest and the singing rose loudest, beneath a rich canopy, came the casket, borne by four priests sumptuously robed, who changed relays every now and again.

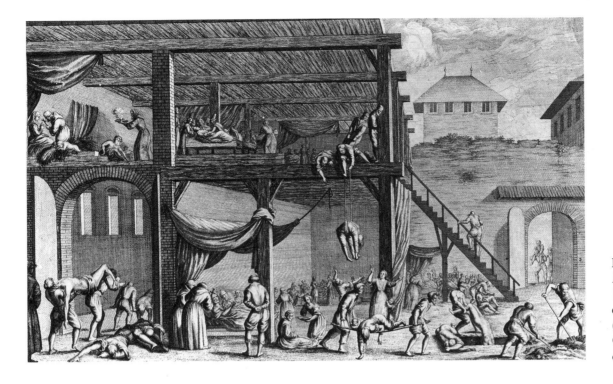

Through the glass could be seen the venerable form [of St. Charles Borromeo—*eds.*] dressed in splendid pontifical robes, and the mitred skull. In the mutilated, decayed features could still be seen some trace of his former appearance as shown in the pictures of him, and as some could remember seeing and honouring in life. Behind the mortal remains of the dead shepherd . . . and near him, as he was in merit, blood and dignity, came Archbishop Federigo. Then followed the rest of the clergy; then the magistrates in their full robes of state; then the nobles, some dressed magnificently, as for a solemn religious ceremony, and some in mourning, as a sign of penitence, or barefoot and in sackcloth with their faces hooded; all bore tapers. The rear was brought up by a mixed crowd.

The whole way was decked as for a festival. The rich had brought out their most precious hangings. The fronts of the poorer houses had been decorated by their wealthier neighbours or at the public expense. Here and there in place of hangings there were leafy branches. Pictures, inscriptions, coats-of-arms, dangled down on every side; on the window-sills were displayed vases, antiques, and various rarities; there were lights everywhere. The sick in quarantine looked down at the procession from many of these windows, and followed it with their prayers. The other streets were silent and deserted, save where some, also from their windows, strained their ears to the moving sounds. Others, among whom even nuns could be seen, had climbed up on the roofs, hoping to catch a glimpse from afar of casket, procession, anything.

The procession passed through every quarter of the city. It stopped at each of the cross-roads or small squares where the main streets came out on to the suburbs. . . . The casket was set down by the cross erected at each of these points by San Carlo during the last plague, some of which are still standing; so that it returned to the cathedral some time after midday.

And then next day, while the presumptuous confidence and indeed in many the fanatical certainty that the procession had ended the plague was at its height, the death-rate suddenly increased to such an extent in every class and every part of the city, with such a sudden leap, that no one could fail to see the cause or the occasion of it in the procession itself. But oh, the wondrous and awful power of general prejudice! Not to so many people being together for so long, not to the infinite multiplication of chance contracts, did most people attribute the increase. They attributed it to the facilities which the anointers had found in it to carry out their nefarious designs. It was said that they had mingled in the crowd and infected as many people as they could with their ointment. . . .

From that day the plague raged with constantly increasing violence. Within a short time there was scarcely a house left untouched. Within a short time, too, the population of the *lazzaretto* . . . rose from two thousand to twelve thousand; later, according to almost everyone, it reached as much as sixteen thousand. On the 4th July, as I find in another letter from the Commissioners of Health to the governor, the death-rate exceeded five hundred a day. Still later, at the very height, it reached, according to the most common computation, one thousand two hundred, one thousand five hundred, and more than three thousand five hundred . . . [T]he population of Milan, which had before been more than two hundred and fifty thousand, was reduced after the plague to little more than sixty-four thousand souls. According to Ripamonti, it had been only two hundred thousand; he says the number of deaths on the civic registers came to one hundred and forty thousand, apart from those that could not be counted. Others say less or more, but still more at random.

Imagine now the plight of the Council of Ten, on whom rested the burden of providing for the public needs and remedying what was remediable in such a disaster. The public servants of various kinds had to be replaced and increased every day—*monatti, apparitori,* commissioners. *Monatti* were employed in the ghastliest and most dangerous duties of the plague removing the corpses from the houses, streets, and *lazzaretto,* carting them to graves and burying them; taking or leading the sick to the *lazzaretto,* and controlling them; burning or fumigating infected and suspected matter. . . . The special task of the *apparitori* was to go ahead of the carts and warn passers-by to get out of the way, by ringing a hand-bell. The commissioners controlled both under the immediate orders of the Tribunal of Health. They also had to keep the *lazzaretto* furnished with doctors, surgeons, medicines, food, and all the necessities of a hospital; they had to find and prepare new quarters for the sick flowing in every day. For this purpose they had hurriedly had huts of wood and straw erected in the space inside the *lazzaretto;* a new enclosure grew up, made up of shacks, surrounded by a simple fence, and capable of holding four thousand people. And as these were not enough, two others were decreed, and even begun, but never finished, owing to lack of means of every kind. Means, men, and energy decreased as the needs increased. . . .

So also when an ample but single grave that had been dug out near the *lazzaretto* was found to be completely full of corpses, and when fresh corpses, becoming more numerous every day, were being left unburied not only in the *lazzaretto* but in all parts of the city, the magistrates, after searching in vain for the labour to carry out this grisly task, were reduced to saying that they no longer knew where to turn. Nor was it easy to see how things would have ended, had not help been forthcoming from an unusual quarter. The president of the Tribunal of Health came and appealed with tears in his eyes to the two good friars who were superintending the *lazzaretto;* and Fra Michele pledged himself to clear the city of corpses within four days, and within eight days to open up sufficient graves not only for present needs, but for the very worst previsions of the future. With a brother friar and some officers of the Tribunal given him by the president he went out into the country to look for peasants; and, partly by the Tribunal's authority, and partly by the influence of his habit and words, he succeeded in collecting about two hundred, whom he set to digging three enormous graves. Then he sent *monatti* from the *lazzaretto* to collect the dead; so that, on the appointed day, his promise was fulfilled.

<div align="center">★　　★　　★</div>

Rogues whom the plague spared and did not frighten found new chances of activity, together with new certainty of impunity, in the common confusion following the relaxation of every public authority; in fact the very exercise of public authority came to be very largely in the hands of the worst among them. The only men who generally took on the work of *monatti* and *apparitori* were those more attracted by rapine and licence than terrified of contagion or sensible to natural repulsion. The strictest rules were laid down for these men, the severest penalties threatened them. Posts were assigned them by commissioners placed over them, as we have said. Above both were magistrates and nobles

delegated for every quarter, with authority to punish summarily every breach of discipline. This organization kept going effectively for some time, but with the number of those dying, leaving, or losing their heads growing from day to day, the *monatti* and *apparitori* began to find there was almost no one to hold them back. They made themselves, particularly the *monatti,* the arbiters of everything. They entered houses as masters, as enemies, and (not to mention their thieving or treatment of the wretched creatures reduced by plague to passing through their hands) they would lay those foul and infected hands on healthy people, on children, parents, wives, or husbands, threatening to drag them off to the *lazzaretto* unless they ransomed themselves or got others to ransom them by money. At other times they set a price on their services, and refused for less than so many *scudi* to carry away bodies that were already putrefying. It was said . . . that *monatti* and *apparitori* let infected clothes drop from their carts on purpose, in order to propagate and foster the plague, for it had become a livelihood, a festival, a reign for them. Other shameless wretches, pretending to be *monatti* by wearing bells attached to their feet, as the latter were supposed to do for recognition and to warn others of their approach, would introduce themselves into houses and commit every sort of crime. Some houses, which were open and empty of inhabitants or occupied only by some feeble dying creature, were entered by robbers with impunity and sacked. Others were broken into and invaded by bailiffs who did the same and worse.

As crime grew, so did panic also. All the errors already more or less rampant gathered extraordinary strength from the general dismay and agitation, and produced even quicker and vaster results. They all served to reinforce and intensify that predominating terror about anointers, the effects and expression of which were often, as we have seen, another crime in themselves. The idea of this imaginary danger beset and tortured people's minds far more than the one that was real and present. 'And while,' says Ripamonti, 'the corpses always strewn about and lying in heaps before our eyes and underfoot made the entire city seem like an immense charnel-house, there was something even more ghastly, even more appalling in that mutual frenzy, that unbridled orgy of suspicion . . . not only was a neighbour, a friend, or a guest distrusted; even those names that are the bonds of human love, husband and wife, father and son, brother and brother, became words of terror; and (horrible and infamous to tell!) the family board and the nuptial bed were feared as hiding-places for the lurking poisoner.'

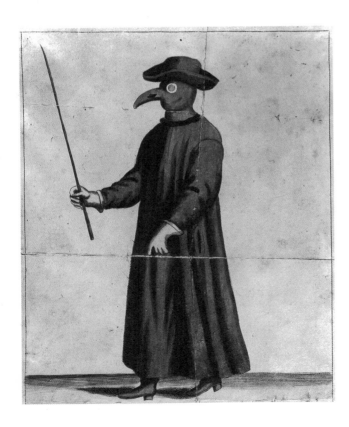

Protective Clothing of Doctors and Others Who Visit Plague-Houses. c. 1720. Illustration from *Der Pestarzt Dr. François Chicoyneau.* Colored copper engraving. 10¼ × 7 in. (26.1 × 17.8 cm). Germanisches Nationalmuseum, Nuremberg.

Molière

FROM THE IMAGINARY INVALID

Challenges to traditional Galenic medicine and the elite university system supporting it proliferated during the Scientific Revolution. Focusing on the outcome of medical efforts, rather than the process of medical diagnosis and prognosis, popular ridicule of the "educated" doctor's pretensions to knowledge was nowhere better captured than in the plays of Molière (1622–1673). This excerpt is taken from an adaptation by Miles Malleson.

———————————

ARGAN. . . . (*To Cléante*) So you want to marry my daughter.

CLÉANTE. Yes, yes I do.

ARGAN. But she can't marry a music master.

CLÉANTE. I'm not a music master.

ARGAN. But you said you were.

CLÉANTE. Oh—yes—so I did.

ARGAN. But why?

CLÉANTE. It was a trick.

ARGAN. Outrageous! If there's anything I disapprove of—it's a trick.

BÉRALDE } (*together; in loud protest*) { Really, brother!
TOINETTE } { Oh, Monsieur Argan!

ARGAN (*cutting them short*) All right, all right—enough of that! (*Turning to Cléante*) You're not a doctor by any chance?

CLÉANTE. No.

ARGAN. Pity. If you'd been a doctor, you could have had her.

CLÉANTE. Then I'll become one.

BÉRALDE. I have a better idea.

ARGAN. You and your ideas!

BÉRALDE. Become a doctor yourself.

ARGAN. *Me?*

BÉRALDE. Why not?

ARGAN. And what do I know of illness and disease?

BÉRALDE. What do you need to know? Except about your own? And about those, you know more than any man in Paris—a doctor or layman.

ARGAN. That's true enough.

BÉRALDE. And only this afternoon you had an example—that vigorous young doctor of eighty, who treated himself.

ARGAN. But I know no Latin.

BÉRALDE. You'll pick it up in no time. And, with a smattering of it, everything you say will sound a pearl of wisdom.

ARGAN. But how do I become a doctor?

BÉRALDE. Easily! A simple ceremony that can be performed here and now.

ARGAN. Here and now?

BÉRALDE. I happen to know that in the house next door, there is a meeting of the Faculty! Toinette, away with you, and invite them here at once.

(TOINETTE, *bewildered as to what he means, stands hesitating*)

And you, Angelica, and you, Cléante—both of you—go with her.

(*But for the moment both* ANGELICA *and* CLÉANTE *hesitate, wondering where they are to go*)

I'll follow, in a moment, to explain.

(TOINETTE, ANGELICA *and* CLÉANTE *exit*)

(*He moves to Argan*) Now, brother, this is the greatest moment of your life. In a few minutes you will be Dr. Argan. I must go and summon the Faculty and you must be alone for a few moments, to prepare yourself for the Ordeal.

ARGAN. *Ordeal?*

BÉRALDE. My dear fellow, there can be no sort of Achievement, without some kind of Ordeal. (*He hurries to the door, where he turns*) The ceremony, of course, will be in Latin.

ARGAN. Latin!

BÉRALDE. You must do your best.

(BÉRALDE *exits.*

ARGAN *is alone, apprehensive. He rises and moves about the room and ends up before his long row of medicine bottles. He consults them*)

ARGAN. No; I'll have to wait till I'm a doctor—I don't know which to take.

(*Suddenly, the door bursts open and* ELEVEN PEOPLE, *in fact, the rest of the cast, come into the room. They are all disguised in the tall hats and flowing gowns of the Medical Faculty, and each carries an outsize instrument connected with the profession. They form a ring round Argan, and circle round him chanting and singing. The tune should be a simple one, gay and exciting, with a phrase capable of repetition at an ever-increasing crescendo*)

THE ELEVEN (*circling and chanting*)
Here we are—Hic nos sumus
Omnes Learnéd Doctorī,
Eminent Professiorēs,
Clever, skilful Surgēonī,
Venerable Physicianēs,
Every kind of Medici.

(*One of the figures, in fact,* BÉRALDE, *breaks from the circle to confront Argan*)

1ST FIGURE.
Invalid Imaginarius
You must answer questions various.

(*He rejoins the ring, and again they circle and chant*)

THE ELEVEN.
Omnes Learnéd Doctori,
Eminent Professiorēs,
Venerable Physicianēs,
Every kind of Medici.

(*Another figure,* TOINETTE, *breaks from the circle, to stand in front of Argan*)

After HENDRIK GOLTZIUS. *The Physician as God (above, left)* and *The Physician as Angel (above)*. 1587. Illustrations from *The Medical Professions*. Engraving with woodcut inscription. Each image: 7¹⁵⁄₁₆ × 8⅞ in. (20.2 × 22.5 cm). Philadelphia Museum of Art. Anonymous gift. *As God, the physician is the ultimate hope of the patient, reading mysterious signs in the urine. The history of this patient's fall, leg fracture, and confinement to bed is told in the background, as a rescue narrative about the savior physician. As angel, the physician administers medicine as the patient begins to recover.*

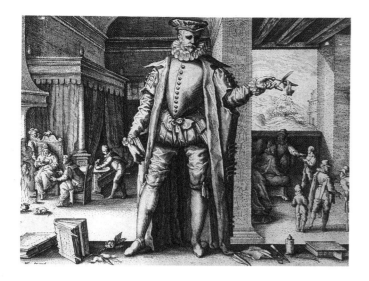 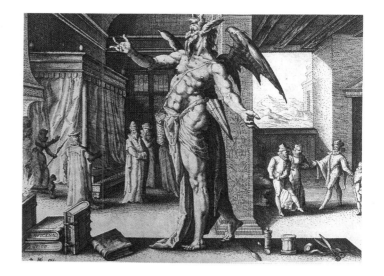

2ND FIGURE.

 Answer why the drug called Opium
 Doctors all prescribe as Dope-i-um.

ARGAN.

 Why? Because, non disputandum.

 (*The circle raises a cheer at his Latin. Thus encouraged,* ARGAN *continues*)

 Et, quod erat demonstrandum

 (*Another cheer. More encouraged,* ARGAN *goes on*)

 Opium is well known to Omnibus
 As the remedy for Insomnibus.

 (*The circle dances more excitedly round him, perhaps joining hands or arms, and the tune increasing in volume and pace*)

THE ELEVEN.

 Excellentē! Excellentē!!
 Argan is Intelligentē!
 Vivat, vivat, vivat Argan.
 He knows all the doctor's Jargon.

 (*Another figure,* BÉLINE, *breaks from the circle*)

3RD FIGURE.

 Answer, why for Gripes and Fever
 Doctors order Laxitiva.

ARGAN.

 Why, because non disputandum
 Et, quod erat demonstrandum—
 Enema administrare
 Et Emitica donare
 Purgitiva praescibēre
 Ergo Purgo!

THE ELEVEN (*dancing round more and more wildly*)

 Jubilate! Jubilate!
 Vivat, vivat, vivat, Argan.

 (*Another figure,* BONNEFOY, *disengages from the circle*)

4TH FIGURE.

 What for Bile and Bad Ōdorum
 Boils of every Categorum?

After HENDRIK GOLTZIUS. *The Physician as Man (above, left)* and *The Physician as Devil (above).* 1587. Illustrations from *The Medical Professions.* Engraving with woodcut inscription. Each image: 8 × 9⅛ in. (20.3 × 23.2 cm). Philadelphia Museum of Art. Anonymous gift. *The physician begins to look like a mere man to the patient, and the doctor must now cling to his books and surgical instruments. The patient's problem, shown on the right, now seems a much less serious illness than formerly. The physician as devil emerges when it comes to paying the bill, and the whole of medical therapy seems a trifle.*

ARGAN.

 Ergo Purgo.

 (*Again the circle swirls*)

THE ELEVEN.

 Jubilate! Jubilate!
 Vivat, vivat, vivat, Argan!

4TH FIGURE.

 Answer now without Erratum
 What the Learned Facultatum
 Recommends for Diabolicus,
 Collywobbles, and the Colicus?

ARGAN.

 Ergo Purgo.

 (*Another circle of ever-increasing ecstasy*)

THE ELEVEN.

 Jubilate! Jubilate!
 Vivat, vivat, vivat, Argan!

 (*Two more figures disengage, hand in hand. They are* ANGELICA *and* CLÉANTE)

5TH FIGURE.

 What for Bunions, Corns and Callouses,
 Dandruff, Doldrums and Paralysis?

6TH FIGURE.

 Measles, Mumps and Laryngitis,
 Rigor Mortis and St Vitus?

ARGAN.

 Ergo Purgo.

THE ELEVEN (*in a final frenzy*)

 Jubilate! Jubilate!
 Vivat, vivat, vivat, Argan!

 (*Another figure,* DIAFORUS, *steps out of the circle*)

7TH FIGURE (*holding high both his arms*)
 Nunc Silentium!

 (*An exaggerated silence and expectancy falls.* DIAFORUS *makes the most of it*)

 You have made correct responses
 Honi soit qui mal y penses
 Now before this High Assemblibus
 —One of you; and all of us—
 To uphold our Facultatē
 Steadfastly with Dignitatē—
 Swear!

THE ELEVEN.

 Swear, swear.

ARGAN.

 I swear.

 (*Another figure,* THOMAS, *steps forward*)

8TH FIGURE.

 Down in the sink with all Remedia
 Not in our Encyclopaedia.

 (*Another figure,* LOUISE, *steps forward*)

9TH FIGURE.

 You may cure, or you may bury 'em,
 But you get your Honorarium.

(*Another figure, the* APOTHECARY, *steps forward*)

10TH FIGURE.

 Be known as General Practicionarius
 On the Medical Registrarius.

(*Another figure,* DR. PURGON, *steps forward*)

11TH FIGURE.

 Give him his Hat of Learning
 And his Scholar's Robe.

(ARGAN *is robed and hatted and the others pay homage*)

1ST FIGURE.

 Mumbo!

2ND FIGURE.

 Jumbo!

3RD FIGURE.

 Hic!

4TH FIGURE.

 Haec!

5TH FIGURE.

 Hocum!

6TH FIGURE.

 Purge 'em!

7TH FIGURE.

 Bleed 'em!

8TH FIGURE.

 Choke 'em!

9TH FIGURE.

 Soak 'em!

10TH FIGURE.

 Novus Doctor!

11TH FIGURE.

 Quack. Quack. Quack!

THE ELEVEN.

 Quack. Quack. Quack. Quack. Quack.
 Quack. Quack!

1ST FIGURE.

 The Ceremony is over!
 And your state is changed.
 No longer an Imaginary Invalid—
 But, in your own right, "Doctor Imaginaire".

Bernardino Ramazzini

FROM ON THE DISEASES OF TRADES

"Diseases of Painters"

Ramazzini was an epidemiologist before that science or knowledge of statistics had developed, for he noticed the clustering of disease within social and occupational groups. Best known for his early studies of the diseases of workers and artisans, Ramazzini elevated the place of preventive medicine over active intervention at the onset of illness.

Painters . . . are attacked by various ailments such as palsy of the limbs, cachexy, blackened teeth, unhealthy complexions, melancholia, and loss of the sense of smell. It very seldom happens that painters look florid or healthy, though they usually paint the portraits of other people to look handsomer and more florid than they really are. I have observed that nearly all the painters whom I know, both in this and other cities, are sickly; and if one reads the lives of painters it will be seen that they are by no means long-lived, especially those who were the most distinguished. We read that Raphael of Urbino, the famous painter, was snatched from life in the very flower of his youth; Baldassarre Castiglione lamented his untimely death in an elegant poem. Their sedentary life and melancholic temperament may be partly to blame, for they are almost entirely cut off from intercourse with other men and constantly absorbed in the creations of their imagination. But for their liability to disease there is a more immediate cause, I mean the materials of the colors that they handle and smell constantly, such as red lead, cinnabar, white lead, varnish, nut-oil and linseed oil which they use for mixing colors; and the numerous pigments made of various mineral substances. The odors of varnish and the above-mentioned oils make their workrooms smell like a latrine; this is very bad for the head and perhaps accounts for the loss of the sense of smell. Moreover, painters when at work wear dirty clothes smeared with paint, so that their mouths and noses inevitably breathe tainted air; this penetrates to the seat of the animal spirits, enters by the breathing passages the abode of the blood, disturbs the economy of the natural functions, and excites the disorders mentioned above. We all know that cinnabar is a product of mercury, that *cerussa* is made from lead, verdigris from copper, and ultramarine from silver; for colors derived from metals are far more durable than those from vegetables and hence are in greater demand by painters. In fact, the mineral world supplies the materials of almost every color in use, and this accounts for the really serious ailments that ensue. Painters, then, are inevitably attacked by the same disorders as others who work with metals, though in a milder form.

Fernel illustrates this and records a rather curious case of a painter of Anjou who was seized first with palsy of the fingers and hands, later with spasms in these parts, and the arm too was similarly affected; the disorder next attacked his feet; finally he began to be tormented by pain in the stomach and both hypochondria, so violent that it could not be relieved by clysters, fomentations, baths or any other remedy. When the pain came on, the only thing that gave him any relief was for three or four men to press with their whole weight on his abdomen; this compression of the abdomen lessened the torture. At last, after about three years of this cruel suffering he died consumptive. Fernel says that the most eminent physicians disagreed violently as to the true cause of this terrible disorder, both before and after the autopsy, since nothing abnormal in the viscera came to light. When I read this case history I admired the frank confession of Fernel: "We were all beside the mark and completely off the track." As Celsus says, it is only great men who speak

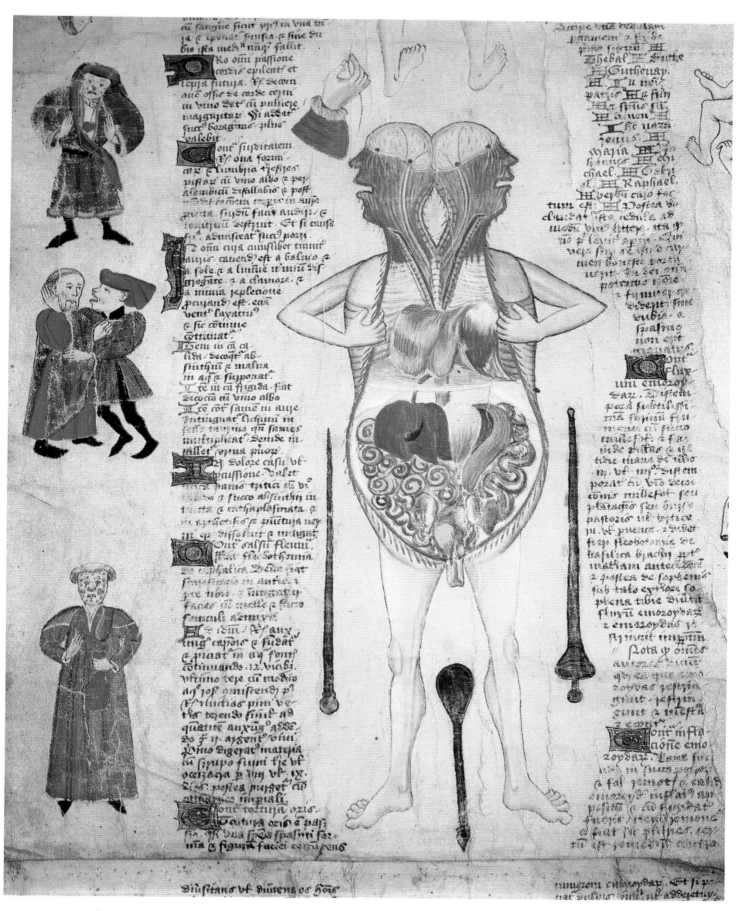

COLORPLATE 33

JOHN OF ARDERNE. *The Art of Medicine and Surgery*. After 1412. Vellum scroll. 213⅝ × 14³⁄₁₆ in. (542.6 × 36.0 cm). The Royal Library, Stockholm. *This page from Arderne's treatise shows a bisected cadaver, surgical instruments, and various skin ailments that 15th-century surgeons had to treat. Arderne, the first English surgeon of note, specialized in diseases of the anus and rectum.*

gen? Drey Tagereise wollen wir gehen in die Wüsten / vnd dem HERRN vnserm Gott opffern / wie er vns gesagt hat.

28 Pharao sprach / Ich wil euch lassen / das jr dem HERRN ewrem Gott opffert in der Wüsten / allein das jr nicht ferner ziehet / 29 vnd bittet für mich. Mose sprach / Sihe / wenn ich hinaus von dir kome / so wil ich den HERRN bitten / das dis Vnzifer von Pharao / vnd seinen Knechten / vnd seinem

Volck genomen werde / morgen des tages / Allein teusche mich nicht mehr / das du das Volck nicht lassest dem HERRN zu opffern.

30 Vnd Mose gieng hinaus von Pharao / vnd 31 bat den HERRN / Vnd der HERR that wie Mose gesagt hatte / vñ schaffte das Vnzifer weg von Pharao / von seinen Knechten / vnd von seinem Volck / das nicht eins vberbleib. Aber Pharao verhertet sein Hertz auch das-selbe mal / vnd lies das Volck nicht.

Das IX, Capitel.

Caput divi-datur.

JSt ein Exempel / wie Gott mit straffen nicht auffhören wolle / wo man von Sünden nicht ablassen / vnd seinem Wort nicht folgen wil. Widerumb / wo man fol-get / da wil er schützen vnd behüten / ob es gleich sonst allent-halben vbel zugehet / wie er seine Jüden behütet / da sonst gantz Egy-pten sich vmb der Sünde vnd vngehorsams willen muste leiden.
Da sprach der HERR zu Mose / Recke deine Hand

auff gen Himel / etc. Ist ein sonderlich Exempel / wie oben / das die verstockte Hertzen sich felschlich demütigen / als wolten sie from wer-den / begeren Gnad vnd Fürbit. Aber es ist jnen nicht lenger ernst / bis das Vnglück fürüber ist. Ob wol solchs fromen Hertzen wehe thut / sollen sie doch diesen Trost daraus nemen / das die Gottlosen mit solcher falscher Demut / jnen selbs jre sach nur erger machen / vnd zu grösserer straff vnd zorn Gott verursachen.

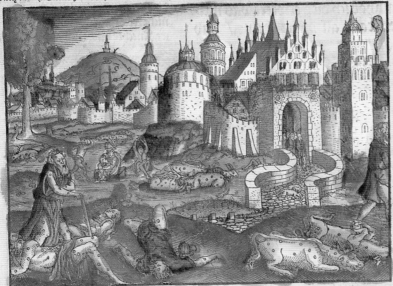

V. Pla-ge / Pestilentz.

1 DEr HERR sprach zu Mo-se / Gehe hinein zu Pharao / vnd sprich zu jm / also sagt der HErr / der Gott der Ebreer / Las mein
2 Volck / das sie mir dienen. Wo du dich des
3 wegerst / vnd sie weiter auffheltest / Sihe / so wird die hand des HERRN sein / vber dein Vieh auff dem Felde / vber Pferde / vber Esel / vber Kamel / vber Ochsen / vber Schafe /
4 mit einer fast schweren Pestilentz. Vnd der HERR wird ein besonders thun / zwischen dem Vieh der Israeliter / vnd der Egypter / das nichts sterbe aus allem / das die kinder
5 Israel haben. Vnd der HERR bestimpt ei-ne zeit / vnd sprach / Morgen wird der HERR solchs auff Erden thun.
6 Vnd der HERR that solches des Mor-gens / Vnd starb allerley Vieh der Egypter / Aber des Viehs der Kinder Israel starb

7 nicht eins. Vnd Pharao sandte darnach / vnd sihe / es war des Viehs Israel nicht eins gestorben. Aber das Hertz Pharao ward verstockt / vnd lies das Volck nicht.

8 DA sprach der HERR zu Mo-se vnd Aaron / Nemet ewre Feuste vol Russ aus dem Osen / vnd Mose sprenge jn gegen Himel für Pharao / das
9 vber gantz Egyptenland steube / vnd böse schwartze Blattern auffahren / beide an Menschen vnd an Vieh / in gantz Egypten-
10 land. Vnd sie namen Russ aus dem Osen / vnd traten für Pharao / vnd Mose sprenget jn gen Himel. Da furen auff böse schwartze Blattern / beide an Menschen vnd an Vieh /
11 Also / das die Zeuberer nicht kundten für Mose stehen / für den bösen Blattern / Deñ es waren an den Zeuberern eben so wol böse
12 Blattern / als an allen Egyptern. Aber der
G

VI. Pla-ge / Böse schwartze Blattern.

Sap.17.v.7.

HERR

COLORPLATE 34

The Plagues of Egypt. 16th century. Colored engraving. 4½ × 5¹⁵⁄₁₆ in. (11.4 × 15.1 cm). Clements C. Fry Collection, Cushing–Whitney Medical Library, Yale University, New Haven. *An illustration from a 16th-century German Bible follows the description in the ninth chapter of* Exodus.

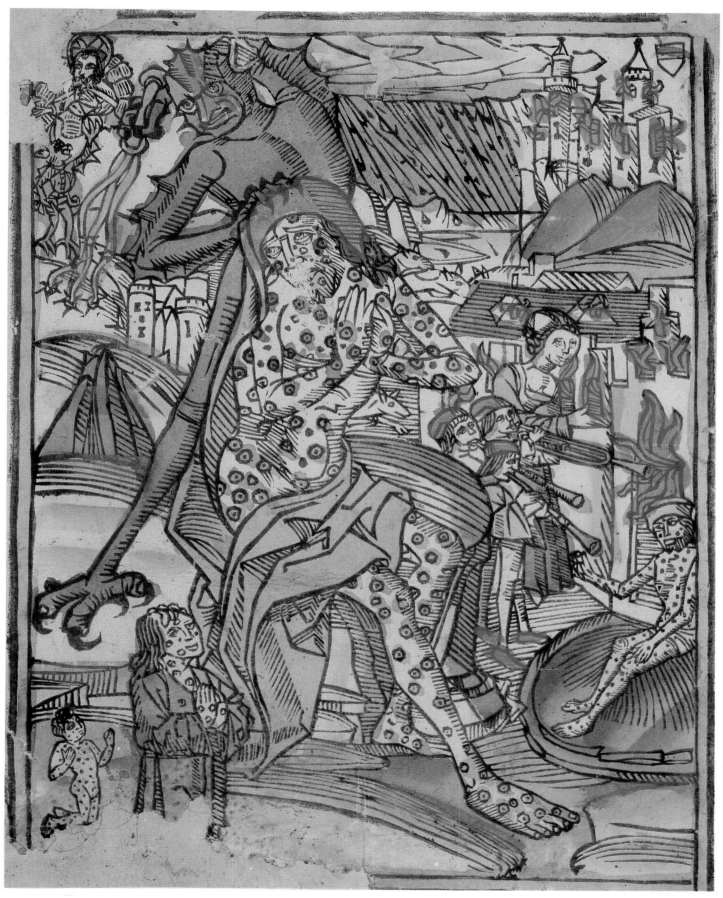

COLORPLATE 35

Job. 1537. Colored woodcut on broadsheet. Kupferstichkabinett Staatliche Museen Preussischer Kulturbesitz, Berlin. *"More sinned against than sinner,"* Job was usually depicted *"full of sores"* and seen *as the patron saint of lepers. This woodcut depicts his lesions as much like those of the contemporary great pox, syphilis, during its early years in Europe.*

COLORPLATE 36

ALBRECHT DÜRER. *Syphilis.* 1496. Woodcut for a broadside or poster. Kupferstichkabinett Staatliche Museen Preussischer Kulturbesitz, Berlin. *Dürer's is the earliest known poster to feature syphilis. It describes and depicts the epidemic of "scabies" predicted by the great conjunction of 1485.*

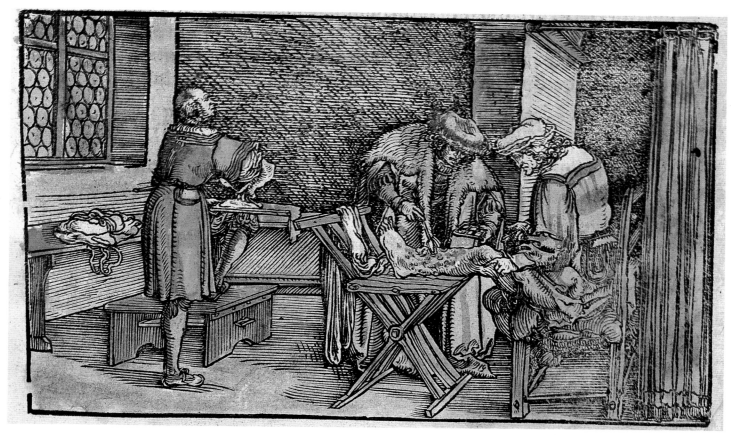

COLORPLATE 37

Treatment of Leg Ulcer. 1536. Illustration from *Der Grossen Wundarztney,* by Paracelsus. Hand-colored woodcut. 10⁷⁄₁₆ × 7 in. (26.5 × 17.8 cm). Courtesy of the Lilly Library, Indiana University, Bloomington. *The hospital treatment of leg ulcers, from an illustration which was common to several surgical texts of the early 16th century.*

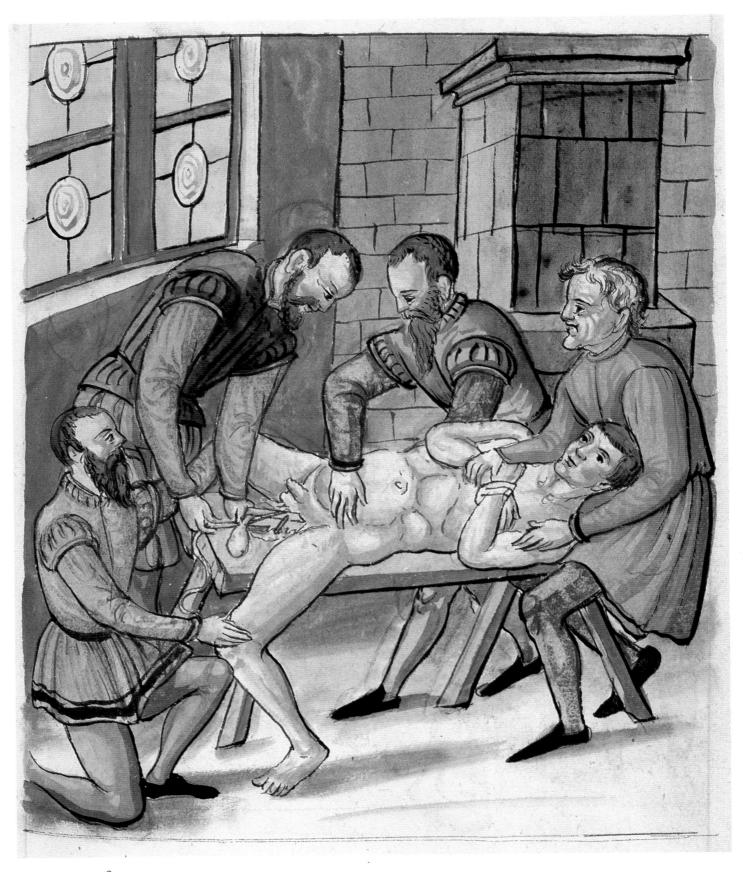

COLORPLATE 38

CASPAR STROMAYR. *Practica Copiosa*. 1559. Manuscript with watercolor. Ehemals Reichsstädtische Bibliothek Lindau (Bodensee). *The German manuscript* Practica Copiosa *was discovered by a librarian in 1909. It may have been illustrated by the surgeon himself. Most of the text describes operations to reduce hernias and hydroceles, Stromayr's specialty, though a small section deals with eye surgery. Stromayr is the first to distinguish inguinal hernias from other forms.*

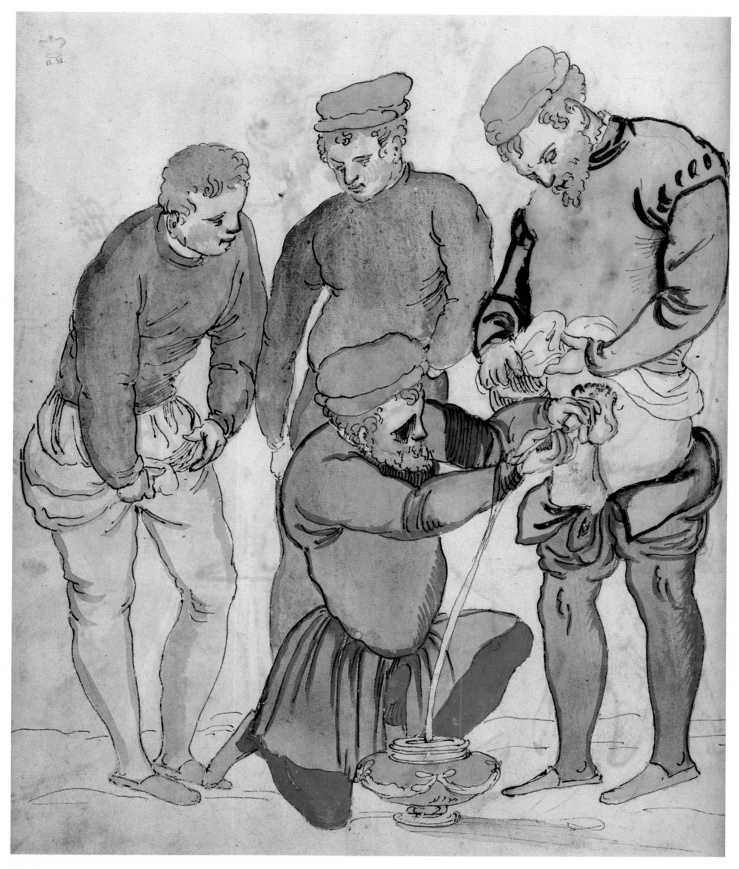

COLORPLATE 39

HEINRICH KULLMAURER AND ALBRECHT MEHER. *Short-Robed Surgeon Catheterizes a Patient.* 16th century. Illustration from *Sketchbook*. Pen and ink and watercolor. 16⁷⁄₁₆ × 10⁵⁄₈ in. (41.8 × 27 cm). Courtesy of the Trustees of the British Museum, London. *A short-robed surgeon catheterizes a patient to relieve urinary obstruction, usually due to stones or "gravel," but the spread of syphilis in the 16th century dramatically increased the problem of obstruction. Other patients wait their turn.*

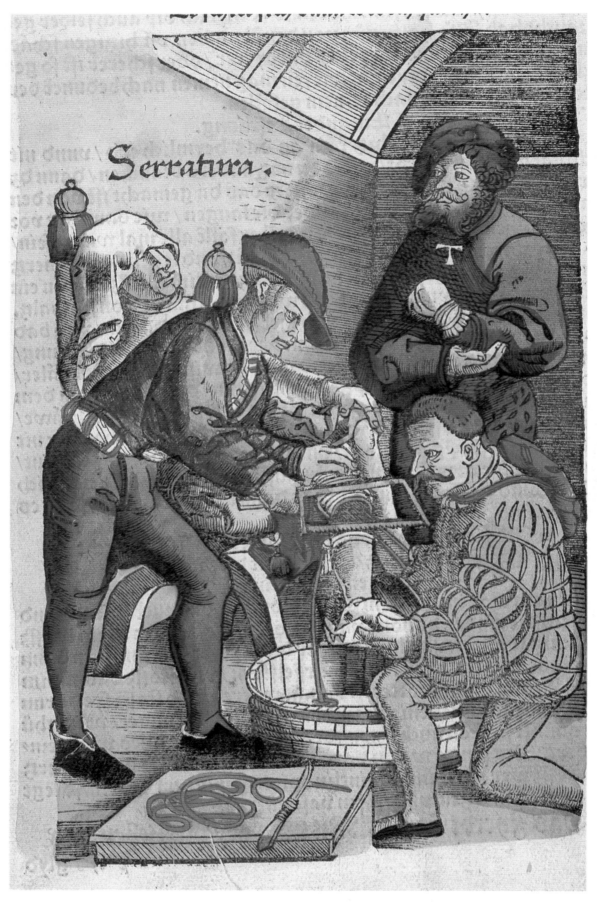

COLORPLATE 40

JOHANN WECHTLIN. *Amputation of a Leg (Serratura)*. 1517. Colored woodcut on antique laid paper. 7⅞ × 5 in. (20 × 12.7 cm). SmithKline Beckman Corporation Fund, Philadelphia Museum of Art. *In this image from Hans von Gersdorff's* Feldbuch der Wundarztney, *the standing figure wears a moistened animal bladder over his arm stump and wears the Greek letter* tau *to indicate that he suffered from St. Anthony's fire.*

out like this. However, Fernel goes on to say that, since this painter was in the habit of squeezing the color from his brush with his fingers and worse still was imprudent and rash enough to suck it, it is probable that the cinnabar was carried from the fingers to the brain by direct communication and so to the whole nervous system; while that which he took in by the mouth "infected the stomach and intestines with its mysterious and malignant qualities and was the occult cause of those violent pains."

FROM PEN-TS'AO

On Medication

Chinese scholars of the pen-ts'ao *tradition were interested in the same objective of many Western scholars: long life without aging. In a culture as different from our own as that of neo-Confucian China, it is easier to see the political and social scaffolding underpinning medical systems. The following* Pen-ching, *or "Original Classic," formed the basis for traditional description and research on drugs, as Paul U. Unschuld, the translator, has shown. Drugs were identified by taste, influence (thermal), clinical efficacy and indications, popular or secondary names, and place of origin.*

The upper class of drugs comprises 120 kinds. They are the rulers. They control the maintenance of life and correspond to heaven. They do not have a markedly medicinal effectiveness. The taking [of these drugs] in larger amounts or over a long period of time is not harmful to Man. If one wishes to take the material weight from the body, to supplement the influences [circulating in the body], and to prolong the years of life without aging, he should base [his efforts] on [drugs mentioned in] the upper [class of this] classic.

The middle class of drugs comprises 120 kinds. They are the ministers. They control the preservation of the human nature and correspond to Man. One part of them possesses medicinal effectiveness, another part does not. For every application, the choice of the suitable [drugs] should be considered carefully. If one wishes to prevent illnesses and to balance depletions and consumption, he should base [his efforts] on [drugs mentioned in] the middle [class of this] classic.

The lower class of drugs comprises 125 kinds. They are the assistants and aides. They control the curing of illnesses and correspond to earth. They possess a markedly medicinal effectiveness and must not be taken over a long period of time. If one wishes to remove cold, heat, and [other] evil influences from the body, to break constipations [of any sort], and to cure illnesses, he should base [his efforts] on [drugs mentioned in] the lower [class of this] classic.

The three classes together are composed of 365 drugs. This corresponds to 365 degrees. One degree corresponds to one day. Together that makes one year.

<div align="center">

★ ★ ★

</div>

The drugs are subdivided into rulers, ministers, assistants, and aides. They should be combined according to mutual usefulness. Suitable [is the combination of] one ruler, two ministers, three assistants, and five aides. [The combination of] one ruler, three ministers, and nine assistants and aides is also possible.

<div align="center">

★ ★ ★

</div>

[In prescriptions] drugs are [matched according to whether they belong to the] *yin* or *yang* [category]. There are child/mother and older/younger brother [relationships], there are also root-, stalk-, blossom-, and fruit-drugs, as well as herb-, mineral-, bone-, and flesh-drugs. There are [drugs] which prefer to act alone, others whose effectiveness depends [on one or more other drugs]. There are [drugs] which reinforce each other [in their effectiveness], and those who fear each other. Some [drugs] hate each other in combinations, and others are directly opposed in their effectiveness. [Finally, there are drugs] which kill each other.

These seven emotions must be kept in mind when combining (drugs). If the application of drugs which depend upon and support each other is called for, one should by no means use those which directly oppose or hate each other. If it is necessary to combine drugs with strongly medicinal effectiveness, drugs which weaken or neutralize each other can be used. The combination [of drugs] must conform strictly to these principles.

<p align="center">★ ★ ★</p>

The drugs have the five basic tastes: sour, salty, sweet, bitter, and acrid. Furthermore, they possess four kinds of [thermo-] influence: cold, hot, warm, and cool. [Some drugs] have markedly medicinal effectiveness, others none. [There are drugs which must be] dried in the shade, [others which must be] dried in the sun. The time of the collection and preparation [of drugs], whether they are raw or boiled, the place of their origin, adulteration and genuineness, as well as whether [the drugs are to be used after having been] stored or in fresh state, everything is subject to specific rules.

<p align="center">★ ★ ★</p>

Drugs may be processed into the following medicinal forms, in accord with [their respective effectiveness]: pills, powders, aqueous decoctions, saturations in wine, and pastes. Sometimes a drug is also suited for several medicinal forms, or there are drugs which must not be immersed in hot water or wine. The characteristic effects of the drugs must always be considered; they must never be ignored.

<p align="center">★ ★ ★</p>

In order to cure illnesses, the origin and progress [of the illness] should first be examined. If the five depots of the body are not yet affected by depletions, if the six palaces are not yet exhausted, if the blood vessels are not yet out of order, and if [one's] subtle matter and spirit have not yet passed away, then medications will certainly be effective. If the illness, however, has broken out already, a cure can still be achieved in 50 percent of the cases. If the influence of the illness has progressed too far, it will be difficult to restore [the respective patient's] existence.

<p align="center">★ ★ ★</p>

In treating illnesses with drugs of a strongly medicinal effectiveness, one should first start with a dosage the size of a millet seed. If the illness is cured [with that], administration of the drug should be halted immediately. If the illness persists, the amount of the dosage should be doubled. If the illness continues even then, the dosage should be increased ten times. The cure [of the illness] should mark the limit [of the treatment].

<p align="center">★ ★ ★</p>

[Illnesses due to the influence of] cold [in the body] should be treated with drugs of a hot [thermo-influence]. [Illnesses due to the influence of] heat [in the body] should be treated with drugs of a cold [thermo-influence]. If the digestion of food and drink ceases, emetics and laxatives should be used. Against demonic possessions and the poison of the *ku,* drugs with powerful effectiveness should be used. For boils, swellings, bumps, and tumors,

abscess-drugs should be taken. [Illnesses caused by the influences of] wind and moisture should be treated with wind and moisture drugs. In each case one should follow a suitable course.

<p style="text-align:center">★ ★ ★</p>

In the case of illnesses located above the diaphragm, the medications should be taken after meals. For illnesses situated below the diaphragm, medications should be taken before meals. If the illness is located in the four limbs or in the blood vessels, the medications ought to be taken in the morning on an empty stomach. If the illness is in the bones, the medication should be taken at night after eating.

<p style="text-align:center">★ ★ ★</p>

The most important kinds of serious illnesses [are the following]: being hit by wind; illnesses caused by cold; succession of hot and cold fits; malaria fevers; being hit by the malevolent; sudden [intestinal] chaos; abdominal swelling; edema; dysentery-like diarrhea; urinary retention and constipation; running pig [syndrome]; cough; vomiting; jaundice; pathological thirst; stagnation of drinking liquids in the body; indigestion; hardenings; obstructive swelling; to be frightened by some evil; madness and cramps; demonic possession; closure of the throat; toothache; deafness; blindness; cuts and bruises; fractures; boils, swellings; malignant boils; hemorrhoids; throat and neck swellings; for men: the five types of fatigation and seven types of injuries, depletions, and consumption; for women: discharge, very strong menstrual flow, absence of period; sores in the female genital area; injuries through the poisons of worms, snakes and *ku*. This is a rough classification. Within it changes and divergences are possible as [in a system of] branches and leaves. In order to master them, beginning and end must be considered.

Laurel Thatcher Ulrich
FROM A MIDWIFE'S TALE

In many histories of obstetrics written by men, midwives have not held a place of prominence. Negative stereotypes dominate and obscure the role apprentice-trained female healers had throughout human history. Ulrich's Pulitzer Prize–winning study is one of the very few to reconstruct the life of a typical midwife. When not restricted by local authorities, traditional healers like Martha Ballard had a much more expansive practice than the delivery of babies. Ballard's granddaughter, Clara Barton, founded the Red Cross.

Martha Ballard was a midwife—and more. Between August 3 and 24, 1787, she performed four deliveries, answered one obstetrical false alarm, made sixteen medical calls, prepared three bodies for burial, dispensed pills to one neighbor, harvested and prepared herbs for another, and doctored her own husband's sore throat. In twentieth-century terms, she was simultaneously a midwife, nurse, physician, mortician, pharmacist, and attentive wife. Furthermore, in the very act of recording her work, she became a keeper of vital records, a chronicler of the medical history of her town.

"Doctor Coney here. Took account of Births & Deaths the year past from my minnits," Martha wrote on January 4, 1791. Surprisingly, it is her minutes, not his data, that have survived. The account she kept differs markedly from other eighteenth-century medical records. The most obvious difference, of course, is that it is a woman's record.

MATHEW BRADY, or assistant. *Clara Barton.* 1866.
Photograph. Courtesy American Red Cross.
*Clara Barton was the granddaughter of Martha
Ballard's younger sister.*

Equally important is the way it connects birth and death with ordinary life. Few medical
histories, even today, do that.

In June of 1787, as Martha's flax blossomed in the field beyond the mill pond, scarlet
fever ripened in Hallowell. She called it the "canker rash," a common name in the eight-
eenth century for a disease that combined a brilliant skin eruption with an intensely sore,
often ulcerated throat. The "Putrid Malignant Sore Throat," a New Hampshire physician
called it. We know it as "strep," scarlet fever being one of several forms of infection from
a particular type of streptococci. Although mild in comparison with the scourges of
diphtheria that had swept through towns like Oxford earlier in the century, scarlet fever
was dangerous. Martha reported five deaths in the summer of 1787, 15 percent of the
canker rash cases she treated.

Six-month-old Billy Sewall, Henry and Tabitha's only child, was the first to die.
"What an excellent thing is the grace of submission!" the young father wrote on the day
of the baby's funeral. Had he been less certain of his own salvation, he might have
interpreted the sickness in his family as a judgment of God upon him for his continuing
quarrel with Mr. Isaac Foster, the Congregational minister of the town. But Henry Sewall
was not given to that sort of self-doubt. "How happy to feel the temper of holy Job,"
he wrote. "Whom the Lord loveth he chasteneth."

The Lord loved the minister too. On July 28, when Sewall came to the Ballard mills
to get a raft of slabs, Martha was in a neighbor's field digging cold water root to treat
the minister, who was himself "very sick with the rash." By then a dozen families had
someone ailing. Martha went back and forth across the river carrying remedies to feverish
children, all the while watching for signs of illness in her own family. When a visiting
nephew "seemed unwell," she swathed his neck with warmed tow and gave him hyssop
tea. When Mr. Ballard and Dolly complained of feeling ill, she bathed their feet and
brewed more tea, adding at the end of that day's entry, "I feel much fatagud my self."

At the height of the epidemic, the heat that lay over the Kennebec exploded in a
cloudburst of hail. "I hear it broke 130 pains of glass in fort western," Martha told her
diary in the August 4 passage. Sewall noted smugly that though the storm "broke all the

windows the windward side of houses, mine I saved, chiefly by taking out the sashes." He weighed some of the hailstones and found they topped half an ounce. Two days later, fire struck at the Ballard sawmill. Martha watched it from the opposite side of the river where she had spent the night nursing four-year-old James Howard, whose sister, Isabella, had already died of the rash. "The men at the fort went over. Found it consumd together with some plank & Bords," she wrote.

For her there was little time to contemplate the loss of the mills. Through August she continued to nurse the sick, tracking their condition in her diary with formulaic phrases that went from "poorly" through "very ill," "very ill indeed," and "Exceeding Dangerously ill" to "seemingly Expireing" or in the opposite direction from "Dangirous" to "revived" or from "much as shee was yesterday" to "Easyer" and then "Comfortable." She recorded all the summer's events, her everyday work as well as the continuing evidence of God's chastening hand, in the same terse style. She "pulled flax," then bathed a child's cankered throat, "worked about house," then found a little boy "seemingly Expireing," picked saffron, then attended another child's funeral, drank tea, then laid out an infant in its mother's arms.

On August 11 she arrived at the McMaster house to find little William "very low." She sat with him all through the day on Sunday and into the night. At about three a.m. on Monday he died. With the help of Mrs. Patten she prepared the body for burial, then, as the neighborhood began to stir, started home, stopping in at the Howards', where James was still "very Low," and at the Williamses', where "shee" (presumably the mother) was "very ill indeed." Although Martha was exhausted by the time she reached her house, she sat down to write in her journal: "William McMaster Expird at 3 O Clock this morn. Mrs. Patin & I laid out the Child. Poor mother, how Distressing her Case, near the hour of Labour and three Children more very sick."

"Poor mother." That entry contains the one burst of emotion to appear in the diary all summer. Although Mrs. McMaster was not the only woman in Hallowell to lose a child nor the only mother with two or three children suffering from the rash, something about her situation had pierced Martha's literary reserve. Perhaps the three-day vigil had brought back that summer of 1769 when she was herself "near the hour of Labour" and diphtheria flourished like witch grass in Oxford. Hannah, the daughter born in the epidemic, turned eighteen on August 6, the day the sawmill burned. Martha remembered the birthday, but for some reason, during this summer of illness, she neglected her usual remembrance of the Oxford deaths. Her daily activities were enough of a memorial.

Not all the illness in Hallowell in the summer of 1787 can be attributed to scarlet fever. There were the usual accidents on farms or in the woods; Martha poulticed a swollen foot for one of the Foster boys in early June and in August, though she wasn't called to administer aid, noted that "Peter Kenny has wounded his Legg & Bled Excesivily." There were also those "sudden strokes" that twentieth-century physicians would attribute to cardiovascular causes. On July 12, 1787, Martha reported that "a man fell down dead in the Coart hous at Pownalboro," a fate that had overcome old James Howard a few months before.

Then there were the troubling deaths of Susanna Clayton and her infant. Martha had delivered the Clayton baby on August 16. The birth was uneventful, with no warning at all of the distressing news she would hear four days later as she was returning home from nursing Mrs. Hinkley, who lived in the southern part of the town opposite Bumberhook. James Hinkley had brought Martha upriver as far as Weston's landing, where she heard "that Mrs Clatons Child departed this life yesterday & that she was thot Expireing." Martha got back in the boat and went back down the river as far as the Cowen farm, where Susanna Clayton had given birth and was lying in.

She arrived in time to help with the last nursing and to lay out the baby in its mother's arms. These deaths brought no exclamation, no "Poor mother" (or "Poor husband"). The mere facts were enough to mark them as singular ("the first such instance I ever saw") and monumental ("the first woman that died in Child bed which I delivered"). Martha had seen newborn infants die, but in the more than 250 deliveries she had per-

formed since coming to the Kennebec, no mother of hers had succumbed. Susanna Clayton's death appears in the diary as an inexplicable stroke of Providence, an event as unrelated to the canker rash as fire or hail. Martha could not have known that puerperal fever and scarlet fever grew from the same invisible seed—Group A hemolytic streptococci.

No one in the eighteenth century could have related the two phenomena. Not until the 1930s did scientists unravel the mysterious epidemiology of scarlet fever. Depending upon prior exposure, the same toxin that produces a sore throat and a rash in one person may produce a sore throat, a wound infection, a mild and fleeting illness, or no symptoms at all in others. Yet all these persons can spread the infection. Scarlet fever can even be transmitted through the milk of infected cows. It is not surprising, then, that Martha treated Isaac Hardin's son for an abscess as well as a rash, that Mrs. Kennedy had "a sweling under her arm" at the same time as her children were sick with the fever, or that puerperal infection and the canker rash both appeared at one house. Susanna Clayton was the daughter of Ephraim Cowen, the man who summoned Martha on August 23 to treat his younger daughters, "who are sick with the rash." She had given birth on her father's farm just upriver from the Kennedys', where Martha had administered cold water tincture. Susanna Clayton was the only one of Martha's obstetrical patients to die, yet other women and their babies may have been infected. Mrs. McMaster, the "poor mother" of the August 13 entry, gave birth on September 8. Her infant, whom Martha described as "very weak and low," lived only two days, and by September 23 the mother was herself so ill that Dr. Cony was summoned. He apparently recommended some sort of laxative. "Mrs Cowen & I administred remdys that Doct Coney prescribd," Martha wrote, adding that when the "physic began to operate," she left to care for another patient. Fortunately, Mrs. McMaster survived.

Focusing on the progress of an epidemic, as we have done here, obscures the fact that most of those infected eventually recovered. Billy McMaster and his newborn brother died, but his mother got better. Saray and Daniel Foster, Polly Kennedy, and the younger Cowen girls were soon up and about, and little James Howard, a child "Exceeding Dangerously ill" in August, was once again "mending" in September. At the end of one of her diary packets, Martha tallied births and deaths for the six years 1785 through 1790. In eighteenth-century terms, Hallowell was a healthy place. Its death rate averaged fifteen per thousand, about what one would find in parts of southern Asia today, but only half of that recorded for eighteenth-century seaports like Salem or Boston. Just as important, in almost every year the town had four times as many births as deaths. Even in a sickly season, there was reason for hope as well as sorrow.

The Physician. 18th or 19th century. English porcelain plate. Diameter 10½ in. (26.6 cm). The Mütter Museum, College of Physicians of Philadelphia.

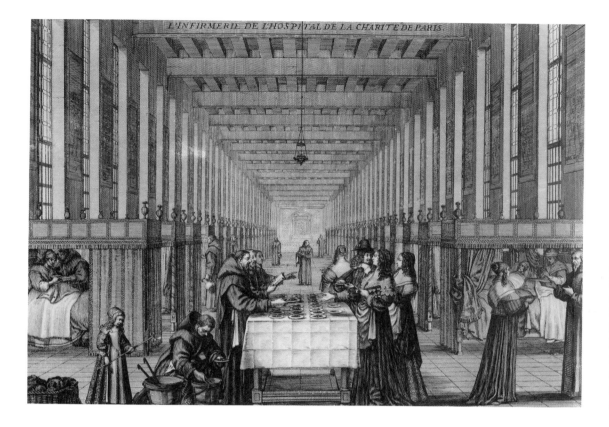

Grace Goldin

"A Walk Through a Ward of the Eighteenth Century"

Old medieval hospitals kept pace in the 18th century with a flurry of new hospital construction, assimilating a variety of medical services with their traditional charitable obligations. As a site for anatomical dissections, formal training in surgery, and intensified interest in clinical observation, hospitals became integral to the development of modern medicine. In this selection, a work of art serves as an invaluable record of medical history: see Colorplate 64 on page 209.

The old ward of St. John's Hospital, Bruges, housed patients continuously from the 12th century, when its first section was built, until the 20th. Until 1855, there was no other accommodation for patients of this hospital, and the great hall remained essentially as it had been in the Middle Ages.

Like other medieval foundations, the hospital grew from small beginnings, perhaps miscellaneous cottages adapted to patient use that predated even the first section of the 12th century hall, but by how much it is impossible to say. By the end of the 12th century the hospital had amassed sufficient funds from bequests and donations of grateful patients and devout townspeople to build a ward. It ran north and south, the south end parallel to, but at a little distance from, the Reie River. In the northern end was a chapel, in the same room with patient beds, as was typical of the time. The area to the north of the hospital was used as its graveyard. In that old cemetery stood another chapel, small and cross-shaped, which was demolished in 1856 to make way for new construction.

No sooner was the first hospital built than, like modern ones, it had to be enlarged. Three separate additions in the 13th and early 14th centuries filled in the space between

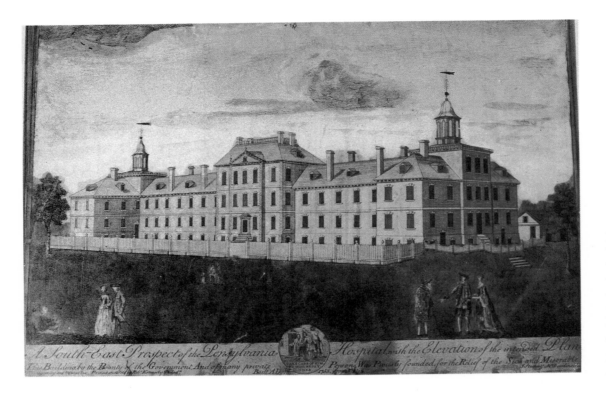

Architectural firm of Montgomery and Winter. *A South-East Prospect of the Pennsylvania Hospital with the Elevation of the Intended Plan.* (Rendering of the Pine Building.) 1751–1755. Tinted engraving. Used by permission from Pennsylvania Hospital, Philadelphia.

the original ward and the river, creating an open floor space of about 5,000 square feet. The first three sections were in two stories, but what the top floor was used for I cannot say. The rather low, timbered ceiling of the ground floor was supported by stone columns. The eastern end of the fourth section was the full two stories high, with a ceiling which was upheld by great branched beams of wood. This ward, built in four stages, housed patients for five hundred years. It is still standing but cannot be seen as a whole. The chapel has been walled off; the body of the ward today is vast, dark, and empty; and the high southeastern section along the river, receiving excellent light from Gothic windows clear to the ceiling, is now partitioned off and serves as a museum for the hospital's fine collection of paintings by Hans Memling.

Tourists drawn into the hall to view the Memlings generally overlook a remarkable painting on a dark back wall, Johannes Beerblock's "View of the Sick Ward of St. John's Hospital in Bruges, 1778" (oil, 2.67 × 4.97 ft.). It hangs over a high chest that makes examination of detail even more difficult; small northern windows opposite cast an inescapable glare; but when you ask why it should be thus hidden away in the very ward it portrays, you are told that the picture hangs in the exact spot from which the artist viewed the hall, and besides, Bruges is rich in art but very short of wall space. . . .

The ward scene at St. John's Hospital was painted at the request of its curé, G. Kinjedt—painted twice, in fact, Beerblock or the curé being perhaps dissatisfied with his first [1773] version. "Put in *everything!*" Kinjedt must have said, and Beerblock did. The painting is charming, lively, humorous, second or third rate only by comparison with the transcendent genre paintings of the Flemish masters. Its value as a document far surpasses its value as a work of art. Perhaps the artist had no high ambitions, but his kindly naïveté is our assurance that this is a reasonably literal transcription of 18th century, indeed of medieval, conditions. If this hospital's architecture remained substantially unaltered until 1855, we know that in *all* hospitals the level of medical care remained "medieval," in many respects, at least two decades longer than that. . . .

From a medical-historical point of view, the painting is thoroughly satisfactory. It embraces dramatic moments and practical minutiae; as you scan it aisle by aisle, cubicle by cubicle, everything seems to be going on but the resurrection of the dead. The coexistence of mundane and spiritual affairs is particularly medieval. The Middle Ages never felt the slightest incongruity in ministering under the same roof to the patient's body and

his soul. High Mass and menial nursing routine proceeded simultaneously, each according to its own time-table. In the left-hand upper corner of this painting we look into the hospital church, not yet walled off from the ward proper. All these patients could see the holy images, or hear, at least, the Mass. But in the foreground, as a dying patient receives the last rites, the sisters are serving dinner. In the center of the ward the crucifix is held before the eyes of a dying woman while just a bit downstage a serving boy flirts with a housemaid. In the right foreground a desperately ill woman has arrived by ambulance—a sedan chair labelled "The Parish of St. Anne, 1770." One of the bearers has his foot up on the pole of the chair and is adjusting his stocking. Above his head is the one holy image we can see in the ward proper, a bas relief of a crucifixion with the Virgin and St. John. To the left, foreground, a messenger ambles in with a dog at his heels. All this (with the exception of the dog) goes on in modern hospitals as well—simultaneously, but not in the same room.

Today we tuck death scenes away in small single rooms; the dying constitute one class of patient for whom private rooms are unquestioningly reserved in modern hospitals. With no great expectations, we go out on a sigh. Some patients in the hospitals of Beerblock's day went out with a triumphant shout, as the whole ward watched and listened. These people were all "poor objects" of religious charity, for in the 18th century the rich, Catholic or Protestant, were nursed at home. Yet their deaths were dramatic public events and the dying were thought of as going to a far, far better life than they had ever known.

<p style="text-align:center">* * *</p>

From Beerblock we learn almost everything about the dietary service, since we come upon the ward at meal-time. . . . The serving table . . . stands where it does to save steps. Food was surely cooked and served in the huge black pots we see being delivered to the ward by wheelbarrow, together with metal plates—of pewter, my guess is, since pewter was used at this time in European hospitals as far away as Malta. The plates are efficiently designed, with a round, overlapping rim, to contain food without spilling, and a handle, like that of modern Dutch flameware, for the patient to grasp, for if the sick could not sit alone in this hospital they ate flat from their bolsters. Weak patients were spoon-fed. We see this happening in the right rear of the ward). The artist did not quite complete the nurse's black veil and a bedpost shows through it, but her hand, the spoon, and the plate are clear enough. A distinct specimen of plate can be found on the table at the foot of the dying woman's bed, and that these plates could be stacked we know—they are stacked in the serving boy's wheelbarrow.

There were also mugs. A mug is shown being filled from a large pottery jar at the rear of the left-hand aisle. Presumably the patient is being given beer, the hospital beverage of the 18th century. A full diet at St. Thomas's Hospital, London, in 1752 calls for two pints of beer a day in winter, three pints in summer. Bread per patient per day came to 14 ounces at St. Thomas's. At St. John's, a sister at the serving table can be seen pulling flat cakes of bread out of a larger wicker basket and slapping one on each dish. Patients at St. Thomas's were allotted half a pound of meat and one pint of the broth it was boiled in, nearly every day; in the St. John's ward one can literally look into the cooking pot and see chunks of meat floating in broth. At The London Hospital it was recorded that patients got the worst cuts, the "scragg and veiney Pieces." But The London was a voluntary hospital, the matron and porter requiring a certain increment to stay with the job. We gather that food at St. John's was good, and carefully supervised, from the way a sister at the serving table licks her finger. Smaller pots on that table may contain special diets. At St. Thomas's these might call for rice milk, pudding, mutton, veal; or, for the very ill, barley water, water gruel, milk porridge. A small open pot at St. John's seems to contain boiled eggs. Salad or dessert plates were not needed; fresh fruits and vegetables were not stressed at the time, certainly not in hospitals.

So much for the patients' intake of food. Beerblock is as specific, if more discreet, on the subject of elimination. In the oil, a cheerful ward maid bears one, possibly two chamber pots down the first aisle to the right, but neither she nor her burden is painted

distinctly. Another chamber pot has been tossed on an empty bed in front of the one meant for the ambulance case. A chair stands alongside and the patient's street clothes lie in a heap on the floor. Perhaps, as they changed her into the hospital's white, long-sleeved gown with red V-necked collar, they offered her the chamber pot sitting on the chair. Or perhaps, since the artist thought it best to leave this bed empty so as not to distract attention from a dramatic episode, he was moved to decorate that emptiness unobtrusively yet appropriately with a not irrelevant chamber pot.

<p style="text-align:center">★ ★ ★</p>

We have said nothing as yet about the medical service, clearly represented in the person of a red-coated lay practitioner, in knee-breeches and broad-brimmed hat, pen in mouth and a prescription tablet in his left hand. This doctor is being shown a patient by one of the sisters and with his right hand he is taking the patient's pulse.

The patient is a man. We know this, though only the hand is visible, because he is bedded left of the center aisle. Patients to the left are men, to the right are women. A division was customary in medieval times, either this one or the more decisive plan where an actual partition was erected, forming two wards side by side with separate entrances; or two wards built one above the other to separate the sexes.

Almost all the cubicles we can see into show patients to the left of the columns facing us and patients to the right facing away. . . . [T]he way most patients lie serves the sisters' convenience. Closet beds can be approached from only one side; the predominant pattern permits each patient to be cared for right-handedly. In general, it is important to realize that our ancestors tried to set up their work as conveniently as possible; that, however charitable their motives, they were no masochists; and that our age did not invent efficiency.

As for the kind touch in nursing, it may be that we fall further and further behind. One has only to study the gesture and expression of the two nuns lifting the emergency case into bed. The Catholic hospital of the 18th century was a dangerous place, mortality there was higher than among patients nursed at home, and therefore, it catered only to wretches with no alternative; but among these, many got better. The bonneted beldame at the rear of the center aisle, being shown out the door with a pat on the shoulder, is very likely being discharged "cured."

Two stock medical indicators are missing from our picture. The first is the doctor studying a flask of urine, symbol of ultimate scientific diagnosis. He is just not there. He may be in the taphouse, having the flasks of his private patients brought to him. On the other hand, uroscopy having declined in importance, he may simply have vanished. The second is a bleeding scene. For more than a thousand years, a high proportion of patients were bled for whatever ailed them. To this Beerblock does allude. The boy leering back at the housemaid has run the front wheel of his barrow into someone, someone who shouts and shakes something that looks like a fistful of ribbons. But they are not ribbons, they are red and white bandages, like those that once entwined barber poles; so here, indirectly, we have our bleeding scene after all. Small cruets for internal medications and a spoon for administering them may be found on the table at the foot of the dying woman's bed.

<p style="text-align:center">★ ★ ★</p>

Beerblock's subject is the *hospital*, in both its aspects. He shows its secular, administrative, medical, and nursing activities, the bustle, humor, ingenuity, and indignities of its daily life. He also shows the hospital as a place in which to die and was concerned with death— in its medieval form as the passage to a better life. If we were to sum up that better life in one word, we might call it God. I think it conceivable, therefore, that this messenger is a symbolic figure, a philosopher, whom Beerblock introduced into his painting to express a saying of the Middle Ages most relevant to his subject matter: "Continuous contemplation of death is the highest philosophy."

Modern Medicine

FROM THE PATIENT'S ILLNESS TO THE DOCTOR'S DISEASE

Edward Jenner

"An Inquiry into the Causes and Effects . . . of the Cow-Pox"

Jenner (1749–1823) possessed acute powers of observation that were usually spent bird-watching, and he gained admission to the Royal Society of London through a paper on ornithology. (He noted that the bowed, broad back of a fledgling cuckoo for twelve days formed the perfect nest for the egg of the hedge sparrow, ready to hatch when the cuckoo was ready to fly.) The story of milkmaid Sarah Nelmes and Jenner's vaccinee James Phipps is well known. Less familiar is Jenner's attribution of cowpox to "grease" and groomsmen.

The deviation of man from the state in which he was originally placed by nature seems to have proved to him a prolific source of diseases. From the love of splendour, from the indulgence of luxury, and from his fondness for amusement he has familiarized himself with a great number of animals, which may not originally have been intended for his associates.

The wolf, disarmed of ferocity, is now pillowed in the lady's lap. The cat, the little tiger of our island, whose natural home is the forest, is equally domesticated and caressed. The cow, the hog, the sheep, and the horse, are all, for a variety of purposes, brought under his care and dominion.

There is a disease to which the horse, from his state of domestication, is frequently subject. The farriers call it the grease. It is an inflammation and swelling in the heel, from which issues matter possessing properties of very peculiar kind, which seems capable of generating a disease in the human body (after it has undergone the modification which I shall presently speak of), which bears so strong a resemblance to the smallpox that I think it highly probable it may be the source of the disease.

In this dairy country a great number of cows are kept, and the office of milking is performed indiscriminately by men and maid servants. One of the former having been appointed to apply dressings to the heels of a horse affected with the grease, and not paying due attention to cleanliness, incautiously bears his part in milking the cows, with come particles of the infectious matter adhering to his fingers. When this is the case, it

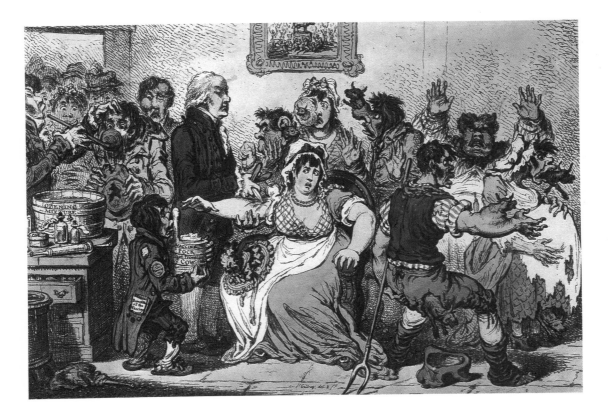

JAMES GILLRAY. *The Cow-Pock*, or *The Wonderful Effects of the New Inoculation!* 1809. Colored etching on soft ground. 9¼ × 13⅝ in. (23.5 × 34.6 cm). Philadelphia Museum of Art, SmithKline Beckman Corporation Fund. *Napoleon had his troops vaccinated for smallpox, but not everyone welcomed the chance to be inoculated with morbid matter collected from cows.*

commonly happens that a disease is communicated to the cows, and from the cows to dairy maids, which spreads through the farm until the most of the cattle and domestics feel its unpleasant consequences. This disease has obtained the name of cow-pox. It appears on the nipples of the cows in the form of irregular pustules. At their first appearance they are commonly of a palish blue, or rather of a colour somewhat approaching to livid, and are surrounded by an erysipelatous inflammation. These pustules, unless a timely remedy be applied, frequently degenerate into phagedenic ulcers, which prove extremely troublesome. The animals become indisposed, and the secretion of milk is much lessened. Inflamed spots now begin to appear on different parts of the hands of the domestics employed in milking, and sometimes on the wrists, which quickly run on to suppuration, first assuming the appearance of the small vesications produced by a burn. Most commonly they appear about the joints of the fingers and at their extremities; but whatever parts are affected, if the situation will admit, these superficial suppurations put on a circular form, with their edges more elevated than their centre, and of a colour distantly approaching to blue. Absorption takes place, and tumours appear in each axilla. The system becomes affected—the pulse is quickened; and shiverings, succeeded by heat, with general lassitude and pains about the loins and limbs, with vomiting, come on. The head is painful, and the patient is now and then even affected with delirium. These symptoms, varying in their degrees of violence, generally continue from one day to three or four, leaving ulcerated sores about the hands, which, from the sensibility of the parts, are very troublesome, and commonly heal slowly, frequently becoming phagedenic, like those from whence they sprung. The lips, nostrils, eyelids, and other parts of the body are sometimes affected with sores; but these evidently arise from their being heedlessly rubbed or scratched with the patient's infected fingers. No eruptions on the skin have followed the decline of the feverish symptoms in any instance that has come to my inspection, one only excepted, and in this case a very few appeared on the arms: they were very minute, of a vivid red colour, and soon died away without advancing to maturation; so that I cannot determine whether they had any connection with the preceding symptoms.

Thus the disease makes its progress from the horse to the nipple of the cow, and from the cow to the human subject.

Morbid matter of various kinds, when absorbed into the system, may produce effects

in some degree similar; but what renders the cow-pox virus so extremely singular is that the person who has been thus affected is forever after secure from the infection of the smallpox; neither exposure to the variolous effluvia, nor the insertion of the matter into the skin, producing this distemper.

<p style="text-align:center">★　　★　　★</p>

The more accurately to observe the progress of the infection I selected a healthy boy, about eight years old, for the purpose of inoculating for the cow-pox. The matter was taken from a sore on the hand of a dairymaid, who was infected by her master's cows, and it was inserted on the 14th day of May, 1796, into the arm of the boy by means of two superficial incisions, barely penetrating the cutis, each about an inch long.

On the seventh day he complained of uneasiness in the axilla and on the ninth he became a little chilly, lost his appetite, and had a slight headache. During the whole of this day he was perceptibly indisposed, and spent the night with some degree of restlessness, but on the day following he was perfectly well.

The appearance of the incisions in their progress to a state of maturation were much the same as when produced in a similar manner by variolous matter. The difference which I perceived was in the state of the limpid fluid arising from the action of the virus, which assumed rather a darker hue, and in that of the efflorescence spreading round the incisions, which had more of an erysipelatous look than we commonly perceive when variolous matter has been made use of in the same manner; but the whole died away (leaving on the inoculated parts scabs and subsequent eschars) without giving me or my patient the least trouble.

In order to ascertain whether the boy, after feeling so slight an affection of the system from the cow-pox virus, was secure from the contagion of the smallpox, he was inoculated the 1st of July following with variolous matter, immediately taken from a pustule. Several slight punctures and incisions were made on both his arms, and the matter was carefully inserted, but no disease followed. The same appearances were observable on the arms as we commonly see when a patient has had variolous matter applied, after having either the cow-pox or smallpox. Several months afterwards he was again inoculated with variolous matter, but no sensible effect was produced on the constitution.

LEOPOLD MENDEZ *Vaccination*.
1935. Wood engraving.

René Théophile Hyacinthe Laënnec
"The Invention of the Stethoscope"

Laënnec's avocation as a flutist suggested to him a means of "mediate" auscultation: listening to chest sounds through the medium of a tube. At Parisian hospitals the demand for intensive clinical examination required that one place an ear immediately on the patient's thorax or back, percuss the chest with the hand, and shake the thorax vigorously—Hippocratic succussion—to listen for fluid. Laënnec himself died of advanced pulmonary tuberculosis in 1825.

In 1816 I was consulted by a young woman presenting general symptoms of disease of the heart. Owing to her stoutness little information could be gathered by application of the hand and percussion. The patient's age and sex did not permit me to resort to the kind of examination I have just described (i.e., direct application of the ear to the chest). I recalled a well-known acoustic phenomenon, namely, if you place your ear against one end of a wooden beam the scratch of a pin at the other extremity is most distinctly audible. It occurred to me that this physical property might serve a useful purpose in the case with which I was then dealing. Taking a sheaf of paper, I rolled it into a very tight roll, one end of which I placed over the praecordial region, while I put my ear to the other. I was both surprised and gratified at being able to hear the beating of the heart with much greater clearness and distinctness than I had ever done before by direct application of my ear.

I at once saw that this means might become a useful method for studying not only the beating of the heart but likewise all movements capable of producing sound in the thoracic cavity, and that consequently it might serve for the investigation of respiration, the voice, râles, and even possibly the movements of a liquid effused into the pleural cavity of pericardium.

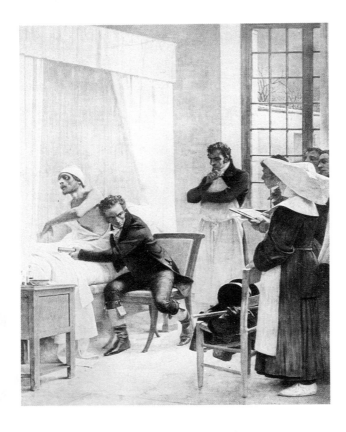

T. CHARTRAN. *Laënnec Listening with His Ear Against the Chest of a Patient at Necker Hospital.* Oil. 5¾ × 4 in. (14.6 × 10.2 cm). National Library of Medicine, Bethesda, Md.

With this conviction, I at once began and have continued to the present time, a series of observations at the Hospital Necker. As a result I have obtained many new and certain signs, most of which are striking, easy of recognition, and calculated perhaps to render the diagnosis of nearly all complaints of the lungs, pleurae, and heart both more certain and more circumstantial than the surgical diagnosis obtained by use of the sound or by introduction of the finger.

★ ★ ★

The first instrument employed by me consisted of a cylinder or roll of paper, sixteen lines in diameter and one foot long, made of three quires of paper rolled very tightly round, and held in position with gummed paper and filed smooth at both ends. However tight the roll may be, there will always remain a tube three or four lines in diameter running up the center, because the sheets of paper composing it can never be rolled completely on themselves. This fortuitous circumstance gave rise, as will be seen, to an important observation upon my part: I found that for listening to the voice the tube is an indispensable factor. An entirely solid body is the best instrument that can be used for listening to the heart; such an instrument would indeed suffice also for hearing respiratory sounds and râles; yet these last two phenomena yield greater intensity of sound if a perforated cylinder is used, hollowed out at one end into a kind of funnel one and one half inches in depth.

The densest bodies are not, as analogy would lead us to suppose, the best materials for constructing these instruments. Glass and metals, apart from their weight and the sensation of cold that they impart in winter, are not such good carriers of the heartbeats and the sounds produced by breathing and râles, as are bodies of lesser density. . . .

Substances of medium density, such as paper, wood, and cane, are those which have always appeared to me preferable to all others. This result may be in contradiction with an axiom of physics; nonetheless I consider it to be quite established.

I consequently employ at the present time a wooden cylinder with a tube three lines [2.256 mm.] in diameter bored right down its axis; it is divisible into two parts by means of a screw and is thus more portable. One of the parts is hollowed out at its end into a wide funnel-shaped depression one and one half inches deep leading into the central tube. A cylinder made like this is the instrument most suitable for exploring breath sounds and râles. It is converted into a tube of uniform diameter with thick walls all the way, for exploring the voice and the heartbeats, by introducing into the funnel or bell a kind of stopper made of the same wood, fitting it quite closely; this is made fast by means of a small brass tube running through it, entering a certain distance into the tubular space running through the length of the cylinder. This instrument is sufficient for all cases, although, as I have already said, a perfectly solid body might perhaps be better for listening to the beating of the heart.

The dimensions indicated above are not altogether unimportant; if the diameter is larger it is not always possible to apply the stethoscope closely against all points of the chest; if the instrument is longer, it becomes difficult to hold it exactly in place; if it were shorter, the physician would often be obliged to adopt an uncomfortable position, which is to be avoided above all things if he desires to carry out accurate observations.

I shall be careful, when discussing each variety of exploration, to mention the positions which experience has taught me to be most favorable for observation and least tiring for both physician and patient.

Suffice it to say for the moment that in all cases the stethoscope should be held like a pen, and that the hand must be placed quite close to the patient's chest in order to make sure that the instrument is properly applied.

The end of the instrument intended to rest on the patient's chest, that is to say the end provided with the stopper, should be very slightly concave; it is then less liable to wobble, and as this concavity is easily filled by the skin it in no case leaves an empty space even when placed on the flattest part of the chest.

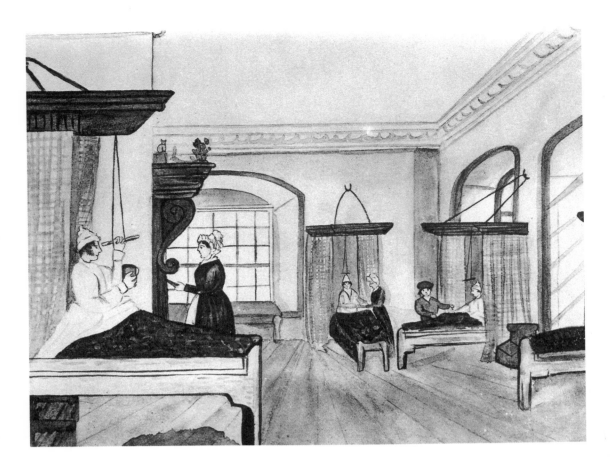

Rahere Ward (St. Bartholomew's Hospital). c.1832. Medical College of St. Bartholomew's Hospital, London.

Ignaz Semmelweis

FROM THE ETIOLOGY, CONCEPT AND PROPHYLAXIS OF CHILDBED FEVER

"Autobiographical Introduction"

As a Hungarian trainee in Vienna's great hospital, Semmelweis (1818–1865) was isolated from the easy camaraderie of Austrian medical students in the wards and autopsy rooms. Although he told of his discovery of the association between autopsies and childbed fever many different ways, he probably first noticed the too-frequent ringing of a little bell as the priest came to give last rites to a dying mother. Becoming a crusader, Semmelweis angrily attacked European obstetricians as murderers. He himself died from the skull fractures he sustained after admission to an asylum.

Because Vienna is so large, women in labor often deliver on the street, on the glacis [earthwork], or in front of the gates of houses before they can reach the hospital. It is then necessary for the woman, carrying her infant in her skirts, and often in very bad weather, to walk to the maternity hospital. Such births are referred to as street births. Admission to the maternity clinic and to the foundling home is gratis, on the condition that those admitted be available for open instructional purposes, and that those fit to do so serve as wet nurses for the foundling home. Infants not born in the maternity clinic are not admitted gratis to the foundling home because their mothers have not been available for instruction. However, in order that those who had the intention of delivering in

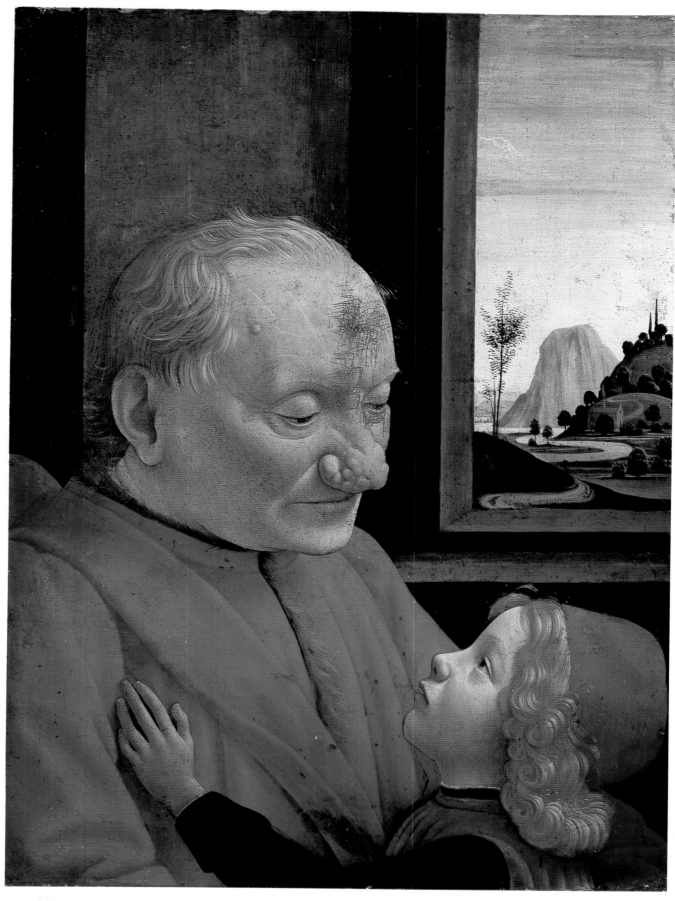

COLORPLATE 41

DOMENICO GHIRLANDAIO. *An Old Man and His Grandson.* Late 15th century. Oil on wood panel. 24⁷⁄₁₆ × 18⅛ in. (62.1 × 46 cm). Louvre, Paris. © Photo R.M.N. *The old man probably had a rhinophyma.*

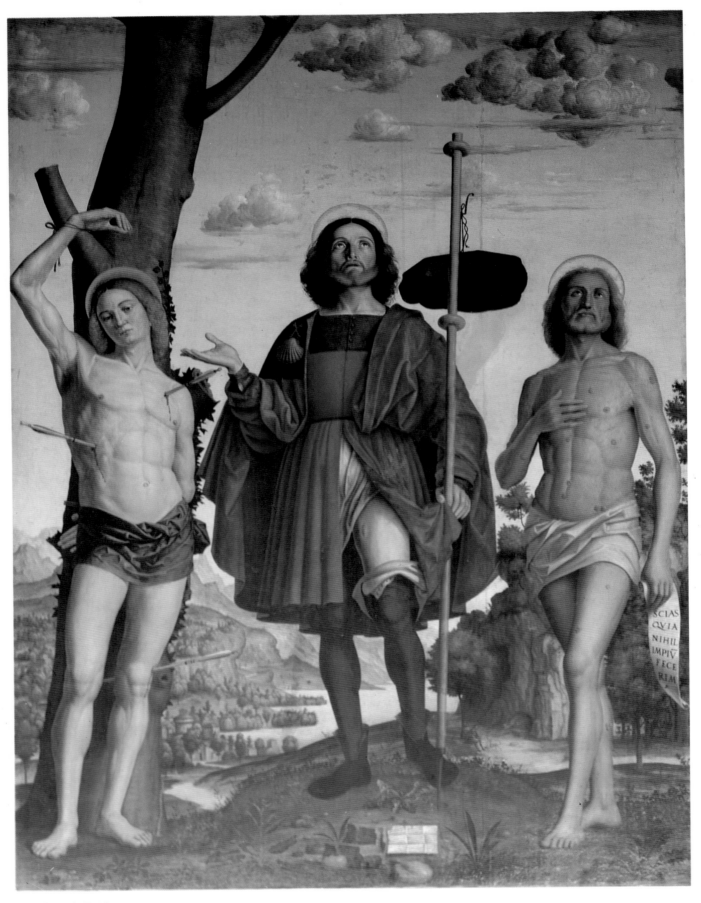

COLORPLATE 42

GIROLAMO DEI LIBRI. *St. Roch Between St. Sebastian and St. Job.* c.1505. Oil on canvas. Church
of San Tommaso Canturicense, Verona. *Three patron saints of pestilence: St. Roch, center,
reveals a plague bubo by turning down his legging; St. Sebastian, martyred by the arrows of Diocletian's
soldiers, stands as a symbol of plague's corruption of the air; St. Job is the patron saint of leprosy.*

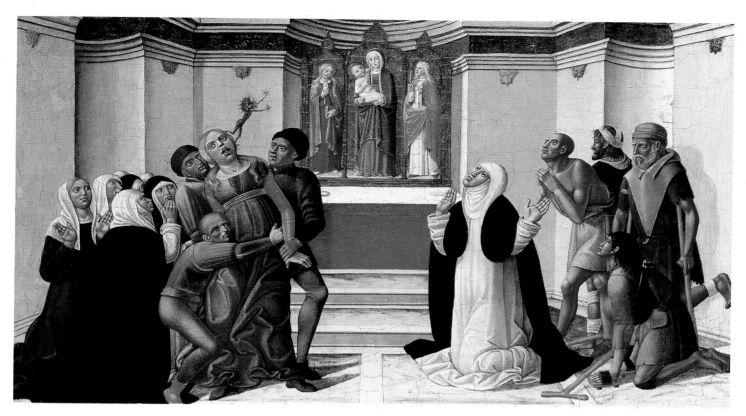

COLORPLATE 43

GIROLAMO DI BENVENUTO. *St. Catherine Exorcising a Possessed Woman.* 15th century. Oil on wood
panel. 12⁷⁄₁₆ × 21¹⁵⁄₁₆ in. (31.6 × 55.7 cm). © The Denver Art Museum, Samuel H. Kress
Foundation Collection. *In medieval illustrations, the insane were typically shown with the head thrown
back, strong men restraining them, and a devil escaping from the mouth. Because she had received the stigmata
in imitation of Christ's wounds on the cross, St. Catherine could heal. Cripples here wait their turn.*

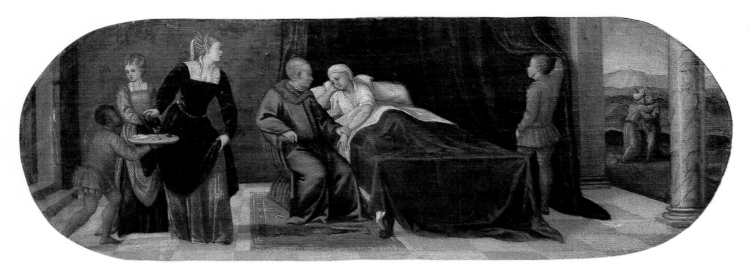

COLORPLATE 44

BONIFACIO DE' PITATI. *The Doctor's Visit.* 16th century. Oil on canvas. Museo Poldi Pezzoli, Milan. *At the bedside, the physician and patient seem oblivious to the ministrations of wife, children, and a young black slave.*

COLORPLATE 45 *(opposite)*

Attributed to TIBURZIO PASSAROTTI. *Gaspare Tagliacozzi.* Second half of the 16th century. Oil on canvas. Istituto Rizzoli, Bologna. *Gaspare Tagliacozzi illustrates and indicates his own classic of plastic surgery, particularly the method of restructuring a nose from skin of the upper arm. Ancient Indian texts describe rhinoplasty, but this is the earliest European treatise on the subject.*

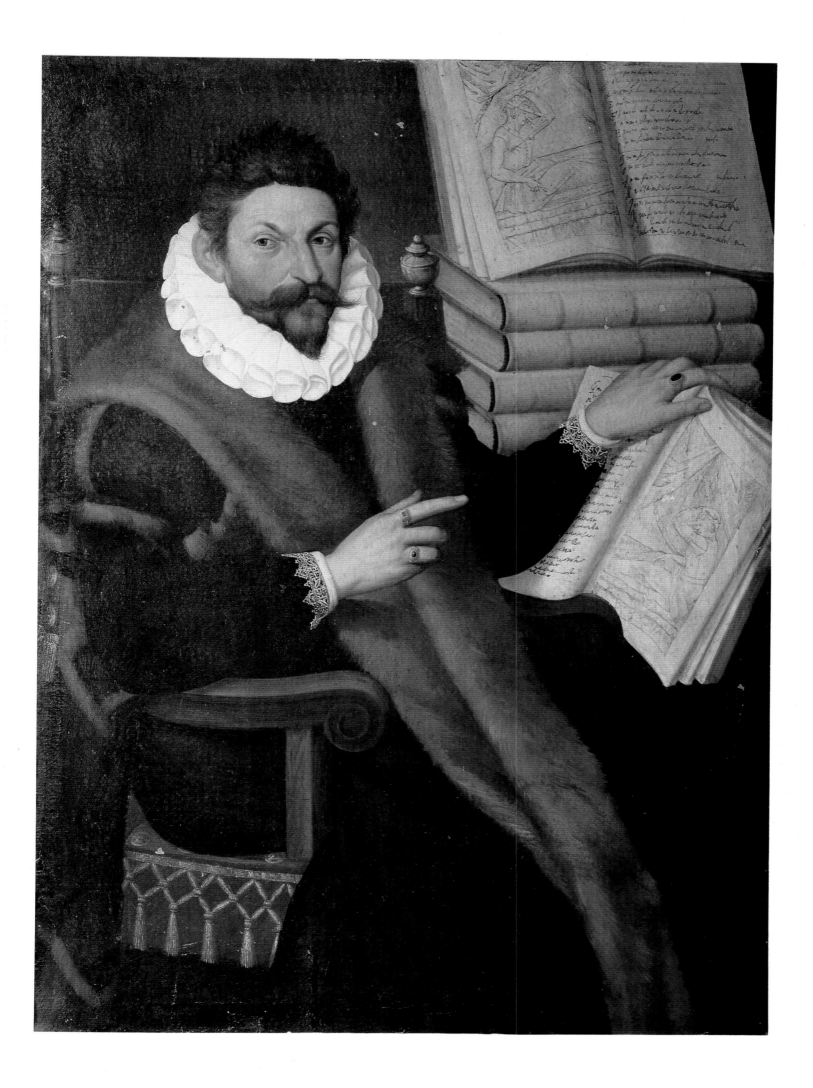

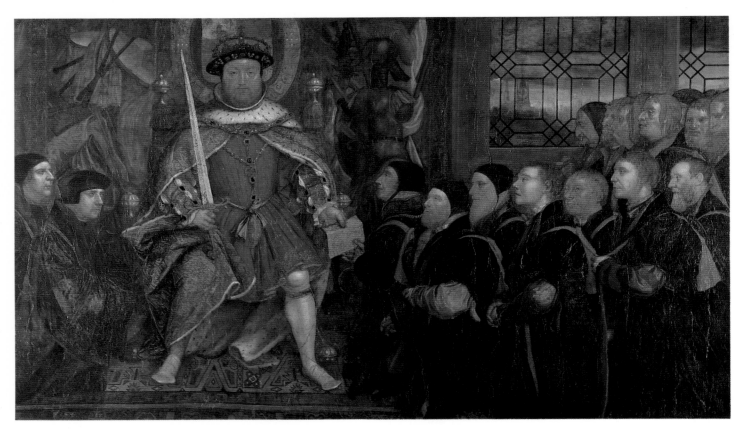

COLORPLATE 46

The studio of HANS HOLBEIN, THE YOUNGER. *Henry VIII in 1540 Handing to Thomas Vicary the Act of Union Between Barbers and Surgeons of London*. 1541. Oil over a cartoon on paper. 63 × 110¼ in. (160 × 280 cm). Reproduced by permission of the President and Council of the Royal College of Surgeons of England, London.

COLORPLATE 47 *(opposite)*

HIERONYMUS BOSCH. *The Cure of Folly,* or *Removing the Stone of Madness.* c.1490. Oil on panel. 18¹⁵⁄₁₆ × 13¼ in. (48.1 × 35 cm). Prado, Madrid. *Lubbert Das, a Dutch fool figure, has the "flower" of folly cut from his head, as the Church (priest figure) looks on. Mania, analogous to demonic possession, escapes from his head. The woman represents melancholia, carrying on her head a book symbolizing false learning.*

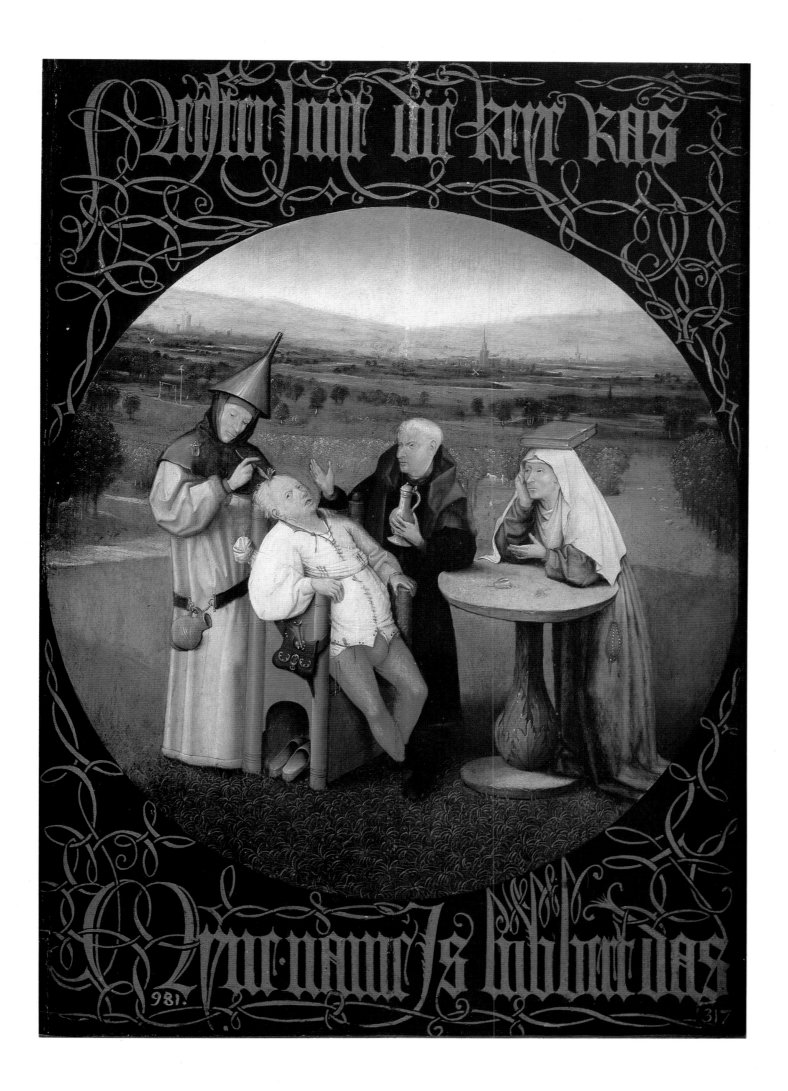

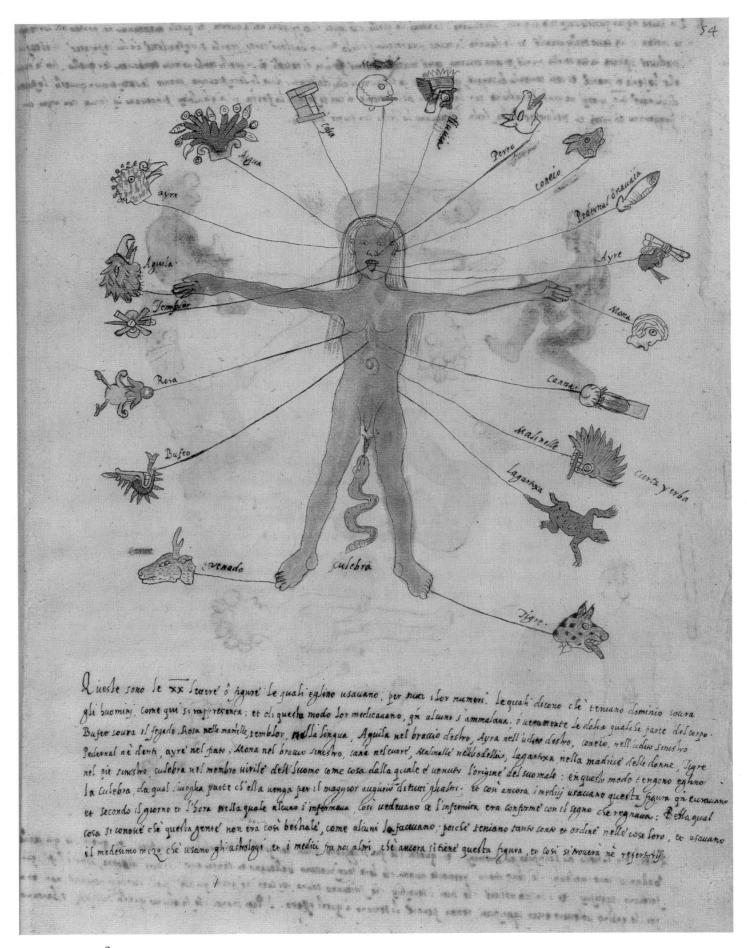

Aztec Figure with Signs of the 20 Days of the Week. c. 1570. Manuscript illustration. Vaticano Biblioteca
Apostolica, Rome. *This treatise depicts the 20 days of the Aztec week, the gods that govern each day, and the area
of the body each god controlled. The illustration probably shows the assimilation of European medicine, because the
iconography is similar to contemporaneous European astrological figures and the parts of the body each sign controls.*

the maternity hospital but who delivered on the way would not innocently lose their privilege, street births were counted as hospital deliveries. This, however, led to the following abuse: women in somewhat better circumstances, seeking to avoid the unpleasantness of open examination without losing the benefit of having their infants accepted gratis to the foundling home, would be delivered by midwives in the city and then be taken quickly by coach to the clinic where they claimed that the birth had occurred unexpectedly while they were on their way to the clinic. If the child had not been christened and if the umbilical cord was still fresh, these cases were treated as street births, and the mother received charity exactly like those who delivered at the hospital. The number of these cases was high; frequently in a single month between the two clinics there were as many as one hundred cases.

As I have noted, women who delivered on the street contracted childbed fever at a significantly lower rate than those who delivered in the hospital. This was in spite of the less favorable conditions in which such births took place. Of course, in most of these cases delivery occurred in a bed with the assistance of a midwife. Moreover, after three hours our patients were obliged to walk to their beds by way of the glass-enclosed passageway. However, such inconvenience is certainly less dangerous than being delivered by a midwife, then immediately having to arise, walk down many flights of stairs to the waiting carriage, travel in all weather conditions and over horribly rough pavement to the maternity hospital, and there having to climb up another flight of stairs. For those who really gave birth on the street, the conditions would have been even more difficult.

To me, it appeared logical that patients who experienced street births would become ill at least as frequently as those who delivered in the clinic. I have already expressed my firm conviction that the deaths in the first clinic were not caused by epidemic influences but by endemic and as yet unknown factors, that is, factors whose harmful influences were limited to the first clinic. What protected those who delivered outside the clinic from these destructive unknown endemic influences? In the second clinic, the health of the patients who underwent street births was as good as in the first clinic, but there the difference was not so striking, since the health of the patients was generally much better. . . .

In addition to those who delivered on the street, those who delivered prematurely also became ill much less frequently than ordinary patients. Those who delivered prematurely were not only exposed to all the same endemic influences as patients who went full-term, they also suffered the additional harm of whatever caused the premature delivery. Under these circumstances, how could their superior health be explained? One explanation was that the earlier the birth, the less developed the puerperal condition and therefore the smaller the predisposition for the disease. Yet puerperal fever can begin during birth or even during pregnancy; indeed, even at these times it can be fatal. The better health of patients who delivered prematurely in the second clinic conformed to the general superior health of full-term patients in the clinic.

Patients often became ill sporadically. One diseased patient would be surrounded by healthy patients. But very often whole rows would become ill without a single patient in the row remaining healthy. The beds in the maternity wards were arranged along the length of the rooms and were separated by equal spaces. Depending on their location, rooms in the clinic extended either north-south or east-west. If patients in beds along the north walls became ill we were often inclined to regard chilling as a significant factor. However, on the next occasion those along the south wall would become ill. Many times those on the east and west walls would become diseased. Often the disease spread from one side to the other, so that no one location seemed better or worse. How could these events be explained, given that the same patterns did not appear in the second clinic where one encountered the disease only sporadically?

<p style="text-align:center">★　　★　　★</p>

I was convinced that the greater mortality rate at the first clinic was due to an endemic but as yet unknown cause. That the newborn, whether female or male, also contracted

childbed fever convinced me that the disease was misconceived. I was aware of many facts for which I had no explanation. Delivery with prolonged dilation almost inevitably led to death. Patients who delivered prematurely or on the street almost never became ill, and this contradicted my conviction that the deaths were due to endemic causes. The disease appeared sequentially among patients in the first clinic. Patients in the second clinic were healthier, although individuals working there were no more skillful or conscientious in their duties. The disrespect displayed by the employees toward the personnel of the first clinic made me so miserable that life seemed worthless. Everything was in question; everything seemed inexplicable; everything was doubtful. Only the large number of deaths was an unquestionable reality.

The reader can appreciate my perplexity during my first period of service when I, like a drowning person grasping at a straw, discontinued supine deliveries, which had been customary in the first clinic, in favor of deliveries from a lateral position. I did this for no other reason than that the latter were customary in the second clinic. I did not believe that the supine position was so detrimental that additional deaths could be attributed to its use. But in the second clinic deliveries were performed from a lateral position and the patients were healthier. Consequently, we also delivered from the lateral position, so that everything would be exactly as in the second clinic.

I spent the winter of 1846–47 studying English. I did this because my predecessor, Dr. Breit, resumed the position of assistant, and I wanted to spend time in the large Dublin maternity hospital. Then, at the end of February 1847, Dr. Breit was named Professor of Obstetrics at the medical school in Tübingen. I changed my travel plans and, in the company of two friends, departed for Venice on 2 March 1847. I hoped the Venetian art treasures would revive my mind and spirits, which had been so seriously affected by my experiences in the maternity hospital.

On 20 March of the same year, a few hours after returning to Vienna, I resumed, with rejuvenated vigor, the position of assistant in the first clinic. I was immediately overwhelmed by the sad news that Professor Kolletschka, whom I greatly admired, had died in the interim.

The case history went as follows: Kolletschka, Professor of Forensic Medicine, often conducted autopsies for legal purposes in the company of students. During one such exercise, his finger was pricked by a student with the same knife that was being used in the autopsy. I do not recall which finger was cut. Professor Kolletschka contracted lymphangitis and phlebitis in the upper extremity. Then, while I was still in Venice, he died of bilateral pleurisy, pericarditis, peritonitis, and meningitis. A few days before he died, a metastasis also formed in one eye. I was still animated by the art treasures of Venice, but the news of Kolletschka's death agitated me still more. In this excited condition I could see clearly that the disease from which Kolletschka died was identical to that from which so many hundred maternity patients had also died. The maternity patients also had lymphangitis, peritonitis, pericarditis, pleurisy, and meningitis, and metastases also formed in many of them. Day and night I was haunted by the image of Kolletschka's disease and was forced to recognize, ever more decisively, that the disease from which Kolletschka died was identical to that from which so many maternity patients died.

Earlier, I pointed out that autopsies of the newborn disclosed results identical to those obtained in autopsies of patients dying from childbed fever. I concluded that the newborn died of childbed fever, or in other words, that they died from the same disease as the maternity patients. Since the identical results were found in Kolletschka's autopsy, the inference that Kolletschka died from the same disease was confirmed. The exciting cause of Professor Kolletschka's death was known; it was the wound by the autopsy knife that had been contaminated by cadaverous particles. Not the wound, but contamination of the wound by the cadaverous particles caused his death. Kolletschka was not the first to have died in this way. I was forced to admit that if his disease was identical with the disease that killed so many maternity patients, then it must have originated from the same cause that brought it on in Kolletschka. In Kolletschka, the specific causal factor was the cadaverous particles that were introduced into his vascular system. I was compelled to

ask whether cadaverous particles had been introduced into the vascular systems of those patients whom I had seen die of this identical disease. I was forced to answer affirmatively.

Because of the anatomical orientation of the Viennese medical school, professors, assistants, and students have frequent opportunity to contact cadavers. Ordinary washing with soap is not sufficient to remove all adhering cadaverous particles. This is proven by the cadaverous smell that the hands retain for a longer or shorter time. In the examination of pregnant or delivering maternity patients, the hands, contaminated with cadaverous particles, are brought into contact with the genitals of these individuals, creating the possibility of resorption. With resorption, the cadaverous particles are introduced into the vascular system of the patient. In this way, maternity patients contract the same disease that was found in Kolletschka.

Suppose cadaverous particles adhering to hands cause the same disease among maternity patients that cadaverous particles adhering to the knife caused in Kolletschka. Then if those particles are destroyed chemically, so that in examinations patients are touched by fingers but not by cadaverous particles, the disease must be reduced. This seemed all the more likely, since I knew that when decomposing organic material is brought into contact with living organisms it may bring on decomposition.

To destroy cadaverous matter adhering to hands I used *chlorina liquida*. This practice began in the middle of May 1847; I no longer remember the specific day. Both the students and I were required to wash before examinations. After a time I ceased to use *chlorina liquida* because of its high price, and I adopted the less expensive chlorinated lime. In May 1847, during the second half of which chlorine washings were first introduced, 36 patients died—this was 12.24 percent of 294 deliveries. In the remaining seven months of 1847, the mortality rate was below that of the patients in the second clinic. . . .

JACQUES PIERRE MAYGRIER. *Gynecological–Obstetrical Exam.* From *Midwifery Illustrated.* 1834. Courtesy, National Library of Medicine, Bethesda, Md.

Heinrich Heine

FROM FRENCH AFFAIRS

"The Cholera in Paris!"

Although Heine (1797–1856) is best known as the 19th-century German poet whose poems have been set as beautiful lieder *by Schumann and Schubert, he also wrote copiously in prose, from political analysis and satire to history to travel essays, from which this selection is taken. In Paris during the 1832 cholera epidemic, Heine recorded the initial effects this epidemic, which had marched westward inexorably from Russia since 1830, had on Paris. It killed 18,000 people, over two percent of that city's inhabitants. Escaping cholera, Heine himself died of an infectious disease, possibly syphilis.*

I speak of the cholera which for a time has reigned here unrestrictedly, felling its victims by the thousands without regard for rank or opinion.

One had not been apprehensive about that pestilence because the word from London was that it caused comparatively few deaths. In fact, the initial idea seemed to be to deride it, and it was opined that the cholera would be no more able to maintain its reputation here than any other celebrity. So the good cholera could really not be blamed, when in fear of ridicule it resorted to a stratagem which even Robespierre and Napoleon found effective: to gain respect by decimating the people. In view of the great distress prevailing here, the colossal dirt found not only among the poorer classes, the excitability of the people as a whole, their infinite carelessness, and the complete lack of any preparations and precautions—in view of all that, the cholera was bound to spread here more rapidly and terribly than elsewhere.

Its arrival was officially announced on the 29th of March; and as this was the Mi-carême, and a bright and sunny day, the Parisians swarmed more gaily than ever on the Boulevards, where masks were even seen mocking the fear of the cholera and the disease itself in off-color and misshapen caricature. That night, the balls were more crowded than ever; hilarious laughter all but drowned the loudest music; one grew hot in the *chahut*, a fairly unequivocal dance, and gulped all kinds of ices and other cold drinks—when suddenly the merriest of the harlequins felt a chill in his legs, took off his mask, and to the amazement of all revealed a violet-blue face. It was soon discovered that this was no joke; the laughter died, and several wagon-loads of people were driven directly from the ball to the Hôtel Dieu, the main hospital, where they arrived in their gaudy fancy dress and promptly died, too. As in the first shock the cholera was thought to be contagious, and the older guests of the Hôtel Dieu raised cruel screams of fear, those dead were said to have been buried so fast that not even their checkered fool's clothes were taken off them; and merrily as they lived they now lie in their graves.

There is nothing like the confusion with which security measures were now suddenly taken. A Sanitation Commission was created, first aid stations were established everywhere, and ordinances concerning public hygiene were put into effect at once. This caused an immediate collision with the interests of several thousand men who consider public filth their private domain. These are the so called *chiffoniers,* who make their living from the garbage piling up during the day in odd corners outside the houses. These men stroll through the streets with great pointed baskets on their backs and hooked sticks in their hands, pale images of filth who know how to pick much that is still useful out of the refuse, and sell it. And when the police now contracted for the removal of the dung, so that it should not remain long in the public streets, and the rubbish was loaded on carts

and taken out of the city into open country where the chiffoniers were to be free to fish in it to their hearts' content—now these people complained that their business had been hurt, if not quite ruined, and that it was based on ancient usage, a property right as it were, of which they could not be arbitrarily deprived. It is curious that their arguments were just the same as those which our country squires, guild-masters, corporation heads, tithe-preachers, faculty members, and other advocates of privilege usually put forth when the old abuses by which they profit, the rubbish of the Middle Ages, are finally to be cleaned out lest our present life be infected by the ancient rot and fumes. . . .

When the revolt of the chiffoniers had been suppressed by armed force and the cholera still was not spreading so savagely as wished by certain gentry—who hope that each public disaster or turmoil will bring, if not victory to their cause, at least the downfall of the existing government—there suddenly sprang up a rumor that the many people who were so promptly buried had not died from disease, but by poison. Poison was said to have been put into all foods, on the vegetable markets, by the bakers, by the meat-sellers, by the wine merchants. The more odd the tales rang the more eagerly they were seized upon by the people, and even the headshaking doubters had to believe in them when the police chief issued his proclamation. Here, as everywhere, the police are less interested in preventing crimes than in having known about them. They either wanted to boast of their omniscience, or else thought that the poison rumors—true or false—would at least divert suspicion from the government. Whichever it was, the unfortunate proclamation, which said in so many words that they were on the poisoners' track, officially confirmed the evil rumor and threw all of Paris into the most appalling fear of death. . . .

It was as if the end of the world had come. Especially at street-corners, where the red-painted wine shops are, groups gathered and consulted; it was generally there that suspicious-looking individuals were searched, and woe to those in whose pockets anything suspect was found. Like beasts, like maniacs, the people fell on them. Many saved themselves by presence of mind; others were rescued by the resolute Communal Guards who in those days patrolled everywhere; some were seriously wounded or maimed; and six were most unmercifully murdered.

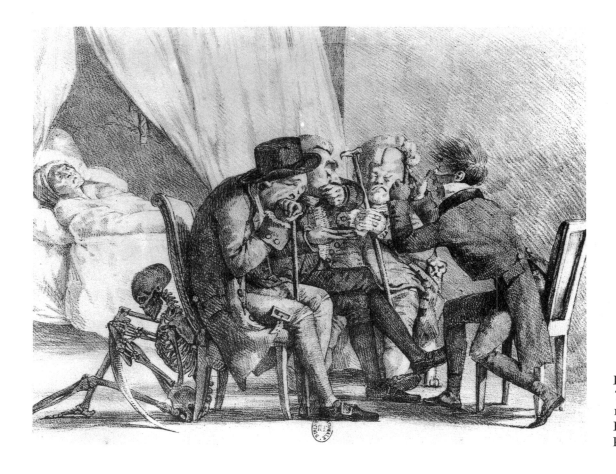

Eugène Delacroix.
The Consultation.
1820. Lithograph.
Bibliothèque Nationale,
Paris.

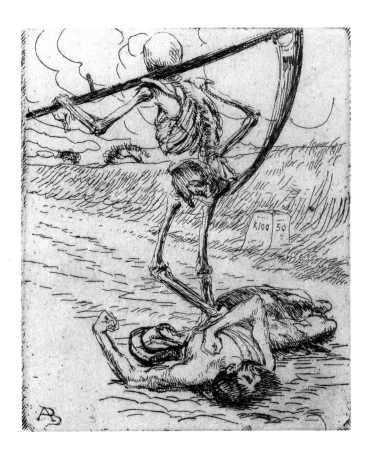

There is no more dreadful sight than such popular anger thirsting for blood and throttling its defenseless victims. A dark human flood rolls through the streets, with workers in shirt-sleeves foaming up here and there like white-caps, and howls and roars mercilessly, heathenishly, demoniacally. . . . In the Rue Vaugirard, where two men were killed who had had white powders on them, I saw one of these unfortunates when he was still breathing and the old hags were just pulling the wooden shoes from their feet and beating him on the head with them till he was dead. He was quite naked and bloody and mashed; they had torn off not only his clothes but his hair, his sex, his lips and his nose, and one ruffian tied a rope to the feet of the corpse and dragged it through the streets, shouting constantly, *"Voilà le Cholera-morbus!"* A very beautiful female, pale with rage, with bare breasts and bloody hands, stood by and kicked the corpse as it came near her. She laughed, and asked me to reward her tender handiwork with a few francs so she could buy herself a black mourning dress; for her mother had died a few hours earlier, of poison.

The next day, it appeared from the public prints that the hapless people so atrociously butchered were all quite innocent, that the suspicious powders found on them consisted of camphor or chlorine or other cholera preventives, and that the supposedly poisoned had died quite naturally of the raging epidemic. The people here, like the people everywhere, are quickly inflamed and readily led to atrocities, but they are as quick to turn gentle again and with touching sorrow deplore their misdeeds when they hear the voice of reason. With this voice, on the very next day, the newspapers knew how to calm and quiet the populace; it may be called a signal triumph for the press that it was able so promptly to undo the mischief done by the police.

<p style="text-align:center">★ ★ ★</p>

All has been quiet here since; "order reigns in Paris," as Horatius Sebastiani would say. The stillness of death reigns in Paris. A stony seriousness lies on all faces. For several evenings there were few people even on the Boulevards, and they passed each other quickly with hands or handkerchiefs held over their faces. The theaters are like ghost

towns. When I enter a salon, people are amazed to see me still in Paris, as I have no urgent business here. Most strangers, my compatriots in particular, left right away. . . .

The people grumbled bitterly, seeing how the rich fled and, loaded with doctors and drugs, escaped to healthier climes. Resentfully, the poor man saw that money had become a prophylactic even against death. The greater portion of the *juste milieu* and the *haute finance* also have departed since, and now live in their castles. But the real representatives of wealth, the Messrs. de Rothschild, quietly remained in Paris, documenting that their boldness and magnificence is not limited to money transactions. . . . The whole royal family likewise proved itself nobly in this desperate time. When the cholera broke out, the good Queen assembled her friends and servants and distributed flannel belly-bands mostly made by herself. The ways of chivalry are not extinct; they merely have become bourgeois. Great ladies now provide their champions with less poetical but healthier scarfs. We live no longer in the old, martial days of armored and helmeted knights but in the peaceful bourgeois time of belly-bands and warm underwear; we live no longer in the iron age but in that of flannel. Flannel, in fact, is the best armor against the assault of the worst enemy, the cholera. "Today," says the *Figaro,* "Venus would wear a flannel girdle." I am up to my neck in flannel, and consider myself cholera-proof. The King, too, now wears a belly-band of the best bourgeois flannel. . . .

[E]ach has his faith in these troubled times. As for me, I believe in flannel. A sensible diet can do no harm, either; only, one must not eat too little food, like some who mistake the nightly pangs of hunger for cholera symptoms. It is amusing to see the cowardice with which people now sit at table, regard the most humanitarian dishes with suspicion and swallow the best morsels with deep sighs. The doctors told them not to be afraid and to avoid excitement; now they are afraid of suddenly getting excited, and then get excited about having been afraid. They are love itself now, and often use the word *mon Dieu,* and their voices are as gentle as those of expectant mothers. On the other hand, they smell like walking drugstores, feel their stomachs frequently, and inquire every hour after the number of dead.

That this number was never exactly known—or rather, that all were convinced that the published figures were wrong—filled the minds with a vague terror and immeasurably increased the fears. In fact, the newspapers have since admitted that on one day, on the 10th of April, nearly two thousand died. The people would not be officially fooled, and constantly complained that more were dying than were accounted for. My barber told

THOMAS ROWLANDSON. *Death and the Debauchée.* c.1815. Pen and watercolor over pencil on wove paper. 5¼ × 8⅝ in. (13.3 × 21.9 cm). Yale Center for British Art, New Haven, Conn. Paul Mellon Collection.

me that an old woman on Faubourg Montmartre sat by her window all night counting the corpses which were carried past; she counted three hundred, and when dawn broke she herself was seized by the chills and cramps of the cholera and shortly died. Wherever one looked in the streets there were funerals, or looking sadder still, hearses with no one following. There were not sufficient hearses, and one had to use all kinds of other vehicles which looked eccentric enough under their black cloth covering. In the end there was even a shortage of those, and I saw coffins taken away in hacks; they were laid in the middle, with the two ends sticking out of the open side doors. It was revolting to see the large furniture-moving vans driven about as dead men's omnibuses now, as *omnibus mortuis*, halting in the different streets for their loads of coffins and carrying them by dozens to their place of rest.

The neighborhood of a graveyard, where the funerals met, presented the most disconsolate sights. When I wanted to visit a friend and arrived just in time to see his corpse loaded up, I had a gloomy whim to return an honor he had once bestowed on me, and I took a coach and accompanied him to Père la Chaise. There, near that cemetery, my driver suddenly stopped, and when I awoke from my reverie and looked round I saw nothing but sky and coffins. . . .

To spare the reader's feelings, I will not describe here what I saw inside Père la Chaise. Suffice it to say that I, hardened as I am, could not ward off the deepest horror. By deathbeds one can learn how to die, and then await death calmly and cheerfully; but to be buried among cholera corpses, in quick-lime graves, that one cannot learn. I fled as fast as I could to the highest hill of the church-yard, where one can see the city spread so beautifully beneath. The sun was setting; its last rays seemed to bid a sad good-bye; the mists of dusk veiled ailing Paris like white shrouds, and I wept bitterly over the unhappy city, the city of freedom and enthusiasm and martyrdom, the Saviour City which has already suffered so much for the temporal redemption of mankind.

John Snow
"The Cholera Near Golden Square"

Lifelong teetotaler and physician to the poor of London's Soho district, John Snow (1813–1858) is best known for his proof that cholera was a water-borne disease. Amassing a case against the infamous Broad Street pump (1854), Snow succeeded in having the pump handle removed just as the epidemic ended. Snow was also an early proponent of anaesthesia in childbirth, and Queen Victoria knighted him after the safe, painless delivery of her seventh child.

The most terrible outbreak of cholera which ever occurred in this kingdom, is probably that which took place in Broad Street, Golden Square, and the adjoining streets, a few weeks ago. Within two hundred and fifty yards of the spot where Cambridge Street joins Broad Street, there were upwards of five hundred fatal attacks of cholera in ten days. The mortality in this limited area probably equals any that was ever caused in this country, even by the plague; and it was much more sudden, as the greater number of cases terminated in a few hours. The mortality would undoubtedly have been much greater had it not been for the flight of the population. Persons in furnished lodgings left first, then other lodgers went away, leaving their furniture to be sent for when they could meet with a place to put it in. Many houses were closed altogether, owing to the death of the proprietors; and, in a great number of instances, the tradesmen who remained had sent

The Sick Woman in Bellevue Hospital, New York, Overrun by Rats. Illustration from *Harper's Weekly,* May 5, 1860. Wood engraving. National Library of Medicine, Bethesda, Md.

away their families: so that in less than six days from the commencement of the outbreak, the most afflicted streets were deserted by more than three-quarters of their inhabitants.

There were a few cases of cholera in the neighbourhood of Broad Street, Golden Square, in the latter part of August; and the so-called outbreak, which commenced in the night between the 31st August and the 1st September, was, as in all similar instances, only a violent increase of the malady. As soon as I became acquainted with the situation and extent of this irruption of cholera, I suspected some contamination of the water of the much-frequented street-pump in Broad Street, near the end of Cambridge Street; but on examining the water, on the evening of the 3rd September, I found so little impurity in it of an organic nature, that I hesitated to come to a conclusion. Further inquiry, however, showed me that there was no other circumstance or agent common to the circumscribed locality in which this sudden increase of cholera occurred, and not extending beyond it, except the water of the above mentioned pump. I found, moreover, that the water varied, during the next two days, in the amount of organic impurity, visible to the naked eye, on close inspection, in the form of small white, flocculent particles; and I concluded that, at the commencement of the outbreak, it might possibly have been still more impure. I requested permission, therefore, to take a list, at the General Register Office, of the deaths from cholera, registered during the week of 2nd September, in the subdistricts of Golden Square, Berwick Street, and St. Ann's, Soho, which was kindly granted. Eighty-nine deaths from cholera were registered, during the week, in the three subdistricts. Of these, only six occurred in the four first days of the week; four occurred on Thursday, the 31st August; and the remaining seventy-nine on Friday and Saturday. I considered, therefore, that the outbreak commenced on the Thursday; and I made inquiry, in detail, respecting the eighty-three deaths registered as having taken place during the last three days of the week.

On proceeding to the spot, I found that nearly all the deaths had taken place within a short distance of the pump. There were only ten deaths in houses situated decidedly nearer to another street pump. In five of these cases the families of the deceased persons informed me that they always sent to the pump in Broad Street, as they preferred the water to that of the pump which was nearer. In three other cases, the deceased were children who went to school near the pump in Broad Street. Two of them were known to drink the water;

and the parents of the third think it probable that it did so. The other two deaths, beyond the district which this pump supplies, represent only the amount of mortality from cholera that was occurring before the irruption took place. . . .

The result of the inquiry then was, that there had been no particular outbreak or increase of cholera, in this part of London, except among the persons who were in the habit of drinking the water of the above-mentioned pump-well.

<p align="center">★ ★ ★</p>

The additional facts that I have been able to ascertain are in accordance with those above related; and as regards the small number of those attacked, who were believed not to have drank the water from Broad Street pump, it must be obvious that there are various ways in which the deceased persons may have taken it without the knowledge of their friends. The water was used for mixing with spirits in all the public houses around. It was used likewise at dining-rooms and coffee-shops. The keeper of a coffee-shop in the neighbourhood, which was frequented by mechanics, and where the pump-water was supplied at dinner time, informed me (on 6th September) that she was already aware of nine of her customers who were dead. The pump-water was also sold in various little shops, with a teaspoonful of effervescing powder in it, under the name of sherbet; and it may have been distributed in various other ways with which I am unacquainted. The pump was frequented much more than is usual, even for a London pump in a populous neighbourhood. . . .

There is a Brewery in Broad Street, near to the pump, and on perceiving that no brewer's men were registered as having died of cholera, I called on Mr. Huggins, the proprietor. He informed me that there were above seventy workmen employed in the brewery, and that none of them had suffered from cholera,—at least in a severe form,—only two having been indisposed, and that not seriously, at the time the disease prevailed. The men are allowed a certain quantity of malt liquor, and Mr. Huggins believes they do not drink water at all; and he is quite certain that the workmen never obtained water from the pump in the street. There is a deep well in the brewery, in addition to the New River water.

At the percussion-cap manufactory, 37 Broad Street, where, I understand, about two hundred workpeople were employed, two tubs were kept on the premises always supplied with water from the pump in the street, for those to drink who wished; and eighteen of these workpeople died of cholera at their own homes, sixteen men and two women.

Mrs. ——, of 13 Bentinck Street, Berwick Street, aged 28, in the eighth month of pregnancy, went herself (although they were not usually water drinkers), on Sunday, 3rd September, to Broad Street pump for water. The family removed to Gravesend on the following day; and she was attacked with cholera on Tuesday morning at seven o'clock, and died of consecutive fever on 15th September, having been delivered. Two of her children drank also of the water, and were attacked on the same day as the mother, but recovered.

Dr. Fraser, of Oakley Square, kindly informed me of the following circumstance. A gentleman in delicate health was sent for from Brighton to see his brother at 6 Poland Street, who was attacked with cholera and died in twelve hours, on 1st September. The gentleman arrived after his brother's death, and did not see the body. He only stayed about twenty minutes in the house, where he took a hasty and scanty luncheon of rump-steak, taking with it a small tumbler of brandy and water, the water being from the Broad Street pump. He went to Pentonville, and was attacked with cholera on the evening of the following day, 2nd September, and died the next evening.

<p align="center">★ ★ ★</p>

As there had been deaths from cholera just before the great outbreak not far from this pump-well, and in a situation elevated a few feet above it, the evacuations from the patients might of course be amongst the impurities finding their way into the water, and judging the matter by the light derived from other facts and considerations previously

detailed, we must conclude that such was the case. A very important point in respect to this pump-well is that the water passed with almost everybody as being perfectly pure, and it did in fact contain a less quantity of impurity than the water of some other pumps in the same parish, which had no share in the propagation of cholera. We must conclude from this outbreak that the quantity of morbid matter which is sufficient to produce cholera is inconceivably small, and that the shallow pump-wells in a town cannot be looked on with too much suspicion, whatever their local reputation may be.

Whilst the presumed contamination of the water of the Broad Street pump with the evacuation of cholera patients affords an exact explanation of the fearful outbreak of cholera in St. James's parish, there is no other circumstance which offers any explanation at all, whatever hypothesis of the nature and cause of the malady be adopted.

John Collins Warren

"Inhalation of Ethereal Vapor for the Prevention of Pain in Surgical Operations"

John Collins Warren (1778–1856) did not discover chemically mediated surgical anaesthesia, but his prominence as a Boston surgeon and the quick publication of his success with ether did hasten its acceptance. Within a decade the limitations to surgical anaesthesia—postoperative sepsis—moderated its use, and religious opposition to painless childbirth mobilized. But thereafter a patient's pain could not easily be ignored.

The discovery of a mode of preventing pain in surgical operations has been an object of strong desire among surgeons from an early period. In my surgical lectures I have almost annually alluded to it, and stated the means which I have usually adopted for the attainment of this object. I have also freely declared, that notwithstanding the use of very large doses of narcotic substances, this desideratum had never been satisfactorily obtained. The successful use of any article of the materia medica for this purpose, would therefore be hailed by me as an important alleviation to human suffering. I have in consequence admitted the trial of plans calculated to accomplish this object, whenever they were free from danger.

About five weeks since, Dr. Morton, dentist of this city, informed me that he had invented an apparatus for the inhalation of a vapor, the effect of which was to produce a state of total insensibility to pain and that he had employed it successfully in a sufficient number of cases in his practice to justify him in a belief of its efficacy. He wished for an opportunity to test its power in surgical operations, and I agreed to give him such an opportunity as soon as practicable.

Being at that time in attendance as Surgeon of the Massachusetts General Hospital, a patient presented himself in that valuable institution a few days after my conversation with Dr. Morton, who required an operation for a tumor of the neck, and agreeably to my promise I requested the attendance of Dr. M.

On October 17th, the patient being prepared for the operation, the apparatus was applied to his mouth by Dr. Morton for about three minutes, at the end of which time he sank into a state of insensibility. I immediately made an incision about three inches long through the skin of the neck, and began a dissection among important nerves and

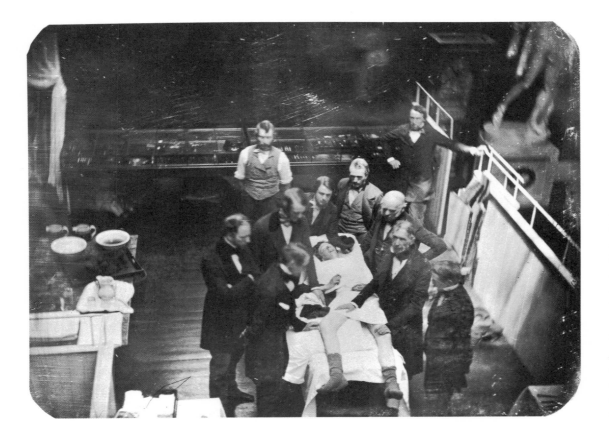

Attributed to Southworth and Hawes. *Operation Under Ether.* c.1852. Daguerreotype. 6 × 8 in. (15.2 × 20.3 cm). Archives of News and Public Affairs, Massachusetts General Hospital, Boston. *The man with his hands on the etherized patient's thighs is Dr. John Collins Warren, chief surgeon and cofounder of the Massachusetts General Hospital. At Dr. Warren's left is Dr. Oliver Wendell Holmes, Sr.*

blood-vessels without any expression of pain on the part of the patient. Soon after he began to speak incoherently, and appeared to be in an agitated state during the remainder of the operation. Being asked immediately afterwards whether he had suffered much, he said that he had felt as if his neck had been scratched; but subsequently, when inquired of by me, his statement was, that he did not experience pain at the time, although aware that the operation was proceeding.

The effect of the gaseous inhalation in neutralizing the sentient faculty was made perfectly distinct to my mind by his experiment, although the patient during a part of its prosecution exhibited appearances indicative of suffering. Dr. Morton had apprised me, that the influence of his application would last but a few minutes after its intermission; and as the operation was necessarily protracted, I was not disappointed that its success was only partial.

On the following day, October 18th, an operation was done by Dr. Hayward, on a tumor of the arm, in a female patient at the Hospital. The respiration of the gas was in this case continued during the whole of the operation. There was no exhibition of pain, excepting some occasional groans during its last stage, which she subsequently stated to have arisen from a disagreeable dream. Noticing the pulse in this patient before and after the operation, I found it to have risen from 80 to 120. . . .

The success of this process in the prevention of pain for a certain period being quite established, I at once conceived it to be my duty to introduce the apparatus into the practice of the Hospital, but was immediately arrested by learning that the proprietor intended to obtain an exclusive patent for its use. It now became a question, whether, in accordance with that elevated principle long since introduced into the medical profession, which forbids its members to conceal any useful discovery, we could continue to encourage an application we were not allowed to use ourselves, and of the components of which we were ignorant. On discussing this matter with Dr. Hayward, my colleague in the Hospital, we came to the conclusion, that we were not justified in encouraging the further use of this new invention, until we were better satisfied on these points. Dr. Hayward thereupon had a conversation with Dr. Morton, in consequence of which Dr. M. addressed to me a letter. In this he declared his willingness to make known to us the

article employed, and to supply assistance to administer the inhalation whenever called upon. These stipulations he has complied with.

<p style="text-align:center">★ ★ ★</p>

On Nov. 21st an operation was performed by Dr. J. Mason Warren on a gentleman for the removal of a tumor, which covered nearly the half of the front of the right thigh. The patient lying upon a bed, the vapor was administered by Dr. Morton in the presence of Drs. Charles T. Jackson, Reynolds, J.V.C. Smith, Flagg, Gould, Shurtleff, Lawrence, Parsons, Briggs, and others. After he had breathed the vapor for three minutes his head fell, and he ceased to respire it, but presently awakening, the inhalation was renewed till he again appeared insensible. The operation was then commenced. At the first stroke of the knife he clapped his hand on the wound, but I immediately seized and held it during the remainder of the operation, though not without some difficulty in consequence of his struggles. The operation was completed in two or three minutes, and the patient remained quietly on his back with his eyes closed. On examination the pupils were found to be dilated; the pulse was not materially affected. After he had lain about two minutes, I roused him by the inquiry, "how do you do to-day?" to which he replied, "very well, I thank you." I then asked what he had been doing. He said he believed he had been dreaming; he dreamed that he was at home, and making some examination into his business. "Do you feel any pain?" "No." "How is that tumor of yours?" The patient raised himself in bed, looked at his thigh for a moment, and said, "It is gone, and I'm glad of it." I then inquired if he had felt any pain during the operation, to which he replied in the negative. He soon recovered his natural state, experienced no inconvenience from the inhalation, was remarkably free from pain, and in three days went home into the country.

In all these cases there was a decided mitigation of pain; in most of them the patients on the day after the operation, and at other times, stated, that they had not been conscious of pain. All those who attended were, I think, satisfied of the efficacy of the application in preventing, or, at least, greatly diminishing the suffering usual in such cases.

<p style="text-align:center">★ ★ ★</p>

I think it probable . . . that so powerful an agent may sometimes produce other and even alarming effects. I therefore would recommend, that it should never be employed except under the inspection of a judicious and competent person.

Let me conclude by congratulating my professional brethren on the acquisition of a mode of mitigating human suffering, which may become a valuable agent in the hands of careful and well-instructed practitioners, even if it should not prove of such general application as the imagination of sanguine persons would lead them to anticipate.

John Kirk Townsend

FROM NARRATIVE OF A JOURNEY ACROSS THE ROCKY MOUNTAINS TO THE COLUMBIA RIVER

The failure of Indian medicine to mimic white cures was all that most Euro-American travelers ever saw. Townsend, a Quaker ornithologist who joined an 1830s Oregon expedition in order to study and collect North American birds, here arrogantly offers a common but useless substitute for

quinine, dogwood bark. His own scientific work was eclipsed by Audubon's classic atlas of birds, necessitating his brief search for another career in dentistry before an early death from chronic illness.

———————

Two days ago I left the fort, and am now encamped on a plain below Warrior's point. Near me are several large lodges of Kowalitsk Indians; in all probably one hundred persons. As usual, they give me some trouble by coming around and lolling about my tent, and importuning me for the various little articles that they see. My camp-keeper, however, (a Klikatat,) is an excellent fellow, and has no great love for Kowalitsk Indians, so that the moment he sees them becoming troublesome, he clears the coast, *sans ceremonie*. There is in one of the lodges a very pretty little girl, sick with intermittent fever; and to-day the "medicine man" has been exercising his functions upon the poor little patient; pressing upon its stomach with his brawny hands until it shrieked with the pain, singing and muttering his incantations, whispering in its ears, and exhorting the evil spirit to pass out by the door, &c. These exhibitions would be laughable did they not involve such serious consequences, and for myself I always feel so much indignation against the unfeeling impostor who operates, and pity for the deluded creatures who submit to it, that any emotions but those of risibility are excited.

I had a serious conversation with the father of this child, in which I attempted to prove to him, and to some twenty or thirty Indians who were squatted about the ground near, that the "medicine man" was a vile impostor, that he was a fool and a liar, and that his manipulations were calculated to increase the sufferings of the patient instead of relieving them. They all listened in silence, and with great attention to my remarks, and the wily conjurer himself had the full benefit of them: he stood by during the whole time, assuming an expression of callous indifference which not even my warmest vituperations could

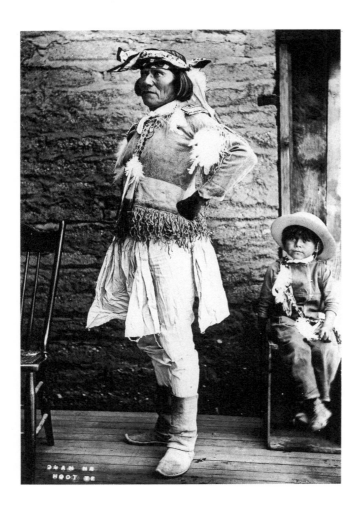

Clan-na-hoot-te, Apache Medicine Man.
1885. Photograph. Courtesy, Special Collections, University of Arizona Library, Tucson.

affect. Finally I offered to exhibit the strongest proof of the truth of what I had been saying, by pledging myself to cure the child in three days, provided the "medicine man" was dismissed without delay. This, the father told me, required some consideration and consultation with his people, and I immediately left the lodge and took the way to my camp, to allow them an opportunity of discussing the matter alone.

Early next morning the Indian visited me, with the information that the "medicine man" had departed, and he was now anxious that I should make trial of my skill. I immediately administered to the child an active cathartic, followed by sulphate of quinine, which checked the disease, and in two days the patient was perfectly restored.

In consequence of my success in this case, I had an application to administer medicine to two other children similarly affected. My stock of quinine being exhausted, I determined to substitute an extract of the bark of the dogwood, (*Cornus Nuttalli*,) and taking one of the parents into the wood with his blanket, I soon chipped off a plentiful supply, returned, boiled it in his own kettle, and completed the preparation in his lodge, with most of the Indians standing by, and staring at me, to comprehend the process. This was exactly what I wished; and as I proceeded, I took some pains to explain the whole matter to them, in order that they might at a future time be enabled to make use of a really valuable medicine, which grows abundantly every where throughout the country. I have often thought it strange that the sagacity of the Indians should not long ago have made them acquainted with this remedy; and I believe, if they had used it, they would not have had to mourn the loss of hundreds, or even thousands of their people who have been swept away by the demon of ague and fever.

I administered to each of the children about a scruple of the extract per day. The second day they escaped the paroxysm, and on the third were entirely well.

Sir William Osler

"William Beaumont: A Backwood Physiologist"

Sir William Osler (1849–1919) is undoubtedly the most famous Western physician of the last hundred years. He was a pioneer in medical education, an insatiable bibliophile, founder of and contributor to several important medical schools and their libraries (especially Johns Hopkins and McGill), an accomplished prose stylist, and a legendary diagnostician. A scientific observer of the first order, writing on conditions from hereditary hemorrhagic telangiectasia to platelets to endocarditis, Dr. Osler was also a practical joker who could publish outlandish pseudo-scientific articles under the pseudonym of Egerton Y. Davis, once even adversely reviewing one of his own papers. Born a Canadian, Osler has also been claimed by the United States and England, where he held the Regius Chair of Medicine at Oxford and was made a baronet in 1911.

Come with me for a few moments on a lovely June day in 1822, to what were then far-off northern wilds, to the Island of Michilimacinac, where the waters of Lake Michigan and Lake Huron unite and where stands Fort Mackinac, rich in the memories of Indian and voyageur, one of the four important posts on the upper lakes in the days when the rose and the fleur-de-lis strove for the mastery of the western world. Here the noble Marquette laboured for his Lord, and here beneath the chapel of St. Ignace they laid his bones to rest. Here the intrepid La Salle, the brave Tonty, and the resolute Du Luht had halted in their wild wanderings. Its palisades and block-houses had echoed the war-whoops of Ojibwas and Ottawas, of Hurons and Iroquois, and the old fort had been the

scene of bloody massacres and hard-fought fights; but at the conclusion of the war of 1812, after two centuries of struggle, peace settled at last on the island. The fort was occupied by United States troops, who kept the Indians in check and did general police duty on the frontier, and the place had become a rendezvous for Indians and voyageurs in the employ of the American Fur Company. On this bright spring morning the village presented an animated scene. The annual return tide to the trading post was in full course, and the beach was thronged with canoes and bateaux laden with the pelts of the winter's hunt. Voyageurs and Indians, men, women, and children, with here and there a few soldiers, made up a motley crowd. Suddenly from the company's store there is a loud report of a gun, and amid the confusion and excitement the rumour spreads of an accident, and there is a hurrying of messengers to the barracks for a doctor. In a few minutes (Beaumont says twenty-five or thirty, an eyewitness says three) an alert-looking man in the uniform of a U.S. Army surgeon made his way through the crowd, and was at the side of a young French Canadian who had been wounded by the discharge of a gun, and with a composure bred of an exceptional experience of such injuries, prepared to make the examination. Though youthful in appearance, Surgeon Beaumont had seen much service, and at the capture of York and at the investment of Plattsburgh he had shown a coolness and bravery under fire which had won high praise from his superior officers. The man and the opportunity had met.

* * *

On the morning of 6 June a young French Canadian, Alexis St. Martin, was standing in the company's store, 'where one of the party was holding a shotgun (not a musket), which was accidentally discharged, the whole charge entering St. Martin's body. The muzzle was not over three feet from him—I think not more than two. The wadding entered, as well as pieces of his clothing; his shirt took fire; he fell, as we supposed, dead.'

'Doctor Beaumont, the surgeon of the fort, was immediately sent for, and reached the wounded man in a very short time, probably three minutes. We had just gotten him on a cot, and were taking off some of his clothing. After the doctor had extracted part of the shot, together with pieces of clothing, and dressed his wound carefully, Robert Stuart and others assisting, he left him, remarking, "The man cannot live thirty-six hours; I will come and see him by and by." In two or three hours he visited him again, expressing surprise at finding him doing better than he had anticipated. The next day, after getting out more shot and clothing, and cutting off ragged edges of the wound, he informed Mr. Stuart, in my presence, that he thought he would recover.'

The description of the wound has been so often quoted as reported in Beaumont's work, that I give here the interesting summary which I find in a 'Memorial' presented to the Senate and House of Representatives by Beaumont:

> The wound was received just under the left breast, and supposed, at the time, to have been mortal. A large portion of the side was blown off, the ribs fractured, and openings made into the cavities of the chest and abdomen, through which protruded portions of the lungs and stomach, much lacerated and burnt, exhibiting altogether an appalling and hopeless case. The diaphragm was lacerated, and a perforation made directly into the cavity of the stomach, through which food was escaping at the time your memorialist was called to his relief. His life was at first wholly despaired of, but he very unexpectedly survived the immediate effects of the wound, and necessarily continued a long time under the constant professional care and treatment of your memorialist, and, by the blessing of God, finally recovered his health and strength.

> At the end of about ten months the wound was partially healed, but he was still an object altogether miserable and helpless. In this situation he was declared 'a common pauper' by the civil authorities of the county, and it was resolved by them that they were not able, nor required, to provide for or support, and finally declined taking care of him, and, in pursuance of what they probably

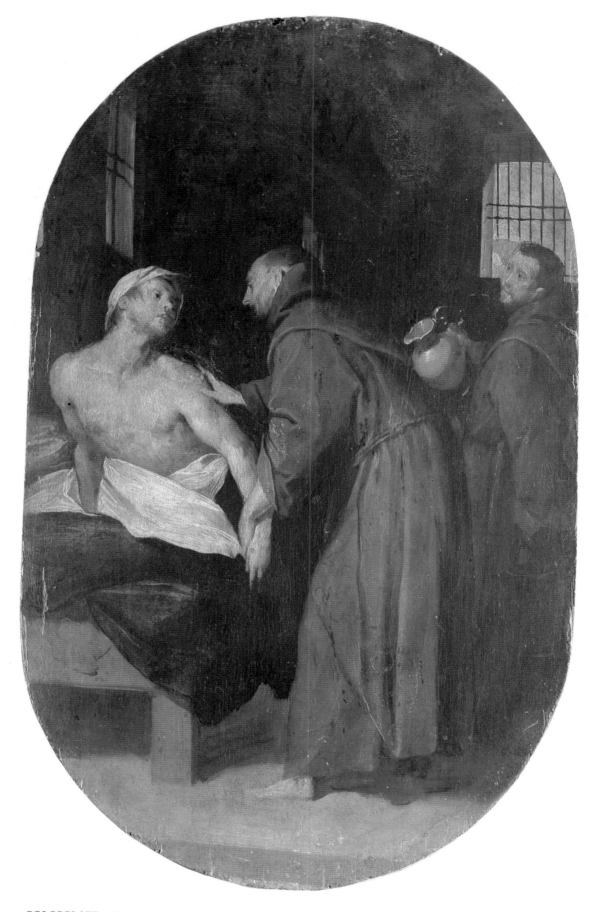

COLORPLATE 49

GIOVANNI BATTISTA CRESPI (called Il Cerano). *St. Francis Healing the Leper*. c. 1630. Oil on wood panel. 16⅛ × 10¼ in. (41 × 26 cm). Pinacoteca di Brera, Milan.

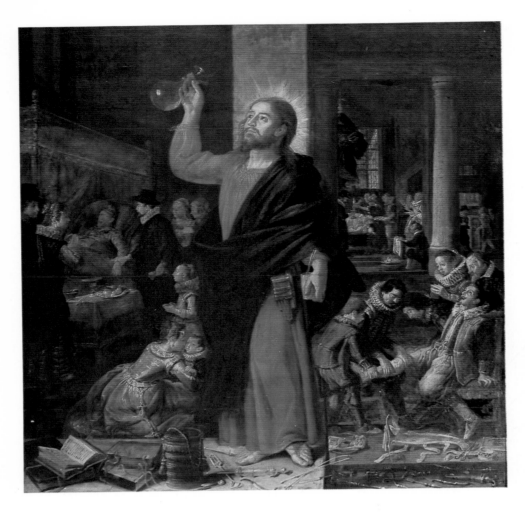

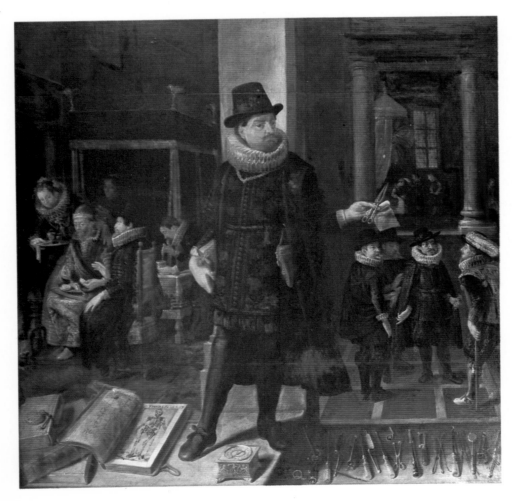

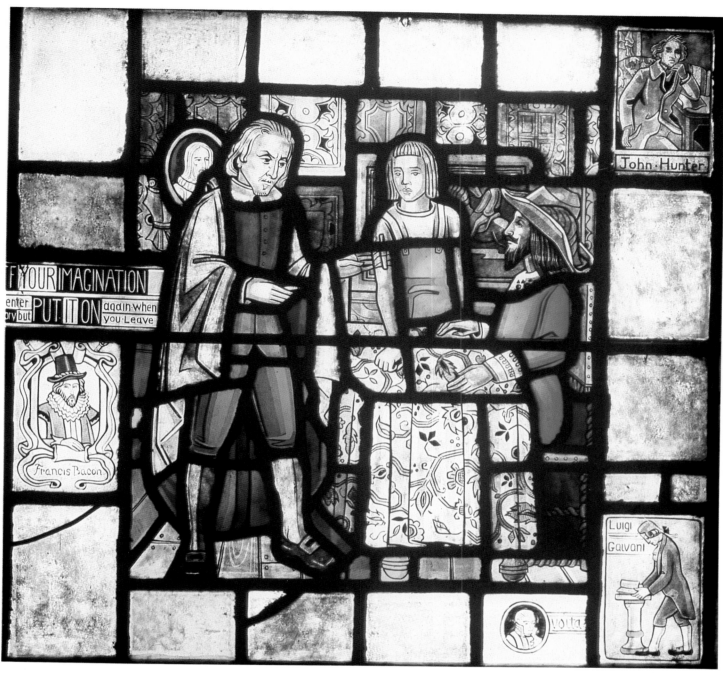

COLORPLATE 52

William Harvey Demonstrates the Circulatory System. c.1943. Stained-glass panel. Published with permission from the Mayo Foundation, Rochester, Minn.

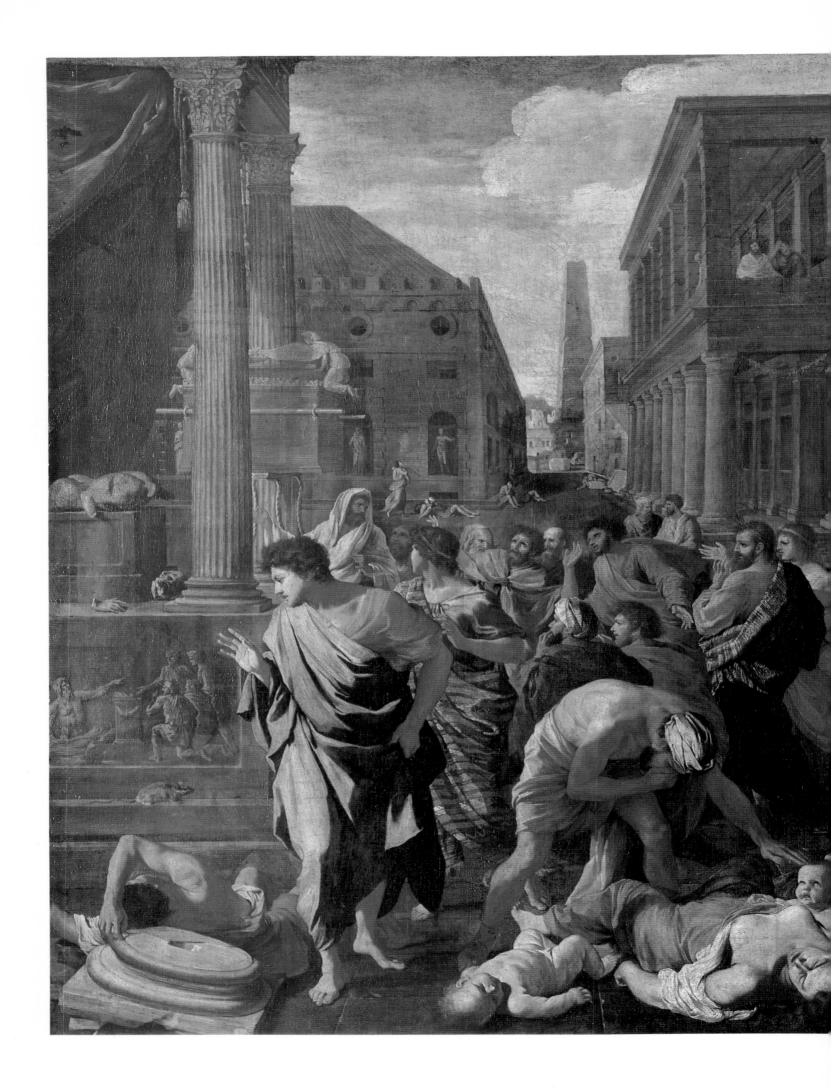

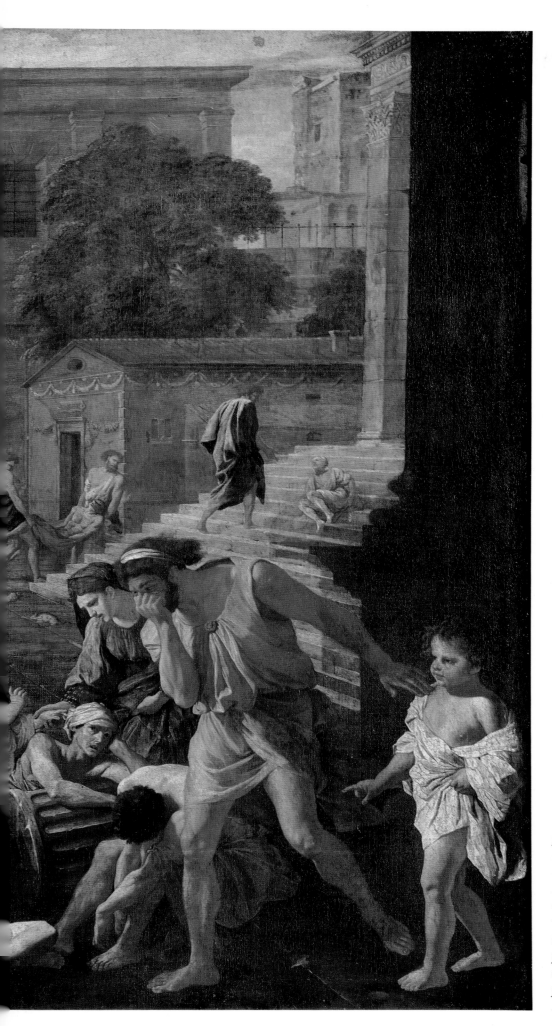

COLORPLATE 53

NICOLAS POUSSIN. *The Plague at Ashdod.*
1630. Oil on canvas. 58¼ × 77¹⁵⁄₁₆ in.
(148 × 198 cm). Louvre, Paris.
Photo © R.M.N. *This large canvas,
which depicts plague as divine
punishment, was painted in Rome during
the great plague of 1630–31. In the
biblical text, the idolatrous Philistines of
Ashdod were punished with pestilence
and a plague of rats because they
worshipped false gods. Poussin links this
to the traditional plague themes of
putrefaction, chaos, and mortality, which
did not discriminate between rich and
poor, old and young, or male and female.
Poussin himself suffered from syphilis.*

COLORPLATE 54

QUIRIJN VAN BREKELENKAM. *The Leech Woman,* or *The Bloodletting.* 1660. Oil on panel.
18⅞ × 14⁹⁄₁₆ in. (47.9 × 37 cm). Mauritshuis, The Hague. *A warmed cupping glass is used to raise a blister on the arm, rather than actual venesection.*

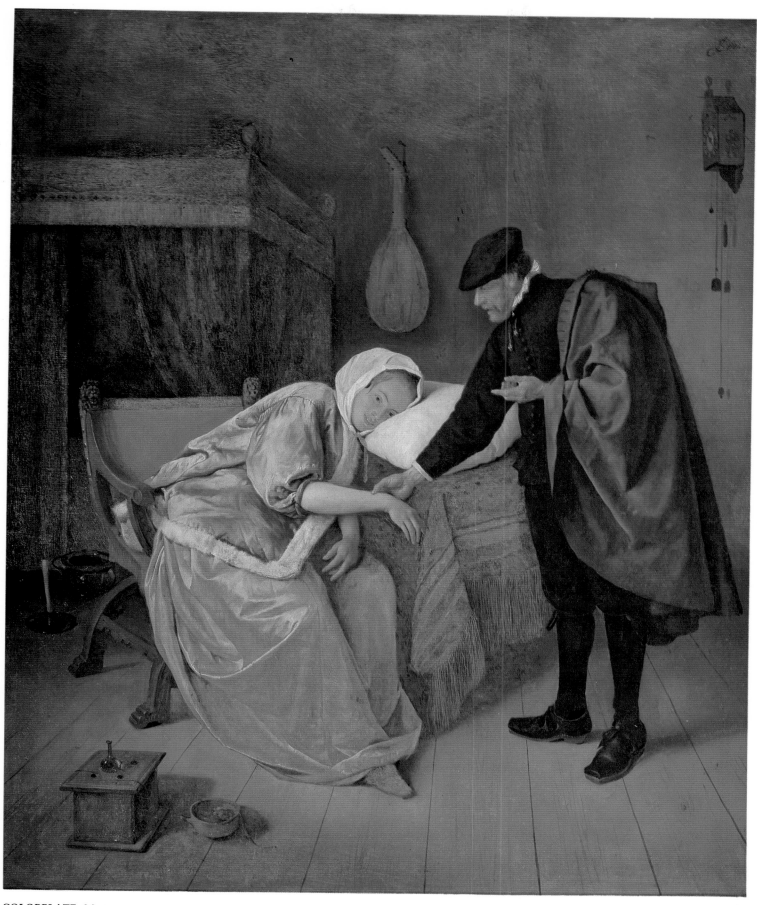

COLORPLATE 55

Jan Steen. *The Sick Lady*. Mid 17th century. Oil on canvas. 29¹⁵⁄₁₆ × 25 in. (76 × 63.5 cm).
Rijksmuseum, Amsterdam. *This young woman probably suffers from lovesickness, but the
physician takes her pulse carefully. Treatises on lovesickness were exceptionally popular from 1500 to
1700. Steen otherwise uses the occasion to depict an elegant chamber.*

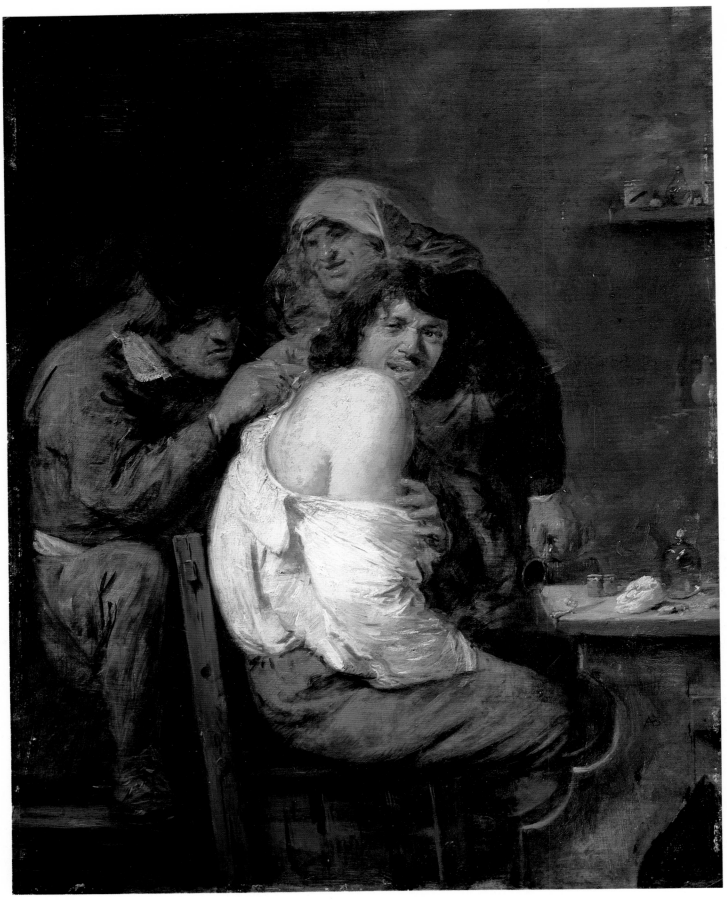

COLORPLATE 56

ADRIAEN BROUWER. *Operation on the Back*. Early 17th century. Oil on panel. 13⅜ × 10⅝ in.
(34 × 27 cm). Städelsches Kunstinstitut, Frankfurt am Main. *Barber surgeons and a miscellany
of self-designated healers provided care to a great proportion of rural Europeans in early modern times.*

believed to be their public duty, authorized by the laws of the territory, were about to transport him, in this condition, to the place of his nativity in lower Canada, a distance of more than fifteen hundred miles.

Believing the life of St. Martin must inevitably be sacrificed if such attempt to remove him should be carried into execution at that time, your memorialist, after earnest, repeated, but unavailing, remonstrances against such a course of proceedings, resolved, as the only way to rescue St. Martin from impending misery and death, to arrest the process of transportation and prevent the consequent suffering, by taking him into his own private family, where all the care and attention were bestowed that his condition required.

St. Martin was, at this time, as before intimated, altogether helpless and suffering under the debilitating effects of his wounds—naked and destitute of everything. In this situation your memorialist received, kept, nursed, medically and surgically treated and sustained him, at much inconvenience and expense, for nearly two years, dressing his wounds daily, and for considerable part of the time twice a day, nursed him, fed him, clothed him, lodged him and furnished him with such necessaries and comforts as his condition and suffering required.

At the end of these two years he had become able to walk and help himself a little, though unable to provide for his own necessities. In this situation your memorialist retained St. Martin in his family for the special purpose of making physiological experiments.

In the month of may 1825 Beaumont began the experiments. In June he was ordered to Fort Niagara, where, taking the man with him, he continued the experiments until August. He then took him to Burlington and to Plattsburgh. From the latter place St. Martin returned to Canada, without obtaining Dr. Beaumont's consent. He remained in Canada four years, worked as a voyageur, married and had two children. In 1829 Beaumont succeeded in getting track of St. Martin, and the American Fur Company engaged him and transported him to Fort Crawford on the upper Mississippi. The side and wound were in the same condition as in 1825. Experiments were continued uninterruptedly until March 1831, when circumstances made it expedient that he should return with his family to lower Canada. The 'circumstances,' as we gather from letters, were the discontent and homesickness of his wife. As illustrating the mode of travel, Beaumont states that St. Martin took his family in an open canoe 'via the Mississippi, passing by St. Louis, ascended the Ohio river, then crossed the state of Ohio to the lakes, and descended the Erie and Ontario and the river St. Lawrence to Montreal, where they arrived in June'. Dr. Beaumont often lays stress on the physical vigour of St. Martin as showing how completely he had recovered from the wound. In November 1832 he again engaged himself to submit to another series of experiments in Plattsburgh and Washington. The last recorded experiment is in November 1833.

Among the Beaumont papers . . . there is a large mass of correspondence relating to St. Martin, extending from 1827, two years after he had left the doctor's employ, to October 1852. Alexis was in Dr. Beaumont's employ in the periods already specified. In 1833 he was enrolled in the United States Army at Washington as Sergeant Alexis St. Martin, of a detachment of orderlies stationed at the War Department. He was then twenty-eight years of age, and was five feet five inches in height.

Among the papers there are two articles of agreement, both signed by the contracting parties, one dated 19 October 1833, and the other 7 November of the same year. In the former he bound himself for a term of one year to

Serve, abide and continue with the said William Beaumont, wherever he shall go or travel or reside in any part of the world his covenant servant and diligently and faithfully, etc., . . . that he, the said Alexis, will at all times during the said term when thereto directed or required by said William, submit to assist and promote by all means in his power such philosophical or medical experiments as the said William shall direct or cause to be made on or in the

Rude Surgery of the Plains.
Illustration from *Western Wilds and the Men Who Redeem Them,* by J. H. Beadle. 1879. Western History Division, Denver Public Library.

stomach of him, the said Alexis, either through and by means of the aperture or opening thereto in the side of him, the said Alexis, or otherwise, and will obey, suffer and comply with all reasonable and proper orders of or experiments of the said William in relation thereto and in relation to the exhibiting and showing of his said stomach and the powers and properties thereto and of the appurtenances and the powers, properties, and situation and state of the contents thereof.

The agreement was that he should be paid his board and lodging and $150 for the year. In the other agreement it is for two years, and the remuneration $400. He was paid a certain amount of the money down.

There are some letters from Alexis himself, all written for him and signed with his mark. In June 1834 he writes that his wife was not willing to let him go, and thinks that he can do a great deal better to stay at home. From this time on Alexis was never again in Dr. Beaumont's employ.

There is a most interesting and protracted correspondence in the years 1836, 1837, 1838, 1839, 1840, 1842, 1846, 1851, and 1852, all relating to attempts to induce Alexis to come to St. Louis. For the greater part of this time he was in Berthier, in the district of Montreal, and the correspondence was chiefly conducted with a Mr. William Morrison, who had been in the north-west fur trade, and who took the greatest interest in Alexis, and tried to induce him to go to St. Louis. . . .

In 1846 Beaumont sent his son Israel for Alexis, and in a letter dated 9 August 1846, his son writes from Troy: 'I have just returned from Montreal, but without Alexis. Upon arriving at Berthier I found that he owned and lived on a farm about fifteen miles south-west of the village.' Nothing would induce him to go.

The correspondence with Mr. Morrison in 1851 and 1852 is most voluminous, and

Dr. Beaumont offered Alexis $500 for the year, with comfortable support for his family. He agreed at one time to go, but it was too late in the winter and he could not get away.

The last letter of the series is dated 15 October 1852, and is from Dr. Beaumont to Alexis, whom he addresses as *Mon Ami*. Two sentences in this are worth quoting:

> Without reference to past efforts and disappointments—or expectation of ever obtaining your services again for the purpose of experiments, etc., upon the proposals and conditions heretofore made and suggested, [']I now proffer to you in faith and sincerity, new, and I hope satisfactory, terms and conditions to ensure your prompt and faithful compliance with my most fervent desire to have you again with me—not only for my own individual gratification, and the benefits of medical science, but also for your own and family's present good and future welfare.' He concludes with, 'I can say no more, Alexis—you know what I *have* done for you many years since—what I have been *trying*, and am still anxious and wishing to do with and for you—what efforts, anxieties, anticipations, and disappointments I have suffered from your non-fulfilment of my expectations. Don't disappoint me more nor forfeit the bounties and blessings reserved for you.

So much interest was excited by the report of the experiments that it was suggested to Beaumont that he should take Alexis to Europe and submit him there to a more extended series of observations by skilled physiologists. Writing 10 June 1833, he says: 'I shall engage him for five or six years if he will agree, of which I expect there is no doubt. He has always been pleased with the idea of going to France. I feel much gratified at the expression of Mr. Livingston's desire that we should visit Paris, and shall duly consider the interest he takes in the subject and make the best arrangements I can to meet his views and yours.' Mr. Livingston, the American minister, wrote from Paris, 18 March 1834, saying that he had submitted the work to Orfila and the Academy of Sciences, which had appointed a committee to determine if additional experiments were necessary, and whether it was advisable to send to America for Alexis. Nothing, I believe, ever came of this, nor, so far as I can find, did Alexis visit Paris. Other attempts were made to secure him for purposes of study. In 1840 a student of Dr. Beaumont's, George Johnson, then at the University of Pennsylvania, wrote saying that Dr. Jackson had told him of efforts made to get Alexis to London, and Dr. Gibson informed him that the Medical Society of London had raised £300 or £400 to induce St. Martin to come, and that he, Dr. Gibson, had been trying to find St. Martin for his London friends. There are letters in the same year from Dr. R. D. Thomson, of London, to Professor Silliman, urging him to arrange that Dr. Beaumont and Alexis should visit London. In 1856 St. Martin was under the observation of Dr. Francis Gurney Smith, in Philadelphia, who reported a brief series of experiments, so far as I know the only other report made on him.

St. Martin had to stand a good deal of chaffing about the hole in his side. His comrades called him 'the man with a lid on his stomach.' In his memorial address, Mr. C. S. Osborn, of Sault Ste Marie, states that Miss Catherwood tells of a story of Etienne St. Martin fighting with Charlie Charette because Charlie ridiculed his brother. Étienne stabbed him severely, and swore that he would kill the whole brigade if they did not stop deriding his brother's stomach.

At one time St. Martin travelled about exhibiting the wound to physicians, medical students, and before medical societies. In a copy of Beaumont's work, formerly belonging to Austin Flint, Jr., and now in the possession of a physician of St. Louis, there is a photograph of Alexis sent to Dr. Flint. There are statements made that he went to Europe, but of such a visit I can find no record.

My interest in St. Martin was of quite the general character of a teacher of physiology, who every session referred to his remarkable wound and showed Beaumont's book with the illustration. In the spring of 1880, while still a resident of Montreal, I saw a notice in the newspapers of his death at St. Thomas. I immediately wrote to a physician and to the parish priest, urging them to secure me the privilege of an autopsy, and offering to pay

a fair sum for the stomach, which I agreed to place in the Army Medical Museum in Washington, but without avail. Subsequently, through the kindness of the Hon. Mr. Justice Baby, I obtained the following details of St. Martin's later life. Judge Baby writes to his friend, Prof. D. C. MacCallum of Montreal, as follows:

I have much pleasure to-day in placing in your hands such information about St. Martin as Revd. Mr. Chicoine, Curé of St. Thomas, has just handed over to me. Alexis Bidigan, *dit* St. Martin, died at St. Thomas de Joliette on the 24th of June, 1880, and was buried in the cemetery of the parish on the 28th of the same month. The last sacraments of the Catholic Church were ministered to him by the Revd. Curé Chicoine, who also attended at his burial service. The body was then in such an advanced stage of decomposition that it could not be admitted into the church, but had to be left outside during the funeral service. The family resisted all requests—most pressing as they were—on the part of the members of the medical profession for an autopsy, and also kept the body at home much longer than usual and during a hot spell of weather, so as to allow decomposition to set in and baffle, as they thought, the doctors of the surrounding country and others. They had also the grave dug eight feet below the surface of the ground in order to prevent any attempt at a resurrection. When he died St. Martin was 83 years of age, and left a widow, whose maiden name was Marie Joly. She survived him by nearly seven years, dying at St. Thomas on the 20th of April, 1887, at the very old age of 90 years. They left four children, still alive—Alexis, Charles, Henriette, and Marie.

Now I may add the following details for myself. When I came to know St. Martin it must have been a few years before his death. A lawsuit brought him to my office here in Joliette. I was seized with his interests; he came to my office a good many times, during which visits he spoke to me at great length of his former life, how his wound had been caused, his peregrinations through Europe and the United States, etc. He showed me his wound. He complained bitterly of some doctors who had awfully misused him, and had kind words for others. He had made considerable money during his tours, but had expended and thrown it all away in a frolicsome way, especially in the old country. When I came across him he was rather poor, living on a small, scanty farm in St. Thomas, and very much addicted to drink, almost a drunkard one might say. He was a tall, lean man, with a very dark complexion, and appeared to me then of a morose disposition.

Henry Clay Lewis
FROM LOUISIANA SWAMP DOCTOR
"The 'Mississippi Patent Plan' for Pulling Teeth"

Lewis might have been the Aesculapian Mark Twain had his life not ended tragically at the age of 27. By that time he had practiced medicine seven full years, after receiving his degree from the Louisville Medical Institute, where Daniel Drake taught. Before that he literally "practiced" medicine in an apprenticeship to a Yazoo City physician. In Odd Leaves from the Life of a Louisiana Swamp Doctor, *published in March 1850, "Madison Tensas, M.D." (Lewis's pseudonym) delightfully captured the dialect and foibles of medical practice in the old South. Five months*

later he was returning from sleepless service during the cholera epidemic in Vicksburg, when willows in the flooded bayou pulled down his horse. Lewis could not swim.

I had just finished the last volume of Wistar's *Anatomy,* well nigh coming to a period myself with weariness at the same time, and with feet well braced up on the mantelpiece was lazily surveying the closed volume which lay on my lap when a hurried step in the front gallery aroused me from the revery into which I was fast sinking. Turning my head as the office door opened, my eyes fell on the well-developed proportions of a huge flatboatman who entered the room wearing a countenance, the expression of which would seem to indicate that he had just gone into the vinegar manufacture with a fine promise of success.

"Do you pull teeth, young one?" he said to me.

"Yes, and noses, too," replied I, fingering my slender mustache, highly indignant at the juvenile appellation, and bristling up by the side of the huge Kentuckian till I looked as large as a thumb lancet by the side of an amputating knife.

"You needn't get riled, young Doc. I meant no insult, sarten, for my teeth are too sore to 'low your boots to jar them as I swallered you down. I want a tooth pulled. Can you manage the job? Ouch! criminy, but it hurts!"

"Yes, sir, I can pull your tooth. Is it an incisor, or a dens sapientiae? one of the decidua, or a permanent grinder?"

"It's a sizer, I reckon. It's the largest tooth in my jaw. Anyhow, you can see for yourself," and the Kentuckian opening the lower half of his face disclosed a set of teeth that clearly showed that his half of the alligator lay above.

"A molar requires extraction," said I, as he laid his finger on the aching fang.

"A molar! well, I'll be cust but you doctors have queer names for things! I reckon the next time I want a money-puss a molear will be extracted too; ouch! What do you ax for pulling teeth, Doc? I want to git rid of the pesky thing."

"A dollar, sir," said I, pulling out the case of instruments and lacing a chair for him.

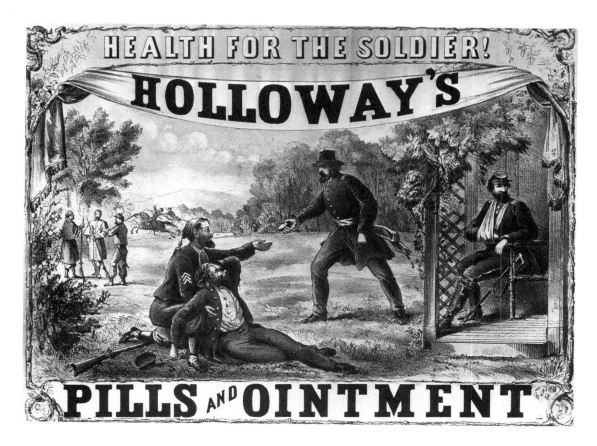

"A dollar! dollar, h—ll! do you think the Yazoo Pass is full of kegs of speshy [specie]? I'd see you mashed under a hogshead of pork 'fore I'd give you a dollar to pull the thing," and picking up his hat, which he dashed on the floor on his first entrance, off he started.

Seeing some fun in store, I winked at the rest of the students whom the loudness of our conversation had called from the other rooms of the capacious office and requested the subject to return.

"It's no use; stranger; I'd squirm all day fust 'fore I'd give you a dollar to pull every tooth in my head," said he.

"Well, Mister, times are hard, and I'll pull your tooth for half a dollar," said I, determined if necessary to give him pay before I would lose the pulling of his tooth.

"You'll have to come down a notch lower, Doc. I wants to interduce Kaintuck fashions on a Southern sile, and up thar you can get a tooth pulled and the agur 'scribed for fur a quarter."

"Well, but recollect, it's harder to pull teeth here than it is in Kentucky."

"Don't care a cuss; dimes is plentyer. I don't want to be stingy though, Doc, and I'll tell you what I'll do. I feels sorter bad from eatin' a mud cat yesterday. I'll gin you a quarter to pull my tooth if you'll throw in a dose of castor ile."

"It's a bargain," said I. "I couldn't possibly afford to do it so low if I didn't manufacture my own oil and pull teeth on the 'Mississippi Patent Plan' without the least pain."

"Well, I'se struck a breeze of luck, sure, to get it 'stracted without hurtin', for I 'spected it would make all things pop, by hoecake." And "all things did pop," certain, as the poor devil found to his sorrow before the "Mississippi Patent Plan" was over.

The room in which we were was the operating one of the office where patients were examined and surgical operations performed. It was furnished with all the usual appliances of such an establishment. In the middle of the room, securely fastened to the floor by screws, was a large armchair with headboard and straps to confine the body and limbs of the patient whilst the operator was at work, in such cases as required it. On either side of the house, driven into the wall, were a couple of iron bolts to which were fastened blocks and pulleys, used when reducing old dislocations when all milder means had failed. The chair, pulleys, and a small hand vice were the apparatus intended to be used by me in the extraction of the Kentuckian's tooth by the "Mississippi Patent Plan."

The patient watched all our preparations—for I quickly let the other students into the plan of the intended joke with great interest and seemed hugely tickled at the idea of having his tooth pulled without pain for a quarter and a dose of castor oil extra.

Everything being ready, we invited the subject to take his seat in the operating chair, telling him it was necessary agreeable to our mode of pulling teeth that the body and arms should be perfectly quiet and that other doctors who hadn't bought the right to use the "Patent Plan" used the pullikins whilst I operated with the pulleys. I soon had him immovably strapped to the chair, hand and foot. Introducing the hand vice in his mouth, which fortunately for me was a large one, I screwed it fast to the offending tooth, and then connecting it with the first cord of the pulleys and intrusting it to the hands of two experienced assistants, I was ready to commence the extraction. Giving the word and singing, "Lord, receive this sinner's soul," we pulled slowly so as to let the full strain come on the neck bones gradually.

Though I live till every hair on my head is as hollow as a dry skull, I shall never forget the scene.

Clothed in homespun of the copperas hue, impotent to help himself, his body immovably fixed to the chair, his neck gradually extending itself like a terrapin's emerging from its shell, his eyes twice their natural size and projected nearly out of their sockets, his mouth widely distended with the vice hidden in its cavity, and the connection of the rope, being behind his cheeks, giving the appearance as if we had cast anchor in his stomach and were heaving it slowly home, sat the Kentuckian screaming and cursing that we were pulling his head off without moving the tooth and that the torment was awful. But I coolly told him 'twas the usual way the "Mississippi Patent Plan" worked and directed my assistants to keep up their steady pull.

174

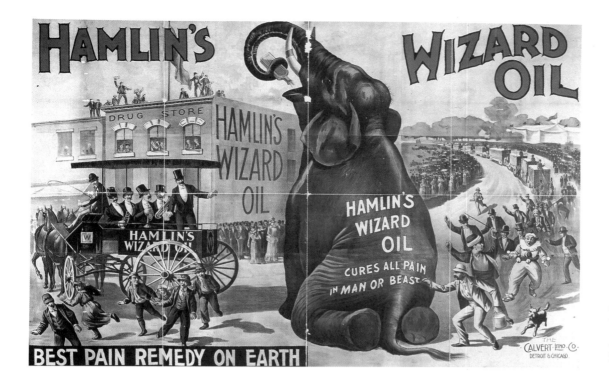

Hamlin's Wizard Oil. 1890s. Chromolith. 6 ft. 7$^{15}/_{16}$ in. × 10 ft. 2 in. (2 × 3.1 m). Library of Congress, Washington, D.C.

I have not yet fully determined, as it was the first and last experiment, which would have come first, his head or the tooth, for all at once the rope gave way, precipitating without much order or arrangement the assistants into the opposite corner of the room.

The operating chair, not being as securely screwed down as usual, was uptorn by the shock of the retrograde motion acquired when the rope broke and landed the Kentuckian on his back in the most distant side of the room; as he fell he struck the side of his face against the wall, and out came the vice with a large tooth in its fangs. He raged like one of his indigenous thunderstorms and demanded to be released. Fearing some hostile demonstration when the straps were unfastened, we took occasion to cut them with a long bowie knife. He rose up, spitting blood and shaking himself, as if he was anxious to get rid of his clothes. "H–l, Doc, but she's a buster! I never seed such a tooth. I reckon no common fixments would have fotch it; but I tell you, sirree, it hurt awful; I think it's the last time the 'Mississippi Patent Plan' gets me in its holt. Here's a five dollar Kaintuck bill—take your pay and gin us the change."

Seeing he was in such good humor, I should have spared him, but his meanness disgusted me, and I thought I would carry the joke a little further. On examining his mouth, I suddenly discovered, as was the case, that I had pulled the wrong tooth, but I never told him, and he had too much blood in his mouth to discover it.

"Curse the luck," I exclaimed, "by Jupiter, I have lost my bet. I didn't break the infernal thing."

"Lost what?" inquired the patient, alternately spitting out blood and cramming in my tobacco.

"Why, a fine hat. I bet the old boss that the first tooth I pulled on my 'Mississippi Patent Plan' I either broke the neck of the patient or his jawbone, and I have done neither."

"Did you never pull a tooth that way before? Why, you told me you'd pulled a hundred."

"Yes, but they all belonged to dead men."

"And if the rope hadn't guv way, I reckon there'd bin another dead man's pulled. Cuss you, you'd never pulled my tooth if I hadn't thought you had plenty of 'sperience; but gin me my change, I wants to be gwine to the boat."

I gave the fellow his change for the five dollar bill, deducting the quarter, and the next day, when endeavoring to pass it, I found we had both made a mistake. I had pulled the wrong tooth, and he had given me a counterfeit bill.

NON-WESTERN VISIONS
OF CARING AND CURING

George Catlin

FROM LETTERS AND NOTES ON
THE NORTH AMERICAN INDIANS

The gifted American artist George Catlin (1796–1872) visited the natives of the Great Plains just a few years before epidemic smallpox (1837) hastened their disappearance from the land. Catlin used both words and portraits to describe the customs and appearances of Native Americans, keenly sensitive to their differing values. For the Blackfeet, the object of medicine was power and control over the present world, aided by the supranatural forces surrounding living things.

"Medicine" is a great word in [Blackfoot] country, and it is very necessary that one should know the meaning of it whilst he is scanning and estimating the Indian character, which is made up, in a great degree, of mysteries and superstitions. The word medicine, in its common acceptation here, means *mystery* and nothing else.

The fur traders in this country are nearly all French. In their language, a doctor or physician is called *"Medicin."* The Indian country is full of doctors. They are all magicians, and skilled, or professed to be skilled, in many mysteries. The word "medicin" has become habitually applied to everything mysterious or unaccountable. The English and Americans, who also trade and pass through this country, have easily and familiarly adopted the same word, with a slight alteration, to convey the same meaning: "Medicine-men" means something more than merely a doctor or physician. Medicine-men are supposed to deal in mysteries and charms, which are aids and handmaids in their practice. Yet it was necessary to give the word or phrase a still more comprehensive meaning, as there were many personages among them, and also among the white men who visit the country, who could deal in mysteries, though not skilled in the application of drugs and medicines. All such men who deal in mysteries are included under the comprehensive and accommodating phrase of "medicine-men." For instance, I am a "medicine-man" of the highest order among these people, on account of the art which I practice, which is a strange and unaccountable thing to them, and of course called the greatest of "medicine." My gun and pistols, which have percussion-locks, are great medicine. No Indian can be prevailed on to fire them off, for they say they will have nothing to do with white man's medicine.

The Indians do not use the word medicine, however. In each tribe they have a word of their own construction, synonymous with mystery or mystery-man.

The "medicine-bag," then, is a mystery-bag. Its meaning and importance must be understood, as it may be said to be the key to Indian life and Indian character. These bags are constructed of the skins of animals, of birds, or of reptiles, and ornamented and preserved in a thousand different ways, as suits the taste or freak of the person who

constructs them. These skins are generally attached to some part of the clothing of the Indian, or carried in his hand. They are oftentimes decorated to be exceedingly ornamental to his person, and always are stuffed with grass, or moss, or something of the kind. Generally there are no drugs or medicines within them, as they are religiously closed and sealed, and seldom, if ever, to be opened. I find that every Indian in his primitive state carries his medicine-bag in some form or other, to which he pays the greatest homage, and to which he looks for safety and protection through life. Feasts are often made, and dogs and horses sacrificed, to a man's medicine. Days and even weeks of fasting and penance of various kinds are often suffered to appease his medicine, which he imagines he has in some way offended.

This curious custom has principally been done away with along the frontier, where white men laugh at the Indian for the observance of so ridiculous and useless a form. But in this country, beyond the frontier, "medicine" is in full force, and every male in the tribe carries his supernatural charm or guardian, to which he looks for the preservation of his life, in battle or in other danger: It would be considered ominous bad luck and ill fate to be without it.

A boy, at the age of fourteen or fifteen years, is said to be "making or forming his medicine" when he wanders away from his father's lodge and absents himself for the space of two or three, and sometimes even four or five days. He lies on the ground in some remote or secluded spot, crying to the Great Spirit, and fasting the whole time. When he falls asleep during this period of peril and abstinence, the first animal, bird, or reptile of which he dreams (or pretends to have dreamed, perhaps) he considers having been designated by the Great Spirit as his mysterious protector through life. He then returns home to his father's lodge, and relates his success. After allaying his thirst and satiating his appetite, he sallies forth with weapons or traps until he can procure the animal or bird, the skin of which he preserves entire and ornaments according to his own fancy. He carries it with him through life for "good luck," as he calls it. It is his strength in battle—and in death his guardian *Spirit*. It is buried with him, and is to conduct him safe to the beautiful hunting grounds, which he contemplates in the world to come.

The value of the medicine-bag to the Indian is beyond all price. To sell it, or give it away, would subject him to such signal disgrace in his tribe that he could never rise above it. Again, his superstition would stand in the way of any such disposition of it, for he considers it the gift of the Great Spirit. An Indian carries his medicine-bag into battle, and trusts to it for his protection. If he loses it, he suffers a disgrace scarcely less than that which occurs in case he sells or gives it away. His enemy carries it off and displays it to his own people as a trophy, while the loser is cut short of the respect that is due young men of his tribe and forever subjected to the degrading epithet of "a man without medicine" or "he who has lost his medicine," until he can replace it again. This can only be done by rushing into battle and plundering one from an enemy whom he slays with his own hand. This done, his medicine is restored. He is then reinstated in the estimation of his tribe, and even higher than before, for such is called the best of medicine, or *"medicine honorable."*

It is a singular fact that a man can institute his mystery or medicine but once in his life—equally singular that he can reinstate himself by the adoption of the medicine of his enemy. Both of these regulations are strong and violent inducements for him to fight bravely in battle. The first, that he may protect and preserve his medicine; and the second, in case he has been so unlucky as to lose it, that he may restore it, and his reputation also, while he is desperately contending for the protection of his community.

During my travels thus far I have been unable to buy a medicine-bag of an Indian, although I have offered them extravagant prices. Even on the frontier, where they have been induced to abandon the practice, though a white man may induce an Indian to relinquish his medicine, yet he cannot *buy* it from him. The Indian in such cases will bury it to please a white man, but save it from his sacrilegious touch. He will linger around the spot and at regular times visit it and pay it his devotions, as long as he lives.

These curious appendages to the persons or wardrobe of an Indian are sometimes

made of the skin of an otter, a beaver, a musk-rat, a weazel, a raccoon, a polecat, a snake, a frog, a toad, a bat, a mouse, a mole, a hawk, an eagle, a magpie, or a sparrow; sometimes of the skin of an animal so large as a wolf; and at others, of the skins of the lesser animals, so small that they are hidden under the dress, and very difficult to find even if searched for. Such then is the medicine-bag—such its meaning and importance. When its owner dies, it is placed in his grave and decays with his body.

<center>★ ★ ★</center>

I saw a "medicine-man" performing his mysteries over the dying chief. The man who had been shot was still living, though two bullets had passed through the center of his body about two inches apart from each other and no one could indulge the slightest hope of his recovery. Yet the medicine-man must be called, and the hocus-pocus applied to the dying man as the last resort, when all drugs and all specifics were useless, and after all possibility of recovery was extinct.

Medicine (or mystery) men are regularly called and paid as physicians to prescribe for the sick. Many of them acquire great skill in the medicinal world and gain much celebrity in their nation. Their first prescriptions are roots and herbs, of which they have a great variety. When these have all failed, their last resort is to "medicine" or mystery. For this purpose, each one of them has a strange dress, conjured up and constructed during a life-time of practice, in the wildest fancy imaginable, in which he arrays himself, and makes his last visit to his dying patient—dancing over him, shaking his frightful rattles, and singing songs of incantation, in hopes of curing him by a charm. There are some instances, of course, where the exhausted patient unaccountably recovers under the application of these absurd forms. In such cases the ingenious son of Esculapius will be seen for several days after on the top of a wigwam, with his right hand extended and waving over the gaping multitude, to whom he is vaunting forth, without modesty, the surprising skill he has acquired in his art, and the undoubted efficacy of his medicine or mystery. But if, on the contrary, the patient dies, he soon changes his dress and joins in doleful lamentations with the mourners. With his craft and the ignorance and superstition of his people, he easily protects his reputation and maintains his influence by assuring them that it was the will of the Great Spirit that his patient should die.

Such was the case in the instance I am now relating. Several hundred spectators, including Indians and traders, were assembled around the dying man, when it was announced that the "medicine-man" was coming. We were required to "form a ring," leaving a space of some thirty or forty feet in diameter in which the doctor could perform his wonderful operations. A space was also opened to allow him ample room to pass through the crowd without touching anyone. This being done, his arrival was announced in a few moments by a death-like "hush—sh—" through the crowd. Nothing was to be heard save the light and casual tinkling of the rattles upon his dress, which was scarcely perceptible to the ear, as he cautiously and slowly moved through the avenue left for him, which at length brought him into the ring, in view of the pitiable object over whom his mysteries were to be performed.

His entrance and his garb were somewhat thus: He approached the ring with his body in a crouching position, with a slow and tilting step. His body and head were entirely covered with the skin of a yellow bear, the head of which (his own head being inside of it) served as a mask. The huge claws of the bear dangled on his wrists and ankles. In one hand he shook a frightful rattle, and in the other brandished his medicine-spear or magic wand. To the rattling din and discord of this, he added the wild and startling jumps and yelps of the Indian, and the horrid and appalling grunts and snarls and growls of the grizzly bear. With ejaculatory and guttural incantations to the Good and Bad Spirits in behalf of his patient, who was rolling and groaning in the agonies of death, he danced around him, jumping and pawing him about, and rolling him in every direction.

This strange operation proceeded for half an hour, to the surprise of a numerous and deathly silent audience, until the man died. The medicine-man danced off to his quarters, and packed up, tied, and secured from sight his mystery dress and equipments.

John G. Neihardt (Flaming Rainbow)
FROM BLACK ELK SPEAKS
"The First Cure"

Among Native Americans, medicine means power. Black Elk suffered a severe illness at age nine, and mystic visions then helped him to identify his own exceptional gifts. He fought at the battle of Little Big Horn, consolidated his powers through fasting and prayer, and effected his first cure (below) at age 19. After aiding his defeated Sioux tribe during the early reservation period, he traveled with Buffalo Bill's Wild West Show, 1886–89, becoming disenchanted with the spiritual and material values of whites. He was present at the Wounded Knee massacre and retired to life as a medicine man, where Neihardt found him in the early 1930s. Black Elk Speaks, *an oral autobiography dictated to Neihardt, still brings attention to the message of a great Indian healer.*

It was in the Moon of Shedding Ponies (May) when we had the heyoka ceremony. One day in the Moon of Fatness (June), when everything was blooming, I invited One Side to come over and eat with me. I had been thinking about the four-rayed herb that I had now seen twice—the first time in the great vision when I was nine years old, and the second time when I was lamenting on the hill. I knew that I must have this herb for curing, and I thought I could recognize the place where I had seen it growing that night when I lamented.

After One Side and I had eaten, I told him there was a herb I must find, and I wanted him to help me hunt for it. Of course I did not tell him I had seen it in a vision. He was willing to help, so we got on our horses and rode over to Grass Creek. Nobody was living over there. We came to the top of a high hill above the creek, and there we got off our horses and sat down, for I felt that we were close to where I saw the herb growing in my vision of the dog.

We sat there awhile singing together some heyoka songs. Then I began to sing alone a song I had heard in my first great vision:

"In a sacred manner they are sending voices."

After I had sung this song, I looked down towards the west, and yonder at a certain spot beside the creek were crows and magpies, chicken hawks and spotted eagles circling around and around.

Then I knew, and I said to One Side: "Friend, right there is where the herb is growing." He said: "We will go forth and see." So we got on our horses and rode down Grass Creek until we came to a dry gulch, and this we followed up. As we neared the spot the birds all flew away, and it was a place where four or five dry gulches came together. There right on the side of the bank the herb was growing, and I knew it, although I had never seen one like it before, except in my vision.

It had a root about as long as to my elbow, and this was a little thicker than my thumb. It was flowering in four colors, blue, white, red, and yellow.

We got off our horses, and after I had offered red willow bark to the Six Powers, I made a prayer to the herb, and said to it: "Now we shall go forth to the two-leggeds, but only to the weakest ones, and there shall be happy days among the weak."

It was easy to dig the herb, because it was growing in the edge of the clay gulch. Then we started back with it. When we came to Grass Creek again, we wrapped it in some good sage that was growing there.

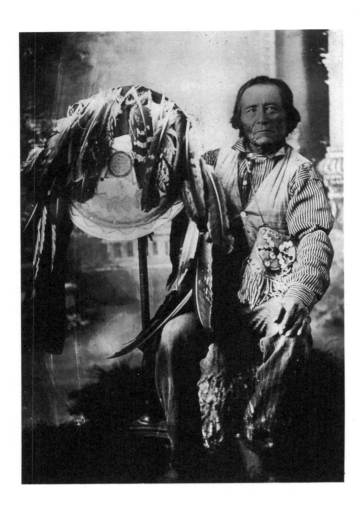

Pesh-Coo (Iron Water), Apache Medicine Man.
1885. Photograph. Courtesy, Special Collections,
University of Arizona Library, Tucson.

Something must have told me to find the herb just then, for the next evening I needed it and could have done nothing without it.

I was eating supper when a man by the name of Cuts-to-Pieces came in, and he was saying: "Hey, hey, hey!" for he was in trouble. I asked him what was the matter, and he said: "I have a boy of mine, and he is very sick and I am afraid he will die soon. He has been sick a long time. They say you have great power from the horse dance and the heyoka ceremony, so maybe you can save him for me. I think so much of him."

I told Cuts-to-Pieces that if he really wanted help, he should go home and bring me back a pipe with an eagle feather on it. While he was gone, I thought about what I had to do; and I was afraid, because I had never cured anybody yet with my power, and I was very sorry for Cuts-to-Pieces. I prayed hard for help. When Cuts-to-Pieces came back with the pipe, I told him to take it around to the left of me, leave it there, and pass out again to the right of me. When he had done this, I sent for One Side to come and help me. Then I took the pipe and went to where the sick little boy was. My father and my mother went with us, and my friend, Standing Bear, was already there.

I first offered the pipe to the Six Powers, then I passed it, and we all smoked. After that I began making a rumbling thunder sound on the drum. You know, when the power of the west comes to the two-leggeds, it comes with rumbling, and when it has passed, everything lifts up its head and is glad and there is greenness. So I made this rumbling sound. Also, the voice of the drum is an offering to the Spirit of the World. Its sound arouses the mind and makes men feel the mystery and power of things.

The sick little boy was on the northeast side of the tepee, and when we entered at the south, we went around from left to right, stopping on the west side when we had made the circle.

You want to know why we always go from left to right like that. I can tell you something of the reason, but not all. Think of this: Is not the south the source of life, and does not the flowering stick truly come from there? And does not man advance from

there toward the setting sun of his life? Then does he not approach the colder north where the white hairs are? And does he not then arrive, if he lives, at the source of light and understanding, which is the east? Then does he not return to where he began, to his second childhood, there to give back his life to all life, and his flesh to the earth whence it came? The more you think about this, the more meaning you will see in it.

As I said, we went into the tepee from left to right, and sat ourselves down on the west side. The sick little boy was on the northeast side, and he looked as though he were only skin and bones. I had the pipe, the drum and the four-rayed herb already, so I asked for a wooden cup, full of water, and an eagle bone whistle, which was for the spotted eagle of my great vision. They placed the cup of water in front of me; and then I had to think awhile, because I had never done this before and I was in doubt.

I understood a little more now, so I gave the eagle bone whistle to One Side and told him how to use it in helping me. Then I filled the pipe with red willow bark, and gave it to the pretty young daughter of Cuts-to-Pieces, telling her to hold it, just as I had seen the virgin of the east holding it in my great vision.

Everything was ready now, so I made low thunder on the drum, keeping time as I sent forth a voice. Four times I cried "Hey-a-a-hey," drumming as I cried to the Spirit of the World, and while I was doing this I could feel the power coming through me from my feet up, and I knew that I could help the sick little boy.

I kept on sending a voice, while I made low thunder on the drum, saying: "My Grandfather, Great Spirit, you are the only one and to no other can any one send voices. You have made everything, they say, and you have made it good and beautiful. The four quarters and the two roads crossing each other, you have made. Also you have set a power where the sun goes down. The two-leggeds on earth are in despair. For them, my Grandfather, I send a voice to you. You have said this to me: The weak shall walk. In vision you have taken me to the center of the world and there you have shown me the power to make over. The water in the cup that you have given me, by its power shall the dying live. The herb that you have shown me, through its power shall the feeble walk upright. From where we are always facing (the south), behold, a virgin shall appear, walking the good red road, offering the pipe as she walks, and hers also is the power of the flowering tree. From where the Giant lives (the north), you have given me a sacred, cleansing wind, and where this wind passes the weak shall have strength. You have said this to me. To you and to all your powers and to Mother Earth I send a voice for help."

You see, I had never done this before, and I know now that only one power would have been enough. But I was so eager to help the sick little boy that I called on every power there is.

I had been facing the west, of course, while sending a voice. Now I walked to the north and to the east and to the south, stopping there where the source of all life is and where the good red road begins. Standing there I sang thus:

"In a sacred manner I have made them walk.
A sacred nation lies low.
In a sacred manner I have made them walk.
A sacred two-legged, he lies low.
In a sacred manner, he shall walk."

While I was singing this I could feel something queer all through my body, something that made me want to cry for all unhappy things, and there were tears on my face.

Now I walked to the quarter of the west, where I lit the pipe, offered it to the powers, and, after I had taken a whiff of smoke, I passed it around.

When I looked at the sick little boy again, he smiled at me, and I could feel that the power was getting stronger.

I next took the cup of water, drank a little of it, and went around to where the sick little boy was. Standing before him, I stamped the earth four times. Then, putting my mouth to the pit of his stomach, I drew through him the cleansing wind of the north. I next chewed some of the herb and put it in the water, afterward blowing some of it on

the boy and to the four quarters. The cup with the rest of the water I gave to the virgin, who gave it to the sick little boy to drink. Then I told the virgin to help the boy stand up and to walk around the circle with him, beginning at the south, the source of life. He was very poor and weak, but with the virgin's help he did this.

Then I went away.

Next day Cuts-to-Pieces came and told me that his little boy was feeling better and was sitting up and could eat something again. In four days he could walk around. He got well and lived to be thirty years old.

Cuts-to-Pieces gave me a good horse for doing this; but of course I would have done it for nothing.

When the people heard about how the little boy was cured, many came to me for help, and I was busy most of the time.

Iroquois People

FROM THE RITUAL OF CONDOLENCE

The Ritual of Condolence was a social ritual occasioned by the death of one of the fifty high chiefs of the Five Nations of the Iroquois. It was intended to keep the social integrity of the culture intact lest excessive mourning in the form of suicidal depression or vengeful murder, i.e., a cult of death, cause even more deaths. According to Iroquois legend, Hiawatha brought this ritual to his people when he united the Five Nations. Originally strictly an oral tradition, the Ritual of Condolence serves a bereavement function for the Iroquois society by controlling the shape and process of grieving, and it establishes the dead chief's resurrected successor, who inherits not only his position but also his name.

Now, oh, my offspring, there is still another matter to be considered at this time.

It is this, that it invariably comes to pass, where a great calamity has befallen a person, that a trail of blood is smeared over the husk-mat couch of that person; now invariably, of course, that one's place of rest is not at all pleasant—sitting cross-legged in wretchedness.

Thus, therefore, art thou stricken in thy person in this very manner, oh, my offspring, whom I have been wont to hold in my bosom, thou noble one, thou yaanehr, *thou Federal Chief.* Is not then what has befallen thy person so dreadful that it must not be neglected? Now, at this time is there not a trail of blood smeared over thy husk-mat couch? Today, thou dost writhe in the midst of blood.

Now, therefore, do thou know it, that the Three Brothers have made their preparations, and now, therefore, let them say it, "Now, then, we wipe away the several bloody smears from thy husk-mat resting place. Moreover, we have employed the skin of the spotted fawn, *the words of pity and comfort,* to wipe away the bloody trails."

It will, moreover, come to pass that on whatever future day that our minds shall be parted, one from the other, and that when thou wilt return to thy mat, it will be in the fullness of peace, and it will be spread out in contentment, when thou wilt again sit cross-legged in thy resting place.

Thus, therefore, may it be that for one poor brief day, also in peace, thou mayst carry on thy thinking in contentment, this one (*indicating*), thou noble one, thou yaanehr, *thou Federal Chief,* whom I have been wont to hold in my bosom.

In this manner, perhaps, let the Three Brothers, so denominated ever since their Commonwealth was completed, do this.

Now, therefore, do thou know it, oh, my offspring, that the Word, *the attesting wampum,* of thy adonni is on its way hence to thee.

<p align="center">★ ★ ★</p>

Now, oh, my offspring, there is still another matter to be considered at this time.

It is this, that where a direful thing befalls a person, that person is invariably covered with darkness, that person becomes blinded with thick darkness itself. It is always so that the person knows not any more what the daylight is like on the earth, and his mind and life are weakened and depressed.

This very thing, then, has befallen thee, my weanling, thou noble one, whom I have been wont to hold in my bosom.

Is not then what has befallen thy person so direful that it must not be neglected? Now, therefore, at this time thou art become thick darkness itself in thy grief. Now, thou knowest not anything of the quality of the light of day on the earth.

Now, oh, my offspring, do thou know it, that now the Three Brothers have made their preparations, and now, therefore, let them say, "Now therefore, we make it daylight again for thee. Now, most pleasantly will the daylight continue to be beautiful when again thou wilt look about thee whereon is outspread the handiwork of the Finisher of Our Faculties on the face of the earth."

Thus, therefore, for one brief little day mayst thou think thy thoughts in peace, thou noble one, thou yaanehr, my weanling.

In this manner, then, perhaps, let the Three Brothers, so denominated ever since they established their Commonwealth, effect this matter.

Now, therefore, do thou know it, my offspring, thou noble one, thou whom I have been wont to hold in my bosom, thou yaanehr, *thou Federal Chief,* that the Word, *the attesting wampum,* of thy adonni is on its way hence to thee.

David Livingstone

FROM MISSIONARY TRAVELS AND RESEARCHES IN SOUTH AFRICA

Scots medical missionary Livingstone (1813–1873) became a household name in the 19th century after the relief expedition of journalist Henry Stanley popularized their encounter with: "Dr. Livingstone, I presume?" Livingstone kept detailed, compassionate journals of his travels in central

and southern Africa during the 1840s and 1850s, reflecting his sincere desire to understand African systems of thought. A "witch doctor" of Malawi here challenges Livingstone's typically Western assumptions about the powers of science and the Christian deity; Africans, too, he shows, developed explanatory schemas for predictable and extraordinary outcomes in everyday life situations.

The natives, finding it irksome to sit and wait helplessly until God gives them rain from heaven, entertain the more comfortable idea that they can help themselves by a variety of preparations, such as charcoal made of burned bats, inspissated renal deposit of the mountain cony—*Hyrax capensis*—(which, by the way, is used, in the form of pills, as a good antispasmodic under the name of 'stone-sweat'), the internal parts of different animals—as jackals' livers, baboons' and lions' hearts, and hairy calculi from the bowels of old cows—serpents' skins and vertebrae, and every kind of tuber, bulb, root, and plant to be found in the country. Although you disbelieve their efficacy in charming the clouds to pour out their refreshing treasures, yet, conscious that civility is useful everywhere, you kindly state that you think they are mistaken as to their power; the rain doctor selects a particular bulbous root, pounds it, and administers a cold infusion to a sheep, which five minutes afterwards expires in convulsions. Part of the same bulb is converted into smoke, and ascends toward the sky; rain follows in a day or two. The inference is obvious. Were we as much harassed by droughts, the logic would be irresistible in England in 1857.

As the Bakwains believed there must be some connection between the presence of 'God's Word' in their town and these successive and distressing droughts, they looked with no good will at the church bell, but still they invariably treated us with kindness and respect. I am not aware of ever having an enemy in the tribe. The only avowed cause of dislike was expressed by a very influential and sensible man, the uncle of Sechele. 'We like you as well as if you had been born among us; you are the only white man we can become familiar with; but we wish you to give up that everlasting preaching and praying; we cannot become familiar with that at all. You see, we never get rain, while those tribes who never pray as we do obtain abundance.' This was a fact; and we often saw it raining on the hills ten miles off, while it would not look at us 'even with one eye'. If the Prince of the power of the air had no hand in scorching us up, I fear I often gave him the credit of doing so.

As for the rain-makers, they carried the sympathies of the people along with them, and not without reason. With the following arguments they were all acquainted, and in order to understand their force, we must place ourselves in their position, and believe, as they do, that all medicines act by a mysterious charm. The term for cure may be translated 'charm'.

MEDICAL DOCTOR. Hail, friend! How very many medicines you have about you this morning! Why, you have every medicine in the country here.

RAIN DOCTOR. Very true, my friend; and I ought; for the whole country needs the rain which I am making.

M.D. So you really believe that you can command the clouds? I think that can be done by God alone.

R.D. We both believe the very same thing. It is God that makes the rain, but I pray to him by means of these medicines, and, the rain coming, of course it is then mine. It was I who made it for the Bakwains for many years, when they were at Shokuane; through my wisdom, too, their women become fat and shining. Ask them; they will tell you the same as I do.

M.D. But we are distinctly told in the parting words of our Saviour that we can pray to God acceptably in His name alone, and not by means of medicines.

R.D. Truly! but God told *us* differently. He made black men first, and did not love us as he did the white men. He made you beautiful, and gave you clothing, and guns, and

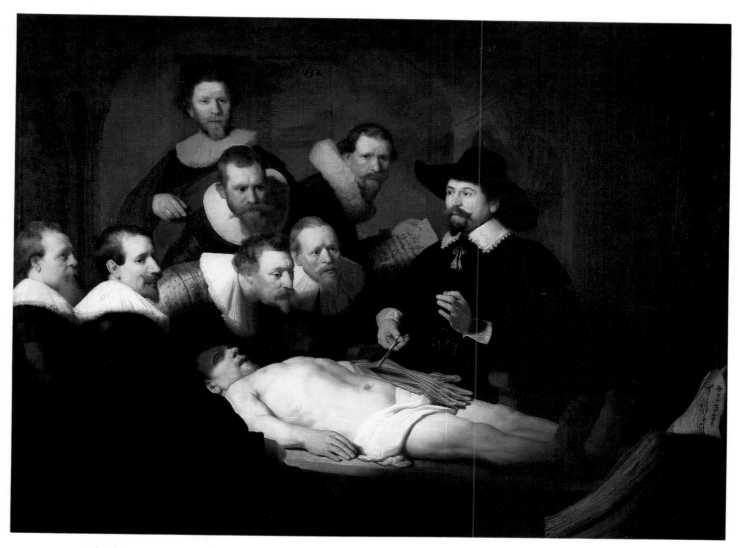

COLORPLATE 57

REMBRANDT VAN RIJN. *The Anatomy Lesson of Dr. Nicolaes Tulp.* 1632. Oil on canvas. 66¾ × 85¼ in. (169.5 × 216.5 cm). Mauritshuis, The Hague. *Posed anatomy lessons were a popular genre among surgeons and physicians of the early 17th century. The surgeon at the far left missed the original sitting and was added to the gathering at a later date. Rembrandt was just 26 when this was painted.*

COLORPLATE 58

JAN STEEN. *A Pregnant Woman in a Medical Consultation*. Mid 17th century. Oil on oak.
19⁵⁄₁₆ × 18⅛ in. (49 × 46 cm). National Gallery, Prague.

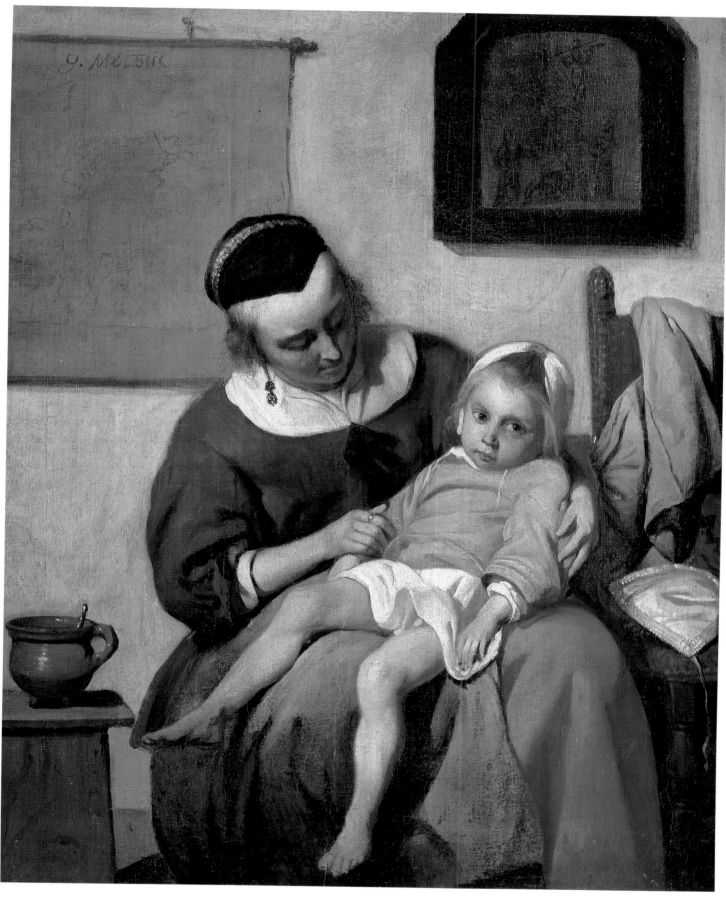

COLORPLATE 59

GABRIEL METSU. *The Sick Child.* 1660. Oil on canvas. 12¾ × 10¾ in. (32.4 × 27.3 cm).
Rijksmuseum, Amsterdam. *This masterpiece among medical paintings shows a young patient flushed,*
languid, and flaccid in his mother's arms. Before the 19th century, only one child in four reached adulthood.

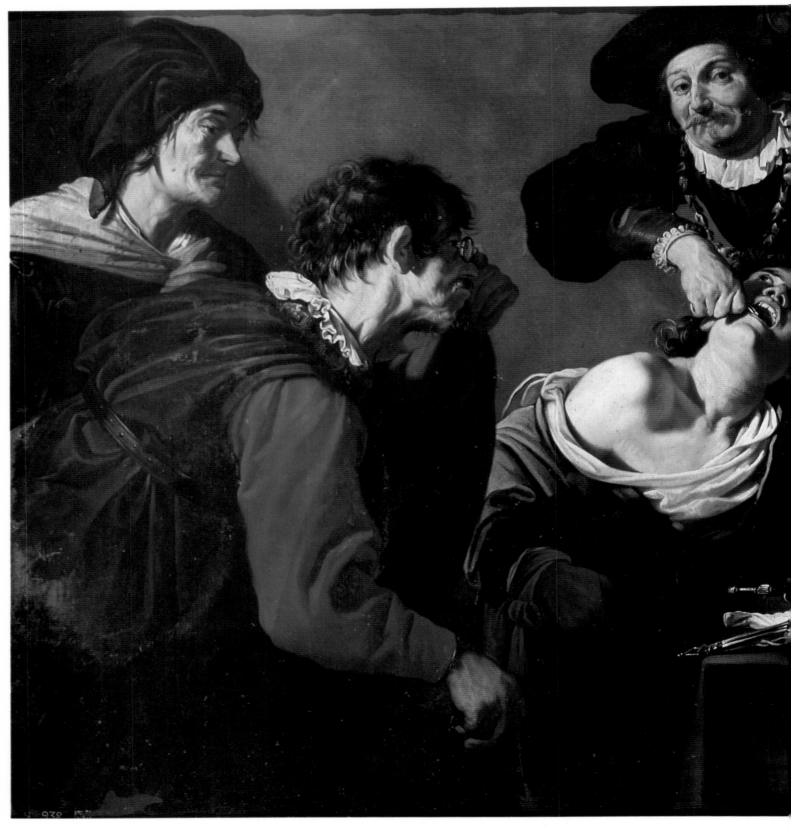

COLORPLATE 60

THEODOR ROMBOUTS. *Itinerant Toothpullers.* Early 17th century. Oil on canvas.
45¾ × 87 in. (116.2 × 221 cm). Prado, Madrid. *Medical themes were a favorite subject of Flemish realistic painters of the 17th century.*

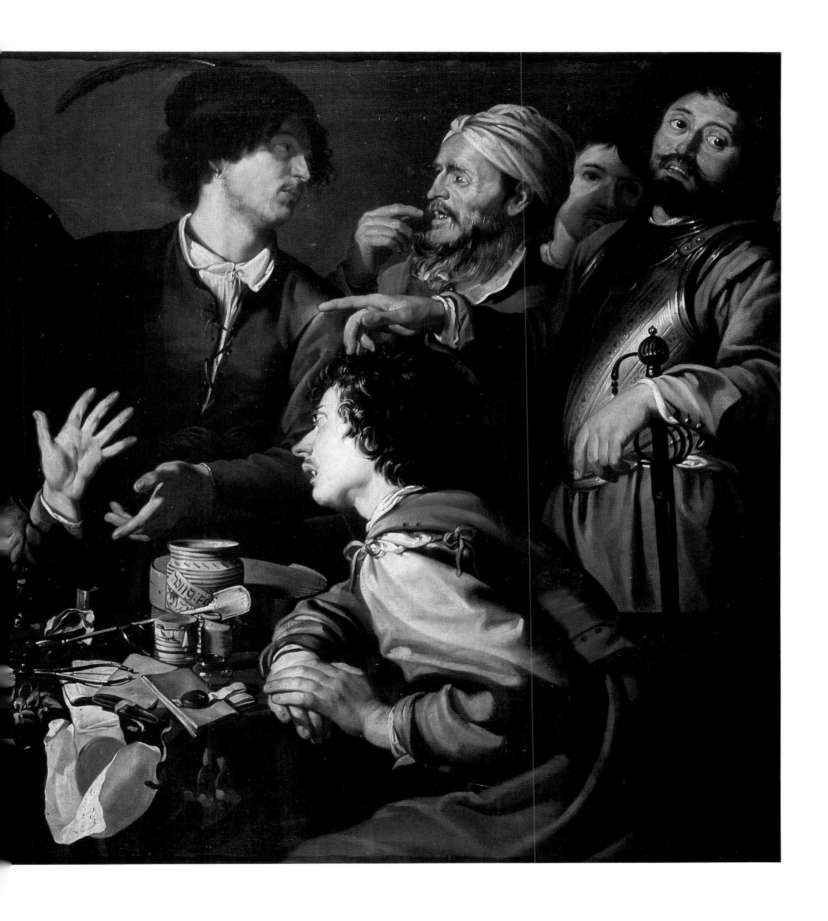

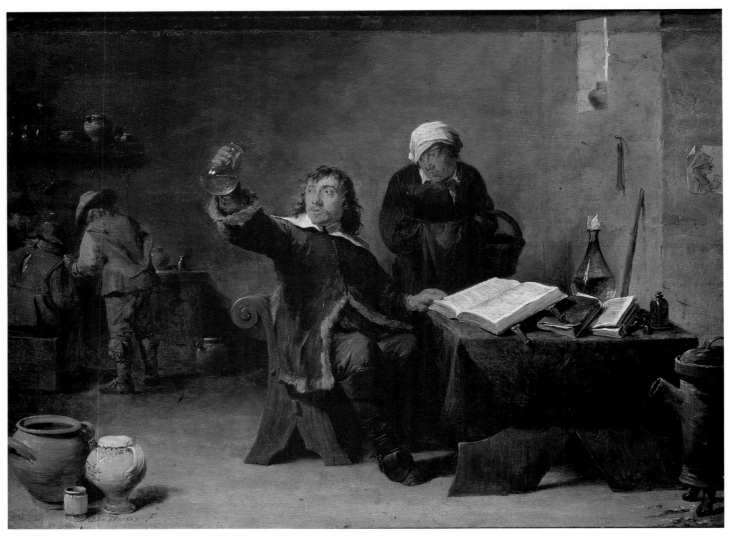

COLORPLATE 61

DAVID TENIERS, THE YOUNGER. *The Village Doctor*. 17th century. Oil on wood. 11 × 14⅝ in. (27.9 × 37.1 cm). Musées Royaux des Beaux-Arts de Belgique, Brussels. *Realistic painters of the 17th century were fond of homely, rustic scenes. Almost comic is the juxtaposition of a serious, would-be prosperous physician with the frightened peasant whose urine he examines.*

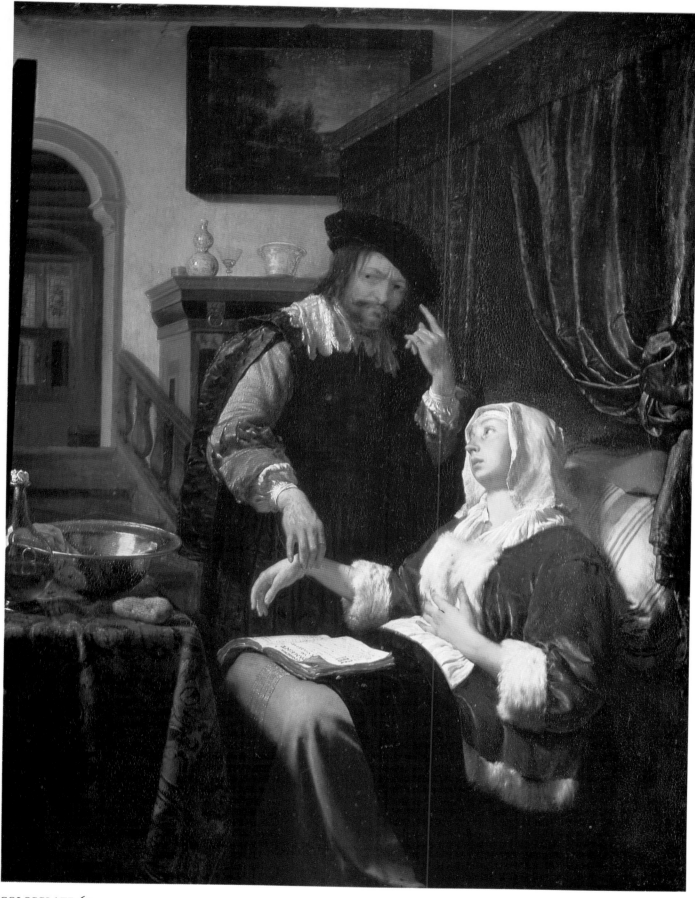

COLORPLATE 62

FRANS VAN MIERIS, THE ELDER. *The Doctor's Visit*. 1657. Oil on oak. 13⅜ × 10⅝ in. (34 × 27 cm). Kunsthistorisches Museum, Vienna.

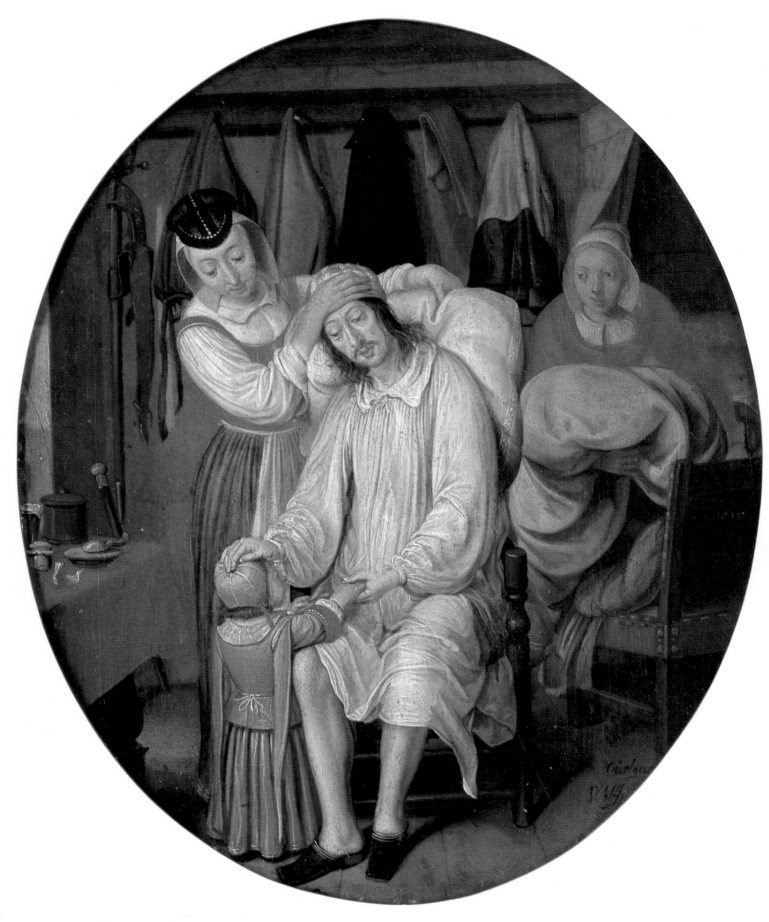

COLORPLATE 63

WOLFGANG HEIMBACH. *The Invalid,* or *The Sick Man.* 1669. Oil on copper.
9¼ × 7½ in. (23.5 × 19.1 cm). Kunsthalle, Hamburg.

gunpowder, and horses, and waggons, and many other things about which we know nothing. But towards us he had no heart. He gave us nothing except the assegai, and cattle, and rain-making; and he did not give us hearts like yours. We never love each other. Other tribes place medicines about our country to prevent the rain, so that we may be dispersed by hunger, and go to them, and augment their power. We must dissolve their charms by our medicines. God has given us one little thing which you know nothing of. He has given us the knowledge of certain medicines by which we can make rain. We do not despise those things which you possess, though we are ignorant of them. *We* don't understand your book, yet we don't despise it. *You* ought not to despise our little knowledge, though you are ignorant of it.

M.D. I don't despise what I am ignorant of; I only think you are mistaken in saying that you have medicines which can influence the rain at all.

R.D. That's just the way people speak when they talk on a subject of which they have no knowledge. When we first opened our eyes, we found our forefathers making rain, and we follow in their footsteps. You who send to Kuruman for corn, and irrigate your garden, may do without rain; *we* cannot manage in that way. If we had not rain, the cattle would have no pasture, the cows give no milk, our children become lean and die, our wives run away to other tribes who do make rain and have corn, and the whole tribe become dispersed and lost; our fire would go out.

M.D. I quite agree with you as to the value of the rain; but you cannot charm the clouds by medicines. You wait till you see the clouds come, then you use your medicines, and take the credit which belongs to God only.

R.D. I use my medicines, and you employ yours; we are both doctors, and doctors are not deceivers. You give a patient medicine. Sometimes God is pleased to heal him by means of your medicine; sometimes not—he dies. When he is cured, you take the credit of what God does. I do the same. Sometimes God grants us rain, sometimes not. When he does, we take the credit of the charm. When a patient dies, you don't give up trust in your medicine, neither do I when rain fails. If you wish me to leave off my medicines, why continue your own?

M.D. I give medicine to living creatures within my reach, and can see the effects, though no cure follows; you pretend to charm the clouds, which are so far above us that your medicines never reach them. The clouds usually lie in one direction, and your smoke goes in another. God alone can command the clouds. Only try and wait patiently; God will give us rain without your medicines.

R.D. Mahala-ma-kapa-a-a! Well, I always thought white men were wise till this morning. Who ever thought of making trial of starvation? Is death pleasant, then?

M.D. Could you make it rain on one spot and not on another?

R.D. I wouldn't think of trying. I like to see the whole country green, and all the people glad; the women clapping their hands, and giving me their ornaments for thankfulness, and lullilooing for joy.

M.D. I think you deceive both them and yourself.

R.D. Well, then, there is a pair of us (meaning both are rogues).

The above is only a specimen of their way of reasoning, in which, when the language is well understood, they are perceived to be remarkably acute. These arguments are generally known, and I never succeeded in convincing a single individual of their fallacy, though I tried to do so in every way I could think of. Their faith in medicines as charms is unbounded. The general effect of argument is to produce the impression that you are not anxious for rain at all; and it is very undesirable to allow the idea to spread that you do not take a generous interest in their welfare. An angry opponent of rain-making in a tribe would be looked upon as were some Greek merchants in England during the Russian war.

Edward S. Ayensu

"A Worldwide Role for the Healing Powers of Plants"

Edward Solomon Ayensu, a plant biologist, is author of over 100 books and articles, many of which are devoted to plant substances used by traditional healers. He worked for many years with the Smithsonian Institution's American Museum of Natural History as a curator in the department of botany and later chairman of the department. Ayensu directed the Endangered Species Program and served as the Secretary-General of the International Union of Biological Sciences. His wide national and international recognition was not enough to lure him permanently to the United States, and he returned to his native Ghana and the Ivory Coast, where he lives today.

The therapeutic value and healing powers of plants were demonstrated to me when I was a boy of about ten. I had developed an acute, persistent abdominal pain that did not respond readily to hospital medication. My mother had taken me to the city's central hospital on several occasions where different drugs were tried on me. In total desperation, she took me to Egya Mensa, a well-known herbalist in my hometown in the Western Province of Ghana. This man was no stranger to the medical doctors at the hospital. He had earned the reputation of offering excellent help when they were confronted with difficult cases where Western medicine had failed to effect a cure.

After a brief interview, not very different from what goes on daily in the consulting offices of many general medical practitioners in the United States, he left us waiting in his consulting room while he went out to the field. He returned with several leaves and the bark of a tree, and one of his attendants immediately prepared a decoction. I was given a glass of this preparation; it tasted extremely bitter, but within an hour or so I began to feel relieved. The rest of the decoction was put in two large bottles so that I could take doses periodically. Within about three days the frequent abdominal pains stopped and I recall regaining a good appetite. I have appreciated the healing powers of medicinal plants ever since.

My experience may sound unusual to those who come from urban areas of the developed world, but for those in the less affluent nations such experiences are a common occurrence. In fact, demographic studies by various national governments and intergovernmental organizations such as the World Health Organization (WHO) indicate that for 75 to 90 percent of the rural populations of the world, the herbalist is the only person who handles their medical problems.

In African culture traditional medical practitioners are always considered to be influential spiritual leaders as well, using magic and religion along with medicines. Illness is handled with Man's hidden spiritual powers and with application of plants that have been found especially to contain healing powers.

Over the years I have come to distinguish three types of medicinal practitioners in African societies, and to classify the extent to which each uses medicinal plants. The first is the herbalist, who generally enjoys the prestige and reputation of being the real traditional medical professional. Some herbalists are unassuming people. Others are very colorful individuals who adorn their wrists and necks with talismans, and thus remind one of a Western medical doctor in a white coat with a stethoscope around his neck. The second group represents the divine healers. They are fetish priests whose practice depends upon their purported supernatural powers of diagnosis. While traveling in villages and towns in West Africa, one is likely to encounter signboards with an inscription and an arrow pointing to the home of a spiritual or divine healer. On occasion they also treat patients by using plants that are supposed to have special spiritual powers. Thirdly, the witch doctor is the practitioner who is credited with ability to intercept the evil deeds of

a witch or who has the ability to exorcise an evil spirit that possesses a patient. Plants thought to have exorcising powers are used as part of the treatment paraphernalia.

All three kinds of practitioners are held in very high esteem in African societies because throughout history they have managed to keep the rural and urban populations in reasonable health. They have done so by relying almost exclusively on herbs for actual treatment, while serving as the people's spiritual leaders and psychologists.

In the spring of 1979 I had a singular opportunity of observing firsthand in Ghana the initiation of three young men and an older woman into the training program of a traditional healer. I visited this herbalist, introduced myself, and in about the same breath asked whether I might witness the initiation of his new recruits. To my amazement he beamed with joy and expressed his willingness to give both a verbal account of the entire three-year program and a demonstration of the preparation of the candidates before they actually begin to practice.

What kinds of people enter a training program to become traditional medical practitioners? I learned that very often a person going about ordinary daily routines or attending some religious ceremony suddenly hears "a voice." Without much warning he may fall into a trance, apparently possessed by a spirit. The relatives will quickly call in a qualified traditional medical practitioner to interpret what is going on. After the recitation of various incantations, the relatives are told that a spirit of a particular god in the possessed person's lineage would like to see him enter herbal practice.

If the relatives and prospective herbalist concur, the new student is first taken to a cemetery where he is given a ritual bath so that he can make contact with the spirits of his ancestors. While witnessing a demonstration of this very complex ceremonial bath, I noticed that parts of several plant species had been stuffed in a bucket of water, including bundles of African cucumber, *Momordica charantia*. This plant is also used in India and Pakistan to reduce fever and promote the secretion and flow of milk in nursing mothers, and in the West Indies it is used against rheumatism, fever and in birth control.

Immediately after the ceremonial bath the trainee is advised to observe certain taboos. The first and the most important instruction is to practice celibacy. If during the course of the three-year training he fails to observe this rule and still wants to become a herbalist, he will be required to make a sacrifice to the god at the shrine and commence his training all over again. In addition, the trainee is not allowed to take any alcoholic beverages, quarrel or fight with anyone, solicit the help of his particular god to harm anyone, go out at night, or serve the chief of his village or any of the chief's court. He is advised to dress very simply, usually in a piece of white cloth. He is also shown how to salute his elders correctly by bending the right knee and touching the ground with his right hand.

The first year of training is generally devoted to instilling discipline in the students. Although not isolated from the village community, a student is not encouraged to mix too freely with the village folk. He is encouraged to develop a distinctive personality by not cutting or combing his hair.

The second year brings the most important part of herbal training. The student is taken into the forests where he begins to study the local names, to hear recounted their descriptions and to learn the uses of plant parts. I had the good fortune of being asked to accompany a second-year trainee and his instructor into a shady enclave near a wayside cemetery. While en route to the bush, the instructor impressed upon the trainee the need for extreme concentration on the aspect of training they were about to undertake, since it involved the therapeutic portion of his program.

Beneath a lovely tree, the instructor picked up a big red bell-like flower known locally as "red tears" or African tulip tree, *Spathodea campanulata*. The first statement made by the instructor, who held the flower with extreme satisfaction, was: "Every plant you see in the forest was placed on this Earth by the Divine Providence with some specific purpose in mind. For example, this flower, when crushed with the bark of the same tree, is used for treating ulcers. The leaf decoction is excellent for gonorrhea, while one prepared from the tree bark is very good for kidney problems. It is therefore absolutely essential that you pay particular attention to the characteristics of the various plant parts, the location

of the trees and shrubs, as well as the spiritual instructions you receive from your deity."

The trainer emphasized to us that students must listen to various sounds while in the forest and observe the behavior of animals such as rodents, lizards, chameleons, snakes, birds and insects.

To stress his point, the trainer narrated his observation of a fight between two chameleons. At the climax of the fight one of the chameleons passed out. The other quickly dashed into a thicket and came back with a piece of a leaf in its mouth. It forcibly pushed the leaf into the mouth of the unconscious lizard. In a matter of two to three minutes the defeated chameleon shook its body and took off.

The specific plant that saved the life of the chameleon was not disclosed to me. When I insisted on knowing, the teacher smiled and said, "This is a trade secret. It is a plant that can spring a dying person to life. Unless you become one of us I cannot tell you."

The last phase of second-year training involves the adornment of the student's wrist, ankles, neck and long hair with various charms. The prospective healers are also taught how to offer a sacrifice to the gods by killing a live fowl and allowing its blood to flow over a fetish, or idol.

The final year is characterized by the art of water gazing. The student is taught how to gaze into a bowl of water with intense concentration so that he can see the faces of spirits or ancestors with whom he wants to communicate. During this period the trainee is further instructed to sharpen his ability to hear "voices," so that he can better interpret what the spirits or ancestors are trying to communicate to his patients. The end of the training program is characterized by the entering of a secret covenant between the trainer and the student. The oath of allegiance, or mutual fidelity, is established when the trainer is satisfied that the student has mastered his craft and can pass as a full-fledged medical practitioner. The licking of each other's blood, drawn from incisions made on their right wrists, is the final act of solidarity, as binding as the oath taken by medical students when they are awarded their medical degrees. A graduation ceremony performed in the open is conducted so that the entire village will recognize the new traditional medical practitioner in their midst and begin to use his services, although it takes several years before this new practitioner becomes a master.

Lu Hsun

"Tomorrow"

Originally trained as a physician, Lu Hsun turned to writing early in his life, first publishing, in 1918, his famous short story "A Madman's Diary," a rendition of Gogol's tale of the same title. Lu Hsun became part of the intellectual movement against feudalism and imperialism, turning to writing to help effect the changes he felt China needed to enter the modern era. The unspoken leader of China's politically radical writers, Lu Hsun also joined the fight to use the vernacular, rather than classical Chinese, in literature.

"Not a sound—what's wrong with the kid?"

A bowl of yellow wine in his hands, Red-nosed Kung jerked his head towards the next house as he spoke. Blue-skinned Ah-wu set down his own bowl and punched the other hard in the back.

"Bah . . . " he growled thickly. "Going sentimental again!"

Being so out-of-the-way, Luchen was rather old-fashioned. Folk closed their doors and went to bed before the first watch sounded. By midnight there were only two households awake. Prosperity Tavern where a few gluttons guzzled merrily round the bar, and the house next door where Fourth Shan's Wife lived. Left a widow two years earlier, she had nothing but the cotton-yarn she spun to support herself and her three-year-old boy; this is why she also slept late.

It was a fact that for several days now there had been no sound of spinning. But since only two households were awake at midnight, Old Kung and the others were naturally the only ones who would notice if there were any sound from Fourth Shan's Wife's house, and the only ones to notice if there were no sound.

After being punched, Old Kung—looking quite at his ease—took a great swig at his wine and piped up a folk tune.

Meanwhile Fourth Shan's Wife was sitting on the edge of her bed, Pao-erh—her treasure—in her arms, while her loom stood silent on the floor. The murky lamplight fell on Pao-erh's face, which showed livid beneath a feverish flush.

"I've drawn lots before the shrine," she was thinking. "I've made a vow to the gods, he's taken the guaranteed cure. If he still doesn't get better, what can I do? I shall have to take him to Dr. Ho Hsiao-hsien. But maybe Pao-erh's only bad at night; when the sun comes out tomorrow his fever may go and he may breathe more easily again. A lot of illnesses are like that."

Fourth Shan's Wife was a simple woman, who did not know what a fearful word "but" is. Thanks to this "but," many bad things turn out well, many good things turn out badly. A summer night is short. Soon after Old Kung and the others stopped singing the sky grew bright in the east; and presently through the cracks in the window filtered the silvery light of dawn.

Waiting for the dawn was not such a simple matter for Fourth Shan's Wife as for other people. The time dragged terribly slowly: each breath Pao-erh took seemed to last at least a year. But now at last it was bright. Clear daylight swallowed up the lamplight. Pao-erh's nostrils quivered as he gasped for breath.

Fourth Shan's Wife smothered a cry, for she knew that this boded ill. But what could she do? she wondered. Her only hope was to take him to Dr. Ho. She might be a simple woman, but she had a will of her own. She stood up, went to the cupboard, and took out her entire savings—thirteen small silver dollars and a hundred and eighty coppers in all. Having put the whole lot in her pocket, she locked the door and carried Pao-erh as fast as she could to Dr. Ho's house.

Early as it was, there were already four patients sitting there. She produced forty silver cents for a registration slip, and Pao-erh was the fifth to be seen. Dr. Ho stretched out two fingers to feel the child's pulses. His nails were a good four inches long, and Fourth Shan's Wife marvelled inwardly, thinking: "Surely my Pao-erh must be fated to live!" She could not help feeling anxious all the same, and could not stop herself asking nervously:

"What's wrong with my Pao-erh, doctor?"

"An obstruction of the digestive tract."

"Is it serious? Will he . . . ?"

"Take these two prescriptions to start with."

"He can't breathe, his nostrils are twitching."

"The element of fire overpowers that of metal. . . ."

Leaving this sentence unfinished, Dr. Ho closed his eyes; and Fourth Shan's Wife did not like to say any more. Opposite the doctor sat a man in his thirties, who had now finished making out the prescription.

"The first is Infant Preserver Pills," he told her, pointing to the characters in one corner of the paper. "You can get those only at the Chia family's Salvation Shop."

Fourth Shan's Wife took the paper, and walked out thinking as she went. She might be a simple woman, but she knew Dr. Ho's house, Salvation Shop and her own home formed a triangle; so of course it would be simpler to buy the medicine first before going back. She hurried as fast as she could to Salvation Shop. The assistant raised his long finger-nails too as he slowly read the prescription, then slowly wrapped up the medicine. With Pao-erh in her arms, Fourth Shan's Wife waited. Suddenly Pao-erh stretched up a little hand and tugged at his loose tuft of hair. He had never done this before, and his mother was terrified.

The sun was fairly high now. With the child in her arms and the package of medicine to carry, the further she walked the heavier she found her load. The child kept struggling too, which made the way seem even longer. She had to sit down on the door-step of a big house by the roadside to rest for a while; and presently her clothes lay so clammy against her skin that she realized she had been sweating. But Pao-erh seemed fast asleep. When she stood up again to walk slowly on, she still found him too heavy. A voice beside her said:

"Let me take him for you, Fourth Shan's Wife!" It sounded like Blue-skinned Ah-wu.

When she looked up, sure enough it was Ah-wu, who was following her with eyes still heavy from sleep.

Though Fourth Shan's Wife had been longing for an angel to come to her rescue, she had not wanted her champion to be Ah-wu. But there was something of the gallant about Ah-wu, for he absolutely insisted on helping her; and at last, after several refusals, she gave way. As he stretched his arm between her breast and the child, then thrust it down to take over Pao-erh, she felt a wave of heat along her breast. She flushed right up to her ears.

They walked along, two and a half feet apart. Ah-wu made some remarks, most of which Fourth Shan's Wife left unanswered. They had not gone far when he gave the child back to her, saying he had arranged yesterday to have a meal at this time with a friend.

Fourth Shan's Wife took Pao-erh back. Luckily it wasn't far now: already she could *see* Ninth Aunt Wang sitting at the side of the street. She called out:

"Fourth Shan's Wife, how's the child? . . . Did you get to see the doctor?"

"We saw him. . . . Ninth Aunt Wang, you're old and you've seen a lot. Will you look him over for me, and say what you think . . . ?

"Um."

"Well . . . ?"

"Ummm. . . ."

When Ninth Aunt Wang had examined Pao-erh, she nodded her head twice, then shook it twice.

By the time Pao-erh had taken his medicine it was after noon. Fourth Shan's Wife watched him closely, and he did seem a good deal quieter. In the afternoon he suddenly opened his eyes and called: "Ma!" Then he closed his eyes again and seemed to be sleeping. He had not slept long before his forehead and the tip of his nose were beaded with sweat, which, when his mother felt it, stuck to her fingers like glue. In a panic she felt his chest, then burst out sobbing.

After quieting down, his breathing had stopped completely. After sobbing, she started wailing. Soon groups of people gathered: inside the room Ninth Aunt Wang, Blue-skinned Ah-wu and the like; outside others like the landlord of Prosperity Tavern and Red-nosed Kung. Ninth Aunt Wang decreed that a string of paper coins should be burned; then, taking two stools and five articles of clothing as security, she borrowed two dollars for Fourth Shan's Wife to prepare a meal for all those who were helping.

The first problem was the coffin. Fourth Shan's Wife still had a pair of silver ear-rings and a silver hair-pin plated with gold, which she gave to the landlord of Prosperity Tavern so that he would go surety for her and buy a coffin half for cash, half on credit. Blue-skinned Ah-wu raised his hand to volunteer to help, but Ninth Aunt Wang would not hear of it. All she would let him do was carry the coffin the next day. "Old bitch!" he cursed, and stood there grumpily pursing his lips. The landlord left, coming back that evening to report that the coffin would have to be specially made, and would not be ready till nearly morning.

By the time the landlord came back the other helpers had finished their meal. And Luchen being rather old-fashioned, they all went home to sleep before the first watch. Only Ah-wu leaned on the bar of Prosperity Tavern drinking, while Old Kung croaked a song.

Meanwhile Fourth Shan's Wife sat on the edge of the bed crying, Pao-erh lay on the bed, and the loom stood silent on the floor. After a long time, when Fourth Shan's Wife had no more tears to shed, she opened her eyes wide, and looked around in amazement. All this was impossible! "This is only a dream," she thought. "It's all a dream. I shall wake up tomorrow lying snug in bed, with Pao-erh sleeping snugly beside me. Then he'll wake and call: 'Ma!' and jump down like a young tiger to play."

Old Kung had long since stopped singing, and the light had gone out in Prosperity Tavern. Fourth Shan's Wife sat staring, but could not believe all that had happened. A cock crew, the sky grew bright in the east, and through the cracks in the window filtered the silvery light of dawn.

By degrees the silvery light of dawn turned copper, and the sun shone on the roof. Fourth Shan's Wife sat there staring till someone knocked, when she gave a start and ran to open the door. A stranger was there with something on his back, and behind him stood Ninth Aunt Wang.

Oh, it was the coffin he'd brought!

Not till that afternoon was the lid of the coffin put on, because Fourth Shan's Wife kept crying, then taking a look, and could not bear to have the lid closed down. Luckily, Ninth Aunt Wang grew tired of waiting, hurried forward indignantly and pulled her aside. Then they hastily closed it.

Fourth Shan's Wife had really done all she could for her Pao-erh—nothing had been forgotten. The previous day she had burned a string of paper coins, this morning she had

burned the forty-nine books of the *Incantation of Great Mercy*, and before putting him in the coffin she had dressed him in his newest clothes and set by his pillow all the toys he liked best—a little clay figure, two small wooden bowls, two glass bottles. Though Ninth Aunt Wang reckoned carefully on her fingers, even then she could not think of anything they had forgotten.

Since Blue-skinned Ah-wu did not turn up all day, the landlord of Prosperity Tavern hired two porters for Fourth Shan's Wife at 210 large coppers each, who carried the coffin to the public graveyard and dug a grave. Ninth Aunt Wang helped her prepare a meal to which everyone who had lifted a finger or opened his mouth was invited. Soon the sun made it clear that it was about to set, and the guests unwittingly made it clear that they were about to leave—home they all went.

Fourth Shan's Wife felt dizzy at first, but after a little rest she quietened down. At once, though, she had the impression that things were rather strange. Something which had never happened to her before, and which she had thought never could happen, *had* happened. The more she thought, the more surprised she felt, and another thing that struck her as rather strange was the fact that the room had suddenly grown too silent.

After she stood up and lit the lamp, the room seemed even more silent. She groped her way over to close the door, came back and sat on the bed, while the loom stood silent on the floor. She pulled herself together and looked around, feeling unable either to sit or stand. The room was not only too silent, it was far too big as well, and the things in it were far too empty. This overlarge room hemmed her in, and the emptiness all around bore hard on her, till she could hardly breathe.

She knew now her Pao-erh was really dead; and, not wanting to see this room, she blew out the light and lay down to cry and think. She remembered how Pao-erh had sat by her side when she spun, eating peas flavoured with aniseed. He had watched her intently with his small black eyes and thought. "Ma!" he suddenly said. "Dad sold *hun tun*. When I'm big I'll sell *hun tun* too, and make lots and lots of money—and I'll give it all to you."

At such times even every inch of yarn she spun seemed worthwhile and alive. But what now? Fourth Shan's Wife had not considered the present at all—as I have said, she was only a simple woman. What solution could she think of? All she knew was that this room was too silent, too large, too empty.

But even though Fourth Shan's Wife was a simple woman, she knew the dead cannot come to life again, and she would never see her Pao-erh any more. She sighed and said: "Pao-erh, you must still be here. Let me see you in my dreams." Then she closed her eyes, hoping to fall asleep at once so that she could see Pao-erh. She heard her hard breathing clearly through the silence, the vastness and emptiness.

At last Fourth Shan's Wife dozed off, and the whole room was very still. Red-nosed Kung's folk song had long since ended, and he had staggered out of Prosperity Tavern to sing in a falsetto:

"I pity you—my darling—all alone. . . . "

Blue-skinned Ah-wu grabbed Old Kung's shoulder, and laughing tipsily they reeled away together.

Fourth Shan's Wife was asleep, Old Kung and the others had gone, the door of Prosperity Tavern was closed. Luchen was sunk in utter silence. Only the night, eager to change into the morrow, was journeying on in the silence; and, hidden in the darkness, a few dogs were barking.

PATIENT VISIONS: THE LITERATURE OF ILLNESS

Thomas De Quincey

FROM CONFESSIONS OF AN ENGLISH OPIUM EATER

A versatile writer celebrated in his own day as a member of the "Lake District School," which included Southey, Wordsworth, and Coleridge, De Quincey (1785–1859) translated Latin and wrote essays, history, and, as here, a highly descriptive type of autobiography. He wrote his classic account of opium use in 1821, when he was 36. De Quincey virtually gulped the narcotic—as much as 8,000 drops a day—for purposes of reverie and to alleviate a presumably gastric abdominal pain.

Wine robs a man of his self-possession: opium greatly invigorates it. Wine unsettles and clouds the judgment, and gives a preternatural brightness, and a vivid exaltation to the contempts and the admirations, the loves and the hatreds, of the drinker: opium, on the contrary, communicates serenity and equipoise to all the faculties, active or passive: and with respect to the temper and moral feelings in general, it gives simply that sort of vital warmth which is approved by the judgment, and which would probably always accompany a bodily constitution of primeval or antediluvian health. Thus, for instance, opium, like wine, gives an expansion to the heart and the benevolent affections: but then, with this remarkable difference, that in the sudden development of kind-heartedness which accompanies inebriation, there is always more or less of a maudlin character, which exposes it to the contempt of the by-stander. Men shake hands, swear eternal friendship, and shed tears—no mortal knows why: and the sensual creature is clearly uppermost. But the expansion of the benigner feelings, incident to opium, is no febrile access, but a healthy restoration to that state which the mind would naturally recover upon the removal of any deep-seated irritation of pain that had disturbed and quarrelled with the impulses of a heart originally just and good. True it is, that even wine, up to a certain point, and with certain men, rather tends to exalt and to steady the intellect: I myself, who have never been a great wine-drinker, used to find that half a dozen glasses of wine advantageously affected the faculties—brightened and intensified the consciousness—and gave to the mind a feeling of being "ponderibus librata suis:" and certainly it is most absurdly said, in popular language, of any man, that he is *disguised* in liquor: for, on the contrary, most men are disguised by sobriety; and it is when they are drinking (as some old gentleman says in Athenæus), that men εὰντοὺς ἐμφανίζουσιν οἵτινες εἰσίν—display themselves in their true complexion of character; which surely is not disguising themselves. But still, wine constantly leads a man to the brink of absurdity and extravagance; and, beyond a certain point, it is sure to volatilize and to disperse the intellectual energies: whereas opium always seems to compose what had been agitated, and to concentrate what had been distracted. In short, to sum up all in one word, a man who is inebriated, or tending to inebriation, is, and feels that he is, in a condition which calls up into supremacy the merely

human, too often the brutal, part of his nature: but the opium-eater (I speak of him who is not suffering from any disease, or other remote effects of opium,) feels that the diviner part of his nature is paramount; that is, the moral affections are in a state of cloudless serenity; and over all is the great light of the majestic intellect.

This is the doctrine of the true church on the subject of opium: of which church I acknowledge myself to be the only member—the alpha and the omega: but then it is to be recollected, that I speak from the ground of a large and profound personal experience: whereas most of the unscientific authors who have at all treated of opium, and even of those who have written expressly on the materia medica, make it evident, from the horror they express of it, that their experimental knowledge of its action is none at all. I will, however, candidly acknowledge that I have met with one person who bore evidence to its intoxicating power, such as staggered my own incredulity: for he was a surgeon, and had himself taken opium largely. I happened to say to him, that his enemies (as I had heard) charged him with talking nonsense on politics, and that his friends apologized for him, by suggesting that he was constantly in a state of intoxication from opium. Now the accusation, said I, is not *prima facie*, and of necessity, an absurd one: but the defence *is*. To my surprise, however, he insisted that both his enemies and his friends were in the right: "I will maintain," said he, "that I *do* talk nonsense; and secondly, I will maintain that I do not talk nonsense upon principle, or with any view to profit, but solely and simply, said he, solely and simply,—solely and simply (repeating it three times over), because I am drunk with opium; and *that* daily." I replied that, as to the allegation of his enemies, as it seemed to be established upon such respectable testimony, seeing that the three parties concerned all agreed in it, it did not become me to question it; but the defence set up I must demur to. He proceeded to discuss the matter, and to lay down his reasons; but it seemed to me so impolite to pursue an argument which must have presumed a man mistaken in a point belonging to his own profession, that I did not press him even when his course of argument seemed open to objection: not to mention that a man who talks nonsense, even though "with no view to profit," is not altogether the most agreeable partner in a dispute, whether as opponent or respondent. I confess, however, that the authority of a surgeon, and one who was reputed a good one, may seem a weighty one to my prejudice: but still I must plead my experience, which was greater than his greatest by 7000 drops a day; and, though it was not possible to suppose a medical man unacquainted with the characteristic symptoms of vinous intoxication, it yet struck me that he might proceed on a logical error of using the word intoxication with too great latitude, and extending it generically to all modes of nervous excitement, instead of restricting it as the expression for a specific sort of excitement, connected with certain diagnostics. Some people have maintained, in my hearing, that they had been drunk upon green tea: and a medical student in London, for whose knowledge in his profession I have reason to feel great respect, assured me, the other day, that a patient, in recovering from an illness, had got drunk on a beef-steak.

Having dwelt so much on this first and leading error, in respect to opium, I shall notice very briefly a second and a third; which are, that the elevation of spirits produced by opium is necessarily followed by a proportionate depression, and that the natural and even immediate consequence of opium is torpor and stagnation, animal and mental. The first of these errors I shall content myself with simply denying; assuring my reader, that for ten years, during which I took opium at intervals, the day succeeding to that on which I allowed myself this luxury was always a day of unusually good spirits.

With respect to the torpor supposed to follow, or rather (if we were to credit the numerous pictures of Turkish opium-eaters) to accompany the practice of opium-eating, I deny that also. Certainly, opium is classed under the head of narcotics; and some such effect it may produce in the end: but the primary effects of opium are always, and in the highest degree, to excite and stimulate the system: this first stage of its action always lasted with me, during my noviciate, for upwards of eight hours; so that it must be the fault of the opium-eater himself if he does not so time his exhibition of the dose (to speak medically) as that the whole weight of its narcotic influence may descend upon his sleep.

Howard Markel

"Charles Dickens and the Art of Medicine"

At mid-century Dickens (1812–1870) was as strong a force for Victorian social reform as had been the great Poor Law of 1832 and the statistical surveys (1840s) of Edwin Chadwick. Dickens described the wretched living conditions of destitute Londoners with a clinical eye that no detail escaped. Dr. Markel shows how retrospective diagnosis is possible with even a minor character in a Dickens novel.

Charles Dickens, one of England's greatest novelists, was fascinated by disease. Dickens studied these elements of humanity carefully, as a skilled physician would, in order to create characters who were as realistic as possible—including those who were ill. Dickens observed physicians and patients, frequently visited hospitals, and was a strong and persuasive advocate of public health reforms. These activities allowed Dickens to comprehend the many disease processes, both physical and emotional, of the people of his world.

<p align="center">★ ★ ★</p>

In *Bleak House*, Phil Squod, Mr. George's assistant at the Shooting Gallery, has a physical mannerism that identifies his presence throughout the novel. Dickens describes Phil's walk as "shouldering his way around the gallery in the act of sweeping it." Quite literally, Phil cannot walk on his own two feet without falling unless he drags one shoulder against the wall for support: "Phil has to sidle round a considerable part of the gallery for every object he wants." The description reminds one of true vertigo, a condition described by Sir William Osler as being "always accompanied by a sensation of falling or turning, even when the person is in bed, and if standing, there is incoordination of the muscles with staggering and falling." Phil's continuous habit of "shouldering his way along walls" is worsened by sudden attacks which render him helpless to walk on his own:

> "It was after the case-filling blow-up when I first see you Commander. You remember?"
> "I remember, Phil. You were walking along in the sun."
> "Crawling, gov'ner, against a wall."
> "True, Phil—shouldering your way on—"
> "And hobbling with a couple of sticks!," cries Phil.

Phil also hears loud, painful, "banging" noises during his attacks. To make Phil's situation worse, he works in a shooting gallery where loud noises are constantly produced. The combination of Phil's intense dizzy spells and the loud noises he hears presents as a type of dysfunction of the vestibular nerve (cranial nerve VIII), most likely Ménière's disorder, which was first described in 1861, 9 years after the publication of *Bleak House*. Ménière's disorder is caused by a dilation of the inner ear and endolymphatic system leading to a degeneration of the delicate vestibular and cochlear hair cells. The connections between these changes and the paroxysmal disorder of labyrinth function is not known, although Barany grouped the conditions in which the labyrinth may be affected and vertigo occur as acute infectious diseases (influenza, meningitis); chronic infections (tertiary syphillis); constitutional conditions and intoxications; tumors and diseases of the central nervous system; trauma and fracture of the base of the skull; and hereditary degenerative diseases and malformations of the internal ear. The cause of the disorder is still unclear although its symptoms are well documented as an intra-aural fullness or pressure that may irritate the patient for weeks, days, or hours before the attack. Such intra-aural

pressure could upset Phil's sense of equilibrium, causing him to walk leaning against walls for support. The increased pressure is quickly forgotten during an acute episode with the abrupt onset of severe vertigo and a depression of hearing in the involved ear due to a loud, roaring tinnitus, leading to one of Phil's "spells."

Phil's remaining history is worth recounting. Raised in his parish's workhouse, Phil left the "beneficence" of Victorian England's welfare system at age 8 to work, for at least 15 years, with a tinker. The tinker was the itinerant kitchen utensil repairman who wandered throughout English literature until the advent of the "Disposable Age." Tinkers usually worked at a fire hot enough to melt the cheap, malleable metals (iron, tin, and, rarely, lead) used to repair small holes in pots and pans. Phil points out that although he was inept as a tinker, the materials he used were "iron and block tin." Phil also explains the occupational hazards of being a tinker:

> "What with blowing the fire with my mouth when I was young, and
> spileing my complexion, and singeing my hair off, and swallering the smoke,
> and what with being nat'rally unfort'nate in the way of running against hot
> metal. . . ."

It is doubtful, however, that Phil's vestibular nerve dysfunction, the inability to process correctly the impressions arising in the labyrinth, cerebellum, and elsewhere, and coordinate these in the cerebrum is a direct result of his occupation as a tinker. For example, exposure to the fumes of copper, zinc, and other volatilized metals can cause a self-limited, influenza-like syndrome—metal fume fever—which is accompanied by shaking, chills, fever, excessive salivation, headache, cough, malaise, and pronounced leukocytosis. Such exposure to heavy metals may cause an infectious neuronitis leading to a Ménière-like syndrome, but it is unlikely. Further, Phil does not use lead in his work and clearly shows none of the complications seen in chronic lead poisoning. Phil has no history of lead-induced colic, his appetite is described by Dickens as "hearty," and it is Phil who prepares the meals taken by Mr. George and himself at the Shooting Gallery.

Phil's neuromuscular condition of vertigo and falling down seems to point more toward a vestibular nerve and labyrinth disorder than a lead-induced polyneuropathy. Such polyneuropathies commonly affect the motor function of the upper extremities with the radial nerve being most involved. Occasionally, one sees a weakness of proximal shoulder girdle muscles and, in the lower extremities, foot drop may appear. Finally, in connection with Phil's "tinkering", we must consider the possibility of poisoning from iron and tin, the two metals Phil admits to using. Iron and tin oxidases, which are used extensively in welding and metallurgy produce "nuisance dusts." The major impact of nuisance dusts seem to be reduction of visibility and irritation of the eyes, ears, nasal passages, and other mucous membranes. These nuisance dusts are benign and rarely cause more than a reversible pulmonary disease.

More relevant to the diagnosis is Phil's history of being "throwed all sorts of styles, all my life." Phil was "blowed out of a winder" while working as a case-filler in a fireworks factory, "scorched in a accident" at a gas works, and is so proud of his "queer beauty" he declares:

> "They can't spoil my beauty, I'm all right. Come on! If they want a man to
> box at, let 'em box at me. Let 'em knock me well about the head. I don't mind.
> If they want a light-weight to be throwed for practice . . . let 'em throw me."

All of these activities, particularly Phil's interest in pugilism and being knocked "well about the head" could lead to a traumatic head injury and hemorrhage into the labyrinth. Such a penchant for head injuries could either cause Ménière's disorder in Phil or exacerbate a preexisting condition.

Sir Frederick Treves

FROM *"Two Women"*

Sir Frederick Treves (1853–1923) was a famous surgeon and the author of medical stories, including The Elephant Man *(1923), the account of John Thomas Merrick's life with neurofibromatosis. Treves's* Surgical Applied Anatomy *of 1883 quickly became the standard surgical anatomy text of the day. King Edward VII made Treves a baronet after Treves diagnosed the king's abdominal pain as acute appendicitis and persuaded the king to have an operation rather than his coronation as scheduled; after the king persisted in refusing surgery, Treves remarked: "In that case, Sir, you will go to the Abbey as a corpse." The following is excerpted from one example of Treves's prolific writing.*

In the course of his experience the medical man acquires probably a more intimate knowledge of human nature than is attained by most. He gains an undistorted insight into character. He witnesses the display of elemental passions and emotions. He sees his subject, as it were, unclothed and in the state of a primitive being. There is no camouflage of feeling, no assumption of a part, no finesse. There is merely a man or a woman faced by simple, rudimentary conditions. He notes how they act under strain and stress, under the threat of danger or when menaced by death. He observes their behaviour both during suffering and after relief from pain, the manner in which they bear losses and alarms and how they express the consciousness of joy. These are the common emotional experiences of life, common alike to the caveman and the man of the twentieth century. Among the matters of interest in this purview is the comparative bearing of men and of women when subject to the hand of the surgeon. As to which of the two makes the better patient is a question that cannot be answered in a word. Speaking generally women bear pain better than men. They endure a long illness better, both physically and morally. They are more patient and submissive, less defiant of fate and, I think I may add, more logical. There are exceptions, of course, but then there are exceptions in all things.

Perhaps what the critic of gold calls the 'acid test' is provided by the test of an operation. Here is something very definite to be faced. A man is usually credited with more courage than a woman. This is no doubt a just estimate in situations of panic and violence where less is expected of a woman; but in the cold, deliberate presence of an operation she stands out well.

A display of courage in a man is instinctive, a feature of his upbringing, a matter of tradition. With women is associated a rather attractive element of timidity. It is considered to be a not indecorous attribute of her sex. It is apt to be exaggerated and to become often somewhat of a pose. A woman may be terrified at a mouse in her bedroom and yet will view the entrance into that room of two white-clad inquisitors—the anæsthetist and the surgeon—with composure. A woman will frankly allow, under certain conditions, that she is 'frightened to death'; the man will not permit himself that expression, although he is none the less alarmed. A woman seldom displays bravado; a man often does. To sum up the matter—a woman before the tribunal of the operating theatre is, in my experience, as courageous as a man, although she may show less resolve in concealing her emotions.

In the determination to live, which plays no little part in the success of a grave operation, a woman is, I think, the more resolute. Her powers of endurance are often amazing. Life may hang by a thread, but to that thread she will cling as if it were a straining rope. I recall the case of a lady who had undergone an operation of unusual duration and severity. She was a small, fragile woman, pale and delicate-looking. The blow she had received would have felled a giant. I stood by her bedside some hours after

the operation. She was a mere grey shadow of a woman in whom the signs of life seemed to be growing fainter and fainter. The heat of the body was maintained by artificial means. She was still pulseless and her breathing but a succession of low signs. She evidently read anxiety and alarm in the faces of those around her, for, by a movement of her lips, she indicated that she wished to speak to me. I bent down and heard in the faintest whisper the words, 'I am *not* going to die.' She did not die; yet her recovery was a thing incredible. Although twenty-eight years have elapsed since that memorable occasion, I am happy to say that she is still alive and well.

There are other traits in women that the surgeon comes upon which, if not actually peculiar to their sex, are at least displayed by them in the highest degree of perfection. Two of these characteristics—or it may be that the two are one—are illustrated by the incidents which follow.

The first episode may appear to be trivial, although an eminent novelist to whom I told the story thought otherwise and included it, much modified, in one of his books.

The subject was a woman nearing forty. She was plain to look at, commonplace and totally uninteresting. Her husband was of the same pattern and type, a type that embraces the majority of the people in these islands. He was engaged in some humdrum business in the city of London. His means were small and his life as monotonous as a downpour of rain. The couple lived in a small red-brick house in the suburbs. The house was one of twenty in a row. The twenty were all exactly alike. Each was marked by a pathetic pretence to be 'a place in the country'; each was occupied by a family of a uniform and wearying respectability. These houses were like a row of chubby inmates from an institution, all wearing white cotton gloves and all dressed alike in their best.

The street in which the houses stood was called 'The Avenue,' and the house occupied by the couple in question was named 'The Limes.' It was difficult to imagine that anything of real interest could ever occur in 'The Avenue.' It was impossible to associate that decorous road with a murder or even a burglary, much less with an elopement. The only event that had disturbed its peace for long was an occasion when the husband of one of the respected residents had returned home at night in a state of noisy intoxication. For months afterwards the dwellers in 'The Avenue', as they passed that house, looked at it askance. It may be said, in brief, that all the villas were 'genteel' and that all those who lived in them were 'worthy.'

The plain lady of whom I am speaking had no children. She had been happy in a stagnant, unambitious way. Everything went well with her and her household, until one horrifying day when it was discovered that she had developed a malignant tumour of the breast. The growth was operated upon by a competent surgeon, and for a while the spectre was banished. The event, of course, greatly troubled her; but it caused even more anxiety to her husband. The two were very deeply attached. Having few outside interests or diversions, their pleasure in life was bound up with themselves and their small home.

The husband was a nervous and imaginative man. He brooded over the calamity that had befallen his cherished mate. He was haunted by the dread that the horrid thing would come back again. When he was busy at his office he forgot it, and when he was at home and with a wife who seemed in such beaming health it left his mind. In his leisure moments, however, in his journeyings to London and back and in sleepless hours of the night, the terror would come upon him again. It followed him like a shadow.

Time passed; the overhanging cloud became less black and a hope arose that it would fade away altogether. This, however, was not to be. The patient began to be aware of changes at the site of the operation. Unpleasant nodules appeared. They grew and grew and every day looked angrier and more vicious. She had little doubt that 'it'—the awful unmentionable thing—had come back. She dared not tell her husband. He was happy again; the look of anxiety had left his face and everything was as it had been. To save him from distress she kept the dread secret and, although the loathsome thing was gnawing at her vitals, she smiled and maintained her wonted cheerfulness when he and she were together.

She kept the secret too long. In time she began to look ill, to become pallid and feeble

and very thin. She struggled on and laughed and joked as in the old days. Her husband was soon aware that something was amiss. Although he dared not express the thought, a presentiment arose in his mind that the thing of terror was coming back. He suggested the she should see her surgeon again, but she pooh-poohed the idea. 'Why should a healthy woman see a surgeon?' At last her husband, gravely alarmed, insisted, and she did as he wished.

The surgeon, of course, saw the position at a glance. The disease had returned, and during the long weeks of concealment had made such progress that any operation or indeed any curative measure was entirely out of the question. Should he tell her? If he told her what would be gained thereby? Nothing could be done to hinder the progress of the malady. To tell her would be to plunge her and her husband into the direst distress. The worry that would be occasioned could only do her harm. Her days were numbered; why not make what remained of her life as free from unhappiness as possible? It was sheer cruelty to tell her. Influenced by these humane arguments he assured her it was all right, patted her on the back and told her to run away home.

For a while both she and her husband were content. She was ready to believe that she had deceived herself and regretted the anxiety she had occasioned; but the unfortunate man did not remain long at ease. His wife was getting weaker and weaker. He wondered why. The surgeon said she was all right; she herself maintained that she was well, but why was she changing so quickly? The doubt and the uncertainty troubled both of them; so it was resolved that a second opinion should be obtained, with the result that she came to see me in London.

A mere glimpse was enough to reveal the condition of affairs. The case was absolutely hopeless as her surgeon, in a letter, had already told me. I was wondering how I should put the matter to her but she made the decision herself. She begged me to tell her the absolute truth. She was not afraid to hear it. She had plans to make. She had already more than a suspicion in her mind and for every reason she must know, honestly and openly, the real state of affairs. I felt that matters were too far gone to justify any further concealment. I told her. She asked if any treatment was possible. I was obliged to answer 'No.' She asked if she would live six months and again I was compelled to answer 'No.'

What happened when she left my house I learned later. It was on a Saturday morning in June that she came to see me. For her husband Saturday was a half-holiday and a day that he looked forward to with eager anticipation. So anxious was he as to my verdict that he had not gone to his business on this particular day. He had not the courage to accompany his wife to London and, indeed, she had begged him not to be present at the consultation. He had seen his wife into the train and spent the rest of the morning wandering listlessly about, traversing every street, road and lane in the neighbourhood in a condition of misery and apprehension.

He knew by what train she would return, but he had not the courage to meet it. He would know the verdict as she stepped out of the carriage and as he caught a glimpse of her face. The platform would be crowded with City friends of his, and whatever the news—good or bad—he felt that he would be unable to control himself.

He resolved to wait for her at the top of 'The Avenue,' a quiet and secluded road. He could not, however, stand still. He continued to roam about aimlessly. He tried to distract his thoughts. He counted the railings on one side of a street, assuring himself that if the last railing proved to be an even number his wife would be all right. It proved to be uneven. He jingled the coins in his pocket and decided that if the first coin he drew out came up 'Heads,' it would be a sign that his wife was well. It came up 'Heads.' Once he found that he had wandered some way from 'The Avenue' and was seized by the panic that he would not get back there in time. He ran back all the way to find, when he drew up, breathless, that he had still twenty-five minutes to wait.

He thought the train would never arrive. It seemed hours and hours late. He looked at his watch a dozen times. At last he heard the train rumble in and pull up at the station. The moment had come. He paced the road to and fro like a caged beast. He opened his coat the better to breathe. He took off his hat to wipe his streaming forehead. He watched

the corner at which she would appear. She came suddenly in sight. He saw that she was skipping along, that she was waving her hand and that her face was beaming with smiles. As she approached she called out, 'It is all right!'

He rushed to her, she told me, with a yell, threw his arms round her and hugged her until she thought she would have fainted. On the way to the house he almost danced round her. He waved his hat to everybody he saw and, on entering the house, shook the astonished maid-servant so violently by the hand that she thought he was mad.

That afternoon he enjoyed himself as he had never done before. The cloud was removed, his world was a blaze of sunshine again, his wife was saved. She took him to the golf links and went round with him as he played, although she was so weak she could hardly crawl along. His game was a series of ridiculous antics. He used the handle of his club on the tee, did his putting with a driver and finished up by giving the caddie half a sovereign. In the evening his wife hurriedly invited a few of his choicest friends to supper. It was such a supper as never was known in 'The Avenue' either before or since. He laughed and joked, was generally uproarious, and finished by proposing the health of his wife in a rapturous speech. It was the day of his life.

Next morning she told him the truth.

I asked her why she had not told him at once. She replied, 'It was his half-holiday and I wished to give him just one more happy day.'

Leo Tolstoy
FROM THE DEATH OF IVAN ILYICH

Tolstoy (1828–1910) was a man of many contradictions. Dissolute as a young man, he later became a stern moralist holding puritanical notions about sexual love; the same writer who described himself as a "general of literature" later espoused nonviolence, corresponding with Gandhi. "The Death of Ivan Ilyich" was written in 1886 and was one of the first works to signal a return to fiction, following seven years of works chronicling Tolstoy's adoption of Christianity, a spiritual conversion readily reflected in this short story.

The whole family was in good health. Ivan Ilyich sometimes complained of a queer taste in his mouth and a sort of uncomfortable feeling on the left side of the stomach, but one could hardly call that illness.

But this uncomfortable feeling got worse and, though not exactly painful, grew into a sense of pressure in his side accompanied by low spirits and irritability. The irritability became worse and worse and began to mar the agreeable, easy, seemly existence the Golovins had settled down to. Husband and wife quarrelled more and more frequently, and before long all the easiness and amenity of life had fallen away and it was with difficulty that they managed to preserve appearances. As before, there were repeated scenes, until very few of those islets in the sea of contention remained on which husband and wife could meet without an explosion. And Praskovya Fiodorovna said, not without justification now, that her husband had a trying temper. With characteristic exaggeration she maintained that he had always had a dreadful temper, and that it had needed all her good nature to put up with it for twenty years. It was true that now he was the one to begin the quarrels. His gusts of temper always broke out as they were sitting down to dinner, often just as he was beginning the soup. He would observe that a plate or dish had been chipped, or the food did not taste as it should, or his son put his elbow on the

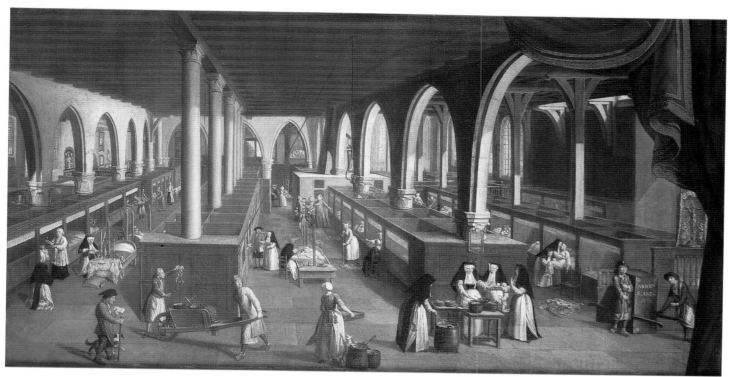

COLORPLATE 64

JOHANNES BEERBLOCK. *View of the Old Sick Ward of St. John's Hospital, Bruges.* 1778. Oil on canvas. 32¼ × 60¼ (81.9 × 153 cm). Memlingmuseum, Bruges. *Beerblock captures details of the varieties of medical and charitable care in large 18th-century hospitals, a time of impressive growth in the number and size of hospitals.*

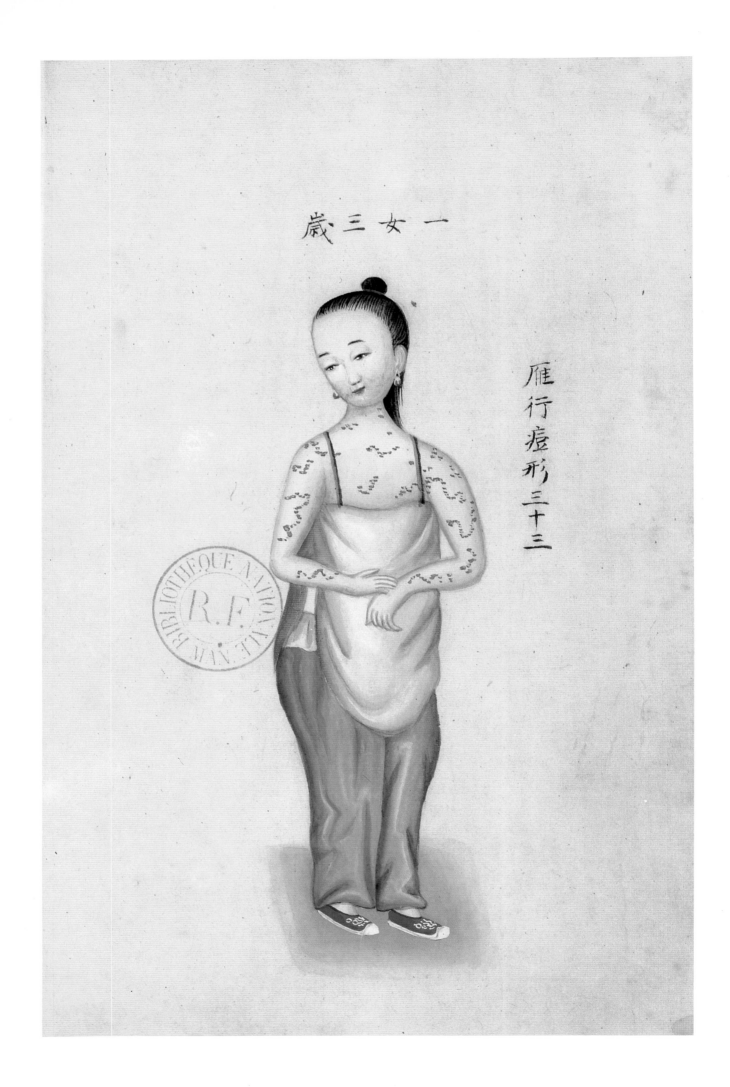

一女三歲

雁行痘形三十三

210

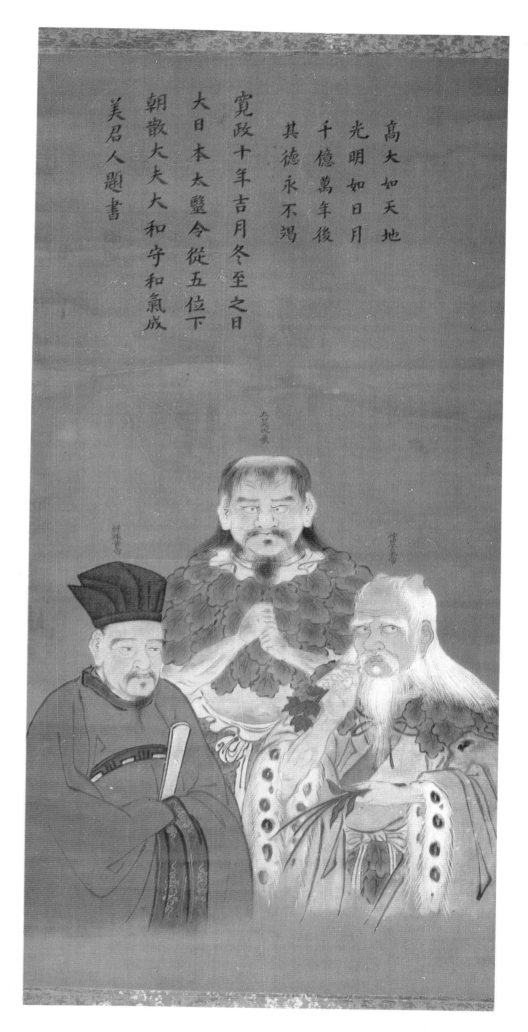

高　大　如　天　地

光　明　如　日　月

千　億　萬　年　後

其　德　永　不　渴

寬　政　十　年　吉　月　冬　至　之　日

大　日　本　太　醫　令　從　五　位　下

朝　散　大　夫　大　和　守　和　氣　成

美　名　人　題　書

COLORPLATE 65 (opposite)

Young Girl with Smallpox.
Illustration from *Notes on Diverse
Eruptions.* 1786. Miniature.
5½ × 7¹⁵⁄₁₆ in. (14 × 20.2 cm).
Bibliothèque Nationale, Paris.
*Usually the face and extremities were
heavily covered with smallpox
pustules, so this 18th-century painting
probably reflects interest in the
worldwide prevalence of smallpox
rather than interest in presenting
accurate clinical detail.*

COLORPLATE 66

Emperors of Chinese Medicine. 18th
century. Painting on silk scroll.
28¾ × 13¾ in. (73 × 34.9 cm).
Oriental Collection, Library,
University of California, San
Francisco. *Fu Hsi, inventor of
cooking and the classification of the
elements of the cosmos, appears in the
center. Shen Nung, tasting a
medicinal herb, was a god of fire who
transformed the jungle into arable land
and discovered the medicinal properties
of plants. At the left is Huang Ti,
supposed author of the* Nei-king, *or*
Yellow Emperor's Classic of
Medicine, *who invented writing,
cloth production, navigation,
sericulture, and other arts.*

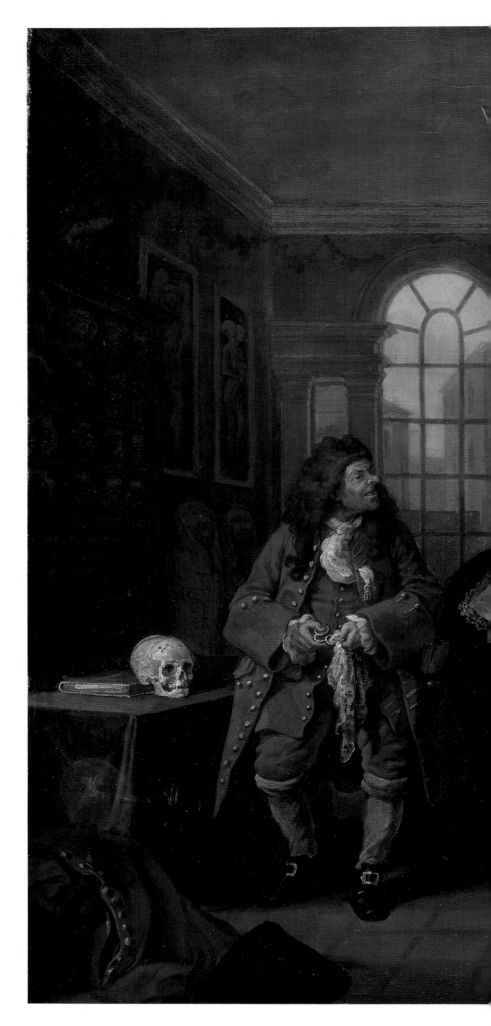

COLORPLATE 67

WILLIAM HOGARTH. *The Visit to the Quack Doctor* from *Marriage à la Mode*. 1743. Oil on canvas. $27\frac{1}{2} \times 35\frac{3}{4}$ in. (69.9 × 90.8 cm). Reproduced by courtesy of the Trustees, National Gallery, London. *Medical satire became ferocious in early 18th-century England, when the scientific aspirations and social prestige of educated practitioners sharply contrasted with failures in therapy and the rising status of "low" practitioners: surgeons, midwives, and dentists. William Hogarth (1697–1764) was particularly virulent on the subjects of alcoholism, prostitution, and the pseudoscientific pretenses of greedy quacks.*

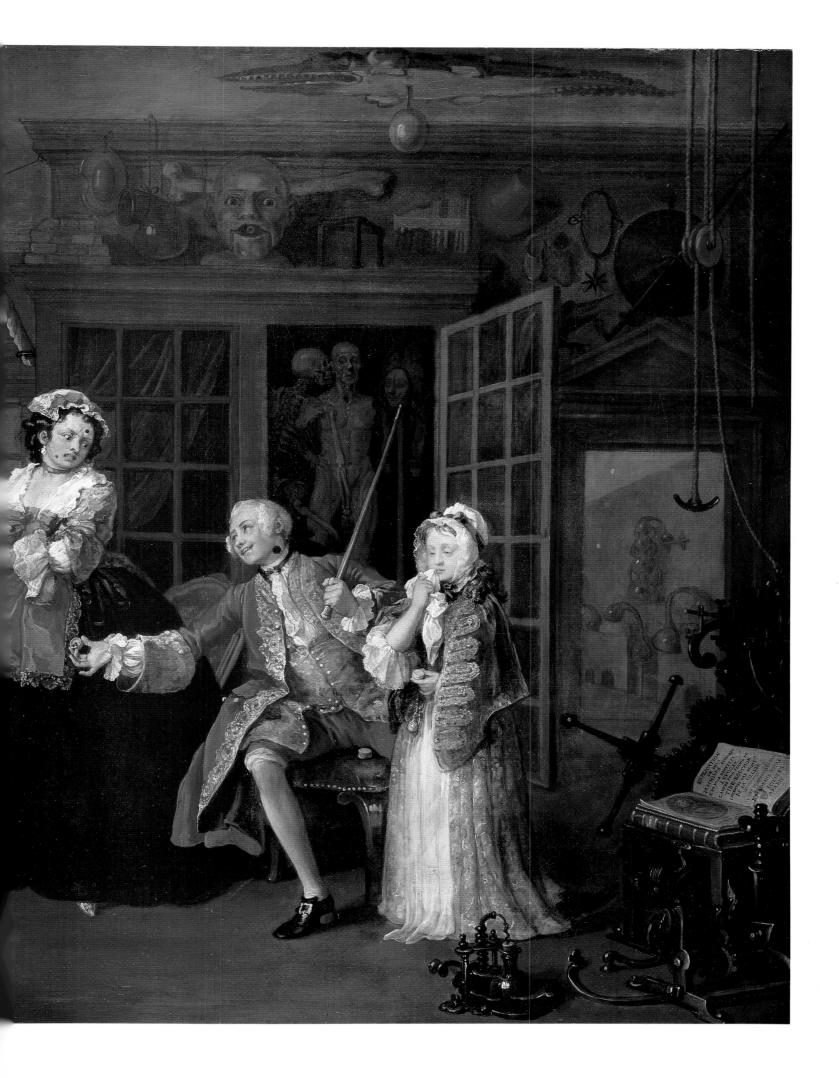

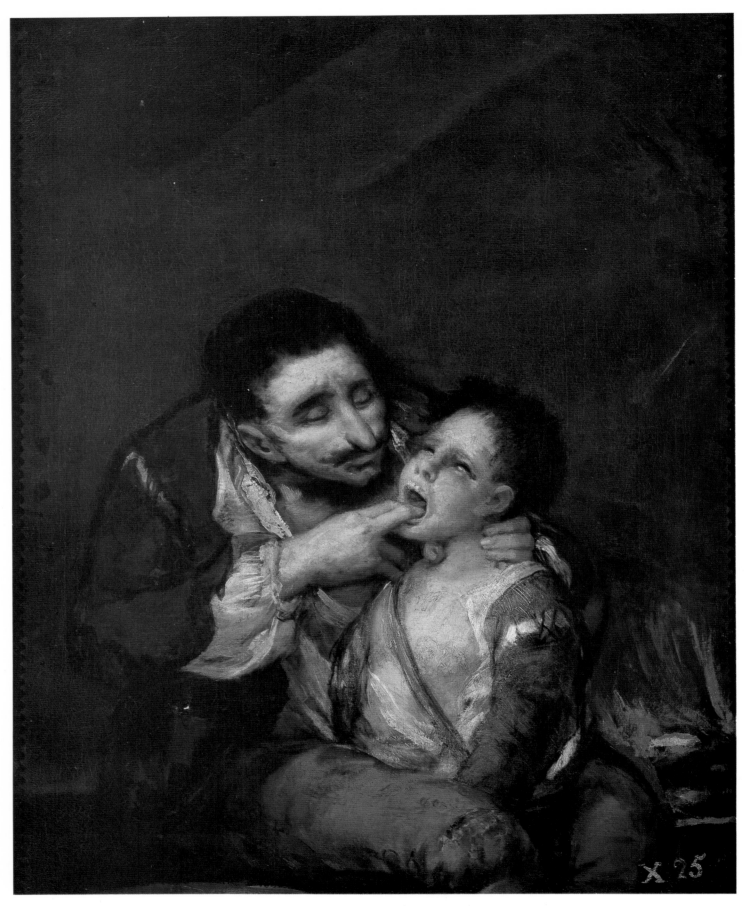

COLORPLATE 68

FRANCISCO GOYA. *Diphtheria*. 1802–1812. Oil on canvas. 31½ × 25⅝ in. (80 × 65 cm). Doña Carmen Marañon, Viuda de Fernández de Araoz, Madrid. *Goya, born in 1746, never paid attention to the artistic fads of his day, and so art historians often link him to painters of the 19th century. But the problem of diphtheria depicted here was a vital one to Goya's early years, for severe, lethal epidemics spread worldwide during the 1740s and 1750s.*

214

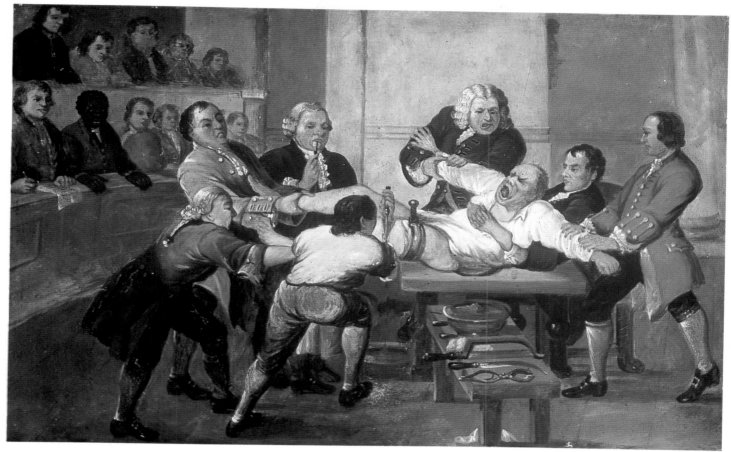

COLORPLATE 69

Artist unknown. *Leg Amputation*. Mid 18th century. Color on board. Reproduced by permission of the President and Council of the Royal College of Surgeons of England, London. *The dark-skinned man in the students' gallery is surely not a slave or servant. One surgeon-researcher identified him as Omai, "a celebrated Polynesian man" who visited London for two years between 1774 and 1776 (returning home with Captain Cook). During the late 18th and early 19th centuries, British philanthropic societies sponsored many Africans in formal surgical training.*

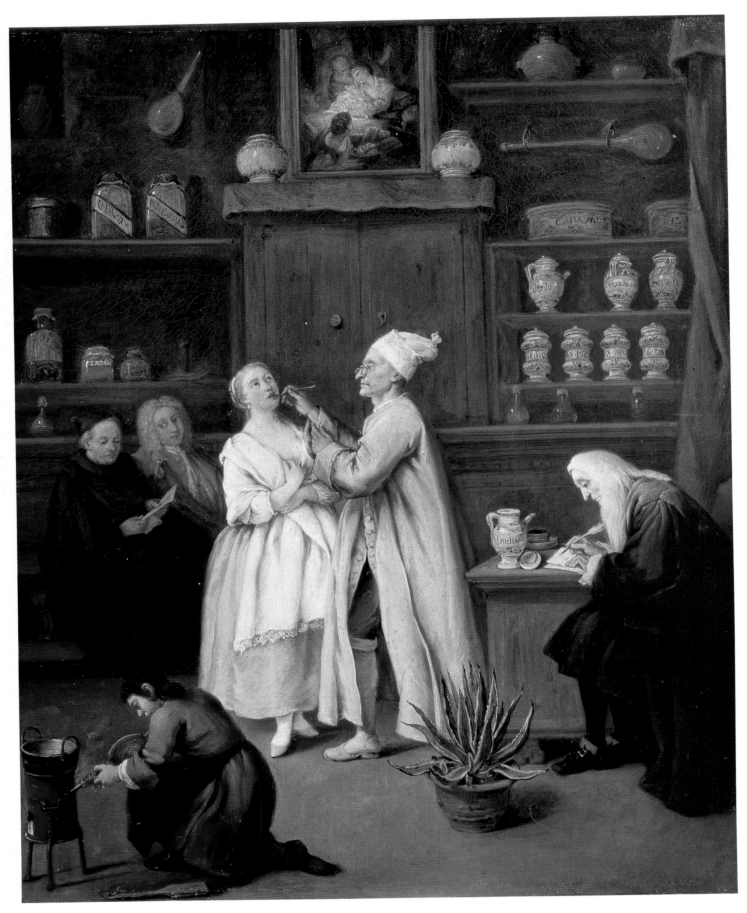

COLORPLATE 70

PIETRO LONGHI. *The Apothecary*. 1752. Oil on canvas. 23⅝ × 18¹⁵⁄₁₆ in. (60 × 48.1 cm).
Galleria dell'Accademia, Venice. *Longhi (1702–1785), a genre painter, devoted his work to the
details of 18th-century Venetian life. Here a young woman, perhaps a courtesan, submits to the
examination of her teeth and gums in the setting of a busy apothecary shop. The pharmacist labors at his
writing desk; aloes grow in a pot at his feet.*

T. Johnson. *Leo Tolstoy*.
1889. Engraving.

table, or his daughter's hair was not done properly. And whatever it was, he blamed
Praskovya Fiodorovna. At first she had answered in kind, and said disagreeable things to
him, but once or twice, just at the start of dinner, he had flown into such a frenzy that
she realized it was due to some physical derangement brought on by eating, and so she
restrained herself and did not reply but simply made haste to get the meal over. Praskovya
Fiodorovna took great credit to herself for this exercise of self-control. Having come to
the conclusion that her husband had a frightful temper and made her life wretched, she
began to feel sorry for herself. And the more she pitied herself the more she detested her
husband. She began to wish he would die, yet she did not want him dead because then
there would be no salary. And this made her still more exasperated with him. She regarded
herself as terribly unhappy precisely because not even his death could bring deliverance,
and, though she concealed her irritation, that hidden bitterness of hers increased his
irritability.

After one scene in which Ivan Ilyich had been particularly unfair, and after which he
had said in explanation that he certainly was irritable but that it was due to his not being
well, she had told him that if he were ill it should be attended to, and had insisted on his
going to see a celebrated doctor.

He went. The whole procedure followed the lines he expected it would; everything
was as it always is. There was the usual period in the waiting-room, and the important
manner assumed by the doctor—he was familiar with that air of professional dignity: he
adopted it himself in court—and the sounding and listening and questions that called for
answers that were foregone conclusions and obviously unnecessary, and the weighty look
which implied, You just leave it all to us, and we'll arrange matters—we know all about
it and can see to it in exactly the same way as we would for any other man. The entire
procedure was just the same as in the Law Courts. The airs that he put on in court for
the benefit of the prisoner at the bar, the doctor now put on for him.

The doctor said that this and that symptom indicated this and that wrong with the patient's inside, but if this diagnosis were not confirmed by analysis of so-and-so, then we must assume such-and-such. If then we assume such-and-such, then . . . and so on. To Ivan Ilyich only one question was important: was his case serious or not? But the doctor ignored this misplaced inquiry. From the doctor's point of view it was a side issue not under consideration: the real business was the assessing of probabilities to decide between a floating kidney, chronic catarrh or appendicitis. It was not a question of Ivan Ilyich's life or death but one between a floating kidney or appendicitis. And this question the doctor, in Ivan Ilyich's presence, settled most brilliantly in favour of the appendix, with the reservation that analysis of the urine might provide a new clue and then the case would have to be reconsidered. All this was to an iota precisely what Ivan Ilyich himself had done in equally brilliant fashion a thousand times over in dealing with persons on trial. The doctor summed up just as brilliantly, looking over his spectacles triumphantly, gaily even, at the accused. From the doctor's summing-up Ivan Ilyich concluded that things looked bad, but that for the doctor, and most likely for everybody else, it was a matter of indifference, though for him it was bad. And this conclusion struck him painfully, arousing in him a great feeling of pity for himself, and of bitterness towards the doctor who could be unconcerned about a matter of such importance.

But he said nothing. He rose, placed the doctor's fee on the table and remarked with a sigh, 'We sick people no doubt often put inappropriate questions. But tell me, in general, is this complaint dangerous or not?'

The doctor regarded him sternly over his spectacles with one eye, as though to say, 'Prisoner at the bar, if you will not keep to the questions put to you, I shall be obliged to have you removed from the court.'

'I have already told you what I consider necessary and proper,' said the doctor. 'The analysis may show something more,' And the doctor bowed.

Ivan Ilyich went out slowly, seated himself dejectedly in his sledge and drove home. All the way home he kept going over what the doctor had said, trying to translate all those involved, obscure, scientific phrases into plain language and find in them an answer to the question, 'Am I in a bad way—a very bad way—or is it nothing after all?' And it seemed to him that the upshot of all that the doctor had said was that he *was* in a very bad way. Everything in the streets appeared depressing to Ivan Ilyich. The sledge-drivers looked dismal, so did the houses, the passers-by and the shops. And this pain, this dull gnawing ache that never ceased for a second, seemed, when taken in conjunction with the doctor's enigmatical utterances, to have acquired a fresh and far more serious significance. With a new sense of misery Ivan Ilyich now paid constant heed to it.

He reached home and began to tell his wife about it. She listened but in the middle of his account his daughter came in with her hat on, ready to go out with her mother. Reluctantly she half sat down to listen to this tiresome story, but she could not be patient for long, and her mother did not hear him to the end.

'Well, I am very glad,' she said. 'You must be careful now and take the medicine regularly. Give me the prescription: I will send Gerassim to the chemist's.' And she went away to dress.

He had hardly paused to take breath while she was in the room, and he heaved a deep sigh when she was gone.

'Well,' he said to himself, 'perhaps it's nothing after all . . .'

He began taking the medicine and to carry out the doctor's instructions, which were altered after analysis of the urine. But it was just at this point that some confusion arose in connexion with the analysis and what ought to have followed from it. The doctor himself, of course, could not be blamed, but the fact was that things had not gone as the doctor had told him, and that he had either forgotten, or blundered, or was hiding something from him.

Nevertheless, Ivan Ilyich still continued to obey the doctor's orders, and at first found some comfort in so doing.

From the time of his visit to the doctor Ivan Ilyich's principal occupation became the

exact observance of the doctor's prescriptions regarding hygiene and the taking of medicine, and watching the symptoms of his malady and the general functioning of his body. His chief interests came to be people's ailments and people's health. When sickness, deaths or recoveries were mentioned in his presence, especially when the illness resembled his own, he would listen, trying to conceal his agitation, ask questions and apply what he heard to his own case.

The pain did not grow less but Ivan Ilyich made great efforts to deceive himself so long as nothing happened to excite him. But the moment there was any unpleasantness with his wife, or he suffered any rebuff in court or held bad cards at bridge, he was at once acutely sensible of his illness. In former days he had borne with such mishaps, hoping soon to correct what was wrong, to master it and be successful, to make a grand slam. But now every reverse upset him and plunged him into despair. He would say to himself: 'There now, no sooner do I feel a little better, no sooner does the medicine begin to take effect, than I have this cursed piece of bad luck, this disappointment . . .' And he would break out against his bad luck or against the people who were causing him the disappointment and killing him, and he felt how these bursts of passion were killing him but he could not restrain himself. One would have thought it ought to have been quite obvious to him that this exasperation with circumstances and people could only aggravate his illness, and therefore he ought not to pay any attention to disagreeable incidents. But he came to exactly the opposite conclusion: he said to himself that he needed peace, and was on the watch for everything that disturbed this peace, and flew into a rage at the slightest infringement of it. His condition was rendered worse by the fact that he read medical books and consulted doctors. The progress of his disease was so gradual that, comparing one day with another, he was able to deceive himself, so slight was the difference. But when he consulted the doctors it seemed to him that he was getting worse, and very rapidly worse. Yet despite this he was continually consulting doctors.

That month he went to see another medical celebrity. The second celebrity said pretty much the same as the first, only he propounded his questions differently; and the interview with this celebrity only redoubled Ivan Ilyich's doubts and fears. Then a friend of a friend of his, a very good doctor, diagnosed his malady quite otherwise, and, though he predicted recovery, his questions and hypotheses still further confused Ivan Ilyich and increased his scepticism. A homeopath made a different diagnosis still, and gave him a medicine which Ivan Ilyich took secretly for a week; but at the end, not feeling any relief and losing confidence both in his former drugs and this new treatment, he became more despondent than ever. One day a lady of his acquaintance mentioned a cure effected by means of wonder-working ikons. Ivan Ilyich caught himself listening intently and beginning to believe in the story as actual fact. This incident alarmed him. 'Can my mind have degenerated to such a point?' he asked himself. 'It's all nonsense, rubbish! I mustn't give way to nervous fears but choose a single doctor and keep strictly to his treatment. That's what I will do. Now it's settled. I will think no more about it but stick to the treatment until the summer, and then we shall see. From now on there must be no more of this wavering!' This was easy to say but impossible to put into practice. The pain in his side harassed him and seemed to grow worse and more incessant, while the taste in his mouth grew more and more peculiar. It seemed to him that his breath smelled very nasty, and his appetite and strength continually dwindled. There was no deceiving himself: something terrible, new and significant, more significant than anything that had ever happened in his life, was taking place within him of which he alone was aware. Those about him did not understand, or refused to understand, and believed that everything in the world was going on as usual. This thought tormented Ivan Ilyich more than anything. He saw that his household, especially his wife and daughter who were absorbed in a perfect whirl of visiting, had no conception at all and were annoyed with him for being so depressed and exacting, as though he were to be blamed for that. Even though they tried to disguise it he could see that he was in their way; but that his wife had taken up a definite line in regard to his illness and adhered to it, no matter what he might say or do. Her attitude was this: 'You know,' she would say to her friends, 'Ivan Ilyich can't do as other people

do, and keep to the treatment prescribed for him. One day he'll take his drops and keep carefully to his diet and go to bed at the right time; but the next day, if I don't see to it, he will suddenly forget his medicine, eat sturgeon—which is forbidden him—and sit up playing cards until one in the morning.'

'Oh come, when did I do that?' Ivan Ilyich would ask in vexation. 'Only once at Piotr Ivanovich's.'

'What about yesterday with Shebek?'

'It makes no difference, I couldn't have slept for pain . . .'

'Be that as it may, but you'll never get well like that, and you make us wretched.'

Praskovya Fiodorovna's attitude to Ivan Ilyich's illness, openly expressed to others and to himself, implied that the whole illness was Ivan Ilyich's own fault and just another of the annoyances he was causing his wife. Ivan Ilyich felt that this opinion escaped her involuntarily, but it was none the easier to bear for all that.

At the Law Courts, too, Ivan Ilyich noticed or fancied he noticed the same strange sort of attitude to himself. At one time it would seem to him that people were watching him inquisitively, as a man who would shortly have to give up his post. Then all at once his friends would begin to rally him in an amicable way about his nervous fears, as though that nightmare thing that was going on inside him, incessantly gnawing at him and irresistibly dragging him away, were the pleasantest subject in the world for raillery. Schwartz in particular irritated him with his high spirits, vitality and correctness, which reminded him of what he himself had been ten years before.

Friends would drop in for a game of cards. They sat down at the card-table; they dealt, bending the new cards to soften them, and he sorted the diamonds in his hand and found he had seven. His partner said, 'No trumps' and supported him with two diamonds. What could be better? It should have been jolly and lively—they would make a grand slam. And suddenly Ivan Ilyich is conscious of that gnawing ache, that taste in his mouth, and it strikes him as grotesque that in such circumstances he could take any pleasure in making a grand slam.

He would look at his partner Mihail Mihailovich tapping on the table with his confident hand, and instead of snatching up the tricks pushing the cards politely and condescendingly towards Ivan Ilyich that he might have the satisfaction of gathering them up without the trouble of stretching out his hand for them. 'Does he suppose I'm so weak that I can't stretch my arm out?' thinks Ivan Ilyich, and he forgets the trumps, and trumps his partner's cards and misses the grand slam by three tricks. And the most awful thing of all is that he sees how upset Mihail Mihailovich is about it, whereas he does not care at all. And it is awful to think why he doesn't care.

They all see that he is in pain, and say to him: 'We can stop if you are tired. You go and lie down.' Lie down? No, he's not in the least tired, and they finish the rubber. They are all gloomy and silent. Ivan Ilyich feels that it is he who has cast this gloom upon them, and he cannot disperse it. They have supper, and the party breaks up, and Ivan Ilyich is left alone with the consciousness that his life is poisoned for him and that he is poisoning the lives of others, and that this poison is not losing its force but is working its way deeper and deeper into his whole being.

And with the consciousness of this, and with the physical pain in addition, and the terror in addition to that, he must go to bed, often to lie awake with the pain for the greater part of the night. And in the morning he must needs get up again, dress, go to the Law Courts, speak, write, or, if he does not go out, stay at home for all the four-and-twenty hours of the day and night, each one of which is torture. And he had to live thus on the edge of the precipice alone, without a single soul to understand and feel for him.

Giovanni Verga
FROM *"Malaria"*

Verga (1840–1922) is an unusual example of a writer who switched styles. Beginning as a melo-dramatic pulp writer, he later adopted a style as spare, taut, and bleak as his favorite subject matter, the impoverished life of peasants in his native Sicily. He reached the height of his success in the 1880s, when abject poverty and the diseases it bore became intolerable to Risorgimento *Italians. "Malaria" captured the energies of a great malariologist, Angelo Celli, and made a literary disciple of D. H. Lawrence, who translated this excerpt.*

And you feel you could touch it with your hand—as if it smoked up from the fat earth, there, everywhere, round about the mountains that shut it in, from Agnone to Mount Etna capped with snow—stagnating in the plain like the sultry heat of June. There the red-hot sun rises and sets, and the livid moon, and the *Puddara* which seems to float through a sea of exhalations, and the birds and the white marguerites of spring, and the burnt-up summer; and there the wild-duck in long black files fly through the autumn clouds, and the river gleams as if it were of metal, between the wide, lonely banks, that are broken here and there, scattered with pebbles, and in the background the Lake of Lentini, like a mere, with its flat shores, and not a boat, not a tree on its sides, smooth and motionless. By the lake-bed the oxen pasture at will, forlorn, muddied up to the breast, hairy. When the sheep-bell resounds in the great silence, the wag-tails fly away, noiselessly, and the shepherd himself, yellow with fever, and white as well with dust, lifts his swollen lids for a moment, raising his head in the shadow of the dry reeds.

And truly the malaria gets into you with the bread you eat, or if you open your mouth to speak as you walk, suffocating in the dust and sun of the roads, and you feel your knees give way beneath you, or you sink discouraged on the saddle as your mule ambles along, with its head down. In vain the villages of Lentini and Francoforte and Paternò try to clamber up like strayed sheep on to the first hills that rise from the plain, and surround themselves with orange groves, and vineyards, and evergreen gardens and orchards; the malaria seizes the inhabitants in the depopulated streets, and nails them in front of the doors of their houses whose plaster is all falling with the sun, and there they tremble with fever under their brown cloaks, with all the bed-blankets over their shoulders.

Down below, on the plain, the houses are rare and sad-looking, beside the roads wasted by the sun, standing between two heaps of smoking dung, propped up by dilap-idated sheds, where the change-horses wait with extinguished eyes, tied to the empty manger. Or by the shore of the lake, with the decrepit bough of the inn sign hung over the doorway, the great bare rooms, and the host dozing squatted on the door-step, with his head tied up in a kerchief, spying round the deserted country every time he wakes up, to see if a thirsty traveller is coming. Or else what looks like little huts of white wood, plumed with four meagre, grey eucalyptus trees, along the railway that cuts the plain in two like a hatchet cleft, where the locomotive flies whistling as the autumn wind, and where at night are coruscations of fiery sparks. Or finally here and there, at the boundaries of the farm-lands marked by a little stone pillar very roughly squared, the farm-places with their roofs shoved up from outside, with their door-frames collapsing, in front of the cracked threshing-floors, in the shade of the tall ricks of straw where the hens sleep with their heads under their wing, and the donkey lets his head hang, with his mouth still full of straw, and the dog rises suspiciously, and barks hoarsely at the stone which falls out from the plaster, at the fire-fly which flickers past, at the leaf which stirs in the inert countryside.

At evening, as soon as the sun sinks, sun-burnt men appear in the doorways, wearing big straw hats and wide canvas drawers, yawning and stretching their arms; and half-naked women, with blackened shoulders, suckling babies that are already pale and limp, so that you can't imagine that they'll ever get big and swarthy and romp on the grass when winter comes again, and the yard-floor will be green once more, and the sky blue, and the country all round laughing in the sun. And you can't imagine where all the people live who go to mass on Sundays, or why they live there, all those who come to the little church surrounded by cactus hedges, from ten miles around, from as far as ever the clanging of the little cracked bell can be heard over the endless plain.

However, wherever there is malaria there is earth blessed by God. In June the ears of wheat hang weighted down, and the furrows smoke as if they had blood in their veins the moment the ploughshare enters them in November. And then those who reap and those who sow must fall like ripe ears as well, for the Lord has said, "In the sweat of thy brow shalt thou eat bread." And when the sweats of fever leave some one of them stiff upon the mattress of maize-sheathes, and there's no need any more of sulphate or of decoction of eucalyptus, they put him on the hay-cart, or across an ass' pack-saddle, or on a ladder, or any way they can, with a sack over his face, and they take him to bury him by the lonely little church, under the thorny cactuses whose fruit no one for that reason eats. The women weep in a cluster, and the men stand looking on, smoking.

So they had carried away the estate-keeper of Valsavoia, who was called Farmer Croce, after he'd been swallowing sulphate and eucalyptus decoction for thirty years. In spring he was better, but at autumn, when the wild-ducks passed again, he put his kerchief on his head and showed himself not oftener than every other day in the doorway; till he was reduced to skin and bone, and had a big belly like a drum, so that they called him the Toad, partly because of his rude, savage manner, and partly because his eyes had become livid and stuck out of his head. He kept on saying before he died, "Don't you bother, the master will see after my children!" And with his wondering eyes he looked them one after another in the face, all those who stood round the bed, the last evening, when they put the candle under his nose. Uncle Menico the goat-herd, who understood those things, said that his liver must be as hard as a stone, and weighed five pounds. But somebody added:

"Well, now he needn't worry about it! He's got fat and rich at his master's expense, and his children don't stand in need of anybody! Do you think he took all that sulphate and put up with all that malaria for thirty years, just to please his master?"

<p style="text-align:center">★ ★ ★</p>

The malaria doesn't finish everybody. Sometimes there's one who will live to be a hundred, like Cirino the simpleton, who had neither king nor kingdom, nor wit nor wish, nor father nor mother, nor house to sleep in, nor bread to eat, and everybody knew him for forty miles around, since he went from farm to farm, helping to tend the oxen, to carry the manure, to skin the dead cattle, and do all the dirty jobs; and got kicks and a bit of bread; he slept in the ditches, on the edges of the fields, under the hedges, or under the sheds for the standing cattle; and lived by charity, straying round like a dog without a master, with two ends of old drawers held together with bits of string on his thin black legs; and he went singing at the top of his voice under the sun which beat down on his bare head, yellow as saffron. He neither took sulphate any more, nor medicines, nor did he catch the fever. A hundred times they had found him stretched out across the road, as if he was dead, and picked him up; but at last the malaria had left him, because it could do no more with him. After it had eaten up his brain and the calves of his legs, and had got into his belly till it was swollen like a waterbag, it had left him as happy as an Easter Day, singing in the sun better than a cricket.

W. B. Howie and S. A. B. Black
"Sidelights on Lister"

After Joseph, 1st Baron Lister (1827–1912) developed his phenol (carbolic acid) spray, it proved difficult for most surgeons to manage, but it led to a dramatic decrease in mortality from postoperative sepsis. He reported the method to The Lancet *in 1867, but its utility was not accepted until adapted by military surgeons during the Franco-Prussian war. The air surrounding a wound had to be purified by a phenol aerosol and the incision or wound site dressed with eightfold-thick gauze drenched in phenol, liquid resin, and paraffin. Under a fully occlusive dressing a scab covered the wound, permitting repair of the tissue in a sterile environment. To obtain optimum results Lister was notoriously demanding of his staff surgeons, and this rare patient account shows the equal fortitude his patients needed to summon.*

Margaret Mathewson was the eleventh child of Andrew Mathewson, parish schoolmaster on Yell, one of the Shetland Islands. She was born in the Parish School House at East Yell on 18 April 1848, and was twenty-eight years of age when she became a patient at the infirmary. For about a year previous to her admission she had been suffering from pain in the left arm and shoulder, and the arm had been becoming increasingly useless. Four months before admission she had fallen and injured the joint further, and at that time an abscess had appeared in the upper arm which had been opened by the Rev. James Barclay, the minister of the parish.

In country districts in Scotland in the eighteenth century the customary source of medical advice had been the minister of the parish. In the isolation of the more remote islands of Shetland this was evidently still so, but in James Barclay the parishioners of Yell had at least the advantage of care from a minister who had more practical knowledge than usual, since his father, John Barclay, had been a surgeon on the neighbouring island of Unst.

The opening of the abscess resulted in the establishment of a sinus, and with increasing incapacity in the arm Margaret Mathewson made up her mind to seek help in Edinburgh. . . . After her arrival there she went to the infirmary with a female cousin who lived in Edinburgh and sought advice from the porter at the gate of the infirmary as to who would be the best person to consult. The porter immediately suggested Lister—an indication of Lister's reputation among the staff—and gave her directions how to find his ward in the surgical block. On arriving at Lister's ward she had a stroke of good fortune, for there she met Lister's house surgeon, Watson Cheyne, a Shetlander like herself, brought up on the neighbouring island of Fetlar by his uncle Daniel Webster, the minister of the parish. To him, whom she recognised, she presented her letter of introduction from Mr. Barclay, and received a kindly reception. Dr. Cheyne examined her shoulder, and explained to her that it was not, as she had thought, dislocated, but that there was an abscess in the joint with 'a glandular abscess on the collar bone.' Having completed his examination Cheyne gave her a seat in the corridor where she was to wait, saying that she would see Lister in an hour or two. Margaret and her cousin had arrived at the infirmary at half past ten, and Lister generally arrived for his daily visit about noon. As a house surgeon with some four months' experience Cheyne was, perhaps, making allowance for Lister's notorious unpunctuality.

Margaret's first contact with Lister was undoubtedly disconcerting. After she and her cousin had been waiting a little time, Lister, whom she describes as an elderly looking gentleman, walked upstairs accompanied by Dr. Cheyne and a group of students, and went into the theatre on the first landing of the stair. Almost immediately they heard

fearful screams and then silence. After an interval two students brought a long basket to the door, a man was lifted into it and carried down the stairs into the ward. A student followed carrying the man's leg rolled in silk paper and with blood dripping from it. 'It was,' wrote Margaret, 'indeed chilling to see it.'

With Lister's extreme sensitivity for the feelings of patients, it is surprising that he should have allowed potential patients to witness such an unnerving scene. A few days later, however, when being demonstrated in one of Lister's clinical lectures, Margaret was to experience a similar lack of forethought when she found herself faced with a series of diagrams of operative procedures applicable to her case on a blackboard. There was, perhaps, the excuse that she was a young woman with a degree of intelligence and perception unusual in the average patient at that time.

The operation on the unfortunate man having been completed, Lister, Cheyne, and the accompanying students walked from the theatre to the room where she had previously been examined by Cheyne. A nurse arranged the patients who had gathered to see Lister outside the door of the examination room in the order in which they had arrived at the ward, Margaret being first. Dr. Cheyne called her into the room, and introduced her to Lister as an acquaintance of his from Shetland.

Lister examined the swollen shoulder and questioned her about her illness, how it had begun, how long ago, if the pain had gone into her shoulder, and if she had ever fallen on it. He asked her about the sinus in her upper arm, and she explained that this had followed the operation by Mr. Barclay a month before. He wondered how a minister came to carry out such an operation, and she replied, 'because, sir, Mr. Barclay is all the practitioner that is on our island.' Surprised, Lister asked Dr. Cheyne if this were so, and Cheyne confirmed that indeed it was. Lister then enquired what was the cause of some marks upon her chest, and she replied that these were the result of drawing plasters applied some years before for disease of the chest. 'Prof then sat down, folded his hands, and closed his eyes as if in silent prayer (which gave me more confidence in his skill). After sitting a little he rose up, came and felt it all over again, then took a silver probe about four inches long and probed with it through the open place on my arm.' She felt the probe jagging painfully in the shoulder joint and the sinus bled profusely. Lister asked if

Joseph Lister. Late 19th century. Engraving.

she had ever had a cough, and what she had done for it. She replied that she had had 'cough and phlegm for about three months,' and that she had taken Kay's Compound Essence of Linseed, chest powders, and used cough plasters. He asked how long she had had chest disease, and if she still had a cough. She replied that she had had chest trouble for three years, but that she had no cough now.

Lister than turned to the students and commented on what he had found.

Now gentlemen this quite accounts for the shoulder being diseased. The patient has had chest disease, and has suffered a great deal from it, but now, instead of falling deeper into the lungs, it has providentially turned from the lungs into the shoulder joint. Had not this operation been made on the arm it evidently would have returned to the lungs, and the patient would have died immediately, but this operation has drawn off a quantity of discharge.

With the statement 'we will sound your chest some day, and see what we can do for you' Margaret was dismissed. Dr. Cheyne helped her on with her jacket, indicated she should follow him, and took her to the ward to which she was to be admitted.

<p style="text-align:center">⋆ ⋆ ⋆</p>

In teaching Lister's main interest lay in the giving of clinical lectures. These were delivered in the theatre, with the students in the gallery, and Lister seated in a worn horsehair covered chair placed behind the operating table. On the Wednesday after her admission Margaret Mathewson was 'called upstairs to be lectured on.' She was put in a dark room, so dark, indeed, that she only knew by hearing their voices that there were other patients ahead of her. Not surprisingly this room was known to the patients and the nurses as 'the dark hole.' There were two doors in the room with a porter at the front one to admit each patient into the theatre as he was called for. Here Margaret sat for two hours until Dr. Cheyne came and told her that she could go back to the ward, there being so many cases to be demonstrated that morning that she was not required. A few days later, however, she was again told by one of the nurses to undress and be ready to go upstairs. On this occasion she was given a blanket to put round her 'so as not to take cold sitting so many hours in the dark hole.' Once more she sat there for over two hours before again being dismissed by Dr. Cheyne. 'I was truly glad,' she wrote in the sketch, 'as I was shaking with fear and cold as well.'

Next day she was called again, but this time she was taken into the theatre and lectured upon. Lister's clinical lectures are generally represented as being attended by great crowds of students packed into the galleries. It is interesting that Margaret Mathewson estimated the student audience upon this occasion as being about forty. Leeson says that in the lectures technical terms only were used, and nothing was said or suggested that could in any way cause anxiety or alarm. Margaret Mathewson found it otherwise. 'All the lecture was in English,' she records, 'so I had the benefit of it too.' After a few minutes she began to feel distressed, and Lister, observing this, patted her reassuringly on the arm and turned her around so that her back was to the audience. This, however, resulted in her facing the blackboard on which Lister was accustomed to draw diagrams illustrative of the case upon which he was lecturing. There upon the blackboard was a chalk drawing of her arm 'in its swelled state, also the natural shape, then special marks where it had to be operated upon, and on seeing this I almost fainted. . . . Dr. Cheyne came and took my arm and helped me down stairs, and told the nurse to put me to bed and stay with me a little.'

Now, however, she at least knew what awaited her, and that she must have an operation. But as always Lister's wards were crowded, and a number of the sick awaited operation. In the main female ward—ward three—there were frequently sixteen patients instead of the nine it was intended to accommodate, with three or four patients in beds made up on the floor. Every day for a fortnight Margaret was called upstairs to the theatre, only to be sent back after a time to the ward 'and thus fear was given place to confidence.' The time of operation was usually about noon, so each day she lost her dinner, till, as

she records in the sketch, she began to get 'as thin as possible.' Finally, however, on 23 March, one month after she had been admitted, the day of trial came. [She wrote:]

> About 10:30 a.m. Nurse Kilpatrick came and told me to undress as usual, and be quick, as I was soon to be called, but it was 1 p.m. ere Dr. Cheyne came and called me. We passed through the crowded stairs as the most of the students were returning to the College. The big Theatre door was open and we went in. Prof bowed and smiled. I returned the bow. He then told me to step up on the chair (set at the side of the table on which was a blanket and two pillows) then lie down on the table.

In the Edinburgh Royal Infirmary the method of administering chloroform was by use of a towel either folded in layers, or shaped into a cone, placed over the face of the patient. Normally the anaesthetic was given by one of the dressers, and Lister had strong views about the advantages of such a procedure, seeing no value in the administration of the anaesthetic by qualified doctors specialising in the technique, roundly declaring that he 'would rather trust myself to one of these young gentlemen than to the great majority of qualified practitioners.' In Margaret's case, however, it was Dr. Cheyne who placed the towel saturated with chloroform over her face, and told her to breathe it in. 'I then felt the Professor's hand laid gently on my arm as if to let me know he was near me which I could, and did confide in, and this did encourage me to hope for the best.'

<p style="text-align:center">★ ★ ★</p>

Margaret had not had it explained to her what kind of operation was to be carried out, and on regaining consciousness her first reaction was to feel her arm to make sure that it had not been amputated. In her movements she disturbed the dressing, for which she was reproved by Lister when he visited her next morning to carry out the first dressing, but her ally, Dr. Cheyne, excused her on the grounds that it had happened while she was still half under the influence of the chloroform. With Lister's constant interest in the comfort of the patient, however, he followed up the reprimand by telling her that if the dressing was at all uncomfortable she was to be sure to tell the nurse in charge of the ward, who would call Dr. Cheyne so that he could ease the bandages for her.

Margaret's postoperative course was exceedingly stormy. She suffered from continual vomiting for several days, and it was the fifth postoperative day before she was able to drink and retain any fluid. For the vomiting she was given large quantities of ice to suck, ice being considered the best method of dealing with this particular complication of anaesthesia.

On the evening after her operation and during the night, she was visited by Dr. Cheyne, and at eleven o'clock the following morning by Lister. Just before one o'clock he returned with a group of students and carried out the first dressing under the carbolic spray. She had had her arm previously dressed under the spray, and so was prepared for it. On the first occasion on which it had been used she had been alarmed by the hissing of the burners and the jets of vapour given off. At first sight, she noted in the sketch, almost all the patients dreaded that the spray would burn them, but she at least understood its use, and believed also that it soothed the wound and helped to reduce the pain during dressings. Having uncovered the wound Lister dressed it with chloride of zinc, and then moved the arm to and fro, the movement causing such severe pain that she almost fainted. Being unable to sit up in bed she was held up during the procedure by two of the dressers. . . .

On the second postoperative day Lister visited her at nine o'clock in the morning, for during the night she had been acutely ill, and the nurse had called Dr. Cheyne to her just before midnight. Cheyne had stayed with her three-quarters of an hour till, as she was told by the nurse next day, she was 'past the crisis.' Just before noon Lister returned and dressed the wound a second time, being delighted to see that the chloride of zinc had kept it clean. Having carried out passive movement of the joint and rebandaged the arm and shoulder, Lister turned to the students to discuss the case. He had had great fears, he said,

of the patient's standing the operation as her condition had been so reduced by the internal medicines she had been taking, and by the tuberculous infection. The anaesthetic had been a further complication. To keep her unconscious for the duration of the operation she had had to be given so much chloroform that he had become alarmed. After the operation it had taken more than an hour to restore her to consciousness. However, it was his hope that all would now be well, and that a useful arm would result. . . .

. . .Lister's next visit was the final occasion on which Margaret saw him while she was an inpatient. . . . On the first morning he dressed her arm and removed the drainage tubes. As was his custom he talked to the students about the case and its progress. The excision of the joint, he explained, had been carried out as an experiment. 'I meant first,' he said, 'to amputate the arm, but I thought again and again how I could save it, and at last concluded on excision as an experiment, and if that did not succeed (as I did not expect it would) then amputation was inevitable. Providentially it has been a perfect success.' He then laid his hand upon the bed and asked her to touch his finger tips with hers. She managed to put her fingers into the palm of his hand. He moved his hand and repeated the experiment, then asked her to touch the pillow behind her head, and she reached the top of it. Finally he asked her to kiss the palm of her hand. 'Now gentlemen, you see how the patient can use it; this arm will be much more useful than either wood or cork, yes than even a gold one could we have given her that instead of this, the natural one. As he left her bedside he told Dr. Roxburgh that she could get up in a day or two, and three days later she was dressed and on her feet again.

★ ★ ★

. . .On 23 October 1877—exactly eight months from her admission—Margaret was discharged from the infirmary as relieved. After a period of convalescence at Campbeltown, where her brother Walter was the lighthouse keeper, she returned to her home in Shetland. A month after her return to Yell the wound began to discharge. She wrote to Dr. John Cheyne of Edinburgh, who had been on Lister's staff at the infirmary, for advice, and he sent her a rubber drainage tube to insert into the wound, and reassured her that all would still be well. In the summer of 1878 Watson Cheyne returned to Fetlar for a holiday and she went to Fetlar to consult him about her arm. By August the wound had finally healed, and when she wrote her sketch she was able to record triumphantly that she could now do any sort of indoor work.

But she did not know how little time lay ahead. On 28 September 1880 she died, her death certificate, written by one of her brothers as Registrar of Births and Deaths for the parish, gave the cause of death as consumption of the lungs. The death was 'not certified' because there was still no doctor on Yell.

Katherine Mansfield

FROM JOURNAL

On Her Illness

Born in New Zealand in 1888, Mansfield seems to have been destined to become a writer, getting her first short story published at the age of 9. She moved to England as a young woman, spending the remainder of her life in England and France, most of it with the critic John Middleton Murry. Mansfield was only beginning to establish a reputation as a short story writer when her pulmonary tuberculosis worsened in the early 1920s. Like a throwback to the Romantic age and the great poets

who wrote furiously through febrile consumption, Mansfield spent much of the last three years of her life seeking a sunny Mediterranean post of recovery. She died of a pulmonary hemorrhage in 1923.

PULMONARY TUBERCULOSIS

[1918]. The man in the room next to mine has the same complaint as I. When I wake in the night I hear him turning. And then he coughs. And I cough. And after a silence I cough. And he coughs again. This goes on for a long time. Until I feel we are like two roosters calling to each other at false dawn. From far-away hidden farms.

 ★ ★ ★

August [1920]. I cough and cough, and at each breath a dragging, boiling, bubbling sound is heard. I feel that my whole chest is boiling. I sip water, spit, sip, spit. I feel I must break my heart. And I can't expand my chest; it's as though the chest had collapsed. . . . Life is—getting a new breath. Nothing else counts.

 ★ ★ ★

SUFFERING

[19 December 1920]. I should like this to be accepted as my confession.

There is no limit to human suffering. When one thinks: "Now I have touched the bottom of the sea—now I can go no deeper," one goes deeper. And so it is for ever. I thought last year in Italy, Any shadow more would be death. But this year has been so much more terrible that I think with affection of the Casetta! Suffering is boundless, it is eternity. One pang is eternal torment. Physical suffering is—child's play. To have one's breast crushed by a great stone—one could laugh!

I do not want to die without leaving a record of my belief that suffering can be overcome. For I do believe it. What must one do? There is no question of what is called "passing beyond it." This is false.

One must *submit*. Do not resist. Take it. Be overwhelmed. Accept it fully. Make it *part of life*.

Everything in life that we really accept undergoes a change. So suffering must become Love. This is the mystery. This is what I must do. I must pass from personal love to greater love. I must give to the whole of life what I gave to one. The present agony will pass—if it doesn't kill. It won't last. Now I am like a man who has had his heart torn out—but—bear it—bear it! As in the physical world, so in the spiritual world, pain does not last for ever. It is only so terribly acute now. It is as though a ghastly accident had happened. If I can cease reliving all the shock and horror of it, cease going over it, I will get stronger.

Here, for a strange reason, rises the figure of Doctor Sorapure. He was a good man. He helped me not only to bear pain, but he suggested that perhaps bodily ill-health is necessary, is a repairing process, and he was always telling me to consider how man plays but a part in the history of the world. My simple kindly doctor was pure of heart as Tchehov was pure of heart. But for these ills one is one's own doctor. If 'suffering' is not a repairing process, I will make it so. I will learn the lesson it teaches. These are not idle words. These are not the consolations of the sick.

Life is a mystery. The fearful pain will fade. I must turn to work. I must put my agony into something, change it. 'Sorrow shall be changed into joy.'

It is to lose oneself more utterly, to love more deeply, to feel oneself part of life,— not separate.

Oh Life! accept me—make me worthy—teach me.

I write that. I look up. The leaves move in the garden, the sky is pale, and I catch myself weeping. It is hard—it is hard to make a good death. . . .

To live—to live—that is all. And to leave life on this earth as Tchehov left it and Tolstoi.

After a dreadful operation I remember that when I thought of the pain of being stretched out, I used to cry. Every time I felt it again, and it was unbearable.

That is what one must control. Queer! The two people left are Tchehov—dead—and unheeding, indifferent Doctor Sorapure. They are the two good men I have known.

André Malraux
FROM LAZARUS

Like Albert Camus, Malraux lived what he wrote and wrote what he lived. An anti-Fascist, Malraux left for Spain during its Civil War and organized an air squadron, becoming its colonel. He served as a private in a tank unit in World War II, was captured, escaped, joined the Resistance, was shot, captured, and made to endure a mock execution. Malraux was the author of many novels (the most famous of which were Man's Fate *and* Man's Hope*) that deal with the meaning of life in an estranged Europe wracked by two world wars; he also wrote works on art and an autobiography,* Anti-memoirs. *In this selection we see the writer–philosopher at the end of his life, reflecting on illness, dying, and death. Of interest is the fact that this book has been translated by Terence Kilmartin, a translator of Proust, another Frenchman preoccupied with death and the mystery of life, suffering, memory, and the transcendence of art.*

Another attack.

It is time for the augurs to forgather.

I was pacing around my study. As though the scene I was describing had pervaded

HENRI GUSTAV JOSSOT. *Above All, Dust My Thorax Well: I Have Cobwebs Where My Heart Should Be.* 1903. Published in *Assiette au Beurre,* no. 154, March 13, 1904. Print. 7⅝ × 6 in (19.4 × 15.2 cm). Museum für Kunst und Kulturgeschichte der Stadt Dortmund, Germany.

the room, I was overcome by a violent spasm of raging tension, swiveled round with all my strength, hurtled head first against the glass front of the bookcase, hit one of the wooden uprights, and collapsed. The upright did not give; had I deflected the fall which had flung me against the glass? I did not lose consciousness; after the shock, I jotted down, so as not to forget it, the phrase *terrifying possession*. What I was threatened with seemed more like madness than a disease; the word *disease,* which cancer or tuberculosis would evoke, does not spring to my mind when faced with an illness that is unknown to me, especially one from which I suffer no pain. Perhaps madmen do not suffer either.

The word *convulsion* haunts me. Is this because it could be used as the title of the passage I have been reworking for the past ten days? And yet its violence (if not its delirium) has abated. I wanted to add to this narrative the memories it arouses in me today. Before the suspended hand of the gas victims of the City of Death, at an hour which all those men regarded as an hour of destiny, I think of fresco of Nefertari opposite Luxor: at the entrance to her tomb the wife of Ramses plays against an invisible god of the underworld, whose presence we can only divine from his pawns on the chessboard. Face to face with the void, she stakes her immortality.

<p style="text-align:center">★ ★ ★</p>

At last, the doctors' conclave. The danger to the cerebellum is confirmed: cure, paralysis, or death. Immediate hospitalization.

The whisper of death alters the appearance of the streets on the way to the Salpêtrière Hospital.

Each change of gear repeats gratingly the word *bizarre.*

I stare at everything I see. As though it had all become very interesting. Self-mockery? Bizarre, simply bizarre and transitory. Even you yourself, transitory. . . .

I am entering the Old Quarter of south Paris, whose upper stories belong to Daumier and whose shops, advertisements, and billboards to the world of universal ugliness. Europe, when I returned to it for the first time, meant shops.

Here is the Gare d'Austerlitz, the bistro which has replaced the luxurious cabaret where Hortense Allart used to sit on Chateaubriand's knee: "I was young, and he used to ask me to sing light songs; and afterwards he did with me what he would. . . ." Here is the Salpêtrière, the ace-of-spades dome of the chapel. My car bounces as it goes under the porch, like the armored Mercedes of the Gestapo as it drove me into Toulouse prison in 1944.

Courtyards, long edifices reminiscent of barracks and palaces: reminders of the past. Then the two clinics, very modern. In the hall, silent figures from a Descent into Hell, mixed with pajama-clad pensioners, furtive wheelchairs.

My room. Two West Indian nurses. One resembles those black mammies who soothed so many infant sorrows during the Creole centuries; the other, tall, cheerful, and handsome, might have been a reincarnation of one of the merry angels of *Green Pastures.* Settling in, dressing gown, corridor: I am conducted to the radiology department. A voice calls for help from the elevator, which is stuck between two floors. Another elevator. Another corridor. Horrible little trolleys, stretchers—from one of which an arm dangles in the age-old posture of dead heroes. An astonishing silence: one expects groans or screams. The nurse ushers me in. The consultant is cordial. Assorted apparatus.

Back to my room. The X-ray room was white-enameled, the corridor was white-enameled, my room is white-enameled. The flowers sent by my friends look out of place in this world devoid of wood or fabric, as alien as a planet on which only white paint, nickel, test tubes, glass objects, sheets—and invalids—could survive. I have been in bed for only a quarter of an hour when a doctor comes in, an old friend who resembles the General de Gaulle of 1940, at the time of his oak-leaved kepi: "There's nothing irreversible." Which means, I suppose, that the cerebellum has not yet been affected. A verdict of life?

Do they ever pronounce the other one? . . .

The clatter of plates and forks subsides, and night falls. In spite of the soundproofing, cries of pain, which I recognize because they all sound like the cries of children, echo through the corridors when the door opens. Cries of patients sunk in pre-coma, who feel nothing, according to the nurse: when they recover, all they can remember is having fallen asleep. "Not true," one of the consultants told me sadly. "We know little about what happens in pre-coma: patients who have recovered sometimes quote back to us things we said in their presence during their catelepsy." Poor nurse! Those who have to live amid the murmur of pain need to ignore it.

The drip solution which immobilizes me is to last for twelve hours. The needle quivers in the vein in my arm. No more light under my door; nothing but the to-and-fro of the night nurses—and, each time they enter, the distant cries unconsciously uttered by those who will recover and those who will not. Crouching like Fates, unconsciousness and death have taken possession of the Salpêtrière.

<p style="text-align:center">★ ★ ★</p>

Pain waits for nightfall at the Salpêtrière. During the daytime there are drip solutions, injections, comings and goings of Green Pastures preceded by her laugh, other nurses who want to chat until the moment comes when I am able to answer them, tomorrow, the day after. . . . Although I am in little pain, I am far away, withdrawn into my fever. The mind surrenders itself to the groping fingers of death as it does to those of sleep.

Once the dinner plates and glasses cease to clatter, the door will not open again except for the visit of the night nurse. The silence with which I am growing familiar descends, filled with its teeming moans, as the silence of a tropical forest descends in the moonlight over the murmur of plants and wakeful insects.

Ten o'clock. The desolation of the Italian child whom I hear calling "Mama" above me every quarter of an hour echoes the cries of the night birds in the Siamese forest, the ululation of monkeys at dawn. Hospitals are haunted, but the exhaustion of the patients accords with the irresistible assuagement of the dark. What do the Buddhists call it? Yes: the Peace of the Abyss.

The days slip by. Released from the drip solution, I can walk as far as the window. In the courtyard, the doctors' and visitors' cars seem to be guarded by walking cripples. Is there nothing left on this earth but invalids? The unreality is reinforced by a jolly nurse whom I secretly call Moulinette, since I do not know her name, and who says to me: "Ah, you young rascal!" The whole thing is like a dream, encouraged by the sleeping pills. But there is also reality. A new patient has been put into the room next to mine. At six o'clock in the evening he snored loudly. "We must transfer him to another room," one of the nurses says to me. I expostulate: "If the patients can't put up with one another, who will put up with them?" Alas, I think I recognize those snores: they will turn into a death rattle. The murmuring of pain gradually starts up in the silence of the night, punctuated by this wheezing, regular and calm.

How can one become accustomed to an intolerable wait? For twelve days I have waited for the doctors' decision; since I came here, I have been waiting, while scribbling illegible notes, for the treatment to take effect, or to fail. If I am to die this time, will dying have consisted of waiting? We think of illnesses as dramas; sometimes they are somnolences—somnolences from which one does not awaken.

The unconscious is an attentive collaborator. I correct my phrase, for I had written simply "If I die"—as if death were a hypothesis.

<p style="text-align:center">★ ★ ★</p>

The nurse comes in, hypodermic at the ready. "Don't be afraid," she says, with an unnecessary laugh, for I no longer feel injections. Those words are no doubt part of her stock-in-trade. She leaves. The sounds of pain rise with the day. From the moment of my departure from Verrières the streets had seemed to me bizarre; nurses and doctors

HENRY TONKS. *The Birth of Plastic Surgery*. 1916. Pen and wash in sepia on paper. 12 × 10⁷⁄₁₆ in. (30.5 × 26.5 cm). Reproduced by permission of the President and Council of the Royal College of Surgeons of England, London.

seem bizarre too, and the plants left on my windowsill in violation of the rules. There are some cyclamens, and I like their fleshy petals, just as I like the texture of mushrooms. A Japanese once told me: "If you looked at flowers in the same way as you look at cats, you would have an honorable understanding of Life." It is Life that is bizarre, and when the wooden carousel horses of memory revolve, it is my life. My cat flew across the drawing room and then stopped, its paws stretched out, licking itself meticulously: it had changed its mind. Dreams of cats, destinies of plants . . . Each form of life seems bizarre to the rest, like the road from Verrières, but all of them together seem bizarre to . . . to whom, to what? Were religions created in order to bring men gods to whom they would not be bizarre?

On Shakespeare's "tale told by an idiot, full of sound and fury, signifying nothing" the wretched little pile of secrets cannot have imposed its paltry meaning for long. "What does life mean?" remains the most tenaciously persistent question. I think of Benares, of General de Gaulle. He is dead now. . . . Looking out at the snow-covered fields of St. Bernard, I had said to him, and he had repeated: "Why should life have a meaning?"

The proximity of the death throes of others drowns the question "What am I?," makes it otiose. Would it be untrue of a solitary death struggle? This tourist trip through the archipelago of death disregards any sequence of events, lays bare only the most inchoate and most intense consciousness, the convulsive "I am." But not beyond the other question: What is human destiny? The snow of Colombey, the snow of the Vézère . . . During the winter of 1943, between illustrious Les Eyzies and unknown Lascaux, where our weapons were hidden, I wondered to myself, as I thought of the distant herds of reindeer in the prehistoric snows, if man was born when for the first time he murmured "Why?" at the sight of a corpse. He has repeated himself a great deal ever since. Inexhaustible brute.

There is a knock at the door. A stranger comes in without waiting for an answer. A white mouse with white hair.

"Forgive me for disturbing you, monsieur. I know you are a very learned man, and

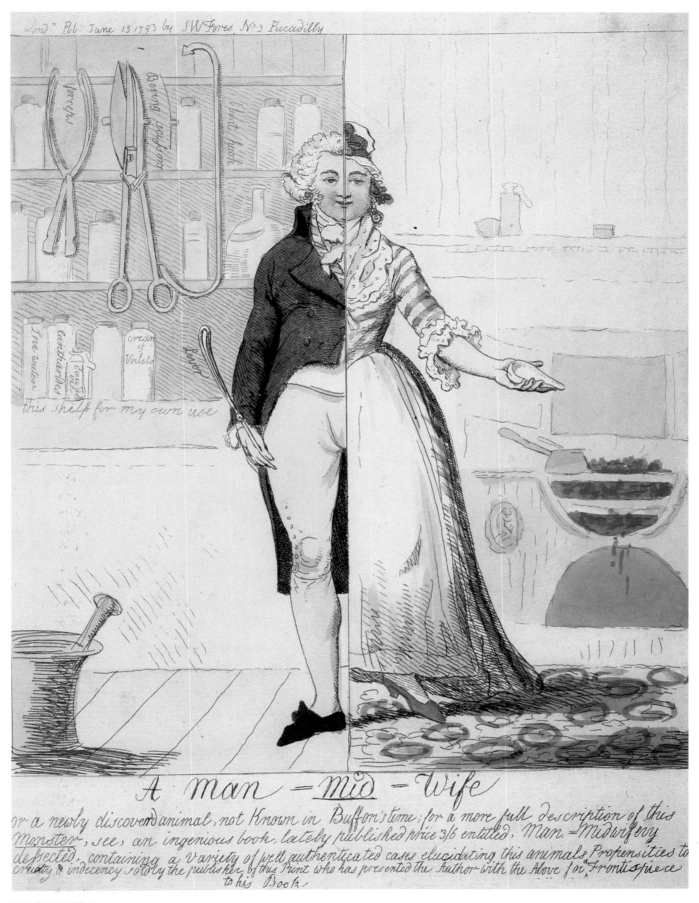

COLORPLATE 71

ISAAC CRUIKSHANK. *A Man Midwife*. 1793. Hand-colored etching. $9^{15}/_{16} \times 8$ in. (25.2 × 20.3 cm). Clements C. Fry Collection, Cushing–Whitney Medical Library, Yale University, New Haven. *Many kings of the late-17th and 18th centuries employed men to deliver their legitimate and illegitimate heirs, popularizing the figure of a male midwife among the upper classes. Midwives were not permitted university education, so the development of obstetrical technology was male-controlled.*

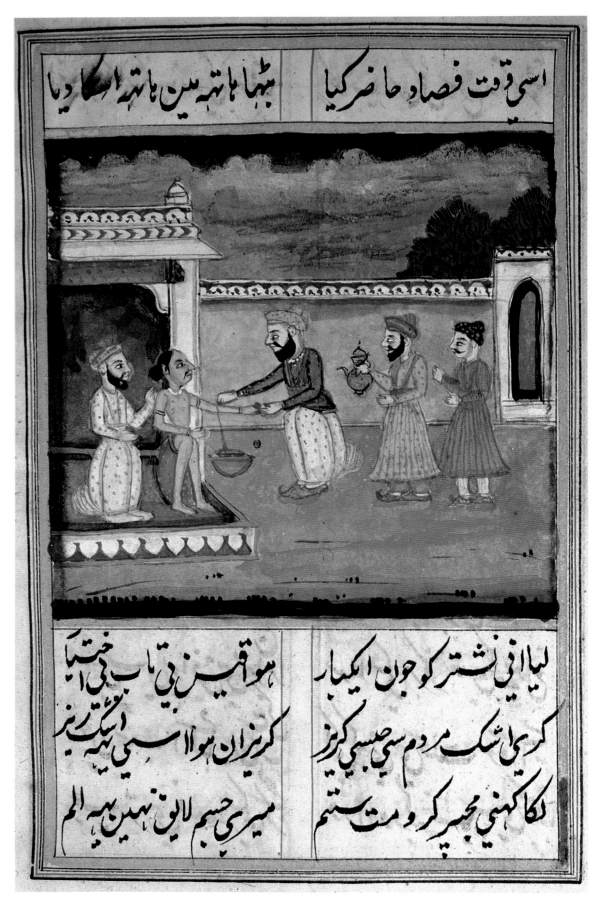

COLORPLATE 72

Bloodletting. 18th century. Persian manuscript illustration. Putti Collection,
Istituto Rizzoli, Bologna.

234

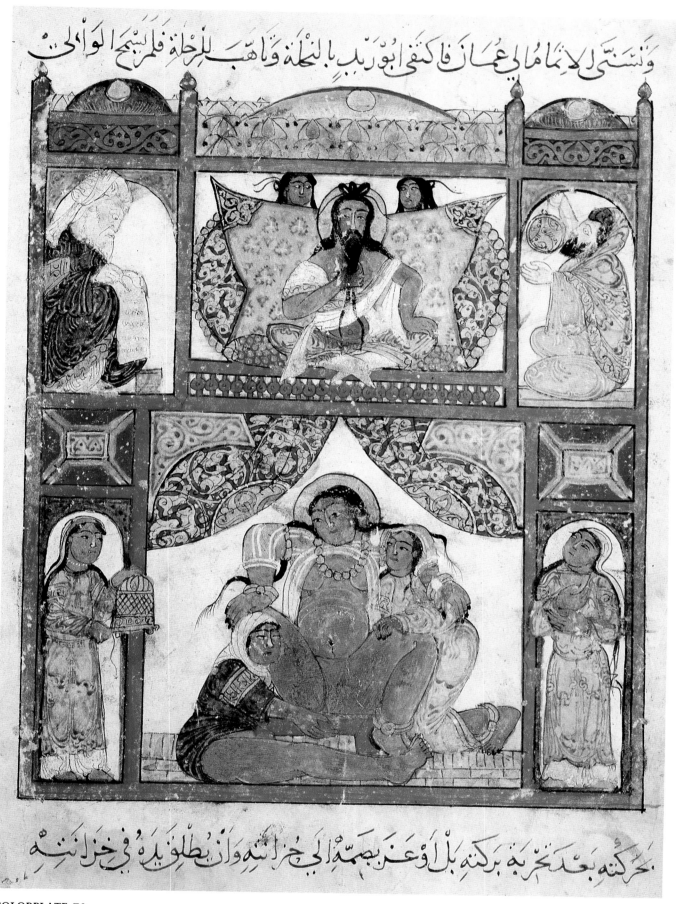

COLORPLATE 73

Delivery. Illustration from *The Makomad,* by Hairiri Neshki. 1237. Miniature. c.10¼ × 8¾ in.
(c.26 × 22.2 cm). Bibliothèque Nationale, Paris. *A copy of a work done in the year 635
of the Hegira by Mahmud ibn Yahyn Aul Hasan ibn Kuvarriha al Wasidi: A classical Western
birthing scene where women attended the gravida. The father is cared for separately.*

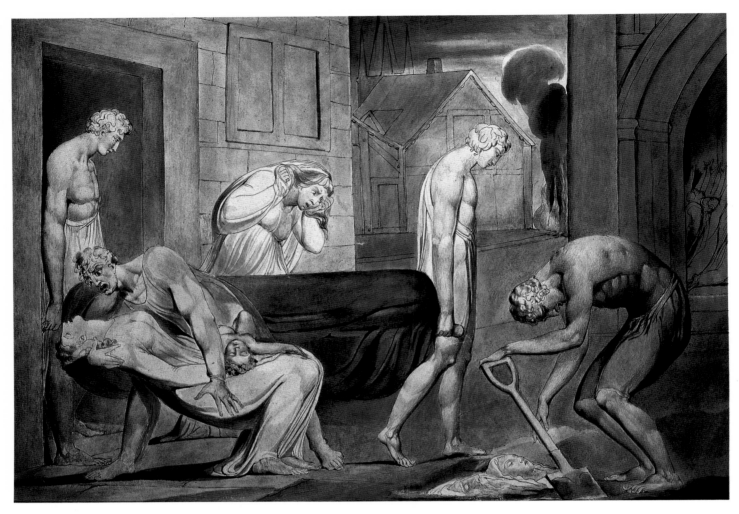

COLORPLATE 74

WILLIAM BLAKE. *Plagues of Egypt: Pestilence*. c.1800. Watercolor and pen on paper. 11⅞ × 17 in. (30.2 × 43.2 cm). Museum of Fine Arts, Boston. *In his poems, Blake was fond of the theme of plagues and scourges, especially syphilis. In art, the subject allowed him to depict human anatomy in meticulous detail, both the ideal and the grotesque.*

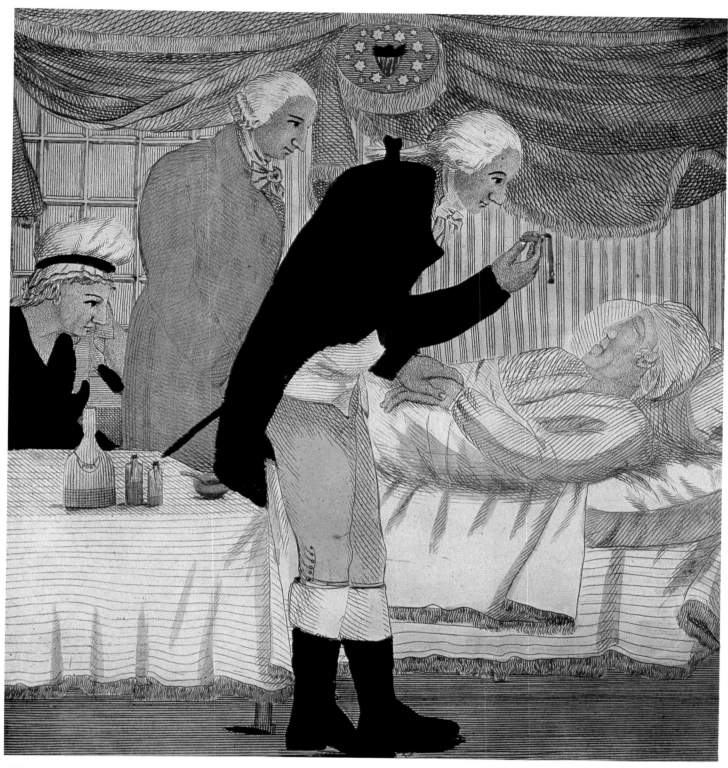

COLORPLATE 75

George Washington in His Last Illness, Attended by Doctors Craik and Brown. c.1800. Colored engraving. 9½ × 10 in. (24.1 × 25.4 cm). New-York Historical Society, New York, Olds Collection, no. 96. *Martha Washington is depicted in the background.*

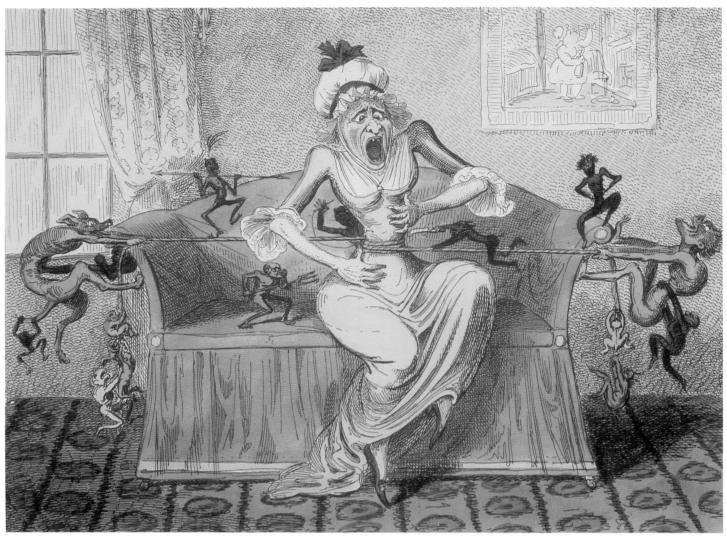

COLORPLATE 76

GEORGE CRUIKSHANK. *The Cholic.* 1819. Hand-colored etching. 10⅛ × 8⅛ in. (25.7 × 20.6 cm). SmithKline Beckman Corporation Collection, Philadelphia Museum of Art. *Influenced by the political and social satires of James Gillray, Cruikshank found favorite themes in the fashionable overindulgence in food and drink.*

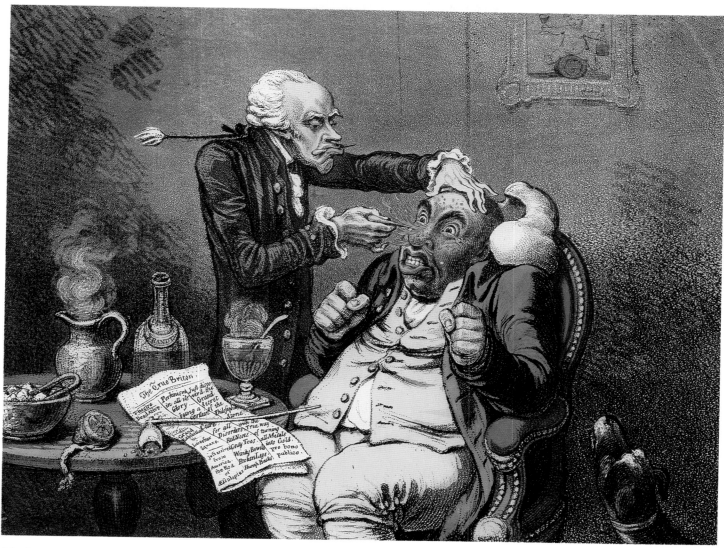

COLORPLATE 77

JAMES GILLRAY. *Metallic Tractors.* 1801. Hand-colored engraving. 8¼ × 10⅝ in. (21 × 27 cm).
Library of Congress, Washington, D.C. *Gillray was particularly fond of representing obesity as reprehensible.*

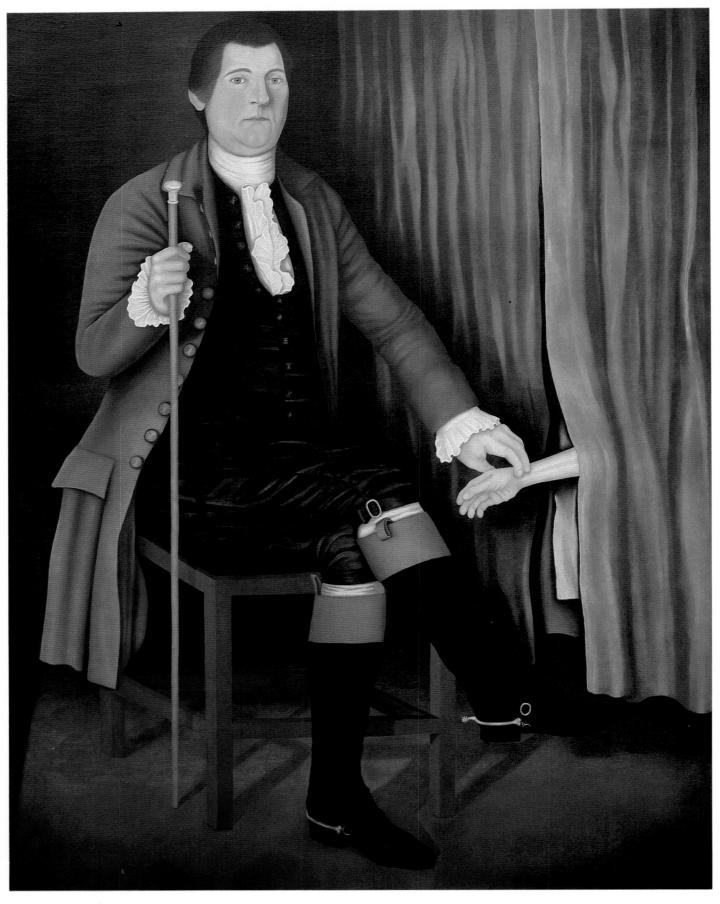

COLORPLATE 78

WILLIAM CHANDLER. *Dr. William Gleason*. 1785. Oil on canvas. 61½ × 47¾ in. (156.2 × 121.3 cm).
Courtesy of the Ohio Historical Society, Columbus.

besides . . . they don't hide things from you so much. I'm your new neighbor, and I thought we might perhaps . . . Well, the point is: people often die here."

I answer, not without a certain uneasiness:

"Not nowadays."

"Ah, do you think so? Not nowadays? Not nowadays. . . . I don't want to disturb you . . . I'm going."

He bows, in little jerky movements.

"Anyhow, in my case, if ever . . . that is . . . if ever, they can be sure that I shall know how to behave: I shan't bother anyone. Thank you, monsieur. I think you've reassured me a little."

<p style="text-align:center">★ ★ ★</p>

I wake up. Night has fallen. "Don't hurt me!" cries my poor neighbor, whom the nurse has failed to reassure. They have let me go on sleeping. I often sink imperceptibly into sleep. Although I am still in little pain, I feel a sort of all-enveloping dizzy nausea, ready to burst, as though I were about to vomit. The tablets I am supposed to take have been left in the bathroom. I go to fetch them without switching on the light, and return toward my bed, which is very high, like all hospital beds. I feel along the wall. No switch. I sink to the floor in the black fog, painlessly, my legs like cotton wool. A coolness: have I fallen on the tiles? The bed should be opposite me. I cannot get up; cannot even move. Not only am I floundering in the darkness like a drowning man, I do not even know where I am. There are no bearings. Nothing is more difficult to describe than an unknown sensation. Our bearings are almost as much a part of us as our limbs; my body has disappeared with them: no more body, no more "I," nothing surrounding me, an agonized consciousness which does not suggest the approach of death, although it is not the consciousness of normal life. The darkness drifts. I manage to turn round and crawl on all fours toward the bed. Shall I be able to pull myself up by the sheets, and find the light switch or the bell push? I have advanced three feet; my hand touches a surface. It is not the bed but a wall—which moves. An "attraction" at Luna Park long ago as a child: wedged in a seat, I saw the little room heave up and turn upside down around me. Later, more menacingly, the moment when the falling aircraft emerged from the clouds to find the earth tilting beneath it. Is it an attack? Of what?

Here is the bed. It seems much smaller. Very had. An object falls from it and breaks. Why have they put glass objects on my bed? And how narrow it is! I must not fall.

Have I lost consciousness? Before my arrival at the clinic, when I fell I remained conscious. The darkness no longer revolves. Gradually I reemerge. It is not my bed. I can place my feet on the cool tiles and skirt round the thing on which I have been lying; once more I am in a void, a darkness without shapes or bearings, in which my weight pulls me down toward the floor. My left hand touches a flat surface; I kneel down. I do not know where I am, but the tiles hurt my knees, and the flat surface is certainly a wall. I try to raise myself up, succeed in doing so at the third attempt, come across another wall. Still no bed. Can I have gone blind? Luckily, though the darkness is intense, it is uneven. I grope my way leftward. A piece of furniture; a lamp falls; it is the bedside table. I touch the bed—and then, the light switch!

Here is the white-enameled room, with the flowers on the windowsill. I realize that I must have walked to the right thinking that I was walking straight ahead, and that I curled up on a low table; a plane surface. Here is my real bed—in which my predecessor perhaps died, in which illness awaits my successor—and which I left twenty-five minutes ago, according to my bedside clock.

And the tablets? The bottle gleams over by the wall, in the opposite corner. I have been right round the room. While I was unconscious? I do not remember having fainted. Does one remember? I am reminded of what the doctor told me about his patients after they recovered from pre-coma. These twenty-five minutes of somnambulistic life under the threat of death do not disturb me as a blackout but as an hallucination. Fainting means nothing to me: I have fainted only once, when I was twelve. Fainting, like being put

under for an operation, suggests sleep; before stretching out on the table, I was not asleep, far from it. . . .

In the corridor, the moans have started again.

So I went right round the room. . . . I have always associated dying with the death throes, and am stupefied by this anguished feeling in which I discern only the unknown threat of finding myself cut off from the earth.

Neither pain, nor memory, nor amnesia—nor dissolution. Loss of consciousness, but not of *all* consciousness. I thought I was in another part of the room, but somewhere; I could not understand what had become of my bed, but I tried to stretch out on it, to settle down in my litter: must try and get to sleep; it will all be clear tomorrow. I remember the effort I made. Can one conceive of Lazarus remembering his efforts to settle into his tomb?

<p style="text-align:center">★ ★ ★</p>

I was conscious of no longer knowing where I was—of having lost touch with the earth. No pain except the pain of others, which beats faintly against the walls of this white room where the little night-light glows, as the muffled roar of the ocean could be heard beating against the shore from my room in Bombay. My mind is lucid, but its activity is limited to the endless recollection of a nowhere land, the amazed contemplation of a state hitherto unknown. What happened bears no relation to what I used to call dying.

Where does that subdued hubbub come from? I see no sign yet of the gray light of dawn. No sound of breakfast trays; in any case the noises seem to be coming from the ground, and I recognize the heavy footsteps of the male nurses who take patients to the radiology room. The steps recede, and the door of the adjacent room closes on hollow silence. I no longer hear those loud moans. The male nurses were not going to the X-ray room: my neighbor is dead.

Leonard Kriegel
"Falling into Life"

Leonard Kriegel is a professor of English at the City College of the City University of New York. A former Fulbright lecturer and Guggenheim fellow, Kriegel is also the author of Quitting Time, *a 1982 novel. In this excerpt, Kriegel addresses the metaphor of falling as an essential step in the process of self-healing and rehabilitation.*

Having lost the use of my legs during the polio epidemic that swept across the eastern United States during the summer of 1944, I was soon immersed in a process of rehabilitation that was, at least when looked at in retrospect, as much spiritual as physical.

That was a full decade before the discovery of the Salk vaccine ended polio's reign as the disease most dreaded by America's parents and their children. Treatment of the disease had been standardized by 1944: following the initial onslaught of the virus, patients were kept in isolation for a period of ten days to two weeks. Following that, orthodox medical opinion was content to subject patients to as much heat as they could stand. Stiff paralyzed limbs were swathed in heated, coarse woolen towels known as "hot packs." (The towels were that same greenish brown as blankets issued to American GIs, and they reinforced a boy's sense of being at war.) As soon as the hot packs had baked enough pain and stiffness out of a patient's body so that he could be moved on and off a stretcher, the treatment was ended, and the patient faced a series of daily immersions in a heated pool.

I would ultimately spend two full years at the appropriately named New York State Reconstruction Home in West Haverstraw. But what I remember most vividly about the

first three months of my stay there was being submerged in a hot pool six times a day, for periods of between fifteen and twenty minutes. I would lie on a stainless steel slab, my face alone out of water, while the wet heat rolled against my dead legs and the physical therapist was at my side working at a series of manipulations intended to bring my useless muscles back to health.

Each immersion was a baptism by fire in the water. While my mind pitched and reeled with memories of the "normal" boy I had been a few weeks earlier, I would close my eyes and focus not, as my therapist urged, on bringing dead legs back to life but on my strange fall from the childhood grace of the physical. Like all eleven-year-old boys, I had spent a good deal of time thinking about my body. Before the attack of the virus, however, I thought about it only in connection with my own lunge toward adolescence. Never before had my body seemed an object in itself. Now it was. And like the twenty-one other boys in the ward—all of us between the ages of nine and twelve—I sensed I would never move beyond that fall from grace, even as I played with memories of the way I once had been.

Each time I was removed from the hot water and placed on a stretcher by the side of the pool, there to await the next immersion, I was fed salt tablets. These were simply intended to make up for the sweat we lost, but salt tablets seemed to me the cruelest confirmation of my new status as spiritual debtor. Even today, more than four decades later, I still shiver at the mere thought of those salt tablets. Sometimes the hospital orderly would literally have to pry my mouth open to force me to swallow them. I dreaded the nausea the taste of salt inspired in me. Each time I was re-submerged in the hot pool, I would grit my teeth—not from the flush of heat sweeping over my body but from the thought of what I would have to face when I would again be taken out of the water. To be an eater of salt was far more humiliating than to endure pain. Nor was I alone in feeling this way. After lights-out had quieted the ward, we boys would furtively whisper from cubicle to cubicle of how we dreaded being forced to swallow salt tablets. It was that, rather than the pain we endured, that anchored our sense of loss and dread.

Any recovery of muscle use in a polio patient usually took place within three months of the disease's onset. We all knew that. But as time passed, every boy in the ward learned to recite stories of those who, like Lazarus, had witnessed their own bodily resurrection. Having fallen from physical grace, we also chose to fall away from the reality in front of us. Our therapists were skilled and dedicated, but they weren't wonder-working saints. Paralyzed legs and arms rarely responded to their manipulations. We could not admit to ourselves, or to them, that we were permanently crippled. But each of us knew without knowing that his future was tied to the body that floated on the stainless steel slab.

We sweated out the hot pool and we choked on the salt tablets, and through it all we looked forward to the promise of rehabilitation. For, once the stiffness and pain had been baked and boiled out of us, we would no longer be eaters of salt. We would not be what we once had been, but at least we would be candidates for re-entry into the world, admittedly made over to face its demands encased in leather and steel. . . .

The fall from bodily grace transformed each of us into acolytes of the possible, pragmatic Americans for whom survival was method and strategy. We would learn, during our days in the New York State Reconstruction Home, to confront the world that was. We would learn to survive the way we were, with whatever the virus had left intact.

I had fallen away from the body's prowess, but I was being led toward a life measured by different standards. Even as I fantasized about the past, it disappeared. Rehabilitation, I was to learn, was a historical, a future devoid of any significant claim on the past. Rehabilitation was a thief's primer of compensation and deception: its purpose was to teach one how to steal a touch of the normal from an existence that would be striking in its abnormality.

When I think back to those two years in the ward, the boy who made his rehabilitation most memorable was Joey Tomashevski. Joey was the son of an upstate dairy farmer, a Polish immigrant who had come to America before the Depression and whose English was even poorer than the English of my own shtetl-bred father. The virus had left both

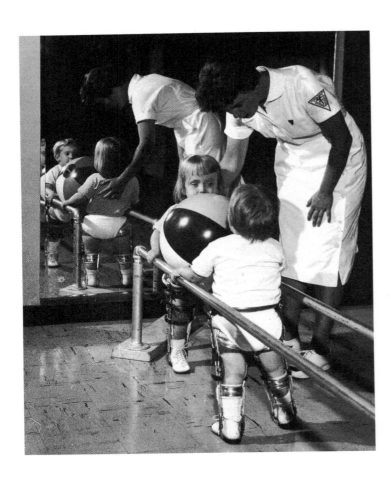

Therapy for Polio Victims. Photograph. 1950s.
Courtesy, Center for Disease Control, Atlanta.

of Joey's arms so lifeless and atrophied that I could circle where his bicep should have been with pinky and thumb and still stick the forefinger of my other hand through. And yet, Joey assumed that he would make do with whatever had been left him. He accepted without question the task of making his toes and feet over into fingers and hands. With lifeless arms encased in a canvas sling that looked like the breadbasket a European peasant might carry to market, Joey would sit up in bed and demonstrate how he could maneuver fork and spoon with his toes.

I would never have dreamed of placing such confidence in my fingers, let alone my toes. I found, as most of the other boys in the ward did, Joey's unabashed pride in the flexibility and control with which he could maneuver a forkful of mashed potatoes into his mouth a continuous indictment of my sense of the world's natural order. We boys with dead legs would gather round his bed in our wheelchairs and silently watch Joey display his dexterity with a vanity so open and naked that it seemed an invitation to being struck down yet again. But Joey's was a vanity already tested by experience. For he was more than willing to accept whatever challenges the virus threw his way. For the sake of demonstrating his skill to us, he kicked a basketball from the auditorium stage through the hoop attached to a balcony some fifty feet away. When one of our number derisively called him "lucky," he proceeded to kick five of seven more balls through that same hoop.

I suspect that Joey's pride in his ability to compensate for what had been taken away from him irritated me, because I knew that, before I could pursue my own rehabilitation with such singular passion, I had to surrender myself to what was being demanded of me. And that meant I had to learn to fall. It meant that I had to learn, as Joey Tomashevski had already learned, how to transform absence into opportunity. . . .

Falling into life was not a metaphor; it was real, a process learned only through doing, the way a baby learns to crawl, to stand, and then to walk. After the steel bands around calves and thighs and pelvis had been covered over by the rich-smelling leather, after the braces had been precisely fitted to allow my fear-ridden imagination the surety of their holding presence, I was pulled to my feet. For the first time in ten months, I stood. Two

middle-aged craftsmen, the hospital bracemakers who worked in a machine shop deep in the basement, held me in place as my therapist wedged two wooden crutches beneath my shoulders. . . .

My future had arrived. The leather had been fitted, the screws had been turned to the precise millimeter, the locks at the knees and the bushings at the ankles had been properly tested and retested. That very afternoon I was taken for the first time to a cavernous room filled with barbells and Indian clubs and crutches and walkers. I would spend an hour each day there for the next six months. In the rehab room, I would learn how to mount two large wooden steps made to the exact measure of a New York City bus. I would swing parallel bars from one side to the other, my arms learning how they would have to hurl me through the world. I balanced Indian clubs like a circus juggler because my therapist insisted it would help my coordination. And I was expected to learn to fall.

I was a dutiful patient. I did as I was told because I could see no advantage to doing anything else. I hungered for the approval of those in authority—doctors, nurses, therapists, the two bracemakers. Again and again, my therapist demonstrated how I was to throw my legs from the hip. Again and again, I did as I was told. Grabbing the banister with my left hand, I threw my leg from the hip while pushing off my right crutch. Like some baby elephant (despite the sweat lost in the heated pool, the months of inactivity in bed had fattened me up considerably), I dangled from side to side on the parallel bars. Grunting with effort, I did everything demanded of me. I did it with an unabashed eagerness to please those who had power over my life. I wanted to put myself at risk. I wanted to do whatever was supposed to be "good" for me. I believed as absolutely as I have ever believed in anything that rehabilitation would finally placate the hunger of the virus.

But when my therapist commanded me to fall, I cringed. For the prospect of falling terrified me. Every afternoon, as I worked through my prescribed activities, I prayed that I would be able to fall when the session ended. Falling was the most essential "good" of all the "goods" held out for my consideration by my therapist. I believed that. I believed it so intensely that the belief itself was painful. Everything else asked of me was given— and given gladly. I mounted the bus stairs, pushed across the parallel bars until my arms ached with the effort, allowed the medicine ball to pummel me, flailed away at the empty air with my fists because my therapist wanted me to rid myself of the tension within. The slightest sign of approval from those in authority was enough to make me puff with pleasure. Other boys in the ward might not have taken rehabilitation seriously, but I was an eager servant cringing before the promise of approval.

Only I couldn't fall. As each session ended, I would be led to the mats that took up a full third of the huge room. "It's time," the therapist would say. Dutifully, I would follow her, step after step. Just as dutifully, I would stand on the edge of those two-inch-thick mats, staring down at them until I could feel my body quiver. "All you have to do is let go," my therapist assured me. "The other boys do it. Just let go and fall."

But the prospect of letting go was precisely what terrified me. That the other boys in the ward had no trouble in falling added to my shame and terror. I didn't need my therapist to tell me the two-inch-thick mats would keep me from hurting myself. I knew there was virtually no chance of injury when I fell, but that knowledge simply made me more ashamed of a cowardice that was as monumental as it was unexplainable. Had it been able to rid me of my sense of my own cowardice, I would happily have settled for bodily harm. But I was being asked to surrender myself to the emptiness of space, to let go and crash down to the mats below to feel myself suspended in air when nothing stood between me and the vacuum of the world. *That* was the prospect that overwhelmed me. *That* was what left me sweating with rage and humiliation. The contempt I felt was for my own weakness. . . .

Shame plagued me—and shame is the older brother to disease. Flushing with shame, I would stare down at the mats. I could feel myself wanting to cry out. But I shriveled at the thought of calling more attention to my cowardice. I would finally hear myself whimper, "I'm sorry. But I can't. I can't let go." . . .

A month passed—a month of struggle between me and my therapist. Daily excursions to the rehab room, daily practice runs through the future that was awaiting me. The daily humiliation of discovering that one's own fear had been transformed into a public issue, a subject of discussion among the other boys in the ward, seemed unending.

And then, terror simply evaporated. It was as if I had served enough time in that prison. I was ready to move on. One Tuesday afternoon, as my session ended, the therapist walked resignedly alongside me toward the mats. "All right, Leonard. It's time again. All you have to do is let go and fall." Again, I stood above the mats. Only this time, it was as if something beyond my control or understanding had decided to let my body's fall from grace take me down for good. I was not seized by the usual paroxysm of fear. I didn't feel myself break out in a terrified sweat. It was over.

I don't mean that I suddenly felt myself spring into courage. That wasn't what happened at all. The truth was I had simply been worn down into letting go, like a boxer in whose eyes one recognizes not the flicker of defeat—that issue never having been in doubt—but the acceptance of defeat. Letting go no longer held my imagination captive. I found myself quite suddenly faced with a necessary fall—a fall into life.

So it was that I stood above the mat and heard myself sigh and then felt myself let go, dropping through the quiet air, crutches slipping off to the sides. What I didn't feel this time was the threat of my body slipping into emptiness, so mummified by the terror before it that the touch of air preempted even death. I dropped. I did not crash. I dropped. I did not collapse. I dropped. I did not plummet. I felt myself enveloped by a curiously gentle moment in my life. In that sliver of time before I hit the mat, I was kissed by space.

My body absorbed the slight shock and I rolled onto my back, braced legs swinging like unguided missiles into the free air, crutches dropping away to the sides. Even as I fell through the air, I could sense the shame and fear drain from my soul, and I knew that my sense of my own cowardice would soon follow. In falling, I had given myself a new start, a new life.

"That's it!" my therapist triumphantly shouted. "You let go! And there it is!"

You let go! And there it is! Yes, and you discover not terror but the only self you are going to be allowed to claim anyhow. You fall free, and then you learn that those padded mats hold not courage but the unclaimed self. And if it turned out to be not the most difficult of tasks, did that make my sense of jubilation any less?

From that moment, I gloried in my ability to fall. Falling became an end in itself. I lost sight of what my therapist had desperately been trying to demonstrate for me—that there was a purpose in learning how to fall. For she wanted to teach me through the fall what I would have to face in the future. She wanted to give me a wholeness I could not give myself. For she knew that mine would be a future so different from what confronts the "normal" that I had to learn to fall into life in order not to be overwhelmed.

From that day, she urged me to practice falling as if I were a religious disciple being urged by a master to practice spiritual discipline. Letting go meant allowing my body to float into space, to turn at the direction of the fall and follow the urgings of emptiness. For her, learning to fall was learning that most essential of American lessons: How to turn incapacity into capacity.

I returned to the city a year later. By that time, I was a willing convert, one who now secretly enjoyed demonstrating his ability to fall. I enjoyed the surprise that would greet me as I got to my feet, unscathed and undamaged. However perverse it may seem, I felt a certain pleasure when, as I walked with a friend, I felt a crutch slip out of my grasp. Watching the thrust of concern darken his features, I felt myself in control of my own capacity. For falling had become the way my body sought out its proper home. It was an earthbound body, and mine would be an earthbound life. My quest would be for the solid ground beneath me. Falling with confidence, I fell away from terror and fear.

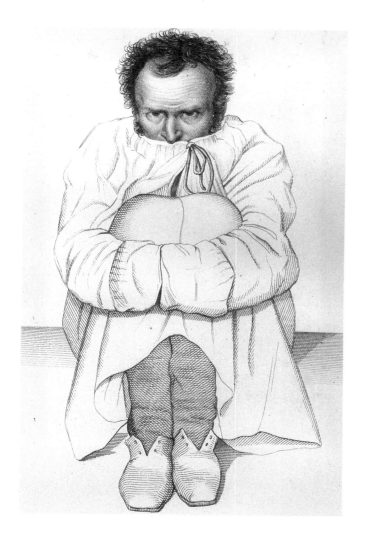

Ambroise Tardieu. *Mania Succeeded by Dementia.* 1838. Etching, stipple etching, and engraving. 6 × 3¹¹⁄₁₆ in. (15.2 × 9.4 cm). Philadelphia Museum of Art, SmithKline Beckman Corporation Fund.

Clifford Whittingham Beers

FROM A MIND THAT FOUND ITSELF

Beers (1876–1943) helped establish, in 1907, what has since been termed "pathography"—the phenomenological description of an illness, often by the sufferer himself or herself. Such accounts are very helpful in presenting, both to physicians and lay readers, the "other side" of illnesses and offer a first-hand version of the signs, symptoms, and natural history sections of medical texts. Beers's book validated William James's prediction that, "As for contents, it is fit to remain in literature as a classic account 'from within' of an insane person's psychology."

On the thirtieth day of June, 1897, I was graduated at Yale. Had I then realized that I was a sick man I could and would have taken a rest; but, in a way, I had become accustomed to the ups and downs of a nervous existence, and, as I could not really afford a rest, six days after my graduation I entered upon the duties of a clerk in the office of the Collector of Taxes in the city of New Haven. I was fortunate in securing such a position at that time, for the hours were comparatively short and the work as congenial as any could have been under the circumstances. I entered the Tax Office with the intention of staying only until such time as I should secure a position in New York. About a year later I

secured the desired position. After remaining in it for eight months (with the firm whose employ I re-entered in 1904), I left it, in order to take a position which seemed to offer a field of endeavor more to my taste. From May, 1899, till the middle of June, 1900, I was a clerk in one of the smaller life insurance companies, whose home office was within a stone's throw of what some men consider the center of the universe. To be in the very heart of the financial district of New York appealed strongly to my imagination. As a result of certain mistaken ideals, the making of money was then a passion with me. I foolishly wished to taste the bitter-sweet of power based on wealth.

For the first eighteen months of my life in New York, my health seemed no worse than it had been during the preceding three years. The old dread still possessed me. I continued to have my more and less nervous days, weeks, and months. In March, 1900, however, there came a change for the worse. At that time I had a severe attack of grip which incapacitated me for two weeks. As was to be expected in my case, this illness seriously depleted my vitality, and left me in a frightfully depressed condition—a depression which continued to grow upon me until the final crash came, on June 23d, 1900. The events of that day, seemingly disastrous as then viewed, but all for the best as the issue proved, forced me along paths traveled by thousands, but comprehended by few.

I had continued to perform my clerical duties until June 15th. On that day I was compelled to stop, and that at once. I had reached a point where my will had to capitulate to Unreason—that unscrupulous usurper. My previous five years as a neurasthenic had led me to believe that I had experienced all the disagreeable sensations an overworked and unstrung nervous system could suffer. But on this day several new and terrifying sensations seized me and rendered me all but helpless. My condition, however, was not apparent even to those who worked with me at the same desk. I remember trying to speak and at times finding myself unable to give utterance to my thoughts. Though I was able to answer questions, that fact hardly diminished my feeling of apprehension, for a single failure in an attempt to speak will stagger any man, no matter what his state of health. I tried to copy certain records in the day's work, but my hand was too unsteady, and I found it difficult to read the words and figures presented to my tired vision in blurred confusion.

That afternoon, conscious that some terrible calamity was impending, but not knowing what would be its nature, I performed a very curious act. Certain early literary efforts which had failed of publication in the college paper, but which I had jealously cherished for several years, I utterly destroyed. Then, after a hurried arrangement of my affairs, I took an early afternoon train, and soon found myself at home. Home life did not make me better, and, except for three or four short walks, I did not go out of the house at all until June 23rd, when I went in a most unusual way. To relatives, I said little about my state of health, beyond the general statement that I had never felt worse—a statement which, when made by a neurasthenic, means much but proves little. For five years I had had my ups and downs, and both my relatives and myself had begun to look upon these as things which would probably be corrected in and by time. Had the seriousness of my condition been realized, earlier arrangements would have been made which would have enabled me to take the long rest I needed. I am now glad that no such rest was taken. Had I been restored to health sooner than I was, or under different conditions, I should not have suffered and learned; nor should I have tasted the peculiar joy of life little known and less understood by mankind at large.

The day after my home-coming I made up my mind, or that part of it which was still within my control, that the time had come to quit business entirely and take a rest of months. I even arranged with a younger brother to set out at once fom some quiet place in the White Mountains, where I hoped to steady my shattered nerves. At this time (to say nothing of the constantly recurring thought that I was about to fall into an epileptic attack) I felt as though in a tremor from head to foot.

This dread to which I so frequently refer was a thing which I seldom, if ever, referred to while it persisted. On more than one occasion I did say to my friends that I would rather die than live an epileptic; yet, if I rightly remember, I never declared the actual fear

ERICH HECKEL. *Insane People at Mealtime.*
1914. Drypoint. Philadelphia Museum of Art.
Gift of J. B. Neumann.

that I was doomed to bear such an affliction. However, I believe that I said on a few occasions, though without meaning it at the time, that, if necessary, I should kill myself rather than endure what I then thought, but do not now think, the most miserable of lives. Though I held the mad belief that I should suffer epilepsy, I held the sane hope, amounting to belief, that I should escape it. This fact may account, in a measure, for my six years of endurance.

On the 18th of June I felt so much worse that I went to my bed and stayed there until the 23rd. During the night of the 18th my persistent dread became a false belief—a delusion. What I had long expected I now became convinced had at last occurred. I believed myself to be a confirmed epileptic, and that conviction was stronger than any ever held by a sound intellect. The half-resolve, made before my mind was actually impaired, namely, that I would kill myself rather than live the life I dreaded, now divided my attention with the belief that the stroke had fallen. From that time my one thought was to hasten the end, for I felt that I should lose the chance to die should relatives find me in a seizure of the supposed malady.

Considering the state of my mind and my inability at that time to appreciate the enormity of such an end as I half contemplated, my suicidal purpose was not entirely selfish. That I had never seriously contemplated suicide is proved by the fact that I had not provided myself with the means of accomplishing it, despite my habit, which has long been remarked by those intimately acquainted with me, of preparing for unlikely contingencies. So far as I had the control of my faculties, it must be admitted that I deliberated; but strictly speaking, the rash act which followed cannot correctly be called an attempt at suicide—for, how can a man who is not himself kill himself?

Soon my disordered brain was busy with schemes for death. I distinctly remember one which included a row on Lake Whitney, near New Haven. This row I intended to

take in the most treacherous boat obtainable. Such a craft could be easily upset, and I should so bequeath to relatives and friends a sufficient number of reasonable doubts to rob my death of the usual stigma. I also remember searching for some deadly drug which I hoped to find about the house. But the quantity and quality of what I found was not such as I dared to trust. I then thought of severing my jugular vein, even going so far as to test against my throat the edge of a razor which, after the deadly impulse first asserted itself, I had secreted in a convenient place. I really wished to die, but so uncertain and bloody a method did not appeal to me. Nevertheless, had I felt sure that in my tremulous frenzy I could accomplish the act with skilful dispatch, I should at once have ended my troubles.

My imaginary attacks were now recurring with distracting frequency, and I was in constant fear of discovery. During these three or four days I slept scarcely at all—even the medicine given to induce sleep having little effect. Though inwardly frenzied, I gave no outward sign of my condition. Most of the time I remained quietly in bed. I spoke but seldom. I had practically, though not entirely, lost the power of speech; and my almost unbroken silence aroused no suspicions as to the seriousness of my plight.

By a process of elimination, all suicidal methods but one had at last been put aside. On that one my mind now centered. My room was on the fourth floor of a house—one of a block of five—in which my parents lived. The house stood several feet back from the street. The sills of my windows were a little more than thirty feet above the ground. Under one was a flag pavement, extending from the house to the front gate. Under the other was a rectangular coal-hole covered with an iron grating. This was surrounded by flagging over a foot in width; and, connecting it and the pavement proper, was another flag. So that all along the front of the house, stone or iron filled a space at no point less than two feet in width. It required no great amount of calculation to determine how slight the chance of surviving a fall from either of these windows.

About dawn I arose. Stealthily I approached the window, pushed open the blinds and looked out—and down. Then I closed the blinds as noiselessly as possible and crept back to bed: I had not yet become so desperate that I dared to take the leap. Scarcely had I pulled up the covering when a watchful relative entered my room, drawn thither perhaps by that protecting prescience which love inspires. I thought her words revealed a suspicion that she had heard me at the window, and speechless as I was I had enough speech to deceive her. For, of what account are Truth and Love when Life itself has ceased to seem desirable?

The dawn soon hid itself in the brilliancy of a perfect June day. Never had I seen a brighter—to look at; never a darker—to live through,—or a better to die upon. Its very perfection and the songs of the robins, which at that season were plentiful in the neighborhood, served but to increase my despair and make me the more willing to die. As the day wore on my anguish became more intense, but I managed to mislead those about me by uttering a word now and then, and feigning to read a newspaper, which to me, however, appeared an unintelligible confusion of type. My brain was in a ferment. It felt as if pricked by a million needles at white heat. My whole body felt as though it would be torn apart by the terrific nervous strain under which I labored.

Shortly after noon, dinner having been served, my mother entered the room and asked me if she should bring me some dessert. I assented. It was not that I cared for the dessert; I had no appetite. I wished to get her out of the room, for I believed myself to be on the verge of another attack. She left at once. I knew that in two or three minutes she would return. The crisis seemed at hand. It was now or never for liberation. She had probably descended one of three flights of stairs when, with the mad desire to dash my brains out on the pavement below, I rushed to that window which was directly over the flag walk. Providence must have guided my movements, for in some otherwise unaccountable way, on the very point of hurling myself out bodily, I chose to drop feet foremost instead. With my fingers I clung for a moment to the sill. Then I let go. In falling my body turned so as to bring my right side toward the building. I struck the ground a little more than two feet from the foundation of the house, and at least three to

the left of the point from which I started. Missing the stone pavement by not more than three or four inches, I struck on comparatively soft earth. My position must have been almost upright, for both heels struck the ground squarely. The concussion slightly crushed one heel bone and broke most of the small bones in the arch of each foot, but there was no mutilation of flesh. As my feet struck the ground my right hand struck hard against the front of the house, and it is probable that these three points of contact divided the force of the shock and prevented my back from being broken. As it was, it narrowly escaped a fracture and, for several weeks afterward, it felt as if powdered glass had been substituted for cartilage between the vertebræ.

I did not lose consciousness even for a second, and the demoniacal dread, which had possessed me from June, 1894, until this fall to earth just six years later, was dispelled the instant I struck the ground. At no time since that instant have I experienced one of my imaginary attacks; nor has my mind even for a moment entertained such an idea. The little demon which had tortured me relentlessly for six years evidently lacked the stamina which I must have had to survive the shock of my suddenly arrested flight through space. That the very delusion which drove me to a death-loving desperation should so suddenly vanish seems to me to indicate that many a suicide might be averted if the person contemplating it could find the proper assistance when such a crisis impends.

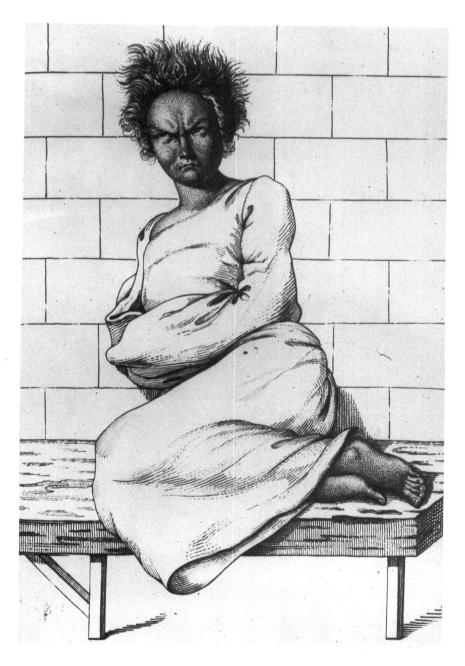

AMBROISE TARDIEU. *A Case of Mania.* 1838.
Etching, stipple etching, and engraving.
8½ × 5½ in. (21.6 × 14 cm).
National Library of Medicine, Bethesda, Md.

Robert Lowell
"Skunk Hour"

Representative of his largely autobiographical poetry, "Skunk Hour" is, like much great literature, a blend of personal experience and the author's reading. It mirrors Lowell's long fight against depression, and several hospitalizations for the same, while paying homage to a fellow poet's "The Armadillo" by Elizabeth Bishop.

(For Elizabeth Bishop)

Nautilus Island's hermit heiress still lives through winter in her Spartan cottage; her sheep still graze above the sea.
Her son's a bishop. Her farmer is first selectman in our village; she's in her dotage.

Thirsting for the hierarchic privacy of Queen Victoria's century, she buys up all the eyesores facing her shore, and lets them fall.

The season's ill—we've lost our summer millionaire, who seemed to leap from an L. L. Bean catalogue. His nine-knot yawl was auctioned off to lobstermen.
A red fox stain covers Blue Hill.

And now our fairy decorator brightens his shop for fall; his fishnet's filled with orange cork, orange, his cobbler's bench and awl; there is no money in his work, he'd rather marry.

One dark night, my Tudor Ford climbed the hill's skull; I watched for love-cars. Lights turned down, they lay together, hull to hull, where the graveyard shelves on the town. . . .
My mind's not right.

A car radio bleats,
"Love, O careless Love. . . ." I hear my ill-spirit sob in each blood cell, as if my hand were at its throat. . . .
I myself am hell; nobody's here—

only skunks, that search in the moonlight for a bite to eat.
They march on their soles up Main Street: white stripes, moonstruck eyes' red fire under the chalk-dry and spar spire of the Trinitarian Church.

I stand on top of our back steps and breathe the rich air—a mother skunk with her column of kittens swills the garbage pail.
She jabs her wedge-head in a cup of sour cream, drops her ostrich tail, and will not scare.

SCIENTIFIC MEDICINE: THE LITERATURE OF CURE

Louis Pasteur

"Prevention of Rabies"

Pasteur (1822–1895) was a brilliant chemist troubled all his life by the problems of symmetry and asymmetry in nature. Meaning to resolve his hypothesis that asymmetry was connected to life, in the 1850s he linked alcoholic fermentations to the action of yeast, showing the co-production of optically active crystals only when microorganisms were present. His other life passion was to champion the image of France. Pasteur turned his laboratory research toward attempts to solve the problems of silkworm diseases and anthrax epidemics that threatened local industries—and toward the elusive manufacture of a competitive French beer. His highly publicized treatment of Joseph Meister against rabies brought lasting fame and glory, overshadowing the achievements of his young German rival, Robert Koch.

We announced a positive advance in the study of rabies in the papers appearing under my own name and under the names of my fellow-workers; this was a method of prevention of the disease. The evidence was acceptable to the scientific mind, but had not been given practical demonstration. Accidents were liable to occur in its application.

Of twenty dogs treated, I could not render more than fifteen or sixteen refractory to rabies. Further, it was desirable, at the end of the treatment, to inoculate with a very virulent virus—a control virus—in order to confirm and reinforce the refractory condition. More than this, prudence demanded that the dogs should be kept under observation during a period longer than the period of incubation of the disease produced by the direct inoculation of this last virus. Therefore, in order to be quite sure that the refractory state had been produced, it was sometimes necessary to wait three or four months. The application of the method would have been very much limited by these troublesome conditions.

Another objection was that the method did not lend itself easily to the emergency treatment rendered necessary by the accidental and unforeseen way in which bites are inflicted by rabid animals.

It was necessary, therefore, to discover, if possible, a more rapid method. Otherwise who would have the temerity, before this progress had been achieved, to make any experiment on man?

After making almost innumerable experiments, I have discovered a prophylactic method which is practical and prompt, and which has already in dogs afforded me results sufficiently numerous, certain, and successful, to warrant my having confidence in its general applicability to all animals, and even to man himself.

This method depends essentially on the following facts:

The inoculation of the infective spinal cord of a dog suffering from ordinary rabies under the dura mater of a rabbit, always produces rabies after a period of incubation having a mean duration of about fifteen days.

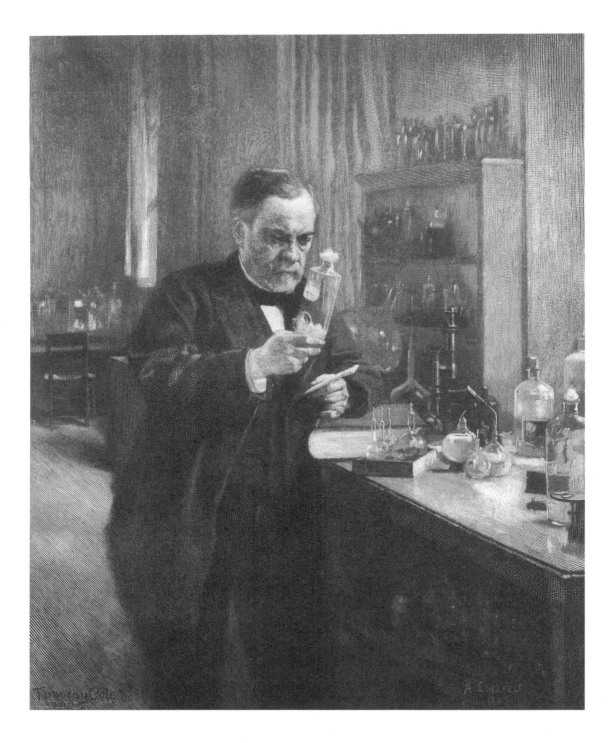

TIMOTHY COLE. *Pasteur in His Laboratory*. 1925. Wood engraving. 11⅞ × 9⅝ in. (30.2 × 24.4 cm). Philadelphia Museum of Art, SmithKline Beckman Corporation Fund.

If, by the above method of inoculation, the virus of the first rabbit is passed into a second, and that of the second into a third, and so on, in series, a more and more striking tendency is soon manifested towards a diminution of the duration of the incubation period of rabies in the rabbits successively inoculated.

After passing twenty or twenty-five times from rabbit to rabbit, inoculation periods of eight days are met with, and continue for another interval, during which the virus is passed twenty or twenty-five times from rabbit to rabbit. Then an incubation period of seven days is reached, which is encountered with striking regularity throughout a new series extending as far as the ninetieth animal. This at least is the number which I have reached at the present time, and the most that can be said is that a slight tendency is manifested towards an incubation period of a little less than seven days.

Experiments of this class, begun in November, 1882, have now lasted for three years without any break in the continuity of the series, and without our ever being obliged to have recourse to any other virus than that of the rabbits successively dead of rabies.

Consequently, nothing is easier than to have constantly at our disposal, over considerable intervals of time, a virus of rabies, quite pure, and always quite or very nearly identical. This is the central fact in the practical application of the method.

The virus of rabies at a constant degree of virulence is contained in the spinal cords of these rabbits throughout their whole extent.

If portions, a few centimeters long, are removed from these spinal cords with every possible precaution to preserve their purity, and are then suspended in dry air, the virulence slowly disappears, until at last it entirely vanishes. The time within which this extinction of virulence is brought about varies a little with the thickness of the morsels of spinal cord, but chiefly with the external temperature. The lower the temperature the longer is the virulence preserved. These results form the central scientific point in the method.

These facts being established, a dog may be rendered refractory to rabies in a relatively short time in the following way:

Every day morsels of fresh infective spinal cord from a rabbit which has died of rabies developed after an incubation period of seven days, are suspended in a series of flasks, the air in which is kept dry by placing fragments of potash at the bottom of the flask. Every day also a dog is inoculated under the skin with a Pravaz' syringe full of sterilized broth, in which a small fragment of one of the spinal cords has been broken up, commencing with a spinal cord far enough removed in order of time from the day of the operation to render it certain that the cord was not at all virulent. (This date had been ascertained by previous experiments.) On the following days the same operation is performed with more recent cords, separated from each other by an interval of two days, until at last a very virulent cord, which has only been in the flask for two days, is used.

The dog has now been rendered refractory to rabies. It may be inoculated with the virus of rabies under the skin, or even after trephining, on the surface of the brain, without any subsequent development of rabies.

Never having once failed when using this method, I had in my possession fifty dogs, of all ages and of every race, refractory to rabies, when three individuals from Alsace unexpectedly presented themselves at my laboratory, on Monday the 6th of last July.

Théodore Vone, grocer, of Meissengott, near Schlestadt, bitten in the arm, July 4th, by his own dog, which had gone mad.

Joseph Meister, aged 9 years, also bitten on July 4th, at eight o'clock in the morning, by the same dog. This child had been knocked over by the dog and presented numerous bites, on the hands, legs, and thighs, some of them so deep as to render walking difficult. The principal bites had been cauterized at eight o'clock in the evening of July 4th, only twelve hours after the accident, with phenic acid, by Dr. Weber, of Villé.

The third person, who had not been bitten, was the mother of little Joseph Meister.

At the examination of the dog, after its death by the hand of its master, the stomach was found full of hay, straw, and scraps of wood. The dog was certainly rabid. Joseph Meister had been pulled out from under him covered with foam and blood.

M. Vone had some severe contusions on the arm, but he assured me that his shirt had not been pierced by the dog's fangs. As he had nothing to fear, I told him that he could return to Alsace the same day, which he did. But I kept young Meister and his mother with me.

The weekly meeting of the Académie des Sciences took place on July 6th. At it I met our colleague Dr. Vulpian, to whom I related what had just happened. M. Vulpian, and Dr. Grancher, Professor in the Faculté de Médicine, had the goodness to come and see little Joseph Meister at once, and to take note of the condition and the number of his wounds. There were no less than fourteen.

The opinion of our learned colleague, and of Dr. Grancher, was that, owing to the severity and the number of the bites, Joseph Meister was almost certain to take rabies. I then communicated to M. Vulpian and to M. Grancher the new results which I had obtained from the study of rabies since the address which I had given at Copenhagen a year earlier.

The death of this child appearing to be inevitable, I decided, not without lively and sore anxiety, as may well be believed, to try upon Joseph Meister the method which I had found constantly successful with dogs. . . .

Consequently, on July 6th, at 8 o'clock in the evening, sixty hours after the bites on July 4th, and in the presence of Drs. Vulpian and Grancher, young Meister was inoculated under a fold of skin raised in the right hypochondrium, with half a Pravaz' syringeful of the spinal cord of a rabbit, which had died of rabies on June 21st. It had been preserved since then, that is to say, fifteen days, in a flask of dry air.

In the following days fresh inoculations were made. I thus made thirteen inoculations, and prolonged the treatment to ten days. I shall say later on that a smaller number of inoculations would have been sufficient. But it will be understood how, in the first attempt, I would act with a very special circumspection. . . .

On the last days, therefore, I had inoculated Joseph Meister with the most virulent virus of rabies, that, namely, of the dog, reinforced by passing a great number of times from rabbit to rabbit, a virus which produces rabies after seven days incubation in these animals, after eight or ten days in dogs. . . .

Joseph Meister, therefore, has escaped, not only the rabies which would have been caused by the bites he received, but also the rabies with which I have inoculated him in order to test the immunity produced by the treatment, a rabies more virulent than ordinary canine rabies.

The final inoculation with very virulent virus has this further advantage, that it puts a period to the apprehensions which arise as to the consequences of the bites. If rabies could occur it would declare itself more quickly after a more virulent virus than after the virus of the bites. Since the middle of August I have looked forward with confidence to the future good health of Joseph Meister. At the present time, three months and three weeks have elapsed since the accident, his state of health leaves nothing to be desired. . . .

Wilhelm Conrad Roentgen
"On a New Kind of Rays"

Roentgen (1845–1923) received numerous honorary degrees and awards following his 1895 discovery of X-rays, including the first Nobel Prize in physics and an honorary doctorate of medicine from his home university of Würzburg. Such accolades helped to make up for his early years at the margins of academe, when he possessed only a humble diploma in mechanical engineering. Roentgen spent two months intensely investigating the properties of the new rays before announcing his discovery to the world. The possibility of seeing "living skeletons," which gave his X-rays instant acclaim, Roentgen first demonstrated with the X-ray photograph of his wife's hand on December 22, 1895.

If the discharge of a fairly large induction coil be made to pass through a Hittorf vacuum tube, or through a Lenard tube, a Crookes' tube, or other similar apparatus, which has been sufficiently exhausted, the tube being covered with thin, black cardboard which fits it with tolerable closeness, and if the whole apparatus be placed in a completely darkened room, there is observed at each discharge a bright illumination of a paper screen covered with barium platinocyanide, placed in the vicinity of the induction coil, the fluorescence thus produced being entirely independent of the fact whether the coated or the plain

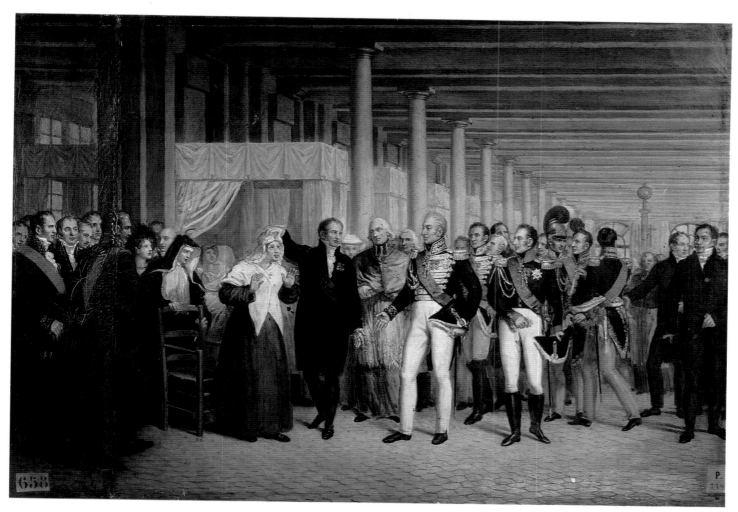

COLORPLATE 79

Showing the Results of a Cataract Operation at the Hôtel Dieu, Paris. 19th century. Musée Carnavalet, Paris. *Cataracts are unusual in a patient this young. If she was not selected simply for the artist's fancy, perhaps the woman suffered from trachoma rather than cataracts.*

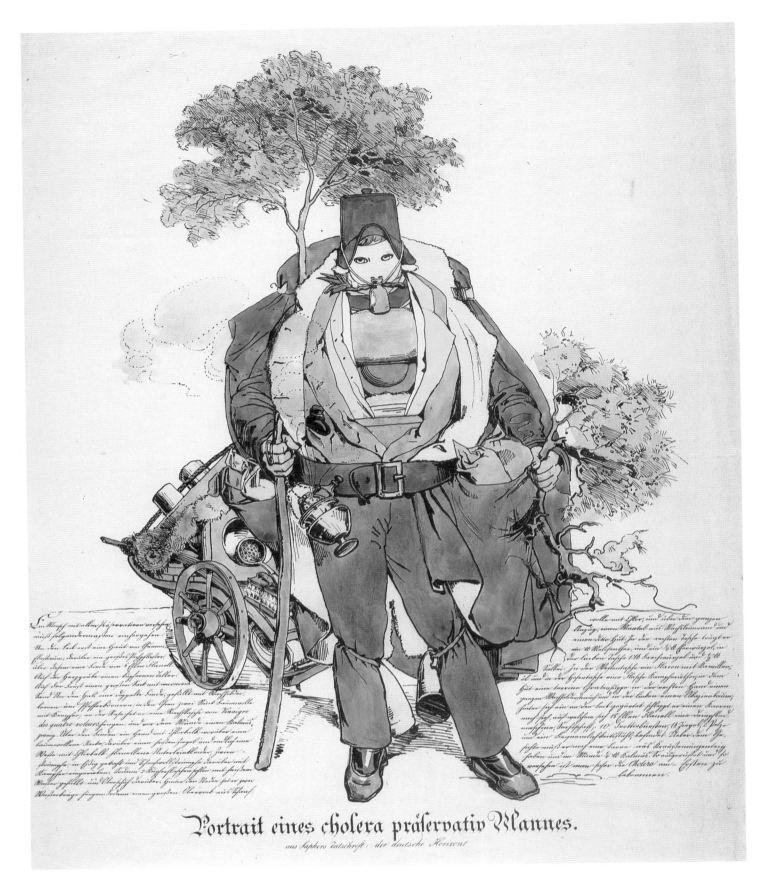

Portrait eines cholera präservativ Mannes.

aus Saphirs Zeitschrift: der deutsche Horizont

COLORPLATE 80

Portrait of a Man Protected Against Cholera. Early 1830s. Color etching. 17⅛ × 13¾ in.
(43.5 × 34.9 cm). Clements C. Fry Collection, Cushing–Whitney Medical Library, Yale
University, New Haven. *The cautious man is protected by a skin of rubber, patched with tar, in turn
covered with six yards of flannel, and on his heart a copper plate. Juniper berries, peppercorns, cotton soaked
in camphor, smelling salts, a cigar, a mash of peppermint dough, and garments soaked in lime chloride are
strategically placed. Behind him and strapped to his legs are various other preventive medicines and devices.
The shared dominance of regular, heroic therapy, sectarian medicine, and quackery permitted this satire.*

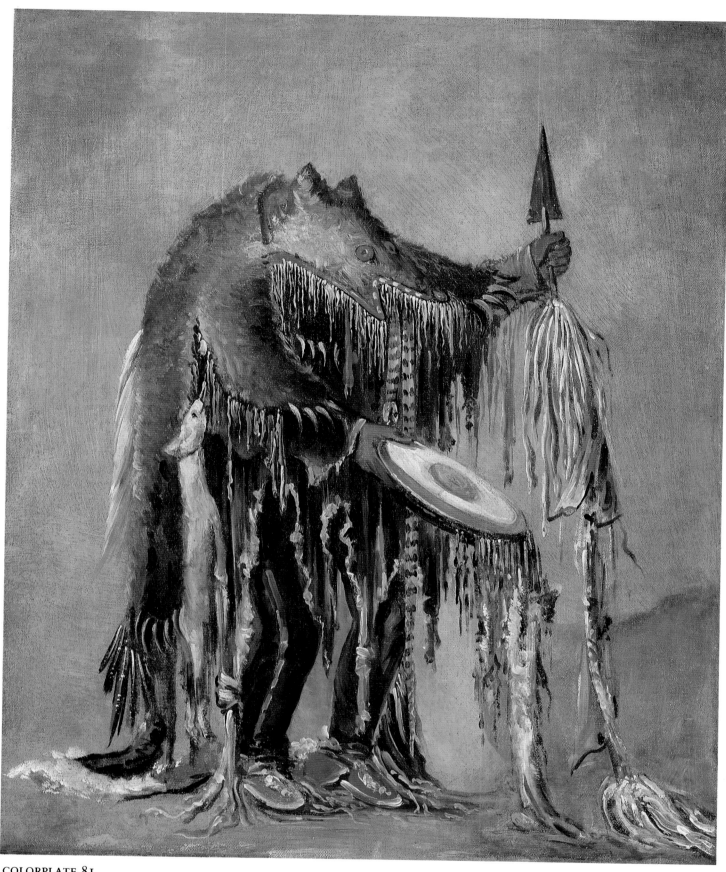

COLORPLATE 81

GEORGE CATLIN. *Blackfoot Medicine Man Performing His Mysteries over a Dying Man.* 1832. Oil on
canvas. 29 × 24 in. (73.7 × 61 cm). National Museum of American Art, Smithsonian Institution,
Washington, D.C. *Catlin witnessed this Blackfoot medicine man—Wun-New-Tow, the White Buffalo—in
full ceremonial dress, trying to summon mysterious powers to save the life of a dying chief. "His body and head
were entirely covered with the skin of a yellow bear."*

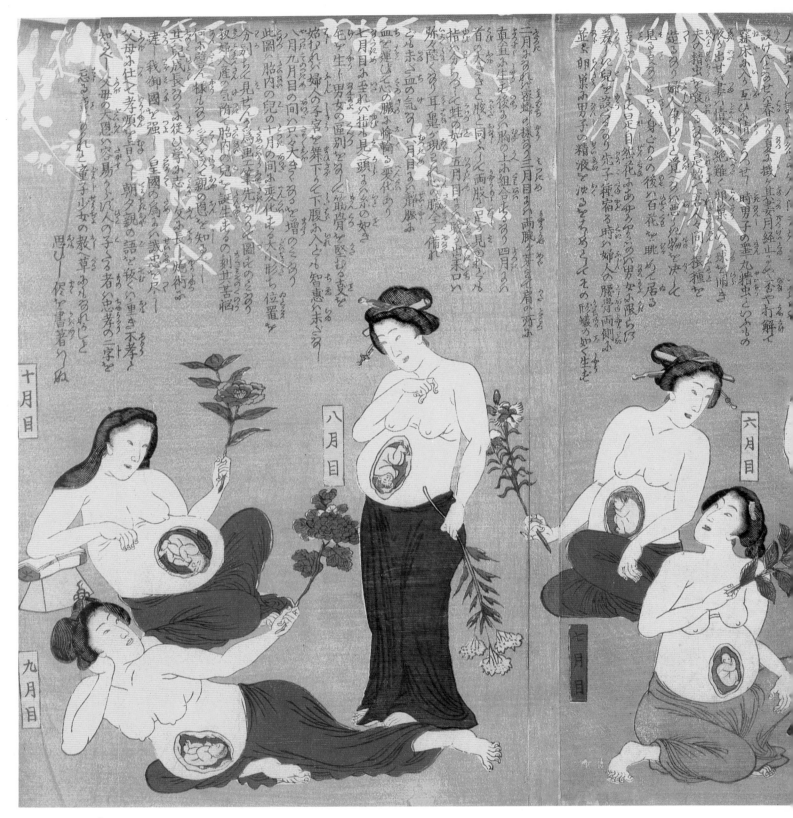

COLORPLATE 82

SONOKOCHI HASEGAWA. *From Conception to Delivery.* c.1890. Colored woodcut. 14⅛ × 27¹⁵⁄₁₆ in. (35.9 × 71 cm). National Library of Medicine, Bethesda, Md. *This Japanese print, featuring a fanciful cutaway view of the gravid uterus, depicts a woman at monthly intervals during pregnancy. Reading right to left, the picture emphasizes breast development and the passing of the seasons, symbolized by flowers from January to October. The text above describes how to become pregnant and the embryological development of the fetus. Not shown is the one historically distinctive feature of Japanese obstetric practice: the binding of the abdomen.*

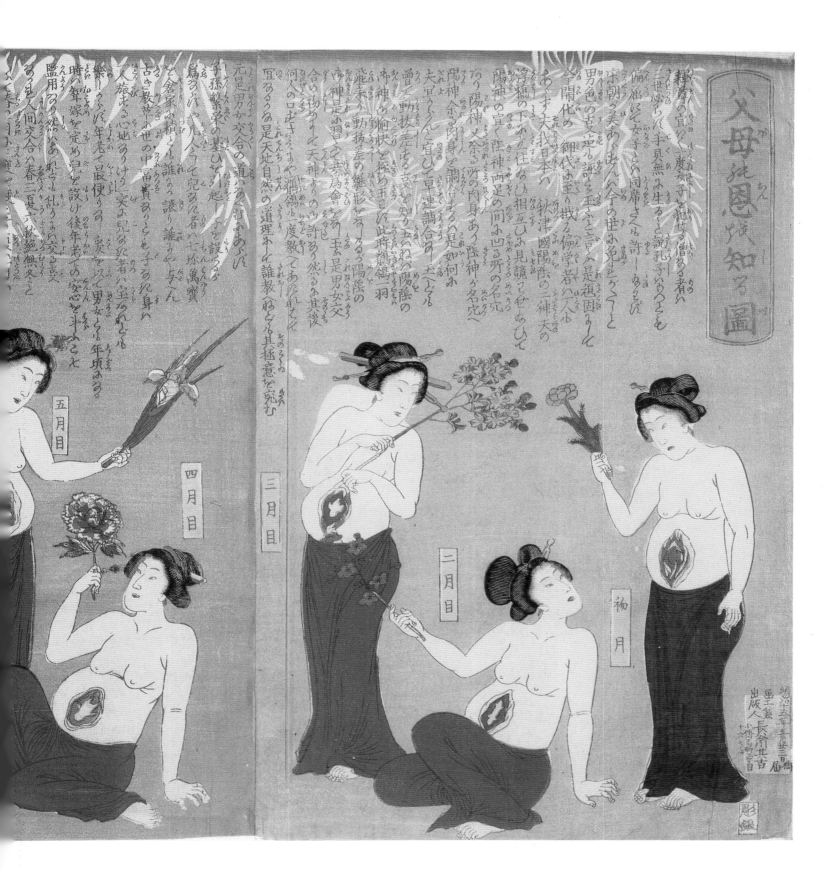

261

WOLCOTT'S INSTANT PAIN ANNIHILATOR.

Fig 1. Demon of Catarrh. Fig 2. Demon of Neuralgia. Fig 3. Demon of Headache. Fig 4. Demon of Weak Nerves. Fig 5.5 Demons of Toothache.

COLORPLATE 83

Wolcott's Instant Pain Annihilator. c.1863. Colored lithograph, published by
Endicott & Co. 18½ × 11¾ in. (47 × 29.8 cm). Library of Congress,
Washington, D.C. *During the heyday of patent medicines, many remedies possessed
a fairly high alcohol content, thus circumventing usual proscriptions of temperance
enthusiasts.*

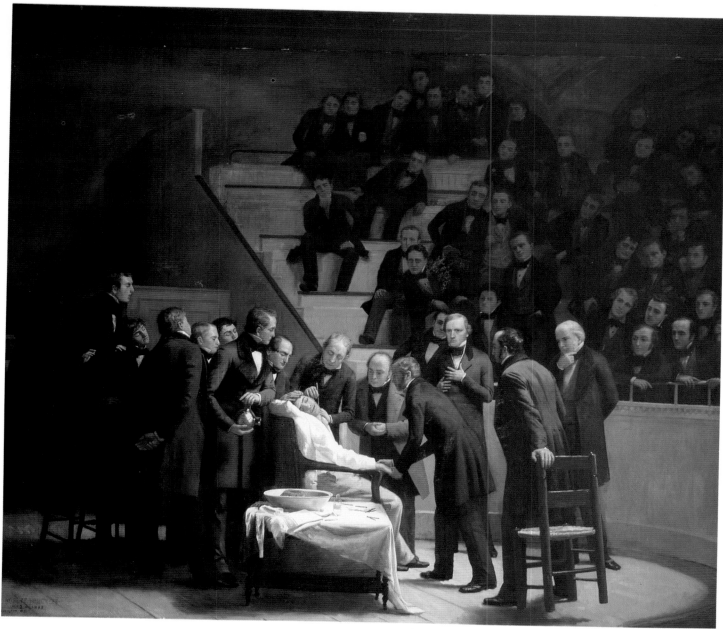

COLORPLATE 84

ROBERT C. HINCKLEY. *First Operation Under Ether.* 1881–94. Oil on canvas. 96 × 115 in.
(243.8 × 292.1 cm). Boston Medical Library, Francis A. Countway Library of Medicine,
Boston. *Hinckley celebrates the first public demonstration of the use of ether anesthesia in surgery,
October 16, 1846, as described by surgeon John Collins Warren.*

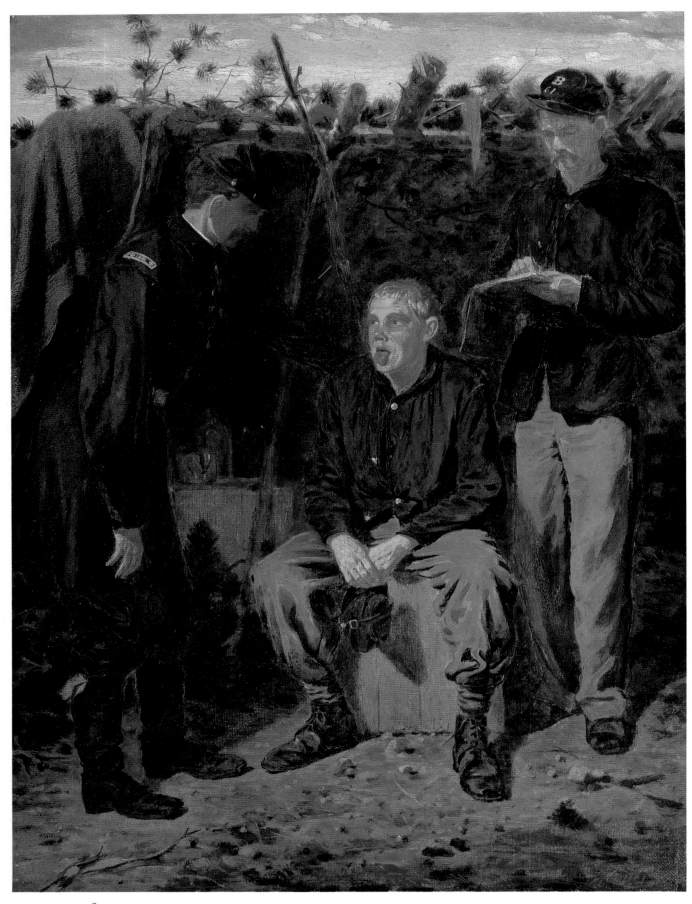

COLORPLATE 85

WINSLOW HOMER. *Playing Old Soldier.* c.1863. Oil on canvas. 16 × 12 in.
(40.6 × 30.5 cm). Museum of Fine Arts, Boston. Ellen Kalleran Gardner Fund.
Homer did many documentary-style lithographs for Harpers' Weekly *and other magazines
during the Civil War, portraying the organization and practices of the innovative U. S.
Army Medical Corps.*

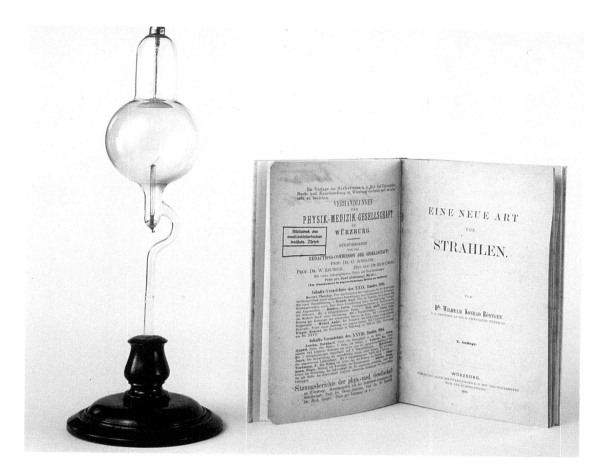

surface is turned toward the discharge tube. This fluorescence is visible even when the paper screen is at a distance of two meters from the apparatus.

It is easy to prove that the cause of the fluorescence proceeds from the discharge apparatus, and not from any other point in the conducting circuit.

The most striking feature of this phenomenon is the fact that an active agent here passes through a black cardboard envelope, which is opaque to the visible and the ultra-violet rays of the sun or of the electric arc; an agent, too, which has the power of producing active fluorescence. Hence we may first investigate the question whether other bodies also possess this property.

We soon discover that all bodies are transparent to this agent, though in very different degrees. I proceed to give a few examples: Paper is very transparent; behind a bound book of about one thousand pages I saw the fluorescent screen light up brightly, the printer's ink offering scarcely a noticeable hindrance. In the same way the fluorescence appeared behind a double pack of cards; a single card held between the apparatus and the screen being almost unnoticeable to the eye. A single sheet of tinfoil is also scarcely perceptible; it is only after several layers have been placed over one another that their shadow is distinctly seen on the screen. Thick blocks of wood are also transparent, pine boards 2 or 3 cm. thick absorbing only slightly. A plate of aluminum about 15 mm. thick, though it enfeebled the action seriously, did not cause the fluorescence to disappear entirely. Sheets of hard rubber several centimeters thick still permit the rays to pass through them. Glass plates of equal thickness behave quite differently, according as they contain lead (flint glass) or not; the former are much less transparent than the latter. If the hand be held between the discharge tube and the screen, the darker shadow of the bones is seen within the slightly dark shadow image of the hand itself. Water, carbon disulphide, and various other liquids, when they are examined in mica vessels, seem also to be transparent. That hydrogen is to any considerable degree more transparent than air I have not been able to discover. Behind plates of copper, silver, lead, gold, and platinum, the fluorescence may still be recognized, though only if the thickness of the plates is not

too great. Platinum of a thickness of 0.2 mm. is still transparent; the silver and copper plates may even be thicker. Lead of a thickness of 1.5 mm. is practically opaque, and on account of this property this metal is frequently most useful. A rod of wood with a square cross-section (20 by 20 mm.), one of whose sides is painted white with lead paint, behaves differently according as to how it is held between the apparatus and the screen. It is almost entirely without action when the X rays pass through it parallel to the painted side; whereas the stick throws a dark shadow when the rays are made to traverse it perpendicular to the painted side.

<center>⋆ ⋆ ⋆</center>

Of special significance in many respects is the fact that photographic dry plates are sensitive to the X rays. We are, therefore, in a condition to determine more definitely many phenomena, and so the more easily to avoid deception; wherever it has been possible, therefore, I have controlled, by means of photography, every important observation which I have made with the eye by means of the fluorescent screen.

In these experiments the property of the rays to pass almost unhindered through thin sheets of wood, paper, and tinfoil is most important. The photographic impressions can be obtained in a nondarkened room with the photographic plates either in the holders or wrapped up in paper. On the other hand, from this property it results as a consequence that undeveloped plates cannot be left for a long time in the neighborhood of the discharge tube, if they are protected merely by the usual covering of pasteboard and paper.

It appears questionable, however, whether the chemical action on the silver salts of the photographic plates is directly caused by the X rays. It is possible that this action proceeds from the fluorescent light which, as noted above, is produced in the glass plate itself or perhaps in the layer of gelatin. "Films" can be used just as well as glass plates.

<center>⋆ ⋆ ⋆</center>

The justification for calling by the name "rays" the agent which proceeds from the wall of the discharge apparatus, I derive in part from the entirely regular formation of shadows, which are seen when more or less transparent bodies are brought between the apparatus and the fluorescent screen (or the photographic plate).

I have observed, and in part photographed, many shadow pictures of this kind, the production of which has a particular charm. I possess, for instance, photographs of the shadow of the profile of a door which separates the rooms in which, on one side, the discharge apparatus was placed, on the other the photographic plate; the shadow of the bones of the hand; the shadow of a covered wire wrapped on a wooden spool; of a set of weights enclosed in a box; of a compass in which the magnetic needle is entirely enclosed by metal. . . .

There seems to exist some kind of relationship between the new rays and light rays; at least this is indicated by the formation of shadows, the fluorescence and the chemical action produced by them both. Now, we have known for a long time that there can be in the ether longitudinal vibrations besides the transverse light vibrations, and, according to the views of different physicists, these vibrations must exist. Their existence, it is true, has not been proved up to the present, and consequently their properties have not been investigated by experiment.

Ought not, therefore, the new rays to be ascribed to longitudinal vibrations in the ether?

I must confess that in the course of the investigation I have become more and more confident of the correctness of this idea, and so, therefore, permit myself to announce this conjecture, although I am perfectly aware that the explanation given still needs further confirmation.

William Stewart Halsted
"The Training of the Surgeon"

Exemplary teaching stories attend every part of the biography of Halsted (1852–1922) from his athletic successes as an undergraduate at Yale, to the care he displayed in anatomical researches, to his inadvertent cocaine addiction born of his self-experimentation with local anaesthesia for delicate surgical operations. Rehabilitated, Halsted led the most prestigious program of surgery in 1900, at the Johns Hopkins Hospital. A typical Halsted story concerns his introduction of the rubber glove in surgery as a response to the dermatitis (caused by Lister's carbolic acid spray) on the hands of a scrub nurse whom he respected as "an unusually efficient woman."

Pain, haemorrhage, infection, the three great evils which had always embittered the practice of surgery and checked its progress, were, in a moment, in a quarter of a century (1846–1873) robbed of their terrors. A new era had dawned; and in the 30 years which have elapsed since the graduation of the class of 1874 from Yale, probably more has been accomplished to place surgery on a truly scientific basis than in all the centuries which had preceded this wondrous period.

<p align="center">★ ★ ★</p>

Anesthesia, one of the greatest blessings, is at the same time one of our greatest reproaches, haemorrhage is still awkwardly checked, and of surgical infection once started we have often little control and then mainly by means of the knife. We have reason to hope that the day will come when haemorrhage will be controlled by a quicker procedure than the awkward, time-consuming ligature; when infections will be controlled by specific products of the laboratory; and when pain will be prevented by a drug which will have an affinity only for the definite sensory cells which it is desirable it should affect. The first of these may be last and the last first. Let us trust that it may, as Gross expresses it, "be a long time before the laws of this department of the healing art will be as immutable as those of Medes and Persians."

<p align="center">★ ★ ★</p>

It is hard to realize that 40 years have passed since Lister and Pasteur made to surgery a contribution rivalled only by Harvey's in importance. It was in 1867 that Lister first made known the almost incredible results of his experiments with carbolic acid in the treatment of wounds. The great merit of Lister lies in his clear recognition of the significance of Pasteur's discoveries in revealing the underlying causes of the infection of wounds and in the adoption of measures fitted to prevent and combat such infection. This merit will remain whatever changes may be made in the details of antiseptic and aseptic surgical procedures.

It was not, however, until 1875 that even in Germany Listerism obtained a substantial foothold. How I should like to tell the true story of this period in this country and abroad, to do full justice to Lister and his few faithful disciples in the United States and Great Britain, who for nearly 20 years contended with prejudice and parried the almost venomous thrusts of the skeptical and the envious.

Why was Germany the country first to adopt antiseptic surgery? Why did almost every surgeon in every German university eagerly embrace Lister's system almost at the same moment and as soon as it was clearly presented? The answers to these questions are, I believe, to be sought in Germany, and it is especially upon the question of the training of surgeons that I wish to dwell in the remainder of this address. What I shall

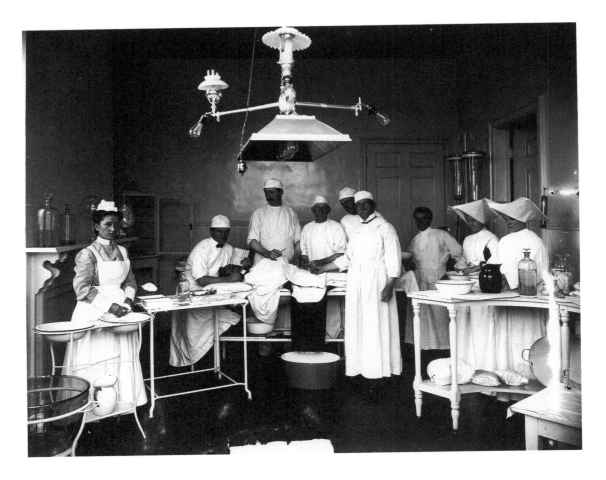

have to say relates not so much to the mere teaching of surgery in the undergraduate curriculum, as to the requirements for the training of those who desire to fit themselves for a career in surgery.

Thirty years ago as I sat upon the benches, often seven hours a day, listening to medical lectures, I was so impressed with the characters and lives of some of my teachers that I believed they represented all that was most advanced in medicine. But a day in Halle, at the clinic of Volkmann, was a revelation to me. There I heard by one of the young assistants at the early morning clinic an impromptu discourse on epithelioma at which I marvelled. At home the whole subject of tumors had been treated of in one lecture, in one hour, in the "tumor lecture." Attending the Congress of German surgeons, which each year takes place at Eastertide in Berlin, I heard the subject of hip joint tuberculosis discussed. One surgeon alone reported on 600 cases, more or less, some of which he had observed 20 years or longer and most of which he had been able to follow. His methods of observation were new to me; his knowledge was inspiring; I was thrilled by his masterful exposition. Within two weeks, by a strange coincidence, I found myself attending in America a meeting of a very superior "surgical society" in one of our large cities, at which the same subject, "morbus coxarius," was under consideration. Only one of the surgeons had had an experience of as many as 28 cases, and of the subsequent history of most of these he knew very little. The contrast was not only in the knowledge and presentation of and interest in the subject, but in the audience. The Deutsche Gesellschaft für Chirurgie admits to its fellowship any reputable surgeon of any country of the world, and its halls at each Congress are filled and overflowing. The membership of the select "surgical society" was limited to 20 and the average attendance was less than this number.

It may be that the rise and multiplication of proprietary schools of medicine without organic connection with a university was a necessary incident in the rapid growth of a new country, but it is absurd to expect them to yield results in the education of physicians and in the advancement of knowledge comparable with those of the well-supported medical departments of European universities. It is difficult to free either the educated

public or our universities from the reproach that they remained so long indifferent to the needs of higher medical education. The times are changing, and we have learned in our own time, indeed within a decade, how superior in all respects is the endowed university medical school to the old-time proprietary school. Who would have believed that one or two well-utilized endowments could have achieved in so short a time so much? It was not only because some of the best men in this country were attracted to the university medical schools, fortunate enough to be so endowed, that the great progress was made; it was also because the further development of these men was made possible by the opportunities which they proffered and the atmosphere which they developed.

<p style="text-align:center">★ ★ ★</p>

What are the inducements which make it worth while for the young men in Germany to devote so many years to preparation for the practice of surgery, what the careers to which they aspire, and what manner of men are they who furnish by their example and by their achievements the great stimulus?

Not only the first assistants but all the members of the surgical staff of one of the great university clinics in Germany enjoy almost ideal facilities for learning surgery and for prosecuting researches. The amount of clinical material is great. The operative work begins early in the morning and often does not cease till late in the afternoon. The out-patient department is controlled by the chief surgeon and is conducted by his assistants; a patient when discharged is consequently not referred to some dispensary or other and lost sight of. The pathological material obtained at operation is carefully worked up in the special laboratories for surgery and, if need be, is preserved in the museum, which should always be an important feature of the surgical department of a university. Every facility and the greatest encouragement is given each member of the staff to do work of research.

Although during the eight to twelve years of hospital service as assistant in some large university clinic he has laid the foundation of his reputation, the real life work of a German surgeon begins when he is invited to fill a professorial chair. He now longs to prove himself worthy of the new position, he has the incentive to inspire others to achieve, he measures himself by a new standard, and there is born in him the desire to rise higher, to sow the seed which will produce a bloom worthy of the greatest universities, possibly even of Berlin. In European countries no effort, no amount of time, few sacrifices would be considered too great if thereby the chair of surgery in a university might be secured. In Germany the prestige of the position is something that we in the United States who have not lived abroad cannot truly comprehend. In each university the chair has its imperishable traditions, its long line of famous surgeons, whose names are cherished and revered for their services to science, to their universities, to their country and to their fellows. . . .

I have known professorial chairs in one of the principal medical schools of this country to go actually a-begging—a-begging, of course, only of men who would adorn the position. Recently I asked a prominent surgeon, to whom a chair in one of our chief universities had been offered, why he had not accepted it. He replied that his practice was a large and lucrative one and that he had neither the time nor the inclination to prepare and deliver 100 lectures, more or less, a year. Young men are naturally only too glad and eager to secure a professorship which would insure a good living and a certain distinction, but older men who are already well known with an assured income have no inclination to undertake teaching of a prescribed kind for which they are not trained and for which the rewards are not in their opinion proportionate to the labor. Even to those who have held the chairs of surgery for years the work sometimes becomes so irksome that they seek to abandon it as soon as directly or indirectly it ceases to yield a sufficient return.

The faults of our system of educating surgeons begin almost at the bottom and continue to the very top. I am considering only the training of the best men, those who aspire to the higher career in surgery. On graduation they become hospital internes, but their term in the hospital is only one and a half, occasionally two years, only a little longer

than the term of hospital service required in Germany of every applicant for the medical degree and not so long, on the average, as that required of each medical graduate of the University of Tokio. The interne suffers not only from inexperience, but also from over-experience. He has in his short term of service responsibilities which are too great for him; he becomes accustomed to act without preparation, and he acquires a confidence in himself and a self-complacency which may be useful in time of emergency, but which tend to blind him to his inadequacy and to warp his career. A surgeon should find his greatest stimulus and support in his assistants with whom he spends or should spend many hours a day; but this is only possible when they have had opportunities for sufficient development. . . .

But much as the interne suffers from the brevity of his hospital experience, the hospital suffers more and the surgeon most. Every important hospital should have on its resident staff of surgeons at least one who is well able to deal not only with any emergency that may arise and to perform any operation known to surgery, but also to recognize the gross appearances of all the ordinary pathological tissues and lesions.

But the interne leaves the hospital unequipped; eventually, it may be, he secures the position of attending surgeon to some hospital and then he is expected to teach others to perform operations which he himself has not learned to do, and to pronounce at the operating table upon conditions with which he is not familiar and which possibly he had never seen nor heard of.

We need a system, and we shall surely have it, which will produce not only surgeons but surgeons of the highest type, men who will stimulate the first youths of our country to study surgery and to devote their energies and their lives to raising the standard of surgical science. Reforms, the need of which must be apparent to every teacher of surgery in this country, must come on the side both of the hospital and of the university, and it is natural to look to our newer institutions, unhampered by traditions and provided with adequate endowment, for the inception of such reforms. It is eminently desirable, if not absolutely essential, that the medical school should control a hospital of its own. There should be such an organization of the hospital staff as I have indicated, providing the requisite opportunities for the prolonged and thorough training of those preparing for the higher careers in medicine and surgery, and permitting the establishment of close and mutually stimulating relations between chief and assistants.

The professors of medicine and surgery occupy a peculiar position. They are teachers in the universities and at the same time teachers in the technical schools, the hospitals, which in this country are in only one or two instances, unfortunately, under the control of the university. As university instructors it is still a question just how much of the technical they shall teach, and as workers in the technical school, the hospital and in private practice, how much time they shall devote to laboratory investigation. It is doubtful if an ideal adjustment, if there were such a thing, could always be preserved, because in one individual there reigns a passion for laboratory pursuits, in another the love of the practical and the reward which practice may bring.

* * *

After all, the hospital, the operating room and the wards should be laboratories, laboratories of the highest order, and we know from experience that where this conception prevails not only is the cause of higher education and of medical science best served, but also the welfare of the patient is best promoted. It remains with the teachers of medicine and surgery to make them so. The surgeon and the physician should be equipped and should be expected to carry on work of research; they hold positions which should make them fertile in suggesting lines of investigation to their assistants and associates; they should not only be productive themselves, but should serve as a constant stimulus to others. . . .

While it has been my main purpose in this address to call attention to certain defects in the existing methods of medical education, especially in the opportunities for the advanced training of surgeons in this country, I would not be understood to minimize

or to decry the great achievements of American surgery. Courage, ingenuity, dexterity, resourcefulness are such prominent characteristics of our countrymen that it would have been surprising if from the labors of her many earnest and devoted teachers and practitioners there had not resulted contributions to the science and art of surgery which have carried the fame of American surgery throughout the civilized world. . . .

I should do my countrymen scant justice did I fail to emphasize the importance of at least one monumental contribution, which, I believe, redounds more to the glory of American surgery than any achievement of the past. It is hardly possible to overestimate the value of the modern work on the subject of appendicitis nor to attribute to it too great a share in stimulating and clearing the way for the great strides made in the entire field of abdominal surgery in the past 12 or 14 years. It is convincing testimony to the advanced character of this epochal work that continental surgeons were for several years unable fully to comprehend and accept the teachings of their co-workers in the new country. As operators some of our surgeons are not surpassed by any I have seen; there are, I believe, few operations in surgery which cannot be performed as well in this country as anywhere in the world, and not a few operations are best performed by the surgeons of America.

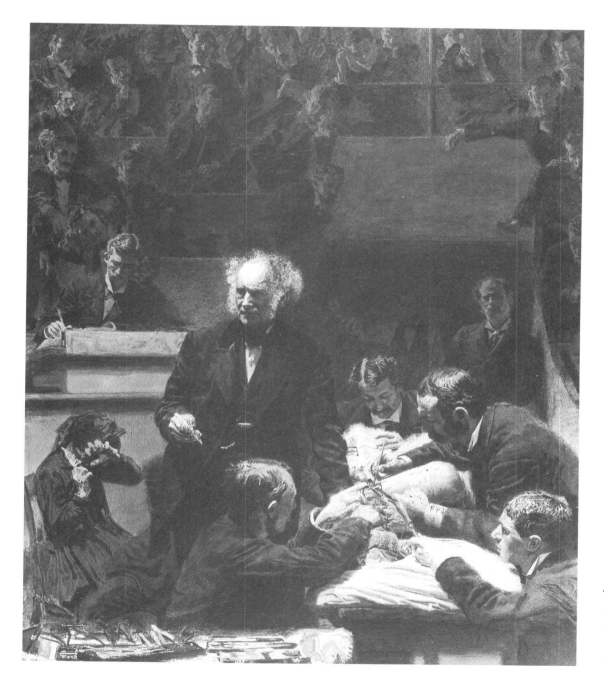

THOMAS EAKINS. *The Gross Clinic*. Before 1916. India-ink wash on cardboard. 23⅝ × 19⅛ in. (60 × 48.6 cm). Metropolitan Museum of Art, New York. Rogers Fund. *American surgeon and teacher Samuel Gross (1805–1884) gained world renown for his numerous publications, such as his two-volume* System of Surgery, Pathological, Diagnostic, Therapeutic, and Operative *(1859).*

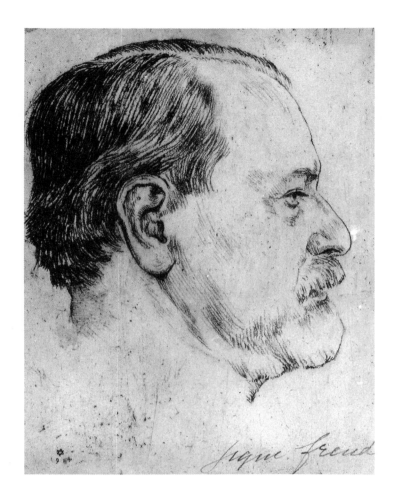

Sigmund Freud

Letter to Wilhelm Fliess

Correspondence with Berlin physician Wilhelm Fliess was the avenue for a rapid development of Freud's "metapsychology"—his theories of the determinants of human thought and behavior. By 1897 Freud (1856–1939) was leaving behind the work he did with Ernst von Brücke on Studies in Hysteria *and, as this letter shows, mapping the way to his pathbreaking* Interpretation of Dreams *(1901). Fliess seems to have provided the ideal passive audience for Freud's research at this crucial period. Freud first suffered from cancer of the jaw in 1923, probably related to his demand for 15 to 20 cigars each day. He died in London, a refugee from his native Austria.*

21. 9. 97
IX. Berggasse 19.
[Vienna]

My dear Wilhelm,

Here I am again—we returned yesterday morning—refreshed, cheerful, impoverished and without work for the time being, and I am writing to you as soon as we have settled in again. Let me tell you straight away the great secret which has been slowly dawning

on me in recent months. I no longer believe in my *neurotica*. That is hardly intelligible without an explanation; you yourself found what I told you credible. So I shall start at the beginning and tell you the whole story of how the reasons for rejecting it arose. The first group of factors were the continual disappointment of my attempts to bring my analyses to a real conclusion, the running away of people who for a time had seemed my most favourably inclined patients, the lack of the complete success on which I had counted, and the possibility of explaining my partial successes in other, familiar, ways. Then there was the astonishing that that in every case . . . blame was laid on perverse acts by the father, and realization of the unexpected frequency of hysteria, in every case of which the same thing applied, though it was hardly credible that perverted acts against children were so general. (Perversion would have to be immeasurably more frequent than hysteria, as the illness can only arise where the events have accumulated and one of the factors which weaken defence is present.) Thirdly, there was the definite realization that there is no "indication of reality" in the unconscious, so that it is impossible to distinguish between truth and emotionally-charged fiction. (This leaves open the possible explanation that sexual phantasy regularly makes use of the theme of the parents.) Fourthly, there was the consideration that even in the most deep-reaching psychoses the unconscious memory does not break through, so that the secret of infantile experiences is not revealed even in the most confused states of delirium. When one thus sees that that unconscious never overcomes the resistance of the conscious, one must abandon the expectation that in treatment the reverse process will take place to the extent that the conscious will fully dominate the unconscious.

So far was I influenced by these considerations that I was ready to abandon two things—the complete solution of a neurosis and sure reliance on its aetiology in infancy. Now I do not know where I am, as I have failed to reach theoretical understanding of repression and its play of forces. It again seems arguable that it is later experiences which give rise to phantasies which throw back to childhood; and with that the factor of hereditary predisposition regains a sphere of influence from which I had made it my business to oust it—in the interests of fully explaining neurosis.

Were I depressed, jaded, unclear in my mind, such doubts might be taken for signs of weakness. But as I am in just the opposite state, I must acknowledge them to be the result of honest and effective intellectual labour, and I am proud that after penetrating so far I am still capable of such criticism. Can these doubts be only an episode on the way to further knowledge?

It is curious that I feel not in the least disgraced, though the occasion might seem to require it. Certainly I shall not tell it in Gath, or publish it in the streets of Askalon, in the land of the Philistines—but between ourselves I have a feeling more of triumph than of defeat (which cannot be right).

<p style="text-align:center">★　　★　　★</p>

I vary Hamlet's remark about ripeness—cheerfulness is all. I might be feeling very unhappy. The hope of eternal fame was so beautiful, and so was that of certain wealth, complete independence, travel, and removing the children from the sphere of the worries which spoiled my own youth. All that depended on whether hysteria succeeded or not. Now I can be quiet and modest again and go on worrying and saving, and one of the stories from my collection occurs to me: "Rebecca, you can take off your wedding-gown, you're not a bride any longer!"

There is something else I must add. In the general collapse only the psychology has retained its value. The dreams still stand secure, and my beginnings in metapsychology have gone up in my estimation. It is a pity one cannot live on dream-interpretation, for instance.

Martha came back to Vienna with me. Minna and the children are staying away for another week. They have all been very well. . . .

I hope to hear from you soon in person . . . how things are going with you and whatever else is doing between heaven and earth. . . .

Gwyn Macfarlane

FROM ALEXANDER FLEMING

Heroic accounts of Fleming's discovery of penicillin embrace the serendipity Fleming sometimes attributed to his research. "Always be on the look-out for the unusual" was Fleming's own moral to the story. Pathologist Gwyn Macfarlane's painstaking reassessment of Fleming's status as a medical hero illuminates not the "great man" myth, but the laboratory traditions and careful microbiological techniques on which Fleming was nurtured—the scientific community that truly created the antibiotic era in which we now live.

Any simple account of the events of Fleming's life raises obvious questions. The story involves mysteries that are real ones, and apparent mysteries that are no more than myths. The time has now come to examine some of these, and if one or two mysteries remain unsolved, at least the strangeness of the truth can be distinguished from the lesser strangeness of fiction.

Let us begin with a technical mystery. Just how did the discovery of penicillin—possibly the most momentous in the history of medicine—actually come about? On the face of it, it seems simple enough. Everyone knows that penicillin destroys germs, and Fleming saw staphylococci being destroyed around a mould growing on one of his culture plates. His published account suggests that what happened was this: first, he had grown the germs until they formed colonies, and then left the plate on the bench to be examined "from time to time"; next, during one of these examinations, a mould fell onto the surface of the plate, and grew; finally, some time later, he noticed that, around this mould, the colonies "were obviously undergoing lysis." But in the first experiment to be recorded in his notebook, we find that he had reversed this sequence. First he grew the mould for five days at room temperature, and then sowed staphylococci near to it, putting the plate in the incubator to grow them into colonies. And these colonies failed to grow within about 3 cm of the mould. The reason for the change in technique was that he had found that he could not reproduce his original observation by implanting a mould among existing staphylococcal colonies and letting it grow at room temperature. Though the mould might grow, the colonies remained visibly unchanged. Hughes writes that if Fleming needed to reproduce the appearance of his original plate for demonstration purposes "he had to 'fake' it by growing the mould first (giving it plenty of time to produce penicillin) and then planting the staphylococci." The mould would have been grown at room temperature, and the staphylococci at 37°C, because these are the temperatures at which each grows best.

If Fleming was puzzled by this failure to reproduce the phenomenon as described in his paper he made no note of it. But other people discovered the puzzle for themselves. D.B. Colquhoun, in a paper published in 1975, writes that he found, in 1929, that Fleming's mould implanted among staphylococci either refused to grow or, if it did, had no visible effect on their colonies. And in 1955 he found that inhibition of staphylococci only occurred if the mould had been grown first. Margaret Jennings, working with Florey, had a similar experience, published in 1944 and found that penicillin itself did not lyse staphylococcal colonies. But it was Ronald Hare who made the most extensive study of the problem, published in his book *The Birth of Penicillin* in 1970. This led him to conclude that it is almost impossible to "discover" penicillin in the way that Fleming seemed to describe in his published paper.

It was not until 1940, when penicillin was becoming of intense interest, that its mode of action began to be understood. In that year, A. D. Gardner, working with Florey,

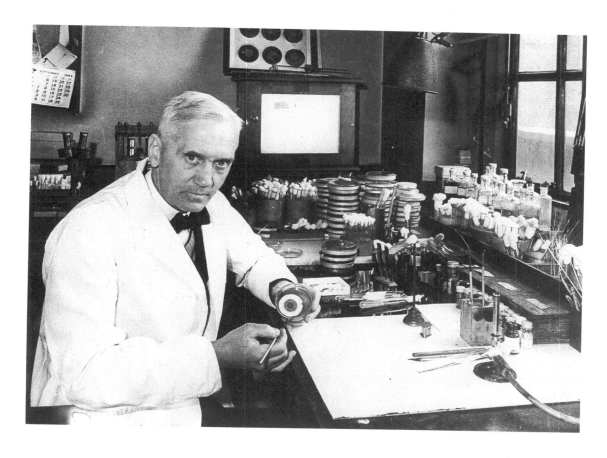

Dr. Alexander Fleming.
Photograph.

watched through his microscope the behaviour of bacteria in the presence of penicillin. The adult cells seemed to be unaffected. But when they divided, the young cells became abnormally swollen and transparent and finally burst. This effect was explained by the work of Park and Stominger, reported in 1957. They found that penicillin blocks the synthesis of compounds needed by young bacteria to build their cell walls. Penicillin, in fact, does not kill adult bacteria; it produces a fatal defect in succeeding generations. Hence the delayed action observed by Fleming.

The mode of action of penicillin thus explains why its discovery could not have involved the sequence of events suggested by Fleming's description. At room temperature the grown colonies of staphylococci on his plate would have consisted largely of adult, quiescent cells impervious to the action of penicillin. A mould alighting among them and producing penicillin would not have changed their appearance and there would have been nothing of interest for him to see. It is an almost inescapable conclusion that the mould must have grown *before* the staphylococci, in order to produce what he did see. But how could this have happened?

Colquhoun has suggested that the mould colony *was* there, and producing penicillin, when Fleming seeded the plate with staphylococci and then, presumably, incubated it. The objection to this theory is that Fleming—a first-class bacteriologist—must surely have seen it, and would not have used a mouldy plate. But Colquhoun suggests further that Fleming, having noticed the mouldy colony, seeded his staphylococci nevertheless just to see what would happen. Colquhoun supports his idea by quoting what Fleming had said in a speech in Louvain, in 1945:

> "I play with microbes. There are, of course, many rules in this play . . . but
> when you have acquired knowledge and experience it is very pleasant to break
> the rules and to be able to find something that nobody had thought of . . ."

It is true that Fleming liked breaking established rules in any game and that, when telling Bustinza about his work on penicillin, he said "I was just playing." But if Fleming had deliberately broken the unwritten rule against inoculating mouldy plates, why did he not say so in his paper?

The most plausible explanation is that given by Hare in *The Birth of Penicillin*. His basic assumption is that Fleming, having sown his plate with staphylococci, did not incubate it but left it on the bench, where it was contaminated by a mould spore. The omission of incubation, which might have been by accident or design, is essential to Hare's thesis because he suggests that what happened next depended on the weather. If the plate remained cool for several days the mould would grow and produce penicillin while the staphylococci would remain dormant. If there was then a hot spell, the staphylococci would grow into normal colonies, except for those in the penicillin zone, which would either not grow at all, or would form colonies that lysed. The picture would then be as Fleming described it, and Hare was able to reproduce it exactly by following this temperature sequence experimentally. He then obtained records of the 1928 summer temperatures in London. These showed that, after a heat-wave in mid-July, there was a cold spell from 27 July to 6 August, with maximum temperatures between 16° and 20°C, followed by a warm spell with temperatures reaching 25° or 26°.

Hare quotes evidence that Fleming's penicillin plate was among a batch that he had sown before leaving for The Dhoon at the end of July, and that these plates remained on his bench during August while he was away on holiday. Thus the conditions required by his theory would have been fulfilled. Any contaminating mould would have grown until August 6, and only after that date would the staphylococci have had enough heat to grow. It is not known with certainty when Fleming next saw the plate but from an entry in his notebook, Hare deduces that Fleming returned from The Dhoon on September 3.

Where the mould came from is a matter of dispute. La Touche, the mycologist working in the room below Fleming's, had none of the usual facilities for preventing spores becoming airborne, and one of the moulds he later supplied to Fleming seemed identical to the original penicillin producer. So the mould probably came from La Touche, through Fleming's ever-open door, rather than from the richly contaminated air of Praed Street through his seldom-opened window. Even the window is in dispute. Hare maintains that it was hardly possible to open it. Allison says that it could be opened at the top by cords and pulleys, and remembers that, on hot days, it was. But whether it came through the window or the door the important point is that the mould did, in fact, arrive; just as the weather was, in fact, at first cool and then warm.

Though the chance events required by Hare's theory are by no means unlikely ones, the whole chain of chance events involved in the discovery has an almost unbelievable improbability. Let us list them in the order required for the final result to occur. First, Fleming inoculates a plate with staphylococci and it happens to become contaminated with a rare, penicillin-producing strain of mould. Second, he happens not to incubate this plate. Third, he leaves it on his bench undisturbed while he is away on holiday. Fourth, the weather during this period is at first cold and then warm. Fifth, Fleming examines the plate, sees nothing interesting and discards it, but by chance it escapes immersion in lysol. Sixth, Pryce happens to visit Fleming's room, and Fleming decides to show him some of the many plates that had piled up on the bench. Seventh, Fleming happens to pick the discarded penicillin plate out of the tray of lysol (in which it should have been immersed), and on a second inspection sees something interesting.

It is hardly possible to calculate the odds against the occurrence of such a sequence of accidents. At a rough guess they might be of the same order as those against drawing, in the right order, the winners of seven consecutive horse races from a hat containing the names of *all* the runners. But, applied retrospectively to an actual happening, such speculations are academic. What has happened has happened—whatever the chances against it might have been.

What might be called Bustinza's theory almost transcends probability. He maintains that Fleming discovered penicillin exactly as described in his paper, and that no one has the right to dispute this. It is true that lysis of grown colonies by penicillin *can* occur, though only with certain rare strains of staphylococci, and with penicillin concentrations kept between very narrow limits. Fleming demonstrated such lysis in 1945, but by an elaborate culture technique that bore no resemblance to his original, essentially simple,

one. Bustinza, in fact, assumes the chance occurrence of an extra set of events so unlikely to have happened that his theory is hardly tenable.

There is therefore no definitive solution to the mystery, only theories, plausible and implausible. Fleming himself never clarified the matter, and he probably did not know precisely the history of the one plate among the many that he had left on the bench. It seems to have had no identifying marks, and there is no record of when it was made or when it was examined.

As if the chances against Fleming discovering penicillin were not enough, one has to add yet another improbable antecedent, his discovery of lysozyme. It was his interest in lysozyme that prepared his mind and eye for the chance gift of the penicillin plate. Moreover, it was the resemblance to lysozyme in Fleming's *description* that attracted Chain's attention when he read the penicillin paper. Lysozyme, therefore, prepared the way not only for Fleming's discovery of penicillin, but for the work in Oxford that established its value.

The discovery of lysozyme is a sort of "déjà vu" mirror-image of the discovery of penicillin. With penicillin we have a rare antibacterial agent acting on a very common microbe. With lysozyme we have a widely occurring antibacterial agent revealed by the chance contamination of a plate by a very rare bacterium. The origin of the *Micrococcus lysodeikticus* is even more obscure than that of Fleming's mould. Allison suggests that it floated in from Praed Street, and states that neither he nor Fleming had ever come across the microbe before or since. The popular myth, that Fleming discovered lysozyme when a drip from his nose happened to fall on a culture plate, leaves the main mystery unsolved. How was it that the culture plate also happened to be covered by colonies of *M. lysodeikticus*? However they arrived, Fleming was extremely lucky to have had two such rare and important visitors as his mould spore and his *M. lysodeikticus*. Or, perhaps, we should say that the world was lucky that such chances were given to Fleming, the man with the eye to notice them and the mind to grasp their significance.

Albert Schweitzer

FROM ON THE EDGE OF THE PRIMEVAL FOREST

Schweitzer's birth in the French and German-speaking border area of Upper Alsace in 1875 was but the beginning of a life that blended many disparate cultures, interests, and eras. Establishing his reputation as a gifted theological scholar at the age of 31, Schweitzer became, successively, a noted researcher and performer of Bach's organ works; an international physician–missionary in Lambarene, Gabon; and the Nobel Peace Prize winner in 1952 for his attempts to create a "Brotherhood of Nations." During his thirty years in Africa he never learned to speak any African language. Still, he communicated well with Europeans and Americans and, during the 1950s, became a powerful early medical spokesman against nuclear proliferation. He died in 1965.

The hut for the sleeping sickness victims is now in course of erection on the opposite bank, and costs me much money and time. When I am not myself superintending the labourers whom we have secured for grubbing up the vegetation and building the hut, nothing is done. For whole afternoons I have to neglect the sick to play the part of foreman there.

Sleeping sickness prevails more widely here than I suspected at first. The chief focus

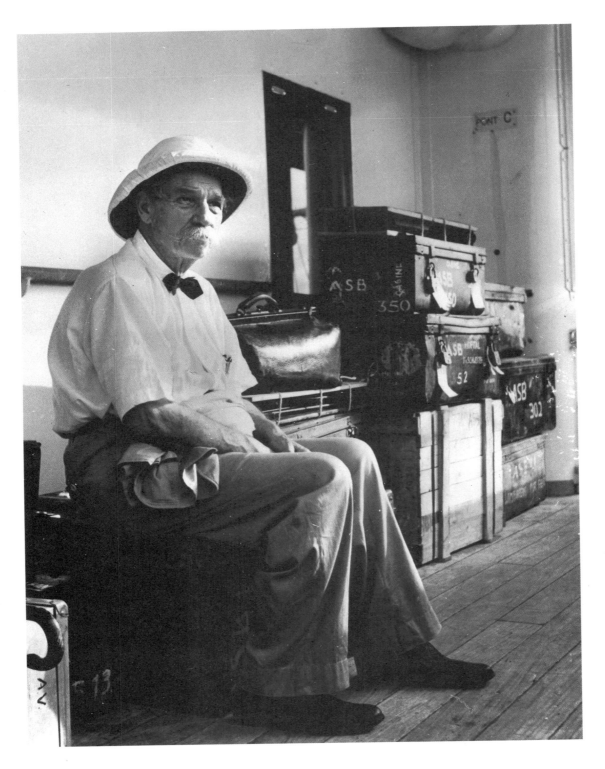

Dr. Albert Schweitzer. January 1955. Photograph. United Press International/Bettmann. *The famous physician and missionary, shown aboard a ship on his return to Port Gentile, Gabon, Africa, had just celebrated his 80th birthday. He provided primary medical care in central Africa for more than 30 years, in later years with the assistance of dedicated young doctors.*

of infection is in the N'Gounje district, the N'Gounje being a tributary of the Ogowe about ninety miles from here, but there are isolated centres round Lambaréné and on the lakes behind N'Gômô.

What is the sleeping sickness? How is it spread? It seems to have existed in Equatorial Africa from time immemorial, but it was confined to particular centres, since there was little or no travelling. The native method of trade with the sea coast was for each tribe to convey the goods to the boundary of its territory, and there to hand them over to the traders of the adjoining one. From my window I can see the place where the N'Gounje enters the Ogowe, and so far only might the Galoas living round Lambaréné travel. . . .

When the Europeans came, the natives who served them as boats' crews, or as carriers in their caravans, moved with them from one district to another, and if any of them had the sleeping sickness they took it to fresh places. In the early days it was unknown on the Ogowe, and it was introduced about thirty years ago by carriers from Loango.

Whenever it gets into a new district it is terribly destructive, and may carry off a third of the population. In Uganda, for example, it reduced the number of inhabitants in six years from 300,000 to 100,000. An officer told me that he once visited a village on the Upper Ogowe which had two thousand inhabitants. On passing it again two years later he could only count five hundred; the rest had died meanwhile of sleeping sickness. After some time the disease loses its virulence, for reasons that we cannot as yet explain, though it continues to carry off a regular, if small, number of victims, and then it may begin to rage again as destructively as before.

The first symptom consists of irregular attacks of fever, sometimes light, sometimes severe, and these may come and go for months without the sufferer feeling himself really ill. There are victims who enter the sleep stage straight from this condition of apparent health, but usually severe headaches come during the fever stage. Many a patient have I had come to me crying out: "Oh, doctor! my head, my head! I can't stand it any longer; let me die!" Again, the sleep stage is sometimes preceded by torturing sleeplessness, and there are patients who at this stage get mentally deranged; some become melancholy, others delirious. One of my first patients was a young man who was brought because he wanted to commit suicide.

As a rule, rheumatism sets in with the fever. A white man came to me once from the N'Gômô lake district suffering from sciatica. On careful examination, I saw it was the beginning of the sleeping sickness, and I sent him at once to the Pasteur Institute at Paris, where French sufferers are treated. Often, again, an annoying loss of memory is experienced, and this is not infrequently the first symptom which is noticed by those around them. Sooner or later, however, though it may be two or three years after the first attacks of fever, the sleep sets in. At first it is only an urgent need of sleep; the sufferer falls asleep whenever he sits down and is quiet, or just after meals.

A short time ago a white non-commissioned officer from Mouila, which is six days' journey from here, visited me because, while cleaning his revolver, he had put a bullet through his hand. He stayed at the Catholic mission station, and his black boy accompanied him whenever he came to have his hand dressed, and waited outside. When the N.C.O. was ready to go, there was almost always much shouting and searching for his attendant, till at last, with sleepy looks, the latter emerged from some corner. His master complained that he had already lost him several times because, wherever he happened to be, he was always taking a long nap. I examined his blood and discovered that he had the sleeping sickness.

Towards the finish the sleep becomes sounder and passes at last into coma. Then the sick man lies without either feeling or perception; his natural motions take place without his being conscious of them, and he gets continually thinner. Meanwhile his back and sides get covered with bed-sores; his knees are gradually drawn up to his neck, and he is altogether a horrible sight. Release by death has, however, often to be awaited for a long time, and sometimes there is even a lengthy spell of improved health. Last December I was treating a case which had reached this final stage, and at the end of four weeks the relatives hurried home with him that, at least, he might die in his own village. I myself expected the end to come almost at once, but a few days ago I got the news that he had recovered so far as to eat and speak and sit up, and had only died in April. The immediate cause of death is usually pneumonia.

Knowledge of the real nature of sleeping sickness is one of the latest victories of medicine, and is connected with the names of Ford, Castellani, Bruce, Dutton, Koch, Martin, and Leboeuf. The first description of it was given in 1803 from cases observed among the natives of Sierra Leone, and it was afterwards studied also in negroes who had been taken from Africa to the Antilles and to Martinique. It was only in the 'sixties that extensive observations were begun in Africa itself, and these first led to a closer description of the last phase of the disease, no one even suspecting a preceding stage or that there was any connection between the disease and the long period of feverishness. This was only made possible by the discovery that both these forms of sickness had the same producing cause.

Then in 1901 the English doctors, Ford and Dutton, found, on examining with the microscope the blood of fever patients in Gambia, not the malaria parasites they expected, but small, active creatures which on account of their form they compared to gimlets, and named Trypanosomata, i.e., boring-bodies. Two years later the leaders of the English expedition for the investigation of sleeping sickness in the Uganda district found in the blood of a whole series of patients similar little active creatures. Being acquainted with what Ford and Dutton had published on the subject, they asked whether these were not identical with those found in the fever patients from the Gambia region, and at the same time, on examination of their own fever patients, they found the fever to be due to the same cause as produced the sleeping sickness. Thus it was proved that the "Gambia fever" was only an early stage of sleeping sickness.

The sleeping sickness is most commonly conveyed by the *Glossina palpalis*, a species of tsetse fly which flies only by day. If this fly has once bitten any one with sleeping sickness, it can carry the disease to others for a long time, perhaps for the rest of its life, for the trypanosomes which entered it in the blood it sucked live and increase and pass in its saliva into the blood of any one it bites.

Still closer study of sleeping sickness revealed the fact that it can be also conveyed by mosquitoes, if these insects take their fill of blood from a healthy person immediately after they have bitten any one with sleeping sickness, as they will then have trypanosomes in their saliva. Thus the mosquito army continues by night the work which the *glossina* is carrying on all day. Poor Africa! I must, however, in justice add that the mosquito does not harbour the trypanosomes permanently, and that its saliva is poisonous only for a short time after it has been polluted by the blood of a sleeping sickness victim.

In its essential nature sleeping sickness is a chronic inflammation of the meninges and the brain, one, however, which always ends in death, and this ensues because the trypanosomes pass from the blood into the cerebro-spinal fluid. To fight the disease successfully it is necessary to kill them before they have passed from the blood, since it is only in the blood that atoxyl, one weapon that we at present possess, produces effects which can to any extent be relied on; in the cerebro-spinal marrow the trypanosomes are comparatively safe from it. A doctor must, therefore, learn to recognise the disease in the early stage, when it first produces fever. If he can do that, there is a prospect of recovery.

In a district, therefore, where sleeping sickness has to be treated, its diagnosis is a terribly complicated business because the significance of every attack of fever, of every persistent headache, of every prolonged attack of sleeplessness, and of all rheumatic pains must be gauged with the help of the microscope. Moreover, this examination of the blood is, unfortunately, by no means simple, but takes a great deal of time, for it is only very very seldom that these pale, thin parasites, about one eighteen-thousandth (1/18000) of a millimetre long, are to be found in any considerable number in the blood. So far I have only examined one case in which three or four were to be seen together. Even when the disease is certainly present one can, as a rule, examine several drops of blood, one after another, before discovering a single trypanosome, and to scrutinise each drop properly needs at least ten minutes. I may, therefore, spend an hour over the blood of a suspected victim, examining four or five drops without finding anything, and even then have no right to say there is no disease; there is still a long and tedious testing process which must be applied. This consists in taking ten cubic centimetres of blood from a vein in one of the sufferer's arms, and keeping in it revolving centrifugally for an hour according to certain prescribed rules, at the same time pouring off at intervals the outer rings of blood. The trypanosomes are expected to have collected into the last few drops, and these are put under the microscope; but even if there is again a negative result, it is not safe to say that the disease is not present. If there are no trypanosomes to-day, I may find them ten days hence, and if I have discovered some to-day, there may be none in three days' time and for a considerable period after that. A white official, whose blood I had proved to contain trypanosomes, was subsequently kept under observation for weeks, in Libreville, without any being discovered, and it was only in the Sleeping Sickness Institute at Brazzaville that they were a second time proved to be there.

COLORPLATE 86

LUIGI NONO. *Convalescing Child*. 1889. Oil on canvas. 38⅝ × 24⁷⁄₁₆ in. (98.1 × 62.1 cm).
Courtesy Auction House Finarte, Milan.

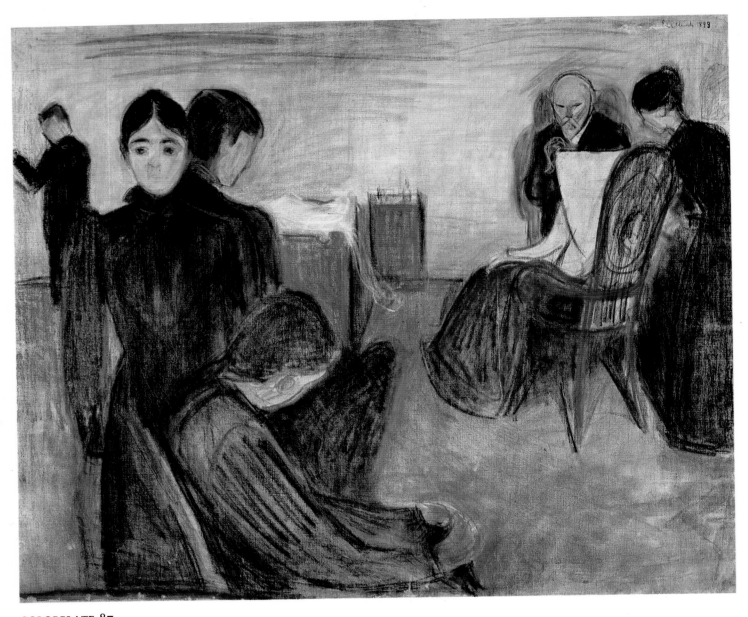

COLORPLATE 87

EDVARD MUNCH. *Death in the Sickroom*. 1893. Pastel on cardboard. 35¹³⁄₁₆ × 42¹⁵⁄₁₆ in.
(91 × 109.1 cm). Munch Museum, Oslo. *As a child, the artist saw his family ravaged by illness.*
In 1878, his sister died of tuberculosis.

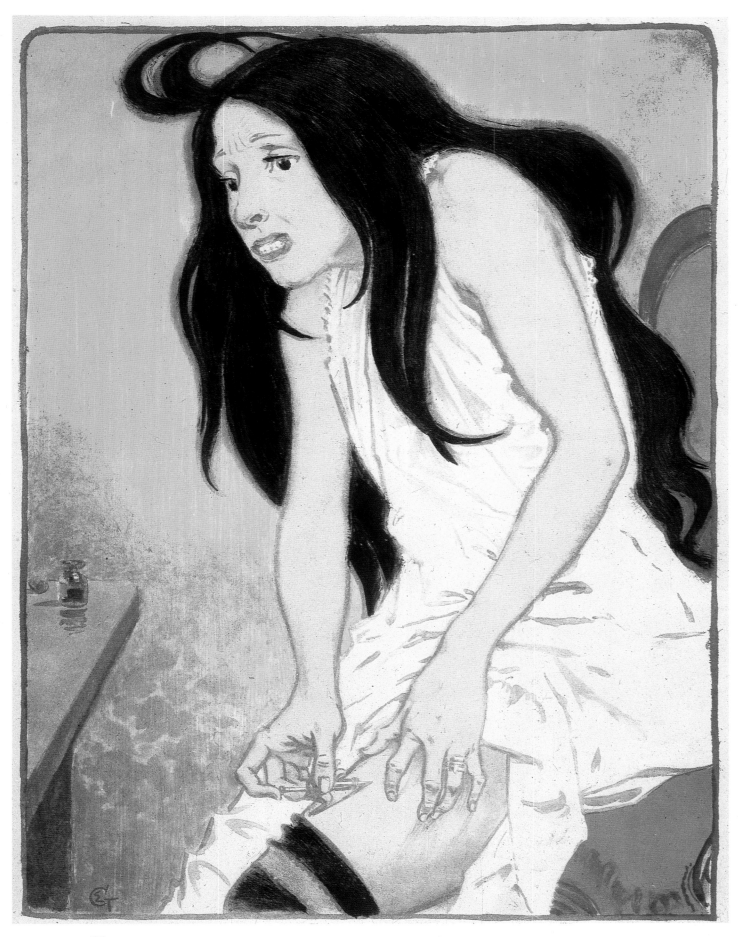

COLORPLATE 88

EUGÈNE-SAMUEL GRASSET. *Morphinomaniac*, from *L'Album des Peintres-Graveurs*, by Ambroise Vollard. 1897. Color lithograph. 16⁵⁄₁₆ × 12³⁄₈ in. (41.4 × 31.4 cm). SmithKline Beckman Corporation Fund, Philadelphia Museum of Art.

COLORPLATE 89

THOMAS EAKINS. *The Agnew Clinic.* 1889. Oil on canvas. 7½ × 10½ ft. (2.28 × 3.2 m). University of Pennsylvania, School of Medicine, Philadelphia. *One of the esteemed surgeons of 19th-century America, D. Hayes Agnew taught at the medical school of the University of Pennsylvania. On his retirement in 1889, Agnew's students commissioned Thomas Eakins to depict the doctor in his surgical theater. Eakins himself had studied anatomy at the Jefferson Medical College in Philadelphia and became director of the Pennsylvania Academy of Fine Arts, which had the most thorough program in anatomical study of any school in the United States or Europe. Painted in just three months, this large canvas was harshly criticized in the conservative art establishment of Eakins' time because of its vivid realism and presumably unpleasant subject.*

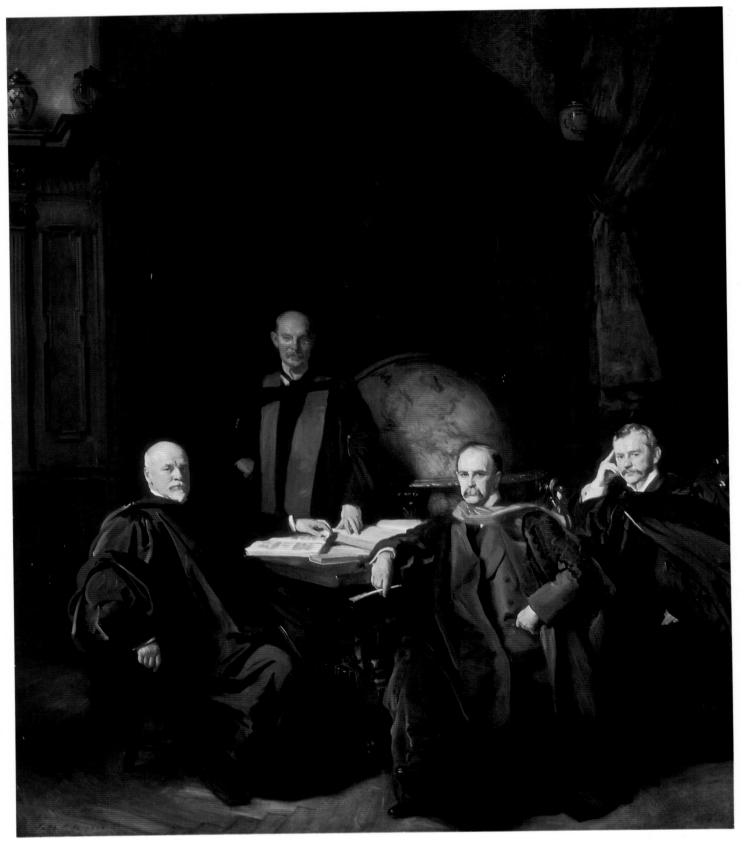

COLORPLATE 90

JOHN SINGER SARGENT. *Members of the First Clinical Faculty of Johns Hopkins, Baltimore, Maryland.*
1905. Oil on canvas. 10.75 × 9.1 ft (3.28 × 2.77 m). Johns Hopkins Medical Institutions, Office of
Public Affairs, Baltimore. *(Left to right) Sir William Osler, Howard Attwood Kelly, William Stewart
Halsted, and William Henry Welch.*

COLORPLATE 91

JOHN SLOAN. *Professional Nurse.* 1893. Watercolor on heavy paper. 10⅞ × 9¼ in. (27.6 × 23.5 cm).
Delaware Art Museum, Wilmington. Gift of Helen Farr Sloan.

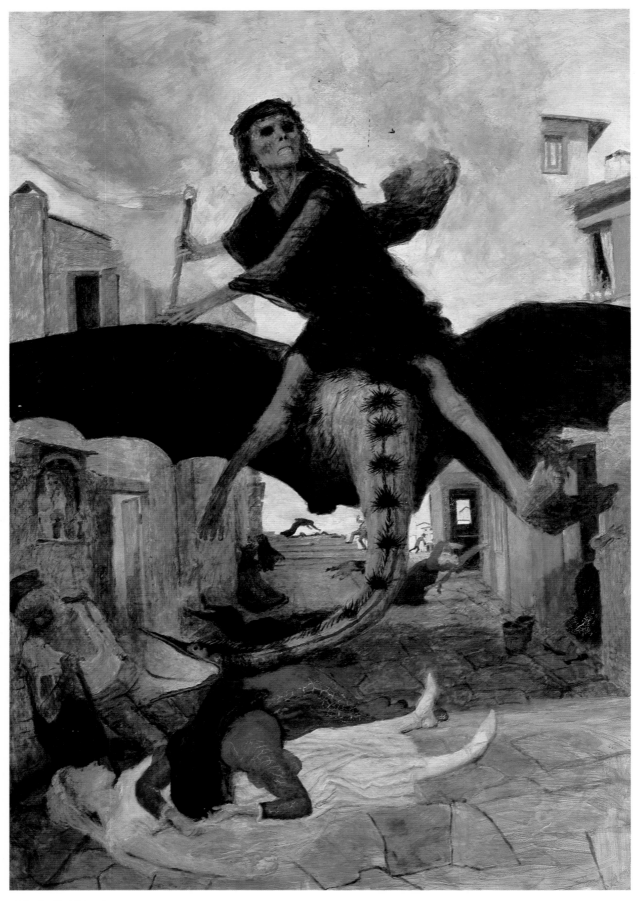

COLORPLATE 92

ARNOLD BÖCKLIN. *The Plague.* 1898. Tempera on varnished pine. 58¹⁵⁄₁₆ × 41⅛ in.
(149.7 × 104.5 cm). Depositum der Eidgenössischen Gottfried Keller-Stiftung
Kunstmuseum, Basel.

If, then, I wish to treat such patients conscientiously, a couple of them together can tie me for a whole morning to the microscope while outside there are sitting a score of sick people who want to be seen before dinner-time! There are also surgical patients whose dressings must be renewed; water must be distilled, and medicines prepared; sores must be cleansed, and there are teeth to be drawn! With this continual drive, and the impatience of the waiting sick I often get so worried and nervous that I hardly know where I am or what I am doing.

Bernard Shaw

FROM TOO TRUE TO BE GOOD

Shaw (1856–1950) was a music critic, playwright, and social critic who won the Nobel Prize for Literature in 1925. He was a self-styled philosopher who rabidly espoused vegetarianism and movements against alcohol, tobacco, vaccination, and vivisection. Shaw's long flowering in the public eye seems to have inextricably intertwined his very showy life with his less durable work, prompting Joseph Wood Krutch to surmise that "Shaw's major contribution to Western culture was as a stimulant and beater of drums, drawing the attention of the apathetic public to that main tent where greater men than he were performing."

The patient is sleeping heavily. Near her, in the easy chair, sits a Monster. In shape and size it resembles a human being; but in substance it seems to be made of a luminous jelly with a visible skeleton of short black rods. It droops forward in the chair with its head in its hands, and seems in the last degree wretched.

THE MONSTER. Oh! Oh!! Oh!!! I am so ill! so miserable! Oh, I wish I were dead. Why doesnt she die and release me from my sufferings? What right has she to get ill and make me ill like this? Measles: thats what she's got. Measles! German measles! And she's given them to me, a poor innocent microbe that never did her any harm. And she says that *I* gave them to her. Oh, is this justice? Oh, I feel so rotten. I wonder what my temperature is: they took from under her tongue half an hour ago. [*Scrutinizing the table and discovering the thermometer in the glass*]. Here's the thermometer: theyve left it for the doctor to see instead of shaking it down. If it's over a hundred I'm done for: I darent look. Oh, can it be that I'm dying? I must look. [*It looks, and drops the thermometer back into the glass with a gasping scream*]. A hundred and three! It's all over. [*It collapses*].

The door opens; and an elderly lady and a young doctor come in. The lady steals along on tiptoe, full of the deepest concern for the invalid. The doctor is indifferent, but keeps up his bedside manner carefully, though he evidently does not think the case so serious as the lady does. She comes to the bedside on the invalid's left. He comes to the other side of the bed and looks attentively at his patient.

THE ELDERLY LADY [*in a whisper sibillant enough to wake the dead*] She is asleep.

THE MONSTER. I should think so. This fool here, the doctor, has given her a dose of the latest fashionable opiate that would keep a cock asleep til half past eleven on a May morning.

THE ELDERLY LADY. Oh doctor, do you think there is any chance? Can she possibly survive this last terrible complication.

THE MONSTER. Measles! He mistook it for influenza.

THE ELDERLY LADY. It was so unexpected! such a crushing blow! And I have taken such care of her. She is my only surviving child: my pet: my precious one. Why do they all

die? I have never neglected the smallest symptom of illness. She has had doctors in attendance on her almost constantly since she was born.

THE MONSTER. She has the constitution of a horse or she'd have died like the others.

THE ELDERLY LADY. Oh, dont you think, dear doctor—of course you know best; but I am so terribly anxious—dont you think you ought to change the prescription? I had such hopes of that last bottle; but you know it was after that that she developed measles.

THE DOCTOR. My dear Mrs Mopply, you may rest assured that the bottle had nothing to do with the measles. It was merely a gentle tonic—

THE MONSTER. Strychnine!

THE DOCTOR.—to brace her up.

THE ELDERLY LADY. But she got measles after it.

THE DOCTOR. That was a specific infection: a germ, a microbe.

THE MONSTER. Me! Put it all on me.

THE ELDERLY LADY. But how did it get in? I keep the windows closed so carefully. And there is a sheet steeped in carbolic acid always hung over the door.

THE MONSTER [*in tears*] Not a breath of fresh air for me!

THE DOCTOR. Who knows? It may have lurked here since the house was built. You never can tell. But you must not worry. It is not serious: a light rubeola: You can hardly call it measles. We shall pull her through, believe me.

THE ELDERLY LADY. It is such a comfort to hear you say so, doctor. I am sure I shall never be able to express my gratitude for all you have done for us.

THE DOCTOR. Oh, that is my profession. We do what we can.

THE ELDERLY LADY. Yes; but some doctors are dreadful. There was that man at Folkestone: he was impossible. He tore aside the curtain and let the blazing sunlight into the room, though she cannot bear it without green spectacles. He opened the windows and let in all the cold morning air. I told him he was a murderer; and he only said "One guinea, please". I am sure he let in that microbe.

THE DOCTOR. Oh, three months ago! No: it was not that.

THE ELDERLY LADY. Then what was it? Oh, are you quite quite sure that it would not be better to change the prescription?

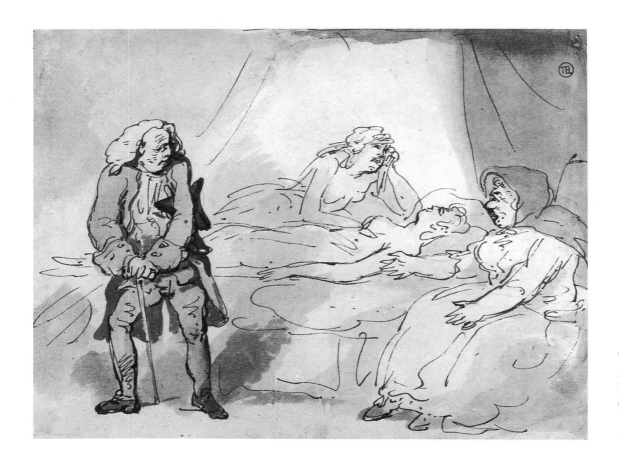

THOMAS ROWLANDSON.
A Sick Bed. c. 1815.
Pen and wash on paper.
6¾ × 9 in. (17.2 × 22 cm).
Yale Center for British
Art, Paul Mellon Collection.

THE DOCTOR. Well, I have already changed it.

THE MONSTER. Three times!

THE ELDERLY LADY. Oh, I know you have, doctor: nobody could have been kinder. But it really did not do her any good. She got worse.

THE DOCTOR. But, my dear lady, she was sickening for measles. That was not the fault of my prescription.

THE ELDERLY LADY. Oh, of course not. You mustnt think that I ever doubted for a moment that everything you did was for the best. Still—

THE DOCTOR. Oh, very well, very well: I will write another prescription.

THE ELDERLY LADY. Oh, thank you, thank you: I felt sure you would. I have so often known a change of medicine work wonders.

THE DOCTOR. When we have pulled her through this attack I think a change of air—

THE ELDERLY LADY. Oh no: dont say that. She must be near a doctor who knows her constitution. Dear old Dr Newland knew it so well from her very birth.

THE DOCTOR. Unfortunately, Newland is dead.

THE ELDERLY LADY. Yes; but you bought his practice. I should never be easy in mind if you were not within call. You persuaded me to take her to Folkestone; and see what happened! No: never again.

THE DOCTOR. Oh, well! [*He shrugs his shoulders resignedly, and goes to the bedside table*]. What about the temperature?

THE ELDERLY LADY. The day nurse took it. I havnt dared to look.

THE DOCTOR [*looking at the thermometer*] Hm!

THE ELDERLY LADY [*trembling*] Has it gone up? Oh, doctor!

THE DOCTOR [*hastily shaking the mercury down*] No. Nothing. Nearly normal.

THE MONSTER. Liar!

THE ELDERLY LADY. What a relief!

THE DOCTOR. You must be careful, though. Dont fancy she's well yet: she isnt. She must not get out of bed for a moment. The slightest chill might be serious.

THE ELDERLY LADY. Doctor: are you sure you are not concealing something from me? Why does she never get well in spite of the fortune I have spent on her illnesses? There must be some deep-rooted cause. Tell me the worst: I have dreaded it all my life. Perhaps I should have told you the whole truth; but I was afraid. Her uncle's stepfather died of an enlarged heart. Is that what it is?

THE DOCTOR. Good gracious, NO! What put that into your head?

THE ELDERLY LADY. But even before this rash broke out there were pimples.

THE MONSTER. Boils! Too many chocolate creams.

THE DOCTOR. Oh, that! Nothing. Her blood is not quite what it should be. But we shall get that right.

THE ELDERLY LADY. You are sure it is not her lungs?

THE DOCTOR. My good lady, her lungs are as sound as a seagull's.

THE ELDERLY LADY. Then it must be her heart. Dont deceive me. She has palpitations. She told me the other day that it stopped for five minutes when that horrid nurse was rude to her.

THE DOCTOR. Nonsense! She wouldnt be alive now if her heart had stopped for five seconds. There is nothing constitutionally wrong. A little below par: that is all. We shall feed her up scientifically. Plenty of good fresh meat. A half bottle of champagne at lunch and a glass of port after dinner will make another woman of her. A chop at breakfast, rather underdone, is sometimes very helpful.

THE MONSTER. I shall die of overfeeding. So will she too: thats one consolation.

THE DOCTOR. Dont worry about the measles. It's really quite a light case.

THE ELDERLY LADY. Oh, you can depend on me for that. Nobody can say that I am a worrier. You wont forget the new prescription?

THE DOCTOR. I will write it here and now [*he takes out his pen and book, and sits down at the writing table*].

THE ELDERLY LADY. Oh, thank you. And I will go and see what the new night nurse

is doing. They take so long with their cups of tea [*she goes to the door and is about to go out when she hesitates and comes back*]. Doctor: I know you dont believe in inoculations; but I cant help thinking she ought to have one. They do so much good.

THE DOCTOR [*almost at the end of his patience*] My dear Mrs Mopply: I never said that I dont believe in inoculations. But it is no use inoculating when the patient is already fully infected.

THE ELDERLY LADY. But I have found it so necessary myself. I was inoculated against influenza three years ago; and I have had it only four times since. My sister has it every February. Do, to please me, give her an inoculation. I feel such a responsibility if anything is left undone to cure her.

THE DOCTOR. Oh very well, very well: I will see what can be done. She shall have both an inoculation and a new prescription. Will that set your mind at rest?

THE ELDERLY LADY. Oh, thank you. You have lifted such a weight from my conscience. I feel sure they will do her the greatest good. And now excuse me a moment while I fetch the nurse. [*She goes out*].

THE DOCTOR. What a perfectly maddening woman!

THE MONSTER [*rising and coming behind him*] Yes: aint she?

THE DOCTOR [*starting*] What! Who is that?

THE MONSTER. Nobody but me and the patient. And you have dosed her so that she wont speak again for ten hours. You will overdo that some day.

THE DOCTOR. Rubbish! She thought it was an opiate; but it was only an aspirin dissolved in ether. But who am I talking to? I must be drunk.

THE MONSTER. Not a bit of it.

THE DOCTOR. Then who are you? What are you? Where are you? Is this a trick?

THE MONSTER. I'm only an unfortunate sick bacillus.

THE DOCTOR. A sick bacillus!

THE MONSTER. Yes. I suppose it never occurs to you that a bacillus can be sick like anyone else.

THE DOCTOR. Whats the matter with you?

THE MONSTER. Measles.

THE DOCTOR. Rot! The microbe of measles has never been discovered. If there is a microbe it cannot be measles: it must be parameasles.

THE MONSTER. Great Heavens! what are parameasles?

THE DOCTOR. Something so like measles that nobody can see any difference.

THE MONSTER. If there is no measles microbe why did you tell the old girl that her daughter caught measles from a microbe?

THE DOCTOR. Patients insist on having microbes nowadays. If I told her there is no measles microbe she wouldnt believe me; and I should lose my patient. When there is no microbe I invent one. Am I to understand that you are the missing microbe of measles, and that you have given them to this patient here?

THE MONSTER. No: she gave them to me. These humans are full of horrid diseases: they infect us poor microbes with them; and you doctors pretend that it is we that infect them. You ought all to be struck off the register.

THE DOCTOR. We should be, if we talked like that.

THE MONSTER. Oh, I feel so wretched! Please cure my measles.

THE DOCTOR. I cant. I cant cure any disease. But I get the credit when the patients cure themselves. When she cures herself she will cure you too.

THE MONSTER. But she cant cure herself because you and her mother wont give her a dog's chance. You wont let her have even a breath of fresh air. I tell you she's naturally as strong as a rhinoceros. Curse your silly bottles and inoculations! Why dont you chuck them and turn faith healer?

THE DOCTOR. I am a faith healer. You dont suppose I believe the bottles cure people? But the patient's faith in the bottle does.

THE MONSTER. Youre a humbug: thats what you are.

THE DOCTOR. Faith is humbug. But it works.

THE MONSTER. Then why do you call it science?

THE DOCTOR. Because people believe in science. The Christian Scientists call their fudge science for the same reason.

THE MONSTER. The Christian Scientists let their patients cure themselves. Why dont you?

THE DOCTOR. I do. But I help them. You see, it's easier to believe in bottles and inoculations than in oneself and in that mysterious power that gives us our life and that none of us knows anything about. Lots of people believe in the bottles and wouldnt know what you were talking about if you suggested the real thing. And the bottles do the trick. My patients get well as often as not. That is, unless their number's up. Then we all have to go.

THE MONSTER. No girl's number is up until she's worn out. I tell you this girl could cure herself and cure me if youd let her.

THE DOCTOR. And I tell you that it would be very hard work for her. Well, why should she work hard when she can afford to pay other people to work for her? She doesn't black her own boots or scrub her own floors. She pays somebody else to do it. Why should she cure herself, which is harder work than blacking boots or scrubbing floors, when she can afford to pay the doctor to cure her? It pays her and it pays me. That's logic, my friend. And now, if you will excuse me, I shall take myself off before the old woman comes back and provokes me to wring her neck. [*Rising*] Mark my words: someday somebody will fetch her a clout over the head. Somebody who can afford to. Not the doctor. She has driven me mad already: the proof is that I hear voices and talk to them. [*He goes out*].

THE MONSTER. Youre saner than most of them, you fool. They think I have the keys of life and death in my pocket; but I have nothing but a horrid headache. Oh dear! oh dear!

MEDICINE AND MODERN WAR

Florence Nightingale

Letter to William Bowman

Nightingale (1820–1910) was best known to her contemporaries for her tireless insistence on army medical reform. Only in her later years did she gather a dedicated following in nursing. Nightingale returned from the Crimean War in 1856 fearing she had not long to live, and the pace of her letter-writing redoubled, vividly and relentlessly exposing the many needs of army medical care. Bedridden, she remained a semi-invalid until her death.

Barrack Hospital,
Scutari 14 Nov 1854

'I came out, Ma'am prepared to submit to Everything. to be put upon in Everyway. But there are *some* things, Ma'am one can't submit to. There is the caps, ma'am that suits one face. and some that suits another. And if I'd known, Ma'am about the Caps, great as was

my desire to come out as nurse at Scutari, I wouldn't have come, ma'am'.—Speech of Mrs. Lawfield.

Dear Sir Time must be at a discount with the man who can adjust the balance of such an important question as the above—& I, for one have none: as you will easily suppose when I tell you that on Thursday last we had 1715 sick & wounded in this Hospital (among whom 120 Cholera patients and 650 severely wounded in the other Building, called the Gen'l Hospital, of w'ch we also have charge, when a message came to me to prepare for 510 wounded on our side the Hosp'l who were arriving from the dreadful affair of the 5th of Nov'r at Balaclava, where were 1763 wounded & 422 killed, beside 96 Officers wounded & 38 killed. I always expected to end my days as Hospital Matron, but I never expected to be Barrack Mistress. We had but ½ an hour's notice, before they began landing the wounded. Between one and nine o'clock, we had the mattrasses stuffed, sewn up, and laid down, alas! only upon matting on the floor, the men washed and put to bed, & all their wounds dressed—I wish I had time or I would write you a letter dear to a surgeon's heart, I am as good as a 'Medical Times'. But oh! you gentlemen of England who sit at home in all the well earned satisfaction of your successful cases, can have little idea, from reading the newspapers, of the horror & misery in a military Hosp'l of operating upon these dying exhausted men. A London Hosp'l is a garden of flowers to it. We have had such a sea in the Bosphorus, and the Turks, the very men for whom we are fighting are carrying our wounded so cruelly, that they arrive in a state of agony—one amputated stump died two hours after we received him, one compound fracture just as we were getting him into bed, in all 24 cases on the day of landing. We have now 4 miles of beds—& not 18 inches apart. We have our quarters in one Tower of the Barrack & all this fresh influx has been laid down between us and the main guard in two corridors with a line of beds down each side just room for one man to pass between, and four wards. Yet in the midst of the appalling horror, there is good. And I can truly say like St. Peter 'it is good for us to be here'—tho' I doubt whether if St. Peter had been here, he would have said so. As I went my night-round among the newly wounded that first night, there was not one murmur, not one groan the strictest discipline, the most absolute silence & quiet prevailed.

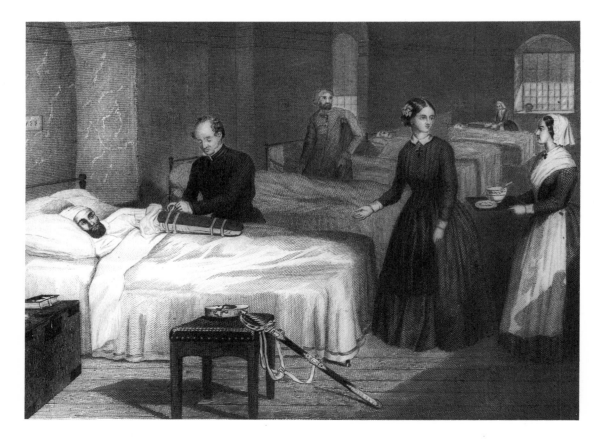

Florence Nightingale. 1854. Steel engraving. *Nightingale created a unit of 38 nurses for the British military hospital at Scutari, Turkey, during the Crimean War. Understandably, the suffering of the wounded was radically diminished.*

Only the step of the Sentry & I heard one man say 'I was dreaming of my friends at home', & another said 'and I was thinking of them'. These poor fellows bear pain & mutilation with unshrinking heroism & die without complaint. Not so the officers, but we have nothing to do with the Officers. The wounded are now lying up to our very door & we are landing 540 more from the 'Andes'. I take rank in the army as Brigadier General, because 40 British females, whom I have with me, are more difficult to manage than 4000 men. Let no lady come out here who is not used to fatigue & privation—for the Devonport Sisters, who ought to know what self-denial is, do nothing but complain. Occasionally the roof is torn off our quarters, or the windows blown in & we are flooded & under water for the night. We have all the sick Cookery now to do—& have got in 4 men for the purpose, for the prophet Mahomet does not allow us a female. And we are now able to supply these poor fellows with something besides Gov't rations. I wish you w'd recall me to Dr. Bence Jones remembrance, when you see him, and tell him I have had but too much occasion to remember him in the constant use of his dreadful present. In all our corridor I think we have not an average of three units per man, and there are two ships more 'landing' at the Crimea with wounded, this is our phraseology. All who can walk come in to us for Tobacco—but I tell them we have not a bit to put into our own mouths—not a sponge, not a rag of linen, not an anything have I left. Every thing is gone torn to make slings & stump pillows & shirts. These poor fellows had not had a clean shirt nor been washed for two months before they came here & the state in w'ch they arrive from the Transports is literally *crawling*. I hope in a few days we shall establish a little cleanliness. But we have not a basin, nor a towel, nor a bit of soap, nor a broom. I have ordered 300 scrubbing brushes. We are getting on nicely in many ways. They were so glad to see us. The Senior Chaplain is a sensible man, w'ch is a remarkable providence. I have not been out of the Hospital wall yet. But the most beautiful view in the world I believe lies outside. If you ever see Mr. Whitfield the House Apothecary of St. Thomas's will you tell him that the nurse he sent me, Mrs. Roberts, is worth her weight in gold. There was another engagement on the 8th, & more wounded, who are coming down to us. The text w'ch heads my letter was expounded thus Mrs. Lawfield was recommended to return home and set her cap, vulgarly speaking, at some one elsewhere than here, but on begging for mercy, was allowed to make another trial. Mrs. Drake is a treasure. The four others are not fit to take care of themselves nor of others in a military Hosp'l. This is my first impression but it may modify, if I can convince them of the necessity of discipline and propriety in a drunken garrison. Believe me dear Sir yours very truly & gratefully

<div align="right">Florence Nightingale</div>

This is only the beginning of things. We are still expecting the assault.

Emily Elizabeth Parsons

FROM MEMOIR

Staunch Lincoln supporter Theophilus Parsons initially opposed his 37-year-old daughter's desire to become a nurse. Emily Parsons's multiple handicaps did not obstruct her own resolve, and in 1863 she became the nursing supervisor of a 2,500-bed field hospital in St. Louis, one of the most important posts given a woman during the Civil War. Parsons contracted malaria by summer 1864, but continued her philanthropic efforts from Boston, aiding black freedmen and founding a local hospital.

Darling Mother,

I got as far as the above, and now, June 11, am going on with the letter. I received yours of June 2. I was so glad to get it, I wish there was more of it; and yet I do not know that any amount would satisfy me. I have been very busy lately. The demand for nurses is on the increase, I have written to some, and shall write to more, under Dr. Russell's orders. We shall want surgical nurses: one of our best nurses is going down the river. The excitement here is very great; I shall be glad when Vicksburg is taken, and this terrible news of battle is over. The amount of wounded is already very great, by and by they will be coming up the river. . . . It only takes a little time to order meals, and we now live very comfortably; I take my meals alone, at a later hour than the nurses; they breakfast at six, I at seven, after I am through my morning first round; they dine at twelve, I at one; they take tea at four, I at six, after my afternoon walk of inspection. All our nurses are ladies. I do not believe it would be easy to find such a set of nurses in any other hospital I have to keep careful watch over every one of the nurses, as I am responsible for them, and a good deal it involves. I have to look in many different directions. There are not many patients here now; they are being drafted off to make room for the sick and wounded when they come; those here being most of them convalescents. We have a lesser round building, called the *rotunda,* which will be for surgical cases, as also will some other wards. These great buildings are called wards, then subdivided into divisions, and nurses assigned to each division. They will hold a great number of men.

Sunday afternoon. I have just come from Communion. It was given in the rotunda, now used as a chapel. It was all very plain, and somehow, from that very reason, made me think more of that "upper chamber" so many hundred years ago in Jerusalem. There were soldiers and women present, weary men, some just able to walk in, all intent on the solemn occasion. I saw one man walk in leaning on his cane, and wrapped up in one of the comfortable wrappers you ladies sent him and others. I was glad to see him there; a month ago he was next to death. Some time since, one poor fellow got his discharge; he was far gone in consumption, he had been wearing one of those wrappers and seemed to enjoy it very much; I told him he might take it home with him; he was poor and will be very thankful to have something comfortable to wear as he sinks away in the disease he caught while fighting for his country. I hope to have more nurses in soon, before the sick and wounded come up the river; we shall be full then; our hands will have enough to do. We send off all that we can to convalescent places and camps. One ward has decreased from one hundred and thirty-seven to thirty-five or six patients, I tell the nurses it is only resting time and they must make the most of it. They are not allowed to go out of the grounds without my permission. Two of them came to me just now, and I sent them off to walk in the woods; a little while after over came another, with a friend, to know if she might go. I hope they will have a good time: it is a lovely evening.

The other evening I attended a prayer-meeting and was very much interested. One of the speakers took for his theme the necessity of coming to Jesus now, and illustrated it very forcibly. Many of the men present were under marching orders and will soon be before the enemy. The preacher specially addressed them, reminded them that it was the last time they would stand there: would they go into the field and not take Jesus with them? He asked, what would they do without him there, sick or wounded, or passing forever into another life; where would they go in that life if they did not take Him with them in this life and follow His commandments by leaving off all sinful ways and turning to Him. One feels a good deal when seeing men thus addressed who are going off to the battle-field. I tell you, mother, we realize war out here: it is at our door. I have been very much interested in one of the wards here. Back of this house I live in is a ward consisting of two long rooms: it is the erysipelas ward. When there is a bad case of that kind it is sent here, and the disease is held in great horror by many who fear taking it. When Dr. Russell came here in early spring, these patients were scattered about in out-rooms and

not properly cared for; he had these two rooms, which were barracks, turned into the erysipelas ward. There was no woman in there to keep things nice; no one hardly would go in or near it; it was looked upon as a sort of Botany Bay among the wards. I went in after I had been here a while and got my duties under head-way elsewhere. I found the wards dirty: no whitewash, old wooden bunks, mattresses that had not been changed for a long time; everything requiring renovation. I passed some time there, then went over and asked the Doctor to let me have the ward arranged like the other wards. He told me it would not do to order one of the lady nurses there; I told him "no, but I could go myself." He asked if I did not fear taking it, I told him if there was risk it was already run, for I had passed about two hours over the worst cases. He laughed and finally gave me permission to go in and do whatever I pleased; didn't I go! I found a German Doctor who did not understand neatness, and who was going away; I waited till he went, then a skilful Doctor possessed of Yankee neatness joined forces with me and in we went.

We revolutionized the place. We got in an army of whitewashers, for lime is a disinfectant; while the new Doctor superintended whitewashers, I went to the head surgeon, and asked for clean furniture: he kept his word and said I should have it. So, going from one place to another, I got in iron bedsteads, new mattresses, pillows, bed furniture, mosquito nettings; had the tables and cupboards washed; lime was put in boxes on the floor; the Doctor had the beds arranged in two files, each side of the room, two feet from the wall, so that every part of the floor is exposed and there is no excuse for not washing every part; everything is now as clean and nice as any other ward, walls and ceiling whitewashed, the floor clean, and order generally. The next thing I wanted was a lady nurse; I could not order one there; so I kept on superintending myself, but that was not enough. I longed for a volunteer nurse; I concluded at last, if one did not present herself, I would pray for one. I went over to the wards in that state of mind, and one of my best nurses informed me she should like to take the ward! I brought her over, installed her, and she says she is happy. The men are so glad to have a woman about all the time. Yesterday they dressed their ward up with evergreens and improved it very much. As the ward nurse informed me last night, it is going to look as well as other places. I look upon the nurse of that ward as a heroine; I wish I had time to tell you all she has done elsewhere. Her name is Miss Melcenia Elliott. I am using the money Mr. S. sent me to buy fruit for this ward; they need it very much, and it is doing them a great deal of good. I take all the flowers I can get to this ward: they make the air so pleasant. I would write

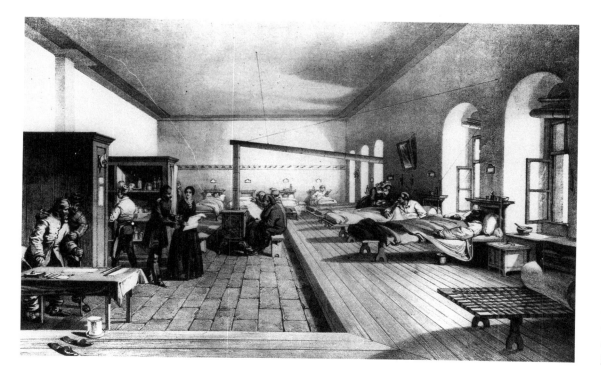

Florence Nightingale. 1854. Engraving. *Supervising the hospital at Scutari, Turkey during the Crimean War, Nightingale achieved the cleanliness and order shown here only after great struggles against chaos, squalor, and military protocol.*

better; but it makes my eyes ache, so I cannot. It is very hot here, but we have the Mississippi; my respect for this useful stream increases daily. There was an octagonal house here of one room, lately vacated, I asked the Doctor what he was going to do with it; he told me he would give it to me, and I should have it for myself, if I wanted it; I suggested that it would make a good parlor for the lady nurses to see the visitors in. The Doctor liked the idea, and said it should be done; it is doing and will make them a very pretty room. Love to all, and hope that I may be able to go on.

Walt Whitman

FROM DRUM-TAPS

"The Dresser"

After summoning others to fight with the rousing first poems of Drum Taps, *Whitman (1819–1892) himself volunteered as a nurse, receiving no pay. He was as old as most of the Union generals, and as long as his health permitted he stationed himself near Armory Square, Washington, where the worst cases were taken. Surgeon John Burroughs in 1896 remembered Whitman on the wards "as a kind of crank. . . . His talk to us was chiefly . . . of poetry, and what he considered poetry."*

An old man bending, I come, among new faces,
Years looking backward, resuming, in answer to children,
Come tell us old man, as from young men and maidens that
 love me;
Years hence of these scenes, of these furious passions, these chances,
of unsurpass'd heroes, (was one side so brave? the other was equally brave;)
Now be witness again—paint the mightiest armies of earth;
Of those armies so rapid, so wondrous, what saw you to tell us?
What stays with you latest and deepest? of curious panics,
Of hard-fought engagements, or sieges tremendous, what deepest remains?

O maidens and young men I love, and that love me,
What you ask of my days, those the strangest and sudden your talking recals;
Soldier alert I arrive, after a long march, cover'd with sweat and dust;
In the nick of time I come, plunge in the fight, loudly shout in the rush of
 successful charge;
Enter the captur'd works yet lo! like a swift-running river, they fade;
Pass and are gone, they fade—I dwell not on soldiers' perils o. soldiers' joys;
(Both I remember well—many the hardships, few the joys, yet I was content.)

The hurt and the wounded I pacify with soothing hand,
I sit by the restless all the dark night—some are so young;
Some suffer so much—I recall the experience sweet and sad;
(Many a soldier's loving arms about this neck have cross'd and rested,
Many a soldier's kiss dwells on these bearded lips.)
The crush'd head I dress, (poor crazed hand, tear not the
 bandage away;)
The neck of the cavalry-man, with the bullet through and through, I examine;
Hard the breathing rattles, quite glazed already the eye, yet life struggles hard;

(Come, sweet death! be persuaded, O beautiful death!
In mercy come quickly.)

From the stump of the arm, the amputated hand,
I undo the clotted lint, remove the slough, wash off the matter and blood;
Back on his pillow the soldier bends, with curv'd neck, and side-falling head;
His eyes are closed, his face is pale, he dares not look on
 the bloody stump,
And has not yet looked on it.

I dress a wound in the side, deep, deep;
But a day or two more—for see, the frame all wasted and sinking,
and the yellow-blue countenance see.

I dress the perforated shoulder, the foot with the bullet wound,
Cleanse the one with a gnawing and putrid gangrene, so sickening, so offensive,
While the attendant stands behind aside me, holding the tray and pail.

I am faithful, I do not give out;
The fractur'd thigh, the knee, the wound in the abdomen,
These and more I dress with impassive hand—(Yet deep in my breast a fire, a
 burning flame.)

Thus in silence, in dream's projections,
Returning, resuming, I thread my way through the hospitals;

MATHEW BRADY, or assistant. *Camp of Chief Ambulance Officer, 9th Army Corps—Field Hospital Near Petersburg, Virginia.* 1864. Daguerreotype. 7⅝ × 8½ in. (19.3 × 21.6 cm). Library of Congress.

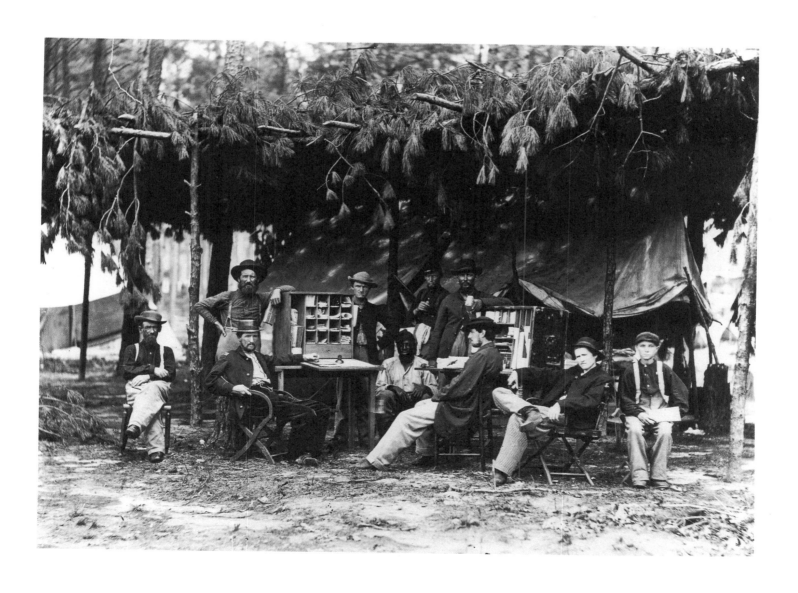

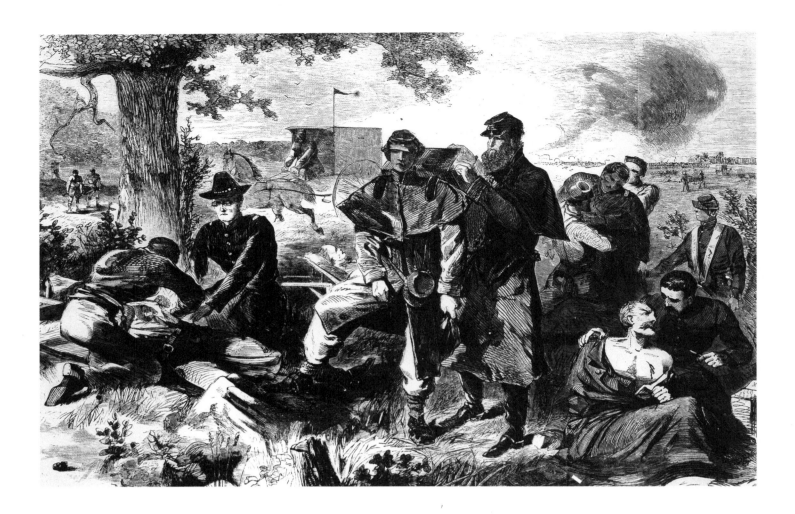

But in silence, in dream's projections,
While the world of gain and appearance and mirth goes on,
So soon what is over forgotten, and waves wash the imprints off the sand,
In nature's reverie sad, with hinged knees returning, I enter the doors—(while
 for you up there,
Whoever you are, follow me without noise, and be of strong heart.)

Bearing the bandages, water and sponge,
Straight and swift to my wounded I go,
Where they lie on the ground, after the battle brought in;
Where their priceless blood reddens the grass, the ground;
Or to the rows of the hospital tent, or under the roof'd hospital;
To the long rows of cots, up and down, each side, I return;
To each and all, one after another, I draw near—not one do I miss;
An attendant follows, holding a tray—he carries a refuse pail,
Soon to be fill'd with clotted rags and blood, emptied, and fill'd again.

I onward go, I stop,
With hinged knees and steady hand, to dress wounds;
I am firm with each—the pangs are sharp, yet unavoidable;
One turns to me his appealing eyes—(poor boy! I never knew you,
Yet I think I could not refuse this moment to die for you, if that would save
 you.)

On, on I go---(open, doors of time! open, hospital doors!)

WINSLOW HOMER.
*Surgeon at Work During
an Engagement.*
1862. Engraving.
From *Harper's Weekly.*

Emily Dickinson

FROM POEMS

The poet who spent most of her days in her own house and yard in Amherst, Massachusetts, wrote over 1,700 poems and fragments, only two of which were published during her lifetime. Dickinson (1830–1886) wrote her finest poems in the 1860s, perhaps in response to the great war that was shaking the Union. Like Virgil, Dickinson wanted her poetry destroyed after her death, but her sister Lavinia decided to have the work published.

XX

The last night that she lived,
It was a common night,
Except the dying; this to us
Made nature different.

We noticed smallest things,—
Things overlooked before,
By this great light upon our minds
Italicized, as 't were.

That others could exist
While she must finish quite,
A jealousy for her arose
So nearly infinite.

We waited while she passed;
It was a narrow time,
Too jostled were our souls to speak,
At length the notice came.

She mentioned, and forgot;
Then lightly as a reed
Bent to the water, shivered scarce,
Consented, and was dead.

And we, we placed the hair,
And drew the head erect;
And then an awful leisure was,
Our faith to regulate.

Albert Haas

FROM THE DOCTOR AND THE DAMNED

Physicians living within totalitarian regimes or as prisoners of war have unusually difficult, often unsolvable, ethical dilemmas. Albert Haas was trained in Hungary, taking the M.D. degree in 1937, but was captured among members of the French Resistance as a political prisoner of the Nazis.

He survived imprisonment and torture in Dachau and Auschwitz, perhaps because of his medical and linguistic skills. Since the war he has practiced as a pulmonologist in France—where he was named to the Legion of Honor—and in the United States at New York University Medical Center. Haas is a pioneer in the creation of modern rehabilitation centers for patients with chronic pulmonary diseases. In this excerpt, "Stubendiests" were Nazi youths serving the dictates of concentration camp Blockältester.

The next morning during the count one of the Stubendiensts called out for doctors. My friends and I stepped forward. We were asked who spoke German, and I raised my hand. The three of us were led into the Blockältester's room. Kugelkopf, as we called him, lay on his bed perspiring profusely and doubled over in severe abdominal pain. Dr. Ottinger examined him, hastily diagnosed appendicitis, and advised him to go to the infirmary. The Blockältester insisted that we treat him in his room even if an operation were necessary. . . .

We feared for our lives if this murderer died in the barrack during our treatment. As a ploy to gain time, I told the Blockältester that we needed specialized instrumentation and sterile materials. He answered that he could get everything just as soon as we gave him a list of what we needed. He moaned and begged us to hurry.

As we started to draw up our list, Dr. Aarons suggested that we request several semirigid catheters. In response to our puzzled reactions, he explained that they would be better than rubber hoses as breathing tubes. Dr. Ottinger recited all of the pharmaceuticals and materials he would need, including iodine, then enumerated the necessary instruments. I translated everything into German and wrote it down.

Back at our bunks I asked Dr. Ottinger what he planned to do if Kugelkopf really turned out to have appendicitis.

"Operate, of course," he said. "A successful appendectomy on this Prominent will help me get out of this barrack and help you and Kalka escape. The catheters will make effective and scarcely visible breathing tubes. You can use the iodine to paint out the white stripes in your uniforms."

Roll call came then, and we were counted and lined up outside for work. We decided that it would be premature to share these sudden developments with Kalka because of our doubts about him. Before we could leave, one of the Stubendiensts called Dr. Ottinger from the line and disappeared with him into the barrack. . . .

★ ★ ★

One of our Stubendiensts was talking with the SS guards as we passed through the camp gate. He ran over to us and called out Dr. Aarons' and my numbers. Dr. Ottinger needed us. He was obviously going to operate. Seized by a dread apprehension, we turned to each other. Seeming to read each other's thoughts, we both muttered at the identical moment. *"Il a perdu son nord!"* ("He has lost his marbles!") What if Kugelkopf died? But we couldn't refuse to join Dr. Ottinger. Damned either way, we returned to our barrack.

We couldn't believe our eyes as we took in the scene before us! The Blockältester was lying on a table in his room, and the barrack's barber was shaving his pubic hair. Dr. Ottinger, completely unruffled, his gestures radiating total authority, was pushing the Stubendienst around and, in his customary operating room manner, thoroughly terrorizing everyone. You would have thought he was back in Paris at the Hôpital St. Louis.

"Thank God you're here," were his first words to us. "This idiot doesn't understand a word of my orders." I was too flabbergasted to point out that he was speaking French to people who didn't understand it. "Haas, have them bring hot water continuously. We will scrub. I'm sure he has a hot appendix."

I began to suspect that Dr. Ottinger's basic motivation in operating might well be an all-consuming need to perform again in front of an audience. How powerfully he must miss the operating theater. At this moment it seemed of little real importance to him that

he might be placing us in jeopardy, but he was also helping us to escape and I couldn't refuse to assist him in achieving his goal. I asked if he felt Dr. Aarons' presence to be really necessary. Before he could reply Dr. Aarons said that we were all in this together, up to the end.

In front of my unbelieving eyes was every last item on our supply list, all anxiously guarded by the SS Blockführer. The three of us began to scrub. The door swung open and a high-ranking SS physician entered. The Blockschreiber shouted, *"Achtung!"* We stopped in the midst of scrubbing. He addressed himself directly to Dr. Ottinger, sensing that he was the captain of our team. "So you want to operate on this prisoner?" My heart jumped into my throat. Someone had denounced us! This was the end. But then he introduced himself.

"I am Hauptsturmführer Koenig, head of Dachau's medical division and our SS hospital. I personally approved your request for instruments, and supplies. I know the excellent reputation of Dr. Ottinger. I want to watch him operate, and perhaps I will learn something from him.

I translated. Dr. Ottinger answered contemptuously that he was sure Dr. Koenig would learn something, and he was most welcome to observe. I translated again, judiciously omitting the first part.

Dr. Ottinger still seemed untouched by the extraordinary nature of our situation, continuing in his role of chief surgeon in the operating room at the Hôpital St. Louis. We finished scrubbing. Dr. Ottinger asked me to invite the SS physician to assist him. I stared—he had lost his hold on current reality, no longer a prisoner with a number on his chest but an authority figure in a real operating room in a real hospital. Despite my anxiety I asked if *Häftling* ("prisoner") number such-and-such could have permission to address the Hauptsturmführer. He nodded affirmatively. "The *Häftling Arzt* ["prisoner-physician"] would like to know if the Hauptsturmführer would like to assist him in the operation." "No, I just want to watch." Dr. Ottinger said, "Fine. Haas, you will assist me."

We tied on butcher aprons. Dr. Aarons poured iodine into a kidney dish while Dr. Ottinger and I pulled on rubber gloves. Holding a piece of gauze with his forceps, Dr. Ottinger soaked it in the iodine and painted the patient's abdominal area.

While he draped the sterile sheets he informed me of his plan to do a modified MacBurney incision, a demanding technique used on physical laborers and dancers that left a tiny three-inch scar and reduced postoperative weakness of the abdominal wall. I recalled then that Dr. Ottinger had been the physician for many of the dancers at the famous nightclubs in Paris. As he finished draping he muttered, "I'll show this *schleu* ("scum") what a surgeon can do under pressure!"

He signaled Dr. Aarons to inject the Evipan. The Blockältester began to count backward from one hundred and was asleep by the time he reached sixty-seven. Ether would be used to continue the anesthetic, using thick gauze in place of a mask. The SS physician, to my great surprise, secured Dr. Ottinger's mask for him. Mine was secured by Dr. Aarons before he stationed himself by the Blockältester's head to administer the ether.

Dr. Ottinger grasped his scalpel and made an incision of *only one inch!* I was so astonished that I forgot to clamp the severed vessels on my side. He bawled me out, irritably claiming that this always happened to him when he had an internist for an assistant. I began to perspire.

Dr. Ottinger carried on as if we were all medical students attending his surgery, describing each step in a kind of singsong chant. "I am now cutting the external oblique." He asked for retractors, then, "Put it in, Haas! Hold it, Haas! And here is the fascia, and here we are at the peritoneum. Clamp the vessels, Haas! You cut the peritoneum, and you see the cecum. Pull the retractors, Haas, so that I can see!" Using the forceps, he continued: "I retract the cecum, and here is the fat pad, which I am pushing to the left. And here is the dirty bastard." He held up the appendix and pointed out the black spot and sac of pus to the SS physician. "Ready to perforate."

A thud resounded as the Blockführer fainted and crashed to the floor. Dr. Ottinger

didn't break his rhythm as he ordered, "Someone put cold water on that idiot. Haas, clamp the appendix at the base!" He tied off the column of the appendix, secured it, then cut by the edge of the clamp. He pushed the fat pad back into place and closed the cecum, then the peritoneum. He put a small tube into the opening, closed the fascia, then the muscles, then the skin.

From the initial tiny incision to the final closing, the entire procedure had taken seven minutes. The SS physician was obviously impressed. He assured Dr. Ottinger that he would keep him in mind, then left as abruptly as he had entered.

I asked Dr. Ottinger what would have happened if the appendix, whose location is known to be variable, hadn't been in a common position and a different incision had been needed. He shrugged. "Sometimes, *mon petit,* you have to take a risk, and you can only pray that you are right. But I had to do so many almost invisible incisions on the cabaret dancers that I had something up my sleeve besides a prayer!"

$$\star \quad \star \quad \star$$

After breakfast we tied our civilian coats around our waists and hid our catheters under our shirts. There were camp identifying patches on the coats, but we could rip them off later. Dr. Aarons put the iodine in his pocket, I put the gauze and tape in my pockets, and Kalka carried the schnapps in his pocket. Dr. Ottinger was still tending the Block-ältester full time. We had no time to find a replacement for him.

Our preparations went smoothly. We hid our supplies at one edge of the ditch and covered them with horse manure, knowing that no one would try to dig through it. When we returned to the barrack Dr. Ottinger gave each of us five marks. He was being transferred to head the HKB, the prisoners' infirmary, first thing in the morning. He did not want to call further attention to us by spending too much time in our barrack. As he said this brief good-bye to us his eyes were filled with warm affection. He promised Dr. Aarons that he would do everything possible to get him transferred to the HKB as well. He wished us *"Merde,"* "good luck" in French slang, and turned and walked away without shaking hands.

Dr. Aarons' words echoed my thoughts. "He's not so tough after all! I always took him to be a cold and calloused professional. It's become obvious to me now that he surrounds himself with an aura of arrogant detachment to hide his true feelings." He then added an important piece of news for us. "One of the workers here is an old comrade of mine from the Maquis. He will arrange things with his work unit so he can join us and take Dr. Ottinger's place."

That night I was dead tired but much too excited and frightened to close my eyes. I stared at the ceiling beam and thought about tomorrow. If we were caught in the garbage ditch it would mean certain death. But so would remaining in the camp. The Gestapo knew that I had been trained in London and worked with the French Resistance. They had sent me to Dachau and kept me alive only to get information out of me. I would be interrogated again, tortured and, whether they broke me or not, I would finally be murdered. My days here were numbered, and the number was very small. I still had misgivings about Kalka, but now I had no choice. I had to go through with our escape plan.

As I lay there my weakened bowels began to bother me. I had to control them because I was terrified of being caught out of bed if I went to the latrine. It dawned on me that this might be a real problem for me tomorrow and might even incapacitate me. Why hadn't I realized this earlier and gotten myself some constipating medication through the Blockältester's surgery? I could have kicked myself.

What would we do if the priest Kalka knew was not at the Frauenkirche when we got there? The more I worried, the more guilty and anxious I began to feel about those I was leaving behind, particularly Dr. Aarons, who was physically very frail. Fears, rational and irrational, besieged me, gradually turning my excitement to panic. I called Dr. Aarons, but he was asleep.

I tried to focus on the reality that escape was my only alternative. I told myself over

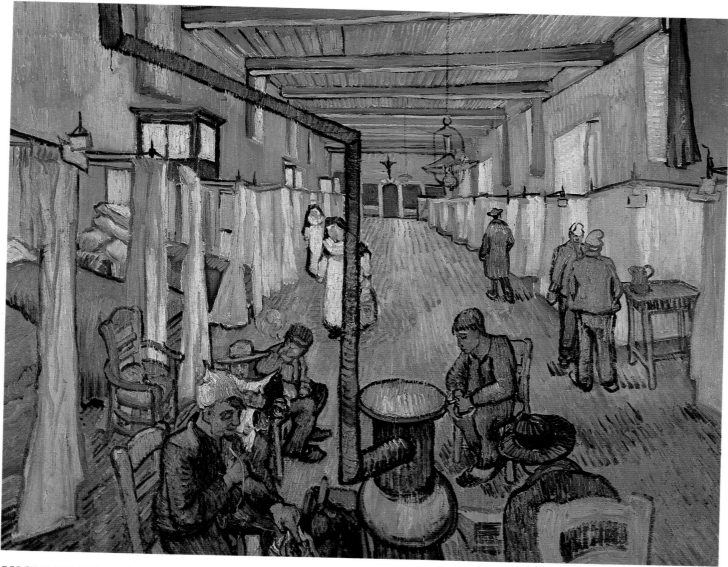

COLORPLATE 93

Vincent van Gogh. *The Hospital at Arles.* 1889. Oil on canvas. 28⅜ × 35¹³⁄₁₆ in. (72.1 × 91 cm). *Sammlung Oskar Reinhart, Winterthur, Switzerland. Following Van Gogh's mutilation of his ear in December of 1888, he was admitted to the hospital at Arles, France, the town where he had been living and working alongside Paul Gauguin. Released in January of 1889, Van Gogh was readmitted in February after having hallucinations.*

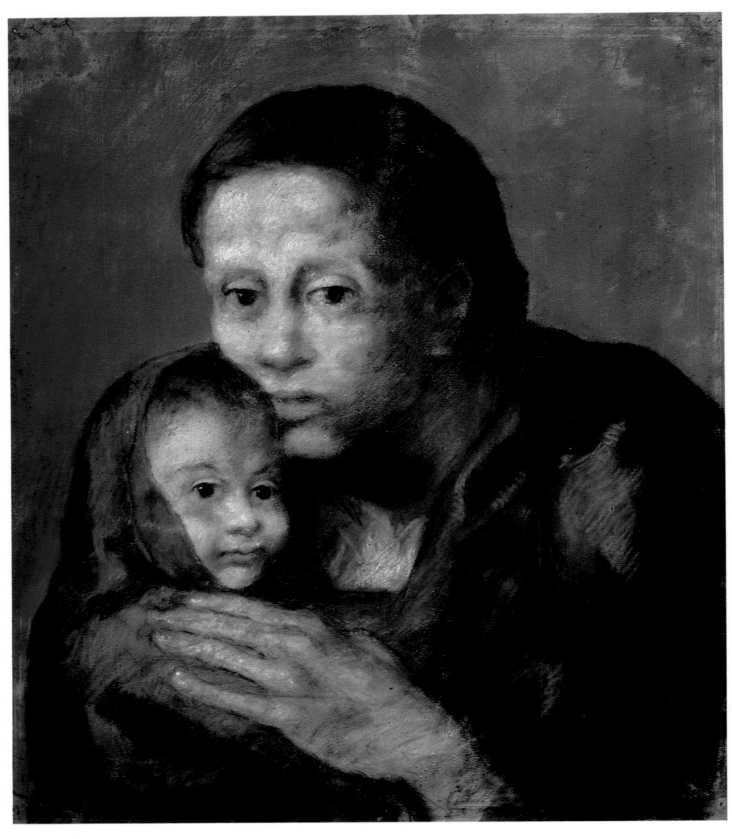

COLORPLATE 94

PABLO PICASSO. *The Sick Child.* 1903. Pastel and charcoal on paper. 18⅛ × 15¾ in. (46 × 40 cm).
Museo Picasso, Barcelona. © 1991 ARS, N.Y./SPADEM.

COLORPLATE 95

Baido (Baichosai) Kokunimasa. *A Visit by the Empress to the Tokyo Army Reserve Hospital.* 1895. Triptych. Woodblock print. Metropolitan Museum of Art, New York. Gift of Lincoln Kirstein.

COLORPLATE 96

LAUREN FORD. *The Country Doctor*. c. 1938. Oil on canvas. 54 × 72 in. (137.2 × 182.9 cm).
Canajoharie Library and Art Gallery, New York.

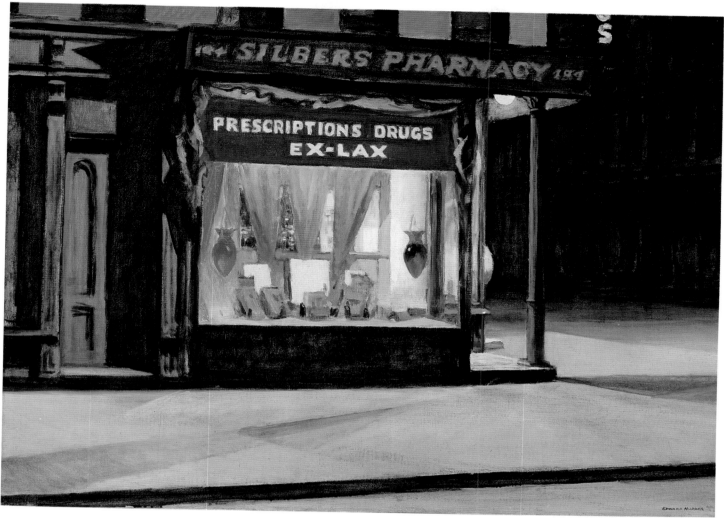

COLORPLATE 97

EDWARD HOPPER. *Drug Store*. 1927. Oil on canvas. 29 × 40 in. (73.7 × 101.6 cm).
Courtesy Museum of Fine Arts, Boston. Bequest of John T. Spaulding.

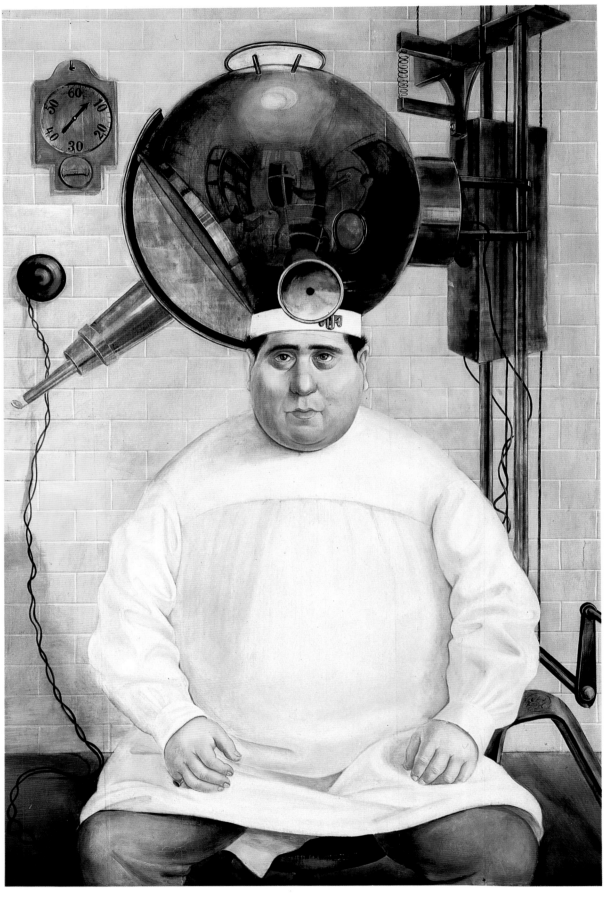

COLORPLATE 98

OTTO DIX. *Dr. Mayer-Hermann*. 1926. Oil and tempera on wood. 58¾ × 39 in.
(149.2 × 99.1 cm). The Museum of Modern Art, New York. Gift of Philip Johnson.

COLORPLATE 99

ROBERT R. VICKREY. *Sister of Charity.* 1965. Tempera. 23 × 27 in. (58.4 × 68.6 cm).
Collection IBM Corporation, Armonk, N.Y. © Robert Vickrey/VAGA, N.Y. 1991.

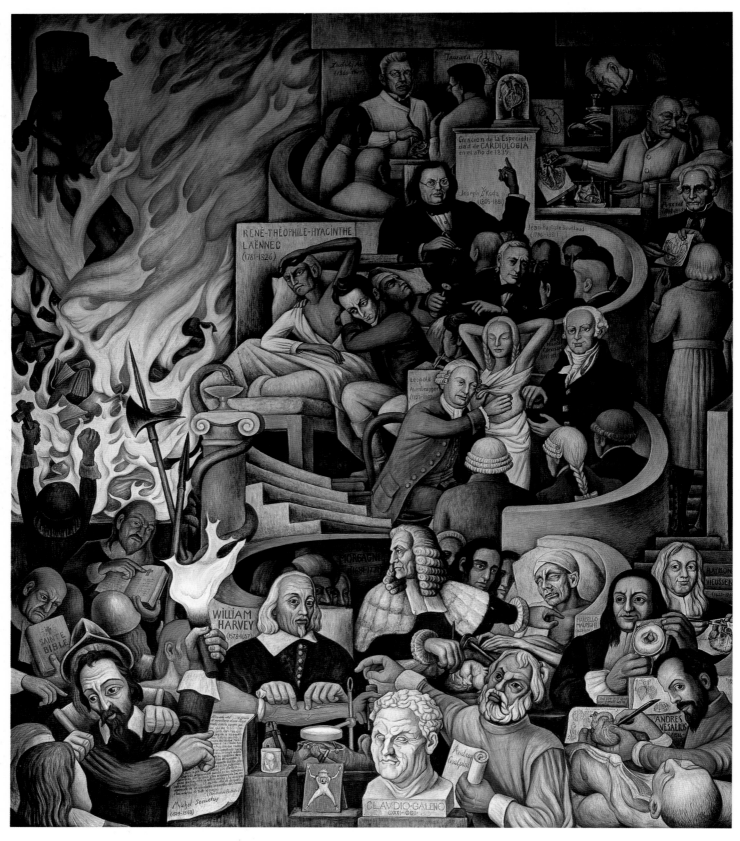

COLORPLATE 100

DIEGO RIVERA. *Anatomists,* detail from *The History of Cardiology.* 1943–44. Fresco (one of two panels). 19.6 × 13.2 ft. (6 × 4 m). Instituto Nacional de Cardiologia Ignacio Chavez, Mexico, D.F. Photograph courtesy Detroit Institute of Art.

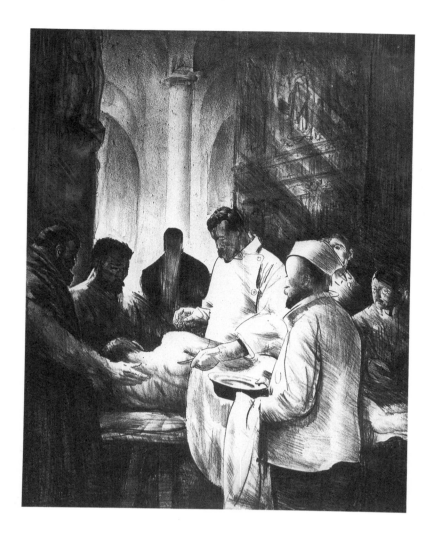

GEORGE BELLOWS. *Base Hospital*. 1918.
Lithograph. 17⅝ × 13⁹⁄₁₆ in. (44.8 × 34.4 cm).
Philadelphia Museum of Art,
SmithKline Corporation Fund.

and over that nothing could go wrong. Our plans were as good as they could be. My thoughts grew fuzzy and confused. I closed my eyes. Exhaustion and the sleeplessness of the previous night finally overtook me.

The next morning I hoped in vain to see Dr. Ottinger in the washroom. Kalka, Dr. Aarons, and I volunteered to carry breakfast back to the barrack. On our way to the kitchen we rehearsed our plans again. At each dumping Kalka and I would take turns concealing ourselves in the ditch. At the last dumping of the day, both of us would hide. Dr. Aarons and his Maquis comrade would make sure that we were both well covered by the garbage.

The day was gray and overcast. It was impossible to say how much of my gloom reflected the weather and how much my own forebodings. I was dismayed that this cloud cover might mean no moonlight that night. It would reduce our risk of being seen but increase the difficulties of finding our way.

We were called to our work units after breakfast. Our routine was the same as always, loading the container, pushing it to the gate where our SS guards joined us, and proceeding to the ditch. I hid during this first transport, then it was Kalka's turn, and we continued to alternate.

Finally, Kalka jumped into the ditch and I joined him. As I placed my catheter in my mouth I felt the garbage covering me. My heart was pounding in my throat. The squeaking noise of the wagon receded farther and farther into the distance. Then there was only silence.

I let a little time go by before pushing the garbage away from my face and opening my eyes to the dusky twilight. I cleaned off my mouth and said, "Psst!" Kalka answered. We dug ourselves out and retrieved our belongings from under the horse manure. Then we ripped the patch of striped fabric off the back of each coat. We decided to put off painting our striped berets and pants until we had put a little distance between ourselves

and the camp. Kalka took out his small bottle of schnapps and we each took a warming swallow.

Kalka suggested that we crawl away from the ditch so that if we were spotted from a distance, we could be mistaken for stray cats or dogs foraging for food. I didn't want to. I had heard that the German food shortages were so acute in rural areas that stray pets often ended up on the dinner table. I wanted to find the railroad tracks and follow them to Munich. Kalka vetoed that idea. The German railroad workers were among the most fanatic of Nazis. We should make our way to the neighboring village of Dachau and find the bus that went to Munich.

Our discussion had taken us to the end of the garbage ditch. We stood up and started to clean ourselves off. Despite all our efforts the stench of rotting garbage clung to us. Night was falling quickly. It had gotten perceptibly colder. We took another swallow of schnapps before walking briskly for the next twenty minutes. We kept off the road and didn't see anyone.

As we approached the outskirts of the village in the dark of early evening the rural silence was born by sirens. In the distance we saw the glow of exploding bombs and searchlights raking the sky for attacking American planes.

"Now," Kalka said, "at least we know where Munich is!"

We neared the road and saw people running, all in the same direction, most likely to a community bomb shelter. We sat down in a ditch off the roadside and began to paint our pants and berets right away. We did not want to run into a patrol with our stripes clearly advertising where we had just come from.

<p style="text-align:center">★ ★ ★</p>

The old stone church faced a town square that must have been filled with people during the day. We went around to the side and pushed through an unlocked door and went directly to the confessional booth. Kalka pushed the button to summon the priest. We waited. For twenty minutes we sat almost motionless and exchanged an occasional whispered word. Kalka pushed the button again. We heard approaching footsteps. I made out a black-clothed figure in the dim light. Kalka questioned the man as to his name. The voice on the other side of the grill let out a joyous whoop, and he and Kalka launched into a rapid exchange in Polish. Kalka seemed completely unmindful of the cramped confines of the narrow booth. I finally interrupted him to suggest that we continue this conversation elsewhere.

As we stepped out of the confessional the priest kissed each of us warmly on both cheeks. He was slender and fair-haired, with the high cheekbones and almond-shaped blue eyes of the Polish aristocrat. An air of cool reserve was softened by a kindness that was obvious in his gentle eyes. The priest led us through his private quarters and down to the church cellar to join two Polish escapees from a nearby forced labor camp. He told us to get some sleep. In the morning he would give us a nourishing meal and begin all the preparations for our flight. We had come to the right place for help.

Gordon S. Seagrave
FROM BURMA SURGEON

Born in Rangoon, Gordon Seagrave was in the fourth generation of Seagraves to serve as an American missionary, but the first to do so as a doctor. Trained at Johns Hopkins, Dr. Seagrave was better prepared for his practice culturally than medically. Arriving in Burma in 1922, Dr. Seagrave soon saw malaria, dysentery, plague, and all types of tropical diseases never encountered by a surgical house officer in Baltimore. Burma Surgeon *is a fascinating story of one surgeon's third-world practice, a story replete with crises, humor, and good will. Engulfed by the Second*

World War, Seagrave became a lieutenant colonel, M.C. Burma Surgeon Returns, *published in 1946, picks up the story after the war.*

"Gordon, Gordon, wake up! Those are Japanese bombers!" I took one look at the flock of "swans," discovered it was no dream, and yelled to the two boys to run to the valley where we had arranged for them to hide. Leaving Tiny to dress frantically, I ran over to the hospital. Nurses were already evacuating the patients according to our prearranged plan, and I passed several who were carrying male patients on their shoulders out into the woods. E Hla and the operating-room nurses were loading the Dodge with all our surgical instruments and baskets of sterile goods. On the far side of the hospital a Burmese was staggering along with his wife in his arms. I had just finished a major abdominal operation on her that morning. The husband was shaking with fright and his wife was fast sliding out of his arms, so I snatched her from him and carried her into a nullah. Running back I found a little five-foot nurse with a huge insane Kachin woman on her back. She was determined that if the Japanese were saving a bomb for us, as we expected, they should at least not hurt a crazy woman! We were just depositing our patient in safety when the bombers circled back over us. They had saved a bomb, but it missed us by a mile, and nearly massacred a Palong picnic party.

The bombers had passed over neutral Burma, both on their way to Loiwing and on their return.

The Dodge now loaded and volunteer cars coming to help, I started on with a team of nurses, Tiny coming along a few minutes later with another team. Four carloads, in all, went. I touched an occasional high spot in the road on my way, reaching Loiwing about half an hour after the bombing; but somehow or other Tiny, in spite of her late start, arrived at the hospital simultaneously. Dr. Yu and the first-aid men he had trained had already carried most of the casualties in. The operating staff was distracted; but with one Chinese nurse and Low Wang, the Chinese orderly who is still with me, to help, our nurses lit primus stoves and boiled instruments. The power mains had been destroyed and we had no electricity. We were just ready to begin operating when some fool turned in a false alarm. All the factory nurses ran, so I told our nurses to hide out, too. When nothing appeared and we came back, we began operating. Dr. Yu took the amputation and other orthopedic cases on one table, with Tiny to give his anesthesias, and I took the abdominal cases on the other while E Hla put them to sleep. We both worked fast. The internes selected cases and had them waiting in the doorway of the operating room. As I finished one major abdominal case and the nurses lifted him onto the stretcher, I moved over to the patient nearest the entrance. He moaned to me in Chinese, "Take me next, please take me next." He was covered with a blanket so I could not see just how badly he was hurt. I wheeled him toward my table, but the head factory nurse jerked him back and insisted I take another patient who, she said, needed operation more urgently. Thinking she knew her job, I took her patient, finding it to be a simple flesh wound. Then I went again to the other man, drew back the blanket and found one leg almost completely severed at the thigh with no tourniquet in evidence. Disgusted that favoritism should come into play during a time like this, I hurried to control hemorrhage; but the patient died. If I had operated on him first, as I intended, I could very probably have saved his life.

It is extraordinary what a ghastly wound can be caused by an insignificant bit of shell.

Not nearly so many casualties would have occurred if the Chinese had thrown themselves flat on the ground. Instead of lying down, however, everyone had started to run. The total number of killed was never accurately known. An entire family was buried alive in a hole they had dug to cache their personal possessions. Some children never found their parents again. One woman lost her husband and three children and went mad for several months.

A patient reached my table who had an apparently simple wound of the right hip

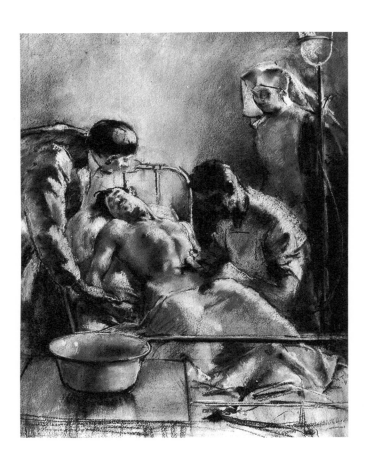

HENRY TONKS. *Saline Infusion.* 1915. Pastel. 26¾ × 20½ in. (67.9 × 52.1 cm). Imperial War Museum, London.

below the crest of the ilium. There was no sign of abdominal involvement that I could describe verbally, but I opened the abdomen just for the fun of it, and there was a two-inch rip in the small intestine. This was one of the pitifully few abdominal cases that lived.

A woman, eight months pregnant, had a tiny puncture in the left flank, from which oozed a little blood. Sure the shell fragment must have passed into the uterus, I opened the abdomen which contained a lot of blood and amniotic fluid. Tying off the ovarian artery that had been injured, I delivered the baby by Caesarian section. Across the dorsum of the baby's right foot the shell had made a wound, the scar of which that child will carry till the day he dies. Both mother and child did well.

And so on, case after case: splenectomies, removal of several feet of lacerated intestine, amputations of the leg and arm. A shell fragment had penetrated the skull of a little lad just John's size and build. Dissatisfied with some of the first-aid work, I became very impatient that all my calls for one of the physicians were unavailing. Where had that man disappeared to? Dr. Yu and Tiny were working heroically at the other table, saving lives by the dozens, yet losing patients just as I was, because the inexperienced internes could not decide correctly which cases were most urgent. Had the head of the Department of Internal Medicine been killed by a bomb?

Night was coming on and we were not half done. No electricity. Americans were trying to buy Storm King gasoline lamps across the valley and to borrow those the mission owned; but they had not returned. What light could we use? I remembered two packages of candles in the drawer of the desk in my office and sent a nurse for them. Entry to my office was possible either through the door of my secretary's room or through that of the office shared by Dr. Yu and another physician. Both doors were locked. The nurse looked for the orderly who kept the keys. He was nowhere to be seen. She tried the door again. Surely there was someone in that room? She knocked and knocked and nothing happened, yet that soft noise, like a child crying, persisted. Then the orderly appeared with the keys and opened the door. In the office, his head bowed on his arms, sobbing, was the physician we had been looking for.

Some people just cannot take it. . . .

John Hersey

FROM HIROSHIMA

A writer with an intensely moral vision, John Hersey has blended a life of journalism (he was originally a correspondent for Time *magazine during World War II) with fictive writing. His A* Bell for Adano, *a book about a Sicilian village victimized by the Fascists during the war, won the Pulitzer Prize in 1945.* Hiroshima *was originally published as an entire issue of the* New Yorker *magazine and illustrates his reporter's eye for detail and his crisp pen for recording it.*

On the train on the way into Hiroshima from the country, where he lived with his mother, Dr. Terufumi Sasaki, the Red Cross Hospital surgeon, thought over an unpleasant nightmare he had had the night before. His mother's home was in Mukaihara, thirty miles from the city, and it took him two hours by train and tram to reach the hospital. He had slept uneasily all night and had wakened an hour earlier than usual, and, feeling sluggish and slightly feverish, had debated whether to go to the hospital at all; his sense of duty finally forced him to go, and he had started out on an earlier train than he took most mornings. The dream had particularly frightened him because it was so closely associated, on the surface at least, with a disturbing actuality. He was only twenty-five years old and had just completed his training at the Eastern Medical University, in Tsingtao, China. He was something of an idealist and was much distressed by the inadequacy of medical facilities in the country town where his mother lived. Quite on his own, and without a permit, he had begun visiting a few sick people out there in the evenings, after his eight hours at the hospital and four hours' commuting. He had recently learned that the penalty for practicing without a permit was severe; a fellow-doctor whom he had asked about it had given him a serious scolding. Nevertheless, he had continued to practice. In his dream, he had been at the bedside of a country patient when the police and the doctor he had consulted burst into the room, seized him, dragged him outside, and beat him up cruelly. On the train, he just about decided to give up the work in Mukaihara, since he felt it would be impossible to get a permit, because the authorities would hold that it would conflict with his duties at the Red Cross Hospital.

At the terminus, he caught a streetcar at once. (He later calculated that if he had taken his customary train that morning, and if he had had to wait a few minutes for the streetcar, as often happened, he would have been close to the center at the time of the explosion and would surely have perished.) He arrived at the hospital at seven-forty and reported to the chief surgeon. A few minutes later, he went to a room on the first floor and drew blood from the arm of a man in order to perform a Wassermann test. The laboratory containing the incubators for the test was on the third floor. With the blood specimen in his left hand, walking in a kind of distraction he had felt all morning, probably because of the dream and his restless night, he started along the main corridor on his way toward the stairs. He was one step beyond an open window when the light of the bomb was reflected, like a gigantic photographic flash, in the corridor. He ducked down on one knee and said to himself, as only a Japanese would, "Sasaki, *gambare!* Be brave!" Just then (the building was 1,650 yards from the center), the blast ripped through the hospital. The glasses he was wearing flew off his face; the bottle of blood crashed against one wall; his Japanese slippers zipped out from under his feet—but otherwise, thanks to where he stood, he was untouched.

Dr. Sasaki shouted the name of the chief surgeon and rushed around to the man's office and found him terribly cut by glass. The hospital was in horrible confusion: heavy partitions and ceilings had fallen on patients, beds had overturned, windows had blown

in and cut people, blood was spattered on the walls and floors, instruments were every-where, many of the patients were running about screaming, many more lay dead. (A colleague working in the laboratory to which Dr. Sasaki had been walking was dead; Dr. Sasaki's patient, whom he had just left and who a few moments before had been dreadfully afraid of syphilis, was also dead.) Dr. Sasaki found himself the only doctor in the hospital who was unhurt.

Dr. Sasaki, who believed that the enemy had hit only the building he was in, got bandages and began to bind the wounds of those inside the hospital; while outside, all over Hiroshima, maimed and dying citizens turned their unsteady steps toward the Red Cross Hospital to begin an invasion that was to make Dr. Sasaki forget his private night-mare for a long, long time.

<p style="text-align:center">★ ★ ★</p>

Dr. Sasaki worked without method, taking those who were nearest him first, and he noticed soon that the corridor seemed to be getting more and more crowded. Mixed in with the abrasions and lacerations which most people in the hospital had suffered, he began to find dreadful burns. He realized then that casualties were pouring in from outdoors. There were so many that he began to pass up the lightly wounded; he decided that all he could hope to do was to stop people from bleeding to death. Before long, patients lay and crouched on the floors of the wards and the laboratories and all the other rooms, and in the corridors, and on the stairs, and in the front hall, and under the porte-cochère, and on the stone front steps, and in the driveway and courtyard, and for blocks each way in the streets outside. Wounded people supported maimed people; disfigured families leaned together. Many people were vomiting. A tremendous number of school-girls—some of those who had been taken from their classrooms to work outdoors, clear-ing fire lanes—crept into the hospital. In a city of two hundred and forty-five thousand, nearly a hundred thousand people had been killed or doomed at one blow; a hundred thousand more were hurt. At least ten thousand of the wounded made their way to the best hospital in town, which was altogether unequal to such a trampling, since it had only six hundred beds, and they had all been occupied. The people in the suffocating crowd inside the hospital wept and cried, for Dr. Sasaki to hear "*Sensei!* Doctor!," and the less seriously wounded came and pulled at his sleeve and begged him to go to the aid of the worse wounded. Tugged here and there in his stockinged feet, bewildered by the numbers, staggered by so much raw flesh, Dr. Sasaki lost all sense of profession and stopped working as a skillful surgeon and a sympathetic man; he became an automaton, mechanically wiping, daubing, winding, wiping, daubing, winding.

<p style="text-align:center">★ ★ ★</p>

By nightfall, ten thousand victims of the explosion had invaded the Red Cross Hospital, and Dr. Sasaki, worn out, was moving aimlessly and dully up and down the stinking corridors with wads of bandage and bottles of Mercurochrome, . . . binding up the worst cuts as he came to them. Other doctors were putting compresses of saline solution on the worst burns. That was all they could do. After dark, they worked by the light of the city's fires and by candles the ten remaining nurses held for them. Dr. Sasaki had not looked outside the hospital all day; the scene inside was so terrible and so compelling that it had not occurred to him to ask any questions about what had happened beyond the windows and doors. Ceilings and partitions had fallen; plaster, dust, blood, and vomit were everywhere. Patients were dying by the hundreds, but there was nobody to carry away the corpses. Some of the hospital staff distributed biscuits and rice balls, but the charnel-house smell was so strong that few were hungry. By three o'clock the next morning, after nineteen straight hours of his gruesome work, Dr. Sasaki was incapable of dressing another wound. He and some other survivors of the hospital staff got straw mats and went outdoors—thousands of patients and hundreds of dead were in the yard and on the driveway—and hurried around behind the hospital and lay down in hiding to snatch some sleep. But within an hour wounded people had found them; a complaining

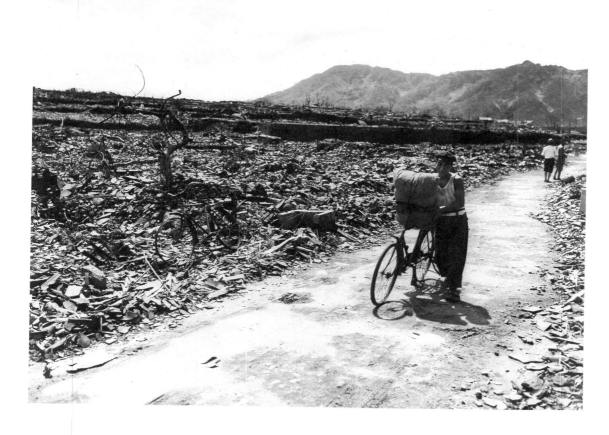

circle formed around them: "Doctors! Help us! How can you sleep?" Dr. Sasaki got up again and went back to work. Early in the day, he thought for the first time of his mother, at their country home in Mukaihara, thirty miles from town. He usually went home every night. He was afraid she would think he was dead.

<p style="text-align:center">★ ★ ★</p>

At the Red Cross Hospital, Dr. Sasaki worked for three straight days with only one hour's sleep. On the second day, he began to sew up the worst cuts, and right through the following night and all the next day he stitched. Many of the wounds were festered. Fortunately, someone had found intact a supply of *narucopon*, a Japanese sedative, and he gave it to many who were in pain. Word went around among the staff that there must have been something peculiar about the great bomb, because on the second day the vice-chief of the hospital went down in the basement to the vault where the X-ray plates were stored and found the whole stock exposed as they lay. That day, a fresh doctor and ten nurses came in from the city of Yamaguchi with extra bandages and antiseptics, and the third day another physician and a dozen more nurses arrived from Matsue—yet there were still only eight doctors for ten thousand patients. In the afternoon of the third day, exhausted from his foul tailoring, Dr. Sasaki became obsessed with the idea that his mother thought he was dead. He got permission to go to Mukaihara. He walked out to the first suburbs, beyond which the electric train service was still functioning, and reached home late in the evening. His mother said she had known he was all right all along; a wounded nurse had stopped by to tell her. He went to bed and slept for seventeen hours.

<p style="text-align:center">★ ★ ★</p>

A comparative orderliness, at least, began to be established at the Red Cross Hospital. Dr. Sasaki, back from his rest, undertook to classify his patients (who were still scattered everywhere, even on the stairways). The staff gradually swept up the debris. Best of all, the nurses and attendants started to remove the corpses. Disposal of the dead, by decent

cremation and enshrinement, is a greater moral responsibility to the Japanese than adequate care of the living. Relatives identified most of the first day's dead in and around the hospital. Beginning on the second day, whenever a patient appeared to be moribund, a piece of paper with his name on it was fastened to his clothing. The corpse detail carried the bodies to a clearing outside, placed them on pyres of wood from ruined houses, burned them, put some of the ashes in envelopes intended for exposed X-ray plates, marked the envelopes with the names of the deceased, and piled them, neatly and respectfully, in stacks in the main office. In a few days, the envelopes filled one whole side of the impromptu shrine.

<p style="text-align:center">★ ★ ★</p>

Dr. Sasaki and his colleagues at the Red Cross Hospital watched the unprecedented disease unfold and at last evolved a theory about its nature. It had, they decided, three stages. The first stage had been all over before the doctors even knew they were dealing with a new sickness; it was the direct reaction to the bombardment of the body, at the moment when the bomb went off, by neutrons, beta particles, and gamma rays. The apparently uninjured people who had died so mysteriously in the first few hours or days had succumbed in this first stage. It killed ninety-five per cent of the people within a half mile of the center, and many thousands who were farther away. The doctors realized in retrospect that even though most of these dead had also suffered from burns and blast effects, they had absorbed enough radiation to kill them. The rays simply destroyed body cells—caused their nuclei to degenerate and broke their walls. Many people who did not die right away came down with nausea, headache, diarrhea, malaise, and fever, which lasted several days. Doctors could not be certain whether some of these symptoms were the result of radiation or nervous shock. The second stage set in ten or fifteen days after the bombing. Its first symptom was falling hair. Diarrhea and fever, which in some cases went as high as 106, came next. Twenty-five to thirty days after the explosion, blood disorders appeared: gums bled, the white-blood-cell count dropped sharply, and *petechiae* appeared on the skin and mucous membranes. The drop in the number of white blood corpuscles reduced the patient's capacity to resist infection, so open wounds were unusually slow in healing and many of the sick developed sore throats and mouths. The two key symptoms, on which the doctors came to base their prognosis, were fever and the lowered white-corpuscle count. If fever remained steady and high, the patient's chances for survival were poor. The white count almost always dropped below four thousand; a patient whose count fell below one thousand had little hope of living. Toward the end of the second stage, if the patient survived, anemia, or a drop in the red blood count, also set in. The third stage was the reaction that came when the body struggled to compensate for its ills—when, for instance, the white count not only returned to normal but increased to much higher than normal levels. In this stage, many patients died of complications, such as infections in the chest cavity. Most burns healed with deep layers of pink, rubbery scar tissue, known as keloid tumors. The duration of the disease varied, depending on the patient's constitution and the amount of radiation he had received. Some victims recovered in a week; with others the disease dragged on for months.

As the symptoms revealed themselves, it became clear that many of them resembled the effects of overdoses of X-ray, and the doctors based their therapy on that likeness. They gave victims liver extract, blood transfusions, and vitamins, especially B_1. The shortage of supplies and instruments hampered them. Allied doctors who came in after the surrender found plasma and penicillin very effective. Since the blood disorders were, in the long run, the predominant factor in the disease, some of the Japanese doctors evolved a theory as to the seat of the delayed sickness. They thought that perhaps gamma rays, entering the body at the time of the explosion, made the phosphorus in the victims' bones radioactive, and that they in turn emitted beta particles, which, though they could not penetrate far through flesh, could enter the bone marrow, where blood is manufactured, and gradually tear it down. Whatever its source, the disease has some baffling quirks. Not all the patients exhibited all the main symptoms. People who suffered flash

burns were protected, to a considerable extent, from radiation sickness. Those who had lain quietly for days or even hours after the bombing were much less liable to get sick than those who had been active. Gray hair seldom fell out. And, as if nature were protecting man against his own ingenuity, the reproductive processes were affected for a time; men became sterile, women had miscarriages, menstruation stopped.

<p style="text-align:center">★　　★　　★</p>

It took six months for the Red Cross Hospital, and even longer for Dr. Sasaki, to get back to normal. Until the city restored electric power, the hospital had to limp along with the aid of a Japanese Army generator in its backyard. Operating tables, X-ray machines, dentist chairs, everything complicated and essential came in a trickle of charity from other cities. In Japan, face is important even to institutions, and long before the Red Cross Hospital was back to par on basic medical equipment, its directors put up a new yellow brick veneer façade, so the hospital became the handsomest building in Hiroshima—from the street. For the first four months, Dr. Sasaki was the only surgeon on the staff and he almost never left the building; then, gradually, he began to take an interest in his own life again. He got married in March. He gained back some of the weight he lost, but his appetite remained only fair; before the bombing, he used to eat four rice balls at every meal, but a year after it he could manage only two. He felt tired all the time. "But I have to realize," he said, "that the whole community is tired."

THE ART OF MEDICINE IN A SCIENTIFIC AGE

Arthur Conan Doyle

FROM THE MAN FROM ARCHANGEL

"Behind the Times"

Best known as the creator of Sherlock Holmes, Doyle (1859–1930) also wrote sixteen non–Sherlock Holmes books. Taking one of his medical school instructors, Joseph Bell, at the University of Edinburgh as the basis for Holmes's character, Doyle began A Study in Scarlet in 1887. Knighted in 1902 for his defense of the British cause in the Great Boer War, Doyle turned to spiritualism in his later years and became the proponent of, among other projects, a Channel tunnel.

My first interview with Dr. James Winter was under dramatic circumstances. It occurred at two in the morning in the bedroom of an old country house. I kicked him twice on the white waistcoat and knocked off his gold spectacles, while he, with the aid of a female accomplice, stifled my angry cries in a flannel petticoat and thrust me into a warm bath. I am told that one of my parents, who happened to be present, remarked in a whisper

that there was nothing the matter with my lungs. I cannot recall how Dr. Winter looked at the time for I had other things to think of, but his description of my own appearance is far from flattering. A fluffy head, a body like a trussed goose, very bandy legs, and feet with the soles turned inwards—those are the main items which he can remember.

From this time onwards the epochs of my life were the periodical assaults which Dr. Winter made upon me. He vaccinated me, he cut me for an abscess, he blistered me for mumps. It was a world of peace, and he the one dark cloud that threatened. But at last there came a time of real illness—a time when I lay for months together inside my wicker-work basket bed, and then it was that I learned that that hard face could relax, that those country-made, creaking boots could steal very gently to a bedside, and that that rough voice could thin into a whisper when it spoke to a sick child.

And now the child is himself a medical man, and yet Dr. Winter is the same as ever. I can see no change since first I can remember him, save that perhaps the brindled hair is a trifle whiter, and the huge shoulders a little more bowed. He is a very tall man, though he loses a couple of inches from his stoop. That big back of his has curved itself over sick beds until it has set in that shape. His face is of a walnut brown, and tells of long winter drives over bleak country roads with the wind and the rain in his teeth. It looks smooth at a little distance, but as you approach him you see that it is shot with innumerable fine wrinkles, like a last year's apple. They are hardly to be seen when he is in repose, but when he laughs his face breaks like a starred glass, and you realise then that, though he looks old, he must be older than he looks.

How old that is I could never discover. I have often tried to find out, and have struck his stream as high up as George the Fourth and even of the Regency, but without ever getting quite to the source. His mind must have been open to impressions very early, but it must also have closed early, for the politics of the day have little interest for him, while he is fiercely excited about questions which are entirely prehistoric. He shakes his

head when he speaks of the first Reform Bill and expresses grave doubts as to its wisdom, and I have heard him, when he was warmed by a glass of wine, say bitter things about Robert Peel and his abandoning of the Corn Laws. The death of that statesman brought the history of England to a definite close, and Dr. Winter refers to everything which had happened since then as to an insignificant anti-climax.

But it was only when I had myself become a medical man that I was able to appreciate how entirely he is a survival of a past generation. He had learned his medicine under that obsolete and forgotten system by which a youth was apprenticed to a surgeon, in the days when the study of anatomy was often approached through a violated grave. His views upon his own profession are even more reactionary than his politics. Fifty years have brought him little and deprived him of less. Vaccination was well within the teaching of his youth, though I think he has a secret preference for inoculation. Bleeding he would practise freely but for public opinion. Chloroform he regards as a dangerous innovation, and he always clicks with his tongue when it is mentioned. He has even been known to say vain things about Laennec, and to refer to the stethoscope as "a newfangled French toy." He carries one in his hat out of deference to the expectations of his patients; but he is very hard of hearing, so that it makes little difference whether he uses it or not.

He always reads, as a duty, his weekly medical paper, so that he has a general idea as to the advance of modern science. He persists in looking upon it, however, as a huge and rather ludicrous experiment. The germ theory of disease set him chuckling for a long time, and his favourite joke in the sick-room was to say, "Shut the door, or the germs will be getting in." As to the Darwinian theory, it struck him as being the crowning joke of the century. "The children in the nursery and the ancestors in the stable," he would cry, and laugh the tears out of his eyes.

He is so very much behind the day that occasionally, as things move round in their usual circle, he finds himself, to his own bewilderment, in the front of the fashion. Dietetic treatment, for example, had been much in vogue in his youth, and he has more practical knowledge of it than any one whom I have met. Massage, too, was familiar to him when it was new to our generation. He had been trained also at a time when instruments were in a rudimentary state and when men learned to trust more to their own fingers. He has a model surgical hand, muscular in the palm, tapering in the fingers, "with an eye at the end of each." I shall not easily forget how Dr. Patterson and I cut Sir John Sirwell, the County Member, and were unable to find the stone. It was a horrible moment. Both our careers were at stake. And then it was that Dr. Winter, whom we had asked out of courtesy to be present, introduced into the wound a finger which seemed to our excited senses to be about nine inches long, and hooked out the stone at the end of it.

"It's always well to bring one in your waistcoat pocket," said he with a chuckle, "but I suppose you youngsters are above all that."

We made him President of our Branch of the British Medical Association, but he resigned after the first meeting. "The young men are too much for me," he said. "I don't understand what they are talking about." Yet his patients do very well. He has the healing touch—that magnetic thing which defies explanation or analysis, but which is a very evident fact none the less. His mere presence leaves the patient with more hopefulness and vitality. The sight of disease affects him as dust does a careful housewife. It makes him angry and impatient. "Tut, tut, this will never do!" he cries, as he takes over a new case. He would shoo death out of the room as though he were an intrusive hen. But when the intruder refuses to be dislodged, when the blood moves more slowly and the eyes grow dimmer, then it is that Dr. Winter is of more avail than all the drugs in his surgery. Dying folk cling to his hand as if the presence of his bulk and vigour gives them more courage to face the change; and that kindly, wind-beaten face has been the last earthly impression which many a sufferer has carried into the unknown.

When Dr. Patterson and I, both of us young, energetic, and up-to-date, settled in the district, we were most cordially received by the old doctor, who would have been only too happy to be relieved of some of his patients. The patients themselves, however, followed their own inclinations, which is a reprehensible way that patients have, so that

we remained neglected with our modern instruments and our latest alkaloids, while he was serving out senna and calomel to all the country-side. We both of us loved the old fellow, but at the same time, in the privacy of our own intimate conversations, we could not help commenting upon this deplorable lack of judgment.

"It is all very well for the poorer people," said Patterson, "but after all the educated classes have a right to expect that their medical man will know the difference between a mitral murmur and a bronchitic râle. It's the judicial frame of mind, not the sympathetic, which is the essential one."

I throughly agreed with Patterson in what he said. It happened, however, that very shortly afterwards the epidemic of influenza broke out, and we were all worked to death. One morning I met Patterson on my round, and found him looking rather pale and fagged out. He made the same remark about me. I was in fact feeling far from well, and I lay upon the sofa all afternoon with a splitting headache and pains in every joint. As evening closed in I could no longer disguise the fact that the scourge was upon me, and I felt that I should have medical advice without delay. It was of Patterson naturally that I thought, but somehow the idea of him had suddenly become repugnant to me. I thought of his cold, critical attitude, of his endless questions, of his tests and his tappings. I wanted something more soothing—something more genial.

"Mrs. Hudson," said I to my housekeeper, "would you kindly run along to old Dr. Winter and tell him that I should be obliged to him if he would step round."

She was back with an answer presently.

"Dr. Winter will come round in an hour or so, sir, but he has just been called in to attend Dr. Patterson."

Edgar Lee Masters

FROM SPOON RIVER ANTHOLOGY
"Doctor Meyers"

Masters (1869–1950) left the practice of law in 1920 to devote his time to writing. As occasionally happens with such decisions, this was probably a mistake, since he never equaled the critical or popular success of his Spoon River Anthology *(1915), a collection of imaginary epitaphs he based on Greek epigrams when he was still practicing law in Chicago. The Spoon River neighborhood of the anthology is the Petersburg and Lewistown vicinities of Illinois in which Masters grew up.*

No other man, unless it was Doc Hill,
Did more for people in this town than I.
And all the weak, the halt, the improvident
And those who could not pay flocked to me.
I was good-hearted, easy Doctor Meyers.
I was healthy, happy, in comfortable fortune,
Blest with a congenial mate, my children raised,
All wedded, doing well in the world.
And then one night, Minerva, the poetess,
Came to me in her trouble, crying.
I tried to help her out—she died—
They indicted me, the newspapers disgraced me,
My wife perished of a broken heart.
And pneumonia finished me.

Hans Zinsser

FROM AS I REMEMBER HIM

Among the occasional works of Zinsser (1878–1940), Rats, Lice and History, *a wide-ranging tour through the history of medicine vis-à-vis rats and their epizoötic relation to human illness, is a classic in the history of human infections. Zinsser is also justly remembered for his textbook of microbiology and this fictional biography-as-autobiography. In this selection, Zinsser recounts some of his brief experiences in general practice, which were to contrast so vividly with his travels around the world. From 1923, he was on the faculty of Harvard Medical School.*

————————————

Early in my medical career I developed a deep and lasting admiration for the old-fashioned, self-reliant country practitioner, the "horse and buggy doctor" so sympathetically described in the recent book by Dr. Hertzler. While a medical student in New York, I was accustomed to recuperate from strenuous days and nights under a lamp by spending occasional week ends on my father's farm in Westchester County. I slept in a cold house, with a wood stove in my bedroom, stoked till the lid glowed red, with my collie dog keeping my feet warm. All day and into the night I would ride the horses—each one in turn—across country over the snow-covered hills. Those were unforgettably lovely vacations. The utter loneliness of the big house (the farmer lived at the other end of a beech wood), the nights silent except for the cracking of the frozen branches of the big trees in the wind, the brittleness of the air and the incandescent brilliance of the stars! And the rides! Physical fitness that could spend itself on three successive unexercised horses, and the spiritual peach that only a good horse or a small boat at sea can give—the white landscape, woods and fields crisp, cold, and lifeless except for the silent testimony of tracks in the snow, an occasional squirrel and, once in a while, a flock of crows angrily clamoring away from a leafless perch. I knew all the paths and openings and the hidden spots in the birch woods where, in the summers, I hunted birds; where the foxes went to earth; and where, among the big rocks on Piano Mountain, one could get a glimpse of the Hudson. I still remember those rides as among the happiest gifts of a Providence that has been munificent. Often, galloping through the fields and across the hills between snowbound villages, I would see far off on the valley roads the familiar "cutter" sleighs of our local doctors—Jenkins and Hart—answering calls that often meant hours of driving and small fees, irrespective of roads or weather, with an unfailing and expected fidelity not demanded of the rural delivery. Sometimes I would meet one of them, whiskers frosted, nose red and dripping, with not much more showing than these between the fur cap and the muffler. Always they stopped for a chat, to tell me about the case and exchange medical gossip—for they treated me as a professional equal who was getting things they wished they had time to catch up with. For their difficulties made them modest; whereas I, with the arrogance of a young and silly student (arrogance, being a state of mind, I have noticed is always intensified by sitting a horse), was just a trace patronizing. I lost all that as a matter of course when I tried to practise by myself. But a good deal of it was jarred out of me by the episode of Dr. Kerr.

Dr. Kerr is now dead. He is probably forgotten by all but few old farmers' wives. He had neither fame nor more than a frugal living. He was probably unhappy, while he lived, not for the reasons mentioned, but because he never could do for his people as much as he wanted to do. He practised in St. Lawrence County, near Chippewa Bay. His office was a little surgery extension of a small village house. He was tall, thin, and very dark, with hairy wrists, a big nose, a bushy moustache, and kind, tired brown eyes. I was camping on my island in the bay and was known to the grocer in the village as a

young doctor from New York. One day at about 4 A.M. a motorboat approaching my island aroused me and the grocer's son shouted through the fog and drizzle that Dr. Kerr needed my help in a difficult case. He landed while I dressed, and we were off four miles to the village. There Dr. Kerr was waiting for me with his buggy. I had never seen him before and he impressed me, in my young self-confidence, as probably a poor country bonesetter whom I would have to show how a case should be handled. This, however, lasted only until we were bumping along a muddy country lane and he had begun to tell me about the patient.

It was a woman, a farm hand's wife, who was having her first baby. She had developed eclampsia seven months along, and the child had died. She was having convulsions. The problem was to deliver the dead baby from a uterus with an undistended cervix, and the mother dangerously toxic. At this point, I was thoroughly scared. I had had training at the Sloane Maternity, but this was a "high forceps" under difficulties, a case for Professor Cragin in a well-equipped operating room, with an assistant and two or three nurses.

We drove about four miles into the river flats. I could see the little unpainted cottage next to a haystack a mile away. I offered no suggestion while I was trying to recover my old ambulance courage. He didn't ask me any questions.

The place was a picture of abject poverty. The husband, a pathetic little bandy-legged, redheaded fellow in torn overalls, was waiting at the door, anxious and silent. The kitchen was a mess from his efforts at housekeeping. In the next room the woman, half-conscious, her bloated face twitching, lay on a dirty double bed, on a mattress without sheets under an old quilt half kicked off, leaving her almost naked.

While I stood looking at her with frightened sympathy, Dr. Kerr unpacked his bag. Without asking me to do anything, he filled a wash boiler with hot water from a kettle, added a little lysol, and put on his forceps to boil. Then he took off his coat, rolled up his sleeves, filled a basin, and began to soap and lysol his hands. Not until he was doing this did he speak.

Then he began to give me directions. In a few minutes I was cleaning up the patient, spreading clean towels under her, preparing a chloroform cone and jumping at his words as though in Dr. Cragin's clinic. With no essential help from me, he performed as neat a cervix dilation and forceps delivery as I had ever seen. When, after the long and arduous task, with everything complete as possible, he began to clean up, he didn't even thank me. He took it for granted that, being a doctor and being in the neighborhood, I was on call. It was his only compliment, except for a friendly smile.

He asked me to stay there the rest of the day while he made his rounds, gave me a few directions, and left a sedative. Then he went out, patted the husband on the back, and drove away. The woman recovered. Dr. Kerr, I heard later, spent the first two nights after this on a rocking chair, drinking cider with the husband, and napping when he could. His fee, I also heard, accepted to please the husband, was a peck of potatoes.

Some time later, I had occasion to ask him to open a boil on my neck. He sat me down in a chair, wiped my neck with alcohol, took a knife out of a little leather case, wiped that with alcohol, and let me have it. I made no suggestion whatever. I saw him often after that, and I sincerely hope—even now—that he liked me.

One of Dr. Kerr's colleagues from up near Ogdensburg, whom I had met at this time, did a most extraordinary thing. I met him on the river one day when we were both fishing off the head of Watch Island. Just as I came in sight of him as I rounded the point, he pulled out a magnificent pickerel.

"Good for you, doctor!" I shouted to him.

"What d'ye think, young feller?" he called back. "I caught that fish with a nice fat appendix I took out this mornin'."

Owen Tully Stratton

FROM MEDICINE MAN

Stratton was a medicine-show pitchman from 1898 to 1904, then a Salmon, Idaho country physician until his death in 1950. He had a brief medical education during the last of the pre-Flexner days, and his autobiography reveals the trial-and-error education his generation of rural doctors acquired in the practice of medicine. Far from any center for continuing education or access to the lastest features of a rapidly modernizing medicine, Stratton portrayed a Western physician dramatically different from the contemporary portrait of Dr. Martin Arrowsmith in Sinclair Lewis's 1925 Pulitzer Prize–winning novel.

Playing a lone hand in the practice of medicine has its drawbacks, but it does compel the practitioner to assume responsibility while keeping his mind on the race. Any misstep, and he is in trouble.

One day a rancher stopped me and asked me to come to see his father-in-law, who had injured his leg while riding the running gear of a wagon. Since the trip was twelve miles, and it was late in the evening, I asked, "How long has he been hurt?"

"Oh, about a week."

"Well, if he's stood it that long," I said, "he ought to be able to stand it until tomorrow."

The rancher agreed, and the next morning on my way to his place, I tried to guess the nature of the father-in-law's injury. I guessed that it was a Pott's fracture—both bones of the leg broken above the ankle. When I arrived, I found that I was right.

They had been trying to cure the old man with home remedies, and the leg was badly swollen and very painful. I could see no choice but to chloroform him, which was not the best thing that could happen to a man of his age. I checked him over, and he seemed sound enough, so I took a chance.

When I got him under, I turned the mask over to a volunteer neighbor and began applying a plaster of Paris cast to the leg. I became too interested in what I was doing, and when I looked up, the patient had stopped breathing.

I abandoned the leg and began to apply artificial respiration while fighting off the family, who saw that something had gone wrong with Grandpa and tried to keep him from taking off for the Golden Shore by hugging him. Through loud talk and some profanity, I got them out of the way and got the old man breathing again. Then I finished putting on the cast.

This was before the day when the Rotary Club or the Elks Lodge presented the fire department with a pulmotor. When I see a picture of the donors and the recipients sitting up like picket-pin gophers at the presentation, I always wonder how many helpless victims will have their lungs overextended by the machine. When you need a pulmotor, time is of the essence, and the Shaefer method of artificial respiration will do everything that a machine can do if anything at all can be done.

Three weeks after I resuscitated the old man, his son-in-law brought him to town to have a new cast put on. The son-in-law served as my assistant by holding the leg while I worked on it. I was washing the leg and looked up to find my helper on the verge of fainting and trying to keep from falling by hanging onto the injured limb. I pried his fingers loose, and he fell like a log onto the floor. Since he had assumed a position with his head low, he needed no further assistance, and I finished the new cast while he got himself back together.

Fainting is hard to predict. There was nothing particularly repulsive about the old man's leg, and there was no pain or blood, which affects some observers. On another

occasion, I had put a patient on the kitchen table in her ranch house and had her daughter holding a kerosene lamp while I performed a curettement. The patient cried, "Look, doctor!" and I turned around just in time to take the lighted lamp out of the girl's hands before she fell. A narrow escape!

Another narrow escape came when I had delivered a baby at a ranch without much trouble and was hurrying to get away because a blizzard was coming up. I got into my fur coat and went into the bedroom before I left to say good-by to the patient.

"I don't feel very good, doctor," she said. I thought she was complaining unnecessarily until I felt of her abdomen, which was ballooned out as though she were about to have another baby.

Believe me, I shucked out of my fur coat like a quick change artist. I forgot all about the blizzard and spent the next few hours trying to save my patient from a postpartum hemorrhage. Fortunately, I succeeded, but I still flinch when I think what would have happened if I had moved a little faster and got away.

<p style="text-align:center">★ ★ ★</p>

I have delivered many babies, some of which were difficult instrument deliveries, in every type of surroundings, but I always tried to keep my mind on my chain of asepsis. The only case I lost was one in which the patient had septemia from an infected induced abortion and was having chills that shook the house when I first saw her. We gave her about a million units of penicillin, but it was no more effective in her case than so much rainwater would have been.

My experience makes me agree with what Dr. Will Mayo once said. "People acquire a resistance to their own germs. If no aliens are introduced, they will have little trouble." That is why an aseptic conscience in a surgeon is so valuable.

William Carlos Williams
FROM SPRING AND ALL
"By the Road to the Contagious Hospital"

William Carlos Williams (1883–1963) was the United States' premier physician–poet. The winner of the Bollingen Prize in 1953 and a Pulitzer Prize in 1963 after his death at the age of 80, Williams had also been busy at what would now be called a general practice. For over 40 years, in Rutherford, New Jersey, Dr. Williams delivered over 3,000 babies while writing approximately the same number of poems, stories, and reviews. Although he more commonly incorporated aspects of his medical life into his short stories than his poetry, this selection is one of his 'medical poems' and was originally written on prescription blanks, probably in Williams's car while he was making a house call.

By the road to the contagious hospital
under the surge of the blue
mottled clouds driven from the

northeast—a cold wind. Beyond, the
waste of broad, muddy fields
brown with dried weeds, standing and fallen

patches of standing water
the scattering of tall trees

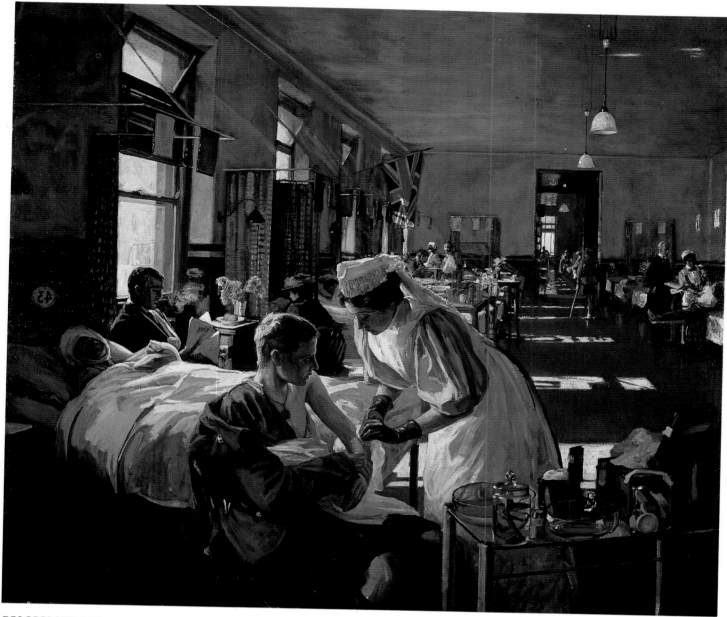

COLORPLATE 101

JOHN LAVERY. *The First Wounded in London Hospital, August 1914.* 1915. Oil on canvas. 69⅛ × 79 in.
(175.6 × 200.7 cm). Dundee Art Galleries and Museums, Dundee, Scotland.

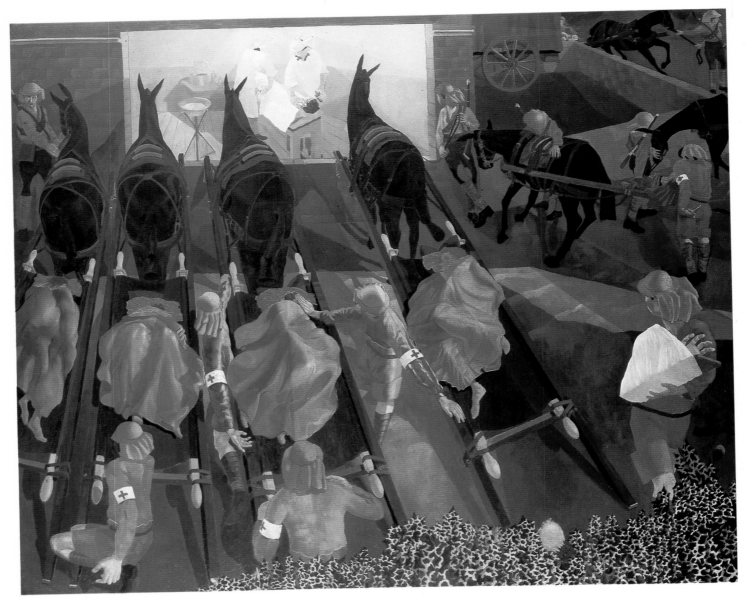

COLORPLATE 102

STANLEY SPENCER. *Travoys Arriving with Wounded at a Dressing Station at Smol, Macedonia*. 1919. Oil on canvas. 72 × 86 in. (182.9 × 218.4 cm). Imperial War Museum, London.

COLORPLATE 103 *(opposite)*

ROMAINE BROOKS. *The Cross of France*. 1914. Oil on canvas. 46.5 × 34 in. (118.1 × 86.4 cm). National Museum of American Art, Smithsonian Institution, Washington, D.C. Gift of the artist.

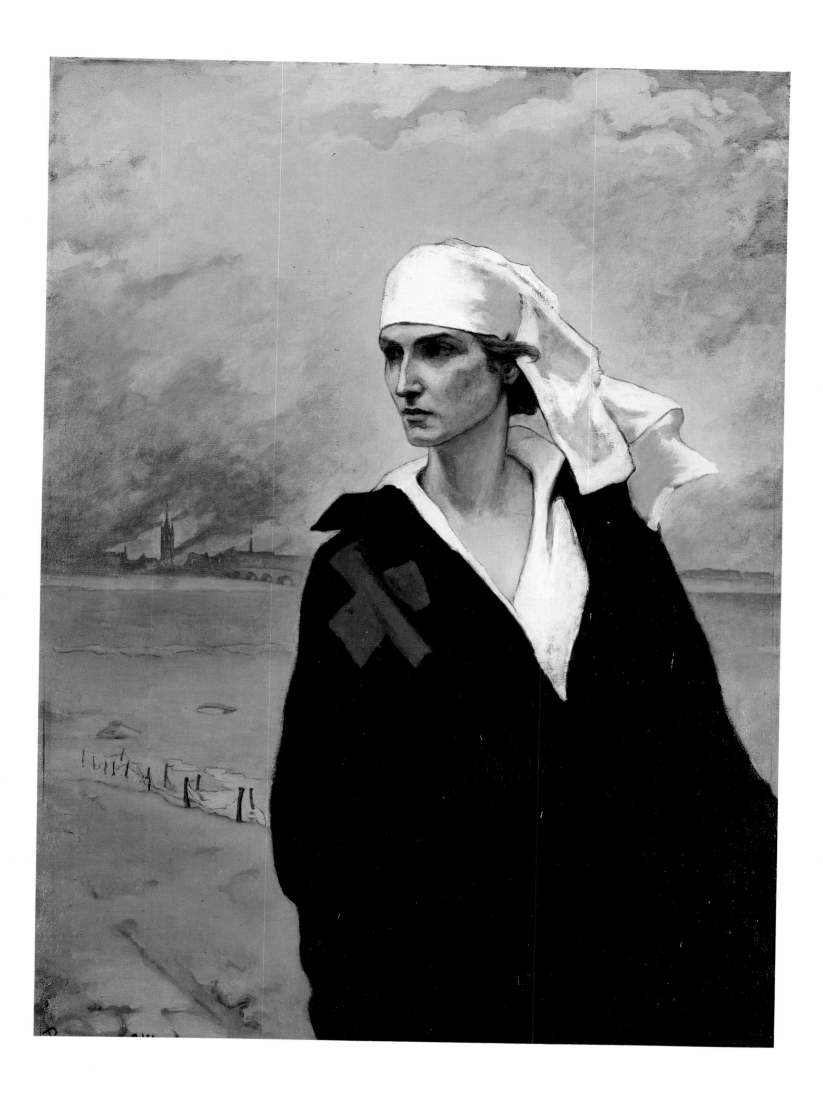

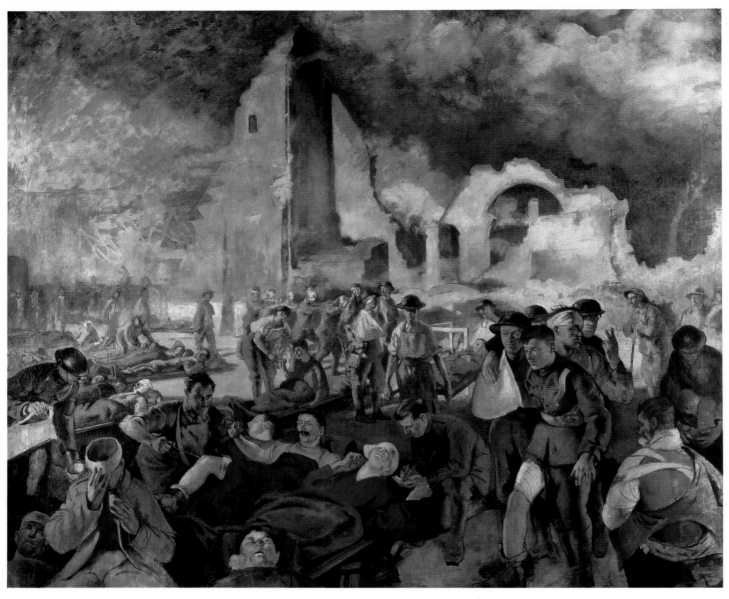

COLORPLATE 104

HENRY TONKS. *An Advanced Dressing-Station in France, 1918*. 1918. Oil on canvas. 72 × 86 in. (182.9 × 218.4 cm). Imperial War Museum, London.

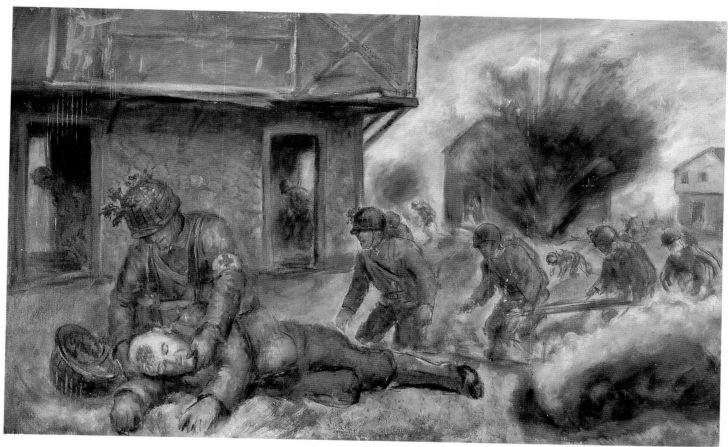

COLORPLATE 105

JOHN STEUART CURRY. *Medical Training in Texas.* 1943. Oil on canvas. 31 × 50 in. (78.7 × 127 cm).
Courtesy Mongerson-Wunderlich Gallery, Chicago, and the Estate of John Steuart Curry.

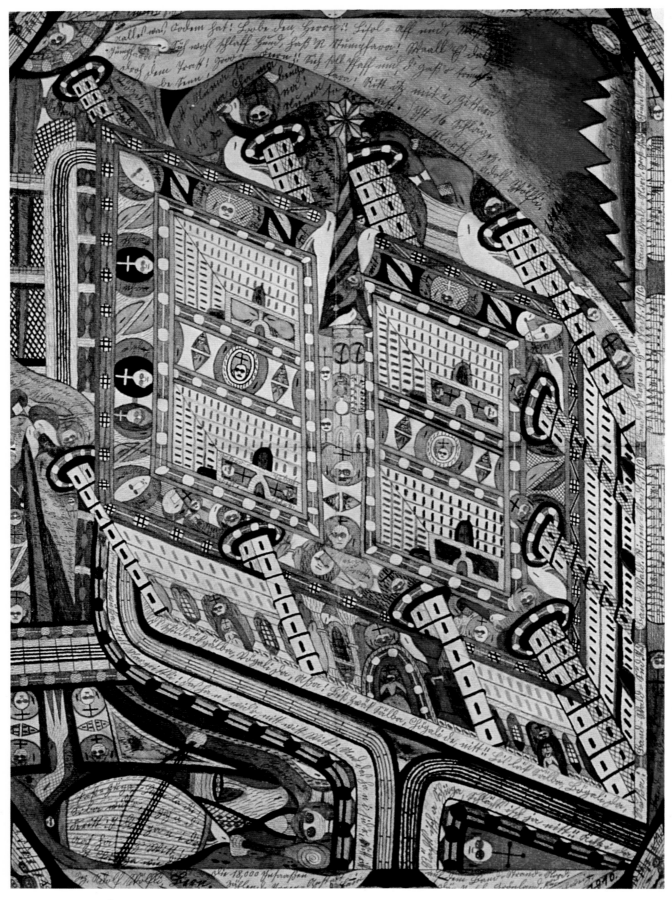

COLORPLATE 106

ADOLF WÖLFLI. *Mental-Asylum Band-Hain.* 1910. Pencil and colored pencil. 39⁵⁄₁₆ × 28⁷⁄₁₆ in. (99.9 × 72.2 cm). Adolf-Wölfli-Foundation, Museum of Fine Arts, Berne.

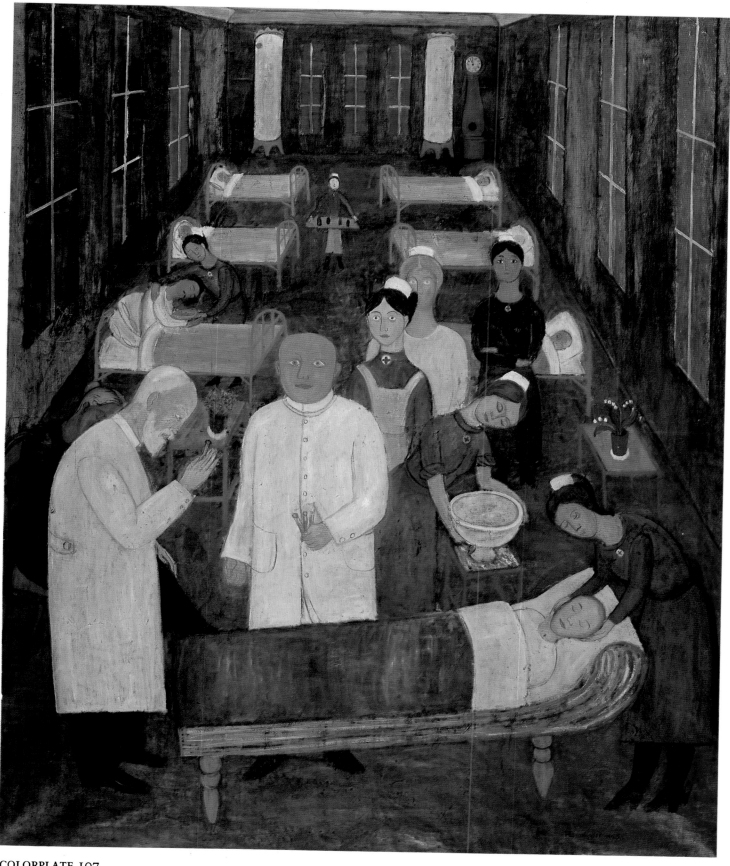

COLORPLATE 107

HILDING LINNQVIST. *Hospital Ward II.* 1920. Oil on canvas. 57 × 48 in. (144.8 × 121.9 cm).
Moderna Museet, Stockholm. © Hilding Linnqvist/VAGA, N.Y., 1991.

COLORPLATE 108

Andrew Stevivoch. *Portrait: Wrapped Head.* 1989. Oil on linen. 5 × 3¼ in.
(12.7 × 8.3 cm). Courtesy Coe Kerr Gallery, New York.

All along the road the reddish
purplish, forked, upstanding, twiggy
stuff of bushes and small trees
with dead, brown leaves under them
leafless vines—

Lifeless in appearance, sluggish
dazed spring approaches—

They enter the new world naked,
cold, uncertain of all
save that they enter. All about them
the cold, familiar wind—

Now the grass, tomorrow
the stiff curl of wildcarrot leaf

One by one objects are defined—
It quickens: clarity, outline of leaf

But now the stark dignity of
entrance—Still, the profound change

has come upon them: rooted they
grip down and begin to awaken

Anne Sexton

"Doctors"

Originally a fashion model, Sexton (1928–1974) began writing confessional poetry like W. D. Snodgrass and Robert Lowell, two American contemporaries whom she admired. Awarded the Pulitzer Prize in 1967 for a volume of poetry, Live or Die, *Sexton was preoccupied with depression and dying. She described that volume as reading "like a fever chart for a bad case of melancholy." She committed suicide in 1974.*

They work with herbs
and penicillin.
They work with gentleness
and the scalpel.
They dig out the cancer,
close an incision
and say a prayer
to the poverty of the skin.
They are not Gods
though they would like to be;
they are only a human
trying to fix up a human.
Many humans die.
They die like the tender,
palpitating berries
in November.

But all along the doctors remember:
First do no harm.
They would kiss if it would heal.
It would not heal.

If the doctors cure
then the sun sees it.
If the doctors kill
then the earth hides it.
The doctors should fear arrogance
more than cardiac arrest.
If they are too proud,
and some are,
then they leave home on horseback
but God returns them on foot.

James T. Farrell
"My Friend the Doctor"

James T. Farrell (1904–1979) was a second-generation Irish-American and the son and grandson of teamsters in Chicago, where Farrell grew up and described the life of one of this country's most famous literary characters, Studs Lonigan, in his novel trilogy of the 1930s. Working many different jobs before becoming a writer (from gas station attendant to cigar store clerk), he incorporated his experiences into what critics called naturalistic or realistic fiction. Farrell himself, who often wrote from 7 P.M. until dawn, only said, simply, "I don't have a method; I sit down and write."

Only sick people come to see Doc; they come, spout out their troubles; and sometimes they forget to pay. Then, he goes up from his office, for dinner, and his wife has more troubles. She is a rip, anyway.

When Doc was a kid in a middle-class Jewish home, he wanted to write. When he was a young man, without parents, slaving his way to a medical education, he dreamed of writing. When he was an intern, when he was, by necessity, in a large public health factory treating venereal diseases, he consoled himself with the intention of writing. Now a father, a hen-pecked husband, a young man forced to get the money out of a profession that is both over-crowded and threatened by the corporate momentum of our age, he is still imbued with this hope.

It seems unnecessary writing of Doc. The world is full of his brothers; it has always swamped and swallowed the silent Miltons, the ineffective Judes. It always shall. Their story is older than the first dirty joke; and more illustrative.

Doc is a roly-poly little man. He is round-faced with a boy's brown eyes; eyes that betray an unconscious hurt-puppy feeling. He is stout and rotund, baldheaded. His wife is lean and tall.

Doc is writing an autobiographical novel. It is a long dull affair, a scrambled mountain of words. It tells of the spiritual history of the dreamy Jew kid, of the lonely medical student, the hopeful intern, the revolting doctor of the public health institute, with his sensitivities strained through daily treatment of a disease, dirty in itself, and made worse when it has afflicted itself upon hundreds of a large city's unwashed herd, of the isolated husband, cut off from friendly intercourse, godless, seeking some personal element that

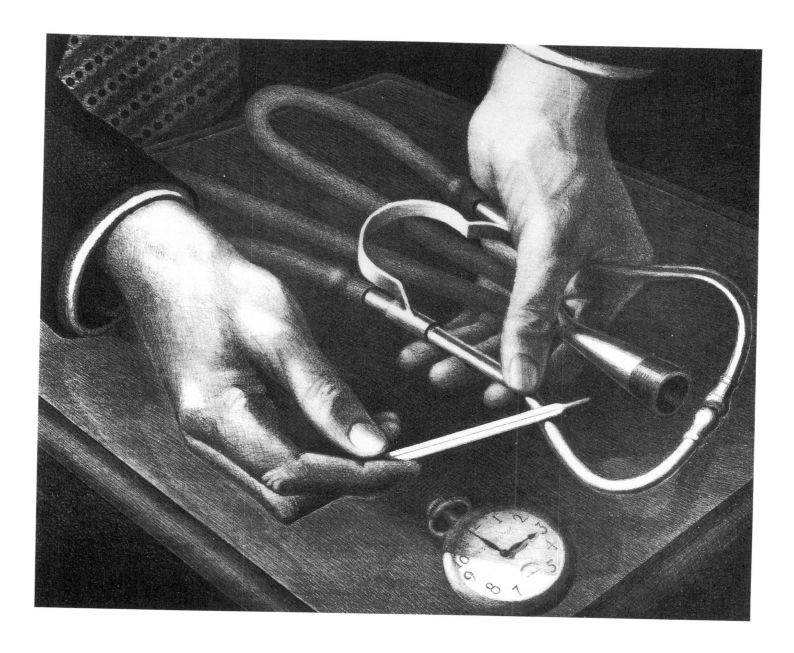

GRANT WOOD. *Family Doctor.*
1941. Lithograph. 10 × 12 in.
(25.4 × 30.5 cm). ©Cedar
Rapids Museum of Art,
Michigan Gift of Harriet Y.
and John B. Turner II.

will be spiritual fortification in a life that freezes around him like a blizzard. Daily, he labors over this manuscript, that pile of paper; daily he strives, full of self-questionings, shames, humiliations, the mental evils that plague any man. Throughout the world thousands are doing this. I speak of Doc because I know him; and because his dull words cannot completely obscure the spiritual bravery behind the book, the determination to face it all out, to brace oneself to whatever may come. Doc knows that the world makes every man's bargain for him, and that the world is an efficient policeman in preserving the letter of these unfair bargains. Nobody starts from scratch. Doc does not whimper. Neither does his novel. It is an honest record of a life. But we have heard of that before. We care little for the history of another nameless journey through the years.

Someday the novel will be finished. But it will never be accepted. It has not the necessary spiced-up interest, the verbal flexibility, the unity and force that it should. It is full of loose ends, insubstantialities, insufficiencies. It is a man's life. Even were it to be accepted, some clever squirt would have to touch it up. Doc's story is, like Ethan Frome's, a silent, lost one.

There he is, the roly-poly man, frustrated, unpropped. Sometime in the future his daughter might grow and understand what went on in his head; what tortured him to fail in giving a clarified expression of all his baffled impulses. But now, there is nobody but sick patients. And when there are none, and his wife is not too noisy, he sits writing, writing bravely, while those boy's brown eyes betray a hurt-puppy expression.

W.P. Kinsella

"Dr. Don"

Although he prefers to write about baseball, in this case W. P. Kinsella has written a powerful story about a medical imposter and the uneasy questions such a presumably clear-cut issue raises when the patients have little else to expect or receive. Born in Canada, Kinsella describes his duty, as a writer, "to entertain. If you can then sneak in something profound or symbolic, so much the better."

"How come you don't mind?" I ask Mad Etta our medicine lady.

"Hey, when you're young like you, Silas, you don't like nobody move in on your territory. But when you get old as me, you look forward to all the help you can get."

Who and what I been asking about is Dr. Don. His whole name is Dr. Donald Morninglight. He is an Indian and a doctor who come to the reserve about three months ago.

"He ain't as good as me. Never will be," say Mad Etta, as she laugh and laugh, shake on the tree-trunk chair in her cabin.

Must be ten years since we had a full time doctor here on the Ermineskin Reserve. Maybe three times a year the Department of Indian Affairs doctors come around but they is all white and wear coats white as bathroom fixtures, smell of disinfectant, and to see them work remind me of a film I seen of assembly line workers who put cars together. Them doctors treat people as if they was cars need a new bolt or screw to be whole again.

But Dr. Don don't be like that. Guess being an Indian helps. One reason we never been able to keep a doctor here is they never like to live on the reserve. Even Indian Affairs can't get for them a fancy enough place to live. But Dr. Don when he come, just move into a vacant house near to Blue Quills Hall. He don't act like doctors we know, except that he make sick people better, and, as I say, even Mad Etta like him. And you got to be liked by Mad Etta if you is to get any respect around the reserve.

"Dr. Don he know which side his medical practice be buttered on," says my friend Frank Fence-post. And I guess Frank is right. Quite a few times in the first month Dr. Don was here, he come over to Etta's place in the evening, have a beer with her and tell her about patients he having trouble curing. Etta give him advice. I don't know if he ever take it but it sure make Etta feel good. So good, that right now she would do just about anything for Dr. Don.

It is easy to tell by looking at Dr. Don that he is some kind of Indian. But he never say which kind.

"I'm a mongrel," he say when asked, and laugh. "If you went far enough back you'd find Cree blood in me."

Dr. Don ain't a handsome man at all. He is about 40, got short legs and a little pot belly. His hair be thin on top and what he got stand out like it never seen a comb. His eyes is dark and deep-set, his nose too big, and he got a thick black moustache that droop over his top lip. But he got such a friendly way about him that everybody like him. He ask a lot of questions and he already know how to make a good try at speaking Cree.

His wife is named Paula. She is an Indian, too, and as shy as anything. She have a new baby the doctor say is called Morning After Rain. I think it was a girl.

He only been here, I bet a month, when I see him walking across the reserve with Chief Tom. At least Chief Tom is walking, taking long steps with his head down. Dr. Don have to almost dance to keep up with him, and to get a bit in front so he can talk to his face.

I'm a long way behind them, but the words carry in the cold air. From Dr. Don I hear words like clinic, Government Grants, nurse, disgrace, and about ten times, money.

Chief Tom only shake his head. We all know the Chief, being a Government MLA, could do lots of things for us if he really wanted. But he is more interested in sell off timber or give away land to make himself look good to the white people.

It don't take Dr. Don long to spot him for what he is.

"When is the next election for Chief?" he ask us.

"Next summer," we tell him.

"We'd better get an organization started soon. That Chief of yours needs to be replaced and fast."

We suggest he should run.

"Hey, I'm Indian, but not Cree. How about a woman Chief? Bedelia Coyote isn't afraid of anyone, and she's a very knowledgable young woman where Indian problems are concerned."

Some of us get working on that right away.

I sure hope Dr. Don knows what he is doing. Chief Tom be a dangerous man to have as an enemy, 'cause he know lots of white people in high places.

At Christmas time, Dr. Don he stay right on the reserve. All the doctors in Wetaskiwin and Ponoka run off to Hawaii or someplace hot, but Dr. Don just pitch in and act like he is one of us. Funny thing is that a few sick white people who can't find their own doctors come to the reserve to see Dr. Don. Ordinarily, you couldn't get a white man to the reserve with a gun to his head unless he want to convert us to his religion or repossess one of our cars.

On Christmas Eve, Dr. Don emcee the Christmas Concert down to Blue Quills Hall. Boy, he can tell good jokes and everybody have a happy evening.

At the end of the concert he make a little speech to say how happy he and his family is here at Hobbema, and how he plans to work here until he retires and then still stay here.

It make everybody feel all warm inside.

Then he take from his pocket a sheet of paper, and what he read is kind of a poem. I couldn't remember it too good, so I went to see his wife just before her and the baby moved away and she gived it to me. It is the same copy he read at the concert, wrote in blue ink in real tiny handwriting. It seem to me it is both happy and sad at the same time.

> Words are nothing
> like pebbles beside mountains
> Deeds are all that count
> Watch and listen with me this Christmas
> For it is the small daily deeds of men
> that tell the heart what it needs to know
> Quietly, as you have made me welcome
> I will quietly go about my work
> But listen not to my words—wait and watch.

Everybody is silent for about 10 seconds after Dr. Don finish. And, as Frank Fencepost would say, you could have heard a flea fart. Then everybody break into clapping for a long time. Finally, Eli Bird start in soft on his guitar and Mary Boxcar join in on the piano, and we all sing "Silent Night."

One morning in January I meet Dr. Don walk down toward the General Store.

"You ever see anything this beautiful, Silas?" he say, and point at the pinky sky where two pale sundogs hang like grapefruit, one on each side of the sun. It is really cold and Dr. Don's moustache be froze white as if he dipped it in flour.

"That's what I want to be when I die," he say.

"A sundog?"

"A child of the sun—just floating in the morning sky, free as a balloon. Do your people have any legends about sundogs?"

It sure embarrass me but I have to admit I don't know.

"You should write one then," he say.

"Legends aren't really in my line," I say. I sure don't figure that in just a few weeks, I will be writing this story about Dr. Don.

It was Chief Tom's girlfriend, Samantha Yellowknees, who started up the trouble. Chief Tom ain't smart enough to do something like that himself. In fact, if it weren't for Samantha, Chief Tom would still be cutting ties for the railway.

What she done, she tell us one evening at Blue Quills Hall, was to phone the Department of Indian Affairs. "I told them to call the College of Physicians and Surgeons and check out this Dr. Morninglight. There's something not right about him. I can smell a phoney," say Samantha, glare at us, mean as a school teacher.

"If anybody know the smell of a phoney, it be you," says Frank Fence-post. That go right over Chief Tom's head but Samantha look ugly at us and square her chin. Her and Chief Tom been living together for a couple of years in an apartment in Wetaskiwin, ever since the Chief left his wife Mary. Samantha be a city Indian, been to the Toronto University to study sociology.

When we tell Dr. Don what been done he just smile kind of sad and say, "A man should be judged by his deeds." Then he stand silent for a long time.

It was about a week later in the late afternoon that the RCMP car pull up in front of the Residential School where Dr. Don hold his office hours in the Nurse's Room. It is Constable Greer, who be about the only nice RCMP I ever known. Constable Greer got grey hair and sad pouches under his eyes like a dog. But he got with him a young Constable who be about seven feet tall in his fur hat, and speak hardly nothing but French.

Constable Greer read out the charge against Dr. Don, only the name he read don't be Dr. Don's, but three long words that sound like Mexican names you hear on the television. He kind of apologize, but say he got to take Dr. Don to the RCMP office in Wetaskiwin. What he read out say Dr. Don is charged with "Impersonating a Doctor."

Dr. Don finish bandaging up the hand of Caroline Stick. Then he put on his parka and nod to Constable Greer. They is about to walk out when the French Constable step forward, pull out his handcuffs and snap them on Dr. Don's wrists. Then he sort of steer Dr. Don in front of him, look like a giant pushing a child.

Some of us stand around as Dr. Don duck his head and get into the back of the RCMP car. We still stand around even after the car is gone. It is a big shock to all of us. For me it is like that whole place where my stomach is, been empty for a long time.

But the shock is ten times worse the next day when the word come from Wetaskiwin that Dr. Don is dead. Hanged himself with his shirt from the cell bars is what everybody say.

All of a sudden the reserve is crawling with reporters. One of them big trucks from CFRN-TV in Edmonton get up to the school before we tear up the culvert in the road so the rest of them got to walk instead of drive.

Them reporters is kind of angry that we can't tell them anything they don't already know. They are waving a copy of the *Edmonton Journal* with a story that start out:

HOBBEMA—Donato Fernando Tragaluz took his own life after he was unmasked as a medical imposter.

Tragaluz killed himself in the Wetaskiwin RCMP lockup after police arrested him here Tuesday for impersonating a doctor. Using the medical documents of the real Dr. Donald Morninglight, the 42-year-old Tragaluz practised as the town's doctor for nearly four months.

The Journal has learned that Tragaluz posed as a doctor under several aliases in communities in Canada, the U.S., and Mexico for about ten years, evading medical authorities, police and the FBI.

One group is interviewing Samantha Yellowknees.

"I knew there was something wrong with him," says Samantha, baring her upper

teeth like a dog looking at you over a bone. "No real doctor in his right mind would start a practice out here."

"What about his funeral?" they all want to know.

Mrs. Morninglight said she guessed he was Catholic if he was anything. She get some of us to call on the Catholic church, but the priests shy away from the whole deal as if they get germs if they get too close. "He can't be buried by the church because he killed himself," they say. "People who kill themselves is going to hell for sure," is what they say. It seem to me the church do all they can to help them along.

Nobody know what to do for a while. Mrs. Morninglight who always been silent, is even more now. She say she didn't know he wasn't who he said he was. They only been married a little over a year.

"All I want to do is go home," she say. Turn out home for her is South Dakota.

Then Mad Etta step in. Suppose with Mad Etta, I should say waddle. "We got to show we ain't as stupid as the white men, about a lot of things," say Etta and she get me to call a meeting of all the newspaper people who been creep around the reserve on their tip-toes for the last couple of days, take pictures and talk to anybody who even say they knew Dr. Don.

Etta can speak English good as me, but she just sit big as a bear on the tree-trunk chair in her cabin, arms fat as railroad ties folded across her big belly.

"This here is our tribal Medicine Lady," I tell them, squint into the glare of the lights that go with the TV camera. "You ask me questions. I'll translate them to Cree for her. She'll answer in Cree and I'll translate to English for you."

Things are pretty easy at first, except that Mad Etta she leave those easy questions for me to answer. She give a long speech in Cree that the white people think is her answer, but she really be saying things to make me and the other Indians laugh.

Like somebody ask how long she been Medicine Lady.

What she say to me in Cree is, "Look at that guy with the pointed face who ask the question. He got his hair stiffened up like it been mixed with honey. Try to imagine him naked, make love to a woman, or even a goat." She say this real serious.

"Forty-one years," I tell that weasel-faced man.

About two hours before, we buried Dr. Don after having our own service for him at Blue Quills Hall. Take Eathen Firstrider, Robert Coyote, and about a half-dozen other guys all morning to carve out a grave with pickaxes up on a hill where Dr. Don can look down on the town and up at the sky. Mary Boxcar play the piano and we sing the Hank Williams' song, "I've Seen The Light." A few people say nice things about Dr. Don, like Moses Badland, who tell about the time Dr. Don walk eight miles into the bush to sew up the foot he cut while splitting wood.

"He may not have been a real doctor, but at least he show us the kind of medical attention we should expect," say Bedelia Coyote and a few people applaud a bit.

I leave my ski-cap off as me, Eathen, Robert, Frank, Rufus, and Bedelia carry the coffin out of the hall. The wind chew at my ears with its little needle teeth.

"What do you think makes a man do something like that?" one of the reporters ask.

Mad Etta give a real answer to that question.

"Why shouldn't he? Here, if you or anybody else want to call themselves a doctor, it is okay. You just have to find people who trust you to make them better. Maybe he wasn't a doctor, but he had the call. There ain't very many who have the call."

"Then it didn't matter to you that he had never been to university or medical school?"

"People believed in him," growl Mad Etta. "He had the right touch and loving heart. If you like your doctor, you is half-way better. Most sickness is caused by what's between the ears . . ."

There was sundogs out this morning when we were putting the coffin in the grave, shimmering like peaches there in the cold pink sky. I imagined for a second that I could see Dr. Don's face in one of them, but only for a second.

THE CONTINUING QUEST FOR KNOWLEDGE AND CONTROL

Corey Ford

"Did I Ever Tell You About My Operation?"

Corey Ford (1902–1969) wrote over 30 books and more than 500 articles, many of them humorous pieces published under the pen-name John Riddell between 1926 and World War II. A master of parody, Ford was well acquainted with Dorothy Parker's literary circle and with Dreiser, Faulkner, Fitzgerald, and other noted American authors of the day. After World War II he became best known as an editor of Field and Stream *magazine, while writing spirited books and essays like the one excerpted here.*

Sometimes I wonder whose operation I had. Everybody shook hands with the doctor after it was over. People rushed up to congratulate the surgeon on his skill with the scalpel. There was nothing but praise for the anaesthetist. Tributes were paid to all the nurses and internes and technicians of the efficient hospital staff. Nobody had a word to say for me.

I don't want to sound ungrateful, but isn't it about time that somebody spoke up for the patient? I mean the pathetic little figure that the operation is all about. Everybody else is dressed in crisp white uniforms, but he is attired in an abbreviated nightshirt which barely comes down to the navel and is split all the way up the back, affording the wearer about as much protection as the paper filigree on the end of a lamb chop. His legs are encased in long woolen stockings, like the lower half of a bunny suit. He has a knitted skating cap on top of his head, with a name tag attached to the tassel so he won't get mixed up with some other patient and wind up in the maternity ward by mistake. No wonder that surgeons wear those gauze bandages over their faces. It's so the patient won't see them laughing.

It's his operation, but he has nothing to do with it. He cowers in his room, awaiting the ordeal that lies ahead. Nurses sneak up behind him without warning to take his temperature. Orderlies arrive at odd hours to shave him in even odder places. Surgeons halt beside his bed and study him with the appraising eye of a host about to carve a Thanksgiving turkey. He is thumped and squeezed and poked to see if he's tender. He is looked up and down and over and under and into. They listen to him with stethoscopes, they tap him with rubber hammers, they mark his epidermis here and there with a blue pencil. He can't ask them what's going on, because he has a thermometer in his mouth. All they ever tell him is "Hmm."

He doesn't even get to see the operation when it happens. Just about the time things start to get interesting, someone produces a hypodermic needle and says in a cheerful voice: "Roll over on your stomach." His limp form is wheeled into a shiny white room which bears an unpleasant resemblance to the metal meat counter under neon lights, as naked as Saturday's rib roast special, while two hundred medical students stare at him impersonally from the balcony. When he wakes up, he is back in his bed again with part of his anatomy swathed in bandages, a throbbing headache, and the uneasy conviction

that sometime while he was coming out of the anaesthetic he asked the nurse's hand in marriage.

I speak with feeling, having served a stretch of time in a hospital myself. The whole affair, as I look back on it now, is a deliberate campaign to reduce the patient slowly but surely to a state of mental zero, in order to destroy his will to resist. From the moment I entered those big glass doors, I was subjected to a series of personal humiliations designed to undermine my pride and deflate my ego. Nobody can go through the daily routine of a hospital and have any dignity left. I defy even General De Gaulle to look austere sitting on a bed-pan.

The brain-washing process started right off with my accident. Actually it wasn't much of an accident. The cause was a brief but violent argument between my car and another car which tried to go where mine already was. I am naturally a law-abiding citizen, and when my car halted abruptly I obeyed the law of inertia and kept on going until my progress was arrested by the dashboard. As a result, the car was towed off to the garage for repairs; I was towed off to the hospital.

I'm not sure what I expected to find when I got there. Obviously I didn't really think the surgeon would be waiting for me on the front steps, tight-lipped and tense; but at least I had an idea that he might be pacing up and down the corridor, chain-smoking and glancing now and then out the window. I could picture the look of relief on his face as the siren of my speeding ambulance grew louder. "Not a moment to lose," I could almost hear him shout, grinding his butt under a heel as he sprang into action. "Light up the main operating room at once. Call Kildare and Casey in for consultation. This is undoubtedly the most unusual case I've encountered in forty years of medical practice."

It didn't quite turn out that way. The ambulance slowed down for every traffic light, and once it pulled over to the curb while the driver went into a store to buy some cigarettes. The only time he blew his siren was when he stopped in front of the emergency entrance, evidently on the chance that some patient inside the hospital might be asleep. The orderly didn't even look up as the ambulance attendant wheeled me in.

"Much of an accident?" he asked, placing a nine of hearts on his ten of spades and pushing back his chair reluctantly.

"Smashed the radiator, crumpled the left fender, and bent in the front axle a little," he attendant shrugged, as they slid me onto a table. "Tied up traffic for half an hour. Boy, was them other cars mad."

He wheeled the empty stretcher out, and the orderly began to take off my clothes. This is the first step when you enter a hospital. It doesn't matter whether you've come there to have a sliver removed from your finger, you have to get completely undressed. It's part of the whole insidious plot to degrade the patient, and is based on the theory that nobody can retain his self-respect when he has nothing on but a pair of black silk socks, with a hole in one toe.

The doctor seemed quite calm when he arrived twenty-five minutes later. In fact, if it hadn't been for my obviously critical condition, I might even have suspected that he was a little bored. He looked me over briefly, humming to himself, and whispered something to the nurse beside him. I braced myself for the worst.

"What's the verdict?" I asked in a grim let's-have-it-Doc-I-can-take-it tone.

"Now, there's nothing to worry about at all," he said in the soothing manner one might employ in addressing a slightly retarded child of six. "Humpty Dumpty had a bad fall, but we'll put him back together again snap! snap! in two shakes of a lamb's tail. The nurse will just give you a little shot, and you'll sleep like a baby."

You do everything else like a baby, too. Once the hospital gates clang behind you, you are as helpless as an infant in arms. To carry the idea out, your bed is covered with a rubber sheet and has slats on either side like a crib, to keep you from rolling onto the floor. The only thing lacking is an abacus and a set of plastic blocks. The nurse (it was all I could do to keep from calling her "Nannie") changes you when you're wet, feeds you through a straw, and pats you on the back to burp you afterwards. Your life is an open chart at the foot of your bed. Your most intimate functions are performed for all

RAOUL DUFY. *The Operation.*
c. 1930–36. Pencil and ink on
beige paper. 19¾ × 23¼ in.
(50.2 × 59.1 cm). Musée
National d'Art Moderne,
Centre Georges Pompidou,
Paris. © 1991 ARS, N.Y./
SPADEM.

to see, and every move you make is eagerly recorded. There were times when I longed for the peace and quiet of an old-fashioned sanctuary behind the barn, hornets and all.

Your day starts at seven—the only institution that keeps worse hours than a hospital is the army—when the nurse tiptoes into your room to see if you're awake. . . . "Well, did we have a nice night's sleep?" (Nurses are also victims of we disease.) "Are we all ready for our bath?"

This daily ritual is always performed with a great show of modesty, as though you had any secrets from the nurse by now. First you are covered with a cotton blanket. While you clutch the upper hem desperately, to keep from skidding out of bed like a watermelon seed, all the rest of the bedclothes and your nightie are whisked out from under it, leaving you quivering raw. A tin tub filled with water is placed beside you, and just to keep pretenses up your limbs are withdrawn from beneath the protective coverlet one by one. Each section of your anatomy is washed and dried in turn, and discreetly put back under the blanket again before the next part is uncovered, so you won't all show at the same time. To make matters worse, my nurse's hands were invariably ice-cold— "Sign of a warm heart," she'd reassure me—and every time one of her frigid digits came in contact with my skin I would react violently, kicking out both legs and upsetting the bathtub.

<p style="text-align:center">★ ★ ★</p>

Then there are the fascinating little side trips to other parts of the hospital to have an X-ray picture taken or perhaps, if it's a red-letter day, to get a barium enema. These expeditions have all the elements of high adventure. You are loaded into a wheelchair and propelled down the corridor at a dizzy rate of speed, weaving in and out between patients on crutches and sideswiping an occasional service wagon filled with dishes. Doors open suddenly as you pass, or some other wheelchair comes hurtling around a corner, missing you by inches. You crowd into an elevator with three or four more patients all bound

for the same destination, and the nurses discuss one another's cases in a detached professional way while the occupants glare at each other with frank loathing. I don't know where they get this theory that misery loves company. I hated every other patient on sight. . . .

Of course, a steady stream of people keep dropping into your room to help you while away the time. Next to a summer clearance sale, there's nothing like a "No Visitors" sign on the door to attract a crowd. Since your door is invariably left open, every passing stranger halts in the corridor and peers at you with morbid curiosity. Ambulatory patients in dressing gowns wander in to sit beside your bed and show you pictures of their grandchildren. If you happen to doze off during the afternoon, the nurse wakes you up to give you another sleeping tablet.

The hospital staff goes out of its way to keep you from getting lonely. There's the cleaning woman, for instance, who arrives in the middle of breakfast and proceeds to mop the floor with some pine-smelling disinfectant, lending a slight taste of turpentine to your coffee. There's the daily visit of the young lady who comes to get another sample of your blood. She carries a tray of bottles hung from her neck, like a cigarette girl in a nightclub, and beams with anticipation as she selects a particularly long needle and inquires: "Let's see, which side did we do yesterday?" I used to shut my eyes whenever I saw her coming, but I have an impression that she had pointed teeth and hung upside down from the ceiling.

And then there's the newsstand lady who brings you the morning paper, along with the latest gossip about your neighbors down the hall. "Number Fourteen had another relapse last night, they got her under oxygen, it probably won't be long now." "I see where the bed in Twenty-Eight is empty, I guess that means one less *Herald-Tribune* for this floor." Or, even more ominously: "I hope I have better luck with your room than the last three times."

Last but not least, there are the acquaintances who drop around to cheer you up. You can hear them coming all the way down the corridor, laughing boisterously at some private joke as they approach your door. They all have deep tans and are fairly bursting with health as they storm into your room and greet you with hearty humor. "Look at you, boy, you sure seem to be taking it easy." "Wish I had nothing else to do but loaf in bed all day." They make themselves right at home, tossing a hat onto your dresser and knocking over a vase of tulips, or selecting an apple from your fruit basket and biting into it with a loud crunch. "Do you mind if I smoke?" one of them asks, lighting a cigar and blowing a cloud of heavy fumes into your face. Another rummages through the books on the table. "Say, here's one I never read," he remarks idly, slipping a half-finished detective novel into his pocket. Another slides everything off your bedside stand and sits on it, propping his feet on the edge of your mattress while he regales you with all the fun they've been having lately.

<p style="text-align:center">★ ★ ★</p>

The days whiz by like glaciers, and you are ready to be discharged from the hospital at last. It takes you most of the afternoon to pack. You arrived with a small overnight bag, but the get-well cards and empty vases and fruit baskets you have accumulated during your illness now fill three suitcases and a large cardboard carton. You dress yourself slowly, taking a good long rest after donning each successive garment, and let Nannie help you lace your shoes. The neckband of your shirt feels as big as a horse collar, and your suit hangs so loosely from your emaciated frame that you glance furtively at the label to see if by any chance it belongs to somebody else. Leaning on a cane, you proceed down the hall, smiling at the less fortunate patients as you pass their doors. "Goodbye, Mrs. Hostetter, hope you'll be getting out soon." "Look out for that blonde nurse of yours, Mr. Freem." You wave a sentimental farewell to all the orderlies and dieticians and student nurses who have been so nice to you, trying to conceal the fervid hope that you'll never see any of their leering faces again, and descend in the elevator to the main floor and totter across the lobby to the street.

So this is that fresh air that everybody else has been breathing all this time. Look at those flowers growing right in the ground, not in a glass receptacle. Look at all those pretty girls in spike-heel pumps instead of sensible white shoes with corrugated rubber soles. Your hospital stretch is over. You're a free man now. All you need is a warden to shake your hand and give you an envelope with ten dollars.

Your apartment looks exactly as it did when you left it that fatal morning. Nothing has changed in your bedroom. Your brush and comb are still on the dresser, your pajamas are still hanging on the floor of the closet, the cap is still off the toothpaste tube, the magazine you were reading is still lying open on the bedside table beside a pack of stale cigarettes. The whole thing has a musty smell, like George Washington's bedroom at Mount Vernon. The only thing missing is an attendant in a mobcap and a velvet rope across the door. Your desk is piled high with mail, but you're too tired to look at it now. A glass of fruit juice would certainly taste good, but there's no buzzer to press for Nannie. Nobody to give you a back rub, you reflect ruefully. Nobody to tuck you into bed tonight, nobody to bring your supper on a tray, nobody to wake you tomorrow morning and ask you if we had a good night's sleep and how would we like our bath?

At least, you comfort yourself, all your friends will be waiting impatiently to hear all about your hospital experience. This illusion is promptly shattered. I've been trying to tell people about my operation ever since I had it, but I can't find anybody to listen. It's getting so that everybody avoids me at parties, and acquaintances cross the street when they see me coming.

That's why I hurried over here to the hospital to see you, as soon as I heard about this operation of yours. Do you mind if I close the door of your room to make sure nobody disturbs us? I'll just sit on the edge of your bed, so you can't wriggle out from under the covers and get away. Maybe I'd better disconnect this buzzer in case you want to ring for the nurse.

Now, then. Let me tell you what happened to *me*.

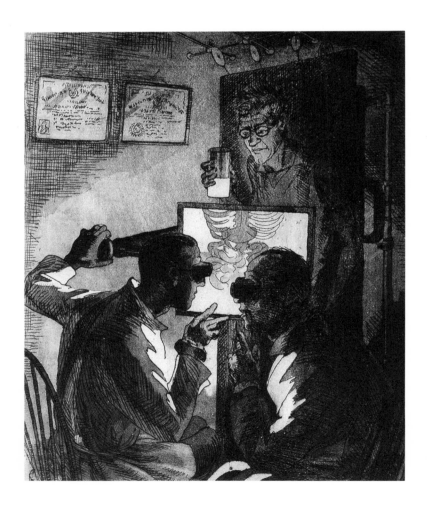

JOHN SLOAN. *X-rays*. 1926. Etching and aquatint. $9\frac{3}{8} \times 7\frac{15}{16}$ in. (23.8 × 20.2 cm). Philadelphia Museum of Art. Purchased Katherine Levin Farrell Fund and funds contributed by Lessing J. Rosenwald.

Richard Selzer

FROM LETTERS TO A YOUNG DOCTOR
"Imelda"

Richard Selzer was a busy surgeon in New Haven, Connecticut, for over 20 years, until his retirement a few years ago. Not beginning to write until the age of 50, Selzer produced predominantly short stories almost exclusively drawn from his surgical experiences; this selection is based on a trip he made to Latin America with a team of United States surgeons. Selzer is particularly interested in the restorative and creative powers of medicine, which this beautiful story, perhaps his finest, exemplifies so well.

We were more than two weeks into our tour of duty—a few days to go—when it happened. Earlier in the day I had caught sight of her through the window of the dispensary. A thin, dark Indian girl about fourteen years old. A figurine, orange-brown, terra-cotta, and still attached to the unshaped clay from which she had been carved. An older, sun-weathered woman stood behind and somewhat to the left of the girl. The mother was short and dumpy. She wore a broad-brimmed hat with a high crown, and a shapeless dress like a cassock. The girl had long, loose black hair. There were tiny gold hoops in her ears. The dress she wore could have been her mother's. Far too big, it hung from her thin shoulders at some risk of slipping down her arms. Even with her in it, the dress was empty, something hanging on the back of a door. Her breasts made only the smallest imprint in the cloth, her hips none at all. All the while, she pressed to her mouth a filthy, pink, balled-up rag as though to stanch a flow or buttress against pain. I knew that what she had come to show us, what we were there to see, was hidden beneath that pink cloth. As I watched, the woman handed down to her a gourd from which the girl drank, lapping like a dog. She was the last patient of the day. They had been waiting in the courtyard for hours.

"Imelda Valdez," I called out. Slowly she rose to her feet, the cloth never leaving her mouth, and followed her mother to the examining-room door. I shooed them in.

"You sit up there on the table," I told her. "Mother, you stand over there, please." I read from the chart:

"This is a fourteen-year-old girl with a complete, unilateral, left-sided cleft lip and cleft palate. No other diseases or congenital defects. Laboratory tests, chest X ray—negative."

"Tell her to take the rag away," said Dr. Franciscus. I did, and the girl shrank back, pressing the cloth all the more firmly.

"Listen, this is silly," said Franciscus. "Tell her I've got to see it. Either she behaves, or send her away."

"Please give me the cloth," I said to the girl as gently as possible. She did not. She could not. Just then, Franciscus reached up and, taking the hand that held the rag, pulled it away with a hard jerk. For an instant the girl's head followed the cloth as it left her face, one arm still upflung against showing. Against all hope, she would hide herself. A moment later, she relaxed and sat still. She seemed to me then like an animal that looks outward at the infinite, at death, without fear, with recognition only.

Set as it was in the center of the girl's face, the defect was utterly hideous—a nude rubbery insect that had fastened there. The upper lip was widely split all the way to the nose. One white tooth perched upon the protruding upper jaw projected through the hole. Some of the bone seemed to have been gnawed away as well. Above the thing,

clear almond eyes and long black hair reflected the light. Below, a slender neck where the pulse trilled visibly. Under our gaze the girl's eyes fell to her lap where her hands lay palms upward, half open. She was a beautiful bird with a crushed beak. And tense with the expectation of more shame.

"Open your mouth," said the surgeon. I translated. She did so, and the surgon tipped back her head to see inside.

"The palate, too. Complete," he said. There was a long silence, At last he spoke.

"What is your name?" The margins of the wound melted until she herself was being sucked into it.

"Imelda." The syllables leaked through the hole with a slosh and a whistle.

"Tomorrow," said the surgeon, "I will fix your lip. *Mañana.*"

It seemed to me that Hugh Franciscus, in spite of his years of experience, in spite of all the dreadful things he had seen, must have been awed by the sight of this girl. I could see it flit across his face for an instant. Perhaps it was her small act of concealment, that he had had to demand that she show him the lip, that he had had to force her to show it to him. Perhaps it was her resistance that intensified the disfigurement. Had she brought her mouth to him willingly, without shame, she would have been for him neither more nor less than any other patient.

He measured the defect with calipers, studied it from different angles, turning her head with a finger at her chin.

"How can it ever be put back together?" I asked.

"Take her picture," he said. And to her, "Look straight ahead." Through the eye of the camera she seemed more pitiful than ever, her humiliation more complete.

"Wait!" The surgeon stopped me. I lowered the camera. A strand of her hair had fallen across her face and found its way to her mouth, becoming stuck there by saliva. He removed the hair and secured it behind her ear.

"Go ahead," he ordered. There was the click of the camera. The girl winced.

★ ★ ★

In the operating room the next morning the anesthesia had already been administered when we arrived from Ward Rounds. The tube emerging from the girl's mouth was pressed against her lower lip to be kept out of the field of surgery. Already, a nurse was scrubbing the face which swam in a reddish-brown lather. The tiny gold earrings were included in the scrub. Now and then, one of them gave a brave flash. The face was washed for the last time, and dried. Green towels were placed over the face to hide everything but the mouth and nose. The drapes were applied.

"Calipers!" The surgeon measured, locating the peak of the distorted Cupid's bow.

"Marking pen!" He placed the first blue dot at the apex of the bow. The nasal sills were dotted; next, the inferior philtral dimple, the vermilion line. The *A* flap and the *B* flap were outlined. On he worked, peppering the lip and nose, making sense out of chaos, realizing the lip that lay waiting in that deep essential pink, that only he could see. The last dot and line were placed. He was ready.

"Scalpel!" He held the knife above the girl's mouth.

"O.K. to go ahead?" he asked the anesthetist.

"Yes."

He lowered the knife.

"No! Wait!" The anesthetist's voice was tense, staccato. "Hold it!"

The surgeon's hand was motionless.

"What's the matter?"

"Something's wrong. I'm not sure. God, she's hot as a pistol. Blood pressure is way up. Pulse one eighty. Get a rectal temperature." A nurse fumbled beneath the drapes. We waited. The nurse retrieved the thermometer.

"One hundred seven . . . no . . . eight." There was disbelief in her voice.

"Malignant hyperthermia," said the anesthetist. "Ice! Ice! Get lots of ice!" I raced out the door, accosted the first nurse I saw.

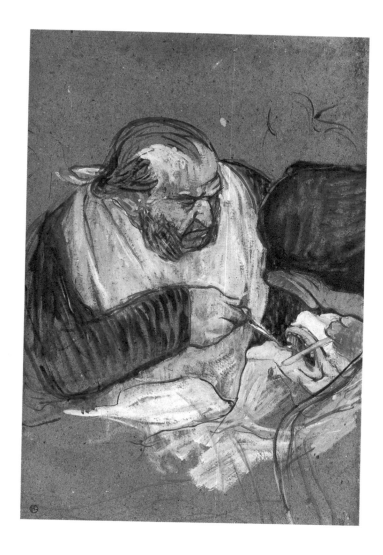

HENRI DE TOULOUSE-LAUTREC. *Dr. Jules-Emile Péan.* 1891.
Oil on board. 29¹⁄₁₆ × 19⅝ in. (73.9 × 49.9 cm).
Sterling and Francine Clark Art Institute, Williamstown, Mass.

"Ice!" I shouted. *"Hielo!* Quickly! *Hielo!"* The woman's expression was blank. I ran to another. *"Hielo! Hielo* For the love of God, ice."

"Hielo?" She shrugged. *"Nada."* I ran back to the operating room.

"There isn't any ice," I reported. Dr. Franciscus had ripped off his rubber gloves and was feeling the skin of the girl's abdomen. Above the mask his eyes were the eyes of a horse in battle.

"The EKG is wild . . ."

"I can't get a pulse . . ."

"What the hell . . ."

The surgeon reached for the girl's groin. No femoral pulse.

"EKG flat. My God! She's dead!"

"She can't be."

"She is."

The surgeon's fingers pressed the groin where there was no pulse to be felt, only his own pulse hammering at the girl's flesh to be let in.

<p style="text-align:center">★ ★ ★</p>

The next morning I did not go to the wards, but stood at the gate leading from the courtyard to the road outside. Two young men in striped ponchos lifted the girl's body wrapped in a straw mat onto the back of a wooden cart. A donkey waited. I had been drawn to this place as one is drawn, inexplicably, to certain scenes of desolation—executions, battlefields. All at once, the woman looked up and saw me. She had taken off her hat. The heavy-hanging coil of her hair made her head seem larger, darker, noble. I pressed some money into her hand.

"For flowers," I said. "A priest." Her cheeks shook as though minutes ago a stone had been dropped into her naval and the ripples were just now reaching her head. I regretted having come to that place.

"Sí, sí," the woman said. Her own face was stitched with flies. "The doctor is one of the angels. He has finished the work of God. My daughter is beautiful."

What could she mean! The lip had not been fixed. The girl had died before he would have done it.

"Only a fine line that God will erase in time," she said.

I reached into the cart and lifted a corner of the mat in which the girl had been rolled. Where the cleft had been there was now a fresh line of tiny sutures. The Cupid's bow was delicately shaped, the vermilion border aligned. The flattened nostril had now the same rounded shape as the other one. I let the mat fall over the face of the dead girl, but not before I had seen the touching place where the finest black hairs sprang from the temple.

"Adiós, adiós . . ." And the cart creaked away to the sound of hooves, a tinkling bell.

There are events in a doctor's life that seem to mark the boundary between youth and age, seeing and perceiving. Like certain dreams, they illuminate a whole lifetime of past behavior. After such an event, a doctor is not the same as he was before. It had seemed to me then to have been the act of someone demented, or at least insanely arrogant. An attempt to reorder events. Her death had come to him out of order. It should have come after the lip had been repaired, not before. He could have told the mother that, no, the lip had not been fixed. But he did not. He said nothing. It had been an act of omission, one of those strange lapses to which all of us are subject and which we live to regret. It must have been then, at that moment, that the knowledge of what he would do appeared to him. The words of the mother had not consoled him; they had hunted him down. He had not done it for her. The dire necessity was his. He would not accept that Imelda had died before he could repair her lip. People who do such things break free from society. They follow their own lonely path. They have a secret which they can never reveal. I must never let on that I knew.

<p style="text-align:center">★ ★ ★</p>

Six weeks later I was in the darkened amphitheater of the Medical School. Tiers of seats rose in a semicircle above the small stage where Hugh Francisus stood presenting the case material he had encountered in Honduras. It was the highlight of the year. The hall was filled. The night before he had arranged the slides in the order in which they were to be shown. I was at the controls of the slide projector.

"Next slide!" he would order from time to time in that military voice which had called forth blind obedience from generations of medical students, interns, residents and patients.

"This is a fifty-seven-year-old man with a severe burn contracture of the neck. You will notice the rigid webbing that has fused the chin to the presternal tissues. No motion of the head on the torso is possible. . . . Next slide!"

"Click," went the projector.

"Here he is after the excision of the scar tissue and with the head in full extension for the first time. The defect was then covered. . . . Next slide!"

"Click."

". . . with full-thickness drums of skin taken from the abdomen with the Padgett dermatome. Next slide!"

"Click."

And suddenly there she was, extracted from the shadows, suspended above and beyond all of us like a resurrection. There was the oval face, the long black hair unbraided, the tiny gold hoops in her ears. And that luminous gnawed mouth. The whole of her life seemed to have been summed up in this photograph. A long silence followed that was the surgeon's alone to break. Almost at once, like the anesthetist in the operating room

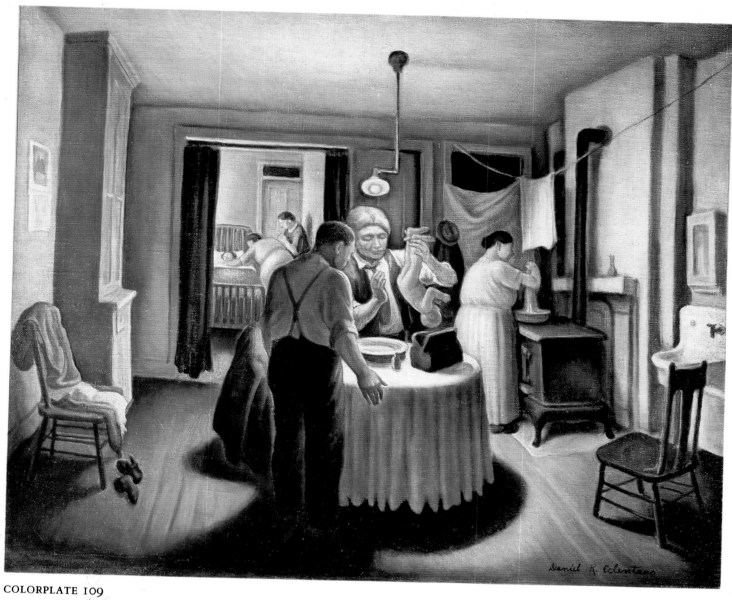

COLORPLATE 109

Daniel Celentano. *Just Born.* 1939. Oil on canvas. 18 × 22 in. (45.7 × 55.9 cm).
Courtesy Janet Marqusee Fine Arts, New York.

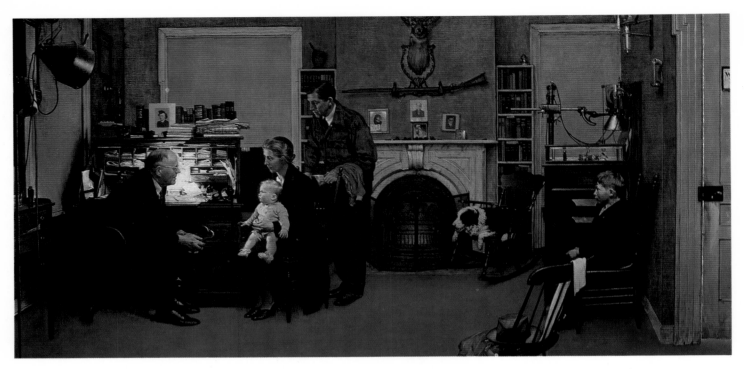

NORMAN ROCKWELL. *Norman Rockwell Visits a Family Doctor*. 1947. Oil on canvas. 32 × 60 in. (81.3 × 152.4 cm). Norman Rockwell Museum, Stockbridge, Mass. Printed by permission of Norman Rockwell Family Trust. ©1947, Norman Rockwell Family Trust.

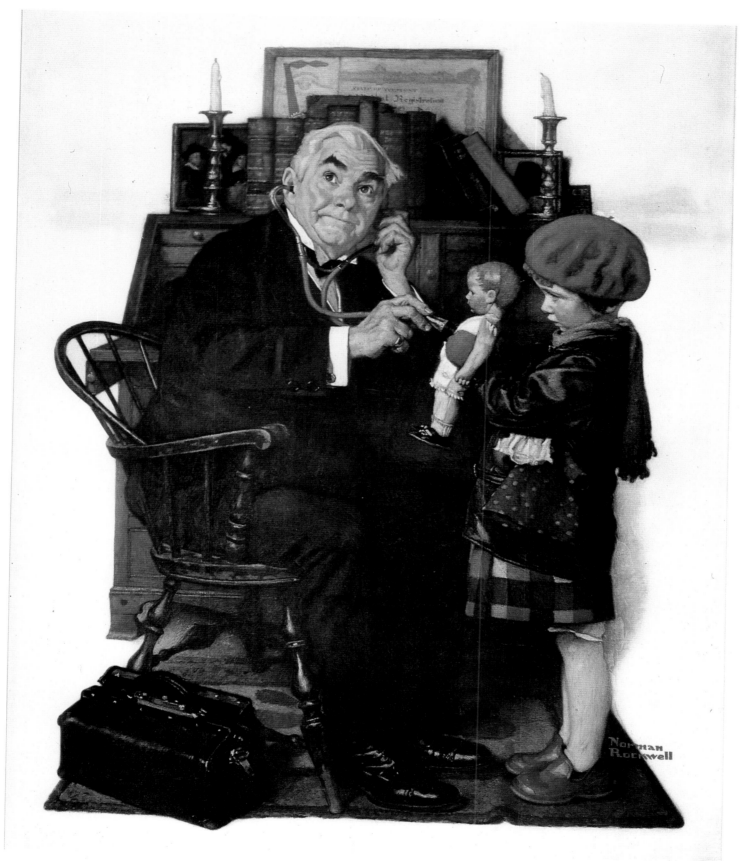

COLORPLATE III

NORMAN ROCKWELL. *Doctor and Doll*. 1929. Oil on canvas. 32 × 26¼ in. (81.3 × 66.7 cm).
Norman Rockwell Museum, Stockbridge, Mass. Printed by permission of Norman Rockwell
Family Trust. ©1929, Norman Rockwell Family Trust.

ROGER BROWN. *Cancer*. 1984. Oil on canvas. 48 × 72 in.
(121.9 × 182.9 cm). Courtesy Phyllis Kind Galleries,
Chicago and New York.

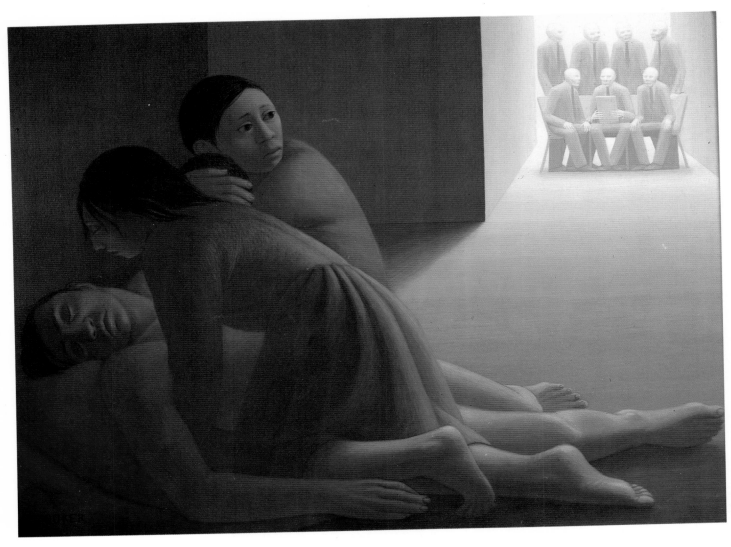

COLORPLATE 113

GEORGE TOOKER. *Corporate Decision.* 1983. Egg tempera on gesso panel.
18 × 24 in. (45.7 × 61 cm). Private collection.

COLORPLATE 114 *(opposite, above)*

KEITH HARING. *Untitled.* 1989. Poster. 24 × 42¾ in. (61 × 108.6 cm).
© Estate of Keith Haring. *The artist himself died of AIDS on February 16, 1990.*

COLORPLATE 115 *(opposite, below)*

Dr. Tom Waddell: A Quilt Panel for Dr. Thomas Waddell. Part of The Names
Project International AIDS Memorial Quilt. 1987. Textile. 3 × 6 ft.
(91.4 × 182.9 cm). ©1987 The Names Project Foundation and photographer
Matt Herron.

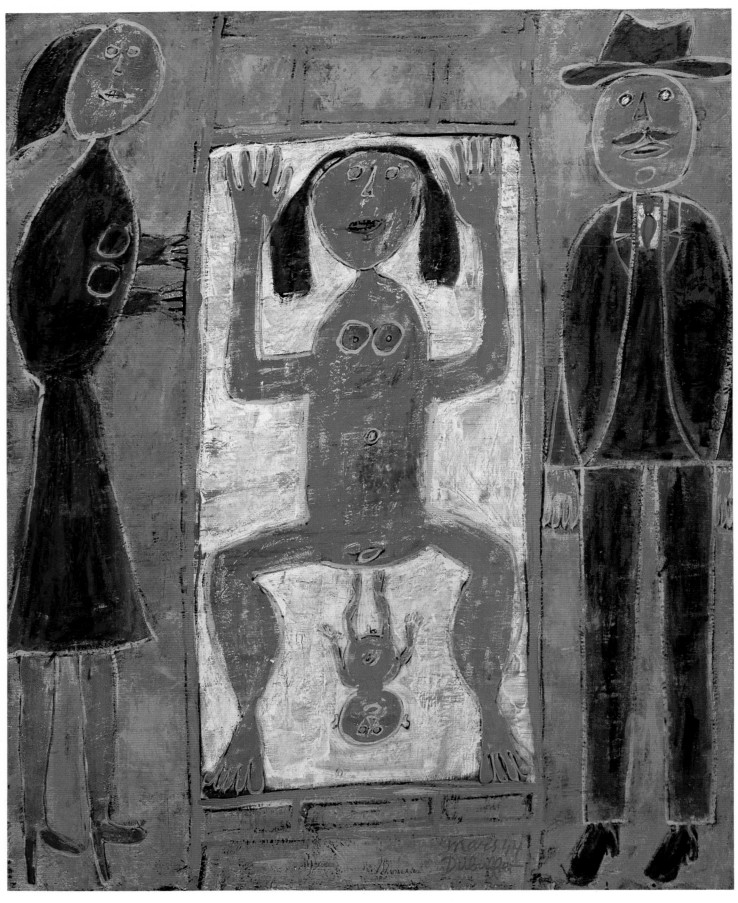

COLORPLATE 116

JEAN DUBUFFET. *Childbirth,* from the *Marionettes de la Ville et de la Campagne* series. 1944.
Oil on canvas. 39⅜ × 31¾ in. (99.8 × 80.8 cm). The Museum of Modern Art, New York.
Gift of Pierre Matisse in memory of Patricia Kane Matisse. © 1991 ARS, N.Y./ADAGP.

in Comayagua, I knew that something was wrong. It was not that the man would not speak as that he could not. The audience of doctors, nurses and students seemed to have been infected by the black, limitless silence. My own pulse doubled. It was hard to breathe. Why did he not call out for the next slide? Why did he not save himself? Why had he not removed this slide from the ones to be shown? All at once I knew that he had used his camera on her again. I could see the long black shadows of her hair flowing in to the darker shadows of the morgue. The sudden blinding flash . . . The next slide would be the one taken in the morgue. He would be exposed.

In the dim light reflected from the slide, I saw him gazing up at her, seeing not the colored photograph, I thought, but the negative of it where the ghost of the girl was. For me, the amphitheater had become Honduras. I saw again that courtyard littered with patients. I could see the dust in the beam of light from the projector. It was then that I knew that she was his measure of perfection and pain—the one lost, the other gained. He, too, had heard the click of the camera, had seen her wince and felt his mercy enlarge. At last he spoke.

"Imelda." It was the one word he had heard her say. At the sound of his voice I removed the next slide from the projector. "Click" . . . and she was gone. "Click" again, and in her place the man with the orbital cancer. For a long moment Franciscus looked up in my direction, on his face an expression that I have given up trying to interpret. Gratitude? Sorrow? It made me think of the gaze of the girl when at last she understood that she must hand over to him the evidence of her body.

<p style="text-align:center">★ ★ ★</p>

Now and then, in the years that have passed, I see that donkey-cart cortège, or his face bent over hers in the morgue. I would like to have told him what I now know, that his unrealistic act was one of goodness, one of those small, persevering acts done, perhaps, to ward off madness. Like lighting a lamp, boiling water for tea, washing a shirt. But, of course, it's too late now.

Dannie Abse

FROM ONE-LEGGED ON ICE

"X-ray"

A Welsh poet, editor, playwright, and novelist, Dannie Abse is also a physician who has practiced in London. In this selection from his eighth book of poems, One-Legged on Ice, *Dr. Abse reflects on the age-old problem of treating one's own family.*

Some prowl sea-beds, some hurtle to a star
 and, mother, some obsessed turn over every stone
 or open graves to let that starlight in.
There are men who would open anything.

Harvey, the circulation of the blood,
 and Freud, the circulation of our dreams,
 pried honourably and honoured are
 like all explorers. Men who'd open men.

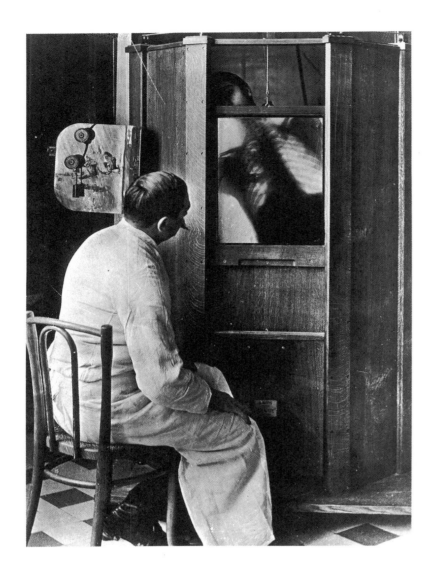

Early Radiographic Examination of the Thorax by Means of a Fluoroscopic Screen. 1895. Photograph.

And those others, mother, with diseases
 like great streets named after them: Addison,
 Parkinson, Hodgkin—physicians who'd arrive
 fast and first on any sour death-bed scene.

I am their slowcoach colleague, half afraid,
 incurious. As a boy it was so: you know how
 my small hand never teased to pieces
 an alarm clock or flensed a perished mouse.

And this larger hand's the same. It stretches now
 out from a white sleeve to hold up, mother,
 your X-ray to the glowing screen. My eyes look
 but don't want to; I still don't want to know.

John Stone

"He Makes a House Call"

John Stone is a man of many facets. He is a cardiologist, a well-known physician-poet, and Dean of Admissions of Emory University Medical School. In addition to the three books of poetry he has published, most of it medical in nature, Dr. Stone has also published a volume of medical essays.

Six, seven years ago
 when you began to begin to faint
I painted your leg with iodine

threaded the artery
 with the needle and then the tube
 pumped your heart with dye enough

to see the valve
almost closed with stone.
We were both under pressure.

Today, in your garden,
 kneeling under the sticky fig tree
 for tomatoes

I keep remembering your blood.
Seven, it was. I was just
 beginning to learn the heart

 inside out.
Afterward, your surgery
 and the precise valve of steel

 and plastic that still pops and clicks
 inside like a ping-pong ball.
I should try

 chewing tobacco sometimes
 if only to see how it tastes.
There is a trace of it at the corner

 of your leathery smile
 which insists that I see inside
 the house: someone named Bill I'm supposed

 to know; the royal plastic soldier
 whose body fills with whiskey
 and marches on a music box

How Dry I Am;
 the illuminated 3-D Christ who turns
 into Mary from different angles;

 the watery basement,
 the pills you take, the ivy
 that may grow around the ceiling

if it must. Here, you
are in charge—of figs, beans,
tomatoes, life.

At the hospital, a thousand times
I have heard your heart valve open, close.
I know how clumsy it is.

But health is whatever works
and for as long. I keep thinking
of seven years without a faint

on my way to the car
loaded with vegetables
I keep thinking of seven years ago

when you bled in my hands like a saint.

Sherwin B. Nuland

FROM DOCTORS

"New Hearts for Old: The Story of Transplantation"

Author of The Origins of Anesthesia *(1983) and numerous monographs on medical history, Dr. Nuland was born in 1930. An attending surgeon at Yale New Haven Hospital, he has also written articles for* The New Yorker *and* Discover. *Here is an excerpt from his "Biography of Medicine," relating the dramatic development of cardiac transplant procedures.*

Of all the clumsy constructions that are part of the florid verbiage used in legal formalities, a candidate for the least felicitous is that painful phrase "purports and holds himself out to be," when it is used against a craftsman or professional person being sued for an unfortunate outcome of his efforts. With those cruel words, the recipient of a subpoena is informed that, contrary to the evidence of his entire career, he is not actually a skilled member of his guild but only someone who lays claim to that honored position. I have seen the most self-confident of surgeons figuratively cringe when they speak about the effect of seeing this kind of terminology leap up at them from the closely typed lines of hyperbolic prose composed by some zealous attorney. Why then, if it is so painful to think about, do I bring up the purporting and holding out in a section of this book that deals with one of the greatest triumphs of the physician's art?

My purpose is to remind all of us, doctors and laymen alike, that even in this most scientific age of medicine, there is indeed an underlying layer of delusion, even if it is primarily a deluding of ourselves that is at work. As physicians, we certainly do purport—not only do we purport to be healers, but we purport also to use in our healing the most modern of the methods of medical science. Most of the time, we are exactly what we present ourselves to be—but not always. On occasion, we are as guilty as the standard subpoena would have us. We hold ourselves out to be something that we are really not. We are, after all, not really scientists. We have discovered, as our herb-dosing forebears did in similar situations, the empirical fact that a drug named cyclosporine has such an effect on the immune system that it allows us to transplant organs from one person to another. By trial and error, almost by happenstance, we have fallen on a wonder fungus

whose real action is an enigma. Although our laboratories come daily closer to some biological explication, the urgencies of patient care have demanded a clinical launch before all the basic mechanisms are clarified. Out goes histocompatibility testing, out goes acquired tolerance, out go all of the truly scientific precedents to this supposedly (and purportedly) most scientific moment in our history. No one would presume to argue that the introduction of cyclosporine is science at work. It is not science—the introduction of cyclosporine is an example of the art of medicine. If the thing works, and it does not violate the dictum of *primum non nocere,* we should damn well use it and let the scientific proof come later. Here we are dealing with the eternal conflict between the scientist and the healer. As long as medicine remains an art, as it forever must, that conflict will always be resolved in favor of the healer.

I am one of those who believe that the term "medical science" has in it the makings of an oxymoron. In the sixteenth and seventeenth centuries, science began to enter the consciousness of the healers. Except in a theoretical sense, it could not be applied to the diagnosis of disease until the early nineteenth century, or to its treatment until fifty years later. Since then, the science of human biology has left off being a handmaiden—it has become the greatest partner that medicine will ever have. But the two allies must not be confused with each other. The healing of the sick remains an art, and it requires a spectrum of skills that range in rigor from those that deal with the cellule to those that deal with the psyche. Sometimes it includes even a bit of well-intentioned subterfuge. As long as judgment, clinical intuition, and bedside decision-making are major components in the treatment of sick people, all hail to the art of medicine. And all hail, also, to those two most unscientific of the physician's resources: listening to the patient, and caring about him.

Judgment, clinical intuition, decision-making—the taste and the smell, if you will, of a patient, his needs, the surroundings of his disease, and the pathophysiology of the process that has brought him to the doctor—these are the real ingredients of the art of cardiac transplantation. Science brought us to the point where we dared to think about such a chimerical fantasy, and even gave us the technical means to make it possible. The ultimate step and the ultimate success by which the chimera became a reality was, however, the product of a strictly clinical sense of what is right, of exactly what it is that this particular patient, at this particular stage of his disease, needs at this particular time. It involves also an informed guess about what will happen if he does not get it.

This particular patient, the one I want to tell about, is Ray Edwards, and his particular time was March 10, 1986. He was the beneficiary of eight decades of laboratory research and almost twenty years of clinical studies, which had resulted in perfection of the surgical methods and recent rapid progress in the prevention of rejection. Alexis Carrel and Charles Guthrie got things started in 1905 when they transplanted a puppy's heart into the neck of a large adult dog, and saw it beat normally for two hours. A long series of studies were undertaken by a number of investigators over the succeeding years, but never with any thought of applying the work in any clinical situation.

The picture changed considerably in 1953, when the heart-lung machine came into use, because it allowed both of those organs to be replaced during the time it takes to repair abnormalities of the major vessels and the atrial and ventricular chambers. There was thus available a piece of equipment that could bypass the heart, and make human cardiac transplantation a real possibility. Using such a machine in the laboratory, Richard Lower and Norman Shumway of Stanford University reported, in the early 1960s, a series of successes in attempting to transplant dog hearts. Although every one of the survivors rejected its new heart within a few weeks of operation, it had been established that good cardiac function took place even though all nerves to the heart had been cut. With the technical and physiological problems solved, Lower and Shumway continued their work to establish mechanisms by which rejection might be prevented, primarily doing research with histocompatibility testing, as well as the use of azathioprine and steroids.

This is where things stood on December 3, 1967, when Dr. Christiaan Barnard

astounded and delighted the world by performing the first transplant of a human heart on a patient named Louis Washkansky at the Groote Schuur Hospital in Capetown, South Africa. Much more astounded than the rest of the world, and a great deal less delighted, were Shumway, Lower, and the others of the several researchers who had been struggling in the laboratory to solve the problems of rejection. They knew that methods of testing for tissue compatibility were still unsatisfactory, and they feared that surgeons all over the world might rush to duplicate Barnard's premature feat. Their greatest concerns proved to be well founded. Three days later, a surgeon in Brooklyn transplanted a heart into a seventeen-day-old boy, who died a few hours later. Louis Washkansky himself died on December 21, the day before Barnard left for a six-day tour of the United States, during which he was lionized as a hero of medicine. Mayor John Lindsay was on hand to greet him on his arrival in New York, and President Lyndon Johnson entertained him in that unique style that is only to be experienced on the ranch of a Texas millionaire.

Barnard, who had learned about transplantation by working with Shumway, captured the imagination of America and Europe like a latter-day Lindbergh. He became an instant media star. Having already chosen his second patient, he flew back to Capetown on December 30, thereby providing an opportunity for a London newspaper to sell out its editions with the dramatic headline "Barnard Flying to Next Heart Operation." On January 2, Philip Blaiberg got a new heart. He was recovering smoothly on January 10, when the Brooklyn surgeon tried again. His patient died eight hours later. Blaiberg lived nineteen months, long enough to join his surgeon in the ranks of celebrity—even Liberace visited him the hospital.

The pressure was on, and even the cautious Shumway could not resist it for long. On January 6, 1968, he operated on his first cardiac-transplant patient, who lived for fifteen days afterward. With the highly regarded Stanford professor having entered the lists, a certain legitimacy was conferred on the cardiac extravaganza; more and more surgeons rushed off to the races. Reports of similar operations came in from England, Brazil, Argentina, France, Canada, and several centers in the United States. Finally even Richard Lower, by then at the Medical College of Virginia, succumbed to transplant fever. Still as worried as Shumway about not having solved the immunity puzzle, he operated on his first patient on May 25. In the previous month alone, thirteen people had undergone heart transplantation in hospitals throughout the world. Lower's patient lived six days. In the fifteen months following the operation on Louis Washkansky, 118 operations were done, in eighteen different countries. The great majority of the patients died within weeks or months.

Finally, the surgeons who had unripely rushed in with too much hope and too little restraint had to face the reality that it was still too early. The figure of ninety-nine transplants in 1968 dropped to forty-eight in 1969, seventeen in 1970, and only nine in 1971. Fifty-six of the world's fifty-eight heart-transplant teams closed up shop and returned to regular cardiac surgery. Barnard persisted, and so did Shumway. At Stanford, Shumway's became the only ongoing program in America, because his laboratory science was at such a high level that it could keep pace with his clinical surgery. Even in August 1970, he maintained enough faith to make a guardedly optimistic comment in an issue of *California Medicine:* "At this point we believe cardiac transplantation remains within the realm of clinical investigation."

Quietly and without fanfare, the Stanford group continued its work. As their methods improved, so did their clinical results. Encouraged by Shumway's reports, other teams gradually began to take heart, in a manner of speaking. Slowly, the long moratorium on cardiac transplantation began to come to an end. In 1984, twenty-nine centers in the United States performed approximately three hundred transplants. At the time of this writing, there are about one hundred American teams operating. Survival is now not only satisfactory, it is downright astounding. Seventy-five percent of these otherwise hopeless patients are alive at one year postoperatively, 65 percent at three years, and almost 60 percent at five years. There is every reason to believe that these figures, as remarkable as they are, will continue to improve.

In order to be considered a candidate for a cardiac transplant, a patient must be in such an advanced state of disease that life expectancy is estimated at no more than a few months. This is designated as Class IV in a categorization established by the New York Heart Association some years ago; it signifies end-stage failure of the heart muscle. The majority of such patients have severe coronary artery disease, and have lost a great deal of function in the ventricles as a result of multiple occlusions of these vessels. Another major group consists of those people who present with progressive deterioration of the heart muscle of undetermined cause, a condition termed idiopathic cardiomyopathy. Although it is often attributed to some preceding viral infection, the underlying basis of cardiomyopathy in any individual is usually difficult to pin down.

It was such a cardiomyopathy, thought to be viral in origin, that first brought Ray Edwards to a cardiologist. For no apparent reason, he began to find himself, in the autumn of 1975, to be increasingly tired and short of breath. Finally, in January of 1976, when he was unable to go on, he went to the emergency room of the Milford Hospital, only to be told that he was suffering from what the duty physician called "a classical case of hypoglycemia." Fortunately, he was given the name of an internist, Dr. Henri Coppes, in order to arrange for a proper workup of his symptoms. When Ray went to his appointment with the internist the following day, he had so much difficulty breathing that he could barely make his way from the parking lot to the office. Dr. Coppes immediately recognized the severity of the cardiac failure presented by his new patient, hospitalized him, and with consultation from a cardiologist, got him out of immediate danger.

Thus began a program of support for a heart that was trying desperately to fail. At first, Dr. Coppes was able to keep his patient in some reasonable semblance of health, but the situation finally began to deteriorate rapidly in 1983. Seeking further help, Coppes arranged for Ray to seek consultation with Dr. Lawrence Cohen, who carries with modesty and a sense of humor the splendiferous title of Ebenezer K. Hunt Professor of Medicine at Yale. By careful titration of medications, Dr. Cohen was able to bring about some improvement, but not enough to make him optimistic about the future. Ray's state of mind was not helped by a transient mild stroke he suffered in June of 1985, manifested by slurred speech. His heart rate had dropped from a normal of seventy-two down to twenty-eight beats per minute—a pacemaker was inserted to bring it back up to normal so that the output of the ventricles might be improved.

Dr. Cohen had first begun to consider heart transplantation for Ray as early as mid-1984. As his condition worsened, this possibility loomed ever larger. A cardiac catheterization and nuclear scans were done in October 1985, and the results were so discouraging that there seemed no other way to turn. With each beat, Ray's massively dilated left ventricle was ejecting only 15 percent of the blood within it. With such an ineffectual pump, it was only a matter of months before intractable failure would supervene. By the time of the catheterization, Ray was taking an array of medications that represented pharmacology's final offensive against the onrushing inevitability of his death.

On January 9, 1986, Ray met with the Yale–New Haven Hospital transplant team of surgeons, nurses, and technicians. The team's director, Dr. Alexander Geha, described the sequence of events that would lead up to the proposed operation, and those that were likely to follow it. Even were Ray Edwards a less stoic Connecticut Yankee than he is, his decision would have been the same. Taking as deep a breath as his congested lungs allowed him, he told Dr. Geha to start the countdown.

The following weeks were difficult ones for Monica and Ray Edwards. Even the meticulous manipulation of medications by Dr. Cohen did not slow the insidious decline of Ray's heart muscle. The threat of a sudden complete collapse loomed like death itself over each day of that long dreary waiting period for a suitable donor. Finally, after two months of restless anxiety, the call came. On the evening of March 9, 1986, Monica packed Ray's small bag, helped him into their Dodge, and drove the fifteen-mile distance to New Haven.

In another New England city, a second couple was also facing a tragedy, of quite a different sort. Unlike Ray Edwards, there was no possible miracle in store for them. On

the night of March 6, their seventeen-year-old son had been brought mortally injured to a local hospital, following an automobile accident. His chest was crushed in the collision, but his robust, healthy heart had not been damaged. It beat still, with the vivacity of youth, belying the ruined body that enclosed it. As gently as possible, the attending physicians told the boy's parents that he was brain-dead.

With what a mixture of courage and altruism and love must that grieving couple have made their decision. Left without hope, they had yet faith and charity. They asked that their son's heart and kidneys be transplanted into the bodies of three anonymous people who could not live without them.

Early on the morning of March 10, Dr. John Elefteriades, accompanied by one of the Yale surgical residents, arrived by helicopter from New Haven in that small New England city where the donor waited, his life having been snuffed out, in the eyes of the law, at the moment of impact four days before, but his strong young heart still beating as though in expectation of some form of reprieve. The boy was taken to the hospital's operating room with all of his mechanical life-support systems intact. Dr. Elefteriades and his assistant made an incision through the middle of the breastbone and harvested the living heart.

Here there is no choice but to pause—that word, "harvest." The transplanters use it so freely, but the rest of us have to stop and think about it every now and then. Perhaps you have never seen it used in such a sense. The word implies that the earth is yielding up its treasures to nourish mankind; it implies the performance of a worshipful act, the receiving of one of the benisons of a fructified soil; it implies a gift of God's abundance; it implies nourishment and life. The heart of an unknown youth was a golden harvest for Raymond Edwards. . . .

Ray Edwards was by this time anesthetized and connected to the heart-lung machine. As soon as Dr. Geha was notified that the helicopter had landed in New Haven, he started the bypass and began cutting away the flaccid bag of diseased cardiac muscle from his patient's chest. When Ray's pitiful excuse for a heart had been excised, its place was taken by the donor organ, which was then rapidly sewn into the proper vascular connections. As soon as all the suture lines were securely in position, the clamps that still separated Ray from his donor organ were removed, and a perfect, spontaneous beat started up instantly. The exhilaration of the operating team was just a bit premature, however, because a dysrhythmic fibrillating motion soon turned the heart muscle into a quivering mass of detumescent flesh. The surgeon immediately administered one quick burst of electric stimulation from the defibrillator, and the transplant resumed its proud, thrusting pulsation, becoming promptly a dynamic part of the still unaware patient whose sleeping body was preparing itself to become its welcoming new home. That single shock brought Ray Edwards back to life. An hour late, he was in the Cardiac Intensive Care Unit, gradually awakening to the realization that he and the heart of his young benefactor had begun their journey together, to a new vitality.

★　　★　　★

Ray Edwards was one of approximately one thousand Americans to undergo cardiac transplantation in 1986. Although there are estimated to be more than twenty thousand hearts potentially available each year and nineteen hundred patients who may be candidates for a transplant, there is not yet a sufficient national effort to ensure that each possible donor heart is used. At least a third of patients with end-stage disease die while awaiting a suitable heart. Through the North American Transplant Coordinators Organization and regional retrieval programs, mechanisms have been set up for speedy identification and transport of organs from one part of the country to another, but the major difficulty has remained a personal one. Too few American families have yet begun to think of transplantation as anything other than a newsworthy example of medical frontiersmanship at its most dramatic. What will be required for the future is a national sense of personal involvement, of a kind of imminence of the possibility that any of us, at any time, may need to decide that the last charity of someone we love may give life to another.

Lewis Thomas

"The Artificial Heart"

Lewis Thomas is the medical profession's premier essayist of the past 25 years. At the end of a prestigious academic and research career, Dr. Thomas began writing a popular column in the New England Journal of Medicine. *He soon gained a worldwide audience with* The Lives of a Cell *(1974), his first collection of these essays, which reflect his lifelong admiration of Montaigne. Unlike Montaigne, Thomas is enthusiastic about the positive role of medicine and physicians, yet this selection reveals one of his rare misgivings about the unqualified good of medical progress.*

A short while ago, I wrote an essay in unqualified praise of that technological marvel the pacemaker, celebrating the capacity of this small ingenious device to keep a flawed human heart working beyond what would otherwise have been its allotted time. I had no reservations about the matter: here was an item of engineering that ranks as genuine high technology, a stunning example of what may lie ahead for applied science in medicine.

And then, out of Salt Lake City, came the news of the artificial heart, a functioning replacement for the whole organ, far outclassing anything like my miniature metronome, a science-fiction fantasy come true.

My reaction to the first headlines, on the front pages of all the papers and in the cover stories of the newsmagazines, was all admiration and pleasure. A triumph, to be sure. No question about it.

But then the second thought, and the third and fourth thoughts, dragging their way in and out of my mind leaving one worry after another: What happens now? If the engineers keep at it, as they surely will, and this remarkable apparatus is steadily improved—as I'm sure it can be—so that we end up without the need for that cart with its compressors and all those hoses, an entirely feasible replacement for anyone's failing heart, what then? The heart disease called cardiomyopathy, for which the initial device was employed, is a relatively uncommon, obscure ailment, entailing very high cost, but for a limited number of patients; no great strain on the national economy. But who says that an artificial heart will be implanted only in patients with a single, rare form of intractable heart failure? What about the hundreds of thousands of people whose cardiac muscles have been destroyed by coronary atherosclerosis and who must otherwise die of congestive heart failure? Who will decide that only certain patients, within certain age groups, will be selected for this kind of lifesaving (or at least life-prolonging) technology? Will there be committees, sitting somewhere in Washington, laying out national policy? How can Congress stay out of the problem, having already set up a system for funding the artificial kidney (with runaway costs already far beyond the original expectations and no end in sight)? And where is the money to come from, at a time when every penny of taxpayers' money for the health-care system is being pinched out of shape?

I conclude that the greatest potential value of the successful artificial heart is, or ought to be, its power to convince the government as well as the citizenry at large that the nation simply must invest more money in basic biomedical research.

We do not really understand the underlying mechanism of cardiomyopathies at all, and we are not much better off at comprehending the biochemical events that disable the heart muscle or its valves in other more common illnesses. But there are clues enough to raise the spirits of people in a good many basic science disciplines, and any number of engrossing questions are at hand awaiting answers. The trouble is that most of the good questions that may lead, ultimately, to methods for prevention (for example, the metabolism and intimate pathologic changes in a failing myocardium, the possible roles of

nutrition, viral infection, blood-clotting abnormalities, hypertension, life-style, and other unknown factors) are all long-range questions, requiring unguessable periods of time before the research can be completed. Nor can the outcome of research on any particular line be predicted in advance; whatever turns up as the result of science is bound to be new information. There can be no guarantee that the work will turn out to be useful. It can, however, be guaranteed that if such work is not done we will be stuck forever with this insupportably expensive, ethically puzzling, halfway technology, and it is doubtful that we can long afford it.

We are in a similar fix for the other major diseases, especially the chronic ones affecting the aging population. Although nothing so spectacular as the artificial heart has emerged for the treatment of stroke, or multiple sclerosis, or dementia, or arthritis, or diabetes, or cirrhosis, or advanced cancer, or the others on the list, the costs of whatever therapy we do possess continue to escalate at a terrifying rate. Soon we will be spending more than 10 percent of the GNP on efforts to cope with such chronic health problems. The diseases are all comparable in at least one respect: it cannot be promised that scientific research will solve them, but it can be firmly predicted that without research there is no hope at all of preventing or getting rid of them.

The artificial heart could, with better science and a lot of luck, turn out to be, one day or other, an interesting kind of antique, similar in its historical significance to the artificial lung and the other motor-driven prosthetic devices that were in the planning stage just before the development of the Salk vaccine and the virtual elimination of poliomyelitis. Or the complex and costly installations for lung surgery that were being planned for the state sanatoriums just before the institutions themselves were closed by the development of effective chemotherapy for tuberculosis.

The biological revolution of the past three decades has placed at the disposal of biomedical science an array of research techniques possessing a power previously unimaginable. It should be possible, henceforth, to ask questions about the normal and pathologic functions of cells and tissues at a very profound level, questions that could not even have been thought up as short a time ago as ten years. We should be thinking more about this new turn of events while meditating on the meaning of the artificial heart.

Paul Monette
"Waiting to Die"

As the AIDS epidemic began to reach full force, the literature of introspection, witness, and grief soon appeared. One of the more poignant voices in this literature is Paul Monette's. Born in 1945, Monette is the author of five novels and three collections of poetry. With his most recent collection, Love Alone: 18 Elegies for Rog, *and with* Borrowed Time: An AIDS Memoir *(both published in 1988), Monette has contributed greatly to the growing body of artistic works describing the tragedy of AIDS.*

takes longer now: whole pharmacies of pain
killers and stopgaps, arsenals of slow
motion hand grenades lobbed at the viral
castle. The trickier thing is where to wait:
you pay by the day, no weekly rates in peak
season. Some are wasted at home craning

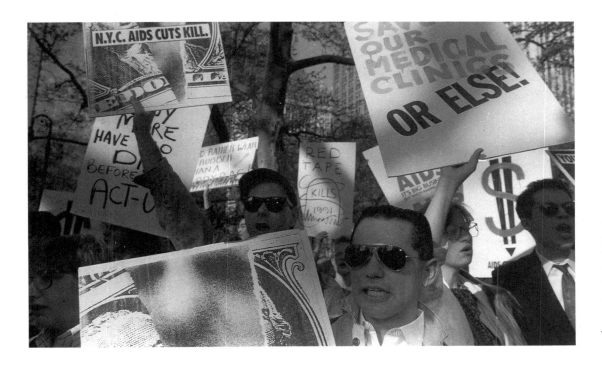

An AIDS Demonstration,
New York City. April 1991.
Photograph. *Activist groups
ACT UP and ADAPT protested
at City Hall against proposed
New York City budget cuts that
would affect treatment programs
for victims of acquired
immune deficiency syndrome.*

out the last bedroom window, some in camps
barbed in the high Mojave, very Japanese
in feeling. Some have no idea where.
Nobody waits all day, not every minute,
there's always sleep. Just last August I stopped
in David's garden, heatstruck as a sundial,
woozy with memory overload, forgetting
the late hour. Van Gogh waited in San Remy
blissed out on a jailyard's flowers, alive
as long as the irises, not dying half
so much as they. Go with the first frost
if possible, miss nothing green. David's place
wide as an island breaks into dogwood,
cherry and wild crab in about ten weeks—
too late now. Whereas spring is already out
of its mind in California, foothills gripped
by sudden pasture, moss on clay, overnight
jasmine clear as a bell. Mid-February
is May here, these narrow weeks of Irish
and months and months of summer coming, pale
as straw and ready to burn. "I look like
E.T.," David drawled, fetching a friend to
supper, careless of shuddering *maitre d's,*
fingers drumming Gershwin. A medicine chest
rides us like a sidecar, like the red-nosed
Fields with his hip flask: *I always carry
a bottle of snake-oil in my pocket. Carry
the snake too.* Spring grows steeper and
steeper, its fifty million irises alone.
Still, there must be something in bloom
somewhere to set on the snow of David's winter
island, being as the roses missed him.
A southern boy learns to play hard to get
before he's out of short pants. So do we

flirt with death, every stem we cut, the riot
of life in a single flower that will not last
the weekend. He never saw Hawaii at all
or anywhere West of East. "Oh you'll love it,"
I raptured, thoughtless in my August swoon.
Once I saw a hardy Boston lady stroke
a pot of ivy above her sink. "Westminster
Abbey," she boasted, who'd smuggled a cutting
through Customs in her purse. Why not that?
A specimen slip from the far edge of aloha,
cliffs for miles vertical green, exploding
orchids down a rotted volcano, rimless
emerald. Its furthest valley is a box
canyon facing the sea, unapproachable
by land. They don't have spring in places
that have no reason. There the leper Koolau
made his stand, him and a band of others
as other as he, who would not go to Molokai
when the great roundup gathered the stooped
and limbless, locking them in waiting rooms.
Angry like us Koolau held his valley
twenty years, the knit of his skin intricate
as a spider tattoo. Something from there would be
nice and gaudy in David's room, whose windows
command the white secret of his garden. A jade
plum sweet as Carolina after rain, borne
ten thousand miles, Venus chasing Mars across
the starry sky. Whatever hurts, whatever
dies at home, bring in flowers as long as
you can, because you are going West
where David is too soon, under this island,
all your waiting done. So go in bloom.

<div align="right">

David Almgren
2.14.88
West Island

</div>

Anonymous, M.D.

"Revised Hippocratic Oath"

This parodistic selection originally appeared in a publication called The Journal of Irreproducible
Results.

I swear by Apollo the physician, by Aesculapius, by Melvin Belli, and by my DEA
number, to keep according to the advice of my accountant and attorney the following
oath:

 To consider dear to me as my stock certificates him who enabled me to learn this art:
the banker who approved my educational loans; to live in common with him and to

acquire my mortgages through his bank and that of his sons; to consider equally dear my teachers, and if necessary to split fees with them and request from them unnecessary consultations. I will prescribe regimen for the good of my practice according to my patients' third party coverage or remaining Medicaid stickers, taking care not to perform nonreimbursable procedures. To please no one, with the possible exception of favored detail men, will I prescribe a non-FDA approved drug unless it should be essential to one of my clinical research projects; nor will I give advice which may cause my patient's death prior to obtaining a flat EEG for 24 hours. But I will preserve the purity of my reputation. In every clinical situation, I will cover my ass by ordering all conceivable labwork and by documenting my every move in the chart. I will faithfully accumulate 25 Category I CME credits per year, and none of these by attending Sports Medicine conferences on the slopes of Aspen. I will not cut for stone, even for patients in whom the disease is manifest, before documenting the diagnosis by I.V. or retrograde pyelogram and obtaining informed consent. In every house where I come I will enter only if a housecall is absolutely unavoidable, keeping myself far from all intentional ill-doing and all seduction, and especially free from the pleasures of love with women or with men. Or, for that matter, with both simultaneously. Such activities I will confine to my office or yacht. I will not be induced to testify against my colleagues in court, nor to disagree with them when asked for a second opinion. I will not charge less for any procedure than the prevailing rate in my community. All that may come to my knowledge in the exercise of my profession, such as diagnoses, prognoses, details of treatment, and fee schedules, I will keep secret and never reveal to patients; I will, however, cheerfully provide these to insurance companies. Finally, under no circumstances will I vote for Ted Kennedy or anyone else of his ilk. If I keep this oath faithfully, may I enjoy my life, build my practice, incorporate, find some solid tax shelters, and ultimately make a killing in real estate; but if I swerve from it or violate it, may a profusion of malpractice claims be my lot.

INDEX Page numbers in *italics* refer to illustrations.

CREDITS

Color illustrations: Jacket, Colorplate 1:
Scala/Art Resource, N.Y.; cpl. 4: Photo,
D. Pineider; cpl. 16: Scala/Art Resource,
N.Y.; cpl. 20: Photo, Deutsche Fotothek/
J. Schön, Dresden; cpl. 22: Photo: D.
Pineider; cpl. 27: Photo, Martin Holzapfel;
cpl. 28; 29: Lauros-Giraudon/Art
Resource, N.Y.; cpl. 30: Photo, INDEX/
Ravenna, Florence; cpl. 31: Scala/Art
Resource, N.Y.; cpl. 35; 36: Photo, Jörg
Anders; cpl. 38: Photo, Reinfried Böcher;
cpl. 40: Photo, Joan Broderick, 1985; cpl.
41: ©Photo Réunion des Musées

Nationaux, Paris; cpl. 42: Photo, INDEX/
Brenzoni, Florence; cpl. 44: Scala/Art
Resource, N.Y.; cpl. 45: Photo, Studio
Pizzi; cpl. 47: Oronoz, Madrid; cpl. 49:
INDEX/G. Costa, Florence; cpl. 53:
©Photo Réunion des Musées Nationaux,
Paris; cpl. 56: Photo, Kurt Haase; cpl. 60:
Oronoz, Madrid; cpl. 61: Photo, G.
Cussac; cpl. 64: Photo, Hugo Maertens;
cpl. 70: Scala/Art Resource, N.Y.; cpl. 79:
Giraudon/Art Resource, N.Y.; cpl. 81:
Art Resource, N.Y.; cpl. 88: Photo, Joan
Broderick; cpl. 92: Photo, Colorphoto
Hans Hinz; cpl. 94: Photo, Gasull
Fotografia; cpl. 103: Art Resource, N.Y.;
cpl. 112: Photo, William H. Bengtson;

cpl. 114: Photo, Robert Rubic. *Black and
white illustrations:* Page 32, 34: Alinari/Art
Resource, N.Y.; 38: The Bettmann
Archive; 51 right: ©Photo Réunion des
Musées Nationaux, Paris; 58: Photo,
Richard Caspole; 81: Alinari/Art
Resource, N.Y.; 85: Lauros-Giraudon/Art
Resource, N.Y.; 88, 97: Photos, M.
Rudolph Vetter; 108, 109: Photos, Joan
Broderick, 1984; 136: Bart's Medical
Illustration; 147: Photo, M. Rudolph
Vetter; 275: Brown Brothers; 278: UPI/
Bettmann; 297, 300: The Bettmann
Archive; 319: UPI/Bettmann; 362: The
Bettmann Archive; 371: Brian Palmer/
Impact Visuals.